W9-BWZ-914

THE ART OF ALL NATIONS
1850–73

THE ART OF
ALL NATIONS

1850–73

The Emerging Role
of Exhibitions and Critics

SELECTED AND EDITED BY

ELIZABETH GILMORE HOLT

Princeton University Press
Princeton, New Jersey

To Betsy, Jay, Peter

Anchor Books edition: 1981
Princeton University Press edition, 1982

Published by Princeton University Press, 41 William Street
Princeton, New Jersey
In the U.K.: Princeton University Press, Guildford, Surrey
Published by arrangement with Doubleday & Company, Inc.

Library of Congress Cataloging in Publication Data

Main entry under title:
The art of all nations, 1850-73.
 Bibliography.
 Includes index.
 1. Art, Modern—19th century—Themes, motives—
Exhibitions. 2. Art and society. 3. Paris.
Salons. 4. Art criticism. I. Holt, Elizabeth
Basye Gilmore. II. Triumph of art for the public.
 N6450.A79 701'.03

ISBN: 0-691-03996-8
Library of Congress Catalog Card Number: 81-47989

PREFACE

The middle of the nineteenth century, dominated as it was by displays of the arts of all nations, saw basic changes in the attitudes of the artists and the public to all forms of art.

News of an ever-expanding and encompassing world of art was brought to an expanding reading public by the proliferation of periodicals and papers. New discoveries and constant improvements in the processes involved in the reproduction of an image permitted more and more visual material to accompany the printed word. During the period from 1850 to 1873 the reproduction of a work of art was in the form of black-and-white copy provided by either a graphic artist or, after the 1860s, a photographer. Copper or wood engravings and lithographs by well-known graphic artists were used for illustrations in fine arts magazines when public interest in a painting or an artist was calculated to be sufficient to sell the print and warrant the cost. For the popular illustrated magazines, wood engravings of news events and works of art were quickly executed by a team of technically skilled, but usually anonymous, engravers. When multiple copies of photographs became economically and technically feasible, outstanding photographers made photographic copies for illustrations and for sale. Since marketability and popular taste determined what work of art was reproduced, apparently no engraving or photograph of Courbet's constantly criticized *l'Atelier* [*The Artist's Studio*] or the *Burial at Ornans* was

offered for sale until the twentieth century. The photographs selected as illustrations for this volume are reproductions of those by some of the period's foremost photographers.

Languages and writers differ in translatability. The difficulty involved in converting the thought of a writer into another language is increased when the writer manipulates his own language to assign new connotations to such words as "beauty," "ideal," "classical," "historical," "real," "natural," and so forth. The translations from the French are by Elizabeth Holt Muench and Susan Waller; those from the German are by David Armborst and John Holt; and those from the Italian are by Julia Wadleigh and Clare Wadleigh Hayes. Clotilde Schlayer gave invaluable assistance with the Italian and German translations and Lucie Arbuthnot with those from the French. These translations are offered as suitable equivalents of the original texts. It has been rightly said that "translations are like wives; the beautiful ones are apt to be unfaithful, the faithful ones ugly."* Bracketed footnotes are my additions to the original texts.

The compilation of texts was assembled to reflect attitudes to the fine arts throughout Europe, as expressed in criticism of exhibitions. It has benefited from the counsel and assistance of Jean Adhémar, Paola Barocchi, Ruth Butler, Wolfgang Freitag, Sandra Galgani, Horst W. Janson, Thomas Lersch, Ulrich Middeldorf, Agnes Mongan, Robert Rosenblum, Joseph Sloane, Gabriel Weisberg, and Siegfried Wichmann. This volume, like the preceding one, owes most to Susan Waller, who assisted me in the research, selection of texts, and throughout all stages leading to publication.

I am grateful for the privileges extended to me by Bowdoin College; the Boston Athenaeum; Harvard University; the Hertziana Library; the Kunsthistorisches Institut, Florence; the Bibliothèque de l'Art et l'Archéologie, Geneva; the Library of Congress; the University of Iowa; and the Zentralinstitut für Kunstgeschichte, Munich.

The encouraging support received from the Chapelbrook

* Robert Adams, *Proteus, His Lies, His Truth: Discussions of Literary Translation* (New York: Norton, 1972), p. xi.

Foundation and the American Council of Learned Societies made possible this volume's completion.

Elizabeth Gilmore Holt

Georgetown, Maine
1980

CONTENTS

Preface v
List of Illustrations xix
Introduction xxiii

1850–51: PARIS
The Official Exhibition of the State:
The Salon 1

Étienne Delécluze 9
"The Salon of 1850–51": II. Palais Royal;
III. Painting; IV. Painting; V. Sculpture;
VII. Landscape; X. Résumé. *Journal des Débats,*
January 7, 21, and 29, 1851

1850: LONDON
The Exhibition of a Semiofficial Society:
The Royal Academy of Art 30

Charles Dickens 38
"Old Lamps for New Ones." *Household Words,
A Weekly Journal,* June 15, 1850
Anonymous [John Forster?] 43
"Fine Arts—Eighty-Second Exhibition of the
Royal Academy"; First Notice; Second Notice
(Turner, Maclise, Dyce); Concluding Notice
(Millais, Hunt, Collins). The
Examiner, May 11, 18, and 25, 1850

1851: LONDON
The First International Exposition:
The Great Exhibition of the Works
of Industry of All Nations 49

Gottfried Semper 59
"Science, Industry, and Art." *Wissenschaft,*
Industrie und Kunst, Braunschweig, 1852

1852: PARIS
The Official Exhibition of the State:
The Salon 75

Edmond and Jules de Goncourt 82
"The Salon of 1852": The Regulations; Salon
Carré (Couture, Dupré, Rousseau,
Vernet); Right-hand Gallery (Landelle); Far
Gallery (Gallait, Meissonier); Second-floor
Gallery (Daubigny, Hoguet); Sculpture (Barye,
Rude); Lithography. *Salon de 1852,* 1852
Clément de Ris 94
"The Salon" (Courbet). *L'Artiste,* April 13
and May 1, 1852

1855: LONDON
The Exhibition of a Semiofficial Society:
The Royal Academy of Art 97

John Ruskin 101
"Notes on Some of the Principal Pictures
Exhibited in the Rooms of the Royal Academy"
Preface. Notes: Maclise, Dyce, Redgrave,
Millais, Leighton. [Privately printed], 1855

1855: PARIS
The Universal Exposition:
The First International Exhibition of Fine Art:
The Exhibition by an Artist of His Work 108

Rudolf Eitelberger von Edelberg 118
"Letters Concerning Modern Art in France at

the Paris Exhibition": I. The Position of French
Art; III. The Influence of the System of
Competition upon Art; VII. Sculpture in France;
X. Reflections; Epilogue: A French Opinion
About German Art at the Exhibition. K. K.
Wiener Zeitung, 1855, 1858

Edmond and Jules de Goncourt 132
"Painting at the Exposition of 1855": I. "Is
painting a book?"; II. ". . . Where are the two
great schools . . . ?"; III. [Materialists];
V. "Religious painting is no more"; VI. [Genre,
Portrait]; VII. "Landscape is the victor . . .";
VIII. "Let us take the world of art in hand";
IX. "England"; X. "Belgium"; XI. "France"
[Ingres]; XII. "Opposite Ingres . . ."
[Delacroix]; XIII. ". . . Where is style?"
[Decamps]. *La Peinture à l'Exposition de 1855,*
1855

Théophile Thoré [William Bürger] 144
"New Tendencies in Art"; I–IX. *Nouvelles*
Tendances de l'Art, 1857

Champfleury [Jules Fleury-Husson] 157
"On Realism, Letter to Madame Sand."
L'Artiste, 1855–56

1857: MANCHESTER
The International Historical Exhibition:
Art Treasures of the United Kingdom 164

Charles Blanc 168
"Treasures of Art at Manchester": I. The
Journey; II. The Palace; III. The Florentine,
Roman, and Lombard Schools; IV. Conclusion.
L'Artiste, 1857

1857: BERLIN
The Gallery Exhibition of a Dealer 177

Anonymous [Max Schasler?] 186
"The Permanent Exhibition of Paintings,

Sachse Gallery": (Larsson, Gude, Kaulbach, Menzel). *Die Dioskuren*, nos. 7 and 10, 1857

1857: PARIS
The Official Exhibition of the State:
The Salon 195

Jules Castagnary 199
"Salon of 1857": The Salon; Nature—The
Landscape; Man—The Portrait; Human Life—
Genre Painting. "Philosophie du Salon de 1857,"
Le Présent, 1857

1858: MUNICH
The National Historical Exhibition:
The Exhibition of German Art in Munich 214

Anton Springer 223
"The All-German Historical Exhibition":
I. (Carstens, Preller); II. (Pre-Raphaelites,
Cornelius, Kaulbach, Schwind); III. (Landscape,
Genre). *Die Grenzboten*, nos. 40–43, October
1, 8, 15, 22, 1858

1859: PARIS and LONDON
The Exhibition of a Society:
The Photographic Society of London
and the Société Française de Photographie 241

Anonymous 249
"The Exhibition of the Photographic Society in
Suffolk Street Gallery": First Impressions; Figures
and Landscapes; Portraits; Stereoscopic,
Miscellaneous, Conclusion. *Photographic Journal*,
V, no. 77, January 21, 1859

Philippe Burty 256
"The Exhibition of the Société Française de
Photographie at the Palais des Champs-
Élysées": I.; II. (Schools); III. (Portraits); IV.

(Landscapes); V. (Architecture); VII.
(Conclusion). *Gazette des Beaux-Arts*, May 15,
1859

1859–61: PARIS
The Official Exhibition of the State:
The Salon 265

Charles Baudelaire 272
"The Salon of 1859": I. The Modern Artist;
II. The Modern Public and Photography;
IV. The Governance of the Imagination. *La
Revue Française*, June 10–July 20, 1859
Théophile Gautier 282
"The A. B. C. of the Salon of 1861": General
Impressions; Painting (Baudry, Cabanel, Puvis
de Chavannes, Courbet, Doré, Gérôme, Manet,
Meissonier, Millet); Battles; Sculpture. *Le
Moniteur*, 1861

1861: FLORENCE
The Official Exhibition of the State:
The National Exposition of
the Kingdom of Italy 296

Pier A. Curti 302
"Italian Exhibition at Florence"; Fine Arts
Division: Sculpture (Dupré); Painting (Ussi,
Morelli, Malatesta, Induno). *Museo di
Famiglia* (November–December 1861)
Pietro E. Selvatico 308
"The State of Contemporary Historical and
Sacred Painting in Italy as Noted in the National
Exposition in Florence in 1861"; A Discourse
Delivered to the Academy of Science, Letters and
the Arts of Padua, 1861
I.; II. (J.-L. David, Delacroix); III. (Benvenuti);
IV. (Mussini, Ussi); V. (Bezzuoli); VI.
(Celentano, Morelli); VII. (Cabiano); VIII.

(Historical Painters); IX. (Battles); X.
(Historical and Sacred Painting). Padua, 1862
John Stewart 327
 "The Exhibition at Florence." *Art Journal,*
 September 1861

1861–67: FLORENCE
The Exhibition of a Society:
The Società Promotrice and
the Società d'Incoraggiamento 334

"Demo" 337
 "The Società Promotrice di Belle Arti of
 Florence: Seventeenth Year." *Il Mondo
 Illustrato,* May 4 and 18, 1861
"Luigi" [Giuseppe Rigutini?] 343
 "Florentine Chat: The Exhibition of the Società
 Promotrice." *Gazzetta del Popolo,* no. 301,
 November 3, 1862
"X" [Telemaco Signorini] 346
 "A Reply." *La Nuova Europa,* November 19,
 1862
Telemaco Signorini 349
 "Exhibition of the Società d'Incoraggiamento":
 VI. The Pictures of Fattori, Lega, and Borrani.
 Gazzettino delle arti del Disegno, January 31
 and February 2, 1867

1862: LONDON
The International Exhibition 355

John Leighton 364
 "On Japanese Art: A Discourse Delivered at The
 Royal Institution of Great Britain, May 1, 1863"

1863: PARIS
The Gallery Exhibition of the Dealer:
Martinet's Gallery and
the Official Exhibition of the State:
The Salon and the Salon des Refusés 378

Ernest Chesneau 384
"Contemporary Art: The Exhibition at 26
boulevard des Italiens." *L'Artiste*, February 15,
1863
Jules Castagnary 390
"The Salon of 1863": The Three Contemporary
Schools; The Classical School; The Romantic
School; The Naturalist School. *Le Nord*, May 14,
19, and 27; June 4, August 1 and 15; September
12, 1863
Philip G. Hamerton 413
"The Salon of 1863": Painting in France
(Baudry, A. Bonheur, Cabanel, Corot, Courbet,
Daubigny, Doré). *The Fine Arts Quarterly*,
October 1863
Jules Castagnary 424
"Salon des Refusés": I.; II.; IX. . . . (Jongkind,
Manet, Sutter, Whistler). *L'Artiste*, August 1
and 15 and September 1, 1863
Philip G. Hamerton 430
"The Rejected Pictures": (Whistler, Manet).
The Fine Arts Quarterly, October 1863

1864–67: NAPLES
The Exhibition of a Society:
The Società Promotrice 432

Francesco Netti 436
"Apropos the Third Promotrice Exhibition,
Naples, 1864–65": The Public Exposition;
Criticism; Execution and Truth; The *Macchia*
and the Finished Painting; The Subject and
History Painting. *Napoli Artistica*, 1865
Vittorio Imbriani 444
"The Fifth Exhibition of the Società
Promotrice": First Epistle; Fourth Epistle; Fifth
Epistle. *La Patria*, December 26, 1867, and
January 9 and 12, 1868

1866–68: PARIS
The Official Exhibition of the State:
The Salon 454

"Claude" [Émile Zola] 463
"My Salon": I. The Jury; III. Present-Day Art;
IV. M. Manet. *L'Événement*, April 27, May 4
and 7, 1866
Émile Zola 471
"My Salon"; II. Édouard Manet. *L'Événement
Illustré*, May 10, 1868

1867: PARIS
The Universal Exposition:
The Exhibition by an Artist of His Work 476

Ernest Chesneau 486
"The Rival Nations in Art: On the Influence of
the International Expositions on the Future of
Art." *Les Nations Rivales dans l'Art*, Paris, 1867
Édouard Manet 491
"Preface, Catalog of Paintings Exhibited at the
Avenue de l'Alma in 1867." *Catalogue des
Tableaux Exposés à l'Avenue de l'Alma en 1867*,
Paris, 1867

1869: MUNICH
The International Art Exhibition 493

Karl von Lützow 501
"The International Art Exhibition in Munich":
I. Introduction; II. Mural Sketches and
Watercolors of Historical Style by German,
French, and Belgian Masters; III. Historical and
True Genre, Portrait Painting; IV. Sculpture.
Zeitschrift für bildende Kunst, 1870, Bd. 5
Eugène Müntz 520
"The International Art Exhibition in Munich."
Gazette des Beaux-Arts, October 1869

1871: BRUSSELS
The Exhibition of a Society:
La Société Libre des Beaux-Arts 533

Léon Dommartin 539
"Manifesto"; Louis Dubois: "Our Program."
L'Art Libre, December 15, 1871

1873: VIENNA
The International Exhibition:
The Universal Exposition of Arts
and Industry in Vienna 545

Camillo Boito 555
"Painting at the World Exposition of Vienna":
I. Art of different nations; II. National painters,
Piloty; III. Genre paintings; IV. Italy. Sculpture:
I. Italy: Monteverde, Dupré, Vela; II. France:
Dubois, Falguière, Frémiet, Carpeaux. *Nuova
Antologia*, September, November 1873
Anonymous 569
"From the Austrian Kunstverein Künstlerhaus":
(Kaulbach's *Nero* and Courbet's *The Artist's
Studio*). *Zeitschrift für bildende Kunst, Beilage*,
June 6 and July 4, 1873
Anonymous 572
"The London and Vienna Exhibitions;
Retrospective." *The Builder*, December 6, 1873

Bibliography 577
Index 581

LIST OF ILLUSTRATIONS

1. Crystal Palace: *The Fine Arts Court, The Crystal Palace and Its Contents*, London, 1852.
2. Crystal Palace: *The Bay of the Fine Arts Court, Illustrated London News*, July 5, 1851, p. 20.
3. Powers; *Greek Slave, Illustrated London News*, July 5, 1851, p. 185.
4. Millais: *Jesus in the House of His Parents, Illustrated London News*, May 11, 1850, p. 336.
5. Leighton: *Cimabue's Madonna Carried in Procession Through the Streets of Florence*, engraving by C. Dietrich; *The Art Annual for 1884*, London, 1884.
6. Maclise: *The Wrestling in "As You Like It," Illustrated London News*, June 9, 1855, p. 568.
7. Meissonier: *Man Choosing a Sword*, engraving by M. O. Gréard, *Meissonier*, Paris, 1897.
8. Exposition Universelle, 1855: *The Queen's Visit to France, Illustrated London News*, September 1, 1855, p. 253.
9. Galerie Goupil, *Guide Paris Illustré*, 1867, p. 948.
10. Hébert: *La Malaria, Die Kunst des 19 Jahrhundert: Supplement der Kunsthistorische Bilderbogen III*, Bogen 7, p. 7.
11. Manchester Exhibition, *Art Treasures of Great Britain*. (Photograph of nave by Caldesi and Montecchi. Courtesy Museum of Fine Arts, Boston)
12. Menzel: *Concert at Sansouci, Illustrierte Welt*, 1883, p. 137.

13. Menzel: *The Meeting of Frederick the Great and Joseph II, Illustrierte Zeitung,* 1863.

14. Gallait: *Last Honors Paid to the Counts Egmont and Horn, Die Kunst des 19 Jahrhundert: Supplement der Kunsthistorische Bilderbogen III,* p. 32.

15. Schwind: *The Tale of the Seven Ravens.* (Photograph by Joseph Albert)

16. Carstens: *The Birth of Light, Die Kunst des 19 Jahrhundert: Supplement der Kunsthistorische Bilderbogen III,* p. 36.

17. Preller: *Ulysses and the Cattle of Helios,* engraving by Hummel, *Zeitschrift für bildende Kunst,* 1866, p. 24.

18. Defregger: *La Dernière Levée, Die Kunst des 19 Jahrhundert: Supplement der Kunsthistorische Bilderbogen III,* p. 57.

19. Gude: *Port of Refuge, Die Kunst des 19 Jahrhundert: Supplement der Kunsthistorische Bilderbogen III,* p. 52.

20. Daubigny: *Spring, L'Artiste,* 1857, sér. 7, vol. 11.

21. Courbet: *Return from the Conference, Die Kunst des 19 Jahrhundert: Supplement der Kunsthistorische Bilderbogen III,* p. 14.

22. Quillenbois: *The Realistic Painting of Courbet, L'Illustration, Journal Universel,* July 1855, p. 52.

23. Courbet: *Burial at Ornans.* (Photo: Giraudon, 17 257)

24. Waldmüller: *The Return Home, Die Kunst des 19 Jahrhundert: Supplement der Kunsthistorische Bilderbogen III,* p. 61.

25. Fattori: *The Three Soldiers.* (Courtesy Collezione Dott. Bartolomeo Pellerano, Genoa)

26. Palizzi: *Prince Amadeo Taken to an Ambulance.* (Photograph by Subalpino, *L'Album,* Turin, 1870)

27. Induno: *Begging for Alms, Gemme d'Arte Italiane,* 1851, anno V, p. 1.

28. Tideman: *The Lonely Old, Die Graphischen Kunste,* vol. I, Vienna, 1879, p. 60.

29. Ribot: *Kitchen Helper,* etching by Ribot. (Photo: Cabinet des Estampes, Bibliothèque Nationale, Paris)

30. Vito d'Ancona: *Dante and Beatrice,* Walker Art Gallery, Liverpool, England.

31. Celentano: *The Council of Ten, L'Album.*
32. *Japanese Court at the Exhibition of 1862, Illustrated London News,* September 7, 1862, p. 320.
33. Puvis de Chavannes: *War, Gazette des Beaux-Arts,* vol. X (1861), p. 205.
34. Doré: *Dante and Virgil at the Tomb of Farinata, Gazette des Beaux-Arts,* vol. XI (1862), p. 364.
35. Manet: *Spanish Singer [Guitar Player],* courtesy of the Cabinet des Estampes, Bibliothèque Nationale, Paris. (Photo: Arts Graphiques de la Cité, Paris)
36. Baudry: *Charlotte Corday, Die Kunst des 19 Jahrhundert: Supplement der Kunsthistorische Bilderbogen II,* p. 13.
37. Millet: *The Gleaners, L'Artiste,* 1859, sér. 7, vol. VI, p. 242.
38. Flandrin: *The Entry into Jerusalem,* engraving by J. B. Poncet. (Photo: Cabinet des Estampes, Bibliothèque Nationale, Paris)
39. Whistler: *Lady in White,* wood engraving by Timothy Cole. (Photo: Museum of Fine Arts, Boston)
40. Préault: *Massacre, L'Art,* 1879, vol. III, p. 3.
41. Carpeaux: *The Dance, L'Illustration, Journal Universel,* 1869, p. 329.
42. Dupré: *Pietà, Die Kunst des 19 Jahrhundert: Supplement der Kunsthistorische Bilderbogen III,* p. 24.
43. Vela: *The Prayer, Gemme d'Arte Italiane,* 1846, vol. 3, p. 27.
44. *Exposition Universelle,* 1867, aerial view, *Guide Paris Illustré,* 1867, p. 948.
45. Ussi: *The Abdication, Illustrazione Universale,* 1867, p. 219.
46. Piloty: *Seni Before Wallenstein's Corpse, Die Kunst des 19 Jahrhundert: Supplement der Kunsthistorische Bilderbogen III,* p. 57.
47. Leibl: *In the Studio, Kunst für Alle,* January 15, 1892, p. 117.
48. Lenbach: *Count Adolf von Schack,* etching by W. Hecht, *Die Graphischen Künste,* Vienna, 1883, vol. V, p. 24.

49. Böcklin: *Sea Idyll*, etching by W. Hecht, *Die Graphischen Künste*, vol. II, Vienna, 1880.

50. Kaulbach: *Nero, Über Land und Meer*, no. 31, 1874, p. 5.

51. Worcester Japanese Porcelain at the Vienna Exhibition, *Illustrated London News*, November 1, 1873, p. 420.

52. Makart: *Cleopatra, Die Kunst des 19 Jahrhundert: Supplement der Kunsthistorische Bilderbogen III*, p. 58.

INTRODUCTION

Nature supplies flowers,
Art wreathes them into garlands.

—GOETHE

The violence of the 1848 revolutions throughout Europe toppled many authoritarian powers—and the conspicuous symbols that represented them—from their pedestals. In Paris, Munich, Berlin, Vienna, several Italian cities and in Spain the ancient monuments were assaulted. But in some of these countries the turbulent uprisings also brought on vigorous and quick suppression, and with the restoration of monarchical government the statues were repaired and returned to their pedestals and commissions were awarded for impressive aristocratic portraits to hang in government offices.

In France, however, the Orléans monarchy was overthrown, and it was the government of the Second Republic that required new symbols for its authority. To replace the insignia of monarchy, designs for the great seal of the state and the new national currency, decorated with symbols of "Liberty, Equality, and Fraternity" were selected. Competitions were announced for a statue of the Republic, a national altar, and a painting of *La Patrie en Danger* [*The Country in Danger*], to be hung in the Salle des Séances of the National Assembly. As was the case after the revolution of 1789, the annual art exhibition sponsored by the government, the Salon, was organized without a jury and accepted entries from all artists.

In England, a haven for political refugees from the Continent, plans were under way for an exhibition such as had never been held before. For the first time, all the mechanical

arts, whether hand- or machine-made, along with the machines themselves, would be exhibited together. Of the "fine arts," only sculpture was to be admitted because it was executed with tools. An invitation to participate was sent to each country by the Society for the Encouragement of Arts, Commerce, and Manufacture. A startling design for an immense building of cast iron and glass was approved by the Society, and permission to erect it was secured from Parliament. Construction finally began in 1850, delaying until May 1, 1851, the opening of the Exhibition of the Works of Industry of All Nations. With the pomp and colorful ceremony traditionally associated with an exhibition of the fine arts, the Crystal Palace exhibition was opened by Queen Victoria in the presence of royalty and other heads of government or their representatives; the very presence of monarchs bestowed a new significance upon the objects on display, many of which were utilitarian, having been designed by artisans and produced by machine.

This English initiative awakened a new and worldwide interest both in manufactured objects and in the machines which produced them. At irregular intervals ever-larger expositions were organized throughout Europe, which drew exhibitors from ever farther corners of the world. Improvements in the design of machines could be noted and rewarded with prizes. The jury system traditionally used for fine arts exhibitions was adapted to select the winners.

Four years after the Crystal Palace exhibition, Napoléon III, who was crowned emperor of France in 1852, inaugurated the Exposition Universelle in Paris. The government grasped the significance of the English innovation and, eager for France to maintain its preeminent place in the European art world, combined for the first time the industrial products of all nations with the nations' fine arts in an international exhibition. This established a type of Olympic Games in which artists and artisans from all countries could compete for medals and awards. Following the French example, international fine arts exhibitions became a feature of subsequent world expositions. Paintings and sculptures from the different continents and countries were arranged in galleries situated

alongside those which housed industrial products, and were judged by an international jury. With industrial products, a level of excellence based on ingenuity, originality, and improvement of a machine's design could be demonstrated, recognized, and rewarded. In the fine arts exhibitions, paintings and statues were displayed in a neutral setting, removed from the environments that, in the past, had contributed to their symbolic associations. These had enhanced their meaning or significance for spectators and had allowed them to be judged by the standards of technical proficiency and subject matter that conformed to the values maintained by the academies and the tastes of the jurors.

Academy-controlled exhibitions of painting, sculpture, architecture, and engraving, which had become so important during the first half of the century, continued to hold sway. Throughout Europe the standards that France had established in the eighteenth century for its Prix de Rome competition continued to determine the jurys' selections of works. Instruction in art academies, ateliers, and schools was based on these standards, for artists from other capitals sent their work to the Salon and had to pass its jury for admission and to receive an award.

In France, however, the Academy no longer dominated the Salon as it had before the revolution. In an effort to balance the demands for reform—which, in 1848, culminated in an exhibition without a jury—with the standards that would prevent the Salon from becoming a free-for-all and would maintain the country's position in the art world, the administration of the fine arts altered the process by which the admission jury was selected. For several years members were named by election; in 1857 the Academy was again given the responsibility of selecting the works, a practice that continued until artists' protests forced the administration to initiate new reforms. Throughout all these changes, a newly created category, *hors-concours*, permitted artists whose achievements had been recognized by the government in the past to exhibit without submitting their work to the jury, and assured established artists of their place in the Salon.

As the Academy's hold on the jury was loosened, many of

the standards it had created were tempered. Early in the century a Salon entry could be submitted to the jury as an *ébauche*, or sketch, with the understanding that the *fini*, or finished, painting would be completed before the exhibition's opening. After 1848 the technical requirements for the finished work were relaxed, and artists began to exhibit paintings which some considered closer to an *ébauche* than a finished work. By 1850 the standards established in 1817 for the Prix de Rome in the category of heroic landscapes—standards that had barred Théodore Rousseau's landscapes from the Salon—were ignored, and Rousseau's paintings were finally admitted. Genre was expanded beyond the academic definition of still life to include subjects from everyday life, which could be composed and painted in a less finished method. A similar liberalization of definition occurred in other countries as jurors trained in the academies of the late eighteenth century were replaced by a younger generation.

Equally important in maintaining the state-approved style was the office of the Superintendent of Buildings, Arts and Manufactures, which had been responsible for mounting the French Salon from 1663 to 1849. This office, as well as its equivalent in every government, frequently made purchases from what was exhibited and awarded commissions for the paintings and sculptures to be placed in government buildings and public places. Such locations demanded large historical paintings illustrating episodes of civic heroism and virtue and sculptural figures symbolizing governmental power. In monarchies and republics, wherever funds were available for purchases and commissions, the standards of the state-supported school were observed, and when large-scale building projects were undertaken in Paris, Munich, and Vienna, the importance of the office increased. Artists eager to win a state commission sent to the official exhibition works designed to catch the eye of those who would make the awards.

Political change and industrial expansion had eliminated, to a large extent, the former class of private patrons. Its place had been taken by the societies or art associations founded by new patrons and connoisseurs to encourage the fine arts by supplementing the official exhibition facilities. In England,

the British Institution encouraged independent talent from 1806 to 1867 by providing an alternate place to exhibit. Art associations—such as the Kunstvereine in the German states, the Società Promotrice di Belle Arti in Italy, and the Art Union in England—were formed in the 1820s to give artists access to a wider market and to aid people with a new interest in acquiring pictures and sculpture. The express purpose of these organizations was to promote the sale of contemporary art by means of an exhibition, the cost of which was defrayed by the sale of lottery tickets. The purchaser of a winning ticket received a prize, a painting chosen from the exhibition by the selection committee. Less fortunate winners were compensated with an engraving of the prize picture or, in some instances, received cash for the purchase of a work of art. Local associations merged to form regional federations whose circulating exhibitions did much to determine "taste" in their area. The selection committee thus exercised great influence on the art market and was instrumental in enlisting or maintaining support for "acceptable" artists. Innovative work was exhibited but was rarely selected as a prize.

Artists whose work was not accepted at the official or the art-association exhibitions—either because of the medium or their stylistic innovations—founded their own organizations, which sponsored exhibitions to reach the public and gain recognition and support for their work. The precedent for independent artists' organizations had been established in England, where the Society of British Artists, formed in 1823, offered those of its members whose "progressive" work was excluded from the Royal Academy exhibitions an opportunity to exhibit. The watercolor societies sponsored that important branch of British art. In the second half of the century, photographers in England and France banded together to form societies to sponsor exhibitions of photographs and press for the medium's recognition as an art. The Società d'Incoraggiamento in Florence and the Société Libre des Beaux-Arts in Brussels were founded by artists who were dissatisfied with the place accorded their work in more established exhibitions. Sculptors had long opened their studios to visitors. Early in the nineteenth century, individual painters—Blake, Turner,

Carstens, Friedrich, David, Géricault, and Vernet—had begun to arrange private exhibitions. Sometimes these one-man—or one-picture—shows were held in the artist's studio or a gallery specially built for the occasion; for others the artist made arrangements to rent an exhibition hall, like the Egyptian Hall in London. After 1848 Manet and Courbet not only built galleries to show their work but published brochures which introduced it to the public.

The spread of wealth and the increasing number of persons who wished to own pictures and statues made it profitable for dealers who had long bought and sold old masters to acquire the work of contemporary artists for resale to clients. London art dealers supplemented the offerings available at the annual exhibitions of various societies. In 1853 the Frenchman Ernest Gambart instituted a yearly exhibition of work by his compatriots in London's Pall Mall. Louis Martinet, another enterprising Parisian dealer, was among the first to mingle the work of contemporary painters with that of recognized masters when he opened his elegant gallery on the boulevard des Italiens in Paris. Goupil opened his gallery on the rue Chaptal, in Montmartre, to younger artists in 1860. Suppliers of paints, paper and canvas accepted paintings in exchange for merchandise and then displayed the pictures in their shop windows. Cafes and restaurants frequented by innovative painters were often willing to hang the work of habitués on the walls.

The spread of wealth also increased the number of persons who desired portraits of themselves. For anyone unable to afford a bust in marble or an oil painting, a daguerreotype was available. It was soon followed by the photographic portrait and the popular *carte de visite*, invented by André Disderi. The comfortable, tastefully furnished salons where a "likeness was taken" were often expanded into a gallery in which paintings were displayed for sale. Max Sachse's lithography-photography studio in Berlin and the rooms of Pierre Petit, Disderi's successor in Paris, became important art galleries.

The academy, art associations, and dealer exhibitions included the work of contemporary artists, but the growing

awareness of history and a sense of national identity, defined in part by a nation's cultural heritage, encouraged the organization of historical exhibitions. In 1857 England assembled the "Art Treasures of Great Britain" exhibition in a building constructed expressly for this purpose in Manchester. Owners of paintings, sculptures, photographs, and objets d'art (i.e., the minor arts) lent their possessions. The works were grouped on the basis of national origin and arranged chronologically, a method that implied a progression or "evolution." (The word "evolution" had been brought into popular usage by Robert Chambers' *Vestiges of the Natural History of Creation*, 1844.) In 1858 the Kunstvereine of several German states organized the first all-German historical exhibition in Munich to demonstrate the characteristics and high quality of the German school. Proud of the artistic and cultural heritage of Lombardy and Milan, the Brera Academy opened a historical exhibition with the support of the Società Promotrice di Belle Arti.

The opening of an art exhibition had long been marked by ceremony and, in the case of official exhibitions, was attended by the monarch and his court. Local industrial exhibitions first held in the eighteenth century were accompanied by less ceremony. An event of social importance, the opening was reported in the press, and knowledgeable writers were required to describe the official ceremony and comment on the pictures and statues viewed by the royal party. Reports had appeared early in the nineteenth century in belles-lettres journals: the English *Examiner* and *Athenaeum*, the French *Revue des Deux Mondes*, the German *Grenzboten*, and the Italian *Album*. Soon there was sufficient interest to support magazines which stressed the fact that they were more than belles lettres. *L'Artiste*, founded in 1830, enjoyed wide circulation throughout Europe. The *Schnornsche Kunstblatt*, published between 1820 and 1848 as a supplement to the popular *Augsburger Allgemeine Zeitung*, was supplanted by *Das Deutsche Kunstblatt* in 1850. Art associations could rely on members to support a publication. In Berlin the Kunstvereine supported *Die Dioskuren*, and in London the Art Union published the *Art Union Journal* (1839), which became the *Art*

Journal in 1849. The *Gazette des Beaux-Arts,* the first French periodical devoted exclusively to art and events in the art world, was founded in 1859. The equivalent of the *Gazette des Beaux-Arts* in the German-speaking countries was the *Zeitschrift für bildende Kunst,* edited in Vienna and printed by the foremost publisher of art books in Europe, E. A. Seeman of Leipzig. The *Art Journal, Die Dioskuren,* the *Gazette des Beaux-Arts,* and occasionally the *Album* contained high-quality prints and, later, photographs which reproduced the paintings and sculptures that the magazine's editors assumed had wide appeal. Wood engravings in popular illustrated magazines like *L'Illustration* or the *Illustrated London News* reproduced the works that would attract subscribers.

To the reporters and critics sent to review the exhibitions fell the tasks of formulating aesthetic doctrine and assessing the place of contemporary art in the new industrial world. Some of the critics were the "tastemakers" of the time; their judgments were eagerly heeded by buyers. Many provided descriptive travelogues of the exhibitions, alerting readers to the works they should notice when they walked through the exhibition. Other critics were literary artists whose short stories or poems would appear in the same ephemeral journals or well-established magazines that published their reviews of exhibitions. Still others, like the Goncourts, were connoisseurs who attempted to distinguish differences in taste and spirit. For some critics the exhibition served as the vehicle for a critique of society.

Each interest of the artists during this period was analyzed and commented on by reviewers and critics. Reflected in the explanations or criticism offered to the public in the press is the gradual metamorphosis of European art as it shed the techniques and conventions of preceding epochs to mirror the enthusiasms, desires, and prejudices of the society that produced it. The respect accorded the image, that is, the picture or statue, was extended to include the objet d'art. By the end of the third quarter of the nineteenth century, a limitless world had been opened to the artist for the exercise of his talents.

1850 — 51: PARIS
The Official Exhibition
of the State:
The Salon

Throughout 1850 the people of Paris and artists everywhere anxiously awaited the French government's announcement of the arrangements for the annual Salon. In January the Association des Artistes, formed two years earlier during the February days of the revolution of 1848, had included a plea for an early Salon in their New Year's greeting to the Assembly, but as months passed the plans for the exhibition became immersed in debate, and it seemed to many that no Salon would be held in 1850. The artists' impatience was aggravated by their memories of the limited success of the Salon of 1849, which had been overshadowed by France's tense and uncertain political situation.

The constitution of 1848 had made France a republic; Louis Napoléon Bonaparte was elected President in December 1848, and after the May 1849 legislative elections he governed with an assembly dominated by Royalists. The President and the Royalists were not natural allies, but the left-wing Republicans had won enough seats in the Assembly to frighten them into cooperation. Adolphe Thiers, a member

of the Assembly and advocate of constitutional monarchy, became one of the President's advisers, and at his suggestion Royalists like Odilon Barrot were named to the Cabinet.

The news that French soldiers had been used, in violation of the French constitution, to repress the Republic of Rome and restore the temporal power of the pope provoked a Republican uprising in Paris, on June 13, 1849, that was easily put down. The Assembly ousted thirty-three socialist deputies. The Salon of 1849 opened two days after this uprising. It had few visitors: the political demonstrations and a recent outbreak of cholera had combined to keep Parisians from venturing out.

The exhibition was not a complete loss, however. Its regulations, issued in April 1849 by Léon Faucher, a liberal who had been appointed Minister of the Interior in December 1848 on Thiers's recommendation, and Charles Blanc, who had been named Director of Fine Arts in the spring of 1848, had incorporated several suggestions for the reorganization of the Salon made by artists and critics before the revolution.[1] One of these had been to find a new location. Many had objected to the practice of covering the Louvre's collection in order to hang works included in the Salon; the Louvre was now being refurbished under the direction of Philippe Jeanron, and the exhibition of 1849 was held in the Tuileries, vacant since Louis-Philippe's abdication. It was not the best choice—the Tuileries had neither wall space for huge historical paintings nor adequate light—but the effort had been made. Another was to have an admission jury for each of three sections—painting, sculpture, and architecture—and to have it elected by the artists submitting works. Artists who were members of the institute or had received the Légion d'honneur or first- or second-class medals, however, did not have to submit their works to the jury. The admissions jury

[1] In 1793, during the revolution, the Académie Royale had been abolished. Two years later it was replaced by the Institut de France. When the Institute was reorganized during the Restoration, each of its four sections was designated an academy; the Academy of Fine Arts of the Institute consisted of five sections: painting, sculpture, architecture, engraving, and music composition.

had also awarded prizes: Charles Müller, Jules Dupré, and Charles Sechan, the stage designer, were among those awarded the Légion d'honneur; medals were given to Théodore Rousseau and Antoine Préault—both of whom had been excluded from the Salon before the 1848 revolution, when the Academy had juried it—and to a relative newcomer, Gustave Courbet. At the awards ceremony in September, the President of the Republic remarked:

> I hope that next year's exhibition will be even more beautiful than this year's. The Emperor used to say to his soldiers that as long as there still remained something to be done, they had done nothing. Therefore, you also must redouble your efforts to contribute your part to refurbishing the glory of the French name.[2]

In the following months Louis Napoléon had begun to consolidate his power. In October 1849 he had forced the resignation of the Barrot ministry and appointed one of his own, chosen outside of the parliamentary majority, and in November he had exiled those Socialists who had participated in the uprising of the previous June. Philippe Jeanron (who, it was rumored, had harbored the Socialist Ledru-Rollin in the Louvre after the abortive uprising) had been replaced as Directeur Général des Musées Nationaux in February 1850 by the Comte de Nieuwerkerke, the lover of Louis Napoléon's cousin and official hostess, the Princesse Mathilde. By March, Louis Napoléon had acquired enough power to return control of the schools to the clergy, and by May he was able to rescind universal suffrage. In July the Press Law imposed a stamp duty on minor publications. Pictures of red caps, ties, and sashes and portraits of the exiled Socialists Ledru-Rollin and Barbes were declared seditious.

Amid these political changes, artists waited for the plans for the Salon of 1850 to be announced. All agreed that the Tuileries should not be used again, but when, in late April, the Assembly voted funds for a Salon to be held in the Palais

[2] "Récompenses décernées à la suite de l'Exposition de 1849, extrait du *Moniteur* du 14 septembre 1849"; published in *Catalogue, Salon de 1850.*

Royal, temporarily designated the Palais National, the Association des Artistes objected. They wrote to the Minister of the Interior and suggested that a temporary building be erected to house the exhibition and named possible locations. Nieuwerkerke, as general director of national museums, suggested another site. For a while it seemed that agreement was impossible and the Salon would not be held. Courbet had gone back to his family home in Ornans to prepare for the Salon of 1850. Impatient to learn of the public reaction to his works, he exhibited *The Stone Breakers, Burial at Ornans,* and two landscapes at Besançon in May and at Dijon in July before returning to Paris.

Not until September did the official *Moniteur* announce that the Salon would open in December in a temporary structure to be erected in the Cour d'Honneur of the Palais National. This solution to the impasse was credited to M. de Guizard, once a frequenter of Étienne Delécluze's circle, or *cénacle,* who had replaced Charles Blanc as Directeur des Beaux-Arts in the Ministry of the Interior. The temporary structure was to have at its center a room of the same dimensions as the Salon Carré in the Louvre and four more galleries around it; all would have skylights. Additional space was made available on the second floor of the Palais National.

On October 9, 1850, Guizard and J. Barouche, now Minister of the Interior, issued the regulations for the Salon. One change was made in the rules established the year before: Awards would be made not by the admissions jury alone but by those artists elected to the admissions jury who had received the highest number of votes and additional members named by the Minister of the Interior.

December 26 was named the opening date. On November 26 the jury was installed. Elected by 651 painters were Robert-Fleury, Decamps, Delacroix, Horace Vernet, Corot, Meissonier, Picot, Théodore Rousseau, Abel de Pujol, Diaz de la Peña, Ary Scheffer, and Eugène Lepoittevin and the engravers Henriquel-Dupont and François Antoine Gelée and the lithographer Mouilleron. It was almost the same jury that had been elected the year before. Chosen by 101 sculptors were Rude, Toussaint, Debay, Barye, David d'Angers, Peti-

tot, and Daumas. For the prize jury the government added six names to those of the top four painters and Henriquel-Dupont: Guizard; Nieuwerkerke, Inspecteur Général des Beaux-Arts; Cottrau; de Mercey, who was an attaché of the Minister of the Interior; Ferdinand de Lasteyiu; and Picot, president of the Academy. To the top four sculptors they added five names: Nieuwerkerke (who had been elected by the sculptors to the admissions jury in 1849), Fortoul, and Allier, both members of the Assembly, and the sculptors Augustin Dumont and Jean-Auguste Barre Père.

Construction on the temporary exhibition hall proceeded slowly, but the doors to the Salon of 1850–51 were finally opened on December 30, 1850, only four days late. The curious flocked in, eager to see the new exhibition facility. Sculpture was installed in the gallery of honor, where it could share in the favorable lighting that painting had long enjoyed. Until 1848 it had been seen at the Louvre in a dark, ground-floor hall where, according to Jules Janin, writing in *L'Artiste* in 1833, even a painting by Delacroix would have had difficulty attracting attention. Visitors were also surprised by the decoration of the new galleries, for which Charles Sechan, a pupil of Ciceri, had been responsible. An innovator in theater staging and a pioneer in "interior decoration," he had placed a colossal figure symbolizing the Republic in the center of the grand Salon Carré and an allegorical figure holding a garland of laurel in each corner. Instead of the traditional *boeuf sangue* (oxblood) of the Louvre, the walls were *bleue étoile* (sky blue). Against them Sechan had amassed flowers.

In this pleasing room hung the historical paintings, which, in the tradition of the Academy, would attract the greatest attention and, by virtue of this placement, were already destined to receive official recognition. Charles Müller's academically correct *Last Roll Call of the Victims of the Terror* dominated the room. Opposite the door leading into the far gallery hung Courbet's huge (twenty-three feet long and eleven feet high) *Burial at Ornans*, mistitled in the catalog as *Burial at Ornus*. Courbet's second-class medal of 1848 had won him the right to exhibit without submitting his work to

the jury. The hanging of Courbet's work highlighted its implicit challenge to "ideal art and noble subject," two qualities that had made French art supreme in Europe.

Among the early visitors to the Salon were the critics. Though the censorship laws of July had forced some small journals to fold, there would be over forty Salon reviews—about three times the number that had appeared in 1849. The reviews began appearing in early January and continued —except when forced to give way to reports of ministerial changes and political events—until May. Clément de Ris visited the Palais National for *L'Artiste*, which ran fifteen lithographic reproductions of works carefully chosen from among the three thousand exhibited. In the popular *L'Illustration*, numerous wood engravings accompanied J. Dupays's comments, and there were caricatures by Cham in the *Revue Comique du Salon de 1851*. Young Paul Mantz came for *L'Événement*, published by Victor Hugo's circle.

Few critics could ignore Courbet's works. Delécluze summarized their views.[3] Théophile Gautier visited the Salon for *La Presse* and wrote:

> Our young painter, parodying the verse of Nicolas Despréaux,[4] seems to have said to himself, "Nothing is beautiful but ugliness, ugliness alone is desirable." Plebian types do not satisfy him; he chooses, but in another direction, he intentionally exaggerates the crude and the trivial. Boucher is a mannerist of prettiness; M. Courbet is a mannerist of ugliness; but both are mannerists; each flatters nature in his own way; one lends her graces, the other assigns to her crudities that she does not possess. Happily the pink of the former is no more accurate than the ochre of the latter.

In *Vote Universel*, Pierre Petroz commented:

> Since today we are less stiff-necked, no one is scandalized by M. Courbet's audacious attempts. For our part, we believe that they mark new progress toward complete sincerity in art. In adopting for genre painting the dimensions reserved for history

[3] Étienne Delécluze, *Exposition des Artistes Vivants* (Paris, 1850). The following quotes by various critics are cited from pp. 253–58.
[4] Nicolas Despréaux Boileau (1636–1711), the satirical poet

painting, M. Courbet has perhaps indicated the distinctive character of contemporary art.

Champfleury, a friend of Courbet, defended the latter's works in the *Messager de l'Assemblée:*

> As for the so-called ugliness of the bourgeois of Ornus [*sic*], it is not at all exaggerated or false, it is true and simple. It is the crudity of the provinces, which must be distinguished from the crudity of Paris. . . . Happily, the time of the pantheists, who made nature play such trivial comedies, has passed; realism has appeared, serious and convinced, ironic and brutal, sincere and full of poetry. . . .
>
> The din caused by the *Burial at Ornus* [*sic*] in the Salon Carré is understandable. From a distance as one enters, the *Burial* appears framed by a doorway. You are surprised, as at the sight of those naive images on wood, engraved by an awkward hand, which are found on the masthead of [a scandal sheet publicizing] murders, printed by Chassaignon in the rue Git-le-Coeur. The effect is the same because the technique is just as simple. . . . This is not austerity, it is the modern bourgeoisie at full length, with his follies, his crudity and his beauty. . . .

Recognized by all the critics as he went methodically from gallery to gallery was seventy-year-old Étienne Delécluze (1781–1863), their dean. He was art and drama critic for the *Journal des Débats*, the daily founded in 1799, which had been carefully steered through successive political storms by its owners, the Bertins, a family of distinguished journalists. Its ten to fifteen thousand subscribers were an elite among the bourgeoisie. The paper discussed current questions from a conservative position. Delécluze had joined the paper after he had given up a painting career.

He had been a student in David's studio and had won a first-class medal in the Salon of 1808, but, refusing to compromise his republican sympathies and accept state commissions from an emperor, he had turned to letters. His first Salon review had appeared in 1822 in the *Moniteur*. He had joined the *Journal des Débats* that autumn and, embarking in June 1823, traveled to Italy for fourteen months, sending back accounts of the art and monuments he studied. He re-

turned to Paris in time to write a report on the Salon of 1824. This review established him as a champion of the "Homerists," exemplified by the style of Ingres's paintings. He had disapproved of the "école du laid," or "Shakespearians," whose tendencies had been brilliantly present in Delacroix's *Massacre at Chios*.[5]

As a classicist, Delécluze had early accepted sculpture as the standard for painting. Ideal beauty was found in Greek sculpture, a view reinforced by the discovery of the *Vénus de Milo* (1822) and defended by Antoine Quatremère de Quincy, sculptor, aesthetician, permanent secretary to the Académie des Beaux-Arts, and Delécluze's cherished friend. Sculpture, therefore, was always thoughtfully reviewed by him, whereas other critics mentioned it cursorily. For almost thirty years in his weekly column on art or music Delécluze had defended the standards maintained by the Academy.

Confronted at the Salon of 1850–51 by what he regarded as anarchy, Delécluze felt obliged, for the first time, to reach a wider circle by republishing his reports of the Salon as a book. At this Salon exponents of a new school of sculpture appeared who did not meet Delécluze's standards. To the volume he added a résumé to point out, with the full force of his position, the danger contemporary painting posed to artistic standards. One threat he recognized was a shift from Italian classical models to the northern European school; another was carelessness in technique. He was also alarmed by some of the paintings that depicted episodes of the Terror. Although events of that period, which had occurred more than fifty years before, were still indelibly fixed in his memory—as they were in those of most men of his generation—it was nonetheless difficult for him to reconcile works dealing with those horrors with aesthetic principles that required artistic standards which called upon artists to depict the ideal. Delécluze's standards—identical to those the Academy maintained when they awarded the Prix de Rome to students of

[5] See Elizabeth G. Holt, *The Triumph of Art for the Public: The Emerging Role of Exhibitions and Critics* (Garden City, N.Y.: Anchor Press/Doubleday, 1979), p. 280

the École des Beaux-Arts and through state awards and Salon admission—were now being flaunted in the Salon itself.

Étienne Delécluze: *The Salon of 1850–51*[1]

II. Palais Royal

Of the 50 exhibitors from the first exhibition that took place in the Palais Royal in 1673, we find that the names of one third have remained famous; from the exhibition which took place in the Louvre in 1810, 21 names of artists have been remembered: one twenty-fourth of the total number of 533 exhibitors that year.

Now, the catalog of the Exhibition of 1850 indicates a total of 1,664 exhibitors, including 1,306 painters, 204 sculptors, 44 architects, 78 engravers, 32 lithographers. It also lists 3,952 works of art on display, including those added to the supplement.

Considering, as we have already done for 1810, that of the 1,664 exhibitors in 1850, 21 are destined to still be famous in thirty or fifty years, it should follow that the elite of this year's exhibitors will form only one eightieth of the total number of artists whose works were admitted to the Palais National.

To spare the illusions of the "progressives," and with all due respect to this "je ne sais quoi" that is called posterity, we will raise the number of the elect of 1850 to 42 instead of 21, so that they will form one fortieth of the total exhibitors this year. In spite of these concessions, however, here is the report on the people who have remained, or will remain, famous, along with that of the exhibitors:

1673: 50 exhibitors, 18 celebrities
1810: 333 exhibitors, 21 celebrities
1850: 1,664 exhibitors, 42 assumed celebrities

[1] [Excerpts from a series of articles originally published in the *Journal des Débats*. II. Palais Royal, 7 January 1851; III. Painting, 21 January 1851; IV. Painting, 29 January 1851; V. Sculpture; VII. Landscape; X. Résumé. Delécluze published the collected articles as *Exposition des Artistes Vivants* (Paris, 1851), with the addition of a "Résumé," from which this translation is derived.]

I will leave to the individual the possibility of modifying the number of distinguished artists I assign to the years 1673, 1810, and 1850; but I call the attention of serious men, politicians, philosophers, and artists to the monstrous increase in mediocrity in the space of 167 years; for (in order to finish with calculations), if one adds to the 3,952 works admitted this year the 1,600 pieces refused, it may be boldly advanced that the number of artists hoping to exhibit rises to 2,500.

For fifteen years and more, I have not failed each year to point out to the public the serious disadvantages of annual exhibitions. If I am not mistaken, a very abridged but rigorously exact history of these celebrations, now so frequent, may finally open everyone's eyes to the effects of an institution, valuable in itself, whose abuse, I am not afraid to say, is very disturbing for the future of art and true artists, and finally for governments, whichever they may be, which, like new Cadmuses, sow and give birth to painters and sculptors who will soon devour each other if the state does not nourish them. It is obvious to any man who is *au courant* that the quantity of artists and the number of works they have produced in the last twenty years goes far beyond the need that might be felt in France to decorate churches, public buildings, and private dwellings. After an exhibition, there is not a soul who wonders what becomes of the 1,200 to 1,500 paintings that have been seen, and with good reason, because, apart from the fact that palaces, châteaus, and mansions are becoming very rare, the Lilliputian apartments built for us today in no way lend themselves to accommodating this style of decoration.

Almost all works of painting and sculpture thus fall into the hands of the government, which, having provoked the excessive growth of a crowd of artists, is forced to pay for the fantasies of painters who, for example, often do enormous, uncommissioned paintings for which it is sometimes impossible to find a building, not only because there are few buildings with wall surfaces equal to that of the canvas but also because there are no buildings where the subject would not be incongruous. . . .

Today, let us consider the exhibition. Everyone approves of

the interior arrangements of the new building constructed for the exhibition. It is easy to move about the galleries surrounding the large central hall. Everywhere the light falls equally on the paintings and the statues, and the combination of the marble and the paintings produces a very agreeable effect, at least on the interior decoration of the new edifice.

As it was impossible to place and hang the surplus of artworks in the rooms of the second floor by December 31, the Exhibition of 1850 was not completely opened until January 3, 1851.

When one has climbed the great double staircase and arrived at the upper peristyle, there are no less than thirty-four rooms and galleries to examine in order to obtain a brief idea of the paintings and sculptures exhibited. . . .

However, let us begin. After a very close, though rapid, examination of the Palais Royal's contents, here is the result of my impressions. I believe to have found, first, that the poetic level of art, which has been gradually decreasing for twenty years, has fallen even lower since 1849; second, that all the young artists gifted with some energy and talent have been led, by relying on the methods of imitation and execution bequeathed them by second- and third-rate masters, to portray real, even vulgar, subjects; third, and finally, that the painting of fantasy—grimaces, burlesques, and theatricals—has tended to replace the anecdotal genre so much favored a few years ago.

These general observations on the compositions of figure painters are equally applicable to those of landscape painters.

In spite of the whims of certain sculptors who try to "paint" in clay, marble, or bronze, sculpture, to judge by the best pieces included in the exhibition, continues on the right road, in that it wisely confines itself to the limits imposed on it by its nature and looks upon imitation as the means of attaining its objective, which is the expression of beauty. . . .

[T]he sculpture this year is infinitely superior to the painting, especially because sculpture has not allowed itself, like its sister, to succumb to the vulgar charm of an ordinary imita-

tion or to the calculated portrayal of the common, the ugly, or sometimes the ignoble.

But we must be even more grateful to those painters who, forcefully holding themselves back from the inclination that is carrying away their colleagues, seek to remain in the upper spheres of art. . . .

With his usual wisdom and profundity, Aristotle wrote the history of art in two lines and pointed out the modes successively adopted by artists, depending on the period when they live. "Polygnotus," says the philosopher in his *Poetics*, "painted men better than they are, Pauson [*sic* for Pausias?] worse, and Denys portrayed them as they are." This means that Polygnotus painted only heroes and gods; that vulgar, ridiculous, base scenes and caricature were the share of Pauson, and that Denys, not wanting to rise to the ideal nor descend to caricature, confined himself to reality.

Contemporary descendants of Polygnotus are rare, but we are rich in painters who, like Pauson, enjoy, in their choice of subjects and forms, showing man's ugly, grotesque, repulsive aspects. Perhaps the cult of ugliness has never been practiced as freely as it has this time by M. Courbet in his painting of a *Burial in the country* (at Ornus [*sic*]). . . .

In this scene, which might pass for the result of an impression of a daguerreotype that came out poorly, there is the raw naturalness which one always obtains if nature is caught in the act and reproduced just as captured. As for art, not only is there no shadow of it in this composition, but it is clear that the author has very purposefully avoided putting any in, and that he has even affected an ignorance and simplicity which he is far from possessing. This is a deliberate attempt— even a wager the artist made with himself—to transform himself, as I said, into a daguerreotype and to sacrifice his intelligence in order "to fix" on the canvas what impressed him. But in 1850 one can no longer be the dupe of these little hoaxes. Everyone knows well that for twenty-five years now, complete ignorance of a science or an art has become impossible for all of us who live in an encyclopedic atmosphere whose heat is maintained constantly by courses, books, manuals, museums, and engravings that speak of everything to ev-

eryone. How can one believe that M. Courbet alone could have escaped this scientific chaos in the midst of which we live, especially if, after having accustomed one's eye to the repulsive aspect of his interment, one discovers in certain details of this canvas some parts that are very well painted and even whole figures which reveal a very uncommon skill? Among the people attending this burial, there are some women; especially the one whose face is almost entirely hidden by a handkerchief is not only remarkable because of her real, touching expression, but is treated in a bold, elevated style. How could the artist who did this figure decide to paint two base caricatures such as those of the beadles, who inspire disgust and provoke laughter in the middle of a funeral ceremony, unless, I repeat, this has been done deliberately to defy cheerfully and heartily the conventions of art and all the rules of good sense? No, in spite of the grave faults that mar M. Courbet's large painting, this work includes qualities which are too solid and certain parts of which are too well painted for us to believe in the affected savagery and ignorance of this artist. On this subject, I call on all who have seen a head painted by him and exhibited in the west gallery on the ground floor [*Man with a Pipe*]. This head of a man holding a pipe in his mouth is the portrait of the author. Aside from the cast of the artist's features, which in no way corresponds to the eccentricity of the *Burial at Ornus* [*sic*], this painting is done with rare talent, in a manner which leaves no doubt about the study its author must have made of the Carracci and especially of the painters of the Spanish school. One notices the suaveness and the boldness of the brushstrokes, which are completely remarkable, the skill of the halftones, which are no less so, and the finesse in the imitation of forms and expression which prove that M. Courbet is, after all, much closer to being clever than to being simple and naïve. Without stopping to consider two other pictures by this painter, *The Stone Breakers* and *Return from the Market*, which seem to me insignificant, I shall then tell M. Courbet that, in my opinion at least, the head of his smoker is the best painted piece in the Exhibition of 1850; that his *Burial*, in spite of undeniable qualities in certain de-

tails, is a very bad painting; and that, in sum, he will do well
to be on guard against exaggerated praise that his friends and
admirers—for he has some—might lavish upon him.

In order to broach the subject, I have chosen the *Burial* by
M. Courbet, because the worth of this strange production will
give more force to the severe criticisms deserved by the artists
called *naturalists*—those who, regarding imitation as the final
aim of art, claim that everything, even the ugly and the base,
can and must be depicted, on the one condition that the imi-
tation be faithful; this is the most glaring error that might
unhinge an artist's mind, an error which the study of antiq-
uity and the great modern masters had caused to disappear,
but which the infatuation with the Spanish school had made
more enduring than ever. . . .

Today I am not yet sufficiently informed about all the
works in the Palais Royal to affirm that the painting by M.
Hébert is the best of its kind; and I would consider the pub-
lic fortunate if it found a work which was preferable; but I
may reply from today on that this painting is worthy of all
the attention of true art lovers. . . .

This charming painting [*Malaria*], about one and one half
meters wide, is full of poetry. Its execution is excellent, its
color true and perfectly adapted to the subject; and although
the author, M. Hébert, lives in Rome, nothing in his works
betrays the banal habits of the school. His subject comes
from a lively impression he received from nature; he knew
well how to render it so skillfully that one believes there is no
skill in it. Now that is the great secret of being a true painter.

III. Painting

If a superior, accepted authority could select what is good
from everything dispersed in the numerous rooms of the
Palais Royal, a remarkable exhibition might certainly be put
together. It would undoubtedly still have the flaw I have
pointed out: that of the abundance of subjects which are too
ordinary and are rendered even more prosaic by the slipshod
manner of execution preferred and sought after by the young
artists who have just begun their careers, but it would have a

certain "ragoût de pinceau," as was said eighty years ago, which has become fashionable again these days.

In France, as well as in the nations inclined to become overcivilized, we are better suited to perfecting and modifying than inventing. By virtue of this principle, which I now apply to the cultivation of the arts, one may be assured that when a stimulus we ordinarily receive from the outside leads our painters—as happened under Francis I—to occupy themselves particularly with form and, consequently, drawing, we become draftsmen; that if works of sculpture are offered to us as models—as occurred about 1754 in the scientific work of Heyne and Winckelmann[2]—even our painters compose a sort of bas-relief and apply themselves exclusively to rendering form to the neglect of color. Finally, the moment comes when mediocrity tires of struggling to apply the severe and unalterable principles of the higher schools, and it adopts less troublesome laws under which weak and doubtful talents may peaceably vegetate. At this point, then, this mediocrity is freed from all hindrances and raises its head, swarms, and multiplies to the point where it disdainfully rejects what has been recognized as true for twenty centuries, remakes the rules for its own convenience, and substitutes the most extravagant sophisms for incontestable verities. It was thus that *romanticism* allowed ugliness to triumph in the arts twenty years ago; in the same way today, *naturalism*, its progeny, still refining this bizarre idea, not only willfully neglects form but tries to reduce all the interest and essence of the art of painting to that of coloring. . . .

Of all the remarkable artists exhibiting this year, M. Charles Müller is perhaps the one who most sharply and worthily represents the spirit and flexible tastes of French painting. If this spirited artist had entered the field in 1808 or

2 [Christian Gottlob Heyne (1729–1812), classical scholar and archaeologist, the author of *Antiquarische Aufsätze* (1778–79). Johann Winckelmann (1717–68), archaeologist and art historian, wrote *Gedanken über die Nachahmung der Griechischen Werke in der Malerei und der Bildhauer-Kunst*, 1755 (*Reflections on the Painting and Sculpture of the Greeks*) and *Geschichte der Kunst des Alterthums*, 1864 (*History of Ancient Art Among the Greeks*).]

1810, no doubt he would have painted, and with talent, Agamemnons and emperors at Marengo or Vienna. But since he only left the schools when M. Delacroix had already established a reputation, he imitated this artist and executed some fairly bizarre mischiefs. Later he changed his manner and, captivated in turn by the *far-niente* of M. Winterhalter and the diamondlike paintings of M. Diaz [de la Peña], he exhibited some rather unnatural paintings in which there reigned an extravagance of composition and a brilliance of color which caught the public's attention. Finally, either because the years matured this artist's ideas or because a sojourn in Rome made him recognize that painting is a more serious art than he had first believed, M. Charles Müller painted his *Macbeth*, which last year brought him a deserved distinction, and this year he has shown the *Roll Call of the Last Victims of the Terror* in the prison of Saint-Lazare, from the seventh to the ninth of Thermidor, 1794, the painting which attracts the most public attention in the Palais Royal today—as much by its enormous size as by its merits, for it is thirty feet wide.

As I have said several times, I do not claim that the rule of putting only three characters onstage (as Horace has it: *Nec quarta loqui persona laboret*)[8] must be rigorously followed. [A] crowd, in painting as well as on the stage, is a fault that tends to destroy the subject's unity; and in spite of the excellent merit of Shakespeare's dramas, his most fervent admirers agree that the number of his characters harms the unity of his plays. What is true for dramatic art is even more so for painting and, in effect, the paintings of Leonardo da Vinci and Raphael, in which these artists have concentrated all the force and delicacy of their talent, hardly ever include more than five or six figures.

Essentially, as M. Charles Müller himself was perfectly aware, the soul of his subject, his true subject, is André Chénier,[4] the poet so possessed by his art that he forgets his death sentence, remains deaf to the voice of the bailiff who calls him, and continues composing verses while his compan-

[8] [Horace, *Ars Poetica*]

[4] [André Chénier (1762–94), the neoclassical poet, wrote the elegy *La Jeune Captive* while in prison.]

ions in misfortune have only one idea which extinguishes all others—that of the death that threatens them.

I am not in the habit of redoing artists' paintings, for, on the contrary, I humbly accept their point of departure in order to identify myself with their principal idea. However, on this occasion, would it not be permissible to think that if, instead of having scattered sixty characters over a canvas thirty feet long, the author had limited himself, by relegating this crowd to the background, to presenting to the spectator only the figure of André Chénier, whose pose, feelings and scorn of death sum up so energetically what those around him feel? Would not the composition have had more unity and would it not have produced more of an effect? Rigid moralists at least, I fear, would be justified in reproaching M. Müller for having treated his subject as a genre painting rather than as a history painting.

Such is the chief criticism that may be made of M. Müller's large painting. As for the picturesque merit of this work, it is incontestable. This horrible scene is well presented, the groups are distributed skillfully and all the nuances of courage, grief, and resignation are perfectly expressed by the movement and the faces of the men and women who are awaiting their fate from an insolent bailiff's mouth. A hideous *sans-culotte* sits nearby, lights his pipe while coldly regarding the faces of those already destined to die. However, the truth and power of the coloring constitutes the principal merit of this work. . . .

Since I am bound to stop before such subjects and to turn my thoughts back to that frightful period—I was thirteen at that time—I will note a painting even more horrible than M. Charles Müller's: It is M. A. Debay's, and in the catalog it is only called *Episode in 1793, at Nantes.*[5] Originally the canvas was larger and at the left showed the instrument of torture; today one sees only the stairs leading to the scaffold and the victims awaiting their turn to die: That is the painting's subject. Not far from an old man whose hands are being tied,

5 [The massacre at Nantes was precipitated by the Convention's efforts to enforce a *levée en masse.*]

one sees a mother and her three daughters apparently await-
ing the same fate. The mixture of religious resignation and a
sort of faintness, caused by these women's realization of the
few moments left in their lives, have been very poetically ren-
dered by M. Debay. The mother's serenity, which in this ter-
rible last moment she communicates to her children, touches
the heart and uplifts the spirit and mitigates, as far as is pos-
sible, the revolting aspects of this pitiful massacre.

But although both these artists have treated episodes from
our history's most deplorable period with admirable inten-
tions, I would advise them—along with their young colleagues
—to give up similar subjects: They only revive painful memo-
ries, risk fostering hatreds, and are absolutely futile as warn-
ings. . . . The truth is that paintings and engravings of this
kind, rather than discouraging evil passions, become, on the
contrary, valuable lessons for the mad and the wicked who
wish to know how to make mischief.

And then, I think I should confess to young artists that I
tremble when I see them participate—even by painting—in
politics and revolution. . . .

IV. Painting

It would be useless to try to hide the taste and propensity of
the latest generation of our painters for the vulgar and ugly.
The grand salon, as well as the four ground-floor galleries, are
truly rich in works tainted by this vice. I say *rich* because, in
effect, the talent which is responsible for the execution of a
number of the unpleasant paintings seen there would be en-
tirely praiseworthy if it were more judiciously employed.

Aside from the *Burial at Ornus* [*sic*], about which every-
thing has been said, one may observe *The Scene of a Fire* at
the home of some poor people, very skillfully painted by M.
Antigna. But although the scene is terrible, and despite the
life-size figures, to whom the painter has given a great deal of
expression, this painting does not move the spectator. This
undated event, these nameless people—in a word, this obscure
misfortune, accompanied by neither heroic action nor charac-
ters in whom we are interested, might have provided the sub-
ject for a pretty little genre picture, but this event and these

people are in no way *fit* to be treated on a large scale. Reduced to a height of two or three feet, M. Antigna's picture might have been welcome in a private gallery; but in what public building would *The Scene of a Fire*, abstractly treated, be suitable? I am unable to guess.

. . . What is disturbing in the works of the new school emerging now is the thoughtlessness with which art is treated. The subject and the manner of composing it are unimportant; the idea which dominates all others in the minds of our young artists is to paint one or several figures whose relief and coloring should be strongly accentuated, and which should present to the spectator's eye a sort of *trompe-l'oeil*. Once this vulgar truth is achieved, all the other niceties of art—the unity and the picturesque interest of a composition, the study of form allied to coloring, as well as the elevation of the style—are sacrificed unmercifully to an ordinary, vulgar, and sometimes repulsive imitation.

In support of this assertion, I believe I may still cite the painting *Hunger* by M. J. A. Breton. In this composition, the figures are also full-size, and the painting must be ten or twelve feet high. The scene is a garret; a woman with her youngest child is stretched out on a mattress on the ground, and her older children hurry toward their father, undoubtedly, who is carrying a large loaf of bread. I do not deny to this work a certain audacity of brushstroke and a skill of coloring which so many young artists possess today, a fact that might lead one to believe that this superficial talent is acquired rather quickly; but at the sight of so sad and distressing a composition, one wonders for what purpose it was intended. It is perhaps wrong, but a wealthy amateur will not be in the mood to decorate his salon with it, and the idea of presenting a painting of *Hunger* without the assistance of alms and religion forbids its entrance into churches. So, here is a painting, not entirely devoid of some picturesque qualities, for which a place will not be found because it is twelve feet high and because it has been thoughtlessly conceived, composed, and executed. . . .

There is one painting, however, which might contend for this type of superiority. It is *The Sower* by M. J. F. Millet.

Though it is barely possible to grasp the contours, which are lost in the background of the painting, in effect one catches sight of a man sowing wheat in a field; but the drawing is so indecisive, the relief so problematic, and the general harmony of the landscape so obscure, that the single personage of this composition appears to the eyes to be such as we think to see in a dream. As for the manner in which this picture is painted, if, as the young school says, it is the true and good manner, it must be agreed that Leonardo da Vinci, Raphael, Rubens, Rembrandt, Le Sueur, and Poussin were certainly silly to have spent time and study in perfecting the works that they did. . . .

Among the artists whose works I have just reviewed, there is one, M. A. Antigna, who is a man of talent. Still young, he yields naturally to the impulse that directs the painters of his age; but he has more vitality and a brighter future than most of the other *naturalist* painters. For proof of what I advance, I shall cite his pretty painting of the *Children in the Wheatfields*. One will certainly not find in it the elevation of thought, form, and expression that the great artists know how to introduce even in the humblest subjects; but the lively, innocent joy of this troop of small boys and girls, trampling over the crops to find flowers, offers to the eye a very pleasant painting and gives birth to grave spiritual reflections. Nothing more is necessary to give ballast and aplomb to the most insignificant and futile appearing subject, and M. Antigna has produced in the limited genre a very good composition. One would be strangely mistaken about the meaning of our general criticism if, from our demands for the elevated style, one inferred that we accept as worthy of the painter's brush only subjects which are sacred, mythological, or drawn from the most serious passages of history. . . .

I shall not abandon the question of *naturalism* in painting without pointing out that when it was introduced in Italy and in France at the beginning of the seventeenth century, it produced effects absolutely identical to the ones it produces today: the scorn of the great masters of antiquity and modern times; the abuse of the facile, reckless technique, which is substituted for the conscientious, careful study of art; the

unselective imitation of the natural, proposed as the exclusive aim of painting; exaggerated expression and the ugliness that results from it, which are introduced into painting as a stimulus essential to awaken the blasé taste of the public; and finally, a world of painters and a deluge of paintings. As Salvator Rosa said in one of his satires, written about 1640, "Everyone is a painter today"—"Tutto il mondo e pittore," for in that epoch, as now, the technique and the mechanics of art had fallen into the public domain and the skillfulness of the hand had totally replaced the work of intelligence; mediocrity threw itself on painting like poverty on the world. Today we have reverted to the same thing. If, as we have the right to hope, men similar to Poussin, Le Sueur and [Jacques] L[ouis] David do not emerge in France to oppose the bad taste and the abuses of facility, art will be in grave danger.

V. Sculpture

While awaiting the employment of this measure [the reestablishment of the biennial Salon] or of another—if a more effective measure [to ensure the restoration of the health of French art] could be found—let us congratulate ourselves on the unified principle conserved by our school of sculpture and on the good example our sculptors have not yet ceased to set for our painters. As I have frequently had occasion to note, it is sculpture which always restrains her sister, painting, when, as happens so frequently in France, she has her moments of folly and, as the saying goes, lets down her hair. Painting's faculty for imitating everything transparent—air, water, flesh, clothing, mists—is ordinarily what draws it beyond its natural limits and beyond the kind of poetry to which its art permits it to aspire. But sculpture, denied these resources and always led back to the reality of tangible forms, feels that it can derive the elevated ideas it seeks to express only from such forms. Thus, despite the differences that exist between these two arts, they have a common principle and support in form —for without form color is nothing. In a country where the ambition exists to cultivate the imitative arts to a superior degree, it is thus of great advantage that sculpture and painting should flourish simultaneously—this is what has almost always

occurred in France; so often painting is thus pulled from the evil paths into which her flightiness leads her.

Let us examine the works our sculptors have exhibited this year. For the second or third time I will praise the *Hour of the Night,* gliding through the air, which M. Pollet has very competently executed in marble. It is a charming work, full of grace and poetry, but the author need not try to go beyond the lightness and aerial allure he has given this figure, because the weight and rigidity of the marble severely warn him that he has touched the extreme limits of sculpture, and painting begins only a step beyond.

In M. Pradier's *Atalanta* everyone praises the morbidity of flesh as much as the artist's superior working of the marble, and everyone has remarked that since this is a woman who became famous in athletic contests, the natural forms of this Atalanta should not be ever so slightly chubby or plump. The several antique statues of women running, walking, hunting—Diana, among others—that remain to us all have little of that plumpness; they have long limbs and something a little savage in their features and in the disposition of their bodies. Was it really an Atalanta that M. Pradier wanted to make when he began this figure? Such is the reflection I have heard voiced before this gracious statue. . . .

A Lapith mounting on the rump of a centaur whom he bludgeons with a club is one of this year's best sculptural works. This handsome group, M. A. Barye's composition, recalls the bas-reliefs of the Parthenon, except that the modern artist's verve has lost nothing of its freedom and vivacity. The double movement of the Lapith, combined with that of the centaur, is marvelously grasped, and throughout the work reigns a loving search for nature, so that one cannot long consider the work without being moved. It is a handsome piece of sculpture, full of grandeur even though it is no more than four feet high. . . .

There are three enormous statues of the *Republic.*[6] One is by M. Soitoux and could pass for a recollection of antique

[6] [The statues were executed for the competition held in 1848–49. See *Triumph,* op. cit., pp. 484–88.]

statues of women. She holds her sword to defend the book of the constitution. The other, by M. Bosio, bears a little resemblance to works of antiquity, but it is adjusted with taste and is not without originality. As for the third and the best, by M. Raguet, it is posed and executed with talent, but the sculptor has provided his *Republic* with a recoiling movement that gives her an uneasy and suspicious air of insecurity.

M. Clésinger has produced an important group executed in stone this year. It is what the Italians call a *Pietà*—the Holy Virgin holding her dead son Jesus on her knees—a handsome subject, but disturbing to deal with after Michelangelo's treatment of it. It has called forth worthy efforts from M. Clésinger. Because the principal motif of this group is governed by tradition, one can only deviate from it by varying the details, and this M. Clésinger has done skillfully; but, as often happens when one reproduces an already well-developed idea, one inevitably is led to add a superfluous bit to the essential.

I find the draperies of this group too rumpled for my taste; they lack simplicity and grandeur—a fault, for that matter, which most of our contemporary artists fall into, since the fashion of wearing silk gowns with crooked pleats and stripes of thirty-six different colors has accustomed us to seeing clothing whose folds are always at odds with the forms and movements of the human body. However that may be, M. Clésinger's *Pietà* is a very skillfully executed work, undoubtedly more gracious than strong, but full of qualities that few others could put there. . . .

The *naturalists* are not, thank heaven, as numerous among the sculptors as they are among the painters; nevertheless there are some, and there is certainly something to be learned by studying their practice and theory. The goal which they attribute to art is not only to depict truth when it is crude but to make a particular point of giving a vulgar appearance to subjects and forms. A marked taste for brutal, fantastic, and careless execution naturally follows from this.

It is very regrettable that, having in all sincerity praised M. Frémiet's figures of animals, I find myself forced, after seeing his group *Wounded Bear Smothering a Man*, to consign this

artist, at least for this work, to the ranks of the *naturalists*. But in good conscience, what reverse of ideas—after exhausting his whole talent in modeling a bear and cubs in proportions that one might call heroic when applied to this type of animal—could have led M. Frémiet to decide to depict the man who has been seized by this beast in a manner which repels spectators through the ugliness and excessive sparseness of his bodily form? If the artist had reduced this sad subject to the size of a group of one foot, it would have been acceptable, but to enlarge these combinations of ugliness to a height of three meters—that is too much. What will the fate of this work be—and where will it be placed—at least until the bears of the Alps or the Pyrenees decide to erect statues honoring those of their kind who rid them of men?

It is through his indifference to form and his loose execution that M. Maindron attaches himself to the *naturalist* sect, for his ideas do not lack a certain elevation. But his style is neither pure nor severe enough for sculpture; he falls back on the facile and adventurous manner so commonly used by painters. These are the reflections which pass through my mind while looking at this artist's marble statue of *Saint Cecilia*. The expression which M. Maindron gave to this personage has something more of the amorous ecstasy of the heroine of a novel than the ravishing which the celestial song must have caused the saintly musician.

But the most advanced *naturalist* sculptor is without contradiction M. Préault. I will not speak in detail of his bas-relief of the *Massacre*. It enables the public to comprehend the valuable services which were occasionally rendered the artist by the reputed severity of the former jury.[7] I will also pass over a drowned *Ophelia*, an insignificant bas-relief, to arrive at two better works by M. Préault which are included in this exhibition: a *Christ Crucified* (bronze) and a bust of *M. Poussin* (marble). The marble of the bust is neither well nor badly chiseled. In this respect the work resembles many others of the same kind which surround it. But the modeling of the head, the bone form and expression given to this head,

[7] [Préault had been excluded from the Salon before 1848.]

result from the idea and talent of the artist. All who know the handsome self-portrait left by Poussin—in which the features are so noble, and where there is a modesty, a *contegno* as the Italians say, which reflect a soul so elevated, a spirit so calm, and, finally, a man so sure of himself—will have trouble finding the author of *Manna*, *Rebecca*, and *The Flood* in this swashbuckling head which M. Préault has given him.

According to the *naturalist* theory, all movement which does not become contortion, all form which is not exuberant, all expression which does not degenerate into a grimace, and all execution which does not tend to brutally express this kind of exaggeration is called cold and insignificant.

As for M. Préault's *Christ on the Cross*, if we may remove his crown of thorns in our imagination, so that the figure presents itself to our eyes as the Good Thief, then this figure is very acceptable. From the moment when we are no longer forced to demand the pure nature or chosen forms which clothe the Son of God, and have only to demand, on the contrary, a muscular day laborer attached and dead on a cross, we will praise the artist because, in effect, he has rendered with talent the nature of this latter personage. . . .

VII. Landscape

. . . Recently I promised to devote my attention to the landscapists. I will begin with M. Théodore Rousseau. . . . This artist's works were regularly refused admission by the juries before 1848. Since then, but this year especially, they are not only included in the exhibition, but several of them have even been hung in important places—well lit and at eye level. Consequently, now that they are in full view, it can be easily determined whether these landscapes are masterpieces, as was pretended when the public could not see them to judge. I never, despite my lively taste for painting and some knowledge acquired through my long experience with this art, rely entirely on my own first impressions without first consulting the public's opinion. Since Théodore Rousseau's landscapes have publicly been called masterpieces—an attitude I in no way shared after having seen these sketches, despite the special place in which they were hung—I often patiently

placed myself next to them to note, if possible, what curiosity they attracted and to collect opinions about them. As a result, I state loudly—because nothing would be easier to verify —that none of the public stops, no one looks at them, no one cares about them. Occasionally I saw a group of two or three people stop; one in the group would do his best to establish the merit of these sketches, while the others, whom the first sought to initiate into the secrets of the new art, the "new faith," opened wide eyes, filled at first with uncertainty and then with an admission of their inadequacy and their disbelief. During the month and a half the exhibition has already lasted, I have repeated this experiment, and it always produced the same results; so that, beyond the error to which I, like all men, am subject, I vow that I understand nothing of M. Théodore Rousseau's method of painting and that his sketches hold no charms for me. Regarding his method—that of producing only careless sketches rather than paintings—I would repeat what I have already said, that the great masters of all schools have made finished paintings for the public and that their sketches, their notes, drawn or painted, have not been appreciated or sought after until these men were at the height of their careers—or even until after their deaths. In the latter case, a sketch, even the least drawing of a great artist, becomes precious in the same way as a piece of clothing or a letter from a dead friend whose memory we cherish, as precious as a religious souvenir. M. Théodore Rousseau judges it proper to begin where the masters end; it only remains for him to create finished masterpieces to give to his sketches and his landscape studies the merit and the price which his admirers attribute to them. Of the seven landscapes sketched by M. Rousseau, there is really only one—the one in which a black and a red cow are found in the center—which the most zealous of his partisans give as the most complete example of the talent of this artist. It is also the one that the jury of 1850, so enlightened and so impartial, has given the best place in the rear gallery on the ground floor. Well, even though I might do violence to my acquaintance, I would say that this sketch, perhaps a little more finished than the others in the central portion where the famous cows are, has

the major fault of presenting only a thicket of trees, rocks, weeds, and animals which are illuminated and colored in such a uniform manner that all the different parts of this ensemble blend into each other, and it is barely possible to obtain an idea of it except by a painstaking and tiring analysis made at a foot's distance from the canvas.

It would not be impossible that M. Théodore Rousseau measures today all the overdue recognition which is due to the earlier juries—they did not mistake him—while that of 1850 had played him a perfidious trick, not only by admitting his sketches to the exhibition but by hanging one in a spot that should have been occupied by a good painting.

Now let us seriously approach the material. The most distinguished landscapist today, he whose works have the value of art objects, is M. Paul Flandrin. This year there are five works by him, with lines that are beautiful and gracious and an execution full of truth and delicacy. I would find it very difficult to choose from among *The Mountain, The Banks of the Gardon,* and the *Empty Road,* if the *Shepherd* did not have, in addition to qualities the others possess, a charm all its own. These high trees, majestically outlined against the azure sky; the sweet slope of these lawns, shadowed by the shaggy trees whose tops alone are lit; the penetrating and mysterious freshness of the woods, *gelidum nemus*—on a small canvas which is nevertheless majestic, M. Paul Flandrin has depicted everything which one in fact feels. These five small paintings render the greatest homage to the brush of their author, who seems to me to have perfected his color and execution to an unusual degree. . . .

A *Sunset* by M. Diaz [de la Peña], in which the color is so true, is also appealing. If the artist had added to this quality that of a finer, less vague execution, this would be a pretty painting. Such as it is, it is only a charmingly painted study.

In painting, as in literature, it is only purity of style and execution that confer importance and lasting quality to works. As has been said so many times before, the idea is nothing in art if one does not formulate it energetically and clearly through the power of expression. It is not, therefore, impossible that M. Corot's group of landscapes has more

truth and charm than those of Wynants and Karel Dujardin,
but one still has to resolve the question of whether, despite
the very real charm which our contemporary landscapist has
again put in his compositions, his execution is sufficient for
his thought. Lantara, who did not know how to paint figures,
preferred to represent the noonday hour "because," he said,
"at that hour everyone is at Mass." I think that M. Corot has
more solid reasons to justify the vagueness of his execution.
One wishes that he would just once paint a landscape in
which nature was rendered exactly, in order to demonstrate
that he paints not as best he can but precisely as he wishes.

Because facile, careless painting—the study—overflows in
historical painting and landscape, it is time to erect a dike to
oppose this torrent of improvised paintings that inundate
us. . . .

When one has seen such monstrous paintings, the eye
needs a rest. Thus, we are happy to come across landscapes
and animals like those painted by Mlle. Rosa Bonheur. Such
productions not only delight the eye but also put ideas
back in order. We rediscover skies we have seen, bushes of
flowering hawthorn which recall real springtimes, animals
which live and breathe and in whose eyes one reads the kind
of consciousness they seem to have of the rest and well-being
they enjoy. In these gracious and knowing paintings, the
brush has followed the conception so religiously that the
touch and all the artist's laborious efforts favor the specta-
tor's attention rather than troubling it. That is art!

X. Résumé

At the beginning of the exhibition, after an attentive though
rapid visit, I said that "the poetic level of art, which has so
clearly dropped during the past twenty years, has fallen even
lower since 1849, and that the majority of young artists
gifted with energy and some talent, by pursuing the modes of
imitation bequeathed to them by masters of the decadence of
art, have been led to treat nothing but real—even vulgar—sub-
jects."

Three months of scrupulous examination have not changed
this first judgment, and to sum up, it is the painting known

as genre, the art reduced to the taste of amateurs, which is particularly sought after and cultivated today; it is to the development of this inferior mode *le genre* that the young talents devote themselves and in its treatment that they show themselves to best advantage. . . .

1850: LONDON
The Exhibition of a Semiofficial Society: The Royal Academy of Art

On May 3, 1850, a few two-seater hackney cabs crowded into the line of splendid broughams, cabriolets, and phaetons making for Trafalgar Square, the huge sloping bowl dominated by the towering Devon granite column supporting the statue of the national hero, Nelson, overlooking the National Gallery. When the graceful, finely appointed carriages, drawn by handsome horses perfect in symmetry and adaption, stopped at the broad stairs leading to the terrace, their occupants alighted in order to ascend to the east wing and participate in the private viewing day of the Royal Academy exhibition. The annual event was London's most exclusive gathering of rank and fashion, in which artists and dukes intermingled. The Duke of Wellington appeared, responding to a few cheers from the group of common folk watching the arrivals with his characteristic two-finger salute. Sir Robert and Lady Peel were applauded; as Prime Minister he had guided through Parliament the repeal of the corn laws that had been a barrier to the importation of cheap food, though despite the repeal and the economy's recovery from the crises

of the 1840s, London's poorest people were still wretchedly housed and hungry.

The standing crowd was free to enter the National Gallery's west wing, which housed the state collections. There, as well as in the British Museum, an Englishman could say—in the words of "Parson Lot," the pseudonym used by the Christian Socialist Charles Kingsley in the penny paper *Politics for the People*—"Whatever my coat or my purse, I have a right here." Not all of the crowd, however, could afford the Royal Academy's one shilling admission fee, which included a copy of the catalog. Since 1769 the fee had financed the exhibition, the school, pensions for destitute academicians and their wives, and had permitted the Academy to be independent of the crown.

In 1837 the government had built the National Gallery at the public's expense; in giving the east wing of the building to the Royal Academy, it provoked a debate over whether the institution was public or private. By January 1850 the National Gallery needed the east wing for its growing collection, and this led Parliament to consider providing money for a building in which the Royal Academy could hold exhibitions and have a school. The debate of 1837 was reopened; the government's motion to supply funds was defeated in April 1850 by two votes, a reflection of general dissatisfaction with the status quo and the feeling that the Royal Academy was a bastion of privilege and the "old order." Only the Royal Academy enjoyed the privilege of being listed in the *Royal Gazette* and opened by the sovereign. Since other opportunities to exhibit were provided by various artists' societies and commercial galleries, many agreed with the social reformer Joseph Hume that the country did not need the Academy. As the *Art Journal* put it, "Year after year for the last fifty years, every organ of public opinion has suggested, and as far as possible insisted upon subjecting the Royal Academy to those constitutional remedies which could alone render it healthy and useful to the extent of its capabilities."[1] The defeat of the government's motion did not settle the debate, and the

1 *Art Journal*, June 1, 1850, p. 165

Royal Academy, anxious to gain public favor, invited critics to the private viewing day for the first time. John Eagles of *Blackwood's Edinburgh Magazine*, Frederick Hartman of the *Edinburgh Review*, John Forster of the *Examiner*, Frank Stone of the *Athenaeum*, Angus B. Reach of the *Illustrated London News*, and critics for *Fraser's Magazine*, *The Times*, *The Spectator*, and the *Art Journal* (as the *Art Union Journal* had been renamed in 1848), now mingled with those of high rank and the fashionable.

Guests and critics were astonished at being confronted, before the National Gallery's portico, by two or three young men displaying posters and offering for sale what looked to be a tract. The public was familiar with similar small pamphlets published in the late 1830s and early 1840s by the Oxford Movement to gain support for ceremonial and doctrinal changes in the High Anglican Church. The posters before the National Gallery, however, advertised "Art and Poetry," the title given to the fourth number of *The Germ*. Some visitors recognized the pamphlet as an avant-garde publication put out by seven or eight young artists who had also founded the society that would become generally known as the Pre-Raphaelite Brotherhood when Angus Reach printed his article in the *Illustrated London News* on May 4. These twenty-year-olds—John Everett Millais, Dante Gabriel Rossetti, William Holman Hunt, James Collinson, Frederick Stephens, Thomas Woolner, and William Michael Rossetti—seeking to escape from the current conventions of taste, cast their material in formal devices of the Middle Ages, arguing, "It is simply fuller nature we want." Some of their work had appeared in the Royal Academy exhibition the year before. The *Athenaeum*'s critic had singled out Hunt's *Rienzi* and Millais' *Isabella and Lorenzo* for reserved praise and called attention to the faults which he saw as resulting from the artists' ignoring the accepted methods of representation and reverting "to the practice of a time when knowledge of light and shade and of means of imparting due relief by systematic conduct of aerial perspective had not obtained. Without the aid of these in the treatment of incident and costume, we get but such pictorial form of expression as seen through the magnify-

ing medium of a lens would be presented to us in the medieval illumination of the chronicle or the romance. Against this choice of pictorial expression let the student be cautioned."[2]

Once past these young artists and inside the east wing, the visitors to the eighty-second Royal Academy exhibition found that 1,456 works had been crowded into the East Room (the place of honor), the Octagon Room (where the prices of works might be learned), and the Middle and West Rooms. The 154 pieces of sculpture were downstairs, "forced into the miserable gallery" whose three compartments had been vacated for the six weeks of the exhibition by the Royal Academy school. In the East Room's best place hung Charles Eastlake's *Good Samaritan*. The *Athenaeum* called it "a work of the class academic, a class in which the studies of the artist into human form are those especially applied to the expression of the human form."[3] In 1841 Eastlake had been named Secretary of the Royal Commission appointed to consider "the promotion of the Fine Arts in the Country in connection with the rebuilding of the Houses of Parliament." He was known to be favored to succeed the aged and ill Sir Martin Archer Shee as the Royal Academy's president. As a Royal Academy student, Eastlake had gone to Rome in 1817, where he remained until 1830. The work he exhibited at the Royal Academy in 1827 secured his election as an associate, and on his return to London he became an academician. During his stay in Rome Eastlake had frequented a circle of English and German artists grouped around Baron Christian Karl Josias von Bunsen, secretary of the Prussian embassy, and his wealthy English wife. Bunsen had been influential in making the Prussian embassy available in 1819 for the exhibition of German painters and sculptors resident in Rome. At the embassy the work of the Nazarenes, or Brotherhood of St. Luke, led by Johann Friedrich Overbeck, had first been seen as a group. Now Prussian ambassador to London, Bunsen was still actively interested in the fine arts.

Also in the East Room was William Dyce's *Rachel and*

[2] *Athenaeum*, June 2, 1849, p. 575
[3] *Athenaeum*, May 11, 1850, p. 508

Jacob. Dyce, a Scot, had been in Rome in 1825 and had also come under the influence of the Nazarenes. At Eastlake's suggestion, he was appointed director of the newly founded school of design in 1837. He served in this post until 1844, when Eastlake, secretary of the council of the school of design, arranged for him to be replaced by Charles Heath Wilson, a colleague of Eastlake's on the Royal Commission who had gone to Italy for the Commission in 1842 to make a report on fresco painting. Dyce was now a professor of fine arts at King's College, London. Eastlake's and Dyce's paintings demonstrated their respect for the rules of composition and color which the Nazarenes, revolting against the "academic" manner, had formulated after a study of medieval subject matter and the techniques employed by the High Renaissance painters Perugino and Raphael.

Two of the four paintings exhibited by Turner were also in the East Room. During Turner's 1819 visit to Rome, Eastlake had introduced him to the German artist, Wilhelm von Kobell, a colorist. In 1843 Turner had exhibited two paintings derived from Goethe's *Zur Farbenlehre* (1810), which Eastlake had translated and published in 1847 as *Theory of Color*. This volume and Eastlake's *Materials for a History of Oil Painting*, an explanation of fifteenth-century Flemish technique published in 1847, contributed to the lively interest of English artists in color, an interest paralleled by current scientific studies of the properties of light.

In the West Room hung painting No. 504, *Ferdinand Lured by Ariel*, by John Millais, a former Royal Academy student regarded by many as the most talented of the up-and-coming young English artists. The *Art Journal*'s critic conceded his drawing of figures was superior "to that seen in Giorgione's works, yet the emphasis of the picture is in its botany, which is made out with a microscopic elaboration in so much as to seem to have been painted from a collection of grasses, since we recognize upwards of twenty varieties." The scientific exactitude of Millais' No. 518—entitled *Christ in the House of His Parents*, from a verse by Zechariah, but soon known as *The Carpenter Shop*—caused ordinary visitors to shudder, "The impersonation of Joseph seems to have

been realised from a subject after having served a course of study in the dissecting room."[4]

Other writers were critical of the sources which had inspired this technique: Thornton Hunt, who had studied drawing and painting and was with *The Spectator*, turned sharply on Millais, "who may be conjectured to possess more power than any man in the place, but a painter who can spontaneously go back, not to the perfect schools, but through and beyond them to the days of puerile crudity, seems likely to be conscious of some fatal constitutional disease in his genius;"[5] . . . This criticism was reiterated by Frank Stone, writing for the *Athenaeum*. Stone was also an artist. He had first exhibited at the Royal Academy in 1837, and two of his paintings, whose pretty sentimentality made them popular as engravings, were in the present exhibition. His review, appearing anonymously in the *Athenaeum* on June 1, pointed out the obvious similarities between the Nazarenes' attempt to revive High Renaissance art and the Pre-Raphaelites' interest in earlier forms, and used this comparison to show the latters' inherent weaknesses. "That a young body of English painters—untravelled and below these Germans in intelligence—going back for revival to a yet earlier period from a yet later, should fail far more signally and find that they have arrived at an absurdity, might have been expected from the mere conditions of the case. . . . The quaintness and formal-looking character of Art in the schools of Siena, Pisa, and Florence were a result of a primitive condition of society." As civilization and learning advanced, scientific principles had been applied to art. "The progress shown in the anatomically well-studied forms of Luca Signorelli, in the bold and picturesque combinations of Ghirlandaio, and in the devotional expressions of Perugino's heads, proves the aspiring tendencies of the artist—the developing character of his art. . . . What a wilful misapplication of powers is that which affects to treat the human form in the primitive and artless manner of the Middle Ages, while

[4] *Art Journal*, June 1, 1850, p. 175
[5] *The Spectator*, May 4, 1850, p. 427

minor accessories are elaborated to a refinement of imitation which belongs to the latest days of executive art!"[6]

Stone was a member of an amateur theatrical group which included some of the most brilliant figures of London's dramatic, literary, and artistic world: the novelists Edward Bulwer-Lytton and Charles Dickens; the famous actor William Macready; the painter Daniel Maclise; Douglas Jerrold, the dramatist and witty contributor to *Punch*; and John Forster, the editor and critic for the *Examiner*. Two members of this group singled out the Pre-Raphaelites for criticism in their reviews of the exhibition. Forster (1812–76), who had begun as the *Examiner's* drama critic and was now its editor, may have written the review which appeared in the paper in three installments. After affirming the strength of English art, the critic noted the younger generation's heresy in turning to "the earlier painters of Italy and the Rhine for their models."

Dickens' article appeared on the front page of the June 15 issue of *Household Words*. Once a court reporter, Dickens (1812–70) had been able in 1849, after the success of *Dombey and Son*, to gratify his wish to own and publish a periodical. *Household Words*, when it appeared on March 30, 1850, was an immediate success, selling one hundred thousand copies. Every article was readable and entertaining, calling on its readers to "go on cheerily." Under Dickens' direction it was dedicated to reform, demanding legislation to correct deplorable conditions of housing and work which, as Dickens knew from personal experience, caused people to become drunkards, prostitutes, and thieves. Imbued with an unquestioning belief in progress, he was concerned with legislation which would ameliorate the conditions that caused the problem. Consistently attacking paternalism, he was scornful of the benevolent feudalism that envisaged social harmony between aristocrats and workers as espoused by the Young England movement of John Manners and Benjamin Disraeli. He was vehemently intolerant of any sign of retrogression or disregard for improvement, which included "improved" taste in the arts.

[6] *Athenaeum*, June 1, 1850, p. 590

He respected the dictum of "cultivated taste," which required sacred episodes and noble, sublime personages. A friend of successful artists—especially Maclise, whose theatrical realism appealed to Dickens—he was familiar, after a year's residence and travel in Italy, with the art treasures which formed the basis of cultivated standards. Sensitive to the effectiveness of the illustrations of his novels, Dickens had early assumed their supervision, but even in depictions of harsh realities he insisted that beauty dominate truth. "If we turn back to a collection of works by Rowlandson and Gillray, we shall find, in spite of the great humor displayed in them, that they are rendered wearisome and unpleasant by a vast amount of personal ugliness. Now, besides that it is a poor device to represent what is satirized as being necessarily ugly, which is but the resource of an angry child or a jealous woman, it serves no purpose but to produce a disagreeable result. There is no reason why the farmer's daughter in the old caricature who is squalling at the harpsicord . . . should be squab and hideous. The satire in the manner of her education, if there is any in the thing at all, would be just as good, if she were pretty."[7]

Perhaps aroused by his close friends Forster and Stone, Dickens penned his savage attack on the group of Pre-Raphaelites. He was ready to battle any group that looked backwards to the Middle Ages or seemed to prefer a feudal paternalism that would hinder the progressive improvement of society. He was certainly unaware that the Pre-Raphaelites had banded together to improve both painting techniques—especially the use of color—by a careful observation of nature and household articles, furniture, fabrics, and interior decoration. Dickens was irritated by their apparent unwillingness to follow the path of "educated taste" and their rejection of the current "art language." Unmentioned was the luminosity of their color, their primary interest.

[7] Cited in John Forster, *Life of Charles Dickens* (Philadelphia: Lippincott, 1872–74), vol. II, p. 414

Charles Dickens: *Old Lamps for New Ones*[1]

The Magician in "Aladdin" may possibly have neglected the study of men, for the study of alchemical books; but it is certain that in spite of his profession he was no conjuror. He knew nothing of human nature, or the everlasting set of the current of human affairs. If, when he fraudulently sought to obtain possession of the wonderful Lamp, and went up and down, disguised, before the flying-palace, crying New Lamps for Old ones, he had reversed his cry, and made it Old Lamps for New ones, he would have been so far before his time as to have projected himself into the nineteenth century of our Christian Era.

This era is so perverse, and is so very short of faith—in consequence, as some suppose, of there having been a run on that bank for a few generations—that a parallel and beautiful idea, generally known among the ignorant as the Young England[2] hallucination, unhappily expired before it could run alone, to the great grief of a small but a very select circle of mourners. There is something so fascinating, to a mind capable of any serious reflection, in the notion of ignoring all that has been done for the happiness and elevation of mankind during three or four centuries of slow and dearly-bought amelioration, that we have always thought it would tend soundly to the improvement of the general public, if any tangible symbol, any outward and visible sign, expressive of that admirable conception, could be held up before them. We are happy to have found such a sign at last; and although it would make a very indifferent sign, indeed, in the Licensed Victualling sense of the word, and would probably be rejected with contempt and horror by any Christian publican, it has our warmest philosophical appreciation.

In the fifteenth century, a certain feeble lamp of art arose in the Italian town of Urbino. This poor light, Raphael Sanzio by name, better known to a few miserably mistaken

[1] [Verbatim from *Household Words, a Weekly Journal*, June 15, 1850]

[2] [Young England was a revivalist movement.]

wretches in these later days, as Raphael (another burned at the same time, called Titian), was fed with a preposterous idea of Beauty—with a ridiculous power of etherealising, and exalting to the very Heaven of Heavens, what was most sublime and lovely in the expression of the human face divine on Earth—with the truly contemptible conceit of finding in poor humanity the fallen likeness of the angels of God, and raising it up again to their pure spiritual condition. This very fantastic whim effected a low revolution in Art, in this wise, that Beauty came to be regarded as one of its indispensable elements. In this very poor delusion, Artists have continued until this present nineteenth century, when it was reserved for some bold aspirants to "put it down."

The Pre-Raphael Brotherhood, Ladies and Gentlemen, is the dread Tribunal which is to set this matter right. Walk up, walk up; and here, conspicuous on the wall of the Royal Academy of Art in England, in the eighty-second year of their annual exhibition, you shall see what this new Holy Brotherhood, this terrible Police that is to disperse all Post-Raphael offenders, has "been and done!"

You come—in this Royal Academy Exhibition, . . . to the contemplation of a Holy Family. You will have the goodness to discharge from your minds all Post-Raphael ideas, all religious aspirations, all elevating thoughts; all tender, awful, sorrowful, ennobling, sacred, graceful, or beautiful associations; and to prepare yourselves, as befits such a subject—Pre-Raphaelly considered—for the lowest depths of what is mean, odious, repulsive, and revolting.

You behold the interior of a carpenter's shop. In the foreground of that carpenter's shop is a hideous, wry-necked, blubbering, red-headed boy, in a bed-gown; who appears to have received a poke in the hand, from the stick of another boy with whom he has been playing in an adjacent gutter, and to be holding it up for the contemplation of a kneeling woman, so horrible in her ugliness, that (supposing it were possible for any human creature to exist for a moment with that dislocated throat) she would stand out from the rest of the company as a Monster, in the vilest cabaret in France, or the lowest ginshop in England. Two almost naked carpenters,

master and journeyman, worthy companions of this agreeable
female, are working at their trade; a boy, with some small
flavor of humanity in him, is entering with a vessel of water;
and nobody is paying any attention to a snuffy old woman
who seems to have mistaken that shop for the tobacconist's
next door, and to be hopelessly waiting at the counter to be
served with half an ounce of her favourite mixture. Wherever
it is possible to express ugliness of feature, limb, or attitude,
you have it expressed. Such men as the carpenters might be
undressed in any hospital where dirty drunkards, in a high
state of varicose veins, are received. Their very toes have
walked out of Saint Giles. . . .[3]

Consider this picture well. Consider the pleasure we
should have in a similar Pre-Raphael rendering of a favourite
horse, or dog, or cat; and, coming fresh from a pretty consid-
erable turmoil about "desecration" in connexion with the Na-
tional Post Office,[4] let us extol this great achievement, and
commend the National Academy!

In further considering this symbol of the great retrogressive
principle, it is particularly gratifying to observe that such ob-
jects as the shavings which are strewn on the carpenter's floor
are admirably painted; and that the Pre-Raphael Brother is
indisputably accomplished in the manipulation of his art. It
is gratifying to observe this, because the fact involves no low
effort at notoriety; everybody knowing that it is by no means
easier to call attention to a very indifferent pig with five legs,
than to a symmetrical pig with four. Also, because it is good
to know that the National Academy thoroughly feels and
comprehends the high range and exalted purposes of Art; dis-
tinctly perceives that Art includes something more than the
faithful portraiture of shavings, or the skilful colouring of
drapery—imperatively requires, in short, that it shall be in-
formed with mind and sentiment; will on no account reduce
it to a narrow question of trade-juggling with a palette, pal-
ette knife, and paint-box. It is likewise pleasing to reflect that
the great educational establishment foresees the difficulty

[3] [St. Giles was a hospital for lepers.]
[4] [A proposal for Sunday mail deliveries had recently been de-
feated.]

into which it would be led, by attaching greater weight to mere handicraft, than to any other consideration—even to considerations of common reverence or decency; which absurd principle, in the event of a skilful painter of the figure becoming a very little more perverted in his taste, than certain skilful painters are just now, might place Her Gracious Majesty in a very painful position, one of these fine Private View Days.

Would it were in our power to congratulate our readers on the hopeful prospects of the great retrogressive principle, of which, this thoughtful picture is the sign and emblem! Would that we could give our readers encouraging assurance of a healthy demand for Old Lamps in exchange for New ones, and a steady improvement in the Old Lamp Market! The perversity of mankind is such, and the untoward arrangements of Providence are such, that we cannot lay that flattering unction to their souls. We can only report what Brotherhoods, stimulated by this sign, are forming; and what opportunities will be presented to the people, if the people will but accept them.

In the first place, the Pre-Perspective Brotherhood will be presently incorporated, for the subversion of all known rules and principles of perspective. It is intended to swear every P. P. B. to a solemn renunciation of the art of perspective on a soup-plate of the willow pattern and we may expect, on the occasion of the eighty-third Annual Exhibition of the Royal Academy of Art in England to see some pictures by this pious Brotherhood, realising Hogarth's idea of man on a mountain several miles off, lighting his pipe at the upper window of a house in the foreground.[5] But we are informed that every brick in the house will be a portrait; that the man's boots will be copied with the utmost fidelity from a pair of Bluchers, sent up out of Northamptonshire for the purpose; and that the texture of his hands (including four chilblains, a whitlow, and ten dirty nails) will be a triumph of the Painter's art. . . .

In literature, a very spirited effort has been made, which is

[5] [Hogarth's *Satire on False Perspective* was published in 1754.]

no less than the formation of a P. G. A. P. C. B., or Pre-
Gower and Pre-Chaucer Brotherhood,[6] for the restoration of
the ancient English style of spelling, and the weeding out
from all libraries, public and private, of those and all later
pretenders, particularly a person of loose character named
Shakespeare. It having been suggested, however, that this
happy idea could scarcely be considered complete while the
art of printing was permitted to remain unmolested, another
society, under the name of the Pre-Laurentius[7] Brotherhood,
has been established in connexion with it, for the abolition of
all but manuscript books. These Mr. Pugin has engaged to
supply, in characters that nobody on earth shall be able to
read.[8] And it is confidently expected by those who have seen
the House of Lords, that he will faithfully redeem his pledge.

In Music, a retrogressive step, in which there is much
hope, has been taken. The P. A. B., or Pre-Agincourt Broth-
erhood has arisen, nobly devoted to consign to oblivion Mo-
zart, Beethoven, Handel, and every other such ridiculous rep-
utation, and to fix its Millennium (as its name implies)
before the date of the first regular musical composition
known to have been achieved in England. . . .

The regulation of social matters, as separated from the
Fine Arts, has been undertaken by the Pre-Henry-the-Seventh
Brotherhood, who date from the same period as the Pre-
Raphael Brotherhood. This society, as cancelling all the ad-
vances of nearly four hundred years, and reverting to one of
the most disagreeable periods of English History, when the
Nation was yet very slowly emerging from barbarism, and
when gentle female foreigners, come over to be the wives of
Scottish Kings, wept bitterly (as well they might) at being

[6] [John Gower (1325–1408) and Geoffrey Chaucer (1340–1400)
were poets.]

[7] [The Laurentian Library in Florence contains the Medici col-
lection of manuscripts.]

[8] [Augustus Welby Pugin (1812–52), architect, designer, and
author of *Contrasts* (1836) and *The True Principles of Pointed or
Christian Architecture* (1841), had worked with the architect Charles
Barry on the Gothic revival decoration of the new House of
Parliament.]

left alone among the savage Court, must be regarded with peculiar favour. . . .

We understand that it is in the contemplation of each Society to become possessed, with all convenient speed, of a collection of such pictures; and that once, every year, to wit upon the first of April, the whole intend to amalgamate in a high festival, to be called the Convocation of Eternal Boobies.

Anonymous [John Forster?]: *Fine Arts—Eighty-Second Exhibition of the Royal Academy*[1]

First Notice

This is an exhibition of very high merit, but one of which it is not easy to form a precise and final estimate. . . .

But there is a change, undoubtedly, going on in the character of English art. There is a change very noticeable in our leading artists, in their views and aspirations, and in their modes of execution. . . .

The class of works which stamped their character upon former exhibitions having thus come to occupy less space, and to attract less exclusive attention, more prominence is given to those of the generation of artists next in order and time. Contributions of the latter are beginning to constitute the staple commodity of our exhibitions. And the bent of their natural tastes, as evinced in their choice of subjects, and manner of treating them, differs materially from that of their immediate predecessors. Wilkie coloured as well or better than Teniers in his early career, and by a profusion of asphalte[2] latterly acquired (what he was ambitious of) an embrowned Spanish look; but from first to last Wilkie was a realist who charmed by his colour, his finished execution, and his felicitous expression of everyday character. Every year, however,

[1] [Verbatim from the *Examiner*, May 11, 1850, pp. 293–94; May 18, 1850, pp. 309–10; May 25, 1850, p. 326]

[2] [Asphalte or asphaltum, a petroleum product used as a pigment, was a dangerously impermanent substance which aged badly and caused wrinkling and cracks on the surface of paintings.]

exhibits less and less of this ambition; and a greater consciousness of unrivalled power and truth of drawing has brought with it less care for the niceties, the *curiosa felicitas*, of colour. And apart entirely from natural powers and tendencies, there are influences at work, most obvious among the youngest class of artists, but with effects more or less perceptible in all, that threaten (or promise) to change materially the character of English art.

Artists and amateurs have contracted a habit of theorising more about art than they used to do, and this habit is affecting the productions of the former, and the demands of the latter. The theories of those critics who, with a fanatical sectarianism and sufficient lack of discrimination, have of late years been holding up the pre-Raphael schools as models for painters, have infected some of our cleverest artists. Mr. Dyce was one of the first to give in to these views; but in him sound common sense, and a thorough feeling for the beautiful, have prevented their being carried to any fantastical extreme. In younger and less experienced artists, however, perhaps we might also say in artists of more uncalculating impulse, they have run riot, as any one will be convinced who casts an eye on the strange productions of Mr. Millais in this year's exhibition. Again, the ambition of certain distinguished amateurs to call into existence a school of English art applicable to purposes of public decoration (art with us having hitherto preserved more of a private or domestic character), has inspired our artists with a desire to turn their talents into this new channel.[3] Efforts to produce works of what is called historical painting in fresco, or, at all events, in subordination to architectural decoration, have diversified the subjects treated, and extensively modified the style of manipulation.

[3] [In 1841 a Select Committee determined that the new Parliament buildings should be decorated with frescoes of scenes from British history. A second committee, headed by Prince Albert, conducted a series of competitions, over a period of twenty years, to choose the artists and the subjects. Among those to receive commissions were William Dyce, E. M. Ward, and Daniel Maclise. Because the fresco medium was poorly understood and proved unsuitable for the British climate, the paintings rapidly deteriorated.]

Thus, new ideas, new aspirations, have been infused into the minds of English artists. In one point of view this must be considered as satisfactory, and full of promise for the future. It has given a fresh life and impetus to the exertions of our painters. It inspires hope that they may henceforth embrace a wider range of what is high and beautiful in art, and eschew that mere repetition of clever effects which has been their besetting sin. But, on the other hand, there is the danger of their substituting conventionalities based upon abstract theories, for the spontaneous inspirations of taste and imagination. Revolutionary crises are full of peril. There is always a risk that the tide of change may set in in a wrong direction. In its own peculiar walk of art, the English school has attained to high mastery. It will be lamentable if our artists, in pursuit of novelty, learn to disregard altogether the valuable accomplishments they have inherited from their immediate predecessors.

It is to this transitional state in our art and artists that we are disposed to attribute the difficulty experienced in forming a definite and satisfactory estimate of the present exhibition. The minds and methods of a large proportion of the exhibitors are unsettled, and this imparts a want of definite character to their productions.

On the whole, however, there can be no doubt that the Exhibition is replete with natural and highly-cultivated talent, and is of good omen for the future. . . .

Second Notice

Mr. Turner continues to paint in that style to which self-will and theorising have reduced him. But his arrangement of colours (and his landscapes are now little else) is admirably adapted to impart full force to each individual tint by contrast or association. There never was an artist who attained such mastery in representing the effects of light upon atmosphere, or those thin, delicate, evening clouds, which are something between cloud and air. The softness of his subdued, and the brilliancy of his pure, tints are equally exquisite. But Mr. Turner's power is become simply sensuous. His pictures have for many years been mere harmonious arrange-

ments of colour, with dim indications of impossible moun-
tains, buildings, water, ships, and something approaching to
faintly-descried outlines of groups of figures. As was said of
the works of another great artist, "they are pictures of noth-
ing, and very like." And yet they have a certain indubitable
charm for the cultivated eye of the artist. Mr. Turner is lord
paramount of atmospheric light, as Rembrandt was of atmos-
pheric shade. But Rembrandt had substance, which Mr.
Turner has not. There is a vinous flavour about the produc-
tions of both, but the old master has both body and aroma,
and the modern aroma only. . . .

Pass we now to that class of our living artists which has al-
ready done much, but from which we may still look for
efforts new in kind and yet greater in quality.

Among these, for daring conception and powerful execu-
tion, the first place is undoubtedly due to Mr. Maclise. As
with all men who have tried greatly, he has sometimes failed,
but there has always been the manly force and freedom of
genius even in his comparative failures. Of his *Justice* we, on
a former occasion, expressed our opinion at considerable
length. We see nothing in what we then said to retract or
modify. The composition, intended for and now placed in
fresco on the House of Lords, is characterised by noble and
tender sentiment, and informed with a sense of intellectual
greatness; it is replete with power and dignity; and is admira-
bly adapted to subserve the purposes of architectural adorn-
ment. It is a great achievement by an English artist in a
school almost entirely new to this country. The same artist's
scene from the *Vicar of Wakefield* is in its own line quite
equal to it. It is thoroughly imbued with the sentiment of
Goldsmith. . . .

Mr. Dyce's *Jacob and Rachel* is a work of great beauty and
taste, and mastery of colour and form. Mr. Dyce is pro-
foundly skilled in the technicalities of his art; he feels deeply
and justly the beauty and greatness of other artists; he is him-
self always the accomplished and feeling painter. Much has
been said, and with truth, of the success with which he has
here expressed impetuous eagerness in Jacob, and maiden
reserve in Rachel. But perhaps the beauty of the story is

hardly improved by this. The kiss with which Jacob greeted his kinswoman at their first meeting was the cousin's kiss of the patriarchal age; passion had not yet developed itself; and it was met as frankly as it was given. Mr. Dyce has, in this particular, somewhat missed the severe and simple beauty of the old bible story. . . .

Concluding Notice

Landscapes and portraits are no longer, to such an extent, the staple material of our exhibitions, as they once were; but they still preponderate, and will continue to do so. Affection and esteem on the part of friends, vanity on the part of the person portrayed, will keep the department of the portrait painter, if not the most lucrative, the most steadily and equably remunerative, in pictorial art; and the circumstances of modern English society are more favourable to the cultivation of landscape than any branch of painting, except portrait. . . .

But the greatest offenders in this year's Exhibition are Messrs. Millais, Hunt, and Collins. The productions of these gentlemen must be viewed in connection with the kindred mistakes of Messrs. Deverell and Rosetti in the Regent Street Exhibition,[4] and with the periodical entitled *Art and Poetry*, which is the official journal of their sect. They are avowedly and ostentatiously of the fantastic retrograde school. About the beginning of the century, some ingenious but rather small critics were forcibly impressed by the genius and sentiment which gleam through the rude and imperfect execution of the earlier painters of Italy and the Rhine. The attractive language, full of prettinesses and conceits, in which they expressed their exaggerated admiration of these artists, misled a number of kindred minds; and each new scholar became more perverse and affected than his predecessors. It has become a fashion in certain coteries to admire even the defects of the old masters. . . . Mr. Hunt has a fine feeling for

4 [The Regent Street Exhibition, held at Portland Gallery, 316 Regent Street, was sponsored by the National Institution for the Exhibition of Modern Art. This name was adopted in 1850 by the Society of Artists. Rossetti exhibited *Ecce Ancilla Domini*.]

colour; Mr. Rosetti has a delicate, elaborate, miniature sort of finish; Mr. Deverell is undoubtedly a man of very considerable talent. His *Scene from Shakespeare's Twelfth Night*, in the Regent Street Exhibition, notwithstanding its perverse and wilful stiffness in drawing, and awkwardness of composition, has great power of characteristic expression. We would say that Mr. Deverell has talents for the humorous, did we not fear that what we take for playful humour is with him serious earnest. But all the good qualities of these artists are dashed and perverted by a small coxcombial ingenuity.

The wilful meagreness and uncouthness of their figures may, notwithstanding, be tolerated under protest. Not so the repulsive caricature of a tenderly elevated and sacred subject exhibited by Mr. Millais. It is a *Holy Family*, the very antithesis of poetry, nature, and art. The carpenter's board and shavings are represented with literal fidelity. The figures are meagre in outline, awkward in attitude, hideous in expression, incarnations of physical disease. Simeon Stylites,[5] or the most loathsome of monkish ascetics, might have rejoiced in such a picture. It is conceived in the spirit of the fanatic self-torturing Yogis of Hindustan, not of a Christian . . . It is difficult to conceive that any mind imbued with artistic intellect and imagination should so far deviate from natural and poetical sentiment. The same defects are visible in Mr. Millais' bilious and dyspeptic *Ferdinand* (from the *Tempest*), in which the artist has portrayed Ariel with the lineaments of Caliban; and in his ogre-like caricature of some unfortunate grandfather. Only, in the two last named paintings, we are not shocked by the wilful vulgarisation of one of the loftiest and tenderest conceptions of the human imagination.

[5] [The fifth-century St. Simeon Stylites of Syria was an ascetic who spent over thirty-five years of his life on top of a column.]

1851: LONDON

The First International Exposition: The Great Exhibition of the Works of Industry of All Nations

The first international exposition of the industrial arts, housed in a building constructed of iron and glass and free of architectural traditions, was held at the invitation of the British Crown. Prince Albert expressed the idea behind the undertaking in a speech at the Lord Mayor's Banquet in November 1850:

> Nobody who has paid any attention to the peculiar features of our present era, will doubt for a moment that we are living at a period of most wonderful transition, which tends rapidly to accomplish that great end, to which, indeed, all history points—the realisation of the unity of mankind. . . . The distances which separated the different nations and parts of the globe are rapidly vanishing before the achievements of modern invention, and we can traverse them with incredible ease; the languages of

all nations are known, and their acquirement placed within
reach of everybody; thought is communicated with rapidity, and
even by the power, of lightning. On the other hand, the great
principle of the division of labour, which may be called the
moving power of civilisation, is being extended to all branches
of science, industry, and art. . . . The products of all quarters
of the globe are placed at our disposal, and we have only to
choose which is the best and cheapest for our purposes, and the
powers of production are entrusted to the stimulus of competi-
tion and capital. . . . Science discovers these laws of power,
motion and transformation; industry applies them to the raw
matter which the earth yields us in abundance, but which be-
come valuable only by knowledge. Art teaches us the immuta-
ble laws of beauty and symmetry, and gives to our productions
forms in accordance with them.

Gentlemen—the Exhibition of 1851 is to give us a true test
and a living picture of the point of development at which the
whole of mankind has arrived in this great task, and a new
starting-point from which all nations will be able to direct their
further exertions.

I confidently hope that the first impression which the view of
this vast collection will produce upon the spectator will be that
of deep thankfulness to the Almighty for the blessings which
He has bestowed upon us already here below; and the second,
the conviction that they can only be realised in proportion to
the help which we are prepared to render each other; therefore,
only peace, love, and ready assistance, not only between individ-
uals but between nations of the earth.[1]

The exhibition had come into being, it might be said, by a
series of events which began with the reconstruction of the
Houses of Parliament, leveled by fire in 1834. The rebuilding
necessitated the selection of an architectural style historically
suitable for the "Mother of Parliaments," and brought to the
fore questions of taste and style. Augustus Welby Pugin's
book *Contrasts* (1836), filled with novel and provocative im-
ages, had contributed to the debate. The choice of a Gothic
style for the Houses of Parliament, rather than the Neoclassic
style previously regarded as most suitable for public buildings,

[1] T. Martin, *Life of H. R. H. the Prince Consort*, vol. II, 2nd
edn. (London, 1876), p. 248

marked a change in attitudes towards style and taste. Until Victoria's accession in 1837, a preference for a restrained Greek revival had resisted inroads of eclectic elements. Now other styles—French Rococo, Italian High Renaissance, and Gothic—caught the fancy of those with access to the new sources of wealth that stemmed from manufacturing. The passion for duplicating the furnishings depicted in the engraved illustrations of romantic novels and plays could now be gratified by ingenious carving and tooling machines. Industry was not an arbiter of taste, but freedom of choice was encouraged by the manufacturers' design books and eclecticism flourished.

The very success of the indefatigable machines, already marvelous and capable of constant improvement, brought an uneasy dissatisfaction. In spite of the technical excellence of British manufacture, consumers preferred products created by designers trained in France's state-supported schools for the decorative arts. As early as 1798 France had held a national industrial exhibition to stimulate its manufacturers and encourage artisans and designers employed in industry. Subsequent exhibitions followed. Government support made possible the École des Arts Décoratifs in Paris and schools in Lyons, whose graduates had no desire to become "fine artists," for they were better paid as designers.

In England few such opportunities existed. The Society of Arts and Manufactures had been established in 1754 to "encourage the arts, manufactures, and commerce of the country." For several years it had held exhibitions, awarded prizes to encourage inventions which applied science to practical purposes, and honored native artists, whose works were also shown. The Society's founder, William Shipley, had established a school in 1762 "to introduce boys and girls of Genius to masters and mistresses in such manufactures as require fancy ornament and for which the knowledge of drawing is absolutely necessary." The Royal Academy had held its first exhibition in the Society's rooms, but when it established its school, it imitated the French model. Instruction was limited to training "artists"—painters, sculptors, and architects. There was little concern for the training of de-

signers until critics of the Royal Academy and its teaching
methods, led by Benjamin Haydon, proposed in 1835 that
the government assume responsibility for an educational insti-
tution which would provide industry with trained artists able
to compete with French, Belgian, Bavarian, and Prussian
state-educated designers. The Select Committee of 1835 was
appointed to "enquire into the best means of extending a
knowledge of the arts and principles of design among the
people (especially the manufacturing population) of the
country; also to enquire into the constitution of the Royal
Academy and the effects of the institutions connected with
arts."[2] The Committee had heard evidence from many
witnesses. The Royal Academy's president, Sir Martin Shee,
spoke in its defense. Benjamin Haydon, once a student of,
but never elected to, the Royal Academy, who was currently
giving lectures to members of the Mechanics Institutes, at-
tacked it. Gustav F. Waagen, the respected art historian and
director of the Berlin Museum, and the Munich architect
Franz Karl Leo von Klenze, testified to the efficacy of a close
relationship between artists and artisans.

The Committee had recommended the government estab-
ish a school of design, in reality drawing schools in imitation
of the French École de Dessin. It became the Department of
Practical Art in 1851 and was designated the Science and Art
Department in 1852. Because there was no Ministry of Edu-
cation, and as the matter was directly related to commerce
and industry, the project was assigned to the Board of Trade.
In 1837 a council comprised of industrial representatives,
gentlemen interested in art and industry, and academicians
placed a school in the rooms in Somerset House, recently va-
cated by the Royal Academy. Pupils were to be instructed in
pattern drawing, designs, and technical processes in order to
serve English industry and free it from dependence on im-
ported design.

During the period when the Board of Trade and the Select
Committee were endeavoring to make the School of Design

[2] Quoted from Quentin Bell, *The Schools of Design* (London:
Routledge & Kegan Paul, 1963), p. 52

more effective, Prince Albert, married to Queen Victoria since 1840, had become an important figure in official artistic circles. His natural interest in art had been fostered by his father, Duke Ernest I of Saxe-Coburg-Gotha, and stimulated by a study period in Florence and Rome, where in 1839 he was introduced to the resident German artists as Ludwig I of Bavaria had been twenty years earlier. He was already acquainted with former members of the Nazarene group and had seen the fresco work of Cornelius in Munich in 1838. Since Albert's position as Prince Consort limited the scope of his activities, he had assumed the financial management and reorganization of the royal household, its properties and estates, and the supervision of new buildings and furnishings compatible with the royal family's taste. These activities gave him firsthand knowledge of the state of British manufacturing and its relation to the decorative arts. In 1841, when the Royal Commission on the Fine Arts was formed, Prince Albert was named chairman, a position which involved him in all decisions of state patronage of the arts. In this capacity he worked with Charles Eastlake, secretary of the Commission, on the plans for the decoration of the Houses of Parliament.

By 1843, when Prince Albert became president of the Society for the Encouragement of Arts and Manufactures, he was well prepared to strengthen the Society's programs. In 1846 he expressed his opinion to the Society's council that "the department most likely to prove immediately beneficial to the public, would be that which encourages most efficiently the application of the Fine Arts to our manufactures." That year the Society offered prizes for the design of a tea service for common use; a design by Felix Summerly was awarded a silver medal and was later manufactured by Minton.

Felix Summerly, the pseudonym of Henry Cole, was well known for a series of small, inexpensive guidebooks to historic English sites, and for *The Home Treasury*, 13 vols. (London, 1843–45), children's stories illustrated by wood engravings after well-known paintings by contemporary artists. Cole was also known to Albert for his efficient reorganization of the Public Record Office and his innovations in the Post

Office. In 1846 he was induced to become a member of the Society. As a member of the Society's council, Cole helped to arrange the exhibitions of "art manufactures" held by the Society in 1847, 1848, and 1849, as well as an important exhibition of ancient and medieval decorative art held in 1850. In 1847 Cole founded Summerly's Art Manufactures, an organization of artists, designers, and manufacturers devoted to reviving "the good old practice of connecting the best art with familiar objects of daily use." Invited by the Board of Trade to suggest improvements in the School of Design, Cole found the school's educational principles incorrect for their purpose. In 1849, with the painter Richard Redgrave serving as editor, Cole established *The Journal of Design and Manufactures*. It would give practical assistance, designs, and technical information to industry and "establish principles of ornamental art" as well as constructive criticism.

When, in January 1848, Cole suggested that the Board of Trade, the Royal Society of Arts, and the School of Design sponsor a national exhibition of British Manufactures every four years, Prince Albert was sympathetic. At the Prince's request, the project, scheduled for 1851, was expanded to become an international one, the first ever to be held. A royal commission was appointed to organize it and raise the necessary funds. Hyde Park was chosen for the site. When the Building Committee was unable to design an acceptable building to cover the eighteen or nineteen acres of required space, Joseph Paxton's brilliant, ingenious design for a glass and iron structure was accepted. Developed from Paxton's experience constructing greenhouses, the building was dubbed the Crystal Palace as soon as the plans were published. Paxton, the engineering firm of Fox and Henderson, and William Cubitt's architectural firm, were backed by an assembly-line type of "production engineering" provided by Chance Brothers glass manufacturers and other suppliers. As a result, the entire structure—including the preparation of working drawings—was completed between August 1850 and May 1851.

The Superintendent of Works in charge of decoration was Owen Jones, the author of *The Polychromatic Ornament*

of Italy (1845). Mary Philadelphia Watkins Merrifield, the noted translator of Cennino Cennini's *Trattato della Pittura* (*A Treatise on Painting*, London, 1844), who had been commissioned to go to Italy in 1845 to collect manuscripts on fresco techniques—her book entitled *The Art of Fresco Painting* (1846) had been followed in 1849 by her translations of *The Original Treatises* dating from the twelfth to eighteenth centuries (London, 1849)—wrote an article for a special issue of the *Art Journal*, "The Harmony of Colours as Exemplified in the Exhibition." She examined the application of Chevreul's study of color contrasts published in *De la Loi du Contraste Simultané des Couleurs* (Paris, 1839; *The Principles of Harmony and Contrast of Colours*) and detailed Jones's use of polychromy in the building:

> Mr. Owen Jones' coloured decorations of the building in Hyde Park are a convincing proof of his intimate knowledge of the laws regulating the harmony and contrast of colours. It will be observed that, in painting the roof, he has not introduced yellow, which, next to orange, is the most exciting colour to the eye, and should therefore be admitted in small quantities only. . . . The pale sky blue on the upper part of the building would neutralise but a small portion of yellow or orange. Mr. Jones, therefore, placed white of a warm tint next to the blue, knowing that in conformity with the laws of the simultaneous contrast of colours, the white stripes by their opposition to the blue, would be slightly tinged with the complementary colour (pale orange) and thus perfect harmony would be produced, by one of the most beautiful contrasts in nature—namely sky blue with the warm tint of delicate orange, which is frequently seen in clouds. The red stripes beneath the girders are only seen on looking upwards from below, and from being in shadow they do not strike forcibly on the eye.[3]

The total effect was magical and almost intoxicating, as Mrs. Merrifield noted:

> For practical purposes the effect of the interior of the building resembles that of the open air. It is perhaps the only building in the world in which atmosphere is perceptible; and the very

[3] *Palace Exhibition: Illustrated Catalogue* (special issue of the *Art Journal*, London, 1851), p. II‡, col. 1, fn.

appropriate style of decoration adopted by Mr. Owen Jones has added greatly to the general effect of the edifice. To a spectator seated in the gallery at the eastern or western extremity, and looking straight forward, the more distant part of the building appears to be enveloped in a blue haze, as if it were open to the air, the warm tint of the canvas and roof contrasts with the light blue colours of the girders into which it is insensibly lost, and harmonising with the blue sky above the transept produces an appearance so pleasing, and at the same time so natural, that it is difficult to distinguish where art begins and nature finishes. The busy groups in the nave below, while by their movement they give life to the scene, contrast by their broken and motley colours with the cool and aerial effect of the upper part of the edifice.[4]

The Exhibition of the Industries of All Nations included four classes of exhibits: raw materials, machinery and mechanical inventions, manufactures, and sculpture and plastic art. Sculpture was included because many contemporary artists used mechanical procedures: sculptors working in marble relied on "points"; both full-size and reduced works were cast in metals; and small reproductions were cast in ceramic materials. For the first time sculpture was exhibited in sufficient quantity to survey the prevailing taste in technique and subject. As in painting, many of the works—especially slaves clad only in their chains, as in Hiram Powers's *Greek Slave*—catered to a desire to be entertained and titillated by voluptuousness. Few paintings were included, and, as Merrifield observed, "when admitted they are to be regarded not so much as examples of the skill of the artist as of that of the preparer of the colours." To make up for this deficiency, an independent "General Exhibition of Pictures of the Various Schools of Painters," to include continental, British, and American artists, was organized by French artists and opened in May at Lichfield House, St. James Square.

Within the Crystal Palace, the effect of the arrangements of the individual exhibits on the attractiveness of the items displayed was a vital concern to the exhibitors. Mrs. Merrifield commented:

[4] Ibid., p. II‡, col. 1

The decorators of the different counters in the exhibition are in this predicament;—they are furnished with materials of certain colours which they must not only arrange so as to display their beauties of colour and texture to the greatest advantage, but must take care that they are not injured by the proximity of other coloured objects. In this respect their task resembles that of the "hanging committee" of an exhibition of pictures. Our good or bad opinion of an artist's colouring will frequently be influenced by the pictures near his work.[5]

An eminent German architect and advocate of polychromy, Gottfried Semper (1803–79) was given a contract to come to England to arrange the Canadian, Egyptian, Swedish, and Danish displays. In London Semper added his considerable talents to those of Owen Jones, Richard Redgrave, Matthew Digby Wyatt, and Henry Cole; all were concerned to improve the uneducated taste of producers and to provide the populace with better-designed goods. A native of Hamburg, Semper had begun his studies in Munich with the eclectic architect Friedrich von Gärtner, and continued them at the École des Beaux-Arts, where he studied with Franz Gau and Jacques Ignace Hittorff. After four years devoted to the study of classical monuments in Provence, Italy, and Greece, and of Italian Renaissance palaces and villas, he returned to Hamburg. In 1834 he published a pamphlet on the Greek use of color in architecture which was denounced by Franz Kugler, art professor at the Prussian Academy in Berlin, who wrote the influential and oft translated *Handbuch der Kunstgeschichte* (*A Handbook of Art History*) in 1841–42.

Despite Kugler's opposition, Semper was named director of the School of Architecture at the Saxony Academy in Dresden in 1834. Through his position and his commissioned buildings—the Dresden Opera House and Art Gallery—Semper furthered a close relationship between architecture and the applied arts. Semper was engaged in work at the palace at Gotha the year Prince Albert's father died (1844), and may have met the Prince Consort there. Because he mounted the barricades in the Dresden uprising of 1849, Semper was

[5] Ibid., p. II‡, col. 2

forced to flee to Paris. There he was befriended by the artists he had employed to decorate the Dresden Opera House and was welcomed by the advocates of polychromy, in its use in the new ferrous-vitreous construction, who were grouped around Henri Labrouste and Hittorff; the latter was Semper's former teacher. Semper had been about to migrate to the United States when he received the invitation to come to England.

The exhibition, which closed in October after it had been seen by six million persons, focused attention on the need for a close relationship between art and industry. The *Art Journal*'s prize for an essay on the exhibition was won by Ralph Nicholson Wornum's "The Exhibition as a Lesson in Taste." It was published—with essays by Mrs. Merrifield and others —in a special issue, *The Art Union Catalogue*, with engravings of "the most interesting and the most suggestive" of the objects exhibited. Prince Albert proposed that a series of lectures on "The Results of the Exhibition of 1851" should be delivered to the Society of Arts. Semper received a suggestion to report in a similar way on the plan for improving the training of artisans. This may have resulted in his essay, written in London and published in Braunschweig, Germany, *Wissenschaft, Industrie und Kunst* [*Science, Industry, and Art* (1852)], with the subtitle "Proposals for awakening a national art consciousness at the conclusion of the London Industrial Exhibition." It briefly enumerated Semper's concept of the principle by which the progressive development of forms leads to a style which is related to the native origin of the forms. Semper, like Wornum in his essay, treated style historically and according to classifications.

The juxtaposition of seven thousand exhibits from thirty nations aroused questions of the sociopolitical conditions and the development of national styles, as well as discussions of style, taste, function, and the role of ornament. The influence of the exhibition was incalculable. The exhibition included not only "all nations, but also all stages in the lives of nations," and demonstrated that "man is by nature an artificer, an artisan, an artist. . . . In savages how much practical knowledge and manual dexterity [are to be seen]! In

more developed countries [Persia and India] . . . how much which we must admire, which we might envy, which, indeed, might drive us to despair."[6] In those countries the arts gratified the tastes of the few; now it was seen that by means of the machine art now "works for the poor no less" than for the rich to the comfort and enjoyment of the public.

The financial success of the exhibition permitted immediate plans to be made to employ the surplus profits for education. A Museum of Manufactures was established. In it, while students were offered "specimens of ornamental art, most of which illustrate correct principles in decoration, it has been deemed advisable to collect and exhibit to the student examples of what, according to the views held in this department, are considered to show wrong or false principles. The chief vice in the decoration common to Europe at the present day is the tendency towards *direct imitation of nature,* which in respect to ornamental art is opposed to the practice of all the best periods of art among all nations."[7] By 1857 it became a Museum of Ornamental Art in the group of buildings devoted to the promotion of science and art known as the South Kensington Museum, and in 1899 it was named the Victoria and Albert Museum.

Gottfried Semper: *Science, Industry, and Art*[1]

I. Scarcely four weeks have passed since the Exhibition closed. The wares still stand, partially packed, in the desolate halls of the Hyde Park building. Public attention has already rushed beyond this "world phenomenon" towards other more thrilling, imminent events. None of the enthusiastic newspaper correspondents who began a new calendar on the day the "world fair" opened concerns himself anymore with this matter. But it left behind a stimulation which continues to ferment in thousands of thinking minds and striving spirits and which is impossible to measure. . . .

[6] Loc. cit.
[7] Ibid.
[1] [Translated from Gottfried Semper, *Wissenschaft, Industrie und Kunst,* Braunschweig, 1852; rpt. Mainz: Kupferberg, 1966]

The building of 1851 to which the nations carried their goods produced a sort of Babel. This apparent confusion marks, however, nothing more than the clear emergence of certain anomalies in contemporary society—anomalies whose causes and effects could not be generally and clearly recognized by all the world until now.

This, essentially, is the important significance of the Exhibition. . . .

At the opening of the Industrial Exhibition, I considered appraising its contents and sought a method to follow.

There were three possible approaches.

The first and simplest was to wander through the entire building, from one end to the other, and to describe in order the products of the various nations. That smacked too much of the guidebook.

The second existed in the so-called "Head Juries," the classification of the objects prepared by the Royal Commission. According to this system, objects were first arranged in the space and were later divided into the divisions set by the judges.

This plan is skillfully conceived, and is of interest for similar undertakings in the future. The objects are divided into four main sections: 1. raw materials 2. machinery 3. manufactures 4. fine arts. . . .

At an industrial exposition, the products of artistic competence surely derive from needs—the need for sustenance, shelter, protection, the need to measure time and space, and so forth—and these needs should determine the first and most essential areas of consideration. Subdivisions must exist within these areas, determined by an object's particular use and the materials and techniques used to produce it. In addition, raw materials, tools, machines—in short, all the factors necessary to the product's creation—must be recognized. . . .

The plan I formed was architectonic, based upon the elements of the home: hearth, wall, terrace, roof. A fifth main division would have included the interaction of these four elements, higher art [i.e., the fine arts] and, symbolically, higher science. This plan would have allowed the derivations of objects and forms to emerge by themselves from their orig-

inal uses, and stylistic changes to emerge according to the conditioning circumstances.

But the proposed critical approach was not used, partially because of external difficulties, but also because I had begun to have doubts about it. The Head Juries are, in fact, quite well adapted to most recent cultural developments and to the contemporary relationship in human activities. No other plan could have been established as the basis for the General Industrial Exhibition of 1851. . . .

Necessity was the mother of science, beginning in the narrow sphere of what had already been achieved and soon coming, empirically and with youthful ingenuity, to confident conclusions about the unknown and creating a world out of its hypotheses.

At later periods science felt restricted by its dependence on utility and became an end in itself. It entered into the area of question and analysis. Classification and nomenclature replaced the systems of the intellect or imagination. . . .

It is already evident that inventions are no longer, as they once were, the means for warding off want and providing pleasure. Instead, want and enjoyment are the means to sell inventions. The order of things has been reversed.

What is the inevitable consequence of this? The present age does not have time to become familiar with and master the blessings forced upon it. It is like the Chinese person who is asked to eat with a knife and fork. Thus, commercial speculation [capitalism] forces itself upon the means, and palatably displays its benefits to us. Where there are no needs, capitalism creates a thousand small and large useful things. Old, outdated comforts are revived if nothing new occurs in commerce. The most difficult and laborious tasks are playfully accomplished with means borrowed from science. The hardest porphyry and granite are cut like chalk and polished like wax; ivory is softened and pressed into molds; india rubber and gutta-percha[2] are vulcanized and used for deceptive imitations of carving in wood, metal, and stone.

2 [Gutta-percha is a derivative of the latex from a tree found in the South Pacific and South America.]

These imitations far exceed the natural realm of the simulated materials. Metal is no longer cast or embossed, but is deposited galvano-plastically [by electrotyping] by natural powers unknown until recently. The talbottype[3] follows the daguerreotype, which is already forgotten. The machine sews, knits, embroiders, carves, paints, and, reaching deep into the area of human art, puts to shame every human skill.

Are these not grand, magnificent achievements? I do not deplore the general conditions of which these are only minor symptoms; I am certain that sooner or later these achievements will spread happily to advance the welfare and honor of society. I am too modest to touch upon the more difficult and larger questions raised by these advances, and in the following I attempt only to call attention to the confusions in the field of man's capabilities—manifest in the recognition and depiction of beauty—to which these achievements presently give rise.

II. If separate facts were enough to constitute a proof, the recognized victory that the half-barbarian peoples—above all the Indians—won over us in several areas by their splendid art industry would be sufficient proof that we, with our science, have not yet accomplished very much.

The same humiliating truth is forced upon us when we compare our products with those of our ancestors. In spite of great technical progress, we have remained far behind them in formal qualities and, yes, even in suitability and practicality. Our best things are more or less faithful re-creations. Other things show a laudable attempt to borrow directly from nature; but how seldom have we been successful in this. Most of our efforts result in confused mixtures of designs or childish dallying. Our success had been primarily with objects whose serious use permits nothing useless—as with carriages, weapons, musical instruments, and the like; wholesome qualities are also seen in cases where the formal detailing and refinement are strictly dictated by the object's use.

[3] [William Henry Fox Talbot (1800–77), an English scientist and mathematician, invented a photographic process in the 1830s which bears his name.]

Facts, as we have said, are not arguments; they can even be denied. It is, however, easy to prove that contemporary circumstances are definitely dangerous for the art industry and ruinous for traditional higher forms of art.

The excess of technology with which all must struggle is the first great danger. This statement is, I admit, illogical (there is no excess of techniques, only an inability to master them); it is justified, however, insofar as it correctly indicates the contradictory nature of our situation.

In practice we labor in vain to master the material, particularly in terms of its spiritual aspects. Technology receives its material from science for whatever further utilization it desires, without the material having been able to develop a style through centuries of use by the people. Formerly the founders of a highly developed art received their techniques already thoroughly shaped, as it were, by the people's natural instinct; they formed and plastically processed the original motif to a higher significance. Their creations simultaneously received the stamp of strict necessity and spiritual freedom and became the generally intelligible expression of a true idea which historically continues to live in them as long as a trace and knowledge of its origin remain.

What a marvelous invention is gas illumination! How greatly it enriches our festivities (quite apart from its infinite importance for the necessities of life!) Nevertheless, in drawing rooms the gas outlets are disguised to look like candles or oil lamps. On the other hand, illuminations for festivals, which are supplied by a series of pipes with consecutive small openings, are arranged so that all sorts of stars, fire wheels, pyramids, escutcheons, inscriptions, and the like hover in the air before the walls of houses as if held by an invisible hand.

This hovering quiet of the most lively of all elements is indeed effective (the sun, moon, and stars give the most remarkable examples of this), but who can deny that these changes in the traditional method of lighting houses efface the evidence of the householders' participation in the public celebration. Formerly, moldings and windowsills were lined with oil lamps, brilliantly accentuating the familiar shapes

and masses of the house. Now the brilliance of these lights blinds the eye and makes the facades behind them invisible.

Whoever has attended illuminations in London and remembers similar festivities in the old style in Rome will admit that the art of illumination has suffered a serious blow through these improvements.

This example shows the two main dangers—the Scylla and Charybdis—between which one must steer in order to achieve something new for art.

The invention of illumination is excellent, but in the one case it is sacrificed to traditional forms and in the other the false application of the invention completely obscures its basic purpose. Indeed, all the means were present to accentuate the house more brilliantly while enriching it at the same time with a new purpose (that of a constant firework display) . . .

Were aesthetics a complete science—were it, in addition to its incompleteness, not filled with indefinite, often erroneous notions; were it not lacking in clear concepts, particularly concerning application to architecture and general tectonics—aesthetics could step into this gap. But in its present state, aesthetics is, with reason, scarcely considered by the more talented professional men. Its wavering precepts and principles are approved of only by the so-called art experts, who use them to measure the worth of a work because these men have no inner standard of their own. Art experts believe they have grasped the secret of the beautiful in a dozen rules, but the endless variations of the world of forms are shaped to characteristic significance precisely in the denial of a system.

Style, one of the concepts that aesthetics has struggled to define, plays a main role in art. . . . Perhaps one might say: Style is the emergence, raised to artistic significance, of the content of the basic concept and all internal and external elements which modified the basic idea. Lack of style is, then, according to this definition, the term used to describe the deficiencies of a work which arise from a lack of consideration of the basic concept of the work and from an awkward aesthetic use of the means available for the work's completion.

Similarly, Nature, however various her motifs, is, in fact, rather simple and frugal, as she herself shows by constantly renewing the same forms. These forms appear modified a thousandfold—changed according to the degree of development and according to the various requirements of the creations. . . .

The basic form—the simplest expression of the idea—is particularly modified by the materials used in its further development, as well as by the tools used to develop it. Influences outside the work itself also contribute in important ways to its design . . . One can, without being too arbitrary or too tied to these preceding thoughts, conveniently separate the theory of style into three parts.

The doctrine of basic uses and the earlier forms derived from them may form the first part in an art-historical sense of the theory of style.

Feeling is undoubtedly satisfied when the original motif of a work—no matter how far removed from the source from which it arose—continues as the basis for the work. In a work of art, clarity and freshness in the conception of the original motif are certainly very desirable. Through them one guards against arbitrariness and meaninglessness and strives for positive direction in invention. The new is thereby joined to the old without being a copy of it and is freed from dependence upon the empty influences of fashion.

Allow me, for clarity's sake, to give an example of the determining influence of an original form on the development of the arts.

The mat and the woven (later embroidered) tapestry developing from the mat were originally room dividers and, as such, the basic motif of all later wall decorations and of several other related branches of industry and architecture. The techniques employed in subsequent room dividers may differ, but their style always displays their common origin. We also readily see that in ancient times, from the Assyrians to the Romans and, later, in the Middle Ages, walls—their division into areas, their ornamentation, the principle of their coloring and, yes, even the historical painting and sculpture on them, the painted glass, and floor decoration—in short, ev-

erything relating to them—remained dependent on the original motif, whether unconsciously or in a consciously traditional fashion.

Fortunately, the historical aspect of the theory of style can easily be followed even through our confused contemporary circumstances. What rich material for the [study of style]—for its development, for comparison and reflection—was offered at the London Exhibition by those works, already mentioned, of peoples still in more primitive cultural stages.

The second part of the theory of style—which should teach us how, with our contemporary techniques, forms ought to be created differently from the [original] motifs and how, with our advanced technology, the actual material is to be treated according to the principles of style—is regrettably obscure. Another example may be given here to illustrate the difficulties in understanding the principles of the technical theory of style.

Egyptian granite and porphyry monuments exercise an incredible power over every spirit. What does their magic consist of? Certainly they derive power, in part, from [the fact that] they are the neutral ground where hard, resistant material and man's weak hand, with his simple tools (the hammer and chisel), meet and form a pact with each other. "So much, and no more; so, and not differently!" They have spoken this mute language for centuries. Their sublime repose and massiveness, the somewhat angular and flat fineness of their lines, the restrained treatment of difficult material evident in them—their entire constitution is stylistic beauty which now is no longer possible to the same degree, since we can cut the hardest stone as easily as bread and cheese. How should we treat granite now? A satisfactory answer to this question is difficult. The next consideration will surely be that we must use this material only where permanence is a necessity, and we will devise the rules for its stylistic treatment from this new requirement. That little regard is given to this requirement in our age is proved by certain extravaganzas which the great Swedish and Russian granite and porphyry factories paraded before us at the exhibition.

This example leads to a more general question, which

would supply the material for a long chapter if this essay could be extended into a book: Where does the depreciation of material—through its treatment by a machine, through substitutions for it, and through so many new inventions—lead? Where does the depreciation of the labor necessary in pictorial, sculptural, or other decoration—caused by the same factors—lead? Naturally, I do not mean their depreciation in price, but rather in significance, in concept. Has the machine not made the new Houses of Parliament unenjoyable? How will time or knowledge regulate these conditions, which until now have been completely confused? How will time and knowledge prevent the general depreciation from extending to work executed truly by hand, in the old-fashioned way, and how will one be prevented from seeing in hand execution something other than archaism, affectation, oddity, and caprice?

While the technical doctrine of style offers such difficulties in the determination and application of its principles, an important third part of the theory of style will scarcely be spoken of in our age. I mean the aspect that should deal with the local, contemporary, and personal influences—influences external to artworks, which affect their formation and should give expression to the unification·among them, to their common character. . . .

Attention was called above to the dangers which threaten our industrial art, and art in general, through the excess of techniques, to retain the expression used above. Now we must also ask about the influence that commercial speculation, supported by large capital and led by science, will exercise upon the art industry, and about the final result of this steadily growing protectorate.

Capitalism will, if it recognizes its best interests, seek out and recruit the best work forces and for that reason will show more zeal as protector and cultivator of art and artists than ever a Maecenas or a Medici did.

Surely! But there is a difference between working for a commercial concern and freely completing one's own work. In working for a commercial concern one is doubly depend-

ent: a slave both of one's employer and of the contemporary fashion which procures for the employer a market for his wares. One sacrifices one's individuality, one's "birthright," for a dish of lentils. Once artists practiced self-denial and sacrificed their egos, but only for the honor of God.

But let us not follow this course of reflection further, for capitalism leads along a fairly direct path to a definite goal, and to indicate the goal more clearly now seems all-important.

The house of H. Minton and Company of Staffordshire deserves praise for the revival of a magnificent branch of art which was, so to speak, lost. Its earthenware is not only technically excellent but also gives evidence of true artistic endeavor. The selection of objects that highly recommend themselves is manifold, and no doubt the firm will do good business with them. The articles will often be used for architectonic and decorative purposes and, in addition, are available in large quantity and therefore are cheap to buy. The molds, once made, will be cheaper than newly ordered ones, and thus they will decisively influence production.

This is one example from among hundreds. Everything that one uses for and in the house can be had cheaply, quickly, and in good quality.

Furniture, wallpaper, rugs, windows, doors, cornices, entire room decorations—in short, all interior and exterior, all fixed and movable, parts of a house, indeed, entire houses—can be bought ready-made at the Exhibition.

Domestic architecture in England, and still more decisively in the United States, has already modeled itself completely upon these conditions. . . .

The course relentlessly pursued by our industry and art is clear: Everything is calculated and cut out for the market.

A ware designed for the market must, however, permit the widest possible use and may possess no other characteristics beyond those permitted by the purpose and material of the object. The place in which it will be used is as unspecified as the characteristics of the person who will own it.

Therefore, it may not possess individuality or local color

(in a broad sense of the word); instead, it must be able to adapt harmoniously to every environment.

The products of oriental industry evidently fill these requirements completely and do so best when they include fragments from their own now ruined art or foreign art. They are most at home in a bazaar. Nothing is more characteristic of them than that previously indicated ease of adapting to all environments. Persian rugs suit a church as well as a boudoir. The ivory boxes from India, with their inlaid mosaic patterns, can be used as incense boxes or cigarette cases or sewing boxes, according to the whim of their owner.

Undoubtedly the influence of these wares, which quite properly arouses such general amazement, will soon be seen in our artistic manufactured products as one of the immediate effects of the London Industrial Exhibition.

But as much as these achievements of the Asiatics are in themselves perfected—and in technical-aesthetic beauty in style constitute the opposite to our modern European lack of fundamental principle—we miss just as much in them: individual expression, language, higher phonetic beauty, soul. This individual expression, however, even if prevented from elevating itself to greater significance in an object that is determined for the market, is always attainable to a certain degree as soon as the object is not merely an end in itself but rather has some usefulness, a requirement. Tritons, nereids, and nymphs will always receive significance on a fountain, Venus and the Three Graces on a mirror, trophies and battles on a weapon, regardless of whether these objects were made for commercial speculation or belong to a specific place.

We possess a wealth of knowledge, unsurpassed technical virtuosity, abundant artistic traditions, generally intelligible images, a true view of nature, and, indeed, we cannot give all this up for half-barbaric ways. What we must learn from the peoples of non-European culture is the art of finding those simple, understandable melodies in forms and colors which instinct imparts to the simplest of human works but which are always more difficult to seize and retain on works of more elaborate technique. We must therefore study the simplest

works of the human hand and the history of their develop-
ment with the same attentiveness with which we study the
phenomena of nature itself. . . .

But, as long as our industry continues to manage without
direction, it will unwittingly perform a noble deed: the disso-
lution of traditional types through their ornamental treat-
ment. . . .

III. I hear two objections being raised: "What you have said
about the influence of science and capitalism on the practice
of art is applicable only to individual countries. The condi-
tions which exist among the backwoods Anglo-Saxons, who
since their origin have been hut dwellers, are not comparable
to the conditions which possess old Europe, with its still vital
and fresh artistic traditions. Granted, were those primitive
conditions generally introduced, a true art would emerge in
monuments—an art more pure and noble, like [that which
existed] among the Greeks, who knew almost no domestic
architecture."

Let no one deceive himself! Those conditions indeed have
in themselves the certainty of general value in the future,
since they correspond to circumstances which are valid in all
countries and, secondly, we realize all too painfully that the
most fatally affected will be higher art forms.

Art also has been going to the marketplace for a long time,
not to speak to people there but to offer herself for sale.

Who was not seized by sorrow and melancholy upon enter-
ing the Lombard-Austrian market, which was filled with
lovely naked and veiled marble slave figures? . . .

A work of art destined for the market, unlike an industrial
object, cannot have an actual reference, since, unlike the in-
dustrial object—in which the artistic qualities are at least sup-
ported by the use which is supposedly to be made of the ob-
ject—the work of art stands alone, entirely by itself, and
always betrays its purpose, which is to please and entice
buyers, in an unpleasant fashion.

The bust and the portrait remain the healthiest of the plas-
tic arts of our age; but anyone familiar with the question
knows how absurd and rotten the situation is even here. For

the sake of artists lolling about, city squares are populated with [statues of] famous men. The arts must be protected! A hero cult similar to that of the Greeks exists neither among those who erected the sculptures nor among the people. The people no longer look at these statues; just as one once was conscious that the square was empty, one now is conscious that there is a pedestal in it. If I am not mistaken, among the numerous portrait statues of famous men of the past, present, and future which decorated the exhibition building, there were, in fact, several made purely on speculation. Nevertheless, the portrait still remains perhaps the most important connecting link with something better.

Painting was excluded from the exhibition, otherwise the market would have had a more colorful appearance.

That what has been said applies also to painting needs no great proof. After all, has not a year's cycle of picture fairs, completely regulated and listed in calendars, been established and permanently arranged in art clubs and art exhibitions?

"But," I hear it said, "our monuments—with their frescoes, their glass paintings, their statues, their pediments, and their friezes—nevertheless remain the treasure hoard of true art!"

Yes, if the works haven't been borrowed or stolen! They don't belong to us at all. They consist of still undigested elements; nothing new which we could call our own has been formed in them. Nothing of them has gone into our flesh and blood. The present has indeed painstakingly collected them, but it has not yet sufficiently decomposed or dissolved them.

This process of dissolution of contemporary art forms must first be completed by industry, capitalism, and the application of science before anything wholesome and new can result.

Nothing new happens in the world; everything was already there once before. According to the philosophers, society moves (if it progresses at all) in a spiral; seen from certain points, the beginning of a period coincides with its end.

Thousands of years ago luxury dwelt in crude tents, in farmsteads by pilgrim routes, in castles and camps. Archi-

tecture did not yet exist, but certainly a rich manufacture of art did. The market, trade, and robbery supplied households with luxury articles, with rugs, materials, tools, containers, and ornaments. This is still the case today in the tents of the Arabians, and it is almost so among us, in our highly civilized age, although we believe ourselves to be near the frontier of human perfection. . . .

IV. We have artists but no actual art. Artists are trained in the grand style by our state academies, but, apart from the mass of mediocre talents, even the number of highly talented artists far exceeds the demand for them. Only a very few of them see their aspiring youthful dreams fulfilled and, indeed, even then their dreams are fulfilled only at the expense of reality, by a negation of the present and a phantasmagoric evocation of the past. The others find themselves thrown on the market and seek employment where they find it. Here again one of the many contradictions of our age emerges. How can I put it most concisely? It should be clear if I say that art applies itself to handicrafts, as the handicrafts earlier applied themselves to art; but I do not intend to imply that a commercial, unartistic attitude has become predominant. Only insofar as the impulse towards formal refinement no longer arises from below, but rather descends from above, can this assertion be justified. But even this interpretation is unsatisfactory, for the same thing occurred in Phidias's and Raphael's time, happened even more consistently among the ancient Egyptians, and has been the case whenever architecture ruled hierarchically over the arts. The anomaly consists essentially in the fact that [today] this influence from above is felt at a time when no dominant architecture exists, at a time that is clearly related to that period when luxury built its nests in tents and farmsteads. Thus, everyone goes his own way. It is evident that under such conditions and circumstances no consistent attitude can be maintained.

It is all the less attainable since, as we have previously stated, the efforts of the fine arts to influence industry from above lack the proper basis for doing so.

The results prove this. The influences of the academic art-

ists on the art industry reveal themselves immediately in the following: First, the requirements of the object often emerge artistically only insofar as the object treated lends itself to pictorial references and decorations; the influence of the fine arts does not express itself in the general appearance but only in the accessories of the object. Second, in objects created under academic direction, the achievement is far inferior to the intention, and violence must be done to the material to fulfill even partially the artist's intention. No wonder, for though the artist is certainly skilled and inventive in drawing and modeling, he is neither an ironworker, potter, tapestry weaver, or goldsmith. A third indication of these influences is revealed by the fact that the ornamental accessories are generally poorly understood: They either blend too much with the main subjects or have no connection at all to them. Often a variation in scale is the only differentiation made between the two. On the other hand, the artist often scorns ornamentation as unworthy of his talent and leaves it to other hands, causing an unpleasant lack of uniformity in the treatment of the work. Fourth, and last, there often appears in such works of the art industry a lack of definition in the connection of the architectonic forms and conditions for those forms. The indefiniteness is joined with an arbitrary mixing of traditional architectonic types but lacks that freshness through which traditional form, namely, the mixture of long-forgotten types on which higher art condescended to work, becomes meaningful.

One must admit that in areas where architects have exercised this influence, the gross errors noted in the last two points do not emerge. On the other hand, architects' compositions are often only imitative and poor in phonetical art. These unfortunate circumstances, which can be seen particularly in Germany, have been recognized, and it has been possible to alleviate them through the establishment of so-called industrial schools, which operate in conjunction with the fine art academies and regulate the surge of youth toward the latter institutions. Admission to the fine art academies has been made contingent on wealth, and a preliminary test of a true calling for art and good education has been required. Even if

talent developed by previous and often poorly directed instruction were recognizable, one would still have to presuppose the necessary impartiality of the examiners. Thus, the poorer classes and all declared untalented are directed to the industrial schools. In spite of supposedly good equipment and personnel, these schools cannot supply the desired advantage of a practical instruction, since the separation of fine art from industrial art, expressed in the side-by-side existence of the two institutions, is thoroughly unsuitable, and the present generation does not wish to recognize it.

Those lofty art academies are basically little more than welfare institutions for professors. It will be a long time before these professors' organizations recognize their isolation from the people. People may censure and be suspicious of my statements; nevertheless, this *was* and *is* my honest conviction.

The future will settle all this. The true force, in spite of all obstacles, will, with increasing accuracy, find the best place to grasp the lever with which it must work in order to assert itself. A brotherly relation of the master to his journeymen and apprentices will then bring about the abolition of the academies and the industrial schools, at least in their present arrangement.

1852: PARIS
The Official Exhibition
of the State:
The Salon

On December 1, 1851, the usual Monday-night reception held at the Élysée Palace by the President of the Republic, Louis Napoléon Bonaparte, was gay and well attended. The Minister of the Interior, the Duc de Morny, who was Louis Napoléon's half brother, enjoyed a performance at the Opéra Comique. At 12:30 A.M. the President, de Morny, and four others were gathered around a single light in the President's study, making their final plans for the approaching day.

Edmond (1822–96) and Jules de Goncourt (1830–70) had looked forward to the second of December as the publication date of their first novel, but, as they recounted in their journal, they were awakened by a different announcement.

> "Well, there has been a revolution!"
>
> It was M. de Blamont, our cousin Villedeuil's friend, . . . who spoke as he entered our rooms at eight o'clock in the morning.
>
> What a start he gave us! Quickly we went downstairs. Pants, shoes, and the rest and out onto the street. Placards at the street corner announced the order and the march. At the mid-

dle of our street, rue Saint Georges, troops crowded the *National* building.[1]

The placards, posted throughout Paris by order of the President, accused the National Assembly of conspiracy and called for its dissolution, the restoration of universal suffrage, and national elections. Soldiers occupied the offices of important newspapers, the Palais Bourbon, and other strategic locations, and arrested opposition leaders. When the Assembly met to protest, its members were arrested. The unarmed populace resisted sporadically at hastily erected barricades, but was quickly brought under control by the troops. The Goncourts were bored by the coup's efficiency:

> I am sure that coups d'etat would go even more smoothly if there were gallery boxes and orchestra seats, which would allow one to see everything easily and not miss anything. But this coup was deficient; it dared to deprive Paris of one of her great pleasures: It didn't satisfy the spectators. It was played out on the sly, without fanfare, quickly, as though it were a curtain raiser. The audience barely had time to find their seats. The spectators were certainly not taken into account. At the most interesting moments, the bit players fired at the windows—I should say at the house—and, worst of all, they forgot to forget to load their guns.[2]

A few days later the city was quiet. Nearly 27,000 people had been arrested throughout the country and 11,000 were to be deported or exiled, among them Louis Thiers, Victor Hugo, and David d'Angers, who went to the Gare du Nord accompanied by 50 sculptors. Louis Napoléon asked the French to grant him the power he had seized and called for a plebiscite. Louis-Philippe's properties were confiscated and sold; the proceeds were used to finance a number of public-works projects—for example, it was announced that the Louvre would be extended—which, according to cynics, Louis Napoléon initiated to insure the outcome of the election. On

[1] Edmond and Jules de Goncourt, *Journal: Mémoires de la Vie Littéraire, 1851–56*, vol. I, edited by Robert Riccette (Monaco: L'Imprimerie Nationale de Monaco, 1956–58), pp. 41–42
[2] Ibid., p. 43

December 20 the country granted Louis Napoléon a ten-year term of office and on January 1 he offered a splendid Te Deum at Notre Dame.

To calm artists' apprehensions, de Morny had announced that the Salon of 1852 would open April 1 in the costly temporary building in the court of the Palais Royal. At the same time it was announced that the Directeur Générale des Musées Nationaux, whose office would now be separate from the Ministry of the Interior, would be responsible for the organization of the Salon and for proposals to the Ministry of the Interior for the distribution of awards. On January 20 the Directeur Générale, Comte de Nieuwerkerke, issued the regulations for the Salon with the approval of the Duc de Persigny, Minister of the Interior. (De Morny had resigned in opposition to his half brother's seizure of Louis-Philippe's properties.)

Born in 1811 to Dutch parents, Alfred Emilien Nieuwerkerke, who had trained as a sculptor while acting as a page to Charles X, made his debut in the Salon of 1847. He had become the *amant de titre* of Princesse Mathilde Bonaparte when she came to Paris in 1847 after her separation from her husband, the Russian prince Anatole Demidoff. Nieuwerkerke and Mathilde had met in Florence—a favorite residence for the wealthy international society of which Mathilde's father, Jérôme Bonaparte, was a member—when the young sculptor had visited the famous Demidoff collection of contemporary paintings. The studios of the sculptors Lorenzo Bartolini and Giovanni Dupré made Florence an important center for the execution of the gleaming, polished marble busts that were a necessary ornament for fashionable salons. Mathilde had studied painting in Florence, and her competent watercolors and oil paintings were admitted to the Salon after her move to Paris.

When her cousin, Louis Napoléon, was elected President of France in 1850, the princess secured Nieuwerkerke's appointment as General Director of National Museums, replacing the artist Philippe Jeanron. Nieuwerkerke also continued his activity as a sculptor; his state-commissioned equestrian

statue of Napoléon I was unveiled in 1854. The princess and
count resided in the splendid hotel at 24 rue de Courcelles,
which was given to the princess by her cousin. Decorated
with paintings chosen by Mathilde on the advice of Nieu-
werkerke and the Marquis de Chennevières, the elegant inte-
rior was familiar to any Parisian who purchased the popular
L'Illustration, in which it was depicted by wood engravings.
In its rooms the best known persons in French literature,
painting, and music gathered at the princess's Wednesday
evening salon. The musicians Gounod and Saint-Saëns, the
publishers Émile de Girardin of *La Presse,* Samuel Ustazade
de Sacy of the *Journal des Débats,* and Arsène Houssaye
of *L'Artiste,* the writers Renan, Taine, Mérimée, Flaubert,
the Goncourt brothers, and "her poet" Théophile Gautier
were overshadowed by the brilliant literary critic Sainte-Beuve.
Regularly present were such painters as Ernest Hébert, an
intimate friend of the princess from the days in Florence
when he was an art student and she copied old masters in
the Uffizi; Eugène Giraud, who had been her teacher; Eugène
Fromentin, Louis Boulanger, Jules Breton, Jean-Léon Gé-
rôme, Meissonier, and William-Adolphe Bouguereau. The
names of some of these artists and writers frequently appeared
on the list of government-appointed jurors after Nieuwerkerke
reorganized the Salon.

Two major changes were included, the first of which star-
tled the French art world: Each artist could submit only
three works. The second concerned the selection of the jury
for admission and awards: It would be named in two sec-
tions. Half would be elected by the artists who had been ad-
mitted to previous juried Salons, with the exception of the
unjuried Salon of 1848 (three hundred painters and sixty
sculptors would participate in the election); the other half
would be named by the Minister of the Interior. The three
works presented by any member of the Institute or any artist
who had been awarded the Légion d'honneur would not be
submitted to the jury but accepted automatically. When the
jury convened, the Comte de Nieuwerkerke instructed it that
the new regulations had been motivated "by the consid-

eration that the Exhibition should be an honor reserved for the most worthy artists. They themselves must choose the works which most completely summarize the type and progress of their talent."[3] Insisting on the necessity of including only the most remarkable works in the Salon, he called on the jury to be severe.

On April 2 the Salon opened with seventeen hundred works chosen from among three thousand entries. The space in the temporary building, with its Salon Carré, and the Palais Royal—which, in 1850, had accommodated four thousand works—was filled out with flowers and furniture arranged by Philippe Marquis de Chennevières, a favorite of Nieuwerkerke and director general of France's provincial museums. In the Salon Carré was Horace Vernet's *The Taking of Bastion No. 8,* where it would attract much attention. In the far gallery of the temporary building was another work which would draw the crowds, a historical painting by Louis Gallait, a Belgian who was well known both in Germany and France. Sculpture was exhibited not in the Salon Carré but in another room decorated with Gobelin tapestries. The fashionable visitors gladly paid the admission fee, which kept the crowds down on opening day. Journalists mingled among them and noted the works attracting public interest— while the public watched to see which works the critics honored with their attention.

Among the journalists were two novelists, Edmond and Jules de Goncourt. The coup d'etat had discouraged the sale of their novel, so they had turned to art reviews. In January, when their cousin, the Count de Villedeüil, founded *L'Éclair,* "a weekly review of literature, the theater, and the arts," they joined him as editors. The paper had scarcely a subscriber, but it furthered the young men's literary ambitions.

Left fatherless at an early age, the Goncourts had been brought up by their mother. As children they had accompanied her and an aunt, Mme. de Gourmont, on searches for bibelots and objets d'art. The experience had early sharpened

[3] See *Règlement de l'Exposition Publique,* Salon of 1850, pp. 11ff.

the boys' taste for the fantastic and the exquisite. Financially independent after their mother's death in 1848, Edmond left his despised position in the treasury to watch over his younger brother. Political unrest forced them to postpone plans to visit Italy, so they had set off on a walking tour of southern France, sketching as they went. Two of the winter months were spent in Algiers, where the brilliant light stimulated their awareness of color and love of the exotic. A second short trip to the Netherlands had made them aware of the sensuous use of color. Returning to Paris, and in search of a career, they turned their talent for observation, developed from years of making sketches and watercolors, to writing. Collaborating on their first novel, *En 18 . . .* , appeared in 1851. Written in a "formless style," with the plot obscured in a series of apparently unrelated episodes which made for difficult reading, it brought them no recognition beyond a favorable review by Jules Janin in the *Journal des Débats*.

Undaunted, they continued, jotting down the impressions of each day in their journal, destined to become the most famous of their works, and accepted their cousin's offer to join the staff of *L'Éclair*. For this weekly and for *Paris*, a more successful daily also founded by their cousin, they wrote plays, sketches of Parisian life and personalities, and reviews. To boost *L'Éclair's* circulation, they solicited the collaboration of two caricaturists: Nadar, the lithographer who would soon open his photographic studio, and Gavarni, whose precise, slightly satirical comments on Parisian life delighted the Goncourts. They shared his fascination for Parisian types, especially its women, and, observing them with cynical condescension, would make them the subjects of their later novels.

Approaching their first Salon as critics with aloof, aristocratic assuredness, the Goncourt brothers selected 109 paintings and 21 sculptures for comment. They described what they saw in impressionistic sketches and spiced these with satirical comments on the current theoretical debate of color versus line, beauty versus ugliness, and denounced religious painting. Fastidiously repelled by Courbet's realism, they sim-

ply omitted any mention of his paintings, but they did find pleasure in the naturalism of the landscapists and the vitality of Barye's sculpture. Possessing a keen interest in and respect for lithography, they devoted space to the suitability of the technique to recording contemporary scenes. They were reluctant to see their first art criticism vanish with *L'Éclair* and published it in book form in 1852.

More complete, routine coverage of the exhibition and discussion of the works' relation to the current theoretical artistic debates appeared in *L'Artiste*, France's first art magazine, founded in 1831. Its editor, Arsène Houssaye, assigned the review of the 1852 Salon to Louis Clément de Ris (1820–82). Born in Touraine, Clément de Ris had received his name and the title "Comte" when he was adopted as a boy and had received his education at the Collège Royal de Tours. He came to Paris to pursue a literary career and soon was writing literary and art criticism for *L'Artiste*. A number of his articles, including reviews of the work of Henri Murger and Alfred de Musset, would be collected in *Portraits à la Plume* (1853). Since 1847 Clément de Ris had visited the Salon for *L'Artiste*. In 1850–51, though he had admired the energy of Millet's *Sower*, he dismissed Courbet's "pursuit of ugliness" by simply refusing to discuss the *Burial at Ornans*. At the Salon of 1852, however, he thought he recognized a modification in Courbet's principles, and he conceded that the painter's landscapes demonstrated the mastery of his touch.

After publishing a volume of poetry, *Le Bouquet de Violets*, in 1856, Clément de Ris devoted himself exclusively to writing about art. His *Critiques d'Art et Littérature* appeared in 1862, and travels in Spain and the French provinces led to his *Le Musée Royal de Madrid* (1859) and *Les Musées de Province* (1859–60). Official recognition came when he was appointed to the administration of the museums of the Louvre and Versailles.

Edmond and Jules de Goncourt: *The Salon of 1852*[1]

The Regulations

"Each artist is allowed to send only three works to this exhibition."

Article II is the most important of the new regulations. The limitation on the number of works that a painter may send to the exhibition is completely new. Are there reasons for it? The advocates of the new rules say that artists were sending too many works; that it was no longer paintings but sketches that were being submitted to the jury; that with fewer works to receive the works will be more valuable, and that the artist will concentrate in three canvases the time, the work, and the talent that they would have scattered in four or five. They say that one of the aims of the exhibit is to impart value and a "seal of approval," as one might say, to all the works exhibited; that with fewer exhibiting, the value of the numbers appearing on a painting will rise. They say that in three works a man can exhibit his whole range. Disapproving of this measure, we answer that a limitation on the number of works, with the introduction of a jury, seems to be a contradiction; that more than anything else a strict jury will teach artists to submit seriously conceived paintings; that a strict jury is all that gives value to the number of works in an exhibition. We also say that travel, delays, all the details of an artist's life, might prevent a painter from exhibiting for one or even two years and that it is unjust, when he presents seven or eight worthwhile canvases, to limit him to an arbitrary number. When Decamps sends six canvases—and this has happened—our opinion is that one must accept Decamps' six canvases, even if it is necessary to exclude three canvases of less merit. . . .

[1] [Translated from Edmond and Jules de Goncourt, *Études d'Art, Le Salon de 1852, La Peinture à l'Exposition de 1855* (Paris: Librairie des Bibliophiles, 1893). Originally published as *Salon de 1852* (Paris, 1852) in a limited edition by *L'Éclair* as well as in *L'Éclair*]

The Jury. Selected by the artists: [the painters] Léon Cog-
niet, Eugène Delacroix, Decamps, Horace Vernet, Picot; [the
engraver] Henriquel-Dupont; [the lithographer] Mouilleron;
[the sculptors] Toussaint, Rude, Debay; [the architects]
Labrouste, Danjoy.

Named by the Minister of the Interior: le Comte de
Morny; Villot [curator of painting at the Louvre]; Reiset [cu-
rator of drawings at the Louvre]; de Mercey [Chef du Bureau
des Beaux-Arts]; Cottrau [Inspecteur Général des Beaux-
Arts]; Marquis Maison; Varcollier [Chef de la Préfecture de
la Seine]; de Longperier [curator of antiquities at the
Louvre]; de Laborde [curator of medieval monuments at
the Louvre]; Raoul Rochette; Turpin de Crisse; Mérimée; de
Caumont [president of the Institute of the Provinces]. . . .

Salon Carré

. . . And now let us confront what is called popular art. Let
us advance bravely on the monster. First of all, what does the
term "popular painting" mean? Are there then two types of
painting: a popular painting, a *pedestris* painting, as Horace
says, and a nonpopular painting? There was also a time when
one spoke of the noble style, the middle style. Popular art,
that must undoubtedly mean Art for the people. But art is
aristocratic in its essence. Let us look at things frankly: Does
the common man have time to learn about Art? Does he live
in surroundings that give him a desire to learn about it if he
had the time? Obviously not. Do not come and tell us that
beauty is accessible to all: Magnificent phrases have been ut-
tered on this subject and we certainly hope that many more
will be uttered; but this does not prevent beauty from being
accessible to a very few, and Émeric-David's[2] name is not yet
synonymous with everyone. Would you put to a popular vote
the question of who is a more talented painter of still lifes,
Philippe Rousseau or that gentleman who was exhibiting
paintings for a dining room at fourteen francs each on the

[2] [Toussaint Bernard Émeric-David (1755–1839), an archaeolo-
gist, was the author of *Recherches sur l'Art Statuaire Considéré
Chez les Anciens et les Modernes* (1805).]

boulevard opposite the Hotel Rougement? An admirer of
Delacroix has discovered that all blue-collar workers love and
admire Delacroix. It was undoubtedly on the same day that
George Sand discovered that all workers read and reread Jean-
Jacques Rousseau. As far as popular art is concerned, we can
quote the witty phrase that Mademoiselle Dumesnil uttered
to Mademoiselle Clairon: "In a full hall, there are two per-
sons of taste."[3]

And that is that, as far as your public is concerned. Now
let us turn to your works. By popular art you mean nature as
it is; denying yourself a choice. Therefore your ideal is a da-
guerreotype by a blind man, who stops to sit down on every
manure pile. And you claim kinship with Bassano. You claim
kinship with Rembrandt! Go on! The *coup de soleil* is not
popular art. I know of only one popular art: sign painting—
and don't argue with me about the brotherhood of the brush
and the pen, about the correlation of a stylistic school with a
school of painting. Don't talk about the realism of the mod-
ern literary school. Musset, Gautier, Janin, George Sand—
even she, who sometimes tells lies about herself—never wrote
for people who could not read. If you have tenant farmers,
ask them if they have read *Le Tailleur de Pierres de Saint-
Point*.[4] With your narrow system and narrow conception of
realism, it would be necessary to put all of Henri Monnier[5]
above Victor Hugo, and soon Mathieu ·Laensberg[6] would be
placed above Henri Monnier. We are great believers of real-
ism in painting, but not of realism sought exclusively in ugli-
ness. Our personal realism is Murillo's *The Lice Picker*.
Proudhon said, "Property is theft!" Courbet said, "Ugliness

8 [The famous actress Mlle. Marie Françoise Dumesnil's (1713–
1803) chief rival was Mlle. Claire-Joseph Hippolyte Seris (1723–
1803).]

4 [This work was written by Lamartine in 1851.]

5 [Henri Bonaventure Monnier (1805–77), a student of Girodet
and Gros, whose talent for satire and caricature led him to create
M. Joseph Prudhomme, the archetypal bourgeois, in his *Scènes
Populaires Dessinées à la Plume* (1830)]

6 [Mathieu Laensberg, a popular seventeenth-century mathema-
tician and astrologer, published an almanac predicting the weather
and natural events.]

is beauty!"—he is said to have earned ten thousand francs exhibiting pictures at the fairs in Brittany. He may be decorated this year. He is a clever man. At least he will never have the right to answer, as did the man who was asked, "Why have you never been a success?"—"Because I have never believed people to be as stupid as they are." . . .

Thomas Couture (301) *Portrait of a Man.* More of the large strokes, the exaggerated treatment, the lively coloring that are the master's signature. It is of him that Sanzi[7] said, "He grinds flesh on his palette." (302) *A Child's Portrait.* A little girl, ruddy with health, her hair caught up at the back of her head, a simple blue dress, a school uniform: a study possessing much character. The violet black background like ink spread by the thumb on a sheet of paper. The shadows may indeed be too deep, the lines too heavy. But these exaggerations are redeemed by a technique so free, by so much sun on human flesh, by so much movement in the facial planes, that it is one of those faults of a great master that one ends by taking as a quality of their manner. . . . (300) *A Gypsy.* To us this is the most beautiful thing in the Salon. Oh, girl with a silvery laugh! Little Preciosa! Looking at you one is reminded of these words from Cervantes' *Gitanilla.* . . .

Jules Dupré (392). Large gray clouds with white crests, driven to the left, pile upon one another impetuously. Two trees send leafy clumps up against this sky like skyrockets. They bathe their feet in a brook, to which come cows, wading through the luxuriant vegetation and succulent grasses of the pasture. A willow spreads its pearly gray hair to the wind. Trees, sky, earth—all are pebbled in dots of color, yet everything comes with remarkable freshness from this fury of the brush. Joseph Vernet, who never made sketches for fear of dulling his inspiration, would be astonished to see the fieriness of this landscape, redone perhaps four times by Dupré; so that under the picture we see there are perhaps

[7] [Luigi Sanzi (1732–1810), the keeper of the galleries in Florence, wrote *Storia Pittoria della Italia* (1792).]

four other pictures. Even though we like this proud painting, yet we wonder if the building up of the sky does not make it appear to advance over the foreground; if these dense and heavy waters, almost granitelike, are really true; if, finally, "in distributing the highlights to provide perspective, the painter should not spare the transparencies of the background by painting shadows." Also we must note that the *Pasture* by Dupré is not hung at its proper height; it is much too low. . . .

Théodore Rousseau. In contrast to the well known artist who paints at Fontainebleau with a hatchet in his hand and carves out his compositions,[8] Rousseau respects his land-scapes. A painter tells us that he has seen him, I do not know where, bind up a broken branch with his handkerchief. Théodore Rousseau—a painter of the minor aspects of nature —feels that God is a skillful arranger. He does not try to in-vent more dramatic lines, to ennoble the thickets; He studies quite naïvely, quite sincerely; he is no more ashamed of draw-ing the first tree he comes across than Lantara was of paint-ing the banks of the Bièvre. He is very little preoccupied with style, but, on the other hand, he is very preoccupied with truth. He is very daring, and while all his audacities do not have our sympathy, he has pushed further than anyone else the study of the most delicate modifications of daylight and of how to depict the most difficult plays of light on foliage; in the morning, at noon, in the evening, before a rain, after a rain. . . .

Horace Vernet. *Siege of Rome. The Taking of Bastion No. 8.* We are far from denying that Horace Vernet has talent. Horace Vernet has painted a charming easel picture: *The Gate of Constantine.* No one understands large military ma-chines better than he. For more than twenty years—more than thirty years—he has been translating our glories into pic-

[8] [Cornelle Aligny (1798–1870), a landscapist in the beaux-arts tradition who worked in the forest of Fontainebleau, was said to have begun preparations for painting by pulling up the bracken and clipping the bushes.]

tures. He paints quickly, he masses by squadrons, by battal-
ions, with an ease and an enthusiasm that we can certainly
not fail to recognize. All battles wait for him to send them to
Versailles. Once again, it is not just anyone who can launch
five hundred men on a canvas to the attack of a city, a fort, a
bastion. This demands a breadth of vision and audacity of
hand, a knowledge of uniforms, that are very laudable. But
there is a great difference between a circus director and a
painter. Horace Vernet is in the middle. The new painting
by Horace Vernet seems to us the worst yet. We are not talk-
ing about either his handling or his painting. It does not mat-
ter whether he has used simple colors or blended them; the
whole thing is worth no more than a wallpapered wind-
screen. . . .

Right-hand Gallery

Charles Landelle (760). We are going to forget about M.
Landelle. It is not because M. Landelle has not displayed
power and distinction in the *Béatitude* that bears the inscrip-
tion "Blessed are the pure in heart, for they shall see God."
The head of the young woman in a red dress with yellow
highlights like a dress by Rubens is a very pretty thing. But
must we say it? In our opinion religious painting is no longer
possible today. Yes, the religious painting of the religious cen-
turies, that painting, as convinced and absorbed as a prayer,
died with what is dead. Gothic art, when it ascended to
heaven, took Catholic painting with it under its cloak. St.
Peter is a simple pagan, and Raphael's Virgins, and the
Charities, the marvelous Charities by Andrea del Sarto, are
already more women than Virgins: They are beautiful. They
are no longer Mothers of God found in oratories. The only
true Virgins are the Virgins by Memling. Today, in our nine-
teenth century of constitutional faith, one can no more paint
a religious picture than one can build a church. If one tries
the latter, the result is Notre Dame de Lorette.[9] If one

9 [Notre Dame de Lorette (1823–36), designed by Hippolyte
Lebas, was decorated with frescoes by Dulorme, Drolling, Hesse, and
Picot.]

attempts the former, the canvas covers itself with souvenir painting. . . .

Now, do we miss the mystic symbolism of painting? No. And, along with a critic who happens to admire deeply the ancient symbolists, we say "symbols in the living domain of art are of the least importance." No; for the pen, the ideal; for the brush, the reality. The road that leads to allegories, to beliefs which one attempts to incarnate for the eye, is a false one; the road that tries to put an idea in a line, in a flower, a myth on a canvas is a mistaken one. Orsel[10] died attempting this sort of thing. . . .

Far Gallery

Louis Gallait. *Last Honors Given to the Counts of Egmont and of Horn by the Great Oath of Brussels*. It is good that foreign artists sometimes come to exhibit in Paris. They are compared and judged. In their own countries they cannot assess their worth accurately. They are surrounded by facile admiration. Applause is always waiting for them on the steps of their studios. Their reputation is formed without any competition, the way their talent is formed without any criticism. For many years now we have been humiliating foreigners by making them turn to France, that Sun of the Arts. A painter from one's own country, from one's own neighborhood, is a revenge! Belgians and Germans are so happy to have one star with which to oppose our constellation, so happy to place something in the way of a talent on their empty pedestals! . . . Here is a picture by the foremost Belgian painter. What is it but a very weak copy of Paul Delaroche's style, an accentuation of all the faults of French painting, the most complete disappearance of its qualities of composition, organization, and execution? As far as the execution and rendering of the accessories are concerned, the trompe l'oeil of the *Portrait of M. Pourtalès* and of the picture of *Cromwell* are really something quite different from this crucifix thrown on black velvet drapery. The trompe l'oeil qualities do not even

[10] [André-Jacques-Victor Orsel (1795–1850) began the decorations but died before he could finish them.]

exist in M. Gallait's fabrics, which are heavy and inflexible, without elasticity and without great distinctions in the highlights of wool, satin, and velvet. The man with the arrow has his body wrapped in a red scarf that resembles a coil of sheet metal. There is nothing left in this canvas of that coloring we admire in the Baudouin of Versailles; the attitudes, the expressions, the faces—here we touch on the vital points of the work—have nothing moving about them. There is nothing morally dramatic in the attitudes; the faces are heavy and common, worked for the most part like those of porcelain figures without character. In none of them is the secret of a sustained sorrow, the secret of a brooding vengeance. Those men look on without anger, without tenderness; it is a circle of heavy beer drinkers looking at two metallic heads painted in green, with a coating of white lead at the inner corners of their eyes. People could still be found who believed that there was a school besides the French school. M. Gallait has shown them their error. We thank him for it. . . .

Jean Louis Ernest Meissonier (896) *Man Choosing a Sword.* . . . All interest focuses on the silent dialogue between the man and his weapon. We see that he needs faithful service, and that he puts attention and experience into his examination, and that, though he gambles, he wishes to leave as little as possible to chance. In our opinion, scenes with a single character are what Meissonier does best. There is a whole little drama in this small picture, a drama on the point of a sword. The shoes and stockings are M. Meissonier's triumph; he folds, he gathers the latter over the instep with a reality and a touch that are perfection; the leather of the former shines most marvelously. But, it is curious! As he goes upward on his characters, he loses his little square touches, his skillfully accentuated highlights and, having come to the heads, he finds nothing left on his palette with which to paint flesh, human flesh, living flesh, except a *pointille* of red, yellow, white, and blue. The skin looks like petit point embroidery. Blood never ran underneath it. The dome of the forehead, on which the light falls, seems to have been dotted with plaster. The left hand of the man—excuse the petty criti-

cism, but here the critic, to do his work seriously, should pay attention to details—the hand which holds the scabbard shows, in our opinion, in the most obvious ways all the faults of this procedure. The shadow cast by the sword on the ring finger is indicated by a line of ivory black. Meissonier seems to forget that in nature there is no more a white highlight, a rigorously white highlight on skin, than there is an absolutely black shadow. . . .

Second-floor Gallery

Charles François Daubigny (309) *Harvest*. A band of rosy light stretches the width of the sky. Thick brushstrokes with blue smudges trace the distant background crosshatched with seedling plantations. The whole countryside spreads out its squares of grain like a golden checkerboard—some squares are cut and brown, others are still standing and set on fire by the sun. The harvesters are doubled over and their womenfolk hurry through narrow paths; sheaves are bound and carts loaded; all this activity groups itself picturesquely in the golden glow, in the midst of which the brush, wiped free of color, has made a furrow sparkle here and there. The foreground, starred with bachelor buttons and poppies billowing with the swell of the ground; the tight masses of stems whose shadows are coppery red. Harvest has never been better depicted; grain has never come on canvas browner, more crackly, more true to life, than in the burning atmosphere of August, and M. Daubigny's picture is a masterpiece, in spite of his neglect of the background. . . .

Throughout the Salon we find many landscapes to praise; but is not a landscape, as our artists understand it, the greatest glory of the modern paintbrush? Are not landscapes the outstanding feature of this Salon of 1852, a Salon that the superficial observers may find mediocre but which we ourselves find full of promise, full of work, full of experiments, full of good hand-to-hand fights with nature and with sunlight? Let us not regret the great and magnificent painters who have not sent their works when we have humble painters who show their works, and who are named Dupré, Ziem, Rousseau, Daubigny, Hoguet, and so many others. It is the

school of the *petit genre*, so underestimated in former times, that will be the fortune of the nineteenth century; and it is her victories that we have attempted to count. One will only be able to speak seriously of great painting and great pictures when Couture sends his *Volunteers Enlisting*[11] to the Palais Royal.

Sculpture

Antoine Louis Barye (1295) A *Jaguar Devouring a Hare.* The jaguar, his forequarters lifted, sits on his hind legs, his stomach pressed against the earth. . . . We have seen neither Calamis' horses nor Nicias' dogs nor Myron's cows, nor that famous bronze dog licking a wound, a motif repeated last year by M. Frémiet, that was preserved in the temple of Juno at the Capital; but we find it hard to believe that the prodigious beasts of M. Barye have at any time been equaled. At present the movement is taking place in sculpture that we describe in painting. The historical school is dying in the art that makes things touchable as well as in the art that makes things visible. Landscapes are replacing it in painting; animals are replacing it in sculpture. Nature is the successor to man. This is the evolution of modern art. In ancient societies, where the sun also inclined toward nudity, plastic beauty was the ambition, the end and the means of life. Listen to Émeric-David: "A generous chest, strong and subtle shoulders, a strong back, strong, straight legs under a slender torso, elastic calves, light feet—here are true riches, says a philosopher, *because they permit one to undertake many things and to achieve them.*" But in our modern societies, where the beauty of form is not pursued, in our civilization that shivers under icy skies, in our modest religions, the sculptors' roughing chisel may search as it will; the poetry of nudity has mounted to Olympus. . . .

François Rude. *Calvary.* A group in bronze. A puffy Christ with his anatomical foundations completely hidden, a Virgin

11 [Couture, commissioned in 1848 by the Second Republic to execute this painting for the National Assembly, was advised by the Minister of the Interior to discontinue work on the painting after Napoléon III's coup d'etat. It was never finished.]

in the style of fourteenth-century funeral stones, an excellent
apostle's head of an entirely modern character, ornaments
like the decoration of certain German poets make of M.
Rude's *Calvary* a discordant assemblage of every possible
style. . . .

Lithography

The art of Aloys Senefelder[12] has gone far since the early ex-
periments. This manner of reproducing, whose principles
were put in a doubtful light for all that belong to the domain
of art, is today competing strongly with engraving. One may
wonder—when the lithographic processes are fully developed,
when colored lithography has become widely disseminated
among our French artists—one may wonder if lithography will
not replace the engraver, that always slightly awkward transla-
tor of the master's manner. Diderot compared engraving to a
prose translation of foreign poetry. Before the nineteenth
century, the great resource of the men of life and color who
wished to present themselves to the public outside the usual
ways, was etching, whose difficult interpretation demanded a
Rembrandt. But here is lithography, always receptive to an
idea, always docile under one's hand, a freer, truer, easier
facsimile. Painters turn themselves into sketchers on stone,
and in some twenty years they make the new discovery pass
from the embryonic experiments of Engelmann[13] to the
magnificent plates we have before our eyes. Géricault putting
on stone his Michelangelesque sketches; Bonington and his
soft imitations of pencil on paper, and his plays of light and
shadow so gently shading into one another; Delacroix with
his furious illustrations for *Faust*; Harding with his trans-
parent skies, iridescent with white clouds, skies softer than
the caresses of tinder on lampblack, with his cities, with his
background trees drawn in with an invisible pencil, with his
foregrounds all sparkling with luminous points; after Har-
ding, Ciceri carrying into stone the gray shadings of graphite,
working with large touches of a blunt pencil and—whether he

[12] [Aloys Senefelder (1771–1834) invented lithography.]
[13] [Godefroi Engelmann (1788–1839) was among those who in-
troduced lithography to France.]

is depicting the leafy countryside of the old streets of Quimper or Troyes—always losing and drowning the lithographic grain; it is Decamps putting something of his drawings in his lithographs; Isabey tinting the distance, the ocean and the wet beach with those clouds that the thumb spreads with charcoal; it is Haghe, boys searching in lithographic ink the beautiful blacks and the washed-out tones of Chinese ink[14]; Nanteuil putting on his stones the colors of the paintings that he copies; Dauzats translating with his majestic touch the architecture of Languedoc; Lemond, who, with his gently charcoaled halftones, with all those shadows always lightened by small white scratches, either crosshatched or abandoned to the artistic scratchings of his scraper, caused to stand out, poetic and enchanted, *Master Wolframb*, *The Childhood of Callot*, *The Funeral Procession of the Emperor*, *The Bird's-nesters*, *Hoffmann*, *The Legend of the Van Eyck Brothers*; it is Français, Prout, Sabatier, Durand, Balan, Gavarni with his velvety blacks, his halftones of souvenir art, his rubbing with work, his erasing with the scraper, with the inexhaustible treasure of daily discoveries. One after the other, each one brings his design processes, his way of drawing, his wash tints.

Lithography, enriched by all these gifts, becomes the outstanding artistic translation. Since it joined to the merit of art the merit of cheapness, it is becoming the reproduction method used for great works. After *Voyages in Ancient France* came all those publications you have seen in Gihaut's window: *Contemporary Artists*, *Ancient and Modern Artists*, *Living Painters*, etc. This is the terrain on which pure lithographers and painting lithographers have met. On one side, regular lithography has been well behaved, admirably executed according to the recognized processes, carefully hatched in black, too often an engravers' lithography; on the other side, a lithography full of fluidity, always · seeking something new, always original, always daring, all painted. . . .

[14] [Ivory is the source of the carbon with which the black pigment is made.]

Clément de Ris: *The Salon*[1]

. . . Yes, art is progressing, that is evident to those who wish
and know how to see; but here are the thoughts that come
immediately to mind after a conscientious inspection. There
is a mass of talent everywhere which grows daily, but it lacks
a unified tendency, a faith. All artists seek a path, and few
submit themselves to a rule. Each work has a mark of isola-
tion which harms the general effect. Nevertheless, this need
for a unified tendency is so real that an artist has no sooner
found a yet unexplored side, or created something original,
than a host of more or less skillful imitators appears. The ab-
sence of, and the imperative need for, generalization: These
are the two characteristics of today's painting. Amid this lu-
minous chaos the spirit seeks in vain the heights to which it
can attach itself and from which flow the innumerable artis-
tic streams. This dispersion is not found in the great periods
which produced Raphael, Michelangelo, Veronese, Rubens,
Le Brun, and Watteau—those powerfully original artists who
inspired the art of a whole era. Furthermore, to take a more
specialized and technical point of view, the colorists—who,
despite the efforts of a small number of more persistent than
talented artists, are the true contemporary school—are too
aware of their own superiority, and do not take enough care
to maintain it. Sacrificing everything to effect, sentiment, and
impression—in a word, to color—they neglect line and end up
merely making sketches. This fault was obvious last year; it is
less so this year, but is still striking, and those who follow this
course must be warned of the dangers which befall many. To
disregard this advice would be to give unnecessary ammuni-
tion to their opponents. Any exaggeration is bad, and a sys-
tem which, when it is pushed to its furthest limits, produces
M. Courbet reveals its weaknesses too readily for its repre-
sentatives not to be well advised to take precautions against
the eccentricities of their followers.

[1] [Translated from *L'Artiste*, April 13, 1852, pp. 81–82, and May
1, 1852, pp. 99–100]

. . . M. Courbet's manner has been conspicuously mod-
ified since last year; he has, as the saying goes, added
water to his wine. I don't know whether he took the critics'
observations or his own into account, but, in any case, he
should be congratulated on this happy change. Though he
aims at the naïve and simple, M. Courbet is an excessively
cunning and not at all simple fellow who has understood that
to draw attention to himself, he who yesterday was unknown,
it was necessary to fire pistols out the window. A *Burial at
Ornans* was a blast in a cellar. The pursuit of ugliness was
carried so far that any sane person could not take this pro-
duction seriously. Once he was at the center of attention, M.
Courbet was sure to remain there, and to make people
change the grotesque image which they had formulated of
him. He is a realist painter in the most complete sense of the
word; he sees nature from a narrow point of view—it has no
meaning for him, and the mysterious language of each of its
manifestations never whispered a single syllable in his ear. He
will never choose; he will never prefer one of its aspects to
another—they must all be equally indifferent to him, and his
most beautiful canvases will never awaken the shadow of a
feeling of melancholy, grace, grandeur or power, as do those
of MM. Corot, Français, Rousseau, and Daubigny. One must
take M. Courbet as he is and not ask more of him than he
can give. But once these reservations have been noted, it is
not difficult to render justice to his large landscape [*Young
Ladies of the Village*], which is full of truth, energy, and
light. Another of M. Courbet's merits is the simplicity of his
manner. His touch in the large landscape is remarkable; it is
that of a master, without either the exaggerated heaviness of
M. Jules Dupré or the dry economy of M. Aligny. In this re-
spect, time, which judges without passion, will accord to M.
Courbet's landscape its true value. The sky is generally ad-
mired; I cannot share this admiration; I find it, on the con-
trary, cold and without gradations in color, so that the top
appears on the same plane as the horizon. This lack of aerial
perspective is found in those unfortunate cows that evoke so
much criticism and that, at their place in linear perspective,
seem to be chatting with the dog, which is nevertheless lo-

cated at a gunshot's distance from them. The cause of this is the same as for the sky: absence of color gradations on the terrain where the cows and the dog are placed, the hue of which is the same near the edge of the frame as it is at the base of the rocks. The three women giving alms to the little beggar girl evoke recriminations for reasons which, I confess, I don't understand. They are called common, and, as usual, this remark, which is fair, is exaggerated into one that is unfair. They are indeed common people, and it was they, I believe, that the painter wished to represent. In this sense, these reproaches are indirect praise. The humble bourgeois women of a small provincial village, or daughters of artisans accustomed to wool or organdy dresses, cannot have the stylish ease of a Parisian who for years has been accustomed to enfolding herself in cashmere or entwining herself in a cloud of lace. When this reproach is placed in its proper perspective, there is charm in this group, more perhaps than M. Courbet has put in one of his works for a long time. The beggar girl conveys a lovely feeling, and the woman in the yellow dress has a stance lacking neither grace nor suppleness. I am sorry to offend general opinion, but it is mistaken in this instance; this much-maligned group of women provides a happy diversion from the monotonous barrenness of the landscape it arouses and animates. *The Edge of the Loue* does not have as much interest as the *Young Ladies of the Village*, although it does, on a lesser scale, have the same qualities and the same faults. As for the *Portrait of a Man*, M. Courbet, who last year produced a work of merit in this genre, seems to have changed his mind. We shall therefore not speak of it.

I doubt if M. Courbet will ever do anything better than his *Young Ladies of the Village*. He will do other things; but this painting is destined to summarize his talent—his uneven, bizarre, hardly pleasant but undeniable and fascinating talent, because it shows the exaggeration of a principle which is excellent when contained within its appropriate limits. It is a pitfall, but a pitfall with character, and one which would be contemplated with interest by anyone who has been able to pass it by without falling into it.

1855: LONDON

The Exhibition of
a Semiofficial Society:
The Royal Academy of Art

The exhibition season of 1855 opened on May 5 with the inauguration dinner of the Royal Academy exhibition in the east room of the National Gallery. After the customary toasts, the Academy's president, Sir Charles Eastlake, proposed one to the 180 gentlemen present, "The Army and Navy." The unusual toast was well received, even though the Crimean War had provoked great controversy. London had carefully followed the course of the war and, thanks to the laying across the Black Sea of the longest submarine cable yet made, and to photographs taken by Roger Fenton, would continue to do so until peace was concluded in September. Viscount Harding, commander-in-chief of the British Army and responsible for the home management of the war, thanked Eastlake. Then, after enumerating the virtues of the various branches of the British military, he offered a comment on one of the works at the exhibition, Clarkson Stanfield's painting of the siege of St. Sebastion in 1813: "I should refer to the incident described by the artist in that admirable and noble picture as a proof of the skill of the British

artillery and the steadiness of the British infantry." In response to another toast, Eastlake, who had just been named the National Gallery's director, expressed the hope that the government's proposed enlargements of the National Gallery, postponed because of the war, would be resumed when peace was secured, "for this is the time to compare the small expenditures which works relating to social improvement require, with the gigantic outlay necessitated by war."

The press, occupied with the war, had little space for reports of the Royal Academy exhibition, which this year contained little to excite enthusiasm or controversy. Three weeks after the May 7 opening, a pamphlet entitled *Notes on Some of the Principal Pictures Exhibited in the Rooms of the Royal Academy* was offered for a sixpence at the entrance to the exhibition. Its author, John Ruskin (1819–1900), was already well known in the literary world, and his name was currently in the social gossip. Some of the "nobs"—those whose rank won them the privilege of attending the private viewing of the Academy exhibition—had helped circulate the story of his wife's desertion and of the incomplete marriage that had ended in annulment in July 1854. They even spread the rumor that she intended to marry the brilliant painter John Everett Millais, once an intimate of the Ruskin household. Effie Ruskin had confided the story of her husband's neglect to her close friend Lady Eastlake.

Ruskin's *Notes* were received with little sympathy by a press generally supportive of the academicians and social conventionality. It was the first time Ruskin had written and published criticism for the general public. Previously his criticism had appeared in letters to the London *Times*. In the opinion of *Blackwood's Edinburgh Magazine*, the *Notes* were "about the sourest morsel of criticism we have ever looked into. . . . Notwithstanding, Mr. Ruskin's claim to be considered among the foremost of our modern writers upon art are indisputable. . . . Theories of painting and criticism upon pictures are two widely different things. . . ."[1]

[1] Ruskin's letters to the London *Times* appeared on May 13 and 20, 1851, and May 5 and 25, 1854.

Ruskin, the only son of a successful sherry merchant, had had a careful and thorough education. *Blackwood's'* disparagement of Turner's paintings in the Academy exhibition of 1836 first led Ruskin to think seriously about a theory of art. He prepared a defense of Turner's unconventional representation of landscape; it eventually became the basis of his first volume of *Modern Painters*. Basing his defense on a studious observation of chromatic effects in nature, Ruskin demonstrated the accuracy of Turner's portrayal of natural phenomena. His theory of art rested not only on scientific observation but also on the stern religious training which he received from his strict Protestant mother. Science and religion combined to form his aesthetics.

Volume two of *Modern Painters* contained little information on contemporary artists. Ruskin had discovered Giotto and Tintoretto on a trip to Italy and used them to illustrate the importance of the imaginative faculty and to develop a theory of Vital Beauty.

He also took an interest in architecture, entering the current debate on architectural styles with his *Seven Lamps of Architecture* (1849), a work in which his insistence that beauty and truth be always present was translated into an equation of architectural excellence in which social and moral virtues predominated. Between 1851 and 1853, after Effie and he had spent their winters in Italy, he published his three-volume *The Stones of Venice*. After applying his architectural ideas to Venetian architecture, he concluded that the Gothic style was equally appropriate for civic and ecclesiastical buildings.

Ruskin's conception of the interrelation between excellence and beauty in art and a morally correct social condition met with great enthusiasm in circles where others were also searching for an amelioration in all aspects of life. The ideas and theories contained in *Modern Painters* especially appealed to the young painters of the Pre-Raphaelite Brotherhood, who, dissatisfied with traditional art themes and techniques, had banded together to reform art. Severely censured by critics at the 1850 Academy exhibition, they had appealed to Ruskin to defend their "adherence to the simplicity of na-

ture." Ruskin did this in two forceful letters to the *Times*, a pamphlet entitled *Pre-Raphaelitism*, a lecture in 1853 at the Edinburgh Architectural Museum, and in letters of 1854 praising William Holman Hunt's painting *The Light of the World*. It was he, confessed the Brotherhood, who had influenced them to regard art as the "handmaid of justice and truth."

The chapter in *Stones of Venice* entitled "On the Nature of Gothic" offers the best synthesis of Ruskin's thought on political and social questions as they relate to art. Ruskin regarded it as the most important chapter in the book, and it became "the creed of a new industrial school of thought." For Christian Socialists like Charles Kingsley, radicals like David Urquhart (whose *Free Press* published works by Karl Marx), and young Oxford undergraduates like William Morris, Ruskin's writings offered an alternative to the crass and ugly competitiveness of industrial capitalism. "It seemed," in Morris' words, "to point out a new road on which the world should travel."

By December 1855—when *Blackwood's*, in reviewing the *Notes*, had written, "This great critic is one of these unfortunate people whose 'mission' is to prove every other man a blunderer or a fool"[2]—Ruskin had already taken up a second mission. In the fall of 1854 Ruskin began to work actively with the artisan class. When the Christian Socialists F. D. Maurice and Charles Kingsley opened their Working Men's College, Ruskin agreed to superintend the art teaching. "On the Nature of Gothic," published separately, bore the subtitle "And herein the True functions of the Workman in Art" and was distributed to the four hundred men present at the college opening on October 30, 1854. Beginning the next month, and on every Thursday evening for the next four years, Ruskin, in a correct frock coat and blue neckcloth, set up drawing exhibits, corrected sketches, and lectured. He was joined in January 1855 by Dante Gabriel Rossetti, one of the founders of the Pre-Raphaelite Brotherhood.

[2] *Blackwood's Edinburgh Magazine*, "Modern Light Literature— Art," Dec. 1855, p. 704

Ruskin's theory of art put great emphasis on the role of the critic, who, he believed, must be the arbiter and judge of the fitness of an artist's work. Because his commitment was to social and moral values as well as aesthetic ones, Ruskin further believed that a work of art should both contribute to and reflect an artist's political and social environment. He was convinced not only that "there is a right and wrong way in liking and disliking," but that "even the most instinctive inclinations . . . are governable," and that "it is a kind of duty to direct them rightly." Firmly persuaded that he knew the right and wrong ways of liking, Ruskin accepted this duty and, exercising it as a critic, continued to publish his *Notes* on the Royal Academy exhibitions through 1859.

John Ruskin: *Notes on Some of the Principal Pictures Exhibited in the Rooms of the Royal Academy, 1855*[1]

Preface

I am often asked by my friends to mark for them the pictures in the Exhibitions of the year which appear to me the most interesting, either in their good qualities or their failure. I have determined, at last, to place the circular letter which on such occasions I am obliged to write, within reach of the general public. Twenty years of severe labour, devoted exclusively to the study of the principles of Art, have given me the right to speak on the subject with a measure of confidence; but it will be found that in the following pages, few statements are made on my own authority, and that I have limited myself to pointing out simple facts with respect to each picture, leaving to the reader the power of verifying such statements for himself. No criticism is of any value which does not enable the spectator, in his own person, to understand, or to detect, the alleged merit or unworthiness of the picture; and the true work of a critic is not to make his hearer believe him, but agree with him.

Whatever may be their abstract truth, the following re-

1 [From *The Works of John Ruskin*, vol. 14, ed. E. T. Cook and A. Wedderburn (New York: Longmans, Green, 1904)]

marks have at least in them the virtue of *entire* impartiality. Among the painters whose works are spoken of, the greater number are absolutely unknown to me; some are my friends, and some quite other than friends. But the reader would be strangely deceived who, from the tone of the criticism, should endeavour to guess to which class the painter belonged. It might, indeed, be alleged that there is some unfairness in fastening on the faults of one or two works, not grosser in error than many around them; but it would have been tedious to expose all the fallacies in the Academy, and I believe it will be found, besides, that the notice of the particular picture is nearly always justified, if not by excess of demerit, at least by excess of pretension. . . . May 29, 1855.

Notes, etc.

NOTE 78: *The Wrestling in "As You Like It"* (D. Maclise, R. A.)

Very bad pictures may be divided into two principal classes —those which are weakly or passively bad, and which are to be pitied and passed by; and those which are energetically or actively bad, and which demand severe reprobation, as wilful transgressions of the laws of all good art. The picture before us is of the last class. Mr. Maclise has keen sight, a steady hand, good anatomical knowledge of the human form, and good experience of the ways of the world. If he draws ill, or imagines ungracefully, it is because he is resolved to do so. He has seen enough of society to know how a Duke generally sits—how a young lady generally looks at a strange youth who interests her; and it is by vulgar choice, not vulgar ignorance, that he makes the enthroned Duke straddle like a village actor, and the young lady express her interest by a cool, unrestrained, and steady stare. It is not worth while to analyze the picture thoroughly, but let us glance at the two opponent figures—Charles and Orlando. The spectator can certainly see nothing in this "Charles" but a grim, sinister, sinewy monster, wholly devoid of all gentleness or humanity. Was Shakespeare's Charles such an one? So far from it, that into his mouth is put the first description of the love of Rosalind and Celia . . . [s]o far from it, that he comes to Oliver especially

to warn him against allowing his brother to wrestle with him. . . . Poor Charles is as much slandered here by the painter as Orlando was by his brother.

Next to pass from imagination of character to realization of detail. Mr. Maclise is supposed to draw well and realize minute features accurately. Now, the fact is, that this work has every fault usually attributed to the Pre-Raphaelites, without one of their excellences. The details are all so sharp and hard that the patterns on the dresses force the eye away from the faces, and the leaves on the boughs call to us to count them. But not only are they all drawn distinctly, they are all drawn *wrong*. . . .

But to pass from drawing to light and shade. Observe, the light falls from the left, on all the figures but that of the two on the extreme left. These two, for the sake of effect, are in "accidental shadow." Good; but why then has Oliver, in the brown, a sharp light on the left side of his nose! and on his brown mantle? Reflected lights, says the apologist. From what? Not from the red Charles, who is five paces at least in advance of Oliver; and if from the golden dress of the courtier, how comes it that the nearer and brighter golden dress of the Duke casts *no reflected light* whatever on the yellow furs and red hose of the wrestler, infinitely more susceptible of such a reflex than the dress of Oliver?

It would be perfectly easy to analyze the whole picture in this manner; but I pass to a pleasanter subject of examination.

NOTE 181. *Christabel* (W. Dyce, R. A.)

An example of one of the false branches of Pre-Raphaelitism, consisting in imitation of the old religious masters. This head is founded chiefly on reminiscence of Sandro Botticelli. The ivy leaves at the side are as elaborate as in the true school, but are quite false both in colour and shade. There is some sweet expression in the face.

NOTE 240. *The Bird Keeper* (R. Redgrave, R. A.)

We have here two interesting examples of another fallacious condition of landscape—that which pretends to Pre-

Raphaelite distinctness of detail; but is in all detail indus-
triously wrong. In Creswick's work the touches represent
nothing; here they represent perpetual error, assuming that
all leaves of trees may be represented by oval, sharp-pointed
touches of yellow or green—as if leaves had not their perspec-
tives, shadows, and changes of hue like everything else! There
is great appearance of fidelity to nature in these works, but
there is none in reality; they are mere mechanical accumu-
lations of similar touches, as a sempstress mechanically accu-
mulates similar stitches. If the spectator desires to know the
difference between right and wrong in this matter, let him
first examine Mr. Witherington's oval touches, and then
cross the room to No. 321, *The Writing Lesson*, by Collin-
son, a Pre-Raphaelite in which the flowers in the window are
truly and properly painted, and look at the way the leaves are
set and worked there; and if it be supposed that this is only
to be done in a cabinet picture, the question is well worth
settling at once by merely walking out of the Academy into
the National Gallery next door, and looking at the leaves
which crown the Bacchus, and the little dancing faun, in Ti-
tian's *Bacchus and Ariadne* [No. 35], in which every turn of
the most subtle perspective and every gradation of colour, is
given with the colossal ease and power of the consummate
master. Examine, further, the vine-leaves above on the right,
and the flowers in the foreground, and you will return to the
Academy with an eye so instructed, as hardly thenceforward
to accept, in such matters, fallacies for facts.

NOTE 282. *The Rescue* (J. E. Millais, A.)
It is the only great picture exhibited this year; but this is
very great. The immortal element is in it to the full. It is eas-
ily understood, and the public very generally understands it.
Various small cavils have been made at it, chiefly by conven-
tionalists, who never ask how the thing is, but fancy for
themselves how it ought to be. I have heard it said, for in-
stance, that the fireman's arm should not have looked so
black in the red light. If people would only try the experi-
ment, they would find that near black, compared with other
colours, is always black. Coals do not look red in a fire, but

where they are red hot. In fact, the contrast between any dark colour and a light one, is always nearly the same, however high we raise the light that falls on both. Paul Veronese often paints local colour darker in the lights than in the shadow, generally equal in both. The glow that is mixed with the blackness is here intensely strong; but, justly, does not destroy the nature or the blackness.

The execution of the picture is remarkably bold—in some respects imperfect. I have heard it was hastily finished; but, except in the face of the child kissing the mother, it could not be much bettered. For there is a true sympathy between the impetuousness of the execution and the haste of the action.[2]

NOTE 569. *Cimabue's Madonna Carried in Procession through the Streets of Florence.* (F. Leighton)

This is a very important and very beautiful picture. It has both sincerity and grace, and is painted on the purest principles of Venetian art—that is to say, on the calm acceptance of the whole of nature, small and great, as, in its place, deserving of faithful rendering. The great secret of the Venetians was their simplicity. They were great colourists, not because they had peculiar secrets about oil and colour, but because, when they saw a thing red, they painted it red; and when they saw it blue, they painted it blue; and when they saw it distinctly, they painted it distinctly. In all Paul Veronese's pictures, the lace borders of the table-cloths or fringes of the dresses are painted with just as much care as the faces of the principal figures; and the reader may rest assured that in all great art it is so. Everything in it is done as well as it *can* be done. Thus, in the picture before us, in the background is the Church of San Miniato, strictly accurate in every detail; on the top of the wall are oleanders and pinks, as carefully painted as the church; the architecture of the shrine on the wall is well studied from thirteenth century Gothic, and

[2] [The origin of this picture and the circumstances under which it was painted are fully described in J. G. Millais' *The Life and Letters of Sir John Everett Millais by His Son*, 2 vols. (London: Methuen, 1899), vol. 1, pp. 247–57.]

painted with as much care as the pinks; the dresses of the figures, very beautifully designed, are painted with as much care as the architecture; and the faces with as much care as the dresses—that is to say, all things, throughout, with as much care as the painter could bestow. It necessarily follows, that what is most difficult (i.e., the faces) should be comparatively the worst done. But if they are done as well as the painter could do them, it is all we have to ask; and modern artists are under a wonderful mistake in thinking that when they have painted faces ill, they make their pictures more valuable by painting the dresses worse.

The painting before us has been objected to, because it seems broken up into bits. Precisely the same objection would hold, and in very nearly the same degree, against the best works of the Venetians. All faithful colourists' work, in figure-painting, has a look of sharp separation between part and part. I will not detain the reader by explaining *why* this is so, but he may convince himself of the fact by one walk through the Louvre, comparing the Venetian pictures in this respect with those of all other works of its class, it is marked by these sharp divisions, there is no confusion in its arrangement. The principal figure is nobly principal, not by extraordinary light, but by its own pure whiteness; and both the master and the young Giotto attract full regard by distinction of form and face. The features of the boy are carefully studied, and are indeed what, from the existing portraits of him, we know those of Giotto must have been in his youth. The head of the young girl who wears the garland of blue flowers is also very sweetly conceived.

Such are the chief merits of the picture. Its defect is, that the equal care given to the whole of it, is not yet *care enough*. I am aware of no instance of a young painter, who was to be really great, who did not in his youth paint with intense effort and delicacy of finish. The handling here is much too broad; and the faces are, in many instances, out of drawing, and very opaque and feeble in colour. Nor have they, in general, the dignity of the countenance of the thirteenth century. The Dante especially is ill-conceived—far too haughty, and in no wise noble or thoughtful. It seems to me probable

that Mr. Leighton has greatness in him, but there is no abso-
lute proof of it in this picture; and if he does not, in succeed-
ing years, paint far better, he will soon lose his power of
painting so well.

1855: PARIS

The Universal Exposition:
The First International
Exhibition of Fine Art:
The Exhibition by an Artist
of His Work

On May 1, 1855, despite the cold and damp, the Champs
Élysées was crowded with curious Parisians and tourists who
had gathered to watch Emperor Napoléon III and Empress
Eugénie pass by. Accompanied by gorgeous costumed out-
riders and the dashing *Cent Gardes,* they proceeded from
the Tuileries to the Palais de l'Industrie to officially open the
Exposition Universelle.

The Palais de l'Industrie, one of three buildings placed be-
tween the Champs Élysées and the Seine to house the dis-
plays, was "a temple of universal concord" consisting of a
great nave and two side aisles covered by semicylindrical
vaults of glass and iron. It was not as large as London's Crys-
tal Palace, and the architect, Jean-Marie Viel, had not

matched Paxton's audacious use of new materials. The light gray interior had a dowdiness that even the great semicircular stained glass windows at either end could not brighten. The annex, a plain four-thousand-foot-long building, contained the large machinery and materials. A few minutes away, on the avenue Montaigne, was the Palais des Beaux-Arts. Designed by Hector Martin Lefuel, who was engaged on a project begun in 1852 uniting the Tuileries and the Louvre, it housed the sculptures and paintings.

Since 1798, when François de Neufchâteau, Minister of the Interior under the Directory, had first invited French manufacturers to exhibit their products in Paris, an industrial exposition had been held, political events permitting, at four-year intervals. The exhibition of 1801 had been held in the courtyard of the Louvre, the building which regularly housed the Salons, and its gold-medal winners were invited to dine with the First Consul, Bonaparte. The exhibition in the courtyard was repeated the next year, when it coincided with the opening inside the Louvre of the Musée Napoléon, containing the art treasures looted throughout Europe by the victorious French armies. These exhibitions established France as the center of European art and fashion until the revolution of 1848, which thwarted France's ambition to hold the first international exhibition. The country was suddenly eclipsed by the dazzling wonder of London's Crystal Palace, in which the industrial products of the world had been so beautifully displayed.

To recapture France's lead and to demonstrate the country's political stability and aggressive leadership, Louis Napoléon, now secure as emperor of France, authorized an international exposition of art and industry in December 1853. Only the "mechanical" art of sculpture had been included in the Crystal Palace exhibition, but in France—where there was an awareness that excellence in many industrial products was closely and traditionally related to the fine arts, and where the state-supported "industries" produced Sèvres porcelains and Gobelin tapestries—it was decided that the fine arts ought to be included in the exhibition and that they merited a building of their own. The Imperial Commission for the

universal exposition, headed by the emperor's cousin, Prince
Jérôme Napoléon, had two sections: The Agricultural and
Industrial Commission and the Fine Arts Commission. The
latter, under the patronage of the Empress Eugénie, included
Delacroix and Ingres among its twelve members.

Money for the exposition was provided by deficit funding
and municipal bonds, this despite the pressing needs of the
French Army, engaged in fighting in the Crimean Peninsula,
and the monies required to continue the immense public
works to modernize Paris, begun by Haussmann two years
earlier. Countries from all over the world responded to the
invitation to participate—only Russia declined—and 11,986
French exhibitors and 11,968 foreign exhibitors made plans
to transport to Paris the products and machinery that would
testify to their energy and ingenuity. Thousands of Euro-
peans, whose curiosity had been whetted by the imperial de-
termination to limit advance publicity about the exhibition,
were eager to view the results. Traveling to Paris on the
newly laid railways now spreading like a net across Europe,
manufacturers of the exhibited products, merchants who
would buy and sell what was displayed, and the general pub-
lic flocked to the universal exposition. With the five million
visitors came journalists, critics, and reporters eager to pro-
mote discussions that would contribute to the improvement
of their country's products and to defend their country's
achievements.

On free days—initially the admission fee had been five
francs, but it was reduced to one franc in June—every third
man in the crowd was a soldier. The white caps trimmed
with bright ribbons worn by working women, the showy
dresses of bourgeois ladies, and flags and pennants helped to
relieve the drabness of the gentlemen's black coats and the
Palais de l'Industrie's gray interior. Samples of merchandise
had come from everywhere and were artfully displayed to
create "a museum of civilization and progress." When visitors
to the machinery and raw-product galleries were fatigued by
the thousands of labeled bottles filled with grain, the colossal
cakes of soap, the gigantic engines, and by the difficulty of
disentangling the wheels and cranks of one machine from

those of its neighbor, they were refreshed by a short walk beneath the trees to the gleaming white Palais des Beaux-Arts. Having paid the five-franc admission fee, they studied the paintings with the same curiosity they had devoted to machinery and agricultural products.

Although an increasing number of foreign artists exhibited at the Salons, this first great international exhibition of art permitted the public to study, compare, and speculate on the causes for the differences they noted between their own country's art and that produced by other nations. They could consider the relative strength of the different media and genres, the role of patronage, and the position of the artist in the countries represented. The exhibition was at once compared to the Olympic Games held in ancient Greece.

On the opening date (May 15) the Palais des Beaux-Arts was ready with over 5,000 works by 2,054 artists from 29 states (including nine German states). The 1,366 foreign entries had been selected by juries in their home countries. All the works had been arranged by the Comte de Chennevières, assisted by individuals from foreign states, on walls painted a dark sage green. Upon entering the Palais des Beaux-Arts, which consisted of three great central salons, collateral galleries, and a sculpture hall, visitors found in the first transept gallery paintings from Denmark, Sweden, Norway, Peru, the Papal States, and Tuscany. Surprisingly, there were only 19 works from the Papal States and Tuscany, once the cradle of the arts. A central archway led to a room hung with pictures from Switzerland, the United States, and the German state of Baden. Collateral galleries were hung with entries from Belgium, the Netherlands, Austria, Bavaria, Württemberg, and Spain. The first of the large central salons contained 135 works by Prussian artists, Cornelius' large cartoons for the frescoes in the Campo Santo (Berlin), the sculptor August Kiss's colossal equestrian group *St. George and the Dragon*. Some sculptures had been placed in groups or singly in the center of the painting galleries, where they were clearly set off against the walls, but the majority of the 684 works received were exhibited in the sculpture hall.

The remaining galleries and the two large salons were filled

with 2,060 works representing every branch of the French school. There were almost twice as many French as foreign entries. The jury that had chosen the French works had been named by imperial decree and was led by Count Nieuwerkerke, director general of the French museums. It consisted of three sections—painting, sculpture, and architecture—and included collectors and connoisseurs: the Marquis Maison and the Duc de Cambacérès; the curators of the French museums: de Reiset, Villot, de Longperier; artists who were members of the Institute and supporters of the "official" art fostered by the École des Beaux-Arts: Abel de Pujol, Flandrin, Hersent, Léon Cogniet, Picot, Robert Fleury, Turpin de Crisse; and artists who· were not: Rousseau, Troyon, Couture, Barye, and Rude. In addition, the jury included members of the fine arts section of the Imperial Commission for the Universal Exposition, including the politically important Comte de Morny and the Duc de Mercey.

The jury had made sure that the French school would be strongly represented. Both older and more recent works by established masters were included. Ingres, Vernet, and Decamps were each assigned an entire gallery. Delacroix's thirty-five paintings shared one of the large salons with pictures by Henri Lehmann and Paul Flandrin. Because the space was not large enough to house both the retrospective and international exhibits, plus all the works that would normally have been exhibited at the Salon,[1] here was considerable discontent among French artists. Courbet, who had eleven canvases admitted, rented land nearby, on the avenue Montaigne, and built a small pavilion to display forty canvases, including his most recent major work, *The Artist's Studio*, which measured eleven by nineteen feet.

The foreign press generally conceded French artistic superiority but did not fail to note that the exhibition was not "a true competition in which the relative merits and position of the different schools of the civilized world or of Europe

[1] In 1855 the international exposition took the place of the Salon. In 1867, however, both a Salon and an international exposition would take place, and there would be separate juries for each exhibition. See pp. 484–85.

may be fairly ascertained, upon equitable comparison. . . ."[2]
Non-French reviewers were obliged to consider how condi-
tions at home might be modified so that their artists could
compete more advantageously with the French in future ex-
positions. An unsigned report critical of the French domi-
nance in the prize jury appeared in *Die Grenzboten*, pub-
lished in Leipzig.[3] Coverage appeared in *Das Deutsche
Kunstblatt*, published by the active Kunstverein, or Art
Union, and edited by Friedrich Eggers. Holland's *Kunstkro-
nijk*, which had begun publication in 1840, issued a special
edition in 1856 with a section reporting on the 131 works
by 76 Dutch artists. Reports appeared in *The Builder*,
founded in 1842 by the English architect George Godwin.
One of the few trade journals then published, it was ad-
dressed to the half million "British artisans of highest in-
telligence, and, measured by their wages and numbers,
highest in wealth, the working Builder or Building Arti-
san. . . ." The *Art Journal* thoughtfully provided its readers
with excerpts from French publications—*Le Journal*, *L'Un-
ion*, *La Patrie*, *Le Moniteur* (the government paper for
which Théophile Gautier supplied fifty-two articles), *L'Athe-
naeum Français*, and a special publication, *Le Palais de l'Ex-
position*—to acquaint them with French opinion of English
works.

The important *Wiener Zeitung* entrusted the task of re-
porting to Rudolf Eitelberger von Edelberg (1819–85). Eitel-
berger's interest in the past, and particularly in medieval
monuments, had led him to study art history. His desire to
discover the same links uniting history, technique, and theory
in contemporary art that he had observed in the art of the
Middle Ages was stimulated by his visit to the Crystal Palace
in 1851. On his return to Vienna in 1852, Eitelberger was
named professor of art history—the second professorial chair
in that field to have been established in a German university
—and he enlisted support for an Austrian Museum of Art and
Industry and an applied art school. In his exhaustive, con-

[2] *Art Journal*, July 1, 1855, p. 203
[3] *Die Grenzboten*, no. 96, November 9, 1855. See also 1858:
MUNICH, p. 221

structive report on the Universal Exposition, especially the
fine arts section, he analyzed the basic reasons for the excel-
lence of French art and recommended changes and additions
to the system of art education in Austria.

Disdaining such utilitarian considerations, Edmond and
Jules de Goncourt set down the questions and reflections that
occurred to them as they self-assuredly sauntered through the
galleries of the Palais des Beaux-Arts in order to coolly ap-
praise "the national geniuses of different races, and mourn
the sadness of so much decadence, weigh the peaceful work
of the peoples." Their first art criticism had appeared in
1852, but after 1854, when they had been reprimanded in
court for the immorality of a drama review, they had turned
from journalism to history. Their *Histoire de la Société Fran-*
çaise pendant la Révolution (1854) had been followed by a
just-completed second volume, the *Histoire de la Société*
Française Pendant le Directoire (1855). Writing for them-
selves, but willing to share their analysis of the art at the Ex-
position Universelle with friends, they again published their
review privately—this time in an edition of 42, not 250, as in
1852. After a brief survey of past artistic trends and themes,
they predicted that genre, portraiture, and landscape would
predominate in the future. Among contemporary artists, they
preferred Gavarni, the witty, intellectual caricaturist, "faintly
tinged with corruption" (in the words of Baudelaire), whose
work was not represented in the Salons but was well known
to readers of *Charivari*, and Decamps, a member of the now-
dispersed and forgotten romantics who painted exotic scenes
remote from daily life. Though the Goncourts would soon
begin writing novels dominated by a search for the reality of
character that lies beneath the surface, they dismissed realism
in painting as "matter glorified." Fastidious in every aspect of
their life, and repelled by the uncouth, undisciplined "bohe-
mianism" of Courbet and his circle, they chose to ignore
those of Courbet's paintings that had been included in the
exhibition.

Most of the twenty-seven or more reviews in the French
press could avoid comment on Courbet's private exhibition:
it was not within the Palais des Beaux-Arts and critics could

restrict any comments they chose to make to his eleven canvases accepted by the jury. On June 28, between ads for sugarplums and sarsaparilla, a paid newspaper advertisement announced the exhibition. Courbet's *succès de scandale* of past years, however, assured his exhibit of some notice. British tourists were informed by the *Illustrated London News* of June 30 that among the private exhibitions "is to figure that of the pictures of the democratic painter M. Courbet, whose productions, especially a female figure, the Bathers, excited so general (if not so favorable) a degree of attention in the annual exhibition of painters two years hence." For ten centimes visitors bought a catalog whose preface, an explanatory manifesto of realism, announced:

> . . . I have studied, not in any systematic spirit and without preconceived ideas, the art of the ancients and of the moderns. I have no more wish to imitate the former than to copy the latter; neither has my thought been to arrive at the lazy goal of ART FOR ART'S SAKE. No! I have simply wished to draw from the accumulated wisdom of tradition a reasoned and independent sentiment of my own individuality. To know in order to do, this was my thought. To be able to translate the habits, the ideas, the aspects of my epoch according to my understanding, to be not only a painter, but a Man, in a word, to make living art—that is my 'aim.[4]

Courbet had been assisted in the formulation of this preface by Jules Husson (1821–89), who took the name Champfleury when he became a writer. A native of Laon—whose seventeenth-century realist painters of peasant life, the Le Nain brothers, had provided him with his standard of great art—Champfleury, upon his arrival in Paris, had shared with Henri Murger lodgings and "la vie de bohème" of the desperately poor artists and writers—Chintreuil, Nadar, Courbet, Baudelaire, and the socialist philosopher Proudhon—who

[4] Translated from *Courbet, Raconté par Lui-même et par Ses Amis* (Genève: P. Cailler, 1950), vol. I, p. 48. Quoted from Elizabeth G. Holt, ed., *From the Classicists to the Impressionists: Art and Architecture in the 19th Century*, vol. III of *A Documentary History of Art* (Garden City, N.Y.: Anchor Press/Doubleday, 1966), p. 348

gathered at the Café Momus and the editorial offices of *Le Corsaire*. Champfleury had first won recognition as the author of *Chien-Caillou*, the story of the penniless engraver Bresdin, which was published in *Le Corsaire*. His descriptions of *bohème*, more accurate than Murger's *Scènes de la Bohème* (1851), established his reputation as a "realist." Bonvin and Courbet's choice and treatment of subject matter corresponded to Champfleury's literary realism, and when Courbet's *Burial at Ornans* was exhibited at the Salon of 1851, Champfleury wrote in *L'Ordre:* "M. Courbet's history pictures, which will be an event at the Salon, are bound to give rise to an important argument. From today critics can get ready to embark upon the battle for, or against, realism in art."

Champfleury, identified with the unconventional, unpleasant "bohemians," thus established a link between *bohème* and Courbet's realism: Just as the literature of *bohème* deviated from the conventional and dealt with unusual subject matter, Courbet's paintings, in which "genre" subjects were treated like subjects in "history paintings," were a visual protest against the social system. By 1855 a *cénacle* of realism had formed around Courbet. It met fairly regularly on Thursdays at the Brasserie Ändler. Champfleury, the "Courbet" of the writers, a comrade, not an instructor of the artist, defended Courbet's realism. On December 2 *L'Artiste*—Europe's first and still most lively art periodical, for whom Charles Perrier was reviewing the works at the Palais des Beaux-Arts—published a letter written by Champfleury and addressed to George Sand, a prominent adversary of the establishment, defending Courbet's exhibition. The letter explained realism's ambitious attempt to deal with new subjects and kept alive the debate concerning the appropriate subject matter for art.

When the Exposition Universelle officially closed on November 15, 1855, an artillery salvo at noon announced the departure of the imperial cortege for the Palais de l'Industrie. The great nave, already filled with 40,000 guests in formal dress, had been transformed into a brilliantly decorated room, with a raised throne and chairs for the dignitaries gathered at

one end. The masterpieces of painting and sculpture, as well as the inventions and wonders of industry which had won the highest awards, were exhibited for the last time before the dais in a splendid panorama. The winners of the 10,000 awards came forward in groups—each escorted by a huissier carrying a banner identifying the award category—to the foot of the throne, where each received his medal from the hand of Prince Napoléon. Emperor Napoléon III decorated 40 artists, including 13 foreigners, with the Légion d'honneur, and the awards jury, made up of eminent figures from the European art world, bestowed 16 medals of honor, 67 first-class medals, 87 second-class medals, 77 third-class medals, and 222 honorable mentions.

Two years later, art connoisseurs, especially those who had formed the avant-garde in the 1840s, read with interest a volume, published in Brussels, entitled *Nouvelles Tendances de l'Art*. Published under the name of William Bürger, it was written by Théophile Thoré (1807–69), one of Europe's most acute and accurate observers of art. As a follower of Saint-Simon, when Thoré arrived in Paris in the 1830s he immediately became active in socialist circles. In 1834 he founded *La Revue Républicaine* with Louis Blanc and the Arago brothers, and his first article on art, "L'Art Social et Progressif" appeared in *L'Artiste* that same year. The following decade Thoré regularly wrote criticism for *Le Constitutionnel* and consistently defended the works of the Barbizon painters, who were excluded from the Salon. Théodore Rousseau was Thoré's friend, and from the artist the critic learned much as he developed his approach to art and art history. To the "Art for Art's Sake" of Gautier, Thoré opposed "Art for Humanity's Sake." In landscape paintings he found an almost mystical beauty untouched by the destructive materialist spirit of the age.

After the June days of 1848, Thoré had gone into exile because of his political activities. He continued to support himself by writing on historical and political subjects as he traveled in Switzerland, England, and Holland, finally selecting Brussels as his base. In 1856, having developed his connoisseurship by studying the holdings of the art museums and

private collections in the countries he had visited, he resumed his career as an art critic under the name William Bürger. Though he was unable to return to France to visit the Exposition Universelle (he did, however, travel to Manchester to report on the 1857 exhibition for *Le Siècle*), his *Nouvelles Tendances de l'Art* was an eloquent and thoughtful plea for a new and international artistic language.

Rudolf Eitelberger von Edelberg: *Letters Concerning Modern Art in France at the Paris Exhibition*[1]

I. The Position of French Art

Paris, July. Do not expect something complete from me, only fragments, not a detailed description of contemporary French art or of all 2,714 works of art which France has displayed at the Exposition Universelle des Beaux-Arts but only a cursory sketch of the most important phenomena and the impression they produce. Do not expect, either, that I will go beyond France unless for some special reason. One awakens from the dream of an Exposition Universelle des Beaux-Arts nowhere more quickly than in Paris itself. Artists and works of art are so bound up by thousands and thousands of ties that bind them to their native soil that it would be impossible for them, even if they migrated en masse, to reflect outstanding phenomena of any other important cultural area of Europe in the same way. Even if one were able to set aside all the barriers among persons and the moods of artists and friends of art with a single decree, who could set aside those barriers inherent in the nature of things?

Who could undertake to transplant from one place to another those works in which the artist expresses in lofty style not his own ideas but rather those of his people and his century? How would these artworks show up in a foreign country, amid a highly disruptive environment? How do the fragments

[1] [Translated from Rudolf Eitelberger von Edelberg, *Briefe über die moderne Kunst Frankreiche bei Gelegenheit der Pariser Ausstellung 1855* (Vienna, 1858). Originally published in *K. K. Wiener Zeitung*, Beilage, August-September 1855]

of the language of Germany's art show up in Paris, where the key to an understanding of their language is missing? Where, at present, with the increased and better means of transportation, is there even a need for such a migration of the greatest works of art? Whatever was capable of traveling and had its luggage at hand—the easy crowd of minor works of art —set out on foot to be exhibited in Paris. A large number of respectable and important artists, however, preferred to remain at home. Among the Belgian artists, to name just one, Gallait is missing; from Rome, Overbeck, Tennerani, and Riedel, among others, are absent; the number of those missing from Munich, Düsseldorf and the rest of Germany is legion. With the single exception of some few statues of Rietschel and some few cartoons by Cornelius and Kaulbach sent from Berlin, the entire significant art of Germany is missing. Of all the nations, aside from the French, it is the English alone who in painting appeared in number and with closed ranks. Everything other people offered amounts to no more than fragments. There is, therefore, talk not of a general art exhibition but only of a French one to which some artists outside France, mostly English, annexed themselves. This you will see best from the numbers themselves. England exhibited 778 works of art, Belgium 271, Prussia 224, Austria 216, the Netherlands 131, Spain 122, Bavaria 73, Saxony 27. The rest are divided among the smaller German states, Greece, Turkey, the North American republics, Peru, and Mexico. The numbers indicate another fact as well: The German Federation exhibited not as a unit but rather each individual federal state exhibited for itself. . . . There is therefore in Paris no talk of German art but rather of the art of the German states. . . .

With this confused arrangement of the artists of Middle Europe, with the insufficient representation in itself, you will find it doubly understandable that I am limiting myself to France, which did everything to make as splendid and complete an appearance as possible. . . .

French artists have never lacked support, encouragement, and commissions from friends of art, not even when the artists of France had no important talents to exhibit. France has

always considered art as a means of furthering its national glory, of increasing its national wealth, and of elevating the public spirit of the masses. The intelligentsia has always succeeded in making Paris the center of cultural and stylistic currents—a center which did not fail to exercise its effect even far beyond France's border. French art has continuously been enriched through foreign artists who felt themselves drawn to France; but France itself knows no spiritual deserters, and every French artist in a foreign country promotes the glory and taste of his nation. . . .

In France art is a power. It is present not only in the studies of the artists but has permeated the entire life. Art is found in the workshops of the craftsmen and manufacturers just as it is in the buildings that serve the purposes of the State and the Church. The fact that art has penetrated the masses shows that it was not born today or yesterday. It has its history; it has developed. . . .

III. The Influence of the System of Competition upon Art

Paris, July. Art in France has a national background. You might have seen from my last letters that it draws its power from this source. Permit me this time to return to another point, namely, to the means employed in modern France to advance art—means which are so necessary for a glorification of national prestige, for a refinement of industry, for spiritual purification and elevation, and for training the artist.

I believe I do not need to speak particularly of the famous institutions for the advancement of art. Institutions like the École de Dessin, the École des Beaux-Arts (a section of the Institut de France) are as well known as the French Academy in Rome, the Institute in Athens, and the marvelous foundation of the Comité Historique des Arts et Monuments in all its branches. To these institutions are added similar ones which are located throughout France and were founded chiefly to promote taste in the applied arts. All these institutions have as their artistic foundation drawing and study of the world of forms; their vital basis is *competition*. Kugler explained, in a piece which appeared a few years ago, that the principle of competition, the stimulation of a spirit of rivalry,

permeates all of French artistic training from its first stages to its last. The application of this principle is not at all simple but rather quite complicated, and it requires no little perseverance, no ordinary exertion of strength to work one's way through the different schools to the honorary title of an Élève de l'École to a Prix Mercier, to the different levels of an honorable mention, up to a Prix de Rome. It is thus quite natural that the French section of the exhibition's catalog indicates, in the case of each individual French artist, not merely whose *Élève* he was but also if and when he received a medal of first or second class and in which field, whether in *genre* or in *histoire* or in *marine*, and so forth; that the Grand Prix de Rome is not forgotten is self-evident. Compared to such a French catalog, how simple and modest was that of the Munich art exhibition last year. What would a German say if in the catalog under the name of an artist who no longer belongs in the middle, let alone the younger generation, he found indicated with diplomatic precision when the artist received a first or second medal during his advanced studies or at the various exhibitions? The Frenchman, however, finds this quite natural; he would feel its omission to be a slight or insult. Visitors to the Parisian exhibition acquire some interesting facts thanks to this practice. It is certainly not uninteresting to know, for example, that Ingres had already received the Premier Grand Prix de Rome in the year 1801, that H. Vernet and Delacroix never received that prize, that almost all the important painters received medals of first, second, or third class as a result of works which they exhibited at art exhibitions, that they all possess the Légion d'honneur awarded through every grade from Chevalier up to Commandeur de l'Ordre Impérial. An artist who has received such a distinction can reckon on two things in France: first, on the recognition of the art-loving public, which warmly supports native talents; second, on employment from the state or commune if the occasion presents itself. The exhibition's catalog lists no artist of merit who has not been employed by the state, or of whom there are no works in the possession of the state. The catalog indicates the many different offices and persons who have funds for purchases.

There are works "commandé par ordre de l'Empéreur," works which belong to the domain of the crown and are shown in the imperial museums and castles, works which were ordered or purchased by the different ministries or which are in the portfolios of the Commission des Monuments Historiques and, finally, such works as were ordered by the Prefecture de la Seine and by the different communes of France. To receive a distinction is therefore of no little importance to an artist; he depends upon it. He knows that his reputation and his honor depend upon it. He strives for it with all his means.

The manner and fashion in which such distinctions are awarded is festive and suited to the dignity of the occasion. The award of the prizes is usually made at exhibitions which the state arranges; for example, in 1853 in the large Salon Carré of the Louvre in the presence of Prince Napoléon and the ministers of state, members of the jury, and the Academy of Fine Arts. Forty-seven medals were distributed, two artists were named officers, ten Chevaliers de la Légion d'honneur, and upon special order two women, Mlle. Rosa Bonheur and Mme. Herbelin, who had already received all the medals that women artists can receive, were awarded the right to exhibit their works without their being first submitted to a jury.[2] Under such circumstances, is it any wonder that an artist does not rest until he has received a position of respect and has earned himself a name along the path of competition? An artist can be rather indifferent to the judgment a private corporation delivers on his works. He can be indifferent to an office that extends praise or censure only so long as it has no means at its disposal to assert its judgment further and is not in a position to uphold its praise like a palm of victory, during the entire life of an artist, but only keeps praise like a dried plant specimen in a cabinet. But praise—a distinction solemnly pronounced, delivered by the most competent men

[2] [Rosa Bonheur and Jeanne-Mathilde Herbelin (née Habert) had both been awarded first-class medals. Until 1852 first-class medalists could exhibit their work without submitting it to the Salon entrance jury; after 1852 only members of the Institut and the Légion d'honneur enjoyed this privilege. In 1864 Rosa Bonheur would be the first woman artist to be made a member of the Légion d'honneur.]

and authorities, full of the most practical consequences, a distinction which follows an artist to his grave—to such a judgment an artist is not and cannot be indifferent. The spirit of rivalry, the principle of life of every spiritual activity in the public sphere, is nowhere as powerful as in French art. The laurels of his contemporaries let no artist rest. A part of the entire training of artists in France is based upon this fact.

This explains several phenomena in the field of French art. There is no sign of stagnation in it. The pupil cannot be content with achieving merely what his teacher has accomplished. He is forced to give his works their own individual tone in order to make himself noticeable. He must emerge from the customary circles of thought and fashion. He may not be comfortable and sleepy. The perpetual motion in French art, the emergence of new directions and new efforts— though they need not inevitably lead to something good or better—are without doubt a result of this principle, which old France applied with only a certain moderation but which modern industrial France, with its political ferment, has apparently pushed to its furthest limits. This principle also fits the national character of the French; it fits their moral outlook on life.

There can also be no doubt that this principle, applied with a certain purity and with consideration for the more serious directions of style, has a very beneficial effect upon art itself, that it can nowhere safely be completely neglected. But everything has its reverse side, every principle has its limits. These lie in the nature of the different types of art, in the only relative capacity of human powers for intensification. The principles of art rest upon simple great laws, not merely in architecture and in sculpture but also in painting. . . .

As long as the competition is conducted by the forces of the state, there is no danger that these bounds will be overstepped very lightly, and that the transgression of stylistic laws or principles of art will often wound the moral side of a nation.

It is different, however, when the artist ceases to listen only to the purer, stricter demands of art, when he begins to aim not at art but rather at its success with the public. Then

the relation is reversed. Art then becomes for the artist not a purpose but a means; then it is not the artist but rather the public who purifies and advances taste. Then art becomes a business and a competition, and at the same time the prize, the medal, and so forth, become nothing more than large posters announcing the opening of a new business in landscape or genre, historical painting or statues. Then art climbs down from its throne and fashion clambers up to it.

By that I do not mean to say either that the excessively intensified system of competition is the only cause for much in the art of France being fashion or that in France fashion alone reigns. . . . But the current exhibition, which, in its completeness and its scope, provides a sufficient standard for France, shows clearly that fashion has set up its throne there *along with* art and in the field of art.

One of the reasons seems to me to lie in the fact that the artists are held by the system of competition much too closely to seeking success and *only* success; indeed, seeking not just that success which emanates from competent judges of art but that which goes along in the train of exhibitions and prizes, which echoes in the salons of the art speculators, the pretentious rooms of the rich, in the offices of journalism.

How else can one explain that presently in France virtuosity of the brush—that virtuosity which has long outlived itself in music and poetry—has the upper hand? Why else would artists who cannot be denied a natural talent make nothing but futilities and foolishness, not to mention trivialities, the object of their art? Why else would it happen that the most absurd fashions and the harshest contrasts are dragged forth with such intentionality, if fashion did not ever demand new food and the spoiled palate ever stronger and stronger spices? The systematic exploitation of all sorts of nudity, of all shocking objects—where can this come from other than from morbid fantasy, from the success that similar objects achieve in that society which is in a position to spend a great deal of money for things of little value?

One might say the world has always been ruled by fashion, that fashion has always influenced art. And this, too, is partially correct, particularly in France. But aside from the fact

that in healthy periods it is art which is in fashion, fashion in the modern sense first truly began to dominate art when the inner life of art was broken. In our time art has again taken over the mission to dominate life and to restore better taste to its important position. It is not fitting for art to make itself dependent upon the current taste of the speculators, or upon the stock market of the rich. Art is art only if it comes from the spirit and speaks to the spirit. Art which is not the interpreter of the spirit is a stillborn art, like that which is not in complete harmony with the natural needs of life. But where is there a standard for the natural needs of life anymore, and what has become of that which one calls the spirit and life of art?

This excessively intensified competition has forced art into false paths and has produced the influence of a powerful plutocracy. It has dealt France's modern art severe wounds. It will not bleed to death from them. France has already brought to light so many examples of inner strength, so many noble forces are at work in France on the spiritual restoration of the land, that hope is not lost that a nobler, purer element will also win the victory in art. . . .

VII. Sculpture in France

Paris, August. Sculpture has become an unpopular art. The rooms devoted to it at the art exhibition here are almost always empty. Very seldom does anyone but a conscientious viewer go from statue to statue, from bust to bust; most are satisfied with a quick look around from the doorway and return as quickly as possible to those rooms where the bright play of colors and the sheen of gilded frames offer the eye more gratification. One can see this, by the way, not just in Paris and not just at the exhibition. Everywhere that statues are mounted in great number—in the ground-floor rooms of the Louvre, where the sculptural works of all centuries are found in different halls, as well as in the splendid rooms of the Vatican gallery in Rome—one feels that our age has no affection and no understanding for sculpture.

This lack of a plastic sensibility is also noticeable in painting. In French art in particular everything rushes toward

color, toward coloring, with the same onesidedness with
which one chased after ideal form fifty years ago. Feeling for
the plastic world of forms has almost completely disappeared
from painting. At present, the more boldly a painter contrasts
color, the more arbitrarily he proceeds in doing it—yes, the
more he sacrifices beauty, psychic characterization, and ani-
mation of the forms from within to the effect of colors—the
more he is supported by the fashion of the day, by the artistic
taste of most of our patrons. What contrasts does the art of
our decade offer! On the one hand, one sees delicate draw-
ings, contours in severe lines just barely tinged with color
tones. On the other hand, one sees the most material color,
the starkest oppositions of color. On the one hand, color is
merely the guide to a mythic-poetic world of fantasy in which
the artist permits himself to think only incorporeal ideas. On
the other hand, color itself becomes the content of the work
of art, the concept is completely crowded out by color rather
than color being used only to reproduce the forms more obvi-
ously, to represent the concept more vitally. There is rarely a
sense or understanding of the form itself, neither by the par-
tisans of the one direction or those of the other.

In this condition, which is seen not only in modern
French and Belgian art, I can see no consoling phenomenon,
no progress.

France has at present no great plastic artist. France does
not possess a talent like Canova, Thorwaldsen, or Rauch.
France has no monument that could be measured against the
Friedrich Monument in Berlin, no statue in the rooms of the
art exhibition that could be measured against Rietschel's
Lessing statue on exhibit there. Even if the works of David
d'Angers or of Pradier, who recently died, had come to the
exhibition, public opinion would not have changed. There
can be no doubt at all that the greatest sculptural talents are
at present to be found in German art. The strength of
French sculpture is seen in the so-called small sculpture,
and particularly in its application to industry and applied
arts. Major sculpture is almost exclusively decorative in
France. . . .

X. Reflections

Paris, August. You are probably awaiting impatiently the conclusion to my Parisian reports. It follows here. The reports turned out to be longer than I had hoped, but I could not have been briefer without being quite incomplete. . . .

That the French nation as such can develop an artistic activity is, to a certain extent, the fruit of the internal situation in France and of two elements that cannot be emphasized enough: *the wealth of the nation* and *the free movement in trade, commerce, and industry.* Poor nations have never had an art. Art is always and everywhere accompanied by prosperity, trade, and industry. It has had its residence in the Middle Ages as well as in our days in the palaces of the rich and in the emporia of commercial intercourse. . . . Art is incompatible with poverty. The conditions of affluence are various: The institutions which lead to it are different among the different peoples and levels of culture. . . . Spiritual capital, which elsewhere lies fallow or cannot be directly applied, yields interest everywhere in France. How active does the spirit of the French show itself here, how imaginative; what varied phenomena come to life there; how interesting it is to consider the activity of the nation and to ponder those phenomena which relate to fine art. On the streets, in the theater, in homes, in businesses, and in the factories the inborn taste of the French shows itself—this innate taste which stands out so definitely only because its prominence is permissible, because no thousands and thousands of obstacles break the courage, depress the spirit, and cultivate an apathy. If one considers the French people in this respect, then my assertion that, as a whole, France itself is a greater artist than the professional artists of France certainly will not sound paradoxical to many of you.

Nothing is more important, therefore, than for every friend of art to make the acquaintance of French art; for every artist it is instructive but ruinous to imitate. Among the German artists, those who, like the Düsseldorfer Knaus, live in Paris and have no desire to imitate the Frenchmen Diaz or Meissonier, Decamps, or Roqueplan, occupy the most respected

position at the exhibition. Those who, like Lehmann, are nei-
ther fish nor fowl, neither French nor German, who imitate
everything and produce nothing, who pay homage in all di-
rections and have none, go under. This observation can also
be made of other German artists living in Paris, but not at all
of Herbsthofer, a naturalized Frenchman. In him the Vien-
nese is stronger than the French at present, and the tradi-
tions of Viennese art in fullest bloom. Everyone here who
has seen his large historical painting *The Awakening of Laz-
arus* or his *Episode from the Thirty Years' War* has recog-
nized familiar tones from the homeland; more than once I
heard the exclamation, "That's a Viennese! Why is he
placed under France?" To clear up the doubt, I read in the
catalog, "Herbsthofer, Charles, né à Presbourg, naturalisé
Français."

Whatever cosmopolitan art lovers may say—cosmopoli-
tanism by the way, in the case of most of its representatives,
has a very practical and material reverse side—the artist can-
not so quickly leave the milieu to which he has spiritually
and physically become accustomed from his youth. The art-
ists of nations—like Poland, Russia, Scandinavia, and so forth
—which have no independent artistic traditions and who ac-
quire in their entire comfort, in their daily life, the manners
of more highly civilized neighboring peoples, naturally have
no other choice in matters of taste than to follow the lead of
those peoples with whom they have the greatest spiritual
affinity. It is different for the artists of those cultures which
do not merely possess an independent artistic life at present,
but have artistic traditions to uphold that have been alive
among the people for centuries. There are in our century—and
not merely at the exhibition—first and foremost three of these
peoples: the Germans, French, and English. In the second
row come the Belgians and Dutch and, in some respect, the
Italians. The Danes, Swiss, Spaniards, Poles, Greeks, and the
North and South Americans follow more or less the example
either of the Germans or French, according to individual in-
clination and conviction.

Among the artists of these peoples, without any doubt
those of Italy, and specifically the natives of Milan and

Venice, are most important for Austria. It is a sad fact that one becomes better acquainted with them in Paris than in Vienna, and that they have exhibited more in Paris than they ever have in Vienna. This is not their fault; there is at present no exhibition hall in Vienna where Austrian artists might feel particularly inclined to exhibit their work. . . .

Whoever knows the artists of the Austrian part of Italy, especially those of Venice, sees at first glance that only a few of the native artists of Milan and Venice have exhibited in Paris (at the time the *Gazzetta Ufficiale di Milano* indicated the reasons for this)—and even among these artists, how many are known in Vienna? Where are their works found at the exhibitions? Where in the salons of the rich, in the halls of our art patrons and clubs, are works of these Austrian painters found? Is one in a position in Vienna to be able to judge the achievements of Austrian artists, as one can become familiar with those of French artists in Paris?

Is it not evident that an Austrian here in Paris can become familiar with more artists of our most important cities—Milan and Venice—than has ever been possible in Vienna? . . .

Let me hasten to a conclusion. The Parisian art exhibition, without any doubt, has contributed much to extending an opinion about French art to wider circles. Even if everything that glitters is not gold, much true gold is nevertheless present to compensate for all the tinsel so artfully fashioned here. Involuntarily one rejoices upon seeing that art has a home here, that many spiritual forces have been its supporters for decades, and that on the street as in the home, in public life as in industry and in manufacturing, art occupies a position commensurate with its dignity. However, what Paris has for the scholar and artist that is particularly beneficial and elevating is, to use Waagen's words, the fact that "knowledge and the higher significance of the arts are recognized not only by the state but also by all classes of educated society, that their representatives are not merely suffered as superfluous parasitic plants but rather are recognized and distinguished as persons who advance the most important spiritual interests of the human race."

Epilogue: A French Opinion About German Art at the Exhibition

After an exhibition of the extent and purpose of the Parisian one, it lies in the nature of things that the whole world should ask, Who—that is to say, what nation—carried away the prize? Was it the French, the Germans, the English, or someone else in the group of those who took part in it? . . .

Thoughtful writers, as well as thoughtful artists, have recognized that the differing artistic genius of nations has as its base their differing historical development. The two outstanding French critics, Delécluze in the *Journal des Débats* and Gustave Planche in the *Revue des Deux Mondes*, have returned to examine this difference in basic tone which dominates the art of the Germans and the French. The former critic, however, is somewhat prejudiced by a certain special affection for [Jacques] Louis David and his artistic traditions; the latter examines the question more freely and profoundly. Gustave Planche recognizes in the German school those who make the concept the standard-bearer of their artistic endeavors. He, indeed, believes that the German school often separates the ideal from beauty and confuses the idea, the property of philosophy alone, with the ideal, which is uniformly the basis of poetry, music, and the fine arts. . . .

"A nation," so Gustave Planche concludes his report about the German school at the Parisian exhibition, "that offers to Europe painters like Cornelius, Overbeck, Kaulbach, and sculptors like Rauch, Dannecker, Schwanthaler certainly occupies a very noteworthy position in the modern history of art. Using only the elements the exhibition teaches us, we can assert that the German genius is decadent. It is enlivened by an ardent striving; it wants to place itself on a par with the most important works of Greece and Italy. It does not always choose the most certain avenue to reach this illustrious goal; but such an endeavor alone is already most honorable. What I respect and cherish in German art is the unerring march toward the ideal. Even if it does not often encounter true beauty, it at least always seeks it. Even if it sometimes is mistaken in the mode of expression, it nevertheless never

loses its viewpoint. Even if it does not always possess a feeling for harmony of lines, it still does not, however, satisfy itself merely with copying what it sees. And that is real progress on the road to truth. Will it be granted [to German art] to capture and reproduce elegance of form? Will it deny its own history? I am not of a mind to believe so. It is probable that it will remain faithful to its antecedents. It has at least renounced the prosaic imitation that inferior Flemish painters have practiced. It comprehended that literal imitation of nature does not suffice to capture one's attention. And that is the reason why Germany occupies a unique position among the European nations—to the same degree that everywhere else one attempts to suppress the ideal side of painting and sculpture, Germany continues to set concept above form. Germany energetically protests against the doctrines that wish to make the chisel and brush faithful servants of our senses. It is true that by neglecting form in favor of the idea one does violence to the idea itself, for in order to captivate the spirit the idea must present itself to the eye in an attractive form. But I have a deep sympathy for Germany because it places the work of the concept above the work of the hand. There are too many men among us who view the marble which has been fashioned with a chisel or the canvas which has been brought to life by a brush as nothing other than sweet tidbits destined to gratify our palates. Germany conceives the purpose of art and sculpture otherwise, and its stubborn protest against such purposes continually quickens in it the elevation of the concept, which, among the rest of us, becomes rarer every day. However little value one may attach to German art, one must always speak of it with respect. The excellence of its intentions makes up for the imperfection of its works.

Edmond and Jules de Goncourt: *Painting at the Exposition of 1855*[1]

I. Is painting a book? Is painting an idea? Is it a voice made visible, a painted language of thought? Does it speak to the mind? Should its aim and its action be to transform what it makes with colors, overpainting, and glazes into abstractions? Is its preoccupation and its glory to scorn the conditions of its existence, the physical sense from which it comes, the physical sense that perceives it? In a word, is painting a spiritual art?

Is not part of its destiny and its portion rather to tempt the eyes, to bring facts to life, to make an object perceptible, and not to aspire much higher than the stimulation of the optic nerve? Is not painting instead a materialistic art which animates form with color and is incapable of bringing to life through drawing the interior, the moral and spiritual parts of a creature?

Otherwise what is the painter? A slave to chemistry, a literary man at the beck and call of essences and colored extracts, who has bitumen and silver white, ultramarine and vermilion with which to touch our souls.

To continue, do we believe that it would be lowering painting to reduce it to its own domain, to the domain conquered for it by those geniuses with immortal palettes: Veronese, Titian, Rubens, Rembrandt? Great painters! True painters! Fiery conjurors of the only things that the brush can evoke: sun and flesh! That sun and that flesh that nature will always deny the spiritualistic painters, as though she wished to punish them for neglecting and betraying her!

II. But where are the two great parties and the two great schools in the nineteenth century?

An attempt has been made to replace the inspiration and

[1] [Translated from Edmond and Jules de Goncourt, *Études d'Art, Le Salon de 1852, La Peinture à l'Exposition de 1855* (Paris: E. Flammarion, 1893). Originally published as *La Peinture à l'Exposition de 1855* (Paris, 1855)]

the divine element in ancient painting by a lay element, by a human inspiration. A new spiritualism has placed its efforts under the moral patronage of Imagination. Raphael's art has been gently led from pious exaltation to poetic fever, from the supernatural of Catholicism to the supernatural of modern fables. (The representation of theological virtues has been succeeded by the representation of those living and almost luminous souls born of the imagination of refined dreamers.) Canvas, left a widow by Holy Writ, turned to legend. Painters no longer crown with thorns but with melancholy. They no longer have the holy anguish, the tragedy of Calvary; they wish to pull our heart up to our eyes in singing the passion of Genius or of Love, the hymn of moral suffering.

A man of superior spirit, M. Ary Scheffer, was the leader of this rejuvenated spiritualism remade to suit the temper of our century. Certainly, if the new theory was to have been a revolution instead of an accident in the history of art, if it was to reveal a world instead of a talent, Ary Scheffer was predestined to call it to that high position, to that great future. A native tenderness, an instinct for decency in line, the familiarity with and the worship of poets, the vision, the literary background, and the knowledge—all these qualities were uniquely and admirably united in this son of Germany. The living death, the psychological Hell of Dante in which the twin shadows float, wrapped in their torments, and the curious Temptation of the Virgin, of Goethe's Maris-Eve—he alone would have dared incarnate them.

But the attempt was only an ingenious error, condemned by its very successes. Painting is a daughter of the earth. It must have a foothold if it is to fight and win. With its finished and limited qualities, its attempts to paint only willpower, to lock within a frame the perfume of a thought, the breath of a poet, the whispers of a song, are powerless and sterile. What, then, is this inspiration sought in another inspiration, this art which is borrowed from another art? Is it not from himself and from nature alone that the painter should draw—even the historical painter, for whom history should be but a decorative background?

The brush and the pen are unequal foes in our opinion.
The questions of schools and procedures matter very little
here: The Romeo and Juliet of the colorists, like the Fran-
cesca of the draftsmen, proves that, whether one is Delacroix
or Ingres, the duel with Dante and Shakespeare is the duel of
Jacob with the Angel.

III. As in all human things, equilibrium is only maintained in
art by the law of contradictions, by the battle and the opposi-
tion of different currents. Suddenly an army rose against sen-
timentality.

"Halt," cried the band of brash young materialists, "and
what the devil are you fighting about, Raphaels and Jordaens
that you are? Your *casus belli* is a question of overpainting.
Be quiet! Salute, I am the new world! I am neither a school,
nor a church, nor an idea, nor a faith; I am Truth! I banish
imagination from our eyes, our pencils, our brushes: Nature,
it is I! You altered it, you decorate it, I undress it. You seek;
I meet. Some of you disdain some things and others dislike
some other things; but everything exists, everything has the
right to exist. I do not compose pictures, I gather them up.
Creation is responsible for my canvases. You were painters:
Glory to me! I am a dark room!"

"Certainly," answered a deaf man to the manifesto, "the
daguerreotype is a wonderful invention! How mistaken the
Realists of the good old days, the Ostades and the Teniers,
were without knowing it! If they had thought of giving their
works a scholarly title, what a hard time the modest Le Nains
of our century would have had in building up their
fame." . . .

V. Religious painting is no more.
Religious painting, the depiction of the world of faith, the
representation of abstractions and dogmatic creations, can
only exist when it is served, or rather confessed, by a con-
vinced artist whose work is a votive work, a kneeling homage,
a credo of form and color. Can it exist now that the painter
buys his brushes at the chemist's shop, where Jehovah's
thunder, placed in Leyden bottles, sells at so much a light-
ning bolt? How can it spring with its ancient ardor and

naïveté from the triumphs of logic, the apotheoses of science which characterize our century? . . .

VI. Religious painting having therefore died, historical painting remains for nineteenth-century painters; but, frustrated and limited by the conformity of costume, the economical use of accessories, the monotony and the monochrome of contemporary scenes, this painting has been forced to take refuge in the past and veers off into imitation. The painting of battles remains for nineteenth-century painters, but this daughter of Salvator, turned away from her enthusiasm, from her whirling, her whims of fury, has become indentured to the *Moniteur*. It becomes the illustration of tactics, the panoramic *mise-en-scène* of a military report; it has descended to trompe l'oeil in depicting the buttons of a regiment or a general's boot sole.

Genre painting remains for the painters of the nineteenth century. Brought, like great painting, to live in what once was the anteroom, genre reigns everywhere and is honored, cultivated, and practiced as a means of earning bread by every talent of our petty bourgeois times, which is lacking in palaces or frescoes.

Portrait painting still exists for nineteenth-century painters; but the portrait is no longer the moral physiognomy that the Italian school sought, it is no longer the handsome charnal mask of the Flemish, it no longer even leans on the constellation of the eighteenth-century specialists, the Rigauds, the Largillières, the Tocqués.

Landscapes remain for the painters of the nineteenth century.

VII. Landscape is the victor of modern art. It is the pride of nineteenth-century painting. Spring, summer, fall, and winter are served by the greatest and most magnificent talents, which a young and still unknown generation is preparing itself to replace, a generation promised to the future and worthy in its aspirations.

Yes, the ancient world is returning to its childhood, toward the blue and green cradle in which, newborn, its heroic soul

mewed. Weighted with the centuries, it returns to all those beautiful things, to that divine theater where the epic poem of its nomadic, agricultural, and warrior youth was played in the sun. . . . It is very strange! It is when nature is condemned to death, when industry dismembers it, when iron roads plow it, when it is violated from one pole to another, when the city invades the field, when industry pens man in, when, at last, man remakes the earth like a bed, that the human spirit hastens towards nature, looks at it as it never has before, sees this eternal mother for the first time, conquers her through study, surprises her, ravishes her, transports her and fixes her living and *flagrante delicto* on pages and canvases with an unequaled veracity. Will landscapes become a resurrection, the Easter of the eyes? And will we not become [like] those good citizens described in *Faust*, running to warm themselves in the rays of the sun outside the city, fleeing the stone prisons, the night fields, sky and earth? . . .

Only the modern school has gravely opened its eyes without preconceived notions, resolved not to be shocked by anything, to choose but to refrain from correcting. It has knelt in the grass, it has gotten wet, torn, and dirty. It has verified the shadows, the light, the sun, and the branches. Its genius is the same as that of the Apostle Thomas: It has looked and it has seen. To this art which demanded everything of it, the nature that had defended itself and seemed to guard itself against so many others who were less naïve has given itself wholly. From this sincere communion has come our masterpieces, the canvases of Troyon, Dupré, Rousseau, Français, Diaz, and all the others that we omit. Here is the reason for this admirable dawn; the reason for so much air, so much space, and so much repose; the reason for this mist of light, this snow at dawn which caresses with silver the large bovines, *The Oxen On Their Way to Work.*

VIII. Let us take the world of art in hand. Let us look over the national geniuses of the different races and, mourning the sadness of so much decadence, weigh the peaceful work of the peoples.

Italy—alas!

Spain is pursuing Dubufe.

Sweden has one painter, Hockert, who in the northern light in a chapel in Lapland has grouped in a knowing manner Prayer, Attention, the Family, and Motherhood in action.

Peru has a colorist to show, Merino.

Germany possesses Kaulbach and Cornelius. It possesses M. Knaus, that gentle and amusing talent, more skillful, more serious than that of M. Indusco; M. Knaus, that merrymaker with so much taste and so much feeling who, among the dissolute crowd of clowns, throws like a white flower the virginal apparition of a girl with long hair; M. Knaus, whose dual-faced work weds, in a pleasing color scheme with a delicately frank touch, *Wilhelm Meister*[2] to the farce of the *Saltimbanques.*[3]

IX. England. In the first place, doesn't English painting appear to you, as a whole, a private painting, conventional outside the conventions, the traditions, and the examples of the painting of every nation and every century? It has "changed all that," like Molière's doctor. It seeks itself outside itself. It is oil painting and it has dreamed of calling the formulas, the resources, and the skills of watercolor painting to its aid. It holds the large brushes of the Spaniards and the Italians. See how, in its hands, they have become sable brushes, useful for stroking watercolors on Bristol board. All the masterpieces show the calm and the harmony of tones placed side by side. English painting is all made of glazes, of twists of the hand, of sweeping strokes, of little daubs of second thoughts and reworking of colors. From brushstrokes that cross each other and pile on one another, from colors first wiped off, then intensified, a cloud is born and a fountain of effervescent color, a lying radiance of imitation jewels. One might call it a wash drawing in oil that tried to imitate the shimmer of a plaid blotter.

What is the source of the trouble? The bad advice of the English sun and the rich, transparent flesh tones of the Eng-

[2] [A reference to Goethe's novel *Wilhelm Meisters Lehrjahre* (1796)]
[3] [*Saltimbanques* are clowns, jugglers, or tumblers.]

lish race. Each country has for its animated and living palette
the complexion of its women and the play of its light. Bitten
by the sun, bitten by the shade, the Mediterranean complex-
ions lead the painter to exaggerate the blacks, to accentuate
contrasts. But how could one dare those solid preparations,
that bold bistre when faced with these complexions of rose
and milk, with this bright satin lit by the reflections and the
echoes of light even in its least luminous parts? How could
one dare a strong, sharp accentuation faced with the inno-
cent caresses of this sun, which does not tan, which seems to
bathe everything that it does not light in a soft silver like
moonlight? Therefore, we cannot hope for a long time to
come, unless one day the earth should move and England
change its climate, for any other type of English painting
than the cold wallpapers of Maclise, the miniatures of Hunt,
and the witty porcelain of the Mulreadys.

Considered from the point of view of its spirit, English
painting appears to be a moral in action, tempered with
humor. It seems to have a large public in the City and takes
pride in distracting the honest merchants, once their work is
done, the way a short, virtuous, and gay musical would. It
profits from the ridiculous, the amusing, the caricature. It
avoids the solemn and the dramatic and only approaches his-
tory in private scenes. It is a painting for small rooms, for
family interiors, a gay celebration of the home. It is an art of
observation and of malice, seeking the applause of a smile.
The honest and the comic novel, Hogarth and Goldsmith—
this is its portion, these are its masters.

We were about to forget a third master of the English
school who formed its most popular painter: The master is
La Fontaine and his pupil is Landseer.

To us an animal is only an animal. Our animal painters
paint an animal without thinking highly of it. They catch it
in a pose, seize the pose, and deliver it to the public. If, by
chance, they make a personality of it, it is only a comic per-
sonality with which they mock women, children, and grown-
up children. In England—where a law that is very Egyptian
in its charity attributes feelings to animals, where racing men
believe that a horse has self-esteem, and where the master be-

lieves in the good sense of his dog—the animal is not just a
study of a clown to the painter. The painter gives him an in-
tention and a feeling. Thus it is that the English illustrator
of fables, who observes horses, dogs, parrots, donkeys, and
monkeys from the moral point of view, is called to the honor
of composing serious pictures. Where our animals are witty,
M. Landseer's are human. They are those moralists with fur
and feathers that make every man speak, and the whole do-
mestic menagerie of M. Landseer seems to bray, crow, neigh,
or yap.

X. Belgium points with pride to a vigorous and solid Snyders
—a M. Stevens; a polished, skillful, and witty Abraham Brosse
—a M. Willems. It gives first place to those sons who have
rediscovered the Middle Ages.

Do not laugh. The Middle Ages were lost. Painting had
traveled far in search of them. The French school of 1830
had made a pact with literary romanticism to restore to mod-
ern generations the image of that great art that had been so
successfully forgotten by Louis XIV and Poussin, by Louis
XV and Boucher, by the Revolution and David. Painting,
unfortunately, only touched the dramatic aspects of the Mid-
dle Ages. It was more attached to actions than to men, to
catastrophes than to everyday life. It was dazzled by their
cuirasses, the fabrics, the brilliance, and the strangeness of
the costumes. It caparisoned the horses and seated miniatures
drawn from manuscripts on them, sent them into those bat-
tles of iron in which the rash fell boldly. Or else, among the
fracas of lines and colors, it dropped some particolored fools
and, having done this, it believed that the Middle Ages had
risen and walked again.

A citizen of Antwerp who has within his reach all the les-
sons of the Middle Ages, all its recipes, all its marvels, the
confidences of Van Eyck and the advice of Memling, has
given us a completely renewed Middle Ages, a staid and set-
tled Middle Ages, calm and very studied in its good humor
and its Flemish mockery. He exhumes and resuscitates the
Bourgeois, that great unknown actor of the time, that father
of the Fronde,[4] that ancestor of the Third Estate who lived

4 [French civil war of 1648–53]

happily and helpfully, guarding his cities, lending to kings, making money, praying, and *se guabelant*. In this manner—long after the political and warlike chronicle of nations—the priceless chronicle of their lives, and those books entitled *Le Ménagier de Paris*, which shed new light on Froissart[5] and Comines,[6] are discovered.

M. Leys has penetrated to the deepest, the truest, the most intimate, the most private of the joys and sorrows of the good people of the fifteenth century. The figures seem to be portraits. One would swear that he groups families and friends from memory, and that he dresses all these resurrected dead in the very dress that they once wore. . . .

It is this comprehension of the Middle Ages, descended or, rather, raised to the detail of his ideas, this restitution of the human side that is the proper merit of M. Leys's brush. It is this which gives to Belgium, that suburb of France living off us and our works, a true painter of native originality.

XI. France—and it is two only slightly chauvinistic Frenchmen speaking—France is today the master school of painting, the guardian of the sacred flame. It is the portico beneath which systems are argued, the studio in which procedures are worked out. It is the great nation for art, the homeland of two men of great fame: M. Ingres and M. Delacroix.

Ingres is perhaps the best paid painter since the beginning of painting. His talent is recognized by every school, by his enemies, by his friends. He has chained painters, art lovers, the public, even critics to the chariot of his fame. He is the dictator of line, a resurrected Raphael who demands the egotistical apotheosis of a gallery in Florence for the exhibition of his work. . . .

Yes, Ingres is a draftsman, an incontestable draftsman; but the feeling behind the drawing, the moral life that the ancients breathed into it, the intelligent beauty, the kiss of Pygmalion with which they animated its marble coldness, this elevation of the types which they turned into its tri-

[5] [Jean Froissart (1333?–1400?), poet and chronicler, about whose life little is known]
[6] [Philippe de Comines (1447?–1511), chronicler]

umph, and its most desirable trophy, where do you find them
in Ingres? Is it in these mute images of women, in these cold
busts, in these silent physiognomies, in these dead portraits
that are so far outdistanced by the portrait painter Cogniet?
Is it in these ridiculous miniatures of aristocrats and the
beauties of women, in these *précieuses calamines* in which
the swollen wrist has plebian joints, in which the blushing
oval is deformed by morbid jowls, in which the cheekbones
are painted with purple, in which the figure neither turns nor
is round, covered from one contour to the other with a flat
color having no modeling of the tones, an imitation of the
features and not a living mirror of the face and the light.

Ingres has better succeeded in reproducing men's faces,
which are less morbid, less changeable, and of an expression
less fleeting than the face of a woman. . . .

If we speak of Ingres's coloring, it is because Ingres has not
yet completely renounced color. Like the Carracci, cured of
the imperial pomp of his palette, he has not limited himself
strictly to a regime of black and white. Ingres is much more
attached to color than he himself believes. . . . He likes to
paint freshly. Stone us gently if we say that we find this rosy
coloring of Ingres to be a deplorable mania. We would rather
see him use the yellowish tones of the pear wood, found in
wooden mosaics, which he affected in his early portraits and
studies. Let us, however, make an exception of a study of a
naked woman seated on a bed, seen from the back, entirely
in the half light. That master of chiaroscuro, Rembrandt
himself, would envy the amber color of that pale torso. . . .

Take Ingres out of the context of the portrait or the acad-
emy and you will have the measure of his avaricious talent.
Ingres draws nothing from himself. He asks the past to give
him himself. He painfully extracts his work from master-
pieces. He seeks his soul and his glory in the sweat of his
brow. His naïveté is a memory, his character an anachronism.
He entreats genius through painting and its gift through con-
scientiousness. But face to face with history, Ingres calls
vainly for aid from a certain wisdom of organization, de-
cency, propriety, correctness, and that moderate dose of spir-
itual elevation demanded by a public brought up in second-

ary schools run by the Church. He scatters characters around the center of action. He places them without grouping them. He tosses here and there an arm, a leg, a perfectly drawn head, and he believes his background is complete when he has assembled his forms. He is absolutely ignorant of the art of furnishing a canvas, of plotting a historical scheme in the plastic sense, of making the supernumerary individuals in his composition participate in the action, so that those isolated reunions, as one might call them, hang together as little as those banquets of the sovereigns of Europe fashioned in wax.

Ingres is only great, only just reaches the religious, in his [*Martyrdom of*] *St. Symphorian*, that young and beautiful statue of Resignation, calm in the surrounding fury. But I would like to bring out one by one for public enjoyment the little genre paintings of Ingres! How I would like to lead the public in the painter's footsteps, into the families of kings and the alcoves of legends, to Henri IV and Francesca! What a beautiful school! What precious lessons Delaroche, the unexcelled scene producer, would gather there! How much Meissonier would learn about painting fabrics and Leys about historical feeling! . . .

XII. Opposite Ingres's royalty stands Delacroix's royalty, a royalty less settled and less official, founded more on the recognition of his fellow professionals than on the worship of the public.

Action is the genius, the demon of Delacroix. To steal the gesture, seize the animated silhouette of the creature, conquer the movement; to throw upon canvas, to pin down human mobility; to push the picture to that violence of things called drama; move, agitate, excite the line, as though to surpass in the imagination of the viewer the moment, the second in which the action had been suddenly frozen, as one might say—these are the inspirations and ambitions of Delacroix, his road and his fame. . . .

When one looks from M. Delacroix's canvases to the canvases of a newcomer, to the canvases of a colorist, more of a colorist than Delacroix, wiser, more skillful, better acquainted with the difficulties, more of a master of the processes of his

craft, more familiar with the work of the masters than any other at this time—when one looks towards that *Falconer* [by Couture], the most beautiful bit of color that has come out of a French studio since 1830, one asks oneself why Delacroix has kept his place and why Couture has not unseated him. Why? Because, in spite of the faults and the errors, a great talent can stand having very bad things said about him, and Delacroix is the imagination of nineteenth-century painting; because his *Dante and Virgil* [*The Bark of Dante*] is one of the most lofty propositions of our age; because Delacroix is our only colorist of large effects, our only *ceiling painter*; because if Delacroix were not the student of Rubens, Delacroix would triumph in the future as he triumphs in the present.

XIII. . . . Where is the style? That something that is striking and individual and by which the masters may be recognized; that accent that the masters carry within themselves and that they give to things; that new view of creation; the style! That rare and precious seal, that mark of invention, of possession, of personality; that frank and inimitable signature of genius! One alone, among the chosen throng, is influenced by himself alone; one among many possesses style; and through this, in our opinion, he alone is called to take his place as an immortal among the masters.

Decamps is a modern master, the master of picturesque sentiment. He has endowed easel painting with historical energy. He has found the new plastic equivalent to Augustin Thierry's new history. He has brought the grandeur of Michelangelo down to the figures in miniature. He has rekindled Rembrandt's sun at the heart of the Orient. He has been the superb draftsman of the Jewish Hercules. He has been the epic landscapist. He has been the comic and profound poet of the instinct and the cunning of animals.

His powerful "DC," written below with three strokes of the crayon or brush, is a lion's track.

People have been found who, in this rich intelligence, this daring comprehension, this admirable artistic organization, have seen only—or have wished to see only—a skilled craftsman, a puller of *strings*, as they say. In this prodigious inter-

pretation that is Decamps's work, what have they seen? Dry scribblings. That which was only his means has been declared, without a hearing or a chance for appeal, to be his aim. The unfriendly critics and the public who listens to them have closed their eyes in front of that soul of nature which wells up and overflows these works, these experiments, these inventions of a knowing hand. . . .

For Decamps, the village, the farm, the courtyard and the poultry yard, the manure pile and the shanty, tatters and stables, mangers, pigsties, and kennels! For Decamps, the hunt! The partridge in the wheat field, the duck in the marsh, the seeking and the point! For Decamps, the dog, the dogs of the plains, the dogs of the woods, and the bandy-legged bassets! . . .

For Decamps, the collision of peoples and hordes! Savage trappings, crude catapults, barbarian chariots, the anarchy of the carnage of war in its infancy; circuses bounded by the accumulation of mountains, blood which reddens the coppery earth and mounts to veil the firmament with its purple mists! . . .

For Decamps, the Bible! Enormous stones scattered on the earth for Jacob's sleep. For Decamps, the poplars and the slender almond trees of the mountains of Gilead; the sparing cisterns near which the Ishmaelite camels, laden with incense, knelt. . . .

For Decamps, the blue seas, hemmed with diamonds; the fiery countrysides, crackling and moth-eaten! For Decamps, the torrid paradise, opalescent, flowery, blinding, Eden on fire! For Decamps, the Orient! For Decamps, wild color! For Decamps, drunken light!

For Decamps alone, the sun!

Théophile Thoré [William Bürger]:
New Tendencies in Art[1]

I. The Exposition Universelle of 1855 brought definitive recognition to the great artists of the romantic school. The

1 [Translated from *Salons de T. Thoré, 1844, 1845, 1846, 1847, 1848* (Prefaces by W. Bürger) (Paris: Librairie Internationale, 1868)]

foremost talents, until then always contested, were clearly recognized by France and by Europe. Romanticism triumphed over public opinion in art as it had in literature. For this reason it was finished. He who has won has lived. It is the inflexible law: *Vicit, ergo vixit.*

The acquisition of the freedom to invent and to choose a style was very important. But poetry and form, feelings and images, free from this time forward—what will they do with liberty?

Literary and artistic romanticism was only the instrument preparing a new, truly human art, the expression of a new society of which the nineteenth century offers all the symptoms. One of the initiators of romanticism felt this when he wrote that beautiful formula, eternally true: for a new society, a new art.[2]

There is in France and everywhere now a singular restlessness, an unquenchable hope for a life essentially different from what life has been in the past. All the conditions of earlier society have been overturned: in science and in the religions that are the summation of science; in politics and in the social economy that is the application of politics; in agriculture, industry, and commerce, which are the elements of social economy. Unparalleled discoveries have infinitely and unexpectedly extended all ideas, all facts. It is as though an invisible telegraph system transmitted everywhere, almost instantaneously, peoples' impressions, men's thoughts, events, and novelties of all sorts. The slightest moral or physical sensation felt anywhere is transmitted from neighbor to neighbor and all around the globe. Humanity is being formed and will soon become conscious of itself to the tips of its toes.

The character of modern society—of future society—will be universality.

While formerly—yesterday—each peoples shut itself up within the constricting limits of its territory, of its special traditions, of its idolatrous religion, its egotistical laws, its dark and shadowy prejudices, its customs and its language, today

[2] [Victor Hugo coined this phrase in the preface to his play *Hernani* (1830).]

each tends to expand outside its narrow limits, to open its frontiers, to generalize its traditions and mythology, to humanize its laws, and to enlighten its ideas, enlarge its habits, blend its interests, to distribute everywhere its activity, its language, and its genius.

This is the present tendency of Europe and of the other areas of the world as well. With the exception of this characteristic, the rest is only accident, passing phenomena, not worthy of entering into the great schemes of civilization. This is all quite commonly acknowledged, or at least felt. But what seems strange, even to farsighted thinkers, is the transformation that these influences will bring in poetry, literature, and the arts.

How will the character of the arts necessarily be modified by the social metempsychosis taking place?

This aesthetic question is certainly most interesting and is of great importance, especially for the future of poetry and the fine arts. . . .

III. The revolution, therefore, that must come—the revolution that is coming in poetry, art, and literature—directly concerns ideas and not just forms, style, manner, and expression. From now on the plastic genius is free. Originality, individuality—have they not been won? Are not artists' and writers' skills extraordinary? Never have art and literature been practiced with such dexterity. Never have language, color, design, and form in general been handled so skillfully. Never have things been more cleverly executed. Today we cannot improve in these areas.

What is more, if a revolution is to occur in the area of thought, it is therefore to be made in the subjects of art. This is perhaps astonishing, but it is true. When it was bravely maintained that the subject was unimportant in art, this was precisely a simple protest against the assumed importance of heroic and sacred subjects. Yes, perhaps the subject is unimportant—provided that the human spirit is interested in the artist's creation and that man himself is the "hero."

Here nonetheless is how a change in thought brings about a change in subject:

The great change of what has been called the Renaissance was to dare to make figures according to individual patterns rather than orthodox and invariable patterns.

In this sense romanticism followed the impulse of freedom given imagination by the sixteenth century, even though in another sense it reacted against the Renaissance that had resurrected the old Olympian gods and in turn became a resurrectionist in restoring, above all, the old medieval style.

But if the Renaissance and all subsequent schools that have succeeded each other in Europe for three centuries tore religious allegory from its fixed form, they nevertheless kept its basis. Christian art was and continued to be a mythology, just as pagan art was a real hieroglyph, enclosing thought in symbolic form.

Thus, the pagans, instead of making a woman, made a Venus, while the Christians made a Virgin. In one allegory as in the other Venus and the Virgin stood for the perfect woman. For the pagans the rest of the feminine gender were represented as emblems, the choruses of goddesses and nymphs, the gracious following of the mother of Cupid; for the Christians the choruses of saints and martyrs, pious cortege of the Redeemer's mother.

All other ideas were explained in the same way. Every idea could be translated into a metaphorical personification. To depict the torture of genius, the ancients affixed Prometheus to his Caucasus; the Christians affixed Christ to his cross. . . .

Our winged angels are to the Orientals what their winged dragons are to us: more or less charming fantasies. The Chinese are as incapable of guessing the meaning of the lamb kneeling on the cross as we are of guessing the meaning of the dragons and fantastic monsters that wind over their architecture, their flags, their vases, their fabrics. These are, nonetheless, the language of their beliefs, of their science, of their thought, of their life, and a partial résumé of their civilization. Here we call that plastic language *chinoiserie*. So be it. But what do they call the products of Occidental imagination in that far distant land?

Neither the Renaissance nor the schools which followed it

down to the present have broken with the medieval symbol-
ism. The great sixteenth-century men always worked with the
same idea even if they used individual methods. They devel-
oped it differently but according to the same theme. What
difference that Raphael used his Marghenta to make a Ma-
donna: it was nonetheless the Catholic idea. They also re-
vived pagan fictions alongside the Christian fictions. . . .

For the last three centuries all the artistic and literary
schools have alternated between these two languages, these
two arts. In effect, there are in our Occident only two forms,
each of which expresses a partial idea—Catholic allegory and
pagan allegory—equally impenetrable to strangers and also
equally indifferent to the modern spirit of the peoples that
still use them.

This is not what is needed for nineteenth-century art.

IV. . . . Let us leave all that to one side and examine other
ideas that the arts have also employed in every age and which
are apparently the objects of poetry just as much as super-
natural ideas are. Do not the arts also represent historical tra-
ditions, a people's true life?

Well, even there, in the evocation of history, art has al-
ways used a sort of mythology. Here also it is a figurative and
elusive language. A whole series of figures exists—certified by
supposedly competent authorities—that are accepted as repre-
sentatives of human qualities as earlier divine personifications
were used to represent abstract thoughts. This is a dramatic
play as the former was a miracle play. Always disguise, always
in masquerade. Achilles is courage, Ulysses is prudence, Ajax
is audacity, Leonidas is patriotic devotion, the aged Brutus is
stoic virtue, and so forth. . . .

Even in the representation of nature other than man, of
the earth and its magnificences—in landscape—ornaments bor-
rowed from fables have almost always been introduced.

At the beginning of the Renaissance, the genre of land-
scape painting was unknown: When Titian painted that su-
perb landscape in which he placed his Venus (number 468 at
the Louvre), when Correggio painted the thicket under
which his blonde Antiope sleeps, heaven and earth were still

considered as dependent on, as accessories of, the personages. The second generation of old masters, overvalued until now, the Carracci brothers, Albani, Domenichino, Guido, and so forth, began to subordinate figures to external nature. The "genre" of landscape painting was created, separated and detached from the great poetic tradition, but it still had to illustrate the tradition with pretty mythologies.

It was not really the common nature of contemporary Italy; it was an imaginary and apocryphal Greece, with Apollos and Daphnes, Dianas and Actaeons, Herculeses and Achelouses, and Adonises and Narcissuses. . . .

This protection against Nature, if we can call it that, is singular, and yet—except for some fancies of the Neapolitans and the Spaniards, and certain fractions of the northern schools (of which we will speak at a later date)—it continued down to our day, to the new school of landscapists which today is the glory of France. . . .

All the observations about painting apply equally well to sculpture. In sculpture this analysis will be even more self-evident; always the same two molds, from the *Moses* and the *Bacchus* of Michelangelo, through *Diana* and *Christ in the Tomb* by Jean Goujon, *Milo* [*Milon de Crotone*] and *Andromache* by Puget, *Mary Magadalene* and [*Cupid and*] *Psyche* by Canova, down to the *Psyche* by Pradier, the *Spartacus* by Foyatier, *Minerva* by Simart, *Epaminondas* by David d'Angers, *Gracchii* by Cavalier, and all the symbolic subjects that encumber contemporary exhibitions.

What could we not say about the anachronisms and imitations in architecture, of its absolute insignificance!

But we have here in our hands the catalog (by van Hasselt) of the immense work produced by one of painting's freshest geniuses. Fourteen hundred and sixty-one subjects! What subjects? It is interesting to see: 565 subjects borrowed from Christian tradition; 295 borrowed from pagan fables and allegories; only 74 from history—from the history of heroes and princes, of course, from Romulus down through the Archduke Albert; 277 portraits, almost all of them—except those of the painter himself (15), of his wives (5 of Isabelle, 17 of Helen), and of some of his friends (van Dyck,

Brueghel, Snyders)—portraits of heroes or of princes; 66 land-
scapes, most enriched by pagan or Catholic personages; and,
finally, 46 "intimate and imaginary subjects," among which
are found still more portraits, *jardins d'amour*, Roman war-
riors, and studies. Perhaps a dozen paintings remain in which
this tempestuous "naturalist," as Rubens is so often called,
has painted "man for man's sake," without benefit of mythol-
ogy and allegory, heroes and princes.

This former society must have been absolutely theocratic
and oligarchic! But where, then, is a society depicted that is
social, scientific, and industrial, intelligent and hardworking?
Where is man?

V. Man did not exist in the arts of former times, of yester-
day; and he is still to be invented.

Man, with his simple human characteristics, has almost
never been the immediate subject of painting or of the other
plastic arts, not even of literature; for the two poetic schools
always parallel each other and are united.

Without doubt there are exceptions, and these are the
great among the greats, whose genius painted human nature
without the prestige of religious and poetic fictions. This is
their true right to immortality. . . .

In painting, the exceptions to the heroic furor have been
no commoner than in literature.

The ancient Latin race has always by nature been stubborn
about sacrificing its traditional fossils. What a scandal it
created in Italy when Caravaggio and his companions,
Francis Valentin among them, started painting rude adven-
turers like themselves in life-size, well armed, well decorated,
and quite happy to be alive! After them, Ribera, the Span-
iard, and after him Salvator, his pupil, undertook similar
subjects and sometimes depicted "the ordinary man" with
grandiose vigor and terrifying exactness. These violent "natu-
ralists" depicted the wrinkles of the skin or the decorations of
a costume better than depth of feeling and character.

In the eighteenth century, Watteau, Chardin, Greuze,
even Boucher and Fragonard, treated familiar subjects,
pastorals and peasantries, boudoirs and conversations, scenes

of the family and the household, always on a small scale—life-size was reserved, by right, for Venus and Mme. de Pompadour.

Lovers of the "grand style" may try to contradict it, but this "little" school is perhaps the most French—perhaps the only truly French—of our whole tradition. In the sixteenth century, were not all our artists—except for the Clouet brothers, who were Flemish by birth—from Florence? In the seventeenth century, from Rome? The illustrious Poussin, his philosophical value aside, is he not more of Rome than of the Andelys?

Moreover, this lively school of the "little" masters of the eighteenth century was soon held in revulsion. Mythology and herology quickly regained the upper hand and [Jacques] Louis David, who had his *sans culottes* at hand, turned back to seek half-clothed figures of ancient times. But the half-clothed figures of Watteau are better than his. What will remain as the masterpiece of the painter of the Horatii, of Brutus, of Leonidas is a subject of his own times, which he painted from life, from nature: the Marat assassinated in his bathtub.

Truthfully, these schools of gravediggers and resurrectionists seem to have been conquered in turn by romanticism.

VI. A single exception to this "mythomania," a characteristic exception because it is profound and endurable, is to be noted in the history of art: that of the Dutch.

The Germanic genius, as opposed to the ancient Roman genius, has never become infatuated with foreign traditions. The northern races are not tempted to disguise man as a God and heroes. With her the natural man, as one would have described him in the eighteenth century, asserts himself and openly reveals himself the way he really is, without either nimbus or halo. . . .

But it is above all in the north of the Low Countries, in what is today Holland, that the profoundly human character of the Dutch school became most pronounced. Without a doubt, the battles of the Reformation and of patriotism both contributed to this.

Rembrandt . . . he is not at all mystical, and yet he is the most magical of painters; he is the one who loves "mankind" and cares little for heroes; he is the one who is attached to nature, to reality, and who is yet the most bizarre, the most visionary, the most original of all the inventors of images.

And why is Rembrandt such a grand painter and such a great poet? Why has he recently climbed and climbed in artists' esteem, until he is ranked with the princes of art, as their reverent subjects call them? . . .

He painted a troup of harquebusiers rushing pell-mell out of their guild house, their captain and lieutenant at their head, an urchin running in front of them, grotesquely capped with an old helmet, a radiant little girl carrying a cock, a fat drummer with a dog barking at him, confused groups moving in the shadows or shimmering in a ray of light. This is all and it is called *La Ronde de Nuit*, *De Nachtwacht*, *The Night Guard*, *The Night Watch*, or anything else you prefer. The name makes no difference. . . .

And around Rembrandt the whole school of his country has the same tendency. . . . Where can a more conscientious, more naïve, wittier, or livelier history in the annals of any peoples be found than this painted history of customs and actions? It was painting that wrote the history of the Low Countries, and even a certain history of humanity.

Until now, however, all this has been considered "little" painting—"genre" painting—and the "little" masters—Rembrandt himself!—have been considered vulgar naturalists, following in the wake of great European art.

VII. No, man for man's sake has almost never been treated in proportion to his importance and his merit except by that son of a Dutch miller, Rembrandt, and by some realists we have mentioned previously, and by some eccentrics of our own time.

The value of Géricault and Léopold Robert lies in their having touched on contemporary life, the former in his *Medusa* and his *Riders*, the latter in his *Harvesters* and his *Fishermen*. Yet others, some even still alive, have entered

more or less boldly on this deserted but luminous path which does not lead to Parnassus.

However, it must not be believed that the rebellion of romanticism has absolutely freed nineteenth-century art from false gods, has swept out Olympus and empyrean, fired the old heroes, and returned to man what belongs to him.

Art is only transformed by strong convictions, convictions strong enough to transform society at the same time.

When the Christians carved their faith in stone, marble, or metal, they were ready to die for it. It was the idea itself which gripped them and with which they tried to imprint their images. And this primitive Christianity had a completely new art, essentially different from the art that preceded it.

Romanticism was a form that basically mattered so little that one could be a romantic and still place oneself with different parties: Catholic, Protestant, philosophical, absolutist, liberal, republican.

Contemporary painters in general have not yet done what Renaissance painters did; assuredly they have done even less— I mean that they have changed their mold, but only to pour the same subjects and the same ideas into it. This is easily proved by analyzing the catalog of the Universal Exhibition or the catalogs of more recent exhibitions. Leaf through the work of the most famous artists: half Catholic symbols, half pagan symbols; the rest allegories, apotheoses, memorials, or portraits of princes; here a Virgin, there a Mary Magdalene, a Sphinx or a Sybil, an Odalisque or a Venus. Sometimes a queen whose head the executioner is about to cut off, or young princes condemned to death, the majesty of their family being the primary condition of interest and pity; or else images borrowed from lofty poetry and demanding a refined education.

It is lamentably the double hieroglyphic language already noted in the works of the old masters from the time of the Renaissance onward.

How many contemporary painters are an exception to this? Perhaps the painter of the *Massacre at Chios* and the painter of the *Women of Algiers?* Perhaps the painter of poachers

stalking, of Turks smoking in the shade, of children playing in the sun? If they still have ties to pure romanticism, to "art for art's sake" and not exactly to "art for man's sake," in their caprices, which are more spontaneous than studied, they are nevertheless able to put in so much fire, naturalness, and life that they lift their undistinguished subjects to a significance full of feeling and character. Let us say that Eugène Delacroix and Decamps belong, up to a certain point, and through certain irresistible tendencies, to this new art of which romanticism was the precursor, and that Courbet, still almost alone, expresses as much as he is able. . . .

But is the generation which has grown up, and which struggles with backgrounds, to be depended on? It is youth which finds everything easily. Instinct has the luck to invent more often than reason. It is youth which discovers all, which, at all periods and in all countries, leads the world, no matter what their elders might say. . . .

Oh, my dear artists, whom I do not know and who ambitiously seek Beauty and Truth, turn toward that which is as young as you are and which remains eternally young, which does not die—toward Nature. It is through the love and the study of Nature that all the arts and poetry are renewed, as Nature itself is constantly renewed. Attach yourself to the thought that embraces all mankind. . . .

Oh, my dear artists, whom I have never seen, your intuition more than your experience, your impatience more than your wisdom cry out to you, do they not? That which is now should not be, because it exists already; because that which is present is not the future, and tomorrow will be past. That which "should" be—the word indicates at once future and duty—is for you to realize. Each generation is responsible for ideas, as it is said of the poet that he is responsible for souls.

Think, speak, act. As we grow old we reproach ourselves for not having done enough. Do things! Nothing is indifferent. There is not one of your gestures whose repercussions do not extend into the infinite. All men are gods whose frowns disturb the universe. . . .

VIII. In painting and in literature—in all the arts—the gods—who are departing, as one has been saying for a long time—

have left. They are gone and will never again return. And the heroes, too, are already long gone. One might believe that man's time has finally come. Only—and this is the condition of his future success—he must look better than the heroes of the Academy.

Perhaps somewhere right now there are obscure artists, pre-occupied with intellectual research and picturesque wonders, willingly shut up in miserable studios, who, like Corneille, barely have shoes to go out in during the day or a lamp to draw by at night,[3] and who ponder emptily, unhappily, the universal thought in order to express it in a language intelligible to all. *Fiat lux!*

Because what is important now is, first of all, to break the old prison of the double symbol, to leave the Babel of confused tongues and to create, by virtue of common thought, a common language, a common form disengaged from all the shadows cast on human nature by all the high borders of absolute systems, by local prejudices, by all sorts of errors which still divide the family of nations.

(And the alphabet of this truly universal typography can only have one common character: man.) . . .

It has been rightly said that art and literature have always been the true nobility of France. A nobility, in fact, which has not often descended to mingle with the uneducated common people. But it is exactly this boundary between intellectual classes which is unjust and which must be eliminated. . . ,

IX. If form alone were of artistic interest, when a particular plastic perfection embodying a particular idea had been attained by a particular peoples—and this has happened several times, in Greece at the time of Phidias and Apelles and in Italy at the time of Michelangelo and Raphael—there would be nothing more for posterity to do, nothing but to admire and imitate.

When superficial minds which do not penetrate the essence of things and shortsighted minds which do not project

[3] [Pierre Corneille (1606–84), was the author of *Le Cid* and *Horace*.]

themselves into the future see behind them images that have
been created and perfected, they do not imagine that it is
possible to attain a similar or even superior perfection
through the invention of a completely different mode of
thought, and they fix the type of art and beauty, the former
in ancient Greece, the latter in the Italian Renaissance, still
others in the Middle Ages.

But in truth there is no archetype in art, any more than
there is in Nature.

What is the archetype of a beautiful landscape? The bak-
ing countryside of the tropics or the frozen countryside of the
north? Italy or Scotland? Do you prefer the ocean or the
mountains? Spring or fall? Calm or tempest?

What is the most perfect type within the human race?
The Greek or the Roman? The Arab or the English? Or per-
haps the Parisian?

Phrenologists are often asked what is the perfect type of
cerebral organization.[4] Show me a head that has all the
bumps in the right place!

But Raphael the painter, Richelieu the politician, Molière
the poet, Newton the scientist, Beethoven the musician,
Watt the engineer—are they not as they should be, just as
they are, for what they have to do? For each is painter or
poet, scientist or politician only because each is different. If
they all resembled each other and people in general resem-
bled them in one common type, one man would be able to
do without all other men; and then there would no longer be
either humanity or society, neither art nor science nor
thought nor action nor anything at all. One God all alone.
Nothingness.

The search for an archetype in art is therefore absurd. How
can we believe that the future is—behind us!

Art is incessantly and indefinitely changeable and perfecti-
ble, just as are all manifestations of mankind, as is everything
that lives within the universe.

Why therefore did Michelangelo and Raphael not despair

[4] [Thoré published a *Dictionnaire de Phrénologie et de Physiog-
nomie* (Paris, 1836).]

after Phidias and Apelles? And how did they rise to heights of poetry equal to those of the inimitable Greeks?

By not imitating them.

They followed another thought, separate from the thought of antiquity, and they expressed it with the help of faculties which, apparently, are not the privilege of one peoples or of one civilization, but which constitute the inalienable genius of the human species.

And why cannot future centuries produce artists as great as Raphael and Michelangelo? Nothing prevents it. The only condition is the one which permitted the Italians to equal the Greeks: the condition of not imitating the Renaissance and, consequently, of having a different idea and expressing a different civilization.

Without this everything is finished.

Thought alone creates true revolution. To change the form is pure fantasy, and anyone can contribute with the tip of his pen or the tip of his brush. But to change the content, this is not easily done. It is not within the power of one man, or even of several, to change the roots of an art, any more than it is in their power to change a society in its innermost relationships.

The transformation of art will therefore only take place if the universal spirit effectively changes. Is it changing? Will it change?

Champfleury [Jules Fleury-Husson]: *On Realism, Letter to Madame Sand*[1]

At present, Madame, a couple of steps from the exhibition of paintings on the avenue Montaigne, a sign is to be seen on which is written: *REALISM. G. Courbet. An exhibit of forty of his works.* It is an exhibition in the .English manner.[2] A

[1] [Translated from Champfleury, *Le Réalisme* (Paris: M. Lévy Frères, 1857), pp. 270–85. Originally published in *L'Artiste*, 5e série, vol. XVI (1855–56), 1ff.]

[2] [In England artists often arranged to exhibit their work privately. See *The Triumph of Art for the Public*, pp. 121–24, 134–38, 206–8.]

painter, whose name has risen like a skyrocket since the February revolution, has chosen the most significant canvases from among his works and has had a studio built.

It is an incredible piece of audacity, the overturning of all regulations by a jury, a direct appeal to the public, it is freedom, proclaim some.

It is a scandal, anarchy, art dragged through the mud and displayed in a fair booth, exclaim others.

I admit, Madame, that I side with the former, as do all who call for liberty in its most complete manifestation. The juries, the academies, competitions of every kind have shown more than once that they are powerless to create men and works. If liberty existed in the theater, we would not see a Rouvière[3] obliged to play *Hamlet* before peasants in a barn, making the ghost of old Shakespeare smile to think himself, in the nineteenth century, back in London playing his pieces in a cranny of the city.

We do not know how many unknown geniuses die who do not know how to bend themselves to society's demands, who cannot tame their wildness and commit suicide in the dungeons of convention. Courbet is not among them. Since 1848, without interruption, he has exhibited in the various Salons important canvases that have always been privileged to be the subject of lively discussions. The Republican government even bought one of his large canvases, *After Dinner at Ornans*, which I have seen next to old masters in the Lille Museum, and which held its place boldly in the midst of works whose quality is acknowledged.

This year the jury has shown itself miserly in allotting space at the Universal Exposition to young painters. They were so hospitable to the established painters of France and foreign countries that youth has been somewhat restricted. I do not have much time to wander through the studios, but I have seen pictures that were refused which, in other times, would have certainly won a legitimate success. Courbet—backed by public opinion, which has gathered around his

[3] [Philibert Rouvière (1809–65) made his reputation playing Shakespeare.]

name for the past five or six years—was wounded by the jury's refusal, which struck at his most important works, and he has appealed directly to the public. This is how he reasoned: "I am called a *realist*. I wish to show through a series of familiar paintings what I understand by *realism*." Not content with having a studio installed, with having hung canvases there, the painter has issued a manifesto and on his door he has written: *REALISM*.

If I address this letter to you, Madame, it is because of the lively curiosity, full of good will, that you have shown for a doctrine which is taking shape from day to day, and which has its representatives in all the arts. A hyperromantic German musician, M. Wagner, whose works are unknown in Paris, was vigorously denounced in the musical gazettes by Fétis,[4] who accused the new composer of being tainted with *realism*. All who bring forth some new ideas are called *realists*. We will certainly see realist doctors, realist chemists, realist factory owners, realist historians. Courbet is a realist; I am a realist—because the critics say it, I let them. But, to my great shame, I admit to never having studied the code of laws by which the first passerby is permitted to produce realist works.

I dislike the name because of its pedantic ending; I fear schools as I fear cholera, and my greatest joy is to meet clear-cut individuals. This is why Courbet is, in my opinion, a new man. . . .

With ten intelligent persons the question of *realism* could be analyzed to its foundations; with this mass of ignoramuses, of jealous people, of weaklings, of critics, the only product is more words. I will not even define realism for you, Madame. I don't know where it comes from or where it is going at present. Homer would have been called a realist because he observed and accurately described the customs of his time. . . .

Courbet is a joker because he has seriously depicted borgeois, peasants, and village women life-size. This was the first

4 [François Joseph Fétis (1784–1871), Belgian musical historian and theoretician, wrote for *Le Temps* and *Le National*.]

point. We do not wish to admit that a road mender is the equal of a prince. The nobility is offended because the artist has given so many yards of canvas to the common people; only sovereigns have the right to be painted life-size, with their decorations, their embroidery, and their official faces. . . .

Apparently our costume is not a costume. I am truly ashamed, Madame, of finding no better reasons. The dress of every age is determined by unknown hygienic laws which slip unrecognized into fashion. Every fifty years fashion is overturned in France; like faces, fashions become historical and as odd to study and to look at as the clothing of a savage tribe. The portraits by Gérard, in 1800, which might have seemed vulgar in principle, later acquired a singular appearance. What artists call costume—which is to say, a thousand gewgaws, plumes, *aggrettes,* knots of ribbon—may amuse frivolous minds for a moment, but the serious attempt to depict the actual personalities, bowler hats, black suits, varnished boots, or peasant *sabots* is interesting in a very different way.

Perhaps this will be acknowledged, but they will say, "Your painter lacks an ideal!" I will answer that a little later with the help of a man who has been able to analyze Courbet's work and draw conclusions that are full of good sense.

The forty pictures at the avenue Montaigne include landscapes, portraits, animals, large domestic scenes, and a work that the artist has titled *Real Allegory.* One can follow at a glance the evolution of Courbet's feelings and style. First, he is a born painter; that is to say, no one can contest his strong and robust craftsmanship: He attacks a great composition fearlessly. It is possible that he is not enjoyed by all eyes and some parts are perhaps neglected or awkward, but every one of his pictures is *painted.* I consider the Flemish and the Spaniards to be painters above all others. Veronese and Rubens will always be great painters, no matter to what shade of opinion one belongs or from what point of view one speaks. And I know no one who would dream of denying Courbet's quality as a painter.

Courbet does not abuse the *sonority* of the tones, since musical language has been transported into the domain of painting. The impression made by his pictures is all the more

durable because of this. It is up to every serious work not to draw attention by unnecessary loudness; a gentle symphony by Haydn, intimate and unassuming, will still be alive when Berlioz' numerous trumpets are spoken of with derision. The clashing of the brasses in music signifies no more than clashing tonality does in painting. The masters whose furious palettes splash loud tones about are clumsily called *colorists*. Courbet's scale is tranquil, imposing, and calm. Therefore I was not astonished to rediscover the famous *Burial at Ornans,* now consecrated within me, which was the first cannon shot of the painter who is considered an artistic revolutionary. Almost eight years ago I published phrases about an unknown Courbet that predicted his destiny. I shall not quote them. I am no more interested in being the first to be right than in wearing the latest fashions at Longchamp. To discover men and their works ten years before anyone else does is purely a bit of literary *dandyism* which causes one to lose a great deal of time. In his numerous bits of criticism, Stendhal published, in 1825, audacious truths which caused him too much suffering. Even today he is still ahead of his time. "I will wager," he wrote to a friend in 1822, "that in twenty years Shakespeare will be played in prose in France." *Thirty-three* years have passed since then, Madame, and it is quite certain that we will not enjoy such a thing in our lifetime. Courbet is far from being accepted today; he certainly will be in several years. Would it not be playing the role of the fly on the coach to write, in twenty years, that I had discovered Courbet? The public is no longer even slightly interested in the donkeys that brayed when Rossini's music was first played in France; the witty, the lovely Rossini was treated at his debut with as little tenderness as Courbet. As many insults were printed about his works as about the *Burial.* . . .

I reencounter, at the avenue Montaigne, those famous bathers, fatter in scandal than in flesh. That famous scandal wore itself out two years ago; today I see nothing more than a solidly painted creature whose great fault, according to lovers of convention, is that she doesn't bring to mind the Venuses of antiquity.

Proudhon, in his *Philosophy of Progress* [1853], judged the *Bathers* severely: "The image of vice, like that of virtue, is as much a part of the realm of painting as it is of poetry: Depending on the lesson that the artist wishes to give, every figure, beautiful or ugly, can fulfill the goal of art."

Every figure, beautiful or ugly, can fulfill the goal of art! And the philosopher continues, "Let the people, recognizing itself in its misery, learn to blush before its cowardice and to hate its tyrants; let the aristocracy, exposed in its fat and obscene nudity, receive, upon all its muscles, the flagellation of its parasitism, its insolence, and its corruption." Skipping over several lines, I come to the conclusion: "And may every generation, placing on canvas and in marble the secret of its genius, reach posterity with no other blame or apology than the works of its artists." Do not these few words help us forget the idiocies that we should neither hear nor listen to, but which are as annoying as the continual buzzing of a fly?

The Artist's Studio—which will be much discussed—is not Courbet's last word. Charmed by the great Flemish and Spanish masters who, in every era, have grouped their families, their friends, their Maecenases around themselves, Courbet wished to leave the domain of pure reality this time: *a true allegory* he says in his catalog. These are two words that contradict each other and bother me a little. One must be careful of bending language to symbolic ideas which a brush may attempt to translate but to which grammar does not lend itself. An *allegory* cannot be *real*, any more than a *reality* can become *allegorical*. The confusion is already great enough à propos of that famous word *realism*, without it being necessary to confuse matters further.

. . . for my part I prefer the *Burial at Ornans*. Many will agree with me, Courbet's detractors being among the first; but I am not afraid to take their position for a minute, as I explain my idea. In art it is customary to overwhelm the living with the names of the dead, the new works of a painter with his old works. Those who cried out the loudest against the *Burial* when Courbet first showed his work will of necessity be those who eulogize it most today. Not wishing to be confused with the nihilists, I must say that the thought

behind the *Burial* is striking, obvious to all: It is the depiction of a burial in one small town, and yet it reproduces the burials of *every* small town. The triumph of the artist who paints individual characters is to harmonize with everyone's intimate observations, to choose a type that each will feel he has known and so each may cry, "That is true, I have seen it!" The *Burial* possesses these qualities to the highest degree; it moves us, makes us smile, makes us thoughtful, and leaves in our mind, despite the open grave, that supreme tranquility which the gravedigger shares—a grand and philosophical character that the painter has reproduced in all his grandeur as a man of the people. . . .

I have criticized *The Artist's Studio* a little, even though there is real progress in Courbet's manner. It will doubtlessly gain from being revisited more quietly another time. This was my first impression and I generally believe in my first impression. Conversations, comments, critical reviews, friends, and enemies then come to trouble my head to such a point that it is difficult to reconstruct my thoughts in their original purity. But above the first impression I value the mysterious work of *time*, which either demolishes or restores a work. Every work full of conviction is lovingly treated by time, which only wipes away with its sponge the fashionable nothings, conventional works, and the *pretty* imitations of the past.

If there is a quality that Courbet possesses to the highest degree it is *conviction*. One can no more deny him this than one can deny the sun its heat. He walks with a steady step in art, he shows proudly where his point of departure was, how far he has come, resembling in this that rich manufacturer who hung from his ceiling the *sabots* which had brought him to Paris. . . .

1857: MANCHESTER
The International Historical Exhibition: Art Treasures of the United Kingdom

The world expositions of 1851 and 1855 and the visits of the English monarchs to Paris in 1855 and of the French emperor to London had stimulated French and English cultural nationalism and aroused each country's interest and curiosity in one another. When, in May 1857, Prince Albert opened an immense exhibition, "Art Treasures of the United Kingdom," French visitors flocked to the dirty northern industrial city of Manchester to view the unique exhibition, which was housed in a glass and iron building, more vast than any museum, designed by Salomons in the form of a Latin cross.

The idea behind the exhibition had originated with J. C. Deane, who had helped to organize the British exhibition at the Exposition Universelle and had been impressed with the Musée Cluny in Paris. Financed by the industrial magnates of Manchester and sponsored by Prince Albert, the exhibition was organized with the help of Gustav Waagen, the first director of the newly founded Kaiser Friedrich Museum in Berlin. A frequent visitor to Paris and England, where he had impeccable connections with private collectors, Waagen was

one of the first connoisseurs to document the attributions of works of art in private collections. He had published *Kunstwerke und Künstler in England* (Berlin, 1837–39) [*Works of Art and Artists in England*, trans. H. E. Lloyd (London, 1838)] and, encouraged by his English friends, *Treasures of Art in Great Britain*, translated by Lady Eastlake (London, 1854).[1]

English collectors, the aristocracy, the royal family, and the beneficiaries of the Industrial Revolution lent their works to the exhibition, thereby making these works accessible to the general public for the first time. Shortly after the exhibition opened, the *Art Journal* noted:

> . . . We may ask a moment's reflection before we introduce our readers to this marvellous assemblage of grand works of many ages and countries. They are all gathered from private sources; all, if we except the contributions of ancient armour from the Tower, those which are the property of the East India Company, those which belong to the universities, corporate bodies and the London companies, the diploma pictures of the Royal Academy and a few heir-looms of the crown. It is, therefore, not among the least of the remarkable incidents connected with this subject, that so many noblemen and gentlemen should have been willing to entrust and that for a long period, to the care of the committee and its officials, objects, for loss or injury to which no money could compensate . . .
>
> Our first duty, therefore, undoubtedly is to give expression to public gratitude for that liberal and considerate desire to minister to public enjoyment and education by which this marvellous collection has been brought together. . . . The results of this experiment are consequently matters of sincere congratulation; they show the 'higher orders' as willing to share their enjoyments with the 'humbler classes' and to those who have inherited or acquired wealth as anxious to extend among all grades of society the gratification that wealth obtains and for which only wealth is desirable.
>
> The Exhibition at Manchester viewed in this light, therefore, while it contributes to social progress and promotes rational and

[1] Waagen's review of the Manchester exhibition was published in the *Deutsches Kunstblatt*, no. 22, May 28, 1857, p. 185, as well as in the *Art Journal* (August 1857), 233ff.

intellectual pleasure, cannot fail to aid much in removing those barriers which have hitherto separated 'the classes' by exhibiting the aristocracy—of rank and riches—not only willing, but desirous that the people should, as widely as possible, participate in the enjoyments they themselves derive from their 'treasures' and that too in a city which is understood to be the most democratic in the kingdom.[2]

Works previously known only to a few were now seen by large crowds. European stylistic traditions, highlighted by Waagen's rigorous chronological arrangement of the exhibition, emerged in a new light. The early Netherlandish and Italian schools were viewed with delight. Botticelli was recognized as a master. The exhibition gave new impetus to connoisseurship. Financial awards awaited experts who could and would make attributions to satisfy art dealers and their customers. Scholars and critics were stimulated to study further the variations among the schools. The English journalist Joseph Archer Crowe, a former pupil of Delaroche and a correspondent for the *Illustrated News,* and Giovanni Cavalcaselle, an Italian art connoisseur—their joint effort *Early Flemish Painters* (London, 1857) had just appeared—were challenged to distinguish among painters' styles by studying peculiarities of drawing, finish, and general execution in their *A New History of Italian Painting* (London, 1864).

Critics and scholars from all over Europe visited Manchester. Many of them published their impressions. Gustav Waagen gave a report to the *Deutsches Kunstblatt* (May 28, 1857), the magazine of the Kunstvereine. Six months later (November) a brief appraisal appeared in *Die Grenzboten,* a popular political and literary journal published in Leipzig. It was written by Anton Springer, the brilliant thirty-two-year-old art historian, author of a valuable *Handbuch der Kunstgeschichte* (1855). Among the French visitors was Prosper Mérimée, novelist, medieval archaeologist, and *ami de la maison* of Napoléon III. Mérimée, who had often visited England as an unofficial representative of the emperor, summarized contemporary artistic trends in Britain in "De

[2] *Art Journal* (June 1857), p. 185

l'État des Beaux-Arts en Angleterre en 1857," which appeared in the *Revue des Deux Mondes*.[3] After viewing the Pre-Raphaelites' paintings, Mérimée concluded, "The exact imitation of nature, this is the slogan of the innovators . . . The realists have come to protest against academic habits, theatrical poses, and mythological subjects." Another French visitor to Manchester was the exiled Théophile Thoré. His report on the exhibition and its opening, written for *Le Siècle* under the pseudonym William Bürger, was later rewritten and published in book form.

At the exhibition Thoré encountered Charles Blanc, whose brother, Louis, had been a cosponsor, together with Thoré and George Sand, of *La Vraie République* in 1848. Ambitious to become writers, the Blanc brothers had come to Paris in 1830. Their own poverty had led Louis to study the reasons for the poverty of the laboring class and to found the *Revue du Progrès*. In it he published *L'Organisation du Travail* (1841) [subsequently translated as *Organization of Work* (Cincinnati, 1911)], which placed him among the Republican leaders demanding reform. Active in the revolution of 1848, Louis had been named Minister of Labor for the provisional government and had organized Workers' ateliers that provided housing and employment. He was now in exile in England. Charles, who had learned engraving and etching on his way to becoming an illustrator, supplied portraits which appeared in his brother's *Révolution Française: Histoire de Dix Ans, 1830–1840*, 12 vols. (1846) [*The History of Ten Years, 1830–1840*, 2 vols. (1844–45)]. Charles's career as an art commentator and journalist began when Louis, editor of *Bon Sens*, asked him to report on the Salon. Other assignments followed from the liberal press—*Le Courrier Français*, *L'Artiste*—and militant Republican journals. In 1845 Charles completed the first volume of *Histoire des Peintres Français au XIX^e Siècle* (Paris, 1845), which, like the fourteen volumes of his *Histoire des Peintres de Toutes les Écoles* (Paris, 1861–76) [*The History of the Painters of All Nations*, trans. Peter Berlyn (London: John Cassell, 1852)], supplied

[3] *Revue des Deux Mondes*, October 17, 1857, pp. 866–79

the public with information necessary to increase their knowledge of artists and appreciation for art.

The provisional government of 1848, in which Louis was Minister of Labor, assigned Charles the direction of the fine arts. For two years he energetically defended public support for the arts and cooperated with the artists in their efforts to hold an open Salon in 1848. He recruited Philippe Jeanron to assume directorship of the Louvre, employed the stage designer Sechan to stage *fêtes publiques* in 1848 and 1849 and, with the government short of funds, arranged for pieces of Sèvres porcelain—a state manufacture—to be awarded as prizes. Dismissed from office after the 1850 coup d'etat, Charles Blanc resumed writing on art, securing contributions from colleagues like Paul Mantz, Georges Lafenestre, Henri Delaborde, and Théophile Thoré (W. Bürger) for his history of painting. He himself published one of the first analytical catalogs of *L'Oeuvre Complet de Rembrandt* (Paris, 1853).

Sent to Manchester by the *Courrier de Paris* and *L'Artiste*, and unconcerned with the formation of aesthetic theories or speculation on contemporary artistic tendencies, Blanc supplied the papers with a well-written guidebook report on what was to be seen. A historian and chronicler by inclination, Blanc added a thoughtful conclusion to his account which considered the significance of the exhibition and its demonstration of the change of the position of art in society.

Charles Blanc: *Treasures of Art at Manchester*[1]

I. The Journey

It is seventy leagues from London to Manchester, and it takes five and a half hours to cross them by express train; but the country which one crosses is truly curious to see because it is marked with the imprint of English genius, just as if it were a man-made work. . . .

But while the omnibus drives us to the palace of the Exhi-

1 [Translated from Charles Blanc, *Les Trésors de l'Art à Manchester* (Paris, 1857). Originally published in *L'Artiste*, 7e série, vol. I (1857), 133ff.]

bition, situated about two miles from Manchester, let me tell you how this vast enterprise was formed and how it has been achieved. One of the most intelligent Englishmen, M. Deane, having gone to Paris to visit the Cluny Museum, said to himself, "What a shame that England cannot offer a similar exhibition to men of taste and to persons desirous of instructing themselves!" Immediately the thought came to him to temporarily form a collection similar to that of the musée Du Sommerard,[2] and to have the public enjoy it, subject to finance. M. Deane communicated his project to M. Peter Cunningham, one of the editors of the *Illustrated London News*, for which he periodically writes the column "Table Talk"—and with wit. Little by little these gentlemen saw the original plan grow. Why not assemble all the forms of wealth that England possesses in the field of art? Then there were those who proposed not merely to rent a room but to build a palace of glass, to combine there for a time all the private galleries of Great Britain in a single public gallery, and thus to give as a spectacle to England and to Europe that which neither Europe nor England had ever seen: the masterpieces buried in the castles of the English aristocracy, in its most remote country houses, in its most intimate homes. . . . But where to put this exhibition? There, precisely, where no one was expecting to see it: in the city of cotton, in Manchester. . . .

Well, one must agree, the idea was not so extravagant as it seemed, at least with respect to facilities for its execution. Manchester is an enormously rich city and proud of its wealth. . . .

At the first call which MM. Deane and Cunningham addressed to them, the principal manufacturers of Manchester responded by underwriting guarantee funds destined to meet the immense expense that would be risked in the event that the enterprise did not succeed in covering them. The subscriptions arrived so amply and so quickly that in a

[2] [The musée Du Sommerard is now the musée Cluny. The collection of Alexandre Du Sommerard (1779–1842) became the basis of the museum's holdings, which are housed in Du Sommerard's former residence, the hôtel de Cluny.]

short time the fund rose to the sum of eighty-five thousand pounds sterling! One of my friends having sent, for his part, two hundred pounds (five thousand francs) was answered (I have seen the letter) that subscriptions below five hundred pounds (twelve thousand francs) would not be accepted. Such is the abundance of gold here; such is the pride of the rich.

Once the capital was subscribed, the greatest difficulty was not in constructing the palace but in filling it. It was necessary to obtain from the great lords (whether of the nobility or finance) who possess paintings, sculptures, enamels, ivories, porcelains, bronzes, and other art objects, permission to momentarily deprive their dwellings of them, to have these objects, the majority delicate and fragile, undergo the incalculable risks of going and returning, of the packing and unpacking, not to speak of fires and a thousand possible accidents. . . .

The Queen of England, who possesses so many and such beautiful things in her residences at Buckingham Palace, Windsor Castle, and Hampton Court, graciously put them at the disposal of the Executive Committee. Prince Albert, who has gathered an inestimable collection of primitive masters, hastened to send to the Exhibition his rarest paintings, and his well-known love for the arts did not fail in this circumstance, for he himself inaugurated the Exposition. . . .

Here we are, arrived at the door of the Crystal Palace; but we will only enter, if you permit it, in my next letter. . . .

II. The Palace

If you asked me to write five or six volumes on the museum of the Louvre, the proposition would seem reasonable to me, as far as the extent of the work; but if it were necessary to write the description of such a museum in two or three articles, don't you think that it would be senseless to undertake it? Well, the great Exposition of Manchester is even more vast than the museum of the Louvre. With the exception of the sculpture, which is hardly represented here except by modern statues of the English school, one can study there all the arts of design from their beginnings to the present: painting, engraving, numismatics, goldsmith work, damascening,

ceramics, delicate carving, fine cabinetmaking, inlaying, the art of enameling pottery, of doing repoussé work with metals, of cutting crystals, of melting and coloring glass, lithography, engraving in wood, bookbinding and, finally, this new, strange, prestigious art which makes us see nature by glances of the sun, photography.

Imagine a palace all of glass, in which would be found gathered the great gallery of the Louvre, Cluny Museum, the Cabinet des Médailles, the reserve deposits of the Cabinet d'Estampes—in other words, two thousand engravings together worth more than four million francs; the most beautiful armor of the museum of artillery; the Etruscan vases of M. de Pourtalès; rooms of miniatures and enamels; a superb array of four hundred portraits of Holbein, Van Dyck, Lely, Gainsborough, Reynolds; an incomparable collection of the photographs of Bisson, of Baldus, of Legray, that is to say, the most astonishing proofs which have come from the presses of light . . . —and you will still have only an imperfect idea of this exhibition, so justly named Treasures of Art. It is necessary to add, in effect, to this enumeration, which already dazzles you, an ethnographic museum of Persia, India, and China, to which the East India Company, the Royal Asiatic Society and, with the consent of the Queen of England, the Governor of the Tower of London have contributed. One must also add a whole gallery devoted to works *in watercolors*, whose painters have known so well how to wed the limpidity of the *aquarelle* to the solid and frank consistency of oil painting; finally, an immense bay entirely occupied by the masterpieces of the English school, which here is considered from the beginning of the eighteenth century to date, because the early masters all figure in the gallery of four hundred portraits. . . .

The great nave in the middle is flanked by two small side naves, which I will call aisles, in which are exhibited three or four hundred portraits of famous personages of Great Britain painted by no less famous artists, such as Jan Mabuse, Holbein, Zuccaro, Jansen, Lucas de Heere, Rubens, Van Dyck, Lely, Kneller, Rigaud, Richardson, Sir Joshua Reynolds, Gainsborough, and Thomas Lawrence. Of these portraits,

about forty are by Van Dyck's hand and come from the castles of Windsor and Hampton Court, without counting the works of this great master which are found in still other galleries of the Exhibition. Thus, from the entrance forward, the visitor reviews innumerable museums combined into a single one; he has before his eyes majolicas of Urbino, ivories of François Flamand, lacquers of Boulle, miniatures of Petitot, candelabra of Gouthière, Japan lacquer of Martin, and this same visitor, already dazzled, walks, so to speak, beneath the glances of four hundred portraits of illustrious men and women; he embraces in a glance all the biographies that form the modern history of this country. . . .

If we now leave the central nave, we will find, on the right, a great gallery exclusively devoted to paintings of the English school, and, on the left, a parallel gallery of equal size assigned to the masterpieces of European painting from the Byzantines to the masters of the end of the seventeenth century. This one, formed of voluntary, temporary gifts of the rich amateurs of England, contains few of those vast canvases which give to our museums such a national character. Not one piece is comparable, for example, to the *Wedding at Cana*[3] in importance and dimension, at the very least. But with this exception, it is doubtful if the Louvre, all things considered, contains a more beautiful collection than the twelve or fifteen hundred paintings of the gallery called "Paintings of Ancient Masters." If one adds to these treasures those which are exhibited in a separate gallery, the Hertford gallery, containing some two hundred pieces of the first rank, one can be assured that the Exhibition Palace is equal, with respect to painting, to the most beautiful museums of Europe.

III. The Florentine, Roman, and Lombard Schools

Those who enjoy unraveling the origins of modern art will find ample material here for their investigations. . . . One sees how the Gothic Germans, Flemish, Venetians, and Spanish resemble each other and, even better, how they are

[3] [Paul Veronese's *Wedding at Cana*]

distinguished from each other. The Germanic school goes back here to Martin Schongauer and finishes with Rosa di Tivoli [Philipp Peter Roos], passing by Lucas Cranach, Holbein, and Albrecht Dürer. The school of the Low Countries, beginning with Van Eyck and ending with Van Huysum, unrolls for us a continuation of marvels. . . .

The Italian school, with which I should have begun, is arranged, like that of Germany and of the Low Countries, in chronological order, and occupies a single side of the gallery, as if one had thought to show painting seen in its two aspects and on two parallel lines: here, growing in the sun, under the influence of tradition; there, developing in the bosom of the northern mist, with the counsel of nature. There are several Byzantines without a name and without a history which open the exhibition here, recalling what had become of Greek art under the Christian Empire. With these Byzantines Cimabue is connected by his stiff symmetry and by the solemnity of his hieratic forms. Then comes Giotto, a Raphael in swaddling clothes, who stammers with grace the sublime language which painting will speak in Italy. . . .

Twelve Raphaels permit us to judge this great man, to see how all his precursors were the tributaries of his greatness, how, without bringing into art any new element, he gathered all that the others had sown; how he had the wit to use all the elements already discovered or hinted at and, rather than composing of them a cold eclecticism, fused them in a manner to which he would sign his undying name. . . .

Michelangelo! There is here a piece by his hand, yes, by his hand; an unfinished and sublime painting in distemper for which you must cross the sea, all of you who worship art. It is a new thing for the whole world, it as an unhoped-for treasure, a painting of Michelangelo. It had at first been attributed to Ghirlandajo, says the catalog, but it is obviously from his pupil's youth. No, neither Ghirlandajo nor anyone before Michelangelo had this feeling of august elegance and of lofty grandeur. The contour is not yet violent nor the modeling deeply felt, but already a master is revealed who will later have fearsome tones. . . .

Whatever may be the preferences of an amateur, he can

satisfy his taste at the Manchester Exhibition, for all the styles are brought to light here; that of the Florentine and the Bolognese, the Lombard and the Roman, the Venetian and the Spanish. The chronological order, slightly modified by the arrangements which the proportions of the frames cause, has produced here and there curious proximities. . . .

But here I stop, astonished to see the gallery nearly deserted and curious to know where so many departed visitors have gone. The ingenuousness of the Parisians! Should I have not doubted that the English would stay on their feet so long, even in art sanctuaries, without refreshing the stomach? In effect, I find them in a refreshment room. . . .

IV. Conclusion

In saying a last good-bye to this magnificent palace in which we have spent such happy hours—or, rather, days—it is impossible for us not to think of the surprising transformations which have taken place in the last fifteen or twenty years in European society. The admission of the multitudes to the sharing of so many noble pleasures, until now reserved for such a small number of the elect, is indeed a new occurrence in history! In the past the curious (i.e., the interested) constituted a small congregation; to like painting was an exception, to possess it was a privilege. Today everybody is invited to admire beautiful things, and the most humble of citizens can see a collection of masterpieces whose acquisition would exhaust the fortunes of several millionaires. To see is to own, says the poet, and this is especially true with respect to works of art, all the more true since continuous possession soon dulls the pleasure of admiring them.

But what seems miraculous is that the big changes which are taking place in Old World societies manifest themselves precisely in the midst of this England, which is dominated by so many caste prejudices and where there still flourishes an aristocracy that is faithful, in many ways, to Gothic forms and to medieval thoughts. Who would have thought that the idea of popularizing the understanding of art and of propagating enlightenment to this extent would be applied with such brilliance by the country which is preeminently one of

inequality, of individualism, of privilege? Who could expect to see the future civilization rise in the west of Europe? And how can one help but be surprised that a nation of islanders should have inaugurated on her own the festivities of cosmopolitanism by building fairy palaces with the unknown genius of the world to come, *deo ignoto?*

These prodigious transformations had no doubt been expected by certain acute minds, by those whom one likes to call the utopians; but no one was able to foresee that things would go so fast, and that the human race would accomplish so much in so few years.

Formerly the forerunners of progress were doomed to die unknown, sometimes even insulted, and their sole consolation was to thrust into the future the profound visions of their thought. Today humanity moves forward in a geometric progression; it leaps instead of walking, so that the precursors can, in their lifetime, verify the progress which they had foretold, witness the beginning of the triumph of their conceptions, finally see the realization, with their own eyes, of the great innovations of which they had had the heroic presentiment. Thus, in leaving the Manchester palace and its treasures, we remember what an illustrious historian, banned today, said in France on a solemn occasion: "What seemed impossible yesterday will be necessary tomorrow."[4]

Credit is therefore due to the English people for having been the first to conceive of, or at least to execute, these grand and noble projects of a public exposition, by means of which the marvels buried in the inaccessible apartments of a few noblemen who have tired of their opulence have momentarily become the common patrimony of a whole nation! But these sumptuous festivities, whose invisible organizer is the god of progress, are less beautiful through the present which they show us than through the future which they make us foresee. When we saw a whole army of poor, serious workers, dressed· in their Sunday best, enter into this camp of peace, walking in good order, with a band leading them, we felt as if

[4] [Quoted from a speech Louis Blanc, Charles's brother, made in March 1848 to the representatives of employers while a member of the provisional government of 1848]

we were witnessing the spectacle of a new society in motion: *novus rerum mihi nascitur ordo*. Brought together in these immense palaces with transparent walls and a luminous roof, the generations to come will discover the feelings of Christian fraternity and, at the same time, the cult of antique beauty. In the presence of the unperishable models brought together in the temples of art, it seems to me that humanity will raise its spirit, will soften its heart, and will be able to recover the perfection of its forms, which, at the beginning of the world, were molded in the image of God himself.

1857: BERLIN

The Gallery Exhibition
of a Dealer

After the defeat of the French at Waterloo in 1815, Frederick William III of Prussia devoted the remaining twenty-five years of his reign to forging an administration for his country—newly enlarged through the acquisition of the Rhineland at the Congress of Vienna—and to beautifying his capital of Berlin. The center of the city was the wide, tree-lined avenue Unter den Linden, which began at the bridge to the island on which stood the royal castle and ended at the Brandenburg Gate, the magnificent neoclassical structure designed by Karl G. Langhans. Atop the gate was the *Quadriga of Victory* of Johann Gottfried Schadow, which had been taken to Paris as a spoil of war by Napoleon and had been restored to its former place in August 1814.

Though the free city of Frankfurt-am-Main had been made the capital of the confederation of German states created in 1815 at the Congress of Vienna, it was to Prussia and Berlin that many Germans looked for leadership during the second quarter of the century. Frederick William III had created the Zollverein, which reduced tariffs on trade between Austria and the German states and was an important stimulus to industrialization and economic development. In 1848 German liberals, hoping to unite the German states as one nation, met at the Frankfurt Assembly and offered the crown to Frederick William IV of Prussia. When he refused it, hopes for a Ger-

man constitutional monarchy had faltered, but Berlin, the
Prussian capital, became an increasingly important commer-
cial and financial center throughout the 1850s, when its pop-
ulation reached a half million, double what it had been in
1815.

After 1851 the entire length of Unter den Linden was
dominated by the spirit of Frederick the Great, commemo-
rated by the vigorous, realistic equestrian statue by Christian
Daniel Rauch. In the eighteenth century Frederick the Great
had made Prussia a significant power by wresting Silesia from
Austria and had ruled for another quarter century as the most
enlightened of despots. The statue personified the sovereign
for contemporary Prussians as "the hero crowned with glory,
the high-minded promoter of a free spirit, the image of the
prudent creator of popular patriotic force, and the faithful
and just father of his country" who had made Prussia "a cen-
ter from which the sun of spiritual freedom sent her warming
rays into the remotest provinces of the German fatherland."[1]

Midway along Unter den Linden, the narrow Friedrich-
strasse entered it. Flanked by shops and restaurants, the
Friedrichstrasse crossed twelve streets lined with state admin-
istrative offices, official residences, banks, commercial houses,
theaters, and cafes where the official, social, and intellectual
life of the capital was concentrated. In the winters of 1856
and 1857, the eighty-seven-year-old Baron Alexander von
Humboldt headed the scientific community. His explorations
of South America and his discoveries of that continent's vol-
canoes and flora had made him Europe's most celebrated and
acclaimed scientist. The superintendent of the royal theaters,
Botho von Hulsen, a reactionary officer of the guards with no
gift for theater, stifled talented actors, blocked innovations in
the state theater, and indirectly contributed to the success of
Berlin's private theaters. Giacomo Meyerbeer, the general
music director of the Royal Theater and, like his predecessor,
Felix Mendelssohn, a Berliner, was as popular in Venice and
Paris as he was in Berlin. With Jenny Lind as his prima

[1] Prospectus for A. Kugler and A. Menzel, *Geschichte Friedrichs
des Grossen*, 1839–42

donna, Meyerbeer staged his own operas, *Les Huguenots,* *Vielka,* and *Le Prophète.* Only Karl A. Varnhagen von Ense and Bettina von Arnim remained from the circle of romantic novelists and poets. Younger writers and artists who gathered at the weekly meetings of the "Tunnel," the Berliner Sonntagsverein at the Café Belvedere, which had gradually taken the place of the salons, were subscribers and contributors to the liberal *Vossische Zeitung,* founded in 1847, and the political, satirical weekly *Kladderadatsch,* launched in 1848.

By the 1830s Berlin had become an important center for the study of art history thanks to the stimulus of two men: Gustav Waagen, the first director of the museum and first professor of art history at the university—he had developed his knowledge and connoisseurship by studying and comparing works in museums and private collections in Paris and England as well as in Germany—and Franz Kugler, Waagen's younger colleague and a professor at the Royal Academy. Kugler, assisted by his friend and pupil, the Swiss art historian Jacob Burckhardt, wrote the first basic and comprehensive volumes on the history of art, *Handbuch der Geschichte der Malerei von Konstantine dem Grossen bis in die neuere Zeit* (1837) and *Handbuch der Kunstgeschichte* (1841–42). Artists, historians, musicians, and poets gathered at Kugler's Berlin home, for he was a poet, artist, and trusted state official.

The official art world was still dominated by the classicists of the first half of the century: the sculptors Johann Gottfried Schadow, Christian Rauch, Rauch's pupil Reinhold Begas, and the painter Peter Cornelius, who in 1841 had come from Bavaria to direct the Berlin Academy. In 1847 Wilhelm Kaulbach was brought to Berlin to execute the immense fresco cycle illustrating decisive episodes in world history for the stairway of the Neues Museum. By 1857 Cornelius was collaborating with the architect Johann Heinrich Strack on the decoration of the Gedenkhalle, or Hall of Commemoration, within the palace, which was being prepared for Frederick William IV's heir and his wife, the English Princess Victoria. The hall would be lined with paintings

and sculpture commemorating historical events in which England and Prussia both figured.

The work of Cornelius constituted the official style, which still followed the canons established by the Nazarenes, or Brotherhood of St. Luke, the German artists' colony which flourished in Rome between 1810 and 1820, of which Cornelius had been a member. They had been encouraged and supported by the Prussian envoy to Rome, Barthold Niebuhr, and by Niebuhr's secretary and successor, Christian Bunsen. When Frederick William IV, who had studied drawing with Schinkel and Schadow, visited Rome as crown prince, his guide had been Bunsen (now his ambassador at the Court of St. James). On his succession in 1840, he called the former Nazarene, Cornelius, to Berlin to lead the Academy.

Franz Krüger was named court painter. By sketching at the royal stables, Krüger had added accuracy of observation to the precise drawing he had acquired from the classical training he received at the Academy. The court and the landed aristocracy, the Junkers, were delighted with the ordered space, exaggèrated perspective, neat detail, and even luminosity of his paintings of familiar scenes, in which they could often find themselves depicted. For formal portraits, ladies sat for Eduard Magnus, whose style was similar to that of the Rhinelander Francis X. Winterhalter, the favorite of Napoléon III.

The Royal Prussian Academy's biennial exhibition of 1856 had opened in the fall amid complaints that its facilities were markedly inferior to those provided for ancient art in the museum. The exhibitions, which had begun in 1786 with 335 entries, now included 1,667 entries by 563 artists, including 32 foreigners, an increase which reflected the economic prosperity and political importance of Berlin. Landscapes, genre, and portraits were most numerous. The influence of Delaroche and the Belgians Gallait and de Bièfve—as evidenced in the technical dexterity, color, and realism of the history painters—contrasted with the muted color, linearity, balanced composition, and idealism of the Cornelian school.

The exhibition was visited by the painter Adolf Menzel, who reported to a friend that he found Gustav Richter's

Jairus' Daughter a "solid" work: "There is much that is good in the composition. Its best quality is certainly its vigorous, beautiful, full color of finely and deeply mixed tones without an affected brilliance." With respect to Charles Comte's picture, *Before St. Bartholomew's Night*, which Menzel had already seen in 1855 when he visited the Paris exposition for two weeks, he noted, "With the exception of the figure of Charles IX, the composition in no way exhausts the subject, but the effect of the daylight in the room and the painting!" Continuing his examination, he observed, "Rudolf Henneberg's savage *Wild Hunt* is in its conception a fantastic work and in part an excellent thing; presumably he is still young as a painter: there is much of Delacroix, Couture, and even some Führich in him. To speak of Delacroix, Eduard Hildebrandt could certainly teach him something about landscape; Hildebrandt's peculiar mixture of the unaccountable and the admirable could warn Delacroix if Hildebrandt's pictures did not drool so many instructions. The mediocre is numerous, as always; trash is represented in certain splendid samples."[2]

In January 1857 art connoisseurs, collectors, and artists who frequented the theaters and restaurants along Unter den Linden and Friedrichstrasse were—to use the word of Wilhelm Luebke, reporter for the *Deutsche Kunstblatt* and an art historian and professor—"grateful" to the art dealer and print publisher Louis F. Sachse, who had reopened his "permanent exhibition" on January 29, 1857, at Jägerstrasse 30. The exhibitions that Sachse, a member both of Berlin's intellectual and art circles, arranged in his elegant, newly redecorated gallery were free from the regulations and conventions that controlled the Academy's biennial exhibitions and exerted an invigorating influence on art in Berlin. At the age of twenty-three Sachse had been private secretary to the Prussian royal chamberlain, Alexander von Humboldt, a position which did not prevent his arrest and imprisonment for revolutionary activity in 1821, after the Prussian police had been

[2] Cited from a letter to Fritz Werner dated September 23, 1856. *Adolph von Menzels Briefe*, ed. H. Wolff (Berlin, 1914), p. 142

empowered to imprison anyone suspected of conspiratorial activity as a consequence of the assassination of playwright and critic August Kotzebue by a member of the Burschenschaft movement.[3] Upon his release in 1824, Sachse studied lithography in Paris at the Knechtschen Institut and in Munich with Alys Senefelder, the inventor of the process. Returning to Berlin, he established himself as a lithographer and publisher of prints, with a specialty in portraiture. By 1839 he added Berlin's first daguerreotype studio to his prosperous enterprise; skillful lithographers copied daguerreotype portraits of notable persons to create tasteful, inexpensive, and salable prints. In 1833, when Sachse republished a biography of Martin Luther, he hired eighteen-year-old Adolf von Menzel to draw the lithographic illustrations. The following year he issued a small album of lithographs by Menzel illustrating Goethe's poem *Künstlers Erdenwallen.* Menzel had learned lithography from his father—the family had come to Berlin from Breslau in 1830. Menzel had entered the Academy, only to withdraw because he found its system of instruction of no use to him. The technical and artistic excellence of his illustrations for Goethe's work resulted in his unanimous election to the Verein Jüngerer Berliner Künstler. In 1839 Sachse exhibited Menzel's first canvases.

After 1843 Sachse gave up his photographic studio for reasons of health and devoted himself to publishing prints and maintaining a permanent, continuing exhibition of paintings. Works borrowed from private collectors were hung alongside those offered for sale by contemporary painters. Russians, Scandinavians, and Berliners were pleased to have the opportunity to examine and buy paintings by the historical and genre painters in vogue in France, Belgium, Holland, Austria, and Germany. Sachse's gallery and publication were sustained by the patronage of the middle classes, whose interest in art had been stimulated by the art unions or Kunstvereine. However, the increasing success and popularity of art dealers like Sachse and N. Lepke—whose gallery at No. 1 Unter den Linden also exhibited the work of contemporary

[3] See *Triumph,* pp. 77–89

painters—would gradually adversely affect the Kunstvereine exhibition and purchase program, which had been an important source of support for German artists since the 1830s.

Located in cities of every size—the first Kunstverein was created in Munich in 1823; others followed in the cities of the Rhineland and Westphalia (1829), in Berlin (1835), and in Switzerland, Austria, Belgium, and England during the next decade—the Kunstvereine encouraged art and artists through lectures and exhibitions. The annual exhibitions provided opportunities for artists whose realistic treatment of episodes from history and local life did not meet the standards of the Academy but did satisfy the taste of middle-class Kunstverein members. The Kunstvereine purchased works of art, which were distributed among members by a type of lottery, and annually gave each member a lithograph or engraving depicting a work of importance by a living artist. Through such purchases the Kunstvereine contributed substantially to the support of the arts. In 1847, for example, using 600 talers from membership fees, the Kassel Kunstverein commissioned Menzel to execute an enormous canvas, *The Entrance of the Duchess Elizabeth into Brabant*, for the city's tricentennial celebration. In 1854 it spent 646 talers for the purchase of paintings and sculpture and 821 talers on lithographs and engravings.[4] Regional connections were strengthened in 1856 when a general assembly of Kunstvereine established exhibition schedules in order to exchange exhibitions among themselves.

Two years earlier a countrywide Kunstfreund organization had joined with the Kunstvereine to establish the Verbindungen deutscher Kunstvereine für historische Kunst (Association of German Art Unions to Promote Historical Painting). Each region sent representatives to the Association's board, which in 1855 commissioned two paintings to be circulated for exhibition at the various Kunstvereine. The first commission was given to Vienna-born and Munich Academy-trained Moritz von Schwind, who chose for his subject *Kaiser Rudolf Rides to Speyer to Die*. The other was given to the Berlin

[4] A. Rosenberg, *Die Deutsche Kunst*, II, 1848–1886, p. 198

artist Adolf von Menzel, this despite the criticism leveled at
his style by the dean of academic classicism in Berlin, Frie-
drich Schadow. Menzel had already won acclaim for his illus-
trations to Kugler's *Geschichte Friedrichs der Grossen* [*His-
tory of Frederick the Great*] (1839–42) and his own various
works. Menzel selected as his subject the meeting of Fred-
erick the Great and Joseph II at Neisse in 1769, after the
defeat of the Austrians in the Third Silesian War. In the au-
tumn of 1857 Schwind's work was sent on "tour" to the
Kunstvereine in Prague, Vienna, Pest, Frankfurt, Munich,
Zurich, and Stuttgart; Menzel's was sent to Nuremburg, Co-
logne, Münster, Leipzig, Dresden, Pest, and Vienna. The
comparison of the two paintings encouraged critics to refine
their definitions of historical painting: formally schooled, ar-
chaeologically trained critics were spurred on to establish cri-
teria by which a contemporary work could be assigned to the
categories of idealistic history painting or historical genre.

As early as the 1830s, an increasing interest in art had led
to the creation of two art periodicals: Ludwig von Schorn's
successful *Das Kunstblatt*, founded in Stuttgart in 1832, and
Franz Kugler's *Museum*, which was first issued in Berlin in
1833 and ceased publication after only two years. After von
Schorn's death in 1842, Kugler and Ernst Förster, a former
pupil of Cornelius, assumed direction of *Das Kunstblatt* and
continued to publish it until 1848. By 1851 the Kunstvereine
had sufficient members—2,400 in Munich alone—to support
two publications: *Das Kunstblatt* reappeared in Berlin in
1850 as *Das Deutsche Kunstblatt*, and in 1851 *Die Dios-
kuren* was launched in Leipzig.

Friedrich Eggers was editor in chief for the *Deutsche
Kunstblatt*, "the organ of the art associations of Germany."
An editorial board of noted art historians and connoisseurs—
which included Kugler, Waagen, and Schnasse in Berlin,
J. D. Passavant in Frankfurt, Förster in Munich, Wiegmann
in Düsseldorf, and Eitelberger von Edelberg in Vienna—
provided the journal with a steady supply of reviews of con-
temporary art and art historical essays. Drawing contributions
from throughout the German states, it contributed to the rec-
ognition of the Prussian capital as the center of German art.

After it ceased publication in 1858, the *Bremer Sonntagsblatt* analyzed its failure:

> The editors formed an exclusive coterie which believed it had exclusive rights to art and aesthetics. So it was natural the periodical shared the fate of a daily press which had not grown from the heart of the people. It had only its small circle of readers and subscribers and therefore, as a result of the lack of support, it had to disappear after an existence of eight years.[5]

Die Dioskuren had been launched in Leipzig by Eduard Kretzschmar, a wood engraver associated with the only illustrated periodical in the German states, the *Leipziger Illustrierte Zeitung. Die Dioskuren* was also "an organ of the Kunstvereine." It published art essays, detailed accounts of the regional meetings, exhibition schedules, reviews of the exhibitions, and a special feature entitled "Critical Wanderings through the Art Institutes and Studios of Berlin." *Die Dioskuren*'s declared purpose was "to win public support for true art and true artists"; it would oppose "the artists who resorted to mere virtuosity and extravaganza to attract the public eye and the dealers who use publicity and collusion to win customers."[6]

In 1856 direction of the biweekly was assumed by Max Schasler, professor of aesthetics and art history at the Akademie für bildende Kunst in Berlin. Schasler, one of the last representatives of the old aesthetic school of Germany, wrote many of the reviews. He asserted that history painting, the primary interest of the artists caught up in the historicism of their epoch, "represents the great world-historic moments of general human development. . . . Therefore historical style is more abstract, more lofty, without individual and unforseen incidents and charming trifles." By 1858 he had singled out Menzel as "an enemy of all abstraction" who paints not the general "but the particular, the personal, the individual, the incidental—in an extraordinarily drastic way—but without a trace of that higher characterization." A painter such as Menzel, who displayed such an "inclination for ugliness"—

[5] Quoted in *Die Dioskuren*, March 27, 1864, p. 124
[6] Abschied vom Leser, *Die Dioskuren*, December 28, 1875

which at the time was a synonym for "realism"—could only be fitted into a category designated as "historical genre." "*The Dinner in Sanssouci* and *The Concert in Sanssouci* have a specific genrelike quality in their motifs, and the painting *Frederick the Great Traveling* portrays the king as man at least as much as sovereign."[7]

In an ongoing attempt, begun with Lessing, to determine the character of every art, Schasler strove in his criticism to define idealism and realism in history painting. In seeking a classification of the arts, Schasler and his contemporaries were led into the quest for the supreme art. Others claimed the supremacy for the combined arts, *Gesamtkunst*, or "consummate art," exemplified by the operas of the musician-poet Richard Wagner.[8]

Anonymous [Max Schasler?]: *The Permanent Exhibition of Paintings, Sachse Gallery*[1]

The news, given in no. 5 of the *Dioskuren*, that the opening of the new Sachse Gallery would take place on March 1 was premature. The opening did not occur until March 15. The new exhibition gallery consists of two large rooms of different sizes which have been decorated in a practical and elegant manner and illuminated by ceiling lights. Using experience accumulated in his former gallery, the owner has toned down the light so that the glare, which often disturbed viewers before, is avoided. Indeed, Mr. Sachse deserves the gratitude of all the friends of art and artists of Berlin for his consistent efforts to create a worthy location for exhibits where one can comfortably enjoy the works of art.

We have already spoken of Schrader's *Temptation of St. Anthony*. . . . Next we must express our opinion about the recently exhibited colossal marine painting by Larsson, *Ship-*

[7] *Die Dioskuren*, vol. 1, 1856, p. 116
[8] See Benedetto Croce, *Aesthetic as Science of Expression and General Linguistic*, 2nd edn., trans. D. Ainslie (London, 1922), pp. 377–78, 455–58
[1] [Translated from *Die Dioskuren*, no. 7, April 1, 1857, and no. 10, May 15, 1857]

wreck at the Bohus Country Coast of Sweden. . . . Having
inspected the painting ourselves, we can explain why one can,
on the one hand, be caught up in admiration for it and, on
the other, want to crack a cane over it. First we want to ex-
plain why these two extreme judgments are possible. The
judgment one makes depends solely on the position one takes
to view the picture. The colossal dimensions of the painting—
it is eighteen feet long and ten feet high—demand that the
spectator be at least thirty feet away from it to see it prop-
erly. Now comes the question: Why did the artist choose
such large dimensions for this painting? We do not deny that
the moment in nature represented has something of gran-
deur, but this grandeur belongs to the phenomenon of
nature, not to the artistic representation. The motif is
magnificent only from the point of view of nature, not from
the artistic point of view. The effect of the subject's intrinsic
content would lose nothing if the picture measured only so
many inches instead of eighteen feet. We believe the artist
blundered in choosing this colossal scale because therein lies
a claim to significant intellectual content, a right to be no-
ticed, which is not absolutely justified by the artistic
significance of the subject matter. This explains the different
views regarding the picture. The moment represented is of a
splendid natural effect, but it is of slight artistic effect. Some
see only the splendor of the natural phenomenon and are
awed by the glow of the sun, the fury of the waves, and so
forth. Others see nothing in all of this which is artistically so
significant that it could not be presented in small dimension,
and shrug their shoulders at the nature lovers. Since we have
shown the possibility of the two opposing views, we are com-
pletely free of such onesidedness. . . . So that the reader will
better understand our remarks about the dimensions of land-
scape painting, we need to take a comparative look at history
painting and genre. If in history painting life-size or colossal
figures are shown, this is because history itself, in its actions,
produces an imposing and grand impression, because its po-
etry moves along in a powerful rhythm; a presentation on a
small scale would evoke a contradiction between form and
content, so to speak. In genre painting, on the contrary, exe-

cution on a large scale would destroy the specific charac-
teristic of genre, namely, the ingenuous, charming, genial,
the "individually human" (in contrast to the "universally
human" which appears in history painting). A history paint-
ing on a small scale is *mesquin*; a genre painting on a large
scale is cold and dry if not ridiculous. Of course, one cannot
dictate the dimensions in inches, but we still believe, as
strange as it may sound to some artists, that for each subject
there are dimensions which are appropriate, in other words,
which bring out the effect of its inherent spiritual content
most fully and harmonically.

In landscape there are also undoubtedly intrinsic dif-
ferences in style and mood which are somewhat similar to
the differences between history and genre. The expression
"historical landscape" is usually used with reference to style,
yet if it is thought to be an essential aspect of art, style be-
longs equally to the contents and to the form of repre-
sentation. The historical landscape, composed in a certain
grand style, must have the stamp of inner purity, plastic
tranquility, and meaningful strength, but above all it must
have character: Nothing unmanly, nothing feminine, nothing
merely idyllic, no reaching for cheap effects and unspiritual
conquests are allowed to appear in it. But all that is still in-
sufficient, for the historical landscape—because it is intel-
lectually more important than the lyrical landscape—must be
effective more through the drawing than through the colors,
more through the plastic, noble form of its artistic repre-
sentation than through the insinuating effect of nature's
beauty. If we now assume that historical and lyrical landscape
present a contrast similar to that between history and genre
in figure painting, it necessarily follows that only the former,
the historical landscape, has the right to execution in the
grand style. The sublimity of the ideal content in a landscape
by Weber, Zimmermann, or Schinkel—to mention only a few
names—gives the right to great, even colossal, execution be-
cause it approaches more nearly the monumental, epic char-
acter. But Pape, Hildebrandt, Kalreuth, Leu, Gude would err
if they gave their lyrical, middle-sized pictures an overwhelm-
ing dimension. There is no question that the picture by Lars-

son belongs not to the former but to the latter category; in other words, it has no character in its style.

Gude's *Nordic Pine Forest* is of a high poetic beauty and artistic genuineness. Perhaps one remembers a similar painting at the great art exhibition. The one here mentioned is smaller but even more delicately and finely treated. The view into the luminous distance between the red trunks is an especially beautiful effect. Whether the overall tone is not a little too cold we leave undecided, but the effect is a completely harmonious one. . . .

When we turn to figure paintings, we must first mention two drawings which stand in peculiar contrast to one another: Kaulbach's cartoon for the Shakespeare Gallery and Elster's *Christ's March to Jerusalem*. We must mention right away, regarding Kaulbach's cartoon, that we consider this composition the most significant of all the plates so far produced for the magnificent edition of the Nicolai bookshop because it best expresses the character of the given theme. The subject is Caesar's murder by Brutus and Cassius and their co-conspirators. Pierced by the daggers of the conspirators, Caesar sinks backwards to the floor while the murderers, hindering each other in their bloody work, pierce him again. Brutus, a true Roman figure with the Republican austerity which made "the Roman" a historic type throughout the world, stands aside, as if waiting for the moment when it is his turn and he can deliver the coup de grâce. The senators on the benches are paralyzed by fear and horror, while a partisan of the conspirators hands down weapons from a trophy on the wall to distribute them among the intruding mob. The composition has an imposing effect; the arrangement of the groups is simple, the movements are powerful, and the posture of the figures novel and energetic. One clearly recognizes that, more than before, Kaulbach has here filled himself with the character of his task and forced himself to do justice to the poetic content of the whole as well as the details. Moreover, the etching is also treated with great understanding, and perhaps the masterly technical execution is not the least of the great qualities of the cartoon. . . .

Adolf Menzel's *Mass, Recollection of Salzburg* carries the

well-known, characteristic stamp of the master, that remarkable sharpness and precision in the physiognomic characteristics of the figures' posture and expressions which make Menzel's drawing immediately recognizable from among thousands. We are intentionally using the word "drawing" because color has always been Menzel's weakest point. Unfortunately, it seems to grow weaker rather than stronger. The painting in question has a blackish-grayish ground—smoked, as it were—without strength and warmth, without local tone distribution, in short, without true color. Regarding the theme, the subject also offers little interest, since action—whether in an external or internal sense—is out of the question. We perceive a pair of differently dressed persons, some sitting, some kneeling, some standing in front of the grill which separates the choir from the nave of the church. This is all; for a Menzel it seems to us much too little. . . .

Menzel's *Concert of Frederick the Great in Sanssouci* demonstrates the artist's unique talent for endowing his figures with a vivacity which removes the spectator's reserve, so that the perfect joy of the spectator in the work of art is not dimmed by making the spectator self-conscious before the scene. This ingenuous truthfulness to life and the real impression of the depiction cannot be united with the epochal formality which subordinates the figures of a historical painting to the laws of style. Because of this lack of style, Menzel is not a history painter in the narrow sense of the word, though neither natural dignity nor grace are missing in this picture. Yet he achieves this dignity through the energetic characterization of expression and the personal nobility of postures and gestures. The greatness of Menzel's conception of the time of Frederick the Great is the manner in which he "disrobes" historical personalities, even Frederick, of all historical pathos while characterizing them with such nobility that he arouses the spectator's deep interest in the human being without detracting from the historical character's significance. This observation applies specifically to our picture, for Frederick appears here neither as prince nor hero but as an emotional human being, as a lover of music. It should be well known that Frederick loved his instrument, the flute,

so passionately that he traveled everywhere with it during the war; indeed, at times, minutes before he mounted his horse or gave an order for a bloody attack, he paced up and down in his tent improvising on the flute. After his return to Sanssouci, he occasionally arranged private concerts at which only a few persons were allowed to participate. The subject of the painting under discussion is one such concert given on the occasion of a visit by his sister, the Margravine of Bayreuth. All the persons appearing in the picture are historical. Standing at a music stand in the middle of the hall, Frederick the Great performs a solo accompanied by Emanuel Bach on the piano. The musicians who are not playing listen to the king's performance. In addition, the concertmaster, Franz Bendar, and [Johann] Joachim Quantz, the king's teacher, can be seen seated cross-legged by one of the side walls. On the other side the Margravine of Bayreuth is seated on the sofa near the Princess Amelie, the older sister of the king, and some ladies in waiting. Standing behind their chairs are the conductor Graun, Baron Bielefeld, Count Gotter, and the director of the Academy Maupertuis. The light from a chandelier in the middle of the ceiling, which is reflected from the wall mirror above the sofa, and the light from several candles by the music stand at which the king is standing, at the piano, and on the wall were masterfully studied and gave the artist the opportunity to give several effective contrasts. A warm, deeply saturated tone reigns in this picture, which demands a very favorable illumination if all its finesse is to be correctly understood. The attempt to create the aura of evening light has been achieved by the artist in a remarkable way. The picture gives the impression that the spectator himself is standing in daylight and from the outside looks into a room which is lighted by candles. This light appears through the contrast of the whiter daylight seen by the eye with the brownish-yellow used as the basic tone. Yet according to the law of artistic illusion, this relationship should not have been carried into the picture. The spectator is indeed in daylight when he sees the picture, but he should have been able to forget this as he submerged himself in the picture. In a word,

he should be drawn by the picture and its effects into the ac-
tion. That does not happen here. If one is in such a lighted
room, one does not feel that reddish coloring, which is cor-
rect in contrast to daylight but untrue without that daylight
contrast. Out of this principal error in the choice of the basic
tone, several shadows appear almost exaggerated: For exam-
ple, the face of the Margravine seated on the sofa appears al-
most ash gray. With regard to the composition, one has to
emphasize the excellent total effect of the mood. One be-
lieves to hear echoed in the different subjects the true charac-
teristic poses of the figures, who listen to the playing of
Frederick the Great mingled with the tones of the adagio.
With regard to Frederick himself, this task was a very
difficult one indeed. The posture of the flute player, which is
in itself very picturesque, must have been doubly difficult to
render when the real reason for his posture, the musical
sound, is missing. And still the artist overcame this danger!
Frederick stands with the flute at his mouth, quietly but full
of emotion, and the attentive listening of the people present
and the emotions produced by the music, expressed in their
faces and their attitudes, replace perfectly for the spectator
the effect of the real tone. In this regard, the artistic illusion
has been reached in a masterly way. . . .

Gude, who represents another, more naturalistic tendency
of the Düsseldorf school, exhibits a pair of new pictures
which rank in a quite obvious way not only behind the two
mentioned above but also behind the earlier paintings of the
artist. In the larger painting, A Beech Tree Forest, as ap-
pealing as the subject is—it is a pendant to his Spruce Forest
—very little of the romantic element lying within the subject
comes out effectively. Apparently the artist set about to de-
scribe the impression which the first fresh leaves in the spring
make on the sensibilities. This "fresh green," which is in the
right place in a lyric poem, in the painting looks as awkward
as the "flower," "snow," and other similar things which are
indeed poetic but are not to be painted. In addition, the
beech tree foliage, which the artist uses quite lavishly in the
painting described, makes a rather petty and—from the point

of view of color—poisonous impression. One feels, one might almost say "smells," the spring in it, but it is a smell more reminiscent of the sweet scent of woodruff in May wine than that sharp and moist nature scent which gushes towards us from the silent solitude of the forest. The lower part, enclosed by tree trunks, is a forest path which curves to one side, shaded by broad shadows of the trees; it is of great beauty, although maybe—at least in contrast to the green above—a little too brown in tone. The artist's second, smaller painting, *Lake Starnberg*, also suffers from a certain pettiness in the composition, although it cannot be shown just where the reason for this effect lies. A lot is probably contributed by the color of the trees; a little perhaps by the modern *staffage*—two elegant ladies who have been in a boat on the water and are just about to dock. Such reminders of the forms and circumstances of modern civilization, which contrast with the unaffectedness of the atmosphere of nature, must always be disturbing. In this case it is as if the artist, instead of an old ruin or a plain farmer's cottage, had painted a cotton factory or a train station into the romantic landscape. On the ruin, the cottage, or the like, nature has already exercised its right; they are in a twofold way naturalized and blended with nature, just as the shepherds, farmers, and the like, who do not have a consciousness of nature and its poetic content and exactly for that reason form an appropriate *staffage* because they belong to it. It might seem unnecessary to place so much emphasis on such a small point, but if an artist with the talent of Gude makes such a mistake, it is certainly a duty to indicate how such a blunder can completely destroy the intended effect. . . .

No other Austrian has studied his people and picked up their secret peculiarities as thoroughly as Waldmüller. His *Farmer Coming Home from Work* is distinguished by its intimacy and its freedom from any false sentiment. In his *Klostersuppe* it would be difficult to arrange the groups correctly; the composition lacks clarity. That the artist throughout lets well-fed and well-dressed people beg could also be censured. Pettenkofen's *Gypsy Woman* and *Annual Fair Scene* are of

unusual realistic truth; unfortunately, the treatment of the latter already closely approaches the affected and therefore stands far below his above-mentioned *Transport of the Wounded.* . . .

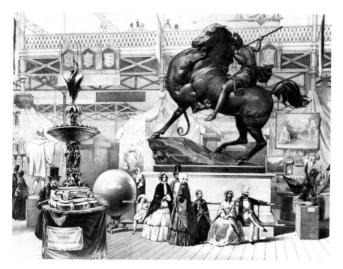

1. Crystal Palace: *The Fine Arts Court*

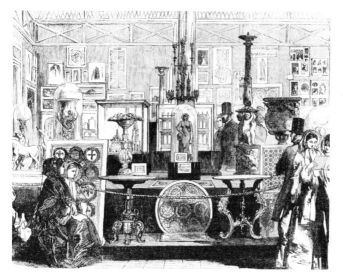

2. Crystal Palace: *The Bay of the Fine Arts Court*

3. Powers: *Greek Slave*

4. Millais: *Jesus in the House of His Parents*

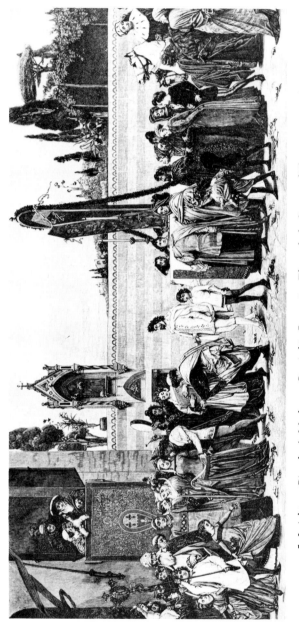

5. Leighton: *Cimabue's Madonna Carried in Procession Through the Streets of Florence*, engraving by C. Dietrich

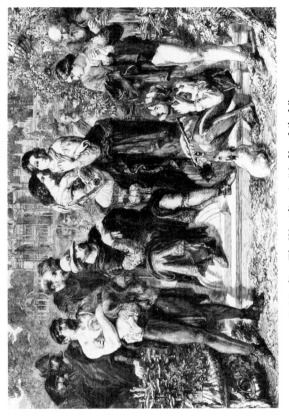

6. Maclise: *The Wrestling in "As You Like It"*

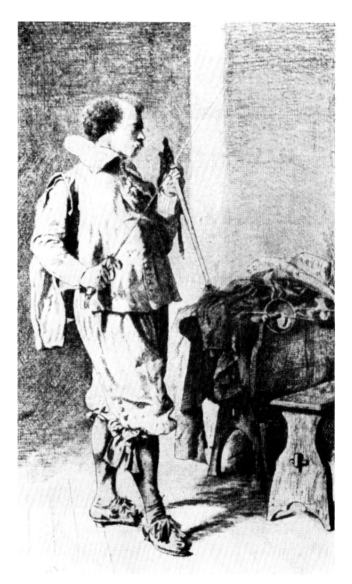

7. Meissonier: *Man Choosing a Sword*

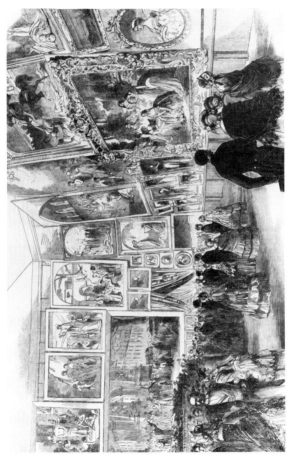

8. Exposition Universelle, 1855: *The Queen's Visit to France*

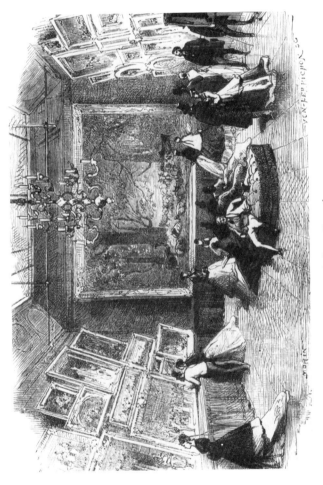

9. Galerie Goupil

10. Hébert: *La Malaria*

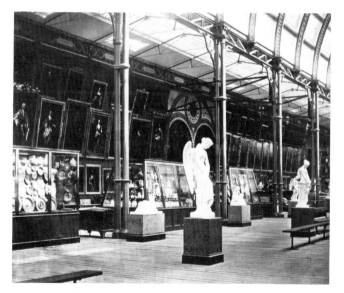

11. Manchester Exhibition, *Art Treasures of Great Britain*.
Photograph of nave by Caldesi and Montecchi (Courtesy of
Museum of Fine Arts, Boston)

12. Menzel: *Concert at Sansouci*

13. Menzel: *The Meeting of Frederick the Great and Joseph II*

14. Gallait: *Last Honors Paid to the Counts Egmont and Horn*

15. Schwind: *The Tale of the Seven Ravens*

16. Carstens: *The Birth of Light*

17. Preller: *Ulysses and the Cattle of Helios*, engraving by Hummel

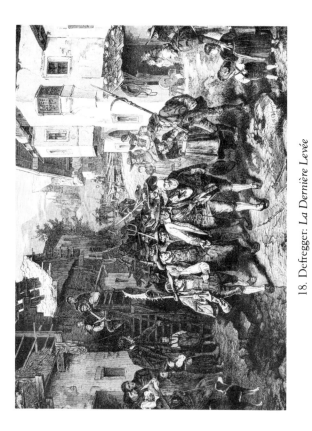

18. Defregger: *La Dernière Levée*

1857: PARIS
The Official Exhibition
of the State:
The Salon

Enthusiasm and optimism were generated by the exposition of 1855. The Treaty of Paris ending the Crimean War was signed on March 30, 1856, by officials of France, Austria, Great Britain, Turkey, Sardinia and Russia. The glittering assemblage of diplomats reminded Parisians of the glory of France at the time of Napoléon I. The new Paris dreamed of by the first Bonaparte was rising before their eyes. Under the direction of Baron Haussmann, prefect of the Seine since 1853, the picturesque buildings of old Paris were being demolished to make way for wide boulevards lined with uniform new buildings. The vast sums required to keep thousands of workers employed were provided by municipal bonds; the financing was unorthodox, but the complacent Parisian bourgeoisie, which prospered by speculating on property values and moved into apartments in the new buildings, was well satisfied.

New cafes opened and new talent appeared to fill the places left vacant by an earlier generation. The poets Alfred de Musset and Heinrich Heine; the composer Adolphe

Adam, whose operettas had sustained the popularity of the
Théâtre Lyrique; the sculptors Rude, Étex, and David
d'Angers—all had passed away. Paul Delaroche, the master of
the firm, polished "finish" required of official painting, had
died on November 4, 1856, as he strove to repair the damage
a fire had caused to his immense fresco on the walls of the
École des Beaux-Arts. It was before this painting—depicting
the great artists of the modern age assembled around three
thrones occupied by the architects and sculptors of the Parthe-
non and illustrating the standard of beauty that was the
heritage of the venerable École—that students whose works
seemed most likely to carry on the academic tradition re-
ceived the awards and recognition that assured them future
employment through official commissions.

Count Nieuwerkerke had hoped to combine the Salon of
1857 with the opening of Lefuel's new wing of the Louvre,
which would connect the building with the Tuileries. Delays
in the building's completion obliged him to refurbish the
Palais des Industries of 1855 to receive the works of painters
and sculptors; because the Palais had been reserved for an Ag-
ricultural Exhibition to be held in May, the Salon would be
held from June 15 to August 15, the feast day of the em-
peror, a celebration which would keep the bourgeoisie, art pa-
trons, and dealers in Paris.

Nieuwerkerke, now both Director General of the Imperial
Museums and Superintendent of the Fine Arts of the Em-
peror's Household—and thus secure against any protest—an-
nounced that the jury over which he would preside would
consist of the first four sections of the Institute's Academy of
Fine Arts. As in 1852 and 1853, the work of members of the
Institute and artists who had been decorated with the Légion
d'honneur would be admitted without examination. Other
artists' works would have to be submitted to the jury. There
was no limit on the number of works an artist could submit.
Acquiescence rather than indignation was voiced in the
strictly regulated press, even by the once-revolutionary
Théophile Gautier. The 2,715 paintings and 427 works of
sculpture arranged in the north wing of the Palais des Indus-
tries included as many as 16 or 20 works by members of the

Institute and the Légion d'honneur, making this Salon as representative of "official" art as any held prior to the revolution of 1848. A Salon of Honor, filled with works chosen by Nieuwerkerke, was reserved for François Winterhalter's *Portrait of the Empress Holding the Imperial Prince*, Adolph Yvon's enormous *The Capture of the Malakoff Tower*, as well as works by Horace Vernet, Charles Müller, and Robert-Fleury.

For some of the younger generation born in the late 1820s, the two years since the Exposition Universelle had been necessary to clarify their understanding of the difference between the art at the Palais des Beaux-Arts and that at Courbet's Pavilion of Realism. The Palais des Beaux-Arts had been dominated by slick, finished depictions of heroic episodes and small, charming genre subjects that evoked either national pride or familial sentiments. Some of Courbet's forty canvases, representative of a conflicting artistic development, depicted scenes of private life in conformity with the traditional genre classification, but their life-size scale was regarded as more appropriate for heroic subjects. Courbet's paintings—like many of the landscape paintings that had been exhibited since the 1840s—were in that "unfinished" state—in the tradition of the École, they had to be followed by the finished state to qualify for official recognition—which many connoisseurs and critics were accustomed to call a "sketch." The changing direction first heralded by the emergence of the landscapists of the 1830s—Théophile Thoré had called attention to it in his salon criticism of the late 1840s and in *Les Nouvelles Tendances*—was now clearly discernible.[1]

After visiting the exhibition of 1855, the young men had gathered to evolve a system of aesthetics which could encompass the changes and serve as a basis for criticism. Contemporary interest in and discussion of the nature of beauty, which was widespread, increased in 1857 when Gustav Flaubert's novel *Madame Bovary* gave a literary form to the real-

[1] See *Triumph*, pp. 387–412, 467–83, 488–91, and the section on Thoré in the present volume.

ity Courbet had described pictorially in his *Burial at Ornans*
of 1850. For many the problem of dealing with the new art
forms was to reconcile them with social changes. The social-
ist-economist Pierre-Joseph Proudhon, whose *Système de
Contradictions Économiques* (Paris, 1846) had included re-
marks on art, brought to the discussions the ideas of his
teacher, Auguste Comte. Now on his deathbed, Comte had
formulated the concept that the arts should serve as a basis
for education and, when united with industry, would contrib-
ute to society's improvement. Art must both represent the es-
sential character of an object and reflect its location, as
Hippolyte Taine suggested, and, in accordance with Saint-
Simon and Comte's "Positivistic Movement," it must con-
tribute to the advancement of an evolving society.

In 1857 Charles Leveque won a competition held by the
Academy of Moral and Political Sciences with his essay, "La
Science du Beau." He emphasized the reciprocal relationship
between the artist and society and argued that the living
model for the artist is Everyman as seen in the street, theater,
or church. Finally elected to the Academy in January 1857,
Delacroix began his essay "Des Variations du Beau" in May;
it was published by the *Revue des Deux Mondes* in June. In
it he enumerated the types of "beauty" found in different
eras and localities.

When twenty-five-year-old Jules Castagnary (1830–88),
who had recently completed his law studies, was asked to re-
view the Salon of 1857 for *Le Présent*, a small sheet, he used
the opportunity to shape ideas about a realist aesthetic which
had been discussed at Courbet's *cénacle*. Aware that in the
eyes of many critics "realism" was associated with the oppro-
brious aspects of "bohemianism," he avoided using the word
"realism" to describe the new art. He believed that a critic
should analyze and detect artistic tendencies rather than con-
centrate on single artists—and remained true to this belief
throughout his life. He therefore limited his discussion to the
categories of genre, portraiture, and landscape, these being
the most interesting to the artists who received their inspira-
tion from what they saw. Castagnary came to believe that
"beauty" was an abstract idea which included phenomena

that varied with social conditions and from individual to individual. His innovative discussion was so well received that he reprinted it in 1858 together with a short preface and a title that conveyed his intention, *La Philosophie du Salon de 1857*. By 1864 he would affirm, "Our artist will thus be of our time, live our life, with our customs and our ideas. The feeling which society and the spectacle of society will give him he will render in images in which we will recognize ourselves and our surroundings."[2]

Jules Castagnary: *Salon of 1857*[1]

The Salon

. . . The Salon of 1857 frankly and neatly shows the tendencies of contemporary minds. From this point of view, its general principle is more accessible and its lessons clearer than those of the Exposition Universelle of 1855.

The latter, in effect, by exhuming, by reassembling at a given moment works of half a century [which had been] scattered everywhere, seems to have had no other result than to bear witness to the anarchy of ideas and the intellectual problems of our past thirty years. . . .

This year, on the contrary, despite the number of works exhibited (almost three thousand for painting alone), the consistency of the tendency is evident. It shines so clearly that there can be no doubts.

But let us first establish the facts.

Religious painting has disappeared from the Salon—or only appears for the sake of propriety. There is still some history painting; but seeing it thus producing works too directly inspired by contemporary political events suggests that it has lost the clear sense of its domain and is venturing into a foreign land. The majority—a solid majority—belongs to genre

[2] Castagnary, "Salon de 1864," *Salons*, 1857–1870, vol. I (Paris, 1892), p. 188

[1] Translated from Jules Castagnary, *Salons*, 1857–1870 (Paris: Charpentier/Fasquelle, 1892), vol. I, pp. 2–48. Originally published in *Le Présent*, 1857

painting. Interior scenes, landscapes, portraits—almost the whole exhibition is there. The human side of art replaces the heroic and divine and asserts itself both by power of numbers and authority of talent. Hardly any more large canvases, hardly any more old names: easel paintings, a host of unknown names. . . .

Thus, this small Salon of 1857, which perhaps does not include a single work of genius, but which abundantly provides all degrees of talent, presents this peculiarity: Visibly and clearly it demonstrates the evolutionary law of art—a law simple in its formulation and imperative in its terms, which unites art totally with the general movements of humanity. . . .

The artist—whatever he attempts or whatever he accomplishes, whether he expresses the pure idea in words or makes it concrete in matter—the artist puts himself, his understanding, his heart into his work. . . .

Art is thus above all an expression of the human self solicited by the outside world, an expression realized under the supreme concept of Beauty, in the infinite variety of types furnished by nature. As a result, art is one of the highest acts of the human personality, a veritable second Creation.

But this conception of beauty by the self, as the pure form of truth, and its realization in the visual arts is not an isolated and independent act from the rest of humanity's actions. However strong his individuality, the artist is always not the expression but the end result of the society existing prior to him. He inherits *ab intestat* the intellectual capital accrued by the preceding generations. . . .

As humanity advances, so advances art. . . .

The history of art furnishes no other conclusions. Religious painting and history or heroic painting have gradually lost strength as the social organisms—theocracy and monarchy—to which they refer become weakened. Their elimination, which is almost complete today, leads to the absolute domination of genre, landscape, and portraiture, which are the result of indi-

vidualism: In art, as in contemporary society, man becomes more and more himself.

No. Religious painting is dead; it is dead even as religion is dead, leaving us immortal works as a testament to its life. . . .

What remains for you, artist? What is left for your genius? Man and Nature remain for you, that is to say, everything there is. The Gods have left! But do you believe that Jupiter took Power with him, and Minerva Wisdom and Venus Immortal Beauty and Jesus Eternal Love? No, Love, Beauty, Wisdom, and Power were in you yourself. You stripped yourself for a time of these things in order to embellish your gods, wanting to make them grand while you remained small, to make them beautiful while you stayed ugly. But once they have disappeared, all the virtues and all the graces with which you endowed them and which belong to you again become yours; you inherit from your dead gods and you grow to the extent of their nothingness. The heroes have gone! But do you think they have taken with them love and hate, vengeance and forgiveness, adultery and murder, astonishing crimes and wild devotions? No. All these are also your part and belong to you. . . .

Go forward from now on without regrets and without fear; you are now on the road. It is no longer gods and goddesses, heroes and epic tales which your blessed art is going to shape and translate; it is you yourself, the scenes of your life, the nature that surrounds you. In them is all truth, in them is all poetry. . . .

The theory of art which I have just set forth tends to establish that art, by a process proper to itself, is changing both its object and its subject: its subject insofar as the traditional spirit is little by little being effaced by the free inspiration of the individual; its object insofar as the interpretation of man and nature is slowly being substituted for divine myths and historic epics.

It remains for me to work out these generalities, to say how and in what part the Salon of 1857 fits this theory, to

determine the meaning of the Salon, and to assign it its legit-
imate value.

. . . A new period of art is beginning, having a new object
—man. This is now an admitted fact. Is it not evident that
from now on the concept of beauty that served painters of
the past and provided so many religious and historical master-
pieces can no longer be suitable for painters charged with
studying human life and depicting on canvas poetry until
now unperceived? The concept must therefore be renewed
and made appropriate to its new use. But this takes time. Art-
ists are, for the present, condemned to an apprenticeship
whose length cannot be foreseen. It is therefore not necessary
to point out their weaknesses, since these can be easily under-
stood; it is necessary to encourage the artists. . . .

In accordance with the principles I have announced, I will
not speak at all of religious or historical painting. The post-
humous efforts of these two genre, lacking, for the most part,
both conscience and individuality, should not cause us to
stop along our way.

Among the rest, I will choose a small number of works,
those which seem to me to involve art most directly, and to
bring out, in measure and by diverse means, the humani-
tarian tendencies. In discussing these works I will follow, in
spite of certain difficulties of classification, the division
furnished by the object of art itself.

This object is triple: nature, man, human life.

I will speak, in succession, of the landscape, the portrait,
and genre painting.

Nature—The Landscape

It is an old truth that eclogues and bucolic idylls have almost
always been the reaction to social ferment. Ruffled by the
world's tumult, poets and dreamers take refuge in the peace
of the meadows, in the contemplation of calm, serene na-
ture. . . .

One of those who has contributed the most to the sudden
elevation of landscape painting among us is Théodore Rous-
seau.

Théodore Rousseau is truly a master of art in the ancient

sense of the word: For his inheritance he has had genius and all the miseries that follow in its train. His obscure battles, his energy, and his perseverance are sufficiently well known. It was only in 1849, after twenty years of determined efforts, that the greatest landscapist of our times saw himself admitted to the honor of a first-class medal. The hour of justice did not come to the faithful worker until his task was almost finished. During the time of his difficult youth, he had for support only the esteem of a few friends, and beyond them he knew neither the sweetness of encouragement nor the savor of praise. But he has since been compensated. The Universal Exposition, by placing in full light the many sides of this handsome talent—the neatness, the precision, the freshness, the exquisite delicacy of this spirit at once certain, profound and charming—has affirmed his late-blooming reputation. Today Théodore Rousseau has reached maturity; he knows himself and he completely possesses all the resources of his art. It seems, then, that in the path he has followed he can rise no higher. The six canvases that he is showing, admirable fruit of his ripened talent, show us nothing new or unexpected in him, but they fully confirm all the qualities that we know he possesses.

The most remarkable of these landscapes is entitled *The Banks of the Loire in Springtime.* It is one of those little canvases in which Rousseau enjoys spreading and extending immense horizons. The gray river, of a marvelous transparency, swells between its winding borders and licks at its banks. . . .

Daubigny is, like Théodore Rousseau, one of those rare spirits that love beauty for its own sake and for the joy it gives. Far from courtly art, far from traditional art, they have both created a beautiful and noble place. They have entered into intimate communion with nature. They love it in its familiarity and for its great simplicity. They take it as it is, such as it is pleased to make itself for human enjoyment. Walking over the paths and the fields of their country, they have not found any Greek temples placed on the high places; they therefore do not place any in their canvases. They are content to convey the emotion born in them from what their

eyes perceive; and naked or adorned, sad or joyous, rich or
scanty, nature has for them unbelievable poetic treasures. But
if they both have for her a love equal in its tenderness and
depth, they express it differently. Where Rousseau puts
strength Daubigny puts grace; when Rousseau impassions and
provokes thought, Daubigny charms and makes us dream.
Does it not seem to you that Rousseau tends to approach
closer to the city, while Daubigny retreats from it? To sum
up, in a word, there is something more human in Rousseau's
landscapes, one feels the presence of man more and the de-
tails that tell of the preoccupations of his life; if man himself
is not present, one feels his presence in the neighborhood, his
person, his hut, or something that belongs to him; and one
even sees that he has just passed; one might say that his
tracks are still warm in the landscape. . . .

. . . I place *The Gleaners* by Millet among the landscapes.
In truth, nature is only a pretext in it, an excuse. Thought is
concentrated on the three figures that occupy the scene. But
these figures are peasants, they are participating in an act
belonging to the life of the fields. I find it difficult to admit
that it is possible to separate the peasant from nature. He
forms, one might say, an integral part of it, like a tree, like an
ox. Individuality is certainly more pronounced in him than in
the animal or the plant, because he masters the one and uses
the other. But from the artistic point of view, he finds him-
self to be only the highest point in a series that begins with
the vegetable and rises to him, a peasant, and proceeds in
such a way that he is linked to nature by chains more solid
than those of serfdom, I mean the laws of harmony. Like the
oak whose strength he has, like the ox whose slowness he
possesses, he is—by his gait, his dress, his attitude—in har-
mony with the nature that surrounds him. In the fields,
whether he is working or resting, he is magnificent in color,
form, and action; elsewhere he is always grotesque and ugly.
On the other hand, the urban man, placed in a landscape,
looks ridiculous to me. He disturbs the eye and makes a
blot. . . .

This canvas, which calls up frightful miseries, is not, like
some of Courbet's pictures, a political harangue or a social

tract. It is a very beautiful and very simple work of art, free of all declamation. The subject is touching in truth; but, treated as it is, in the highest style, with breadth, soberness, and frankness, it rises above party passion and reproduces, far from lies and exaggerations, one of those great and true pages of nature, such as were found by Homer and Virgil. . . .

I have always had a singular mixture of liking and well-intentioned pity for Corot. I do not know where this excellent man, whose manner is so gently emotional, finds his landscapes. I have not seem them anywhere. But such as they are, they have an infinite charm. There is in this way of understanding and translating nature something that recalls Bernardin de Saint-Pierre.[2] It is vague, indecisive; a feeling for the natural individuality of trees, plants, and rocks does not appear; but the lively penetration of things in general, of wet grass, cool shadows, and pure light is strongly present and is sufficient for the simplicity of the motifs. And then these simple landscapes seem drawn into a mystical dance [performed] to the chords of an invisible instrument. . . .

Courbet does not have any of this youth, this freshness, this conviction. Courbet is a skeptic in matters of art, a profound skeptic. And it is really too bad, because he has very beautiful and very great qualities. His brush is vigorous, his colors are solid, his relief is sometimes astonishing. He seizes the exterior attitudes of things; the movements of earth and trees are familiar to him. In a word, he accurately depicts what can be seen. But he does not go beyond this because he does not believe in painting. His spiritual feeling is not exalted enough for him to arrive at a consideration of forms and groups as the condensation of the universal soul, and to pursue the expression of the latter under the figures of the former. No matter what, his landscapes are certainly not lacking in value.

The Banks of the Loue are imprinted with all the qualities of accurate material depiction that I have mentioned. . . . *Hunting Deer in the Forest of the Grand Jura* is one of the

[2] [Jacques Henri Bernardin de Saint-Pierre (1737–1814), author of *Voyages à l'Île de France* (1773), *Études de la Nature* (1784), and *Paul et Virginie* (1788), the latter being his masterpiece]

better pictures exhibited by Courbet. The huntsman who is blowing the quarry, the dogs marbled with brown spots and, above all, the deer hung by the legs are masterpieces of material execution, of a solid and frank execution. . . .

In seeing the whole of the work of Courbet, the master painter, I was involuntarily reminded of that page from Proudhon: "The sculptor, the painter, as well as the singer must cover a vast range; he must show beauty by turns luminous or darkened, the whole length of the social ladder, from the slave to the prince, from the soil to the senate. You have not only to know how to paint Gods; demons must also be depicted. The image of vice, like that of virtue, belongs as much in the realm of painting as in the realm of poetry. According to the lesson the artist wishes to teach, all figures beautiful or ugly can fill the aim of art. Let the people recognizing their misery learn to blush for their cowardliness; let the aristocracy, exposed in its gross and obscene nudity, receive on all its muscles stinging punishment for its parasitism, its insolence and its corruption; let the lawmaker, the soldier, the merchant, the peasant, let all conditions of society, seeing themselves by turns in the idealism of their dignity and at their worst, learn, through pride and shame, to correct their ideas, their habits and their institutions. And let every generation, placing thus on canvas and in marble the secret of its genius, come to posterity with no other blame or apology than the works of its artists."

These words of the illustrious writer give the reason behind all Courbet's work, from the *Stone Breakers* to *The Young Women on the Banks of the Seine*. It is conceivable that, in their familiar conversations, the two men from Franche-Comté should have found themselves in agreement on one point when discussing works of art: the morality of its aim; and then, either Proudhon would have systemized and reduced to a theory the vague ideas of Courbet, or Courbet would have applied to the measure of his temperament the ready-made theories of Proudhon. The latter case is the more probable, the philosopher's theory being larger and higher than the artist's application. In effect, of the vast range indicated by the philosopher, Courbet has covered only a part,

that of somber beauty; he has not been able to rise to the other. His characters have been well painted in the idealism of their baseness but never in that of their dignity. Doubtlessly he wished one thing: "that the people might recognize themselves in their misery and learn to correct their way of living." For, as the theoretician put it, "according to the lesson that the artists wish to give, any figure, beautiful or ugly, can fulfill the aim of art."

But there is an error of aesthetics here for which the painter is more heavily responsible than his theorist. In effect, it is very debatable that art has only an aim of immediate moralizing, that a picture, like a fable, should have its moral. For my part, I am far from thinking this. Art should not impose its ideas; it is not able to make itself either an apostle or a judge; it does not need to chastise manners like a comedy, nor to flog the ridiculous like a satire. In applying itself to this path, it abandons its aim and actually contradicts its mission. The action of art is entirely immediate; it is not concerned with the special education of a generation and with directing its activity by preference toward this or that object. It is concerned with the general education of man and humanity. It reacts—slowly, it is true, but surely—on the source itself of our ideas and our feelings; and by the temporary excitement that it provokes in us, it teaches our being that there is always a step for it to climb in moral elevation, and in inciting us to climb it, it improves and purifies us.

I am almost apologetic in discussing these lofty questions in relation to Courbet's attempts, almost all unsuccessful. The dust and scandal that he raised around his name are well settled today. Since the current of ideas, scattered for twenty years by the profound shocks that our soil has experienced, tends to reform and take direction once again, one is no longer concerned with Realism. The idea that Courbet tried to put in the *Stone Breakers*, *The Burial at Ornans*, *Village Girls*, and *The Bathers* becomes less and less comprehensible. These canvases created for the people have never taken hold of them. And Courbet, who begins to realize this, is revenging himself this year by exhibiting, in a double insult to Paris and the people, *The Young Women on the Banks of the*

Seine, whose lusty title is a clear enough indication of the impertinent thought behind it. By thus jeering at the greater part of his admirers, Courbet condemns himself.

To sum up, Courbet is a good workingman's painter who, because he has not understood the aesthetics of his art, wastes beautiful and rare qualities. As a genre painter, he perhaps believed in former times that painting could have a social destination; but, where he now is, he no longer believes this at all, and in opening a door from behind Saint-Lazare[3] into the flowering fields of Madame Deshoulières,[4] he mocks himself, others, and his art. As a landscapist, he has only seen a frying pan through the window of a kitchen. His locations always bring to mind the idea of *a good party:* one realizes that it is nature that swims in the current of his streams; and in the neighborhood, at the end of his thickets, the perfume of rabbit stew is rising.

It is as a portrait painter that he appears to me to have the most value. The head of *Man with a Pipe* is a work of the first order. . . .

Man—The Portrait

Nature is scattered and diffuse life; man is concentrated life. Out of this basic contradiction from the point of view of art are born two opposed orders of conception that dominate and rule: the one landscape, the other portrait. . . .

The law of landscape is multiplicity. . . .

The portrait is the expression of human individuality. It is this individuality made manifest, externalized, to a certain extent made palpable and visible; not seen from a transitory and partial point of view, not taken in this or that fleeting moment of existence, joy or sorrow, laughter or meditation, watching or working, but treated in a definitive and summary manner, seized and fixed in that instant of pure reason that sums it up in all its aspects, raises it rapidly to the maximum of life, and unveils it completely, in one swoop, in the intensity and the diversity of its strengths.

[3] [Saint-Lazare was a hospital for prostitutes.]
[4] [Antoinette Deshoulières, née du Ligier de la Garde (1638–94), French poet]

As much, therefore, as nature dislikes any systematization of the existence that alights on or moves over its breast; as much does man, in order to be understood and expressed, imperiously demand the strict and severe unification of his being and his qualities.

Unity is the law of the portrait. . . .

If, imbued with the idea of the portrait which I have just expressed, you go through the gallery where the portraits are exhibited, everywhere you will encounter ignorance of the primary attributes of this art, and you will easily be convinced that contemporary painters are far from being Rembrandts and Van Dycks. Not only do they not have within themselves that rapid intuition dispensed by the old masters of science and physiology, not only are they ignorant of the art of showing the moral potential through form, of raising the human being to its maximum power through synthesis, of making the portrait contain the entire man with his possible manifestations, but they don't even know how to choose their models, and they send to the Salon personages whom the theory of portraiture rigorously and absolutely dismisses. They sin both in themselves and in the model. It is too much. I will therefore not elaborate on the inanities of our artists. As long as it is only a question of attacking a velvet, a lace, an armchair, an unimportant accessory, and of rendering it with a realism which easily delights the crowds, these artists are past masters—they would teach things to the oldest—but when it is necessary to tackle a head, put a man in his mask, to make habits and passions comprehensible through form, to make a soul shine through a face (if I be permitted that expression), our artists are all clumsy.

Nevertheless, let us give them this excuse: The portrait, a work of philosophy and meditation, is the form least accessible to pictorial art. It is, furthermore, the veritable touchstone of genius and the most elevated aim a painter can give himself. Great portraitists have always been rare, and this century, burning with activity, has only produced one—I mean M. Ingres. This fellow, who never had either invention or style, whose fame is based on bad paintings and is maintained by bad ceiling decorations, who has gone astray all his

life, and who today, having reached the limit of his means, makes infantile paintings—this fellow, I was saying, has been admirable whenever he has undertaken a portrait. Obstinate patience, indomitable willpower have taken the place of genius. He has had the firmness, the breadth, the elevation, the conceptual intensity of the old masters. All his dry, thin, cramped painting will pass. His portraits will live on. This will be his only baggage for the future. *The Apotheosis of Homer, The Vow of Louis XIII,* and *The Martyrdom of St. Symphorian* will be forgotten; the portraits of MM. Bertin, Molé, and a few others will remain as masterpieces and will make the name of Ingres live on.

Human Life—Genre Painting

The landscape and the portrait—the one radiant poetry, the other concentrated ideology—each by its own particular means translates the double faces—pantheistic and psychological—of Being and are the two high points, indeed, the true originality, of the pictorial art.

Below them—borrowing from them in diverse measure but attenuating them and lessening them both—on a lower step of the aesthetic ladder remains genre painting, the expression of human life, of its innumerable situations and its eternally changing circumstances.

With genre a new principle is introduced to art: action.

Action is a brutal, turbulent, invading element, beloved of the crowd; an element which cannot live happily next to others, which energetically tends to dominate and from the outset claims absolute power. Before it, everything thus diminishes and becomes subordinate. Thought was expanded in landscape and uplifted in the portrait; genre painting takes hold of thought to lower, to restrain and circumscribe it to mere fact. Genre painting attenuates human individuality by subordinating it to the action; it thus reduces human individuality to its narrowest proportions, to its simplest role: that of a part of a group. The group, the contest of forces and beings, is the essence; unity within the group is the law of genre painting.

This violent restriction of the idea and this fatal weakening

19. Gude: *Port of Refuge*

20. Daubigny: *Spring*

21. Courbet: *Return from the Conference*

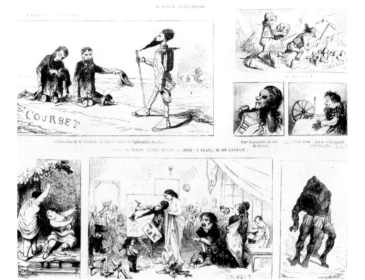

22. Quillenbois: *The Realistic Painting of Courbet*

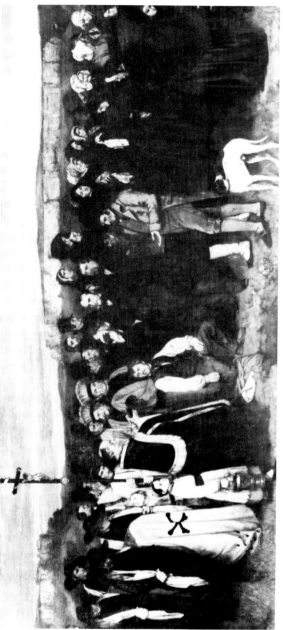

23. Courbet: *Burial at Ornans*

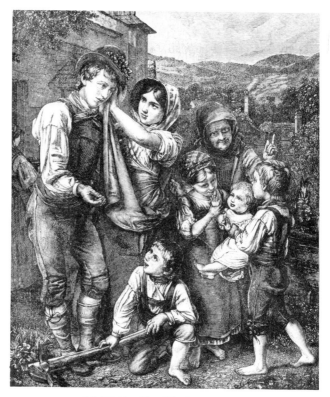

24. Waldmüller: *The Return Home*

25. Fattori: *The Three Soldiers*

26. Palazzi: *Prince Amadeo Taken to an Ambulance.* Photograph by Subalpino

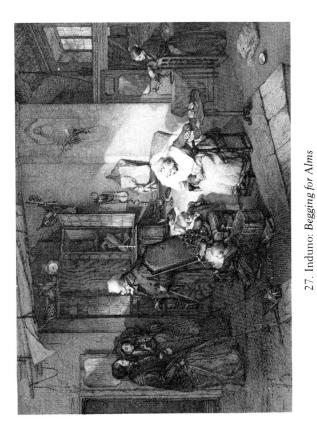

27. Induno: *Begging for Alms*

28. Tideman: *The Lonely Old*

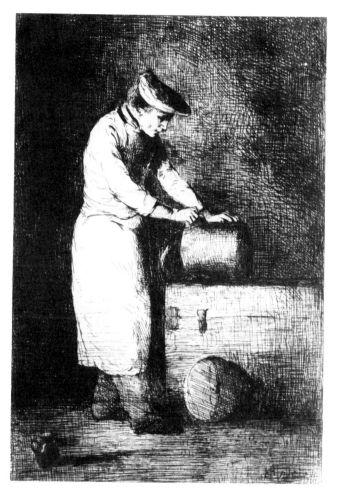

29. Ribot: *Kitchen Helper*, etching by Ribot

30. Vito d'Ancona: *Dante and Beatrice*

31. Celentanò: *The Council of Ten*

32. *Japanese Court at the Exhibition of* 1862

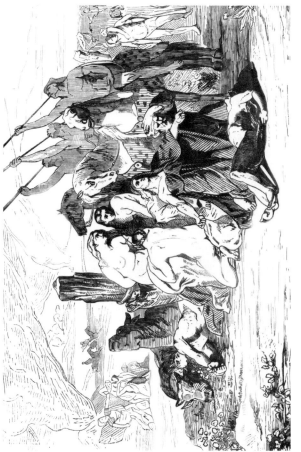

33. Puvis de Chavannes: *War*

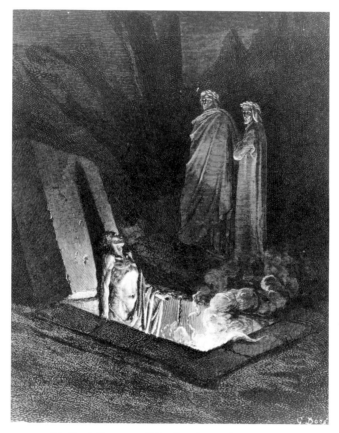

34. Doré: *Dante and Virgil at the Tomb of Farinata*

of the essential artistic elements would be enough to lower genre painting to the second rank, even were its subject—which is limited to the representation of life—to belong to it alone. Human life, seen from the point of view of action, is the domain of literature as much as it is that of painting. Here the artist and the poet—the man of color and the man of the word—walk the same ground. Their field of observation is identical. For the one and the other this field of observation is that of objectified sentiment and applied passion, it is that of man acting, "man finally showing his life, and displaying with its beauty the greatness of his soul—in rest, in action, in joy, in pain, in the midst of various passions."

The processes of production are also the same: to group, dramatize, create relief through contrast, elevation through antagonism, interest through tension and imminence of struggle: All this belongs as much to the writer's composition as to the artist's. Only one thing is different—the extent of the means—and here the scale shifts against the painter; the painter has but the moment, the writer has a succession; the one, to use an expression which is spreading, works in the moment, the other in continuity.

This could explain, if need be, why the majority of our genre painters, even when they draw subjects from real life, find it so difficult to separate themselves from the methods of the novelist and the dramatist, and why the scenes or episodes they depict often have more of a literary than a pictorial character. As examples I will mention *The Death of St. Francis of Assisi* by M. Bénouville and *Malaria* by M. Hébert. One could mention a hundred others. It is not, certainly, that the confusion could be avoided. When the painter is clearly and lucidly conscious of the means and end of his art, he hardly ever falls into this fault. The greatest painters of this century have borrowed pictorial themes from epic, dramatic, or lyric poets and have created, in the form of interpretation, works which stand as original and strong next to those of the poets: M. Delacroix in *Dante and Virgil, Hamlet, Death of Valentin,* and *Shipwreck of Don Juan;* M. Ary Scheffer in *Françoise de Rimini, Faust and Marguerite.* These are not only original creators but still, and especially,

painters. In any case, if genre painting, by its mixed nature and its literary affinities, is aesthetically inferior to landscape painting and portraiture, in terms of its subject—which is the expression of life, of action, of customs and passions, that which Balzac called the "Human Comedy"—it has a rightful claim to a serious and important place in art. But this place must be given to it.

Unfortunately, the artists of our time, for the most part no heirs of poetry and passion, weaned too early from enthusiasm and naïveté, do not seem gifted with the power and qualities necessary to bring to fruition the task which our century has a right to require of its art, with respect to the solidarity of human development. Literary anarchy, troubled aesthetic ideas, and the general uncertainty of minds weigh heavily on artists and increase the difficulty by confusing the strong and stopping the committed. The too precipitous movement of life, the necessity of acting quickly and arriving on time, prevent study and meditation. Artists flee the solitude, which helps them to mature, with the same energy that the old masters pursued it. What is happening? When a painter has acquired a fairly adequate and fairly personal process and manner (which takes several years), he stops and worries only about exploiting this process and this manner and deriving from them both fame and money, if possible, and, if not, only money. Those who, never content with the work accomplished, tire themselves out and wind themselves up in the pursuit of something better are imbeciles: The best in art is the comfort of the artist.

So where are we? Here we are on the last eve of the great Romantic melee. The wind, which for several years has shaken literature, batters the fine arts just as heavily. The old champions of the preceding generation are leaving one by one and fall: David [d'Angers] follows on Rude and Pradier, Delaroche on Chassériau and Roqueplan. All sculpture is already lying dead. When MM. Delacroix and Ingres will have been carried off—the one his crabbed patience, the other his ardent and passionate search, and both their elevated ideals—who will remain with us in painting? No above-average talent is appearing; no genius is rising. All the painters eventually

reach an average talent which few later surpass. In the great army of art I see many soldiers, some officers, if you wish, but no generals. From whence will come he who tomorrow will be proclaimed a leader, because [a man] of genius, and will take the head of the column? No one knows. We must await the new recruits. . . .

1858: MUNICH
The National Historical Exhibition:
The Exhibition of German Art in Munich

In mid July 1858 art patrons and connoisseurs from the German and Austrian states and officials and artists of the various German art academies assembled with enthusiastic anticipation in Munich, the capital of Bavaria, to attend the first general and historical exhibition of Germanic art. Munich had become the "Athens" of Germany through the munificent patronage of King Ludwig I of Bavaria, whose youngest son, Otto, had been chosen in 1832 to be the first king of the Greeks since Alexander the Great. Prior to King Ludwig's abdication in 1848, he had erected buildings in styles derived from classical and Renaissance prototypes along the broad, straight boulevards of the city. Greek architecture inspired his architect, Leo von Klenze, in the design for the Glyptothek and the Königsplatz. Buildings that combined Italian Renaissance elements with German Romanesque details were designed by Friedrich von Gärtner to line the wide Ludwigstrasse, the new street which originated at a replica of the Florentine Loggia dei Lanzi located opposite the palace

and terminated at the Siegestor, an ornate Roman triumphal arch.

Visitors to Munich in 1858 inspected the more recent construction along the broad Maximilianstrasse, named for Ludwig's successor, Maximilian II. Extending at right angles to Ludwigstrasse, the new street ran eastward from the palace to the Maximilianeum, the school for royal pages, located high on the bank of the Isar River. The wide wings of the school were decorated on the outside with large sculptural groups and on the inside with thirty immense paintings depicting important events in the history of the world. Along the Maximilianstrasse, government offices and the museum for Bavarian art were being erected after the designs by Friedrich Burklein, which satisfied Maximilian's taste for perpendicular lines and Gothic tracery. Influenced by the literature of the romantic school, Maximilian II had withdrawn his patronage from the classical school favored by his father.

The buildings along the Ludwigstrasse and the Maximilianstrasse, which comprised the new sections of Munich outside the medieval city, reflected an interest in history awakened by Gibbon's *The History of the Decline and Fall of the Roman Empire* (1776–88), Jules Michelet's *Histoire de France* [*History of France*] (1833–67), and Leopold von Ranke's *Die römischen Päpste* [*History of the Popes*] (1834–39). Von Ranke, an adviser and friend to Maximilian II, had first come to prominence in 1824 with *Zur Kritik neuerer Geschichtschreiber* [*A Critical Dissertation on the Methods of Contemporary Historians*], appended to his *Geschichte der romanischen und germanischen Völker von 1494 bis 1514* [*History of the Latin and Teutonic Nations from 1494 to 1514*] (1824). He insisted that historical writing be based on the "narrative of eyewitnesses and the most genuine immediate documents," and his demand for scrupulous "scientific" accuracy established a standard not only for historians but also for architects, who turned to historical prototypes and painters of historical subjects. In painting these standards were fused with those established by the Nazarenes, the Brotherhood of St. Luke, formed in Vienna in 1809. Selecting fifteenth-century Italian art as an ideal to

be emulated, the Nazarenes required monumental art to be intellectual in content and preferred it to be presented in cycles executed in fresco. In Munich these principles were embodied in the works of Peter von Cornelius, a former Nazarene whom Ludwig I had called from Rome in 1825, and those of his pupil, Wilhelm Kaulbach, the painter presently favored by Maximilian II.

In sharp contrast to the conventional buildings designed in the styles of the past, the immense Glaspalast, constructed of glass and iron, had been built in 1854 by the engineering firm of Kramer-Klett to house the first exposition of industrial products manufactured in the German and Austrian states. The Glaspalast and the exposition were evidence of Bavaria's determination to be recognized as a state equal to Austria and Prussia, should a single political unit be formed from the numerous German states. Although efforts to unify Germany under a liberal constitution had failed in 1848, they did result in the restoration of the loose confederation of thirty-nine states created in 1815 at the Congress of Vienna. The dream of a unified Germany had not been destroyed. Fearful that the economic and political strength of Prussia and Austria would eclipse Bavaria's power, Ludwig I and Maximilian II fostered the industrialization of Bavaria. The first railway in Germany had been inaugurated by Ludwig I in 1835. Ten years later he opened a canal linking the Rhine and Danube rivers so goods could travel by ship from the North Sea to the Black Sea.

At the time of the 1854 exposition celebrating Bavaria's industrial progress, a small collection of contemporary German art had been assembled—through the efforts of the Kunstvereine and artists' organizations in the various principalities —and had been put on view in the exhibition building opposite the Glyptothek. Eager, for some time now, to hold a comprehensive exhibition to show the recent developments of Germanic art, the various Kunstvereine united in 1858 on the occasion of the fiftieth anniversary of the creation of the Bavarian Academy of Art and the eight hundredth anniversary of the founding of the city of Munich in order to secure support for a general historical exhibition of the paintings

and sculpture produced throughout the German states during the past sixty years. The Glaspalast was the only structure of sufficient size in any of the states to accommodate such an exhibition. The Munich Kunstverein—established in 1824 and therefore one of the oldest—assumed responsibility for organizing the exhibition. With the exception of the Berlin group (the Berlin Academy had announced that its exhibition would be held at the same time) it received the cooperation of other Kunstvereine, the Verbindung für historische Kunst (Association for Historical Art), local artists' societies, the academies of art in the different states, the kings of Bavaria and Hanover, the Duke of Saxe-Weimar, princes, and private collectors in assembling this historic exhibition of Germanic art. The King of Prussia consented to the loan of only a few paintings.

Because the German states lacked a geographically central national center where artists could attract attention and secure support beyond their own locality—as well as the political unity that made possible the annual or biennial Salon in Paris or the Royal Academy exhibition in London—the only way an artist in one of the German centers could reach a wider public was to have his work included in a regularly scheduled exhibition sponsored by the local Kunstverein. His works would then be circulated among other Kunstvereine in a specific district. This practice of circulating exhibitions enabled individual artists to establish reputations throughout the German states and did much to erase the insularity and provincialism of the various regions. By 1858 the network of Kunstvereine also provided the organizational base necessary for assembling a general exhibit of work executed throughout the states.

On July 22, 1858, in the presence of the Bavarian kings, symbolically represented by a life-size portrait of Maximilian II, placed on a carpeted dais, and a gleaming white marble bust of Ludwig I, the Cabinet Minister for Church and School, von Zwehl, officially opened the exhibition. After an address by the aesthetician and art historian Moriz Carrière, secretary of the Academy of Fine Arts, Feodor Dietz, the president of the assembly of artists in the various states, who

had been an active organizer of the exhibition, called on the artists to collectively strive for beauty, truth, and harmony and thus "to reveal what German art is!" The artists' choral society concluded the ceremony with a jubilant song.

To mark the triumph of the classical school, the walls of the central nave—the place of honor where the opening ceremony was held—were hung with cartoons and monumental paintings executed according to the rules and laws aestheticians had formulated to control the development of art. There visitors found Cornelius' cartoon for *The Apocalyptic Host*, which decorated the Berlin cemetery of Campo Santo, Philipp Veit's *Germania*, Alfred Rethel's cartoon for *The Deeds of Charlemagne*, in the Town Hall of Aix-le-Chapelle, Wilhelm Kaulbach's cartoons for the Berlin Museum stairway, Overbeck's drawings for the New Testament, Preller's sixteen cartoons for Homer's *Odyssey* for the Weimar Museum, and Schwind's *Fairy Tale of the Seven Ravens*. Schwind's work impressed Grand Duke Carl of Weimar, who wrote in his diary on September 5, 1858:

> It is the most Germanic painting I have yet seen, full of profound and pure artistic feeling, full of fineness of observations, full of poetry, romance, and humor. I couldn't free myself from amazement and joy. I rejoice that it is now mine. . . . I bought it out of the exhibition.[1]

Another visitor, Friedrich Preller, the son of the painter whose cartoons were exhibited, found that the historical exhibition exceeded his expectations and was of the opinion that the victory of the ideal tendency in art over realism had been conclusively decided: "Cornelius, his followers, Genelli, Schwind, Alfred Rethel, and my father celebrated the greatest triumph. The other tendency was scarcely noticed."[2]

Near the central nave were hung Asmus Jakob Carstens's cartoons and drawings, selected by archaeologically trained art historians to mark the starting point of the sixty years of development illustrated in the exhibition. Carstens broke

[1] Cited in Wilhelm Zenter, *München, Das Antlitz einer Stadt im Spiegel ihrer Gäste* (München: K. Desch, 1946), pp. 136–38
[2] Ibid., p. 133

with the eighteenth-century rococo style and with the tradi-
tions of his native art in order to express his personal, subjec-
tive interpretation of the simplicity and harmony he saw in
Greek art. Connoisseurs and aestheticians believed Carstens's
work to be unsurpassed in creative originality and hailed him
as the initiator of the "new German art" that would then be
continued by the Nazarenes (though the source of their in-
spiration was not Greek art but the classical works of the Ital-
ian Renaissance).

A break with the rococo style had likewise been effected by
the romantic painters, who were reawakened to an appreci-
ation for sixteenth-century painters of Germany and the
Netherlands. This was also considered "new German art" and
admiration for it was fraught with a desire for national unity
and identity. First apparent in the work of the North Ger-
mans Philipp Otto Runge and Caspar David Friedrich, the
naturalistic tendency was strengthened by young Scan-
dinavian painters: Johan Dahl, who had come to study and
stayed to teach in Dresden, and Adolph Tidemand and Hans
Gude, who settled in Düsseldorf. The Hamburg painter
Christian Morgenstern, who had studied and was influenced
by the seventeenth-century landscapists Ruysdael and Hob-
bema and had sketched in Scandinavia, settled in Munich to
paint the Bavarian countryside, breaking with the classical
landscape tradition represented by Karl Rottmann, Cornelius'
pupil.

The 1858 Munich exhibition marked the emergence of the
exponents of realism: the Düsseldorfer Karl Lessing, whose
Preaching of the Hussite was on view, and, for the first time,
the self-taught painter Adolf Menzel, who exhibited a
large canvas, *Frederick the Great at Hochkirche,* an un-
commissioned companion piece to his *Meeting of Frederick
the Great and Joseph II,* commissioned by the Association
for Historical Art. Piloty's *Seni before Wallenstein's Corpse*
brilliantly represented the Delaroche-Gallait style of history
painting, which one critic had designated "historical genre."

The Munich historical exhibition recalled the "Art Treas-
ures of the United Kingdom" exhibition held in Manchester
just the year before. The chronological arrangement that had

been used so effectively at the English exhibition was not used in Munich for want of sufficient entries. Artists' works from Berlin, Dresden, and Düsseldorf were placed in the north galleries of the Glaspalast, and those from Vienna and Munich in the south galleries. Sculpture was grouped around an immense fountain in the central nave.

The exhibition provided an occasion for German artists to hold their third general assembly. The exhibition had shown that German artists, scattered over a wide region, needed an organization that would unite Vienna, Munich, Berlin, and Düsseldorf: a Künstlergenossenschaft was formally established. To celebrate its formation, the success of the exhibition, and the eight hundredth year of Munich's founding, the assembly of artists gathered as guests of the city at the huge Pschorrbräukeller at Neuhauserstrasse on September 20. Steins foamed with the favorite Bavarian drink and song filled the vast hall, which had been decorated with hundreds of balloons and laurel wreaths. The painter Wilhelm Kaulbach and the composer Franz Liszt wandered arm in arm among the groups. Shouts of welcome greeted the Munich art Maecenas and former king, Ludwig I, when he unexpectedly appeared.

The exhibition, which brought art patrons, artists, connoisseurs, art lovers, and the curious to Munich, was "news." No newspaper, however, had a countrywide circulation comparable to the *Times* in England and *La Presse* in France, so reviews could appear in the regional papers, the Munich *Süddeutsche Zeitung* and the venerable *Allgemeine Zeitung*. The latter enjoyed a wide circulation; the painter August Friedrich Pecht, an advocate of the emerging realism, was its Munich correspondent.

The absence of chronology in the arrangement of works at least allowed the viewer an opportunity to survey the independent schools; reviewers were prompted to write a brief expository account of each. These résumés of the history of painting in Germany, illustrated in part by examples to be seen at the exhibition, appeared in the two organs of the Kunstvereine: the editor in chief of *Das Deutsche Kunstblatt* published his informative discussion of the exhibition before

the magazine ceased publication in December 1858, and *Die Dioskuren* used the exhibition to summarize the different categories of paintings: history, landscape, religious, and genre painting. Few reports appeared in either foreign or German belles-lettres periodicals, with the exception of the English *Art Journal* and the political and literary weekly *Grenzboten*.

Founded in Leipzig in 1841, *Die Grenzboten* was a strong supporter of the unification of Germany. After 1848, when the popular novelist and playwright Gustav Freytag became its editor, it became the leading journal of German and Austrian liberalism. In Freytag's successful novel *Soll und Haben* (1855) were portrayed—with a realism akin to that which made genre painting popular—the qualities of the middle class that made it the soundest element in German society. To report on the "Art Treasures of the United Kingdom" exhibition in Manchester and the equally significant exhibition in Munich, Freytag chose the popular young journalist and critic, Anton Springer (1825–91), a professor of art history at the University of Bonn, whom he had met at the socialist Otto Jahn's in 1851.

Born and educated in Prague, Springer had traveled in Italy before studying at the University of Tübingen with Friedrich Vischer, professor of aesthetics and codifier of Hegelian aesthetic thought. In 1848 Springer received a university appointment at Prague, but his popular lectures on the history of revolution, in a year marked by political uprisings, and their publication in book form in 1849 resulted in his dismissal. Expelled from Austria as a revolutionary journalist, Springer was named an instructor of art history at the University of Bonn—despite Prussian disapproval—and supplemented his meager salary by writing for journals. He was soon well known for his *Kunsthistorischen Briefe* (1851–57), which contained essays on specific art-historical subjects. In 1855 his systematic outline of Western art, *Handbuches der Kunstgeschichte,* appeared in four volumes, illustrated with chromolithographic plates. In 1857 Springer published his interesting essay "Geschichte der bildenden Künste im neunzehnten Jahrhundert" in the twelfth volume of the encyclopedia *Die Gegenwart.* In it he scrutinized the German,

Belgian, French, and English schools, as well as the role of Italian and Scandinavian artists.

Although influenced by Vischer's aesthetic concepts and Hegelian theories, Springer chose to separate art from aesthetics and philosophy and adapted the scientific methods of the study of history to the study of art, a further manifestation of the current vogue for historicism. He argued that the history of art should differ from other historical disciplines only in subject:

> Art history should reveal the appearance of the beautiful as its story unfolds. It also should depict the necessary inner development of the artistic ideal and should transmit the historical growth of each artistic manifestation. At the same time, it should design a clear picture of the imaginative activity of the various peoples and show the connection between that and the other circles of life.[3]

Springer regarded art as a moving force entirely rooted in a people and subject to its changes. Therefore, he had little sympathy with the Greek-inspired neoclassicist or the Italianate forms which Ludwig I's patronage had encouraged. He preferred the work of the contemporary artists—Schwind, Richter, Menzel—who, he felt, represented the artistic renaissance that was accompanying the German political resurgence, for they had turned from an idealization of form to realism. He regarded art as the embodiment of ideas that appear in the life of a people and held that in essence art is an imitation of nature: In its development it proceeds toward an ever-closer approximation of nature; an increasing realism of representation therefore indicates progress in art. True art appears when a specific development in a culture has been reached and a favorable relationship to nature attained.

For Springer—journalist, revolutionary, federalist, and art historian—the assignment to review the first general retrospective German art exhibition was a congenial one. The exhibition would be influential in creating that sense of national identity in Germany which the English and the French al-

[3] Anton Springer, *Handbuch der Kunstgeschichte*, 5th edn. (Leipzig, 1848), p. 113

ready possessed so naturally. The exhibition contributed to German self-confidence in its own art as the works of Lessing, Goethe, and Schiller had done for German literature. From this exhibition, in the opinion of Pecht, dated the general appreciation for painting, "which for a century had been less highly regarded than science and literature. The creative energy of the nation had finally turned itself in this direction, showing a striking preference for the representation of domestic life or to the discussion of art's form. All this indicated the growing elevation of the national spirit, a requirement for the political development of the nation and the welding of a great and powerful entity."[4]

Anton Springer: *The All-German Historical Exhibition*[1]

I. Last year the rallying cry for art lovers was "To Manchester!" This year it is "To Munich!" The conscientious soldier who used both commands cannot avoid comparing the two exhibitions. He will, of course, not weigh the quantity of art treasures on display against each other since narrower limits were set for the Munich exhibition. Nor will he judge the latter to be of less value merely because of its smaller size. He will, however, examine and compare the various types of layout, the diverse techniques used for awakening and maintaining the interest of the people and, finally, the degree to which the art collectors of England and Germany were willing to contribute.

One must think very highly of the treasures in the exhibition and assume that the appreciation of art among the German public is eager and warm indeed if one expects the exhibition to be a success, in view of the lack of any kind of festive display, references, or helpful hints. One has a certain right to both assumptions, especially with regard to the inner worth of the exhibition. It undeniably contains a great

[4] Friedrich Pecht, *Geschichte der Münchener Kunst im neunzehnten Jahrhundert* (Munich, 1888), pp. 224–26

[1] [Translated from *Die Grenzboten*, nos. 40–43, October 1, 8, 15, 22, 1858]

number of attractive and significant works of art. But there is
a catch to this admission. We really have to turn a blind eye
to the title "General and Historical Exhibition" if we wish to
be justified. We cannot demand the unveiling of a complete
picture of the development of German art in the last sixty
years that we might expect; rather, we must be satisfied with
examples that will add to one's knowledge. Only fifteen ar-
chitects and fifty-four sculptors have contributed to the Mu-
nich exhibition. Of the latter, most are unknowns, presumably
students at the Academy. . . .

It was certainly not merely for the benefit of art historians
that the exhibition was organized. Sufficient proof that one
was not thinking of them would be the fact that Friedrich
and Runge were exiled to opposite corners, although in the
madhouse of romanticism they shared the same cell. A heart-
break like this could not possibly have been intentionally
caused to the art historians. . . . But let us leave the unsatis-
factory studies of catalogs and turn instead to the subject it-
self and, first of all, to the older masters, especially to Car-
stens, for whom the two terms of "old" and "classical" both
apply so aptly.

Carstens has thirteen numbers in the catalog which intro-
duce us to nine different works [and studies]. We hardly
need to describe in detail his unhappy life,[2] the wasting of
his strength from lack of a larger sphere of influence, his ex-
clusive emphasis on antique motifs and forms, or his manner
of presentation with the elementary means of painting. Even
though Carstens's name may not be on everybody's lips, his
historical position is generally correctly assessed and his im-
portance appreciated. The emphasis in Carstens's case should
not be placed on his preference for antiquity. Many of his
contemporaries shared this trait. Carstens differs from them,
above all, in his complete understanding of plastic form and
his keen feeling for the simple forms of beauty. The latter
was almost totally lost in the art of the eighteenth century.
The rococo painters did not paint badly; in certain instances,
in fact, they painted excellently. When we compare their

[2] [See *Triumph*, pp. 52–63]

works with those of modern artists, we notice that they are
far above us in technique and retained many artistic knacks
and tricks that have since been lost. Their schooling was still
based on a craftsman's foundation and permitted a more
thorough technical training. Today, when painters ordinarily
receive only a "dilettantish" type of education, this solid
foundation in the craft is rarely found. What seems intoler-
able to us in the art of the last century is its lack of a serious
concept and its frivolous playing with motifs; no one thought
to portray anything according to its nature without a subjec-
tive flavor. We are repelled by their affected and intricate
manner of representing forms, which neither naïvely ap-
proaches reality nor, carried by a sense of the pure and ideal,
returns to the eternal, basic forms of human perception, but
instead is content to reproduce hackneyed, conventional
types. . . .

Carstens's merit, by the way, does not rest solely upon his
earnest and intense return to the scaffolding of antique
forms. For him classical antiquity is not something su-
perficial, a foreign mantle in which he only subsequently
cloaks the products of his imagination. His whole nature is
inherently plastic; even his slightest sensibilities are pervaded
with that infinite harmony for which only antiquity possesses
the corresponding expression. Goethe's fondness for Carstens
is based on an inner elective affinity; the circumstances which
explain the poet's transformations became crucial for Car-
stens's development as well. It is to this fondness that we
chiefly owe the survival of Carstens's works and that ulti-
mately determined the tendencies of the art lovers in Wei-
mar.[8] (Unfortunately, no trace of their endeavors is to be
seen in the Munich exhibition.) . . .

We let the greatness of our art—be that greatness real or
merely apparent—be defined in terms of a return to the indig-
enous and original, as it is usually praised in the art of the
dwellers of the Monastery of San Isidoro.[4] We attribute the

[8] [After Carstens's death, Goethe arranged for his unsold works
to be purchased by the library at Weimar.]
[4] [The Nazarenes, or Brotherhood of St. Luke, inhabited the
Monastery of San Isidoro in Rome.]

rebirth of our national art to the romantics, we celebrate in
the *Nibelungen* and *Faust* patriotic feats which gave us once
again an art of our own and think little of the earlier German
artistic strength. In addition, a seemingly valid pretext for this
is furnished by the undeniable similarities between German
and French art at the end of the last century. We can only
repeat, however, that no dependence upon the French na-
tional art was intended; rather, a common attitude towards
the cult of classical antiquity called forth this rela-
tionship. . . .

It is a sin to try to force articulate sounds from the nature
of a landscape or to assemble a conventional alphabet from
nature's forms, which are nothing but song and melody. It is
also a sin to distort and deliberately change the true shapes of
nature. By haughtily disdaining to pay close attention to na-
ture's more subtle characteristics, the artist brings immediate
retaliation upon himself. The attempt of Friedrich in Dres-
den to create a religious landscape and his depiction of the
Arctic Sea in which the icebergs are stereometric figures
painted a grayish-green are simply ridiculous.[5] They should,
however, not be forgotten when one speaks of the beneficial
influence of the romantics on the revival of painting; neither
should Runge's symbolic poems of nature. On the other
hand, it is not impossible to achieve a symbolic relationship
between the nature of a landscape and human conditions and
passions. Depending on our mood, we feel attracted or re-
pelled by certain landscape forms, seeking them out or shun-
ning them. There are types of landscape corresponding to
peace of mind, the serenity of enjoyment, storms of passion,
or laments of yearning, and though they cannot reproduce
the inner life of the spirit with the dramatic acuteness and
precision of an external action, they can, like the musical ac-
companiment of a song, transmit the suggestion of a related
sentiment.

Looking at nature this way, accessory figures would be hard

[5] [See *Triumph*, pp. 148–68, on Caspar David Friedrich's
Tetschner altarpiece, *The Crucifixion in the Mountains*, and its
exhibition in Dresden in 1808. *The Wreck of the Hope*, the second
work mentioned, was completed in 1822.]

to do without, especially in the case of southern landscapes, where details of color are less important as the conveyers of expression than the general flow of lines in the drawing. Of course, nature speaks for herself, but to lead the attention immediately to the right track the basic idea of the landscape is often condensed and made obvious in the accessory figures.

This kind of landscape painting is by no means new; it is even older than the opposite trend in which nature's moods are represented by themselves, without any symbolic allusion at all. The pictures of paradise by the old Dutch masters and the group of landscape painters enthusiastic about Italian nature in the seventeenth century have tried it; it was not absent from Rubens's work, and in the beginning of this century Koch has revived it (e.g., in his *Macbeth* landscape). We see it now with rejuvenated vigor and a wise use of the technical skills acquired in the meantime in the works of Schirmer in Karlsruhe and Preller in Weimar. The exhibition possesses, in addition to Schirmer's *Four Times of Day* (with the accessory figure of the Good Samaritan), twenty-six drafts and sketches in oil of biblical landscapes by the same master, as well as fourteen of Preller's landscape illustrations for the *Odyssey*. . . . Like the heroes whose lives and sufferings they reveal, nature appears in them as even greater and more powerful than it has ever appeared to us ordinary human beings. The storms roar more mightily, the trees arch higher, the branches spread wider and fuller, the sea conceals greater terrors, but the lure of nature's delights is sweeter. All forms of nature are embodied in Preller's landscapes; raging passion, blissful calm, and the whole gamut of impressions in between are revealed, yet we are everywhere inspired by the spirit of a classical imagination and stirred by the noble truth of the portrayal. So far as it is possible for landscape painting to strike an epic note, it has been done here. A glance at the drawings of Olivier and Fohr, placed near Preller's illustrations, shows that Schirmer and Preller have pursued a course that already prevailed in landscape painting since the beginning of the century, but it also shows that if contemporary art can claim any progress and any improvement when compared with the works of the older generation, it is here

that one must look for it and here that one will find it. The
poetic spirit has remained, the command over the forms has
grown.

II. In England there is a sect of artists that believes it has dis-
covered in modern painting an excessive dominance of the
conventional, explainable only through a thoughtless echoing
of traditional views. These artists are fighting against this
dominance with a mighty clamor, striving to reproduce pure
nature in art, nothing but nature, the most natural nature.
For these men, color harmony and most of the laws of per-
spective, especially aerial perspective, are conventional. The
selection of forms, too, and the regard for purity of line in a
drawing are to them evils. In general, they regard the devel-
opment of painting since the fifteenth century as a continual
series of mistakes. The patron saints of this sect are the
Italian painters of the fifteenth century; the name under
which it has established itself in England is that of "Pre-
Raphaelites."

In Germany we do not have this name, but we do have the
phenomenon. All the stereotypes from the junk rooms of the
academies—the artificial forms of beauty, the turgidity which
passes for manly strength, the awkward affectation which is
taken for gracefulness—encountered violent opposition among
our aspiring young artists forty or fifty years ago. They de-
cided to return to primitive forms. Lending weight to this de-
cision were literary influences and that well-known spiritual
desperation which causes those too weak to work their way
out of the confusions of the modern age to deny it alto-
gether. The flight from the present means something
different to these artists than to artists inspired by an-
tiquity. The latter take with them to their lonely heights a
general joy of living, a disposition open to all beauty. Their
quarrel is with mankind as it exists today, not with mankind
in general, whereas the former show disgust with life itself
and anger toward the whole world. If this artistic movement
had not brought us the revival of the old German style, the
opposition to the academic nuisance would have earned little
thanks from us, though we certainly can only be happy about

the academic downfall and are far from deploring the ex-
change of the worn-out phraseology of the academies for
primitive forms; rudeness is always better than hypocrisy. If
only this hypocrisy had not entered German art again by an-
other door, if only we did not see now, in place of the power
of hypocritical forms, the power of hypocritical thinking,
which looks upon God's works as if they were the handiwork
of the devil instead of venerating Him in them; if only,
finally, vapidity had not been extolled and a system of art ap-
preciation preached which actually elevates consumptive tai-
lors' apprentices to the ideal of manliness! It is no misfortune
that the Munich exhibition shows only a few examples of
this school. . . .

Of the stars of German art there remain Cornelius and
Kaulbach. The opinion, probably widely held on the outside,
that the works of these two would be the focal point of the
exhibition and would exert the strongest attraction, has not
been confirmed. Most of the visitors walk past, glance at
them calmly—even indifferently—yet have time and attention
to spare for viewing and admiring the rest of the works on ex-
hibit. However, that does not mean anything, for these are
well-known and frequently seen paintings. From Cornelius
there are some of the cartoons for the Glyptothek, the Lud-
wigskirche, and the Campo Santo in Berlin. Kaulbach is
represented by fragments of his decorations for the Neues
Museum in Berlin, the cartoons of *The Dividing of the Peo-
ples,* and some allegorical figures. The hope of seeing the
much-praised sketch of *The Battle of Salamis* has unfortu-
nately not been fulfilled. Moreover, the cartoons are hung
next to richly and often brightly colored oil paintings, a
placement which dulls the eye of the viewer for the plain
drawings. Those who overcome these obstacles will not hesi-
tate to appreciate and admire Cornelius' energetic force, his
moving portrayal of tragic suffering and powerful emotions,
as well as Kaulbach's ingenious and witty conceptions. . . .

Compared to the older masters in the exhibition, Cor-
nelius and Kaulbach show a greater and richer content. They
have opened new realms of thought to painting, called atten-
tion to subjects of incontestable power, and brought force

and daring to the conception of these subjects. They do not, however, completely satisfy the pure feeling for form; nor are the simple beauty and harmony which speak in the works of Carstens, Wächter, and Schick congenial to them. They were concerned with the grandiose, the profound, and the ingenious, so that they had no time to penetrate, as did the old idealists, the laws of form, which are valid in themselves; or they may even have found the laws similar to the barriers which hindered the free embodiment of their visions and which they had to break through. The prevalence of an element of irony [about which one is surprised or amused] is usually first perceived in Kaulbach's work and is emphasized as a peculiarity of his. That this element already existed earlier in the attitude of the artist toward his subject is shown by Koch, who thought to imbue his picture *Tyrolean People's Army* with a special spicy charm by having a snake bearing the caption "Politica" arise at Hofer's feet from an open abyss.[6] Is there not also in Cornelius' approach to form—in his proportions, which destroy all requirements of existence— a certain irony towards the laws of form? At any rate, this trait prevents the artist from developing an effective canon like that which Carstens undoubtedly exerts within a certain circle and will be exerting for a long time.

The groups of artists that gathered around Cornelius in Munich and Schadow in Düsseldorf in the 1830s were insufficiently represented in the exhibition, as were the older Berlin painters. . . .

The opinion of the lovers of antiquity about the branch of history painting, new in Germany, which emphasizes the characteristic truth of the portrayal and concentrates, with obvious preference and often admirable accuracy, upon external appearance, using color as the principal means of expression, is, in a nutshell: A well-formed naked leg is a worthier object for artistic representation than yellow leather shorts,

[6] [Andreas Hofer (1767–1810), Tyrolean patriot, led the Tyrolean People's Army against the French and the Bavarians in the hope that the Tyrol would be returned to Austrian rule. Though the Austrians encouraged his efforts, they betrayed him by first ceding the region to Bavaria and then to France.]

and a budding virginal body offers, for anyone with a healthy
mind, a greater delight to the eye than a rusty sword, a filthy
buffalo collar, or highly polished boots. The powerful impact
of Carstens's drawings and watercolors and the admiration
which is generally showered on Koch's poetic power and
Schick's graceful charm have given the Hellenists renewed
courage and rekindled their hope that they might be restored
to public favor and gain deserved recognition after a long pe-
riod of neglect and, as they believe, misunderstanding. The
old argument has flared up again: Does a painting need in-
teresting subject matter? Does color have an independent
significance? Does the faithful copying of appearance, even
that of impure or indifferent forms, stimulate our imagina-
tion, or does only plasticity of form determine beauty? As
luck would have it, even names have been found for the fac-
tions. In the two words "idealism" and "realism" one has dis-
covered cheap cloaks under which one can easily accommo-
date friend and foe. As the fight grows longer and hotter, the
heads become more muddled, the ideas more confused. The
long neglect they have suffered has so deeply embittered
many of the so-called idealists that they refuse to give any
credit at all to color as a means of achieving artistic effect, de-
claring characterization through color to be a game—and a
frivolous game at that. (Odd, isn't it, that so many should
wish to play this frivolous game, but so few have the courage
to do so.) In many instances their reproaches are fully
justified—that the heads of their opponents contain cameras
instead of imagination, and that they make up for the effort
expended on a detailed reproduction of silver candlesticks,
metal book clasps, damascene sword blades, and so forth, by
leaving the expression of the principal figures lifeless and im-
personal. When, however, they ascribe accidental short-
comings in this or that picture entirely to the artistic princi-
ple, as if the principle demanded the employment of that
specific technique, then they only deceive themselves—or re-
ally do not know that Rembrandt and, indeed, all the later
Dutch painters, the Spaniards of the seventeenth century,
and the Venetians are the exact opposite of corruptors of
art. . . .

Had Carstens used all the possibilities of color in the reali-
zation of his visions, so marvelously full of the spirit of antiq-
uity, we would hardly contrast him so sharply to Mengs, on
the one hand, and to all the later academicians, on the other.
It is simply his renouncing all coloristic effects (which Koch
tried, to a certain extent, to rescue—none too successfully—in
his copies of Carstens's drawings) that gave Carstens's image
of antiquity its naïve assurance and purity. The contemporary
French painters did not want to introduce this spirit of antiq-
uity into modern art at the expense of actual painting. As a
consequence, their achievements were unsatisfactory in both
directions and their school came to an end even before its
founder had died. Carstens's immediate followers, who meant
to give his modeled forms more intensity of color, did not
fare any better. It was precisely the feeling that idealism
could not be satisfactory and be kept alive if it were to remain
locked within the limits of antiquity that called forth the
well-known efforts of Cornelius and his fellow painters. . . .

Unfortunately, for many of our artists the past has no
other charm than that it makes it easier to escape the pres-
ent. From childhood on, we are taught to think little of the
aesthetic side of our lives. The present's absolute incapacity
to rise to lofty artistic heights is solemnly declared a dogma,
and to scoff at the present is regarded as the truest mark of a
sophisticated artistic education. No one has ever considered
that if all this were really so, we would be robbed of any artis-
tic ability whatsoever, and those bad features of the present
might even follow hard on the artist's heels no matter how
far he fled into the distant past. If our history painters only
possessed half the courage of our landscape painters, if they
had the energy to observe without prejudice and to forget
about worn-out aesthetic concepts, the artistic value of con-
temporary life would soon be looked upon differently. The
notion that a male figure is fit to be painted only in a
lasquenet plus-fours or in breast armor would soon give way.
The simple instinct of the people should show these "clothes
mongers" who drag painting down to the level of a costume
show that they are on the wrong track. Why is it that all

those Conrads and Tillys,[7] all those princes who listen to their death sentence or are released from captivity, did not catch on but fail to attract even the most superficial kind of attention, let alone real interest? . . . If, one day, the man appears who has the right approach to our people's activities and sufferings, we will be amazed by the blindness which led us to think of the people as prosaic and obtusely materialistic and to believe triviality to be inevitable in their portrayal, without perceiving the source of a rich and lively poetry. Already in this exhibition we come upon striking proof that even motifs taken from the immediate present do not exclude an idealistic idea if they are treated by a genuine artist. Philipp Foltz has painted a peasant woman with her child in unusually large dimensions. The young woman with her baby has followed her husband into the meadow. Here, resting on the grass, she has nursed her fine boy. We see her in sharp profile as, overcome with happiness, she jubilantly lifts up the child, kicking lustily, in the air and enjoys the full bliss of motherhood. In the distance her husband is leaning on a scythe in a moment of repose, taking full part in the delightful spectacle. This family of peasants is also a Holy Family. The artist has drawn deeply from the fountain of poetry he found in this display of maternal love and happiness and has captured the expression of loving tenderness extraordinarily well. For this picture of common people any unbiased person would willingly give up all those pretentious scenes from the Middle Ages, the peasant wars, and so forth, in which the choice of nondescript, impersonal situations itself betrays the banality of the whole conception. Whoever means well by realism cannot speak out sharply enough against those dry and soulless historic scenes, politely termed historic genre painting. The only compensation for all the many disappointments we meet with when contemplating secular historical pictures is to consider the truly great progress of this branch of painting in the past decade. Although at present

[7] [Conrad was the name of four German kings and emperors who lived between the ninth and the thirteenth centuries. Johan Tserclaes, Count of Tilly (1559–1632), was commander in chief of the Catholic League during the Thirty Years' War.]

we cannot point to any perfect work, we feel that a serious, very promising development is evident when we compare the most recent accomplishments of history painting with the famous works of the earlier decades. There is no need to conjure up Koch's *People's Army* or Tischbein's *Conradin*; it is enough to compare famous historical pictures of the 1830s and 1840s with Piloty's *The Founding of the League*, Dietz's *The Destruction of Heidelberg*, Menzel's *Assault in Hochkirch*, and Leutze's *Washington* [*Crossing the Delaware*] (unfortunately not in this exhibition) in order to recognize the mighty development which this branch of art has undergone in a short time. . . . The newer pictures are not merely different but considerably better than their predecessors. There is more truth and seriousness in their conception; the characterizations are livelier and more detailed; and the clichés, the abstract heads without personal features, the figures merely dressed up in costumes, have become less dominant. . . . If these men could rid themselves of the superstition that every work of art demands the insertion of stylistic embellishments and mere stopgap figures; if they could forget the choirboys, pages, and grooms who do nothing but look bored and take away the best picture space; if these men were not ridiculously afraid of grasping a situation spontaneously and naïvely, of concentrating the action in a dramatic climax, their progress would be even greater and the delight and enjoyment of the unbiased viewer even more unreserved. At any rate, if one compares the fate of idealism since Carstens with the advance of realism in the past twenty years, one cannot have any doubt at all about which side the gods are on, where energetic, constant progress is manifest, and where a lively, serious, and vigorous further development can be confidently expected.

If one could assemble the pearls of the exhibition on a kind of rostrum and collect votes among both the experts and the ordinary public in order to find out to which works the general opinion would award the prize of perfection, the result would show a sharp difference of opinion about a great many of the pictures. In Gustav Richter's *The Raising of Jairus's Young Daughter from the Dead*, for example, some

are known to praise the humanization of the religious story; in the infinite love and truly divine compassion in Christ's face, which permeate every external object, lifting each up to their sphere and fusing each with their own spirit, they see a model solution to the artistic problem presented by a motif that is in itself dry and lacking in appeal to the senses. Others shrug pityingly at the figure of the "mesmerist" to which, they feel, Christ's figure has been debased, and think that rationalism, long overcome in theology,[8] has badly chosen the time and the means to intrude into art. This manner of interpreting biblical scenes cannot be considered absolutely new, for it has been common among the French for quite a while, especially in many works by Ary Scheffer and others. But in Germany the preference for religious subject matter invariably goes hand in hand with a religious persuasion. It is therefore not surprising that a diametrically opposed approach should cause a sensation, and that the appreciation of the excellent quality of the painting (which is perhaps even more noticeable in another of Richter's pictures on exhibition, the *Portrait of a Woman*) should be forgotten amidst arguments about principles. Other works will inflame the passions of the partisans by the choice of the subject matter itself. Piloty's *The Founding of the League*[9] is no more likely to win the favor of the Protestants than Jaroslaw Czermak's portrayal of the reestablishment of Roman Catholicism in Bohemia is able to satisfy the true believers of the Church, despite his rare technical dexterity and his naïve characterization of the Hussite children seduced by images of saints. . . .

There is one work, however, that will be named the pearl of the exhibition . . . and will be carried with shouts of joy to the place of honor. This work is Schwind's version of the fairy tale of *The Seven Ravens and the Loyal Sister*. Schwind

[8] [The rationalist school of German theologians and biblical scholars was active between 1740 and 1836.]

[9] [The Catholic League, led by Duke Maximilian I of Bavaria, was formed during the Thirty Years' War to counter the Protestant Union.]

is known for not having made sparse use of the proverb "to err is human," insofar as it applies to the artist's inalienable right to create poor works of art once in a while. Recently his painting *The Ride to the Grave of Rudolf von Habsburg* was the source of no little embarrassment to his friends. They did not doubt that the power of his imagination is that of a genius; they held onto their conviction that Germany possesses no greater artist, yet, vis-à-vis this wooden emperor, these wooden knights and peasants, they could at best only keep silent. But who thinks of that now; who, looking at the fairy tale of the ravens, cares to remember the illuminated *Knight Kurt*, the caricatured *Singers at the Wartburg*, and the boring *Dedication of the Freiburg Cathedral*? Schwind's *Seven Ravens* not only tells a magical fairy tale, it is itself a magical work that "holds the mind in thrall"[10] and makes all who enter its realm forget everything else in the world. We hear that Schwind had thought of this subject for a picture as far back as fifteen years ago, without, however, immediately finding the right form for its execution. Only after the finest points of the fairy tale had come alive in his imagination and his sensibility had fully penetrated its secret essence did he begin to work on it, completing the painting in a surprisingly short time. Thus, his mature wisdom and his spontaneous enthusiasm were both given an equal chance, and we do indeed find them in perfect harmony in this work, which is the best that Schwind has done to date. We had long known Schwind for a master of naïve story telling. . . . No one equals Schwind in his sincere and moving portrayal of characters who, despite being thrown off course somewhat by a harsh fate, still stand unshaken in their isolated individuality. But never has Schwind displayed his delight in forms, his feeling for grandiose or purely graceful motion, as brilliantly as in the fairy tale of the seven ravens, and never has he combined all his positive qualities and merits as harmoniously as he has done this time. . . .

One cannot pigeonhole this picture in any of the existing

10 [This quotation, from a famous poem by Ludwig Tieck (1773–1853), was a favorite of the German romantics.]

categories. It shows neither knowledge of anatomy nor philosophical scholarship nor theological mysticism. Instead, there is in it the sort of wisdom which pleases both a childlike simplicity and a mature experience. No brilliant intellect speaks in this work; it is the domain of pure, naïve fancy. No showy clichés decorate it; its charm is a heartfelt poetry and a joyful, fresh understanding of the reality of life which we had almost given up for lost. In short, Schwind has made us the gift of a work of art which takes us back to the best times of the past and reveals the peculiarity and strength of the German artistic spirit better than any of the other famous contemporary works. The exultation and the universal enthusiasm it calls forth in all who see it belong to the encouraging signs of our time, proving that our appreciation of true beauty and artistry has remained alive in spite of the mistakes to which it has been, and continues to be, exposed.

III. Almost a third of the pictures on exhibit belong to the category of landscape painting (nearly 500 out of 1,744), and an eighth are so-called genre paintings. . . . Should we compare the forward thrust of these two branches of art to the swamping of our sense of sound with light music and assume a similar decline of our artistic faculties? Many will no doubt answer this question affirmatively. The rise of landscape and genre painting will be explained by the ease with which these pictures can be hung in our living rooms between plant stands and knickknack shelves and made to fit in with the existing decor. Some art lovers and buyers may indeed be guided by such considerations. But this does not mean that the artists themselves pursue alien and inferior aims and are satisfied with the role of mere decorators; nor does the fact that a painting is used badly or improperly by any means warrant the conclusion that it has little intrinsic artistic value. We do not doubt that landscape and genre painting are completely equal in worth to the other branches of art. Poetic power and an eye for artistic values, the essential conditions for a successful work, have as ample a scope here as anywhere. . . .

In another field of art the genre pictures are rather exact counterparts to the small dramatic plays and the one-act novelettes of the modern theater repertory. Everyone agrees that in these works it is the clever handling of the dialogue, the adroit and suspenseful directing of the often quite insignificant plot that assures success and is, indeed, the main contribution of the author. Nobody would doubt that similar conditions apply with regard to genre painting, namely, that the emphasis here must be placed chiefly on the execution by the painter—were not the false doctrine widespread that our painters are, above all, poets. Emphasizing the pictorial aspect would not let this privilege appear clearly enough. But why, then, do these painters not turn to the right material to begin with and write poetry, leaving painting to those willing to forego the glory of shining as "universal artists"? The confusion has been increased even more by intentionally mixing up technical skill with true poetry of color. . . . Just as the musician thinks in sounds, colors express the feelings of the painter, not only palpably demonstrating his thoughts but imbuing them with the right atmosphere. . . .

Granted, even today the eye of our artists could develop a sharper perception of the essential and immediate life in their surroundings, but they are not nearly as shut off from this life—as completely hemmed in by their studio aesthetics, which know nothing higher than the effective poses of worn-out models—as they once were. The dry style of the older Düsseldorf genre painters finds few admirers. We enjoy harmless thoughts, but when harmlessness goes so far as to tolerate dilettantism in the pictorial characterization itself, we turn our backs on it. Even in Düsseldorf, by the way, enormous progress is noticeable, as Vautier demonstrates. However, another bad habit still seems to want to hold the field: a kind of spick-and-span, smooth painting style, a cold neatness of execution for which Dutch housewives rather than the old Dutch masters seem to have furnished the model; and, worst of all, a false coquetry in the characters, which destroys all naïve truth. . . .

In the branch of landscape painting, the established and

long-famous artists have retained their old power of attraction, and the palm they earned long ago still remains in their hands. The well-known favorites of the public—the two Achenbachs and Weber in Düsseldorf; Schirmer in Karlsruhe; Albert Zimmermann, Schleich, Morgenstern, and others in Munich; and Hildebrandt in Berlin—are again strong centers of attraction in the Munich Glaspalast. . . .

The development of modern landscape painting is moving towards a preference for color. Even those painters whose pictures stress the meaningful structure of landscape forms, the beauty of line, and contain a symbolic relation to human conditions use color as a means of expression. . . .

Oswald Achenbach and Flamm are fortunately not the sole but probably two of the most illustrious exceptions to the prevailing delusion that effective coloring can only be attained through glaring light effects. To smear the whole palette over the canvas is not, as many believe, the beginning but rather the end of artistic wisdom; and blinding the eye is by no means the goal of landscape painting. We fully understand the origin of this style. The artist had to enhance the allure of the landscape through the topical interest of the motifs he chose. Our spirit likes to roam afar, our receptivity spans ever-wider circles, and our understanding includes a well-nigh unlimited world of phenomena. Landscape painting did not want to fall behind the culture of our time, and rightly so. But even if we admit that in general only the interest in the subject matter clears the way for the viewer's understanding of the artistic form, and that undoubtedly the creative artist who is unable to muster the proper enthusiasm for an indifferent subject will reveal this indifference in the shaping of his work, we still demand of him not to let himself be subjugated by interest in the subject matter. We want him, instead, to reach beyond it toward the comprehension and mastery of artistic form. Confronted with all those portrayals of oddities of nature and striking light effects, we frequently cannot but believe that the painter himself has been attracted to the motif by sheer curiosity. Any moment we expect to see twirling before our eyes the long staff of the lec-

turer who draws our attention to the marvels. This is not any individual's or any school's fault. It is the great favor which this kind of painting enjoys that provokes exaggerations and calls them forth everywhere.

1859: PARIS AND LONDON
The Exhibition of a Society:
The Photographic Society
of London and
the Société Française
de Photographie*

Early in January 1859 many members of London's world of art and fashion visited the sixth annual exhibition of the Photographic Society of London. Held in the rooms of the Society of British Artists in Suffolk Street, just off Pall Mall, the exhibition was better-attended than the exhibition of 1858, which had been held in the Photographic Society's rooms at No. 1 New Coventry Street, near Piccadilly. Fashionable Londoners more regularly visited the Pall Mall area, the location of the Water Colour Society's rooms, which the Photographic Society had also used for its exhibitions of 1855 and

* I am indebted to Susan Waller for the research, selection, and translation of the documents contained in this chapter, as well as for the introductory section.

1856. Ladies dressed in an amplitude of crinoline, three-quarter-length walking coats, and close-fitting feather-trimmed hats and gentlemen in frock coats, waistcoats, and slightly baggy trousers looked exactly like the *carte de visite* photograph each had given to friends and family as they paused to greet acquaintances. Some of them would have been "taken" by J. E. Mayall, others by the French daguerreotypist Antoine Claudet, a member of the Royal Scientific Society; ladies, in particular, appreciated being gracefully posed by another Frenchman, Camille Silvy.

The Photographic Society of London had been formed in 1853 at the suggestion of Claudet and Roger Fenton, who belonged to a group of amateur and professional photographers that had been meeting informally in the *Art Journal*'s rooms. The painter Sir Charles Eastlake, who had recently resigned as Keeper and Secretary of the National Gallery, was elected the Society's first president. Sir F. Pollock, Lord Chief Baron of the Exchequer, succeeded him as president of the Photographic Society. The Prince Consort encouraged the fine-art photography of J. E. Mayall and Roger Fenton and assured the Society of his active support—the Queen shared his enthusiasm for photography. The Photographic Society immediately began publishing the *Journal of the Photographic Society*, known after 1858 as the *Photographic Journal*. It provided technical information useful both to amateurs and professionals, reports on its activities, and reviews of exhibitions of photographs in England and abroad.

In 1851—twelve years after the invention of the photographic process by Louis Daguerre in France and Henry Fox Talbot in England—daguerreotypes and photographs had first been exhibited in England at the Exhibition of the Works of Industry of All Nations. As the product of a mechanical process, "light writing" qualified for admission to the Crystal Palace; painting, because it was not produced by a mechanical means, did not. The following year, 1852, the Society of Arts and Manufactures held the first exhibition devoted solely to photographs, and in 1857 one thousand photographs had been included in the Art Treasures exhibition held in Manchester.

The Photographic Society's sponsorship of annual exhibitions, to which both members and nonmembers could submit work, followed the practice established in England by independent societies of painters and sculptors like the Royal Academy and the watercolor societies. In 1857 and 1858 reviews of the exhibitions appeared in the Society's journal. In 1859, however, recognizing that there was "an obvious impropriety" in reviewing its own productions, "for the opinions were at once translatable into market values," the *Journal of the Photographic Society* published excerpts of reviews found in the two leading literary journals and the daily press.

Always written by an anonymous critic, who often also wrote the reports on fine arts exhibitions, the reviews focused on determining the aesthetic standards for the new, mechanical art. In the fine arts, historical subjects were placed in the highest category. Landscape, portraiture, and genre, though they often predominated in painting exhibitions, were placed in lower categories. At the exhibitions of photographs these lower categories also had the most numerous entries.

One of the first uses of this mechanical art had been to take "likenesses." Prior to photography's invention, the portrait was a luxury reserved for the rich; the painted miniature was a manifestation of the intimacy enjoyed in a court society that enhanced the cult of the person. The ease with which photography took "likenesses"—in 1850 a miniaturist could furnish thirty to fifty portraits a year, while a photographer could churn out one thousand to twelve hundred—quickly brought the cost of a portrait down to a level the middle classes could afford. The prosperous bourgeoisie was pleased by the intimacy of the photograph's trompe l'oeil realism and the status conveyed by a portrait, albeit one secured by a mechanical art. The operator of the mechanical apparatus soon became a "fine art" photographer who set up his camera *en plein air* and posed his model so as to secure an impression from which an aesthetically pleasing representation could be made. He regarded his creation as a work of art and himself as an artist.

Landscapes, whether views of familiar stretches of countryside or unfamiliar and exotic places, provided many photog-

raphers with subject matter. As early as 1839 Horace Vernet had traveled through Egypt with a camera. As an observing and recording instrument in the service of science and archaeology, photography was invaluable: it secured an exact and accurate copy of a two-dimensional object, an inscription, a painting, a fresco, or flat reliefs, drawings, and cartoons. The British Government gave Thurston Thompson a commission for copies of the precious Raphael tapestry cartoons.

Adapting the academic criteria for painting to the new medium posed problems. Oscar Rejlander's allegory "The Two Ways of Life," a photograph which used models posed in the nude and in ancient Greek dress, aroused a storm of controversy when it was exhibited at the Art Treasures exhibition in Manchester until its purchase by Queen Victoria established its propriety. When it was included in the Photographic Society's exhibition the next year, the anonymous reviewer for the *Journal of the Photographic Society* explained the problem of realism and idealism in the fine and mechanical arts:

> It will be evident to the most unthinking, that human nature, as idealized by the painter and sculptor in all ages, is a very different thing from what we meet in every day life. There has always been an arbitrary conventionalism in art which demands that figures shall more or less run in a certain mould; and notwithstanding Mr. Reijlander's [sic] explanation of the error committed by artists in the muscular development of the human form, convention has made a law, and now it would seem to be as irreversible as that of the Medes and the Persians. We think the whole gist of the matter lies in this, that Ideality cannot be produced by a merely mechanical process. It is only to be produced by the perceptive faculty guiding the ready hand. Mr. Reijlander [sic] has been eminently successful in securing models; but good as these are, they are far, very far, from what the arbitrary conventionalism we have alluded to demands.[1]

In France, as in England, a photographic society was formed. Photographers, scientists bent on improving the invention, and artists alert to the photograph's value as a *note de mémoire* met in 1851 to found the Société Héliographi-

[1] *Journal of the Photographic Society*, May 21, 1858, p. 208

que, which in 1855 became the Société Française de Photographie. It published a journal, *La Lumière* (after 1855 it was renamed the *Bulletin de la Société Française de Photographie*), and sponsored exhibitions of photographs in its meeting rooms at 35 boulevard des Capucines. The exhibitions of the French photographic society, like those of its London counterpart, included photographs of paintings and sculptures as well as landscapes, still lifes, portraits, figures—nudes were excluded from the 1855 and 1857 exhibitions—and scientific and archaeological studies. The exhibitions were biennial, like the Salon. In 1857 a special committee, which included Gautier and Delacroix, was formed to press for the inclusion of photographs in the Salon.

In France, as in England, photographs were first shown in industrial exhibitions: The French Industrial Exposition of 1844 had displayed a large collection of portraits and landscapes, and at the Exposition Universelle of 1855 photographs were still classified with industrial products. Despite the efforts of the Society's committee, in 1859 the government again refused to admit photographs to the Salon; it did allocate space in the Palais des Champs-Élysées for an exhibition of photographs to be held simultaneously. However, it would be accessible only through a separate entrance.

A major reason for the opposition of artists to the inclusion of photographs in the Salon arose from the use of photography to copy paintings. Copies of paintings had never been admitted to the Salon, though copying old masters was a recognized part of academic training. Moreover, engravings and etchings done after paintings were regularly exhibited; they were usually executed with the consent of the artist and both the artist and the engraver or etcher received a share of the receipts from the sale of the print through a dealer or an art union.

In 1855 André-Adolphe-Eugène Disdéri, then director of the Société Française de Photographie, had published, without permission, a photographic reproduction of Charles Müller's painting *Long Live the Emperor! March 30, 1814!*, which had been exhibited at the Exposition Universelle.

Müller sued Disdéri, but the French court ruled in Disdéri's favor on the ground that the reproduction of Müller's painting had not damaged the artist. Photographers everywhere followed the case with interest. In its report on the case, the *Art Journal* disagreed with the decision:

> The case of M. Müller is, we admit, a peculiar one and though we deny that he has received injury, at least such injury as to claim damages, we should under the circumstances have restrained the publication of the photograph. M. Müller had not sold his picture, permission to copy it had not been asked, and consequently there was no opportunity afforded for assent to, or refusal of, the request; he doubtless considered it sacred in a place of public exhibition—as it assuredly ought to have been— M. Disdéri was therefore wrong in availing himself of the opportunity he had to make a photograph without asking the artist's permission.[2]

Copyright was a double-edged problem: Photographers could not only make unauthorized copies of a painter's work, they could do the same to works of other photographers. In 1857, when London's Photographic Society formed a committee to examine the copyright laws and their application to photography, Roger Fenton set forth both sides of the question in a letter to the editor of the Society's journal:

> There will be no dissent from the opinion, that when a photographic artist has obtained—perhaps by much outlay—certainly by the exercise of taste and skill, the fruit, partly of natural gifts, partly of careful cultivation,—a valuable negative, that artist is entitled to all the benefit that he can get from it, and that he has a right to prevent any one from reaping the harvest who has not sown the seed.
>
> Again, no photographer will claim the right to take a negative for publication of any picture, statue, or engraving which belongs to another person, and not to himself or to the public, of which he forms a part. And yet there is nothing so far as we know, in our present law to debar him from encroaching upon the rights of others in the latter case, nor in the former to protect him in the undisturbed possession of what is his own.[3]

[2] *Art Journal*, December 1, 1855, p. 319
[3] *Journal of the Photographic Society*, January 21, 1858, p. 15

In neither France nor England were photographs protected by the copyright law that applied to works of art. The laws predated its invention, and there was doubt as to how—or even whether—the laws designed to protect the fine arts applied to the new medium.

The French Government's decision to permit an exhibition of photographs in the Palais des Champs-Élysées did not satisfy those who believed that the medium was not a mechanical art, but it was a concession. The Société Française de Photographie named a jury and invited its foreign and domestic colleagues to submit photographs for the exhibition. When it opened on April 1—with 1,295 works by 148 exhibitors—the exhibition, half in and half out of the Salon, forced critics to take a stand on the question of whether photography was indeed an art. Baudelaire, whose aesthetic stressed the artist's imagination and individualism, was especially repelled by the material reality conveyed by photography and criticized it harshly.[4]

A more cautious review appeared in the newest Parisian art magazine, the *Gazette des Beaux-Arts*. Launched by Charles Blanc and others associated with him in writing the *Histoire de l'Art en France*, the *Gazette des Beaux-Arts* would present serious competition to *L'Artiste* and would become France's most distinguished magazine of art. Blanc, aware that fifteen years earlier a magazine of this sort might have secured eight hundred subscribers but now could anticipate ten thousand, considered the changes which made this possible in the introduction to the first issue. Frenchmen, Blanc explained, were becoming more prosperous, and as their fortunes increased so did their interest in the arts. But that alone was not enough. The international exhibitions had introduced Frenchmen to strange and wonderful objects from across the globe and had whetted their taste for information about the beauties and mysteries of art. Blanc also believed that it was now possible —as it had not been since 1824, when the romantic painters first exhibited their work—to deal with artistic matters without becoming a partisan of either of the schools whose battles

[4] See the section on Baudelaire in this volume.

wracked the Salon. "Thus," he wrote, "no exclusivity will find space in this journal. Beauty is everywhere, art is present and admirable in different degrees in everything, in a Raphael fresco and a Gravelot vignette, in a heroic composition by Poussin and in a simple flower of Choffard or Salembier."[5]

In keeping with this position, the *Gazette des Beaux-Arts* asked one of its younger staff members, Philippe Burty, to review the photography exhibition of 1859. Born in 1830, Burty had begun as an assistant to a decorative designer at the Gobelins Tapestry manufactury. His first art criticism appeared in *L'Art au XIX^e siècle*, edited by Théodore Labourieu. When the *Gazette des Beaux-Arts* was organized, Charles Blanc asked Burty to serve as critic for sales, books, and prints. In the years to come, Burty would emerge as an important critic of decorative arts and etching, an influential collector of Japanese art, and a staunch supporter of the Impressionists. In 1859 he was a relatively unknown young man of twenty-nine. His thoughtful review of the photography exhibition considered photography both as science and as art. Though he recognized the qualities of Nadar's portraits and noted stylistic distinctions among different photographers' works, he came to the conclusion that photography was not an art.

The courts ruled on the artistic status of photography in 1861 and 1862. Photographs of Lord Palmerston and Count Cavour by Mayer and Pierson were pirated and sold by another photographic team. The photographers appealed for protection under the French copyright laws that protected works of art. This time the court's decision guaranteed the photographers' protection and photographs were now legally works of art. This decision was immediately controversial: Ingres, Flandrin, Robert-Fleury, Troyon, Jeanron, Isabey, and Puvis de Chavannes were among the artists who signed a petition asking the court to revoke its decision. The petition was refused, but the debate was not settled.

Those who believed, like the critic for the London *Times*,

[5] *Gazette des Beaux-Arts*, I, no. 1, 1858, p. 13

that "there is an art in employing the sun to paint for you, just as there is in painting for yourself"[6] would continue to argue with those who believed, like Philippe Burty, that it is not art because art constantly idealizes nature.[7] The exhibitions of the photographic societies—which by 1859 had removed photographs from the industrial exhibitions and had placed them, if not with, at least near the exhibitions of painting and sculpture—would continue to keep the issue before the public and the critics.

Anonymous: *The Exhibition of the Photographic Society in Suffolk Street Gallery*[1]

At the moment of our going to press, our President, the Lord Chief Baron, is doing Photographic Honours to the world of art and fashion in Suffolk Street. The Society's rooms are thronged by a brilliant company; our friends and guests appear to enjoy the opportunity of meeting in friendly circles as well as the splendid and various specimens of Photographic Art displayed on its walls. The Exhibition, we are glad to report, has been more successful up to this date than *any* Exhibition we have yet had the pleasure to hold.

As there must appear an obvious impropriety in the Council of the Photographic Society reviewing their own productions, those of their associates, and also those of their generous emulators and fellow-students far and near—pronouncing opinions which at once become translatable into market values—it is thought wise to discontinue this form of self-examination.

Yet, as our readers will expect to see some adequate record of the Exhibition in our columns, we propose to call to our aid the chief voices of public thought, and listen, under limitations, to what they may praise or blame of our work. . . .

[6] Quoted from Helmut Gernsheim, *Creative Photography; Aesthetic Trends, 1839–1960* (Boston: Faber & Faber, 1962), p. 88

[7] *Gazette des Beaux-Arts*, II, May 1859, pp. 209–21

[1] [Verbatim excerpts from the *Photographic Journal*, January 21, 1859, no. 77, pp. 143–50]

FIRST IMPRESSIONS. "Photography is (there can be no denying it) another wing added to the great palace of Art— perhaps, in comparison with Raphael chapels and Ostade kitchens, a wing of mere workshops and tool-rooms: but still they make the old house larger and more luxurious, they lengthen the vistas and enrich the whole family; so we are glad to see them, and long every year to walk over the "improvements." Except in size, we see no particular advance this year in the new Art: the tent-stakes remain in the same holes, water and cloud with all their fugitive beauties are still as unfixed and chameleon-like as ever,[2] and promise for some time at least to be to the hooded men what quicksilver was to the alchemists, the unchainable and truant spirit that tempted them by apparently listening to their spells and yet refusing to own their power. This year, it is true, the photographs in these rooms, almost entirely English, are sharp as if drawn with a knife-point, and yet full of dark cavernous depths and brooding filmy shadows; still it is in size and breadth that their special originality consists. The portraits are mellow, broad; and the genre pictures original and clever as ever, with the usual defects and limitations, arising chiefly from the obstinate fact that while the sun-machine has eyes keen as an angel's, a hand swift, sure and fluent, it has no soul, no heart, and no intellect. Indeed, after all, it can but copy; create it never can. Set it down before a sunbeam, a breaking wave . . . and it will do it,—but to shape out an ideal purity, nobleness or bravery, that it will do—*never*. It is at best an angel copier; a god-like machine of which light and sunshine is the animating Promethean fire. Put it higher, and you degrade Art to the worshipper of machine."—*Athenaeum*

"The Exhibition has its lessons as well as its encouragements. It shows in a very marked way that there is an art in employing the sun to paint for you, just as there is in painting for yourself. You can no more get a tolerable view or an effective group by merely clapping your camera down, fo-

[2] [This technical problem was first solved by Gustave Le Gray in 1856, but at the end of the century many photographers were still finding it difficult to capture sky or water and land in the same image.]

cusing your object, slipping in your sensitive plate, uncovering your lens, and opening and shutting your slide, than you can make a pleasing sketch from the first spot on which you plant a random easel."—*Times*

"Undoubtedly, the most artistically valuable application of photography, up to the present time, is the noble series of photographs by Messrs. Caldesi and Montecchi, from the cartoons of Raphael at Hampton Court.[3] Another series from the same cartoons of nearly as large dimensions and of almost equal merit, have been undertaken for the government by Mr. Thurston Thompson. We think it of essential consequence to remark that these valuable works, which together form by far the most important feature of the present exhibition, are seen under the greatest possible disadvantage. The visitor naturally follows the order of the catalogue, and by the time he arrives at them, the eye is rendered so fastidious by the dainty delicacy of detail upon which it has been feasting, that the cruel traces of time and ill-usage on old cartoons (so faithfully reproduced in the photographs) and—compared to the 'pencil of light'—the comparative coarseness of the touch of Raphael and his scholars becomes most painfully apparent. It is like being suddenly placed close to a pealing organ after listening to a solo on the violin. The visitor, who would see what the imperfect lighting of the original cartoons at Hampton Court would never permit him to discover, should go to these photographs before he has lost a 'fresh' eye, and before his vision has been rendered incapable of thoroughly appreciating their innumerable beauties."—*Daily News*

FIGURES AND LANDSCAPES. Though mellowed by the dimness of Eastern interiors, nothing can surpass Mr. Roger Fenton's Eastern characters, which convince us that we want new Arabian Nights, and some Eastern painting newer and nearer our own day. The *Nubian Water-Carrier* (608) is the serf-like patient woman of the old servile type, with the talis-

[3] [Seven of Raphael's ten original cartoons depicting the Acts of the Apostles, executed for tapestries for the Sistine Chapel, had been purchased by Charles I in 1630.]

man on her bare breast, and the huge jar poised on her head as if she was one of the Caryatides that Athenian sculptors used to poise up their roofages. In *In the Name of the Prophet, Alms* (617) the Turk's look of impatient, hard contempt is caught in a wonderful flying shot; and in the *Egyptian Dancing Girl* (621), the Bayadère[4] is a beautiful example of voluptuous tranquil beauty, as she stands with the row of dangling gold coins round her brow, and the flower-like castanets pendent from her lithe fingers. . . . The Messrs. Bisson, whose views of the Louvre are so gigantic and highly finished, exhibit a *Swiss View* (202)—we suppose of Sion and the valley under the Simplon. The water threads it in silver lines,—the houses no bigger than nut-shells; yet you can pick out your special window at your inn, almost count the stones that mosaic the steeple of the valley church,—almost estimate what repairs are wanted to the roof of the second house to the right. Beyond, the mountains slope down in slanting walls of softly-tinted, hazy shadow, soft and thin as the greys under a wild dove's wing. . . .

"Foremost among the landscapes of the exhibition stands the magnificent dioramic view of Cairo, upwards of eight feet in length, by Mr. Frith. It was taken from the summit of one of the buildings that command a view of the famous city. The flat-roofed houses, the tall minarets, the narrow streets, the crowded localities, the Nile winding in the distance, and beyond it the dim outline and diminished form of the great pyramids, all contrive to make this one of the most extraordinary and interesting works which have been produced. The dioramic view is surrounded by a number of other views of the locality which have already been made familiar to the public by the charming stereoscopic views published by Messrs. Negretti and Zambra. Next to this in point of size, and remarkable for its boldness, combined with the most remarkable accuracy and clearness of detail, is the great view of the interior of the Crystal Palace, Sydenham, by Mr. Delamotte. The sharpness of outline of the long vaulted roof and its supporting columns, the play of shadow on the water of the

4 [An Indian dancing girl]

basin of the crystal fountain, the foliage of the climbing plants, and the trees and shrubs in the nave, are all given with a success which has rarely or ever been equalled. This work is one of the photographic pictures which it is intended to distribute among the subscribers to the newly-established Crystal Palace Art Union. . . ."—*Morning Chronicle*

"The figure-pieces in the exhibition do not, we confess, impress us very favorably. Mr. Rejlander has some, very clever in their bold coarse way, and very valuable as studies. But photographers mistake, as it seems to us, the capabilities of their art, when they attempt to produce photographic compositions in rivalry with works of the pencil. A picture, as distinguished from a view, or a representation of 'still life,' is valuable only in proportion as it bears the impress of the human intellect. It is not because he has faithfully copied a woman and a child in a certain position that we admire a Madonna by Rafael, but because we see in its depth and purity of feeling a noble realization of an original and poetic idea. A photograph of the models he used in the positions he placed them, and surrounded by all the accessories he introduced, would no doubt form a valuable study for a painter, but it would be a sorry substitute for his picture. What gives his picture all its value is that which he added to its models, and not what he found in them.

When, therefore, a photographer, having placed certain persons in an attitude, and surrounded them with various 'properties,' takes a photograph of the group, and presents it with all the stiffness of arrangement, vulgarity of feature, and blankness of expression—or worse, a coarse exaggerated attempt at the particular expression intended to be conveyed—and asks your admiration for it under some poetic or suggestive title, the most unobservant is struck with the incongruity, and the instructed eye turns from it with disgust. Not the worst—perhaps the best—of such subjects here is Mr. Robinson's *Fading Away*, which has for months past been in every photographic printseller's window; but look steadily at it for a minute, and all reality will 'fade away' as the make-up forces itself more and more on the attention. And you have only to go a few steps and you see the same face, the same

form, and the same character doing duty as *Mariana*, as it has done—the lens having no power to modify or select—for no doubt divers still more dissimilar persons and sentiments.

How awkwardly this repetition of face and form comes in is even more palpable in the photographs, undoubtedly clever, as in many respects they are, of Messrs. Delferier and Beer, where a certain broad-faced female, evidently belonging to a great city, in some pictures is an innocent northern peasant preparing for market, in another a sentimental inmate of an Eastern harem. It will not, we trust, be supposed that we are insensible to the value of photography in those branches of art in which the human form is the chief object. Photography is in truth, or may be made, an invaluable assistant to the painter of history or *genre*; but photographic renderings of historical, poetic, or domestic subjects are, we are convinced, a mistake—only serving to mislead and corrupt the unformed taste. . . ."—*Literary Gazette*

PORTRAITS. In portraiture the exhibition is as rich as might be expected. Pre-eminent for taste and delicacy in this application of the art are the miniatures of Mr. T. R. Williams, over whose frame is placed, not undeservedly, a photograph from Rauch's marble *Victory*, wreath in hand. The miniatures of Messrs. Lock and Whitfield also well merit a high place among the praises of their many competitors; and the veteran Claudet still holds his ground, though the large portraits he exhibits have too much of the painter's work upon them to give the sun quite fair play.

"Dr. Diamond, editor of the *Photographic Journal*, applies the art to the forwarding of medical science, in his photographs from [*sic*] the insane, which illustrate, in a useful and novel manner, the physiognomical characteristics of mania. . . ."—*Daily News*

STEREOSCOPIC. "The least satisfactory branch of the Exhibition is the stereoscopic. In this there is a constant temptation to vulgarity in the choice of subjects, and exaggeration in the rendering of solidity. The subjects of the stereoscopic slides which fill our shop-windows, where they are not land-

scapes or portraiture, are often gross, and almost invariably 'snobbish' to a painful degree. There is a great danger that photography, by the dissemination of this class of works, will be fostering a worse taste than the worst school of painting ever did or can spread."—*Times*

"One of the most curious series is that of ninety stereographic views in Brittany, illustrative of a walking tour made by Mr. Jephson. This work may be said to commence a new era in publishing, as the photographs are to be sold with the volume of the travels. Many of the stereoscopic views and portraits are poor and common."—*Morning Advertiser*

MISCELLANEOUS. "In illustration of new processes and new applications of the art, the Exhibition is rather disappointing. Of Mr. Pouncy's much-talked-of carbon process, and of which the Society is regarded as to a certain extent the exponent, there is only a single example by the inventor, and only one other by a disciple. Whilst we cannot regard it as having succeeded so perfectly as Mr. Pouncy in his zeal very naturally imagined, we are by no means disposed to join in the attempts made to depreciate it in the public estimation. To us Mr. Pouncy's print appears very promising, and if to chemists it really seems permanent, we cannot think either professors or amateurs will do well to neglect it. The present example is wanting in clearness and sharpness of detail, and also in purity of tone: it has what painters and lithographers call 'a mealy look'—something resembling in appearance a drawing made by a stump and brush with powdered black lead. Of the carbon printing processes, either English or foreign, there is not a single example; nor is there one of the application of photography to astronomy; nor of Mr. Talbot's photographic engraving; nor of any of the new and loudly-vaunted photo-lithographic processes. Mr. Pratsch has, however, sent several examples of his photo-galvonographic (or, as he now seems disposed to call it, 'Nature's engraving') process; and as they are 'quite untouched,' they give a much more true, and a much more satisfactory, idea of the process than the public prints. For some classes of subjects it seems

so clearly suited, that we trust it will not be suffered to fall into abeyance."—*Literary Gazette*

CONCLUSION. "Altogether the chief impression left on the mind by this exhibition is one of delight, with the work already accomplished, blended with a puzzled self-questioning as to the limits of the application of an art for which every day opens new fields, and as to the bearings of photography upon the work of the painter, which it must either influence for good, or, in the long run, so far supersede altogether, at least in its unidealized manifestations."—*Times*

"With all its shortcomings and its redundances the Photographic Society may well be proud of its sixth exhibition. If it does not show the entire strength of the art, it very fairly illustrates the point to which the art has reached in the country; and it shows with sufficient clarity the wonderful advance which photography has made during the few years of its existence and the almost unbounded range of its capabilities."—*Literary Gazette*

Philippe Burty: *The Exhibition of the Société Française de Photographie at the Palais des Champs-Élysées*[1]

I. It should be recalled that at the Exposition Universelle of 1855 photography, despite protests, was relegated to a place among the purely industrial products. This was very harsh treatment, and photography has dreamed ever since of winning over the public, that judge of last appeal. La Société Française de Photographie, which was founded late in 1854 under the presidency of M. Regnault, of the Institute, and includes among its officers the Count Léon de Laborde, opened a first exhibition in its meeting rooms, and later, in 1857, a second at the boulevard des Capucines in M. Le Gray's rooms. This year the Society has at last obtained space from the government in the Palais des Champs-Élysées—the

[1] [Translated from the *Gazette des Beaux-Arts*, vol. II, May 15, 1859, pp. 209–15]

space is separate from the fine arts, it is true, but because of its contiguity with them, photography acquires in the public eye an importance which vindicates it to a certain extent. If the photographers want my opinion, they should not for the present ask for more. . . .

When, several months ago, a heated discussion arose between the editors, who felt their interests were compromised, and the photographers, who are as passionate as any newly arrived at the contest, the *Gazette des Beaux-Arts* had to wait until feelings were calmed and until the exhibition, which has just opened, had provided it with sufficient liberty to voice an opinion on this question. If the debate had remained simply circumscribed within the limits of commercial counterfeiting, it would not be hard to place the blame. It is clear, regardless of which method is used, that counterfeiting a work of art is theft, and the publishers were right in invoking government protection. But photography has been treated as a "fraudulent industry"—which tends to throw suspicion on the sun's honesty!—and has been accused of "easily crushing original works without monetary risk, serious work, or intellectual effort." Today we find ourselves in the presence of series of photographs of the greatest commercial and artistic importance, works remarkable and in every sense perfectly realized. What publisher of prints, in any time or place, has dared to undertake an actual reproduction of the *Cartoons of Hampton Court*, as MM. Caldesi and Montecchi have, or of *Flemish Painting of the Fifteenth Century*, as Fierlands of Brussels has? The capital outlay today is enormous, for though the negative can be obtained cheaply, the pulling of proofs costs much more than it would for an engraving or lithograph. The results are risky, both because of the cost of production and the relative aridity of some of these admirable studies. Even if an imaginary publisher had encountered an engraver courageous enough to undertake this gigantic work—something, in fact, impossible—how many fragments of this reliquary of Saint Ursula would he have been able to give us, in our impatience, in a year, compared with what a photographer is able to reproduce in its entirety in a few hours—if not with all of its pictorial effect, at least

with minute fidelity to features, attitudes, and silhouettes? I would also wish, for a moment, that the famous madman who would have commissioned this enterprise had met this tireless engraver who, by a phenomenon unprecedented in the history of art, could have gone back in time and become intimately imbued with the spirit of an epoch in which he no longer lived: Would he find any among the translators who did not constantly tend to substitute their own genius for that of the painter? Translations are as beautiful as they are personal and, by the same token, less faithful. If you leaf through the work of the innumerable engravers of Raphael in the Cabinet des Estampes, you will see that the most illustrious of these were fascinated by only one of the aspects of this multifaceted genius. Some have been impressed by his grace, others have been struck by his power; all, in spite of themselves, but often with great talent, have only brought to light their own intimate personality. Photography is impersonal; it does not interpret, it copies. That is its weakness as well as its strength, because it reproduces indiscriminately the casual or barely visible detail which is the soul of the work and thus creates resemblance. It will, no doubt, eliminate in a very short time those cheap engravings and lithographs, which have been unscrupulously published for less sensitive people, by supplying cheaper but improved reproductions. But photography stops at idealization, and it is precisely here that the role of the talented engraver and lithographer rightly begins. Let the publishers be reassured: Photography scarcely addresses itself to the populace, at least in its current state of development. It provides artists with materials for which long experience is needed to distinguish the fine product from the merely adequate one. It offers the curious, who may lack the means, a way of traveling to the Old and New Worlds—with their feet on the andirons and their noses in books. To the antiquarian it offers reproductions of monuments; to the physiologist pages of anatomy against which no art can argue . . .

Photography carries with it the indelible traces of its mechanical process. If the light grazes the surface of a panel

painting toward which the camera is pointed, the grain of the oak will look like watered silk on the print; if the light falls on a painting with large brushstrokes, the luminous points on the tops of the accumulated paint will look like small white spots; in certain cases one might even see the contour of underpainting which has only been lightly covered by a thin glaze. In portraits photography almost always exaggerates the nose and the chin, which form the planes closest to the camera. In addition, since light does not produce the same set of tones on a chemical substance as it does on our eyes, yellow turns black, as does green; red and blue, on the contrary, turn to white.[2] There are therefore overwhelming problems in rendering the colored effects of a painting, but at least it provides the draftsman with an accurate tracing in the desired size, and he then has only to fill in the relief. . . .

One sees what fuel commercial and artistic interests added to these debates. Photographic products exist throughout the world and the exhibition which has just opened in Paris is a witness to its importance and the interest it arouses in both hemispheres. The catalog, which we find a little cursory, contains 1,295 items and the names of 148 exhibitors. We are happy to see gathered in Paris the results of the unceasing efforts of art aided by science.

II. In passing through the rooms of the photography exhibition, one easily distinguishes not only individuals but also schools. The work of English photographers are as well defined a group as their watercolors and oil paintings were at the Exposition Universelle. The portraits of the Very Honorable Marquis of Aberdeen, of Lord Brougham, and of Professor Faraday by MM. Maul and Folybanc, speak the purest English to our eyes, and even the landscapes have a British accent. . . .

The English know how to give more charm than we do to the pulling of their proofs. Thus, among the photographs of MM. Caldesi and Montecchi (who have undertaken the marvelous pictures of Hampton Court of which we will speak a

2 [In the 1880s orthochromatic film began to correct this problem.]

little later) there is a *Jockey on Horseback* unequaled in its absolute precision, without dryness, of the smallest details of the man's costume and the horse's coat; the hairs could be counted with a magnifying glass. . . .

The choice of certain points of view at certain hours and with preconceived effects, the studied rendition of a feeling which is in some way national, the use of procedures which belong only to them and, above all, the care in the placement of the camera and the pulling of proofs give the English works an appearance that is completely original, which is summarized, as we pointed out, by the velvety blacks and the harmony of lights. . . .

III. . . . Unquestionably, M. Nadar has made portraits which are works of art in every sense of the word. He has accomplished this by the way he lights his models, the freedom of gesture and bearing he allows them, his attentiveness to finding the typical expression of the features. All the contemporary literary, artistic, dramatic, political, and intellectual stars have passed through his studio. The sun is only the assistant; M. Nadar is the artist who is willing to give him a task. The series of portraits which he exhibits is the *Panthéon* —serious this time—of our generation[3]: Daumier meditates on his Robert Macaire epic[4]; P. de Saint-Victor mentally sculpts the Vénus de Milo[5]; M. Guizot stands with his hand in his vest, as cold and severe as if he were waiting for silence at the speaker's platform before giving a devastating retort[6]; Corot smiles at someone who asks him why he doesn't finish his

[3] [In 1854 Nadar had published a large lithograph, the *Panthéon Nadar*, with caricatures of 270 distinguished contemporaries.]

[4] [Daumier's caricatures of Robert Macaire, based upon the disreputable businessman created onstage by Frédérick Lemaître in the play *L'Auberge des Adrets* by Benjamin Antier, Saint-Amand, and Polyanthe, first appeared in 1836.]

[5] [Paul de Saint-Victor (1827–81) was the drama critic for *Le Pays* between 1851 and 1866 and *La Liberté* between 1866 and 1869.]

[6] [François Pierre Guillaume Guizot (1787–1874) began his career as a statesman in 1830 and by 1848 was Prime Minister to Louis-Philippe.]

landscapes; Dumas lifts his powerful, animated head[7]; Jean Journet, with his scraggly beard and the folds of his model's drapery, spouts propaganda[8]; and Mme. Laurent reappears in the four outfits of the *Chevaliers de Brouillard*.[9] We call attention particularly to the simple bust of Mme. Laurent seen from the back. Hair carelessly twisted up, a neck strongly and elegantly connected to the head and shoulders, a shawl draped in large folds; it is nothing, and yet it lives, it resembles, it engraves itself in your memory as does a drawing by a great master. All these photographs show fine effects and execution. Taken individually, in the resemblance they claim (and which is certain) to people one has never seen, or in comparison to the other photographs around them, they show that an intelligent man uses his brain as much as his camera, and that if photography is not a complete art, the photographer nevertheless has the right to be an artist.

IV. The landscapes, several of which are very beautiful, do not offer a very marked progress over those of previous exhibits. The prints of M. Davanne, despite their small format, are perhaps the most remarkable in this group. His photographic studies, made at Pierrefonds or in the parks of Versailles and of Trianon, are surprising for the salient relief of the foliage, which, being green, presents great technical difficulties in practice. . . .

Study of an Elm, in the forest of Compiègne, by M. Margantin has the svelte appearance of a Théodore Rousseau. The details of the foliage, the wild twigs of the bush which forms its pedestal, and the grass, spread out like a tapestry on the far side of the moat, are rendered with unusual vigor, but at the expense of the masses of shadow, which are heavy.

Let us say that in general the landscapes gain much by the

[7] [The elder Alexandre Dumas (1802–87), dramatist and novelist, coauthor of the novels *Les Trois Mousquetaires* (1844) and *Le Comte de Monte Cristo* (1844)]

[8] [Jean Journet, born in 1799, was a self-styled "apostle" of the socialist Fourier.]

[9] [Mme. Marie Lughet Laurent (1826–76), a member of a theatrical family, excelled as an actress in popular dramas.]

absence of people. One always senses the constraint of the pose, unless the person is the amusing poodle that M. Aguado had trained so well. . . .

V. MM. Bisson, in addition to the *Ancient Door to the Library of the Louvre,* with which everyone is familiar, have exhibited a corner of the *Cloister at St. Triomphine* at Arles and a perspective of the inner courtyard of the *Cloister of Moissac;* these prints are unrivaled in the fineness of the details and of the grain of the stone and, above all, in the warmth and transparency of the shadows. These gentlemen have also extended the photographic reproduction of engravings as far as M. Bingham has that of painting, but their work still leaves something to be desired: The light is vague, the half tints soft, the blacks pasty; one no longer senses in these blurred lines the neat cut of the burin. . . .

From Jerusalem M. Graham sends a *Voyage in the Biblical Lands* of which Raphael's genius could supplement nothing. We only knew Raphael as that incomparable master of the judicious arrangement of groups and the profound comprehension of gesture. On studying these prints, he also seems to us as penetrating as Leonardo's *Christ Giving the Keys to St. Peter,* as powerful as Michelangelo's *Miracle of the Fishes,* and as philosophical as Nicolas Poussin's heads of the apostles listening to *St. Paul's Sermon at Athens.* . . .

VII. Photography is still an art in its infancy, and one cannot tell what the future holds for it. Two clever amateurs, Daguerre and Niepce, invented the daguerreotype. Some ingenious person had the idea of replacing the daguerreotype plate first with wet paper and then with collodion-coated glass.[10] These first discoveries were clearly strokes of genius. Today distinguished chemists like MM. Davanne and Niepce de

[10] [The daguerreotype was a unique image on metal. Henry Fox Talbot used paper to make a negative image from which multiple positive images could be printed; Gustave Le Gray was important in the introduction of this process to France. By 1848 and 1851 the use of glass plates for negatives was developed.]

Saint-Victor devote all their knowledge and time to photography. Science, or perhaps chance—that latent science which sometimes ignites like a spark through a shift in the grand pattern of the universe, and which needs only to fall onto an intelligent mind in order to take fire—could tomorrow make that find that is still missing, that is, a substance on which light would make chemically an impression in the same relationship of tones as it affects the retina of our eyes, and which would render light yellow and light green with greater luminosity than dark red and dark blue.

Photography is related to science because of its chemical operations and to art by its choice of subject. Its realm is as large as its uses; it can and it must render great service to history through reproductions of the monuments of all ages and all countries; to art by the comparison of all the various races; to natural history, to medicine, to geology, and generally to the most diverse manifestations of human activity. Its place is alongside the greatest discoveries of which our century is proud. It is one of the forces of nature which man has bent to his will and which, by its practical uses and its unexpected application, will follow the grand law of popularization which humanity ceaselessly pursues. It is not Art, because Art is a continuous idealization of nature and, above all, of human beauty. "Man," Goethe wrote, "will always be the most interesting subject for man, and the rest is only an element in the midst of which we live or an instrument which serves us." But photography is one of the surest, the most complete, and the most original means—because of the abundance and the accuracy of the materials it furnishes—for realizing the absolute beauty of which man dreams and toward which he steadily moves by the most diverse routes. Photography is truly the daughter of this great nineteenth century, which has created chemistry and has resolved more questions than all the previous centuries have even asked. If mythology still reigned, this Prometheus, who stole the light of the sun and made it work like a submissive slave, would be deified; in the Middle Ages photography would have been burned like a witch. But mythology reigns no longer, and the Middle Ages are past, at

least in France. If Heinrich Heine were now writing the burlesque and profound history of the Gods in Exile, he would say that Phoebus Apollo had left his chariot of fire and had taken refuge on earth in the guise of a photographer.

1859 — 61: PARIS
The Official Exhibition of the State: The Salon

The Salon of 1859 opened on April 15 amid some dissatisfaction. The regulations were the same as they had been two years earlier: the Academy acted as jury and members of the Institut and the Légion d'honneur were permitted to exhibit whatever they wished. When the jury's selections became known, it seemed that a surprising proportion of the works—some 2,000 of the 5,045 submitted—had been rejected. Even more surprising, some of the artists whose paintings had been returned with *"refusé"* stamped on the back were well known and well liked by the public. In reaction, it was suggested that a third *hors-concours* category should be established to permit artists without an official title whose previous work had been noticed by the public to exhibit their work without submitting it to the jury. If a popular artist should choose to exhibit a poor work, it would then be his responsibility.

There was also growing dissatisfaction on the part of the public and artists with the holding of the exhibition in the Palais de l'Industrie, now known as the Palais des Champs-

Élysées. The vast iron-and-glass construction did provide
suitable space for sculptures, which were arranged in the
great open space of the ground floor in a garden improvised
by Philippe de Chennevières, but paintings were relegated to
galleries at the sides of the ground and first floors. Pictures by
foreign artists, formerly interspersed indiscriminately with the
French works, were now placed in a special gallery. The Eng-
lish entries had not arrived in time for the opening. In the
opinion of *L'Illustration,*

> The exhibition is located in the palace dedicated to industrial
> exhibitions. . . . It is not just that the name of the Palais de
> l'Industrie is inauspicious, it suggests too directly thoughts of
> producers and consumers.[1]

Expressions of dissatisfaction were cut short, for on April
23 came the news that Austria, antagonized by Sardinia's
threats to oust Austria from its Italian territories, had de-
clared war on that small kingdom. Napoléon III, who had al-
ready agreed to send troops to support the Piedmontese
House of Savoy, left Paris on May 10 to command French
troops already en route to northern Italy. The capital sent
him off from the Gare de Lyon with enthusiastic support.
Ten days later came word of victories at Montebello.

Though the news from Italy was exhilarating, it did not
completely distract Parisians from the Salon or the reports
the exhibition engendered. An unknown publisher, Jean
Morel, hoping to succeed with his recently founded journal,
named the latter after a well-known periodical of the 1830s,
La Revue Française. He asked the poet, essayist, and critic
Charles Baudelaire (1821–67) to write a "general impression
of this year's Salon." Anything Baudelaire wrote would excite
interest and possibly controversy. Stepson of General Jacques
Aupick, onetime ambassador to Turkey and Spain, Baudelaire
had determined early to become a writer and refused to
prepare for the diplomatic service. For two years he lived
lavishly, thanks to a paternal inheritance, in the Île-Saint-
Louis in an apartment furnished with expensive antiques,

[1] *L'Illustration,* April 16, 1859

where he entertained some of France's younger writers, art-
ists, and dandies. Years later Théophile Gautier remembered
the Baudelaire of these years: "His appearance was as-
tonishing; his beautiful black hair was cut very short, falling
in regular points over his astonishingly white forehead; it fit
him like a kind of Saracen cap; his eyes, the color of Spanish
tobacco, had a gaze that was spiritual, profound, and almost
too insistently penetrating."[2] Alarmed at the young man's ex-
travagance, his mother and stepfather appointed the family
lawyer to oversee his finances, putting him in unaccustomed
straitened circumstances. Baudelaire was forced to try earning
a living from his writing.

Like many other writers, he introduced himself to the pub-
lic first as an art critic. He used his mother's maiden name,
Dufays, when he published, at his own expense, a review of
the Salon of 1845. A confrere of *les bohèmes*—which in-
cluded Henri Murger, Jules Husson (Champfleury), the
worker-poet Pierre Dupont, and Gustave Courbet—Baudelaire
was asked in 1846 by Champfleury to write about the ex-
hibition at the Bazaar Bonne Nouvelle for the magazine *Cor-
saire-Satan*. Champfleury himself wrote for the magazine a re-
port on the Salon of 1846. Baudelaire once again printed
privately and sold his review of that Salon. In these first arti-
cles Baudelaire imitated the approach and style of Diderot
and Stendhal, taking various works in the exhibition as a
point of departure for speculations on the nature of art and
the different traditional categories. He returned to art criti-
cism in 1855 with a review of the Exposition Universelle,
which appeared in two papers, *Le Pays* and *Le Portefeuille*.

Most of his energy in the decade following the 1848 revo-
lution, however, had been devoted to his poetry and to trans-
lations. His poems, which first appeared sporadically in a vari-
ety of journals—he was unable to secure a position as a
feuilletoniste—were finally collected in 1857 under the title
Les Fleurs du Mal, which was dedicated to Théophile Gau-
tier. The volume immediately provoked great controversy;

[2] Translated from Théophile Gautier, "Charles Baudelaire,"
Ecrivains et Artistes Romantiques (Paris, 1933)

when it was brought before the French court, the poet was
fined and six of the poems were banned because of their
"perversity." Less controversial were Baudelaire's translations
of the short stories of Edgar Allan Poe, which appeared as
Histoires Extraordinaires (1856) and *Nouvelles Histoires Ex-
traordinaires* (1857).

In Poe Baudelaire had found an artist whose works evoked
the spiritual beauty—what Poe had called "supernal beauty"—
which Baudelaire himself sought in his poems and which he
regarded as essential to all art. This otherworldly beauty, "the
most intense, most elevating, the most pure of abstract pleas-
ures," provided an "intense and pure elevation of the soul,
not of the intellect or heart." Material realism alone—of the
sort found in Courbet's paintings and those of the land-
scapists—was insufficient. "If an assemblage of trees, moun-
tains, water and houses, such as we call landscape, is beauti-
ful, it is not so of itself, but through me, through my own
grace and favor, through the idea or feeling which I attach
to it." For this reason Baudelaire found photography espe-
cially repellent. Neither was supernal beauty a matter of mo-
rality; Baudelaire had as little use for utility in art as Gautier.
"Poetry cannot, except at the price of death or decay, assume
the mantle of science or morality; the pursuit of truth is not
its aim, it has nothing outside itself."[3] There were few con-
temporary artists in any media who created works which met
Baudelaire's criteria; Poe was one, Gautier, occasionally, was
another, and "Delacroix . . . is often without knowing it, a
poet in painting."[4]

Baudelaire did not spend much time visiting the Salon in
preparation for his articles. With characteristic cynicism he
wrote to Nadar, "I am writing a Salon now, without having
seen it. But I have a catalog. Except for the effort of guess-

[3] Baudelaire, "Salon of 1859: Landscape," *The Mirror of Art*,
trans. and ed. by Jonathan Mayne (London: Phaidon, 1955), pp.
279, 467
[4] Baudelaire, "Further Notes on Edgar Allan Poe," *Selected Writ-
ings on Art and Artists*, trans. and ed. by P. E. Charvet (London:
Penguin, 1972), p. 204

ing at the paintings, it is an excellent method and I recommend it to you. Because one fears to praise or blame excessively, one succeeds in becoming impartial." But he later confessed, "As for the Salon, alas, I lied to you a little, but so very little. I did visit the Salon, only once, a visit dedicated to seeking out the novelties, of which I found very few, and as for the old names or the familiar ones, I have trusted to my old memories stimulated by the catalog."[5]

The articles Baudelaire produced did not, in fact, have as much to say about the state of art in France as about the poet's own aesthetic theories. His review was an excuse to consider the role of the imagination, the "Queen of faculties," as Baudelaire—and Poe before him—had called it. If the five senses were the faculties by which one perceived the material world, imagination represented the faculty by which one understood supernal beauty.

In 1859, for the first time, an exhibition of photography was held in the Palais des Champs-Élysées in addition to the Salon.[6] Baudelaire included a section on photography in his review. Though he admired the work of his friend Nadar—he had written to him asking for photographs of Goya's *Nude Maja* and *Clothed Maja,* which were on exhibit in Paris—Baudelaire was repelled by many of the popular uses of photography. He thought the photographs made to meet the public's insatiable demand for portraits—like the *cartes de visite* invented by Disdéri and the work of Camille Silvy, "the Winterhalter of photography"—and the photographs which satisfied the public's curiosity about faraway places cluttered with recently discovered ruins—like the stereoscopic views of J. A. and C. M. Ferrier and Adolphe Braun—were a dangerous, corrupting influence on art.

The Salon closed on July 15 and the awards were distributed. It had not been a particularly exciting exhibition. Perhaps its greatest achievement had been Baudelaire's essay. Nevertheless, *La Revue Française* ceased publication soon

[5] Baudelaire, "Salon of 1846: Delacroix," op. cit., p. 58
[6] See pp. 247–49

after the last of Baudelaire's articles appeared, and his poem "Fantômes Parisiens" arrived too late to be published.

In addition to the Salons, Baudelaire had published around this time an article on Théophile Gautier (1811–72) in *L'Artiste*. Although Baudelaire felt Gautier's poetry was not as appreciated as it deserved to be, Gautier had already met with the kind of success that Baudelaire one day hoped to achieve. A well-known critic on the staff of the government paper, his drama and art reviews were among the most widely read in Paris. As a young man he had formed part of the claque of young writers at the historic opening performance of Hugo's *Hernani* and was a member of the *cénacle* grouped around Hugo. Gautier's first published work was *Les Jeunes-France* (1833), a collection of short stories satirizing his contemporaries, and *Mademoiselle de Maupin* (1835), the sensational, erotic novel whose preface was a credo of art for art's sake. *Émaux et Camées*, Gautier's first volume of poetry, would not be published until 1852, but by the time Baudelaire arrived in Paris in 1842, Gautier was a respected figure in the literary world. In 1859 Baudelaire recalled his first meeting with Gautier when he called at Gautier's house to deliver a book: "Before me was a man with less presence than is his today, but already full of dignity, at ease and gracious, in loosely fitting clothes. What struck me about him first, as he received me, was the total absence of that coldness, so excusable, be it said, in men accustomed by virtue of their position to fear visitors. To describe his welcome, I would willingly use the word *bonhomie*, were it not so hackneyed; it could apply in this case only if seasoned, to bring out its flavor, according to the Racinian recipe, with a decorative adjective such as 'asiatic' or 'oriental' to convey a kind of humor at once simple, dignified, and mellow." Gautier accepted the book and then asked "in a tone of voice someone else might have adopted to inquire whether I preferred reading travel books or fiction," whether the young man enjoyed reading dictionaries. "It was precisely with reference to dictionaries that he added, 'The writer incapable of expressing everything, caught on the wrong foot by an idea,

be it ever so strange or subtle, ever so unexpected, falling like a stone from the moon, was no writer at all.' "[7]

Gautier's art criticism was first published in *L'Ariel* and *La France Littéraire*. Émile de Girardin, the founder of *La Presse* (1836), the daily which was soon to be one of Paris' most popular papers, offered Gautier a contract as a drama critic; he wrote for the paper for nineteen years. In his 1839 and 1841 Salon reports for *La Presse,* Gautier developed the idea of the "microcosm" to explain the mechanism by which the truly creative artist filtered the material reality of his subject through himself to produce a work of art. The microcosm within an artist imposed a unity on nature, idealizing it no matter what subject was represented. In 1845 Gautier had joined *Le Moniteur Universel,* the government paper, for which he wrote thirty-two articles on the Exposition Universelle, later collected under the title *Les Beaux-Arts en Europe* (1855). Arsène Houssaye, a longtime friend, was appointed director of the Comédie Française in 1849. Gautier was subsequently named to succeed him as manager of *L'Artiste.* In 1859, the year Baudelaire's article on him appeared in *L'Artiste,* Gautier was in Russia gathering material for *Trésors d'Art de la Russie Ancienne et Moderne* (1859), which he wrote in collaboration with his son by his first mistress, Théophile Gautier, fils.

His series on the Salon of 1861 appeared in *Le Moniteur.* The paintings exhibited never failed to inspire Gautier to write brilliant, poetic descriptions. His astonishingly fluent writing transferred his often uncritical enthusiasm to his readers and made him one of the most popular of critics. The master *feuilletoniste,* a follower of Diderot and Heine, had long since ceased to theorize in his reviews, but he still endeavored to discern behind each work the expression of a temperament. It was this effort which made him Baudelaire's predecessor in the development of the aesthetics of individualism.

[7] Translated from Baudelaire, *Correspondance Générale,* ed. Jacques Crepet (Paris, 1922), vol. II, pp. 312–13, 317–18

Charles Baudelaire: *The Salon of 1859*[1]

I. The Modern Artist

My dear M——, when you did me the honour of asking for an analysis of the Salon, you said, "Be brief; do not write a catalogue, but a general impression, something like the account of a rapid philosophical walk through the galleries." Very well, you shall have your wish; not because your programme accords (as it does) with my own conception of that tiresome kind of article called a "Salon"; nor because your method is easier than the other—it is not, for brevity always demands more effort than diffuseness; but simply because, above all in the present instance, there is no other possible way . . .

. . . I therefore asked myself the following questions: What *was* he, then, the artist of former times (Le Brun or David, for example)? Le Brun was all erudition, imagination, knowledge of the past, and love of grandeur; and David, that colossus slandered by pigmies—did not he also embody love of the past and love of grandeur combined with erudition? But what of the artist today—that ancient brother to the poet? To answer that question properly, my dear M——, one must not shrink from being too stern. A scandalous favoritism sometimes demands an equivalent response. Despite his lack of merit, the artist is today, and has been for many years, nothing but a *spoiled child.* How many honours, how much money has been showered upon men without soul and without education! I am certainly far from advocating the introduction into an art of means which are alien to it; and yet to quote an example, I cannot prevent myself from feeling sympathetic towards an artist such as Chenavard, who is always agreeable in the way that books are agreeable, and graceful even when he is dull and pompous. What do I care that he is the butt of every dauber's jokes? At least with him I am

[1] [First published in *La Revue Française*, June 10–July 20, 1859. Charles Baudelaire, *The Mirror of Art*, trans. and ed. by Jonathan Mayne (London: Phaidon, 1955), pp. 220–304]

sure that I can have a conversation about Virgil or about Plato. Préault has a charming talent, an instinctive taste which hurls him upon the beautiful like a hunting animal upon its natural prey. Daumier is gifted with a radiant good sense which colours all his conversation. Ricard, in spite of the dazzle and elusiveness of his talk, never fails to let one see that he knows, and has compared a great deal. It is unnecessary, I think, to speak of the conversation of Eugène Delacroix, which is an admirable mixture of philosophical solidity, of witty lightness and of blazing enthusiasm. But apart from these, I cannot think of any other artist who is worthy to converse with a philosopher or a poet. Apart from them, you will hardly find anything but *spoiled children.* . . .

And the *spoiled child,* the modern painter, says to himself: "What is imagination? A danger and a toil. What is reading and contemplation of the past? Waste of time. I shall be classical, not like Bertin[2] (for the classical changes its place and its name), but like . . . Troyon, for example." And he does as he has said. He paints on and on; he stops up his soul and continues to paint, until at last he becomes like the artist of the moment and by his stupidity and his skill he earns the acclaim and the money of the public. The imitator of the imitator finds his own imitators, and in this way each pursues his dream of greatness, better and better stopping up his soul and above all *reading nothing,* not even *The Perfect Cook,* which at any rate would have been able to open up for him a career of greater glory, if less profit. When he is thoroughly master of the art of sauces, of patinas, of glazes, of scumbles, of gravies, of stews (I speak of painting), the *spoiled child* strikes proud attitudes and repeats with more conviction than ever that nothing else is necessary.

There was once a German peasant who went to a painter and said to him: "*Sir,* I want you to paint my portrait. You will show me sitting at the front door of my farmhouse which I inherited from my father. Beside me you will paint

[2] [Victor Bertin, a pupil of P.-H. Valenciennes, the neoclassic landscape painter. Trans.]

my wife with her distaff, and behind us my daughters passing
to and fro, preparing the family supper. By the avenue to the
left come those of my sons who are returning from the fields
after having herded the cattle to their byres; others, with my
grandsons, are bringing back waggons laden with hay. While
I am watching this scene, I beg you not to forget the puffs of
smoke from my pipe, which are shot through by the rays of
the setting sun. I should like the spectator to *hear* the sound
of the Angelus which is ringing from the nearby churchtower.
That is where we were all married, both the fathers and the
sons. It is important that you should paint the *air of satis-
faction* which I enjoy at this moment of the day, when at
one and the same time I contemplate *my family and my
riches increased by the labours of a day!*"[3]

Three cheers for that peasant! Without for a moment
suspecting it, he understood painting. Love of his profession
had heightened his *imagination*. But which of our fashion-
able painters would be worthy of executing this portrait?
Which of them can claim that his imagination has reached
such a level?

II. The Modern Public and Photography

My dear M——, . . . I was speaking just now of artists
who seek to astonish the public. The desire to astonish and
to be astonished is very proper. "It is a happiness to wonder";
but also "it is a happiness to dream."[4] The whole question,
then, if you insist that I confer upon you the title of artist or
of connoisseur of the fine arts, is to know by what processes
you wish to create or to feel wonder. Because the Beautiful is
always wonderful, it would be absurd to suppose that what is
wonderful is always beautiful. Now our public, which is sin-
gularly incapable of feeling the happiness of dreaming or of
marvelling (a sign of its meanness of soul), wishes to be
made to wonder by means which are alien to art, and its obe-

[3] [The above paragraph seems to be an imitation and development
of a passage in Diderot's *Essai sur la peinture*; the passage is quoted in
Crepet's edition of *Curiosités esthétiques* (Paris, 1923, p. 489).
Trans.]

[4] [Quoted from Poe, *Morella*. Trans.]

dient artists bow to its taste; they try to strike, to surprise, to stupefy it by means of unworthy tricks, because they know that it is incapable of ecstasy in front of the natural devices of true art.

During this lamentable period, a new industry arose which contributed not a little to confirm stupidity in its faith and to ruin whatever might remain of the divine in the French mind. The idolatrous mob demanded an ideal worthy of itself and appropriate to its nature—that is perfectly understood. In matters of painting and sculpture, the present-day Credo of the sophisticated, above all in France (and I do not think that anyone at all would dare to state the contrary), is this: "I believe in Nature, and I believe only in Nature (there are good reasons for that). I believe that Art is, and cannot be other than, the exact reproduction of Nature (a timid and dissident sect would wish to exclude the more repellent objects of nature, such as skeletons or chamberpots). Thus an industry that could give us a result identical to Nature would be the absolute of art." A revengeful God has given ear to the prayers of this multitude. Daguerre was his Messiah. And now the faithful says to himself: "Since photography gives us every guarantee of exactitude that we could desire (they really believe that, the mad fools!), then photography and Art are the same thing." From that moment our squalid society rushed, Narcissus to a man, to gaze at its trivial image on a scrap of metal. A madness, an extraordinary fanaticism took possession of all these new sun-worshippers. Strange abominations took form. By bringing together a group of male and female clowns, got up like butchers and laundry-maids in a carnival, and by begging these heroes to be so kind as to hold their chance grimaces for the time necessary for the performance, the operator flattered himself that he was reproducing tragic or elegant scenes from ancient history . . .

As the photographic industry was the refuge of every would-be painter, every painter too ill-endowed or too lazy to complete his studies, this universal infatuation bore not only the mark of a blindness, an imbecility, but had also the air of a vengeance. I do not believe, or at least I do not wish to be-

lieve, in the absolute success of such a brutish conspiracy, in which, as in all others, one finds both fools and knaves; but I am convinced that the ill-applied developments of photography, like all other purely material developments of progress, have contributed much to the impoverishment of the French artistic genius, which is already so scarce. In vain may our modern Fatuity roar, belch forth all the rumbling wind of its rotund stomach, spew out all the undigested sophisms with which recent philosophy has stuffed it from top to bottom; it is nonetheless obvious that this industry, by invading the territories of art, has become art's most mortal enemy, and that the confusion of their several functions prevents any of them from being properly fulfilled. Poetry and progress are like two ambitious men who hate one another with an instinctive hatred, and when they meet upon the same road, one of them has to give place. If photography is allowed to supplement art in some of its functions, it will soon have supplanted or corrupted it altogether, thanks to the stupidity of the multitude which is its natural ally. It is time, then, for it to return to its true duty, which is to be the servant of the sciences and arts—but the very humble servant, like printing or shorthand, which has neither created nor supplemented literature. Let it hasten to enrich the tourist's album and restore to his eye the precision which his memory may lack; let it adorn the naturalist's library, and enlarge microscopic animals; let it even provide information to corroborate the astronomer's hypotheses; in short, let it be the secretary and clerk of whoever needs an absolute factual exactitude in his profession—up to that point nothing could be better. Let it rescue from oblivion those tumbling ruins, those books, prints and manuscripts which time is devouring, precious things whose form is dissolving and which demand a place in the archives of our memory—it will be thanked and applauded. But if it be allowed to encroach upon the domain of the impalpable and the imaginary, upon anything whose value depends solely upon the addition of something of a man's soul, then it will be so much the worse for us! . . .

Could you find an honest observer to declare that the invasion of photography and the great industrial madness of our

times have no part at all in this deplorable result? Are we to suppose that a people whose eyes are growing used to considering the results of a material science as though they were the products of the beautiful, will not in the course of time have singularly diminished its faculties of judging and of feeling what are among the most ethereal and immaterial aspects of creation?

IV. The Governance of the Imagination

Yesterday evening I sent you the last pages of my letter, in which I wrote, not without a certain diffidence, "Since Imagination created the world, it is Imagination that governs it." Afterwards, as I was turning the pages of *The Night Side of Nature*,[5] I came across this passage, which I quote simply because it is a paraphrase and justification of the line which was worrying me: "By imagination, I do not simply mean to convey the common notion implied by that much abused word, which is only fancy, but the constructive imagination, which is a much higher function, and which, inasmuch as man is made in the likeness of God, bears a distant relation to that sublime power by which the Creator projects, creates, and upholds his universe." I feel no shame—on the contrary, I am very happy—to have coincided with the excellent Mrs. Crowe on this point; I have always admired and envied her capacity for belief, which is as fully developed as is that of doubt in others.

I said that a long time ago I had heard a man who was a true scholar and deeply learned in his art, expressing the most spacious and yet the simplest of ideas on this subject. When I met him for the first time, I possessed no other experience but that which results from a consuming love, nor any other power of reasoning but instinct. It is true that this love and this instinct were passably lively; for even in my extreme youth my eyes had never been able to drink their fill of painted or sculpted images, and I think that worlds could have come to an end, *impavidum ferient*, before I had be-

[5] [On Mrs. Crowe's *The Night Side of Nature* (London, 1848) see Margaret Gilman, *Baudelaire the Critic* (New York, 1943), pp. 128ff. and notes. Trans.]

come an iconoclast. Obviously he wished to show the greatest indulgence and kindness to me; for we talked from the very beginning of commonplaces—that is to say, of the vastest and most profound questions. About nature, for example: "Nature is but a dictionary," he kept on repeating. Properly to understand the extent of meaning implied in this sentence, you should consider the numerous ordinary usages of a dictionary. In it you look for the meaning of words, their genealogy and their etymology—in brief, you extract from it all the elements that compose a sentence or a narrative: but no one has ever thought of his dictionary as a composition, in the poetic sense of the word. Painters who are obedient to the imagination seek in their dictionary for the elements which suit with their conception; in adjusting those elements, however, with more or less of art, they confer upon them a totally new physiognomy. But those who have no imagination just copy the dictionary. The result is a great vice, the vice of banality, to which those painters are particularly prone whose specialty brings them closer to external nature—landscape-painters, for example, who generally consider it a triumph if they contrive not to show their personalities. By dint of contemplating, they forget to feel and to think.

For this great painter, however, no element of art, of which one man takes this and another that as the most important, was—I should rather say, is—anything but the humblest servant of a unique and superior faculty.

If a very neat execution is called for, that is so that the language of the dream may be translated as neatly as possible; if it should be very rapid, that is lest anything may be lost of the extraordinary vividness which accompanied its conception; if the artist's attention should even be directed to something so humble as the material cleanliness of his tools, that is easily intelligible, seeing that every precaution must be taken to make his execution both deft and unerring.

With such a method, which is essentially logical, all the figures, their relative disposition, the landscape or interior which provides them with horizon or background, their garments—everything, in fact, must serve to illuminate the idea

which gave them birth, must carry its original warmth, its liv-
ery, so to speak. Just as a dream inhabits its own proper at-
mosphere, so a conception which has become a composition
needs to move with a coloured setting which is peculiar to it-
self. Obviously a particular tone is allotted to whichever part
of a picture is to become the key and to govern the others.
Everyone knows that yellow, orange and red inspire and ex-
press the ideas of joy, richness, glory and love: but there are
thousands of different yellow or red atmospheres, and all
other colours will be affected logically and to a proportionate
degree by the atmosphere which dominates. In certain of its
aspects the art of the colourist has an evident affinity with
mathematics and music. And yet its most delicate operations
are performed by means of a sentiment or perception to
which long practice has given an unqualifiable sureness. We
can see that this great law of over-all harmony condemns
many instances of dazzling or raw colour, even in the work of
the most illustrious painters. There are paintings by Rubens
which not only make one think of a coloured firework, but of
several fireworks set off on the same platform. It is obvious
that the larger a picture, the broader must be its touch; but it
is better that individual touches should not be materially
fused, for they will fuse naturally at a distance determined by
the law of sympathy which has brought them together.
Colour will thus achieve a greater energy and freshness.

A good picture, which is a faithful equivalent of the dream
which has begotten it, should be brought into being like a
world. Just as the creation, as we see it, is the result of several
creations in which the preceding ones are always completed
by the following, so a harmoniously-conducted picture con-
sists of a series of pictures superimposed on one another, each
new layer conferring greater reality upon the dream, and rais-
ing it by one degree towards perfection. On the other hand I
remember having seen in the studios of Paul Delaroche and
Horace Vernet huge pictures, not sketched but actually be-
gun—that is to say, with certain passages completely finished,
while others were only indicated with a black or a white out-
line. You might compare this kind of work to a piece of

purely manual labour—so much space to be covered in a given time—or to a long road divided into a great number of stages. As soon as each stage is reached, it is finished with, and when the whole road has been run, the artist is delivered of his picture.

It is clear that all these rules are more or less modifiable, in accordance with the varying temperaments of artists. Nevertheless I am convinced that what I have just described is the surest method for men of a rich imagination. Consequently, if an artist's divergences from the method in question are too great, there is evidence that an abnormal and undue importance is being set upon some secondary element of art.

I have no fear that anyone may consider it absurd to suppose a single education to be applicable to a crowd of different individuals. For it is obvious that systems of rhetoric or prosody are no arbitrarily invented tyrannies, but rather they are collections of rules demanded by the very constitution of the spiritual being. And systems of prosody and rhetoric have never yet prevented originality from clearly emerging. The contrary—namely that they have assisted the birth of originality—would be infinitely more true.

To be brief, I must pass over a whole crowd of corollaries resulting from my principal formula, in which is contained, so to speak, the entire formulary of the true aesthetic, and which may be expressed thus: The whole visible universe is but a storehouse of images and signs to which the imagination will give a relative place and value; it is a sort of pasture which the imagination must digest and transform. All the faculties of the human soul must be subordinated to the imagination, which puts them in requisition all at once. Just as a good knowledge of the dictionary does not necessarily imply a knowledge of the art of composition, and just as the art of composition does not itself imply a universal imagination, in the same way a good painter need not be a great painter. But a great painter is perforce a good painter, because a universal imagination embraces the understanding of all means of expression and the desire to acquire them.

As a result of the ideas which I have just been making as

clear as I have been able (but there are still so many things
that I should have mentioned, particularly concerning the
concordant aspects of all the arts, and their similarities in
method), it is clear that the vast family of artists—that is to
say, of men who have devoted themselves to artistic expres-
sion—can be divided into two quite distinct camps. There
are those who call themselves "realists"—a word with a dou-
ble meaning, whose sense has not been properly defined, and
so in order the better to characterize their error, I propose to
call them "positivists"; and they say, "I want to represent
things as they are, or rather as they would be, supposing that
I did not exist." In other words, the universe without man.
The others however—the "imaginatives"—say, "I want to illu-
minate things with my mind, and to project their reflection
upon other minds." Although these two absolutely contrary
methods could magnify or diminish any subject, from a reli-
gious scene to the most modest landscape, nevertheless the
man of imagination has generally tended to express himself
in religious painting and in fantasy, while landscape and the
type of painting called "genre" would appear to offer enor-
mous opportunities to those whose minds are lazy and excita-
ble only with difficulty.

But besides the imaginatives and the self-styled realists,
there is a third class of painters who are timid and servile,
and who place all their pride at the disposal of a code of false
dignity. While one group believes that it is copying nature,
and another is seeking to paint its own soul, these men con-
form to a purely conventional set of rules—rules entirely arbi-
trary, not derived from the human soul, but simply imposed
by the routine of a celebrated studio. In this very numerous
but very boring class we include the false amateurs of the an-
tique, the false amateurs of style—in short, all those men who
by their impotence have elevated the "poncif" to the honours
of the grand style.

Théophile Gautier: *The A. B. C. of the Salon of 1861*[1]

GENERAL IMPRESSIONS. The opening of a Salon is a ceremony that is always impatiently awaited. The public crowds in with unquenchable curiosity. Formerly the rivalry between schools raised this curiosity to a passion, and every exposition was like a battlefield on which enemy paintings contested hotly for victory in the midst of a storm of criticism and praise exaggerated on both sides with equal good faith. Sublime! Detestable! An escapee from an asylum! An old fogey! A god of painting! A sign painter! Such were the worthy pleasantries exchanged by the two camps. The disciples ran to the help of their masters, "Clean-shaven classicists with ruddy faces, bearded romantics of pallid mein" looked at each other out of the corners of their eyes, ready to come to blows over line or color. In those days one saw, among the wary bourgeois, truculent and typical art students wandering proudly and aggressively in black velvet vests, gray felt hats on their heads, their hair long, their eyebrows arching, their mustaches turned up, naïvely believing they were Murillo, Rubens, or Van Dyck for having put on their dress. Others, more modest but no less strange, parted their hair in the middle and wore a checked shirt without a tie in honor of Raphael Sanzio.

The former came from the studios of Devéria or Delacroix, the latter from Ingres's studio. Here and there a river of a beard like that of Michelangelo's *Moses* flowed over the shabby overcoat of an elderly man whose satisfied look seemed to say, "Look at me, I am Jehovah, Jupiter, the river Scamander, the Doge, the Hermit, the executioner!" Women in pretentious yet careless dress, with Jewish faces, confident of their figure and disdaining the artifices of corsetry, stopped in front of Venuses, Nymphs, Mermaids, and smiled at their images with complacent quiet, happy to have lent their forms

[1] [Translated from Théophile Gautier, *Abecedaire du Salon de 1861* (Paris, 1861)]

to clothe the ideal of the artists. They were models who espoused, according to their Greek or Medieval appearance, the battles of the schools.

This turbulent crowd somewhat frightened the peaceful spectators, who did not dare come to the Salon for three or four days after its opening for fear of some of those malicious insults which students are wont to throw at Philistines.

The appearance of the Salon has greatly changed and no longer presents any peculiarity. Today the artists—and we are not criticizing them, only observing a fact—wear the most correct clothing; they carefully avoid any slightly conspicuous or bizarre fashion. They flee external originality the way they once pursued it. They are indistinguishable from other people and their secret ambition seems to be to resemble perfect lawyers. They often succeed. . . .

Art itself has been profoundly modified: no more violent contrasts, no more opposing camps, no more exclusive doctrines, no more school rivalries. The Gods, true or false, no longer have any faithful followers; each is his own god and his own priest. The masters, lacking imitators, copy each other. Doubtlessly, groups of similar talents may be perceived here and there, but they are brought together by the accident of a similarity of temperament. It is not the same position, the same teaching that produces these resemblances. The most divergent tendencies are represented, but individually and without attaching themselves to a school. The realist elbows the archaic, the Pre-Raphaelite, as the English say, but the critic would be wrong to see in this isolated manifestation a significant movement. Any general formula that one attempts to apply to contemporary art is subject to so many exceptions that one must soon give up. Even classification by types is no longer possible. The majority of the paintings do not fit those old handy categories: history, genre, landscape; almost none fits in exactly. Infinite diversity without much originality, this seems to us the character of the Salon of 1861, and the diversity is further augmented by the cosmopolitism of the artists, whom steam power scatters to all points of the horizon.

Therefore the canvases this year have been arranged in al..

phabetical order. The pictures are hung on the walls of the exhibition the way they are in the catalog: from A to Z. Surprisingly enough, the neighbors formed by alphabetical chance are as valuable as they would have been in a carefully thought out and argued-over arrangement. There are not too many unfortunate contrasts. Long trials would not have been more successful, and no one can complain. . . .

On the right of the salon facing Yvon's *Battle of Solferino*, the letter A begins; the Z closing this immense chain of paintings is to be found on the left. The alphabetical snake bites its tail like the snake of eternity. We will follow in our account the order of the letters. Some are rich, others are poor. Talent seems to prefer certain initials. . . .

Sculpture has many entries. Marbles, bronzes, plasters stand around the garden at the end of which an obelisk rises covered with mysterious hieroglyphics. We did not have the time to go and examine it and, in addition, looking at 3,146 pictures in half a day deprives one's vision of the necessary clearness to contemplate these lovely, pure, calm forms in their whiteness. . . .

PAINTING. *Paul Baudry.* In painting *Charlotte Corday,*[2] a subject completely different from his usual ones, Paul Baudry seems to have wished to prove that only admiration for the great masters and not a lack of imagination kept him in the calm regions of antiquity and mythology. The picture resulting from his excursion into the domain of recent history is conceived with great originality; its outstanding aspects keep a little knot of spectators constantly before it. The artist has looked up every document that might furnish him with additional details; he has compared various more or less authentic portraits of Charlotte Corday; he has looked up the plan of the room in which the assassination took place (for it still exists, unchanged in its physical details) so as to give his scene a base and a background that are rigorously historically accurate; he has neglected no small detail of the costume to dress

2 [Charlotte Corday (1768–93), sympathetic to the Girondist party during the French Revolution, assassinated Marat, whom she believed to be the architect of its downfall.]

his heroine according to the style of the epoch, for a woman
may revolt against a tyrant, but she is always submissive to
fashion. This attention to truth and exactitude has not pro-
duced, as you might expect, a realistic painting; Paul Baudry
has too much native elegance for that. But by the very limits
which he imposes on himself he has given a great air of nov-
elty to the composition.

Some lines from Michelet[3] served as the artist's theme.
"She pulled the knife from beneath her *fichu* and plunged it
to the hilt in Marat's chest. 'A moi, ma chère amie!' was all
that he could say before he died. Hearing this cry, people
came running and saw Charlotte standing near the window
as though petrified." The figures are life-size since the artist
wished to make a true historical painting, and he has com-
pletely succeeded in the most modern and intelligent sense of
the word. . . .

The artist has depicted very powerfully the profound stu-
pefaction of the idea faced with the accomplished fact, the
sudden weakening of firm resolution, the feminine wave of
nausea as the heroine faces her bloody work. Undoubtedly
the thought of having freed her country from a tyrant and of
having perhaps saved the lives of generous men will later re-
store the virtuous girl's courage. Far from the corpse, in the
prison which she will leave only to go to the scaffold, she may
congratulate herself on this abstract murder, copied from an-
tiquities, of which André Chénier will sing in Greek iam-
bics.[4] But enthusiasm dies here beneath cold horror. Only
the murder appears in its hideous reality.

This pale face, with its fixed glance as though turned to
stone in the midst of its halo of blond hair, engraves itself in-
delibly upon one's memory. She is terrible and charming; she
inspires horror and love, and seeing her one can believe Adam
de Lux's[5] posthumous love. One trembles to think that this

[3] [Jules Michelet (1798–1874), French historian. The lines are
quoted from his *Histoire de la Révolution Française* (Paris,
1847–53).]

[4] [See Delécluze's review of the Salon of 1850–51 in this volume.]

[5] [Adam de Lux (1773–93), German and French politician, fol-
lower of Girondists; his panegyric to Corday cost him his life.]

gracious and supple neck will in a few days wear the purple thread of the guillotine as a necklace. . . .

This painting, one of the most remarkable in the Salon, proves that Baudry knows how to paint things other than Ledas, Venuses, and Madelines; his talent for those, by the way, would be sufficient; for, in our opinion, except for the nude, there is no true historical painting. But while we admire *Charlotte Corday* as much as it deserves, we admire equally and we prefer *Cybele* and *Amphitrite*, two small pictures, sketches of decorations done for the Salon of the Countess de Nadaillac. Mythology! This does not interest the general crowds, eager for dramatic and formal subjects above all. Yet those who seek painting itself in painting will pause long in front of these two small frames whose drawing is so elegant, whose color is so rare and so exquisitely integrated. . . .

Alexandre Cabanel. Alphabetical chance, lucky for once, has placed at the head of the letter C a painter who belongs in this place through his merit: Cabanel. In fact, he dominates this abundant series of remarkable works almost entirely contained in a sort of square room at the end of the gallery of B's, in which the light seemed to us to be better than elsewhere.

A *Nymph Abducted by a Faun* is a charming picture. The word "charming" here is not an idle word of praise. It sums up the very idea of the work. Cabanel has evidently—and we are infinitely grateful to him for it—worked with a preoccupation for *charm*. Contemporary artists do not think of pleasing the eyes, and that is, after all, the aim of painting. They wish to be wise, profound, original, sublime, even bizarre; but they disdain being agreeable as beneath them. Such paintings, greatly praised, impress themselves painfully on one's eyes, and only the mind sees merit in the work. A *Nymph Abducted by a Faun* blooms like a bouquet, and from a distance, before it is possible to pick out the details, the general aspect caresses the eyes with a range of fresh harmonies and gentle tones. One is enchanted, as one is by the view of a bunch of flowers, a beautiful persian carpet, an assortment of changeable silks. This is, we are quite willing to admit, a

purely physical sensation, but it belongs to the very well-springs of painting, and without it, in our opinion, there is no perfect painting. Let us, therefore, be grateful to Cabanel for having given it birth. . . .

Pierre Puvis de Chavannes. We will put Puvis de Chavannes here. He belongs here according to the initial of one of his names, and his two vast paintings take up an entire wall of the room in which Cabanel's canvases are found. Even though Puvis de Chavannes has already exhibited a *Return from the Hunt* full of promise, it may be said that his real debut is this year. With a bound he has emerged from the shadow. The spotlight has fallen upon him and will not leave him. He has been very successful and this gives credit to the public, for Puvis de Chavannes is not, as one says, over-critical. His spirit moves in the highest spheres of art and his ambition exceeds his talent. The very aspect of his two large compositions, *War* and *Concordia,* catches the eye. Are these cartoons? Tapestries? Or are they rather frescoes removed by some mysterious means from an unknown Fontainebleau, these immense canvases surrounded by a frame of flowers and symbols like the painting in the Farnesina.[6] What means was used to paint them? Tempera, wax, oil? It is hard to tell. The tone scale is so odd, outside the usual color scale; they are the neutral tones or the skillfully deadened ones of mural painting which clothe buildings without introducing harsh reality and give an impression of objects more than they represent them. Puvis de Chavannes—let us emphasize this point at a time when so many palaces and monuments are being completed, awaiting their covering of frescoes—is not a picture painter. He wants not the easel but a scaffold and large wall spaces to cover. This is his dream and he has proved that he can achieve it. In an era of prose and realism, this young artist is naturally heroic, epic, and monumental through a strange outcropping of genius. He seems to have seen no contemporary painting and to have come directly from the studio of Primaticcio or Il Rosso.

[6] [Raphael's frescoes of 1518–19 decorate the Villa Farnesina in Rome.]

The subject of *War* is taken in the general sense, outside any particularities of the circumstances of time or place. It is the idea itself made visible with a singular poetic power. War has overrun a country. The work of conquest is completed. Three heralds on horseback, expressionless, similar in their attitudes, sound the triumphal fanfare the way the angels will sound the Last Judgment, and are equally frightening. This is grand, fierce, and savage, with an antique flavor like certain verses of the *Nibelungen*. . . .

There is nothing more tragic than this black storm! Trophies, victory psalms, and war machines grouped severely frame this Homeric poem. *Concordia* takes us to a vale of Tempe shaded by large green trees and irrigated by running water. The warriors have laid down their arms; they are resting or busy training horses. The innocent pastimes of peace occupy the women: One of them, kneeling, milks a goat; another is carrying a basket of fruit; another plaits a garland of flowers. This woman dreams, leaning on her elbows; that one, whose superb nudity brings to mind the elegance of the Florentines, stands proudly, like a Venus emerging from the sea. One might think oneself in the golden age; there is such calm, freshness, and repose in this composition, as tranquil as the other is furious! The color itself is less abstract and more human. The painter seems to have taken advantage of peace to finish certain parts at his leisure, therefore many people prefer *Concordia* to *War*; but this is not our opinion, even though we deeply admire them both. Flowers and fruits of excellent coloring surround this arcadian idyll and complete it. The ornamental and decorative feeling of Puvis de Chavannes extends to the smallest accessories.

And the criticism! You will say, "Have you none? Is Puvis de Chavannes then perfect?" Good lord! Certainly not! He has enormous faults. But here is a newborn painter; let us not kill him off immediately. Let him work. We will criticize him later, when only his good points remain. . . .

Gustave Courbet. It seems that Courbet has at last understood that he is too talented to seek success by willful eccentricities. This year the apostle of realism is content to show us excellent and solid painting. No more upholstered Ve-

nuses, no more village maidens, no more courtesans on the banks of the Seine,[7] but rather animals and landscapes of great accuracy and masterful execution. *The Battle of Spring-time* makes us spectators at one of those battles between amorous rivals which often end in death. In a clearing in a forest of century-old trees, two stags, their antlers enlaced, are fighting with stubborn rage. A third, *hors de combat,* bellows in agony, a large wound in his side. The animals are marvel-ously painted; the landscape is superb. *The Stag in Water,* panting, at the end of his strength, throws himself desper-ately into a dark lake in the middle of a savage and lugu-brious setting. Snyders or Velasquez might sign this canvas. We like *The Huntsman* much less; only the landscape is good. Master Courbet, erase this cardboard horse ridden by a wooden rider, but save the trumpet whose brass is so realistic for the sounding of a fanfare. *The Fox in the Snow* is full of skill. A field mouse is not more eagerly eaten when there are no chickens. Let us mention, to finish, *The Rock at Oragnen:* a gray rock, green trees, clear and shimmery water. . . .

Gustave Doré. . . . "Dante and Virgil in the ninth circle of Hell, visiting the traitors condemned to the torture of ice, meet there Count Ugolino and Archbishop Ruggieri."

This is the lugubrious subject developed on a grand scale by the young illustrator of *The Divine Comedy,*[8] and it may be said that he was not inferior to his task. With fright and horror he struggles with Dante's poetry. It would be difficult to express better the arctic character of this circle in which reign the tortures of cold, so fearful to southern imaginations. The climate of the picture is recognized at a glance. If one put a thermometer near it, the frightened mercury would take refuge in the bulb. . . .

In the poses of the damned, Gustave Doré has exhibited that imaginative drawing, so rare today, which brings to mind Michelangelo turning the human body in every direction as a titan would manipulate a puppet. The most unexpected atti-

[7] [The references are to Courbet's paintings *The Bathers, The Vil-lage Maidens,* and *Young Women on the Banks of the Seine.*]

[8] [Doré's illustrations for *The Divine Comedy* were published in 1861.]

tudes, the most violent foreshortenings, the most exaggerated twistings do not surprise this young artist's audacity. He tangles and untangles the skein of muscles at his pleasure. He places the contours as he pleases, compressing them, enlarging them, outlining them, curving them, and forces them to depict the movement he wishes in every possible perspective. . . .

This imagination in drawing Doré also has in composition. What facility, what richness, what strength, what intuitive depth, what penetration of the most diverse objects! What a sense of reality and, at the same time, what a visionary and dreamy spirit! Being and nonbeing, the body and the ghost, the sun and the night—Gustave Doré can depict them all. It is to him that we will owe the foremost illustration of Dante, since Michelangelo's is lost. . . .

Jean Léon Gérôme. If anything characterizes the amiable Athenian character, it is the acquitting of Phryne by the judges of the Areopagus, dazzled by the charms of the famous hetaera.[9] Allowing beauty as an attenuating circumstance—Venus disarming Themis—that is a wholly Greek and wholly Attic idea. These judges, whose decisions were accepted even by the Gods, shrink from the thought of destroying this perfect body, this living statue that inspired Praxiteles; do they not express, in a charming way, the morals of the Hellenic civilization, which loved beauty even above goodness and truth? . . .

The crowd greatly admires the variety of expression that Gérôme has given to the Areopagites. The feeling shown by most of these hoary heads is not that which the august Athenian judges probably felt. They appear sensually moved by the nudity before their eyes. This is a wholly modern effect. . . .

As far as the execution itself is concerned, it has that skillful neatness characteristic of Gérôme. The smallest details attest to an archaeological researcher who knows his terrain very well. The little statue of Minerva, true idol of the primi-

[9] [Reputedly Phryne was Praxiteles's model for the statue of Aphrodite at Cnidus. Accused of profaning the Eleusinian Mysteries, she was acquitted because of her beauty.]

tive times, has Aeginetan and Daedalien stiffness that is truly amusing. . . .

Edouard Manet. Caramba! Here is a *Guitarrero* [*Spanish Singer*] who does not come from the Opéra Comique and who would not look well in a romantic lithograph; but Velasquez would salute him with a friendly wink, and Goya would ask a light for his *papelito.* How he brays out a song as he strums his guitar! We can almost hear him. This good Spaniard with his *sombrero calenes,* with his marseilles vest, is wearing a pair of pants. Alas, Figaro's kneepants are now worn only by *espadas* and *banderilleros,* but this concession to civilized fashions is redeemed by the *alpargates.* There is much talent in this life-size figure, painted in undiluted paint, with a valiant brush and a very lifelike color.

Jean Louis Meissonier. . . . Let us first speak of the work entitled *The Painter.* It is one of the subjects frequently undertaken by the artist, one in which he always finds agreeable variations. One is no more tired of looking at them than he of producing them. In effect, nothing is more favorable to painting than these studio interiors of another century, with their tapestry, their plaster casts, their canvases hanging on the wall, their Chinese pots for soaking brushes in, their tables and their armchairs with cabriole legs. Place there a painter in a smock, his hair tied back in a queue, seated at his easel and wholly absorbed in his work; group around him some art lovers in French costume who lean over him or who stand off the better to judge the effect, and you will have a charming picture. Meissonier is so skillful at bringing poses to life, expression to faces, accurate mimicry to gestures! It seems as though one is listening to what these tiny figures are saying. One can guess their characters, their feelings, their interests, their weaknesses. One would almost think one had lived with them. For it is not only the finish and the preciousness of his work that distinguish Meissonier, even though this is the side of him that is most admired; in his microscopic pictures he composes the scenes in which two or three main actors perform with a particular skill and a rare accuracy.

Jean Millet. By constantly exaggerating his manner, Millet

—who is otherwise a talented man whom we have more than once praised, as he deserves—arrives at the limits of impossibility. Some fanatical followers continue to admire, under the pretext of realism, these monstrous fantasies, as far removed from truth as Boucher's, Fragonard's, and Van Loo's pink and white whipped creams. Under a stylistic pretext, Millet gives his characters the mournful and fierce stupidity of Indian idols. Their sleepy gestures become fixed, their eyes no longer see, and fabrics as thick as hides weigh down their bodies of colored wool. Undoubtedly there is a certain grandeur in these silhouettes free of all detail and filled out in monochromatic tones; but it is too dearly purchased.

A *Sheep Shearer* shows a peasant girl shearing a sheep, already half stripped of its wool, on a barrel. The animalistic placidity of the shearer blends with the passive resignation of the animal, which is the principal subject of the picture. The sheep is perhaps the more human of the two; he is also of a very handsome color, while the woman, if she can be called that, disappears beneath a layer of brick-colored tones that has never clothed any feminine skin, even one tanned by the rain, the wind, and the sun. On her collar—no one knows why—a white highlight shimmers like a recent scratch on a dirty plaster wall. In the background, solemn and fateful, is an old peasant clothed in a blue smock. . . .

In times of naïve ignorance, anachronisms were excusable. They even have their charm, like a child's early mistakes and stammers; but in 1861 this translation of a biblical legend into peasant dialect is difficult to accept. In his picture *The Wait* Millet clothes Tobias' mother in a jerkin and a blue petticoat as she goes to watch the road for her son's arrival, and he dresses the elderly patriarch as an old village blind man. This would be nothing if he left these disguised characters a human form; but father Tobias has no tibia in his legs, and mother Tobias has stumps instead of hands.

On a bench near the door, an animal, as fantastic as the Japanese monsters on corkscrews, raises itself on its legs and arches its back. Straining the imagination, one ends by recognizing this strange animal as a cat. Polynesian savages would make a better likeness carving a piece of wood with a sharp

shell. It must be admitted, however, that the landscape, bathed in the light of dusk, is of a very realistic and skillful tonality. . . .

BATTLES. As far as the battles are concerned, we will not follow the alphabetical order as we did for the other pictures. Most are hung in the Salon Carré without regard for the first letter of their creator's names, but according to the convenience of dimension or appearance. The painting of battles is, in addition, a particular and very modern art. Doubtlessly, battles were painted in former times, but the artists did not strain for a historical and military accuracy that no one demanded of them, one which is today quite reasonably required, since the events are known to all. They grouped imaginary combatants or threw them against each other according to their fancy, using them as a pretext for color contrast or anatomical studies, presenting the abstract idea of war rather than the depiction of this or that battle. . . .

Many difficulties present themselves to the artist who is placed face to face with a blank canvas, no matter how large it is, on which two armies are supposed to clash. If he makes his figures life-size, he can only show a relatively small number. The battle disappears in favor of an episode. If he reduces them to the proportion of figurines, they diminish in importance, and the painting takes on the aspect of a plan of strategy. Yet he must choose between these two alternatives, each offering their own inconveniences.

Much special knowledge is necessary to a painter of battles. He must know how to paint horses, landscapes, portraits; have at his fingertips the thousand details of uniforms, arms, and maneuvers. This is no small thing. Today we are not content with the fanciful monsters that were once accepted as horses. The ease of travel has made everyone familiar with the look and climate of the sites; the generals and the officers who took part exist, at least those who were not carried away by a bullet or a ball in the midst of the triumph. They may be encountered in the Salon Carré looking at the battle they commanded. Make a mistake in a gaiter button or a bit of

braid, let a soldier execute a wrong move and the first Zouave who passes becomes a competent critic.

We do not speak of the general demands of art, of composition, design, and color. The strategic lines are contrary to carefully balanced groups, their required movements disturb the stylish contour, the regimental colors of the uniforms are themselves sometimes opposed to the harmonies or contrasts that the painter dreams of. Yet all this did not prevent Pils from painting an excellent picture, *The Battle of Alma*. To speak correctly, it is not a battle, for none is waged there, only a grand, irresistible, decisive war maneuver admirably suitable to painting. . . .

SCULPTURE. The beautiful art of sculpture would disappear quickly if it were not for the devotion of its faithful practitioners. The public remains indifferent to it and only descends to the gardens in which the sculpture is exhibited to smoke their cigars. Once the last puff is exhaled, they hurriedly climb back up to the picture galleries. Even though they have a basic, vague respect for the sculptor and the poet, because marble and verses are difficult to work with, they find statues and poetry equally boring. Abstract form is displeasing to them: no interesting subjects, no drama, no sense of actuality. This is not part of their concerns. Also, it must be admitted that sculpture, so natural in Greece, with its anthropomorphic religion, is only a hothouse flower in our Christian civilization, a precious flower that should not be allowed to perish. Our customs, our climate are involuntarily hostile to it. This art, which is meant to glorify the human form and which cannot survive without the nude, shocks our modesty, or at least our habits. A people always clothed from head to foot, as we are, is astounded at the appearance of these marbles, uncovering with the chastity of art the beauties whose veil LOVE barely dares to raise. How can one admire and judge that which one never sees? And what is more unknown to civilized man than his own shape? Without sculpture he would lose all idea of it.

In spite of all these obstacles, the sculptors persist in their ungrateful trade: Neither oblivion, abandonment, nor misery

discourages them. They obstinately maintain the tradition of beauty and would perish at their task if the august protection of the government, their only buyer, did not sustain them with commissions. To embrace this austere art a strong sense of vocation is needed, and even mediocrity demands long study. Both more idealistic and more realistic than painting, sculpture has no loopholes. Light, which never lies, envelops all its surfaces, pointing up the faults and the beauties. Errors on it are obvious. For this reason the anatomical studies of sculptors are generally more detailed than those of painters. In addition, the human body is its only subject. For it external nature does not exist.

The exhibition of sculpture this year is one of the most remarkable that has been seen in a long time for the number, importance, and general quality of the pieces it contains. Marble and bronzes abound, without counting the plaster models that will later receive a more permanent form. The courageous efforts of the artists devoted to the maintenance of this great art cannot be too highly praised.

A crowd of names flows from our pen; but the hour is late, time is passing, the Salon has already been closed for two weeks. Why speak of sculpture to ears that are not deaf but are already listening to other sounds? Let us conclude by asking those whom we have omitted to excuse us. What could we do by ourselves faced with 4,097 objects of art?

1861: FLORENCE

The Official Exhibition of the State: The National Exposition of the Kingdom of Italy

By 10 A.M. on September 15, 1861, an auspiciously fair day, two thousand people who had traveled to Florence by foot, horse, carriage, and railway were jostling Florentines for a place along the streets leading to the Palazzo dell'Espositione Italiana. The crowd in the square in front of the building joked about the awkward horse of the colossal equestrian statue of King Victor Emmanuel II which Ulisse Cambi had hastily executed. "In time we will give him a horse that can carry him to Rome and Venice." A volley of artillery sounded. The enthusiastic crowd, cheering and waving the red, green, and white flag of the new Italian nation, moved back to permit the passage of its forty-one-year-old king, the Turkish ambassador, a few distinguished guests from Portugal and Denmark, and the Prince and Princess Antoine Bonaparte. Cheers gave way to silence as the president of the Exposition stepped forward to declare, "Italy now takes its place among the nations. The exposition will mark the beginning of its liberty and emergence. *Viva il re d'Italia!*" Flanked by

ministers, senators, and officials, the king toured the Exhibition's three sections: agriculture, industry, and art.

Two years earlier Victor Emmanuel II, of the house of Savoy, King of Sardinia, and Napoléon III, Emperor of France, had united their armies to drive the Austrians from the northern Italian state of Lombardy. When the Hapsburgs were defeated at the battles of Magenta and Solferino, the Austrian princes who ruled the neighboring states of Modena, Lucca, Romagna, Parma, and Tuscany fled, leaving their former subjects to vote in favor of annexation with the Kingdom of Sardinia. By 1860 only the Venetians remained under Austrian control in northern Italy. At the southern end of the peninsula, Garibaldi and his thousand red-shirted followers drove the Bourbons from the Kingdom of the Two Sicilies. Neapolitans cheered as Garibaldi and Victor Emmanuel II rode through the city in an open carriage, and Naples and Sicily pledged their loyalty to the king of Sardinia. The Marches and Umbria were ceded to the new Italian state by the pope. At the insistence of Napoléon III and Catholics of other states he retained Rome and the immediately surrounding territory, Latinum, to represent his temporal power. On March 17, 1861, representatives from across Italy, with the exception of Latinum and Venetia, assembled in a new parliament building in Turin and proclaimed Victor Emmanuel II king of Italy. By the time France and England gave formal recognition to the new nation in early June 1861, plans were already under way for a national exposition in Florence in September.

An exposition building was begun behind Santa Maria Novella Church, near the railway terminal—it would later serve as the station—and was completed in time to receive the agricultural, industrial, and artistic products. All artists, including native Italians and foreigners, who resided in the new kingdom, in the Austrian-held state of Venice, or in the Papal State had been invited to send examples of their work executed within the last ten years. The art section was assembled by an executive commission composed of fifty artists and art patrons from all parts of the peninsula. The commission was not limited to Italians: The English sculptor Charles Francis

Fuller, and the American Hiram Powers were members; Fuller and Joel Hart of New York were among the eighteen jurors for sculpture.

Foreign visitors and journalists eager to visit the new nation joined Italians who came to view the 1,000 paintings and 426 sculptures received from every region. The exhibition was the first survey of contemporary Italian art ever held that was comparable to the annual Paris Salon, the Royal Academy exhibition in London, or the German exhibition of 1858 in Munich.

Cautious conservatives paused approvingly before the *Decameron* and *Eudorus and Cymodocea*, sent from Rome by Luigi Mussini. An exponent of the *purismo* school who, like the Nazarenes, was accused by classicists of "copying miserable nature with every defect," Mussini tinged his art with the mystical spirituality of the fifteenth century. The term *purismo* had come into use in the 1830s, when it had been employed to designate painting in which carefully defined form served specific themes. The *purista* sought to achieve an aesthetic unity within his work through his treatment of form. New editions of Vasari's *Lives* published in 1846 provided literary support for the *purista's* artistic theories. Like their counterparts in other countries—Ary Scheffer in France, the German Nazarene Friedrich Overbeck, or the English Pre-Raphaelite William Holman-Hunt—the *puristi* were related to the romantic school.

The formal treatment of the canvases of the *romantici*—who were exponents of history painting—was similar to that of the *puristi*, but their choice of subject matter was very different. Paintings such as *The Expulsion of the Duke of Athens from Florence* by the Florentine Stefano Ussi and *The Iconoclasts*, in which the Neapolitan Domenico Morelli illustrated a heroic defense of liberty in the face of political oppression, attracted enthusiastic viewers. By modifying the traditional academic rules governing composition and color, and by choosing subjects with contemporary relevance, these painters bridged the gap between the academicians and experimental artists.

Domenico Morelli, who had worked briefly in Florence

upon his return from a study trip to Paris in 1855, advocated "a *tocco* of impressions, of values, and of chiaroscuro" in order to achieve the truth *vero*. "I feel that art should represent figures and objects not as they are seen but as they are imagined to have been true in a particular time." The *verista* painted historical or mythological figures, such as Moses or Ulysses, as he might have observed them in their actual environment and under natural sources of illumination. He desired to cover the figures and scenes of the past with a cloak of veracity (*panni veristi*). *The Iconoclasts* was Morelli's first large work illustrative of his concept. Many who viewed it recalled the contemporary "Christian martyrs" of the 1848 revolt in Naples, when Morelli himself had been wounded and the literary historian and aesthetician Francesco de Sanctis had been exiled. Morelli was familiar with de Sanctis' aesthetic theories, based on a concept of form de Sanctis had evolved during three years of imprisonment in Naples. De Sanctis had made the theories public in lectures given at Zurich in 1858 and 1859. He argued that "form is not *a priori*, it is not something existing of itself and distinct from the content, as though it were a kind of ornament of vesture or appearance or adjunct of the content: It is generated by the action of the content in the mind of the artist; as the content is, so is the form."[1] For de Sanctis the concept of form was identical with that of imagination or artistic vision.

Morelli's painting technique had been devised in collaboration with the Palizzi brothers: Giuseppe, Francesco, and Filippo. Filippo, who painted a broken kettle in Morelli's *Iconoclasts*, had, since 1848, endeavored to compose *a macchia*—in spots of color—in an attempt to free his work from every vestige of conventionality. Giuseppe Palizzi, "a painter of landscape and animals," had been awarded a medal at the Salon of 1850 in the section which included the paintings of the Barbizon artists Troyon, Dupré, and Rousseau.

At the Florentine exhibition, beside the works of Morelli and the Neapolitans and the *puristi* academicians, there were

[1] Francesco de Sanctis, *Nuovi Saggi Critici*, 2nd edn. (Naples, 1879), pp. 239-40

other canvases which aroused the public's curiosity. Free of academic formulas, historic themes, and devoid of the *purismo* reverence for linear form, these works were by young artists: Serafino De Tivoli, Cabianca, Lega, Signorini, Fattori. Several were Tuscans, while others had come in the 1850s from Venice, Milan, Rome, or elsewhere to Florence, where there was less political surveillance by the police. Liberal, ardent nationalists, some had fought with Mazzini and Garibaldi in the vain attempt of 1848 and 1849 to establish an Italian republic in Rome. They had begun as early as 1848 to experiment with a technique that used patches or spots of color to accent the contrasts of light and shade; hence their name *macchiaioli*. The impression of space was achieved by the tones of colors laid on like bricks. The sensation of spaciousness created within some of their small canvases recalled that same sense of space present in fifteenth-century Italian paintings. Between 1850 and 1859 they gathered at the Caffè Michelangelo to discuss techniques and formulate theories, for the efficacy of the Academy's system of instruction had already begun to be questioned by 1826 in Milan and elsewhere. *Purismo*, with its deliberate return to fifteenth-century art for technique, models, and themes, was rejected by such painters. Florence was a way station where French, German, and English artists studying in Italy stopped and came into contact with the Florentines, so those experimenting with color were generally informed of each other's efforts. The Palizzi brothers and Morelli were members of a similar group in Naples that was equally innovative in color and techniques. Degas had frequented both groups.

To both Italian and European journalists, the diversity of artistic styles at the Italian art exhibition proved that a spirit of liberty was rejuvenating the arts and that academic methods and subject classifications were being discarded. Liberty and independence also stimulated Italian publishers. Released from political divisions and severe censorship, the number of Italian publications increased from 311 in 1856 to 450 in 1864. Many editors sent critics to the Florentine exposition to review the art section. The well-established *Museo*

di Famiglia—Rivista Illustrate, published since 1839 in Milan, assigned Pier A. Curti (1819–99), the author of biographies and monographs on the history of Milan and its monuments, to review the sculpture and paintings at the exposition.

Pietro Selvatico (1803–80), a Paduan art critic remembered for his active role in the violent debates between the classicists and romantics and for his *Storia Estetico Critica delle Arti del Disegno* (Padua, 1852–56) and *Pensieri sulla Architettura Civile e Religiosa* (Padua, 1840) thoughtfully appraised the state of contemporary Italian art in a lecture delivered to the Paduan Academy and published as a brochure.

The exposition that marked the emergence of Italy in international politics and the art world prompted the foreign press to send reporters to Florence. News of the political events accompanying the unification had been avidly read; now many were curious to discover what elements from Italy's glorious artistic past had persisted, to compare and judge its present achievements against the standards set in earlier times. Special interest in Italian affairs, which had long been present in England, had been fanned by Elizabeth Barrett Browning, who had published her final work, *Poems before Congress* (1860) "to rally support for a liberated united Italy." The *Art Journal*'s report on the exhibition, which it regarded as "gratifying evidence of a new birth of art in Italy," was written by John Stewart, a respected teacher of ornamental design at the government School of Design. France had been Italy's principal supporter in securing independence. The government paper *Le Moniteur* sent the art critic Clément de Ris (1820–82) to Florence. His two articles were later summarized in *L'Artiste,* which also published Cenac Moncaut's thoughtful essay "De l'Influence des Peintres sur les Destinées de l'Italie." The correspondent of *Die Dioskuren,* the organ of the Kunstvereine, observed,

> The general impression is that fewer religious pictures than one is normally accustomed to are included; there are also fewer genre pictures (than in Germany and England) and, likewise, fewer flower pictures and still lifes, but there are many more

historical representations, especially of the last Italian war. Be-
sides these, there are many landscape and architectural pictures.
Worthy of notice, if also not characteristically art, is a whole
series of watercolors that represent events in the war of the last
three years. The most artistically valuable section of the exhibi-
tion, without doubt, is contained in the twelve rooms of sculp-
ture, which are unfortunately crowded in very narrow rooms.
These works of sculpture far surpass the painters' work.[2]

The close of the national exposition was celebrated with
the customary ceremony: the jury awards were announced
and the medals were distributed. The twenty judges of the
painting section represented the conservative school, so thir-
teen painters, Ussi and Morelli among them, returned their
medals to protest the jury's incompetency.

When the political goal of unification had been achieved,
the enthusiasm that had united the Italian people and stimu-
lated its artists subsided. Regionalism returned, and the
renaissance of art in Italy was deprived of much of the vital-
ity that had been evident in the 1850s and 1860s.

Pier A. Curti: *Italian Exhibition at Florence*[1]

FINE ARTS DIVISION

. . . Therefore, it will not waste the reader's time if he ac-
companies me through the rooms dedicated to the Fine Arts
at the Florentine Exposition, particularly as I do not plan to
pause with him before inferior or completely mediocre work.

Sculpture

Since I am anxious to prove immediately that I was not
mistaken when I said that genius burns ever brightly in the
hearts and minds of Italian artists, I will lead my readers
without delay to the hall containing the works of Giovanni
Dupré. This excellent artist did not make up his mind to
send his work to the Exposition until the last moment; I will

[2] *Die Dioskuren* (August 8, 1861), 301–2
[1] [First published in, and translated from, *Museo di Famiglia*
(November-December 1861), 382–84, 404–11]

not ask the reason; what I do know is that he could well say, the minute he came, "*Veni, Vidi, Vici*," as Julius Caesar so laconically wrote to the Roman senate. Dupré is easily the prince of living sculptors: He is the worthy pupil and heir of Bartolini's genius; and each work of art we see here is a masterpiece. Since I was in Florence during the first days of October, when Dupré had not yet sent his work to the Exhibition, I must talk about them in the order that I admired them in his workshop at the Liceo di Candeli. One is drawn, first of all, to admire the clay model of the magnificent bas-relief representing the *Exaltation of the Holy Cross* which is to be executed in marble over the portal of Sante Croce in Florence; its facade is now being constructed.[2] It is impossible to imagine a conception more imposing or more beautiful. The cross itself is placed on the summit of the hemicycle in the midst of saints and angels in heaven; on different levels there are about forty life-size historical figures in total relief, in various attitudes, pointing to the principal men who, each in his own life, worked for the triumph of the cross. This composition becomes a narrative, indeed, an epic poem. One recognizes easily, so felicitous are their expressions, Charlemagne, Dante Alighieri, the Countess Matilda, and several church fathers. After this, it is really superfluous to speak of the execution, for in its perfection it is superior to all other sculptures. As for the knowledge with which the various levels are treated, the character and the animation of the figures, the style of the heads, the rich drapery—all are marvelously carried out. The other work of art well worthy of standing beside it is the great cup of porphyry whose base has been worked around by Dupré with graceful bas-relief . . .

As we leave the Sala Dupré, let us acknowledge the vote of popularity given by the public to the works of Lombard sculpture before our illustrious Tuscan entered the lists and gained the highest honors accorded to plastic art. Let us linger in front of them. It grieves me not to see among them the *Wounded Achilles, Eva, Penthesilea, The Dawn of Ital-*

[2] [The facade, designed by N. Matas, was completed between 1857 and 1863.]

ian Independence, or any other sculpture by Innocenzo Fra-
caroli, an artist of classical taste and well-deserved renown.
However, Lombard statuary is well represented by Magni,
Vela, Tandardini, Argenti, Corti, and several other excellent
artists . . .

I will close this rapid visit to the rooms devoted to plastic
art by praising the handsome bronze statue by the American
Fuller, representing the *Shipwreck Survivor*, for its truth in
conception and expression and by reminding one of the
America by Powers, a statue which, as a matter of fact, has
not the merit of the marble busts he usually completes with
enviable skill. . . .

Painting

Is it possible that the crowds of people drawn to Florence
with the thought of visiting the Exposition could have gone
there without taking the opportunity of admiring or revisiting
all the marvels of art so abundant in this beautiful city?

I, for one, may tell you that when I happened to tour the
Pitti and the Uffizi galleries, where so many treasures of an-
tique art are gathered, I almost forgot the main goal that
brought me to Florence. Then the paintings and the frescoes
of Santa Maria Novella and San Marco, those of San Salvi
and the Bargello, of the Annunziata and the other churches
and cloisters: the marbles of the Palazzo Vecchio and San
Lorenzo, the sculpture of San Giovanni [Battista] and Or
San Michele, the numerous architectural details of palaces in
every quarter of the city and, best of all, Santa Maria del
Fiore and the Loggia dei Lanzi, ended by arousing such
enthusiasm—which, I confess I do not have for the arts of
today—that I reluctantly had to tear myself away from these
miracles to go all the way to the Piazza dei Zuavi, where the
Palace of the Exposition rises.

Arnolfo [di Cambio], Orcagna, Brunelleschi, Donatello,
Ghiberti, Michelangelo, Cellini, Giotto, Masaccio, Raphael,
Andrea del Sarto, Fra Angelico, Guercino, and so many other
illustrious names in the three arts based on drawing—I could
never finish the count of artists unequaled in our times.

Such was my opinion then. Perhaps now it has been

changed to some extent, since I have also seen and seen again works by some of our modern artists, who, if they are not exactly shoulder to shoulder with the glorious ones, happily tread in their footsteps.

In speaking of sculpture, I have already touched on some of them: Painting also boasts such champions.

I begin by placing before you Stefano Ussi, still youthful, who "like an eagle flies over all others." There is a magnificent painting by him representing the *Rout of the Duke of Athens from Florence*. Giovanni Villani's *Chronicles* tells of this tyrant. Using this subject, Ussi has reproduced an occurrence that was repeated in present-day Italy, when the country, for her own welfare, rose up against the rulers that had consumed and divided her. For this reason the scene is as engrossing as is the daily news. . . .

In this great canvas of Ussi's, Duke Gualtieri[3] is ready to sign his resignation. Threatening faces surround him; those of his own Burgundians see clearly the uselessness of holding out against the triumphant will of the people: But perhaps growling voices from outside still hold him in suspense. The composition, the drawing, the palette—all are admirable. They attract and hold you with your eyes fixed on the painting for a long time, and you are moved to declare it to be the best of those shown here. And, indeed, this is one of the artists who represent Italy in the field of painting.

After him, my preference is for the Neapolitan Domenico Morelli. The painting representing *The Iconoclasts*, those heretical enemies of the worship of images, is most able both in inventiveness and execution, and would suffice to justify his reputation as the head of the school in his city. . . .

He has caught quite wonderfully the moment when the artist-monk is standing in front of his painting, which three iconoclasts are tearing to pieces. *The Pompeian Bath*, an en-

[3] [Walter of Brienne, the Duke of Athens (known in Italy as Gualtieri di Brienne); elected conservator and captain of the guard in 1342 by the Florentines to suppress the rioting that had followed the great plague and famine. When he proclaimed himself Lord of Florence for life, its citizens ejected him from the city. Giovanni Villani (1275-1348), author of *Cronica Universale* or *Historie Fiorentine*]

graved reproduction of which enhances these pages, has wonderful light effects besides being very well contrived. The setting is an area in the baths of ancient Pompeii, perhaps taken from life, copied from what the painter saw in the excavations that continually proceed in that city and in Herculaneum, formerly buried in Vesuvian lava. It is peopled with lovely women emerging nude or seminude from bathing in the caldarium, drying themselves, and playing or handling vases of perfume. The subject matter has allowed the famous painter the opportunity of displaying fully all the riches of his palette and his mastery of the flesh tints and the drawing of the many and varied poses. . . .

The third place in order of merit cannot be refused to Professor Adeodato Malatesta of Modena, who, in the grandiose canvas in which he depicts the *Defeat of Ezzelino da Romano*[4] in the Geradadda, shows himself to be one of the strongest painters of our era. One would say that in the expression of the head, as well as in the composition and general coloring, this work was from the brush of Luca Giordano; when it was shown for the first time a few years ago, it alone sufficed to make famous the exposition of Milanese art at the Brera. Most realistic and painted with no less skill is the other picture by Malatesta representing *Hagar*. . . .

After these men I would be unfair if I did not hasten to mark out for public praise the works of our two Milanese painters, Pagliano and Domenico Induno, although after speaking of Ussi, Morelli, and Malatesta I have no intention of mentioning these others in order of talent. The first of these artists, Elentino Pagliano, has chosen for his subject the *Assassins of Buondelmonte*[5] whose death took place on Easter 1215 . . . Domenico Induno, on the other hand, completed a more difficult but wholly successful picture, *The Bat-*

[4] [Ezzelino III da Romano (1194–1259), of Verona, Vicenza, and Padua, enlarged his holdings by such ruthless means that he was said to be the devil's son.]

[5] [To end the political quarrels among Florentine families, Buondelmonte di Bondelmonti, of the Guelph party, was married to a daughter of the Ghibelline Amidei family in 1215 and was immediately assassinated by the Amidei.]

tle of Magenta. The vivacious palettes of other artists' works which surround this work by Induno may have caused the latter to seem cold. I do not agree, as I found both character and passion in the diverse figures and groups, beautifully harmonized with his usual skill. I am sorry that Hayez and Soegni abstained from sending their work, which would have completed a worthy sampling of historical Lombard painting. . . .

Now a most piteous scene depicted with all Conti's veracity commands our attention: *The Massacre of the Cignoli Family* ordered by the most stupid of hyenas, the Austrian General Urban, on the morning after the battle of Montebello in the spring of 1859. Pictures of this type do have a political motive, keeping alive the hatred of the foreign oppressor and reminding us of our obligation to be rid of him forever. For this reason the artist should also be commended for his choice of subject. . . .

So I have ended my account. . . . Let it suffice for readers to realize at first hand that the school of Bartolini, thanks to its head, Dupré, displays splendid examples in Florence itself; that painting also continues its glorious traditions in Florence thanks to Ussi, Bezzuoli, Puccinelli, Pollastrini, Mussini; that Naples, though it does not yet have valiant sculptors, has, by way of compensation, giants like Domenico Morelli and Celentano to support the art of painting; that in Lombardy and Emilia both arts boast such excellent men as the sculptors Vela, Magni, Tandardini, Strazza and the painters Malatesta, Pagliano, Induno, Valentini, to name only the exhibitors; and that, finally, the arts in Italy only ask for protection and favor in order to be able to begin anew with fitting power and win once more that supremacy which in former centuries no one would have dared contest.

Pietro Selvatico: *The State of Contemporary*
Historical and Sacred Painting in Italy as Noted
in the National Exposition in Florence in 1861[1]

I. . . . I hope, distinguished Academicians, I will not strain
your patience to the utmost by speaking about one of the sec-
tions of the National Exposition which took place last au-
tumn in Florence: It was the target of numerous pilgrimages
both from our country and abroad, and it received well de-
served fame and acclaim not only in our peninsula but in
the whole civilized world. As you may perhaps guess, the
section I refer to is the one about which I feel least igno-
rant, that of the arts of drawing. . . . Have no fear . . .
of my talking at length about more than 1,000 paintings,
250 sculptures, over 500 ornamental works, and I have no
idea how many engravings. Rest assured, I will only discuss
historical and religious paintings, and I will not stretch out
the analysis of every scrap of canvas that might belong to
one or the other of these classifications, but will seek among
the best the actual state of historical and religious paint-
ing in Italy. The state of Italian painting was more evident
at the Italian exposition than at any previous exposition in
our country, because many of the best works painted by
our artists were gathered there and many works done fifty
years ago by good painters, some already deceased, were
also wisely included, making possible immediate compar-
isons between the present and a not-too-distant past. By
such comparisons we can discern those areas in which our
painters have improved or regressed and those in which they
have perhaps stood still. . . .

II. One of the most quick-witted of contemporary writers,
Heinrich Heine,[2] said (and I do not think he was wrong in

[1] [Translated from *La Condizione dell'Odierna Pittura Storica e
Sacra in Italia rintracciate nelle Espozione Nazionale Seguita in
Firenza nel 1861* (Padua, 1862)]
[2] [Heinrich Heine (1797–1856), German poet and journalist;
see *Triumph*, pp. 291–316]

this) that since the Revolution of 1789 we Italians have been two-thirds French. What he meant was that we are too often prone to base our habits, customs, predilections, literature—in a word, whatever is related to the moral life of a people—on French models. If proof of this is wanted, it would be enough to consider the art of drawing. Formerly we were famous for our draftsmanship, and we taught it to all the civilized world, but for about seventy years Italy has been subject to the influence of that so-called great nation . . .

The demagogue painter, [Jacques] Louis David, has the idea that it is impossible for art to be worthy of free men unless the composition, movement, and linear design, even in everyday subjects, are classical reminiscences borrowed from Roman bas-reliefs and Etruscan vases; and French painters, followed by ours, almost all hurl themselves into imitating the marble style of the Republican Apelles.

One fine morning, weary of the Grecian mode, that absurd anachronism of sick minds, France falls frenziedly in love with the Middle Ages, so that poets, novelists, architects, and painters go to great lengths to revive helmeted soldiers of feudalism, superstitious legends of troubadours, portcullises of dungeons, and pinnacles of the Gothic cathedrals. And lo, Italy follows obsequiously in the footsteps of the enchantress and invites her artists to rummage among the scraps and old ironmongery of secondhand dealers for medieval armor, shields, and bucklers, and to depict minstrels strumming lutes, Crusaders fighting for the Holy Land, or Romeos asking refuge of too amorous chatelaines.

Even this romantic obsession bores fickle France. And when France is bored, she takes a short cut and manufactures a revolution right away—and not only in politics, but in domestic life, in literature, in art: So the masterly baroquisms of Lebrun, the lascivious pastorals of Lancret, the statuesque rigidity of David, the doctored-up Raphaelism of the "Ingristes" are repudiated. Novelty, novelty at any cost, is sought. But where will it be found when every way seems to be blocked? There is a final way: confused, boiling ideas, feverishly skipping dreams; it doesn't matter if chaos comes

out of it all. But who will dare attempt this apotheosis of delirium? Fortune helps the bold, and the boldest dares to proclaim, in words as rash as his brush, that genius alone should be the guide of art and, scorning the guidelines of tradition and the vehicle of rules, that therefore he must clarify on canvas his momentary thrusts of fancy without thought for accuracy of form and regard for truth.

Dazzling spontaneity of conception, irrational but fascinating magic of color, tones, and chiaroscuro make Eugène Delacroix the standard-bearer of the disheveled school, and all of France praises to the skies the lightninglike blows, even at the cost of not understanding the subject matter or forms of his eccentric paintings. One would think that the Italians, brought up among the noble monuments of the past and endowed by heaven with a genius instinctively inclined to correct elegance and accurate representation, would reject this style more than any other, yet there are not a few of our painters who, rejecting the chosen style of their forebears, hurl figures and landscapes onto their canvases like bas-reliefs or mosaics, all with strokes of their palette knives, in order to follow the fashion of the raging French innovator. And we may as well admit that we are often forced to admire works of imagination, fascinating color, quickness and freedom of brushstrokes, but still these are works about which common sense has to say, "What a pity that instead of a finished painting the artist has given us a sketch."

However, Italian genius is like the prodigal son: It runs away from home, often succumbs to every intemperance, then returns to the family, straightens out, and becomes wise. Indeed, in the midst of this unfortunate mania for copying the French, we do see several artists allowing themselves just a passing infatuation with the fashions of the Seine, and then repenting; they return to the rightful path of our great artists and study nature not just to copy it slavishly, which is a paltry exercise, but to develop an awareness of emotions.

The Florentine exposition, if it did show numerous imitations of the various phases of French art, also offered many examples of a return to a sound, wholesome style.

III. Let us first of all touch on artists who allowed their fertile talents to be "Frenchified"; then we will console ourselves with those who saw the error of their ways or who, by good fortune, remained Italian.

Among the Davideschi we place first, because his manner conforms closely to the Frenchman's, Professor Pietro Benvenuti of Arezzo, who died several years ago. Two huge paintings by him brought him fame, but now they tend, if not to destroy it, at least to diminish it a great deal. They are *The Oath of the Saxons to Napoléon After the Battle of Jena* and *Count Ugolino with His Sons in the Tower of Pisa*. . . .

Many regretted that some of the work of Camuccini and of Luigi Sabatelli (the elder), who were surely in the last half-century the best representatives of the classical school of Italy, were not brought to the exposition. . . .

IV. Fortunately for contemporary Italian painting, classicism is not limited to the imitation of antique marbles and to Davideschi dryness. Many artists preferred to devote their studies to the better *quattrocentisti* and Raphael, deriving from them, if not conspicuous originality, at least a chaste and imposing style. . . .

One of the better contemporary Italian artists, the cavaliere Luigi Mussini of Siena, drew a subject peopled with lovely women. He was asked to picture the Sienese *Decameron* and to place the portraits of elegant ladies of aristocratic families among the many maidens. How fortunate for him! He did not have to seek beauty in the idea; he found it in flowering models of actual truth. He took advantage of this with the exquisite workmanship natural to him, adding to it the correct facility of his drawing and the habitual delicacy of his drapery. What a pity that there was much to be desired in regard to his color, the strength of tone, and the gradation of the chiaroscuro. A great deal of Mussini's fame is based on the other painting he exhibited in Florence, *Eudorus and Cymodoces*. It is indeed a picture worthy of much praise, both for the moving composition and for the severity of the drawing, but it is too much mangled by weak

coloring, lacquerlike and bluish in the French manner; it is too jumpy with scattered highlights, so that very sharp eyesight is needed to recognize its qualities. Who would have believed it? The same Mussini who began with indefatigable study of our best *quattrocentisti*, the Mussini who abhorred the affectations of the Seine, after a short sojourn in Paris, fell into these [affectations] and actually returned a follower of the too exalted Ingres. One might say that he now uses his vigorous powers to pepper the handsome style that did him credit with tokens of the affected Raphaelism on which is based the ill-earned renown of the French master. Oh, why doesn't Mussini reject the frills which come from beyond the Alps to become a Tuscan again, and be what he is capable of, if he only wanted to be—an original artist of the first order? . . . Let us honor Mussini, who knows so well how to teach youth about art, and let us also honor Pollastrini [director of the Academy of Siena], who also trains youth most excellently, both by his own example and by the disciplined instruction which he prefers. . . .

A crown prince, the youth to whom God seems to have assigned the task of leading our painters back to the glory of the past, is Stefano Ussi of Florence, who painted that marvelous canvas representing the *Expulsion of Gualtieri, the Duke of Athens* in 1342, a canvas which, while it is indeed a witness to the high genius of the artist himself, also testifies to his teacher Pollastrini's ability to guide strong minds along the disciplined path and keep them far from the disordered jolts to which they are pushed by their exuberant natures.

Those here who know the history of Florence are well aware of how the reckless French adventurer profited from the perpetual strife in that uneasy city and, like all political opportunists, made himself the spearhead of the democratic faction to which he promised riches, appointments, and honors. He obtained the highest office of the deluded city and, having secured it, tore the city apart with taxes, violence, and torture. The Florentines, soon recognizing the deception, rose up against the tyrant and forced him to relinquish his ill-gotten sovereignty, though they generously let him live. This very important event of our history, or, rather, this to date useless

lesson for Italy, has been represented by Ussi in a fashion so
noble, so true, and so great that his work will earn a place
among the most famous paintings of our epoch. It proves
that our country no longer needs to envy Belgium her Gal-
lait, Prussia her Schrader, Bavaria her Kaulbach, and France
her Delaroche. An exalted and yet simple concept, severe and
at the same time elegant drawing; the authentic character of
the period in the heads, the attitudes, the costumes, the
arms, and the accessories; true coloring, without accidental
naturalisms, and a little heavy only in the background; the
grave, clear expression always suited to the character; the feel-
ing and the temper of the personages—all make this vast can-
vas a masterpiece which will tell those living now and in the
future that the powerful intelligence of the Italians lacks only
a reasonable art education for most excellent brushes to
emerge again.

This would be a happy thought were it not embittered by
the fact that while both by Italian and foreign vote an imper-
ishable crown of superiority was placed on Ussi's head, those
who sat as judges at the exposition were not wise enough—or
not willing—to award him a crown. . . . In the land where
the rough republicans of the thirteenth century knew enough
to honor Cimabue's *Madonna*[3] with the feast of Brogo dei
Allegri, some solemn token could have been devised by the
refined civilization of the nineteenth century to express
Italy's happiness at the rise of so brilliant a genius. The cross
in the buttonhole which the government awarded him cer-
tainly was not sufficient—these days it is given with such in-
temperate largesse that it is no longer really wanted by the
deserving.

V. Now I must speak of another phase of our painting
which originally came to us from the banks of the Seine,
namely, the one we call romanticism, not because it draws its
subject matter exclusively from the Middle Ages but because
it is inspired by the exaggerated, swooning sentimentality

[3] [Cimabue's *Madonna* for Santa Maria Novella was first displayed
at a feast in honor of Charles of Anjou.]

with which French literature decked itself out thirty years ago. Hardly any works from that period are worth looking at now because—we say it without hesitation—they are mediocre. They were the efforts of men who in their day acquired resounding fame as the most able of painters. We should therefore point out the works to be condemned least if only to be consoled by the improved state of our art today. Witnesses of this second period of pictorial slavery to France are the numerous paintings of the late Professor Bezzuoli, who during his lifetime managed to acquire a reputation as one of the most able artists of the peninsula, a reputation which gradually languished until it was totally lost in the void after his death. No less than twelve of his paintings were exhibited. In all but one of them there was, without exception, the same propensity for using exaggerated choreography embellished by haphazard studies made from the model or lay figure. The only quality that might inspire some respect from the well informed was a florid and glittering color in the flesh tones . . . The picture which contains most of these characteristics, as well as the faults we have pointed out, is the huge canvas representing the entry of Charles VIII into Florence in 1494. . . .

VI. The fashion for showy and mawkish romanticism has, thank God, passed: No one wants pale daughters of misfortune or the emaciated hermits à la d'Arlincourt[4] anymore; no one wants to bother with the Templars, Romeos, Abelards, Héloïses, and all the whining legion of misunderstood heroines . . . Now we want reality, dressed like a good housewife in apron and clogs and not masked like a mimic actress.

The century sings with Giusti:

> *"In body and in soul*
> *Serve the real*
> *And do not lose yourself*
> *In the ideal"*

[4] [The Vicomte d'Arlincourt's (1789–1856) romantic novels were very popular in Paris.]

The ideal, in fact, falls as a dead body falls under the blows of prosaic realism, which apparently wants to be a dictator in rather democratic guise since it does not refrain from often appearing before us with rags, scabs, and spots. The worst is that even in that garb Realism seems like poetry in bloom to many who wield pen or paintbrush. So we see writers finding heroism among chimney sweeps or a pearl forgotten in a filthy heap of rubbish. We see painters who believe they have reached the summit of art, copying with a miniaturist's patience the wrinkles of the skin or the broken pots and pans of the kitchen. By such a method the material representation of truth becomes the end rather than the means of art. By such a method, art no longer emerges from the inner feelings of the artist but from the outward aspect of the subject, whatever it may be. To be brief, the sublime mystery of intellectual creativity gives way to the empiricism of hand and eye. Will art continue in this new phase in which it now revolves? I do not know. I do not believe so, especially since France does not seem to support it with her imperial patronage. But I do know it is a method embraced by many of our best talents exhibited at the Florentine exposition. It is my duty to mention some of the best of these.

Today's painters, the straight followers of nature, should be divided into two sections. The first, without idealizing, avoid everything in both type and form that may contradict their original conception. They copy the real; yes indeed, they always copy it; they copy it too much, or, at any rate, too minutely, but they use nothing which is not relevant to the subject represented. On the other hand, the others indiscriminately use any material. As long as everything in their paintings is scrupulously drawn from life, they don't care if it is wholly unsuitable to the subject. If the traditions of the great examples of art had any influence on artists who made a *tabula rasa* of every tradition, one could say that the first follow the doctrine of Leonardo da Vinci, who wanted painting to be the exact reproduction of reality, but a reality subservient to the ideal. The second follow the system of Michelangelo da Caravaggio, who resolved that his only aim was to project the most striking effects of nature, taking any old

laborer he might happen to meet as a model of the Saviour.

I should like to begin the list of those in the Florentine ex-
hibition who belong to the first section with a youth barely in
his twenties, Sig. Celentano of Naples. In a painting of his,
executed entirely from nature, he reveals a strength of con-
ception and an uncommon ability to realize it. He set before
us the Ten of the old Venetian Republic,[5] making their way
across the courtyard of the Ducal Palace to their fearsome,
mysterious meetings, and gave life to a canvas which could be
called a synthesis of the dark history of the severe tribunal.
That lonely courtyard, veiled with cold, somber colors, to
which the sun seems to have denied its golden rays; those pa-
tricians, divided in small groups, speaking among themselves
with suspicious prudence; those faces which, one would
swear, never knew the shadow of a smile and which, in their
bony leanness and livid pallor, suggest night after night of
grave, bloody, circumspect thought; and those gowns, black
as the ideas of the most tenebrous office—all fix on this small
canvas one of the admirable qualities that one vainly seeks in
many works painted by more experienced hands: the quality
of inducing pensiveness in the spectator. . . .

Several other artists at the Florentine exposition were
praised for a certain skill in reproducing nature in detail, but
the greatest approbation went to those who added to this
quality two much more important ones: wise composition
and warmth of feeling consistent with the concept. . . . But
the one who deserved the greatest praise was Sig. Vito
d'Ancona, who, in his *Dante Meeting Beatrice*, offered us a
picture rich in truth, animated with gentle love and, more-
over, arranged with that simplicity of technique that seems to
many people very easy to accomplish and is, on the contrary,
extremely difficult. He proposed to represent the subject at
the hour of sunrise. In that first ray that illuminates the hill-
tops and the chimney pots on the houses comes an effect of

[5] [The Council of Ten was created in 1310 after a conspiracy
attempted to topple the patrician government of Venice. In 1335 it
was made a permanent committee of public safety and could over-
ride the senate. It could act secretly and quickly and was therefore
feared. See illus. 31]

illusion, without distracting the eyes from the scene which is represented. No small merit this, when so many artists seem to try to call attention to the authenticity of details rather than to the principal subject. . . .

I want to point out *The Iconoclasts* by Domenico Morelli of Naples, a marvelous canvas which contended for the first prize with the one already mentioned by Stefano Ussi. Like Ussi's work, it will remain in the memory of Italians and in the annals of art, as do all those intellectual creations that bear witness to deep and certain knowledge, fearless inspiration without unbridled boldness, and a magnificently original style without eccentric and wasteful vanity. An episode from the history of the fanatics—from the eighth to the tenth century in the East they made it their duty to strike down every sacred Christian image—supplied the subject for the young Neapolitan's excellent work of art. A pious monk, a painter of sacred themes, is interrupted in his patient work by infuriated sectarians who, having hurled themselves on his paintings and destroyed them, threaten the very life of the poor wretch. . . . To such aptitude in expressing so clearly a concept not easy to develop are to be added other qualities related to the technique of art, namely, firm drawing; modeling on a large scale; the chiaroscuro, which, if not faultless, on the whole, is otherwise correct in each separate part; the color of the flesh tones, which is a little too chalky, to be sure, and a little flashy because the hues in the drapery are too monotonous, but it is shining and, on the whole, also harmonious because the color is balanced with industrious sagacity. What greater privilege could Morelli want than never to abandon the style that was so original and so deservedly praised? Yet we will shortly see him part from it to follow a new one, aping a French fashion. For it is all too true that everything that descends from Paris, stamped with its favor and applause, has an intoxicating effect on even the best intellects of our country.

VII. The greatest skeptic among the judges of human deeds, La Rochefoucauld, once said that genius is perhaps only patience. I will not enter into any discussion about

the correctness of his statement, but there is no doubt that
the troops of young men—gallant, bold, and fiery—who try to
bestow on Italy the gems of the so-called *jeune école* of
France do not agree with him. Their gems are full of many
splendors, but certainly not those that are obtained only with
assiduous patience, so furious is the haste with which they are
produced. Concepts rich in imagination, life, sometimes ex-
pression, but often outside the possible and always outside
the customary; disdain for form or, rather, a fantastic form
improvised not by the pencil but by the brush, which flings
itself like lightning on the canvas to sketch not figures but
lively blotches of paint, in which the well-traced contour and
the right individual tone suffice; color convulsively poured on,
without modeling, dazzling with the most extravagant combi-
nations of extremely brilliant hues, among which harmony is
attempted with large patches of cold, neutral color—that is
what the productions of these audacious tightrope walkers,
these jugglers of the palette, these magicians of the *chic* (as
they are called in Paris) are reduced to. They call it the man-
ner of Rubens or Rembrandt, as though the great Flemish
artist and the illustrious Dutchman had not made study after
study before giving themselves over to freedom, and as
though what appears to be swift freedom had not been the
child of long and patient meditation on truth and did not re-
veal the sound learning of drawing and chiaroscuro! . . .

. . . There were not a few paintings of the Florentine ex-
hibition in which this bizarre French importation was fol-
lowed, more or less freely, but the very few which could be
said to be really good were as rare as honesty. On the con-
trary, I do not think I put myself in the wrong if I place in
the list (at least as far as historical painting is concerned)
only the pictures of Altamura, Pagliano, Cabianca and the
protean Morelli. . . .

A charming little sketch by Sig. Cabianca from Verona,
in which he imagines the four principal Italian short-story
writers united as a group, could be called a simple sketch and
no more. There was freshness and vivacity of color, an or-
dered composition of alternating lines, shaded and luminous
masses, cautiously contrasted; altogether, the materials were

there to make a painting, but one that seemed to be at an embryonic stage. Everything appeared indicated rather than created, indicated by one who has great natural flights but lacks the training or goodwill necessary to be a first-rate artist. That Morelli is such an artist needs no proof. We saw his capabilities in *The Iconoclasts*. What he needs, rather, is to be satisfied with the handsome style of that work and not to try a new one in which he is doubtlessly superior tò everyone else but inferior to himself. Surely, even among the famous foreign daubers few would be better able than he to give such freshness of hue and such accurate adjustment of local color to those two figures, sketched with bravura, whom he called the Count of Lara with his page. Few could think of placing and arranging groups so happily, with such harmonious and lively color, with such a quick and dexterous touch, as he did in those jests without any real subject, actually like the rhythmic stanzas by Prati[6] entitled *Venetian Gondola* and *Serenade*. No one could discover a more varied innovation of composition and a more dazzling play of chiaroscuro than he did in his *Pompeian Bath*, an assembly of beautiful, cheerful women in Eve's costume. But why did Morelli not want to transform these admirable sketches into paintings, carried out as he knows how to do? He would have won sincere praise both from the public and from knowledgeable artists, and he would not be, as he now is, an excuse or pretext for others, so much less gifted than he, to become bogged down in a swamp of crazy mannerisms from which nothing will result but an ephemeral attraction for the eye and ever-increasing damage to true art. True art, emerging from serious thought, aims to stimulate similar thought in the observer . . .

VIII. Historical painters are still divided into two camps with regard to the advisability of use of the cartoon in the preparation of historical and sacred paintings. He who in-

[6] [Giovanni Prati (1815–84) a poet and an anti-Austrian devoted to the House of Savoy, was the author of the romantic narrative *Ermenegarda* (1841) and volumes of lyric poetry, including *Pische* (1875) and *Iside* (1878).]

tends to follow the methods of the greatest Florentine and Roman masters of painting, having determined the composition with a sketch, then draws it carefully, in the required size, on a frame covered by large pieces of tinted paper, and on it carries out what is customarily called the cartoon, that is, setting out each part with painstaking studies from nature and, most important, establishing according to truth and reason the masses of light and shade. In this way the artist is able to determine the effect of the future picture before actually painting it; and then, having completed the cartoon, he can consider that half the work is completed because nothing is left for him to do at the time of transferring the picture onto canvas than, by means of his brush, to take care of the color and modeling. . . .

IX. Up to now art criticism has pigheadedly maintained the false convention that classifies battle pieces as genre paintings. And as long as an imaginary battle without a name, site, or period is concerned, let the matter pass. But when the paintings represent the pitched battles of Marengo, Montenotte, Jena, or the other recent ones of the Alma, the Cernaja, or Solferino, I don't believe it is reasonable to classify them as genre; rather, they should be classed as history. If we give this title to the ancient battles of Arabella and Cannae, why should we deny it to those of our own times?

In the seventeenth century, when it began to be the fashion to paint battle pieces, subjects were often taken from Roman bas-reliefs depicting similar topics. . . .

Horace Vernet was the first painter to give a stamp of individuality to these legal massacres of humanity, placing in every feat of arms painted by him the details pertaining to it . . . So he was able to array before us, in his Napoleonic battles, not only the soldiers of our day, their way of maneuvering and of fighting, but the heroic privates of the *Little Corporal* in particular. After Vernet, all the painters who were called upon to paint these gloomy subjects tried to follow his example, attempting to represent authentically places, costumes, and the special character of this or that army.

Among our artists, few—let us be frank—no one until now

has succeeded in approaching his standard. But now there arises in our midst an artist who in this field rivals and in some ways even surpasses the power of the celebrated Frenchman. This is Gerolamo Induno, young in years but with mature talent; Gerolamo Induno, who years ago received well-deserved praise for his battles of the Cernaja and Alma. Of those he may well say, with the poet, *quorum pars magna fui*, because (an uncommon love of art!) he wanted to be in the midst of the most perilous Crimean engagements so as to observe nature on the spot. At the Florentine exposition he strengthened his well-earned reputation as the most expert painter of battle pieces by exhibiting a painting of the most decisive moment of the recent battle of Magenta. . . .

X. Having expatiated to the best of my ability on the most essential works of historical and religious painting in the Florentine exhibition, it is left for me to investigate with the help of those pictures, if I can, an important though abstruse question, namely, whether those two most important branches of art are progressing or regressing in comparison with our famous past, or even in comparison with recent times, that is to say, the beginning of this century. . . .

In the flowering of religious art from the middle of the thirteenth century to the last half of the sixteenth, Italian artists attained a height that had never been reached before and never will be again. . . .

As for historical art, the old masters of the thirteenth to the sixteenth centuries could not progress very much, both because history in those centuries was not an idea rooted very deeply in daily life and because narratives which could offer the painter's brush a detailed sequence to be translated into pictures were lacking. We must also add that in those days little was known of the everyday or ceremonial customs of a period or a region. Therefore, the artists had no way of giving character and authenticity to historical compositions. For this reason very few historical paintings were undertaken, and in the few completed there was an almost total absence of every characteristic proper to the period and the men taking part in

the events. Raphael himself, whose frescoes of historical subjects are so much admired, erred gravely in this respect.

We moderns have progressed a great deal in historical art. In our own day, painters—I am speaking of the good ones—imagine and arrange the historical action with well-informed speculation and diligently seek out the costumes, gestures, and physical types best adapted to the time, the place, and the individuals among whom the event represented took place. They do not allow themselves useless figures that almost all the *quattrocentisti*, as a mere matter of form, introduced in their historical paintings. So they often produce paintings that make a deep impression, something that rarely happens in those of the old masters, who used history as subject matter, whose works are marvelous, of course, in color and drawing, but (let us for once cease to flatter the dead) poor in general concept.

This is already a giant step, and it gives modern art, in the branch of which I am speaking, a decided supremacy over the ancient works. But it would be desirable, as far as form and the special techniques of the palette are concerned, that the former should reach the quality of the latter. I will be frank and say that modern art is very far from this quality, particularly in our country.

The old masters of the Italian *quattrocento* and *cinquecento*, and many of those of the too despised *seicento*, made a thorough study of drawing in all its parts. It was the essential base, unshaken by the paintbrush. From this they digressed to a patient research into all the causes of human movement, even the most difficult, and to the application of perspective. From this they went on to give assiduous attention to chiaroscuro and the modeling of the body as seen from distances required by visual laws in relation to the different planes of the picture.

Can we say as much of the painters of our time? I ask you: How many paintings are there in which the rules of perspective are flagrantly, scandalously violated? How many in which the planes of individual objects appear firmly modeled in space whether the light strikes directly or obliquely? How many other canvases in which the chiaroscuro is wrong or un-

certain in details or in general masses? Therefore, it is not surprising if few paintings can be found in which the objects represented appear to be in relief. Now, what causes these shortcomings? I think it comes from a method of studying drawing which is too different from that used by the old masters. The latter, taking great pains with both the overall effect and the instantaneousness of movement, strove to produce the effects of reality as they would be seen from the point of view of an observer. The moderns, on the other hand, do not trouble themselves about the whole and endeavor to portray meticulously every detail of reality. Thus, they pose the subject like a model in the studio, at a distance of a few feet from the eye of the viewer. The rational rules of optics are thus reversed, because the aspect of a thing very far from the eye (and by the laws of perspective, objects represented in a picture all should be far from the eye) differs essentially from that of the same thing seen close by. Because of this, there is in most paintings an irrational reproduction of flashes, small shadows, and tiny reflections. Vasari complained about this in his time: When the painting is seen at the distance from where the spectator is situated, this renders the perspective of the chiaroscuro faulty and prevents the attainment of a sharp relief. We should also not fail to mention another very grave error made by our painters, an error which necessarily diminishes the reality of the chiaroscuro, namely, using studies copied from living models in the workshop, where the light usually comes from a window placed very high up, in pictures that are imagined to be in the open air. This produces effects of light and shade completely different from those that occur outdoors.

When the chiaroscuro is incorrect or inadequately expressed, it follows naturally that the color must, as a result, be either weak or discordant or spotty, because color will never be harmonious or true unless it is prepared for by excellent chiaroscuro. In fact, there are few paintings nowadays in which the color is luminous and strong. In most of them there is a clashing of dazzling color, no transparency in the shadows, and a chalky or yellowish sort of veil in the light tones which one rarely sees in old paintings, not even in

schools most renowned for their color. All these disasters re-
garding color occur because the methods of painting, espe-
cially in oil, are in polar opposition to those of the supreme
old masters, who reached the highest fame as far as their pal-
ettes were concerned. Almost all the moderns sketch with full
paint and finish with a full coat of paint. They will have
nothing to do with glazes. It is therefore impossible for them
to attain the light that the Venetians, the Flemish, the fol-
lowers of Correggio, even the less famous ones, always ob-
tained because they always glazed over well-worked bases in
which the chiaroscuro was already fixed. But this is not to say
that among the innumerable painters trained in incomplete
or harmful techniques there are not strong men of talent who
will, at the cost of Herculean toil, triumphantly succeed in
extricating themselves from erroneous ways and approaching
the old masters' good drawing, knowledgeable color, and ac-
curate modeling. The Florentine exposition provided admira-
ble proof of this; Ussi, for instance, draws with the same cor-
rect simplicity as Ghirlandajo; Morelli (when he does not
allow himself to be dazzled by the blandishments of *chic*) en-
amels and models color as well as Tintoretto did and draws
the nude and limbs better than he did; Zona cares (in the
highest degree) about form and paints with Titian-like vigor;
de Rossi paints with Correggio-like sweetness; de Sanctis with
real knowledge of chiaroscuro. But in the work of so many
others, even among the ablest, there is seen an unevenness in
the merit of the various parts that is always a sign of incom-
plete instruction. . . .

But the young—who now present us with mad, hasty
sketches that they pretend are finished pictures; the crowd
that emerges every year from the public artistic estab-
lishments, more to encumber than strengthen the superabun-
dant army of artists—how do they draw? How do they do
chiaroscuro? How do they color? This the Florentine exposi-
tion affirmed almost too thoroughly. It brought discouraging
proof that knowledge is rare in that great multitude of
painted canvases. It will always be so until the artists them-
selves are convinced that the undeniable foundation of art is,
above all, good drawing. Studies must be made from life with

simple, ready means; sustained by perspective, helped by memory, so that the eye can retain the image of all that is seen and copied so clearly that they can be worth reproduction with the stroke of a brush. In no other discipline was the maxim of the great philosopher ever so true as in that of the figurative arts: "Our knowledge is embedded in our memory." . . . It is comforting to see, however, that prejudices which were still ingrained thirty years ago are every day losing more ground, so that slowly but surely we may expect to be progressing toward the better way. I am therefore confident that in a short space of time our painting will number many more emulators of the Lanfredini, the Zonas, the Indunos, the Morelli, and the Ussi than it does now.

But even if our art is on the way to improvement, what encouragement, what sort of a future can our society, so preoccupied with weighty issues, prepare for it? It is difficult to prophesy in the thick mists of a darkened future. Even so, if it is possible to deduce from some present evidence, it seems to me possible to hazard a prediction without seeming to be too much of a dreamer.

Since the religious spirit is weakened now, it follows that art dedicated to church themes is no longer as necessary as it once was. This restricts the field of art a great deal. . . . This is not the case with history, because in our own time all men refined by education feel the need of knowing history very well. It would seem, therefore, that the art which depicts historical events should have strong encouragement nowadays. But the opposite seems to be happening, for no other reason, I believe, than that analysis, philosophy, paleography, and every branch of knowledge pertaining to history are so much further advanced than they once were that words have become more suitable than art for understanding historical events. On the other hand, there is no doubt that an episode in history represented by drawing helps to clarify the words that describe it and thus becomes the means of intensifying their efficacy. In this way the two instruments are mutually helpful. And it should follow that should there be a vigorous upswing in Italian painting, historical painting would one day win resplendent crowns. But at the moment it seems to me

possible to hope for an energic impulse for another kind of painting which is historical with respect to the daily life of society but does not depict particular events except as revelations of the feelings, affections, and special tendencies of our time. There is a need, a strong need in all of us, to see ourselves as we are, to penetrate into the joys, the sorrows, the way of life of our contemporaries. . . .

Our people prefer to look at what they understand, what touches their feelings. Therefore (the better they understand, the more they are moved by what is close to their own lives, to daily life) the public falls in love with the canvases that offer the obvious image. Here, then, is the reason why in Florence we saw the people standing ecstatically in front of paintings that attributed to them the strength and force of a great nation; this was the reason that people continually collected in great numbers in front of paintings of recent glorious battles, heroic feats of daring and titanic audacity, which reminded them of a father, a brother, a son. Many fear that not even this kind of painting, which depicts the events of our own day, can receive widespread encouragement from the nation, because even here among us most people bow only to the golden calf and the luxuries of life which are bought with it; they do not pay any heed to the arts that educate the heart and the intellect. In short, it is feared that this century is too mercenary, that it smacks too much of the salesman, is too immersed in material possessions to become a Maecenas to any form of fine art that provides nothing other than moral satisfaction.

I certainly do not defend the excessive commercialism of this epoch, which has extended even to us. On the contrary, I condemn it if it aspires only to the display of dinners and horses and dissolute gratification of the senses. But I must observe, on the other hand, that without a certain amount of commercial activity it is very difficult to enrich the nations enough for them to possess a surplus of money to ensure prosperity to the arts of beauty . . . Let the rhetoricians cease their outcries against a century plunged in pecuniary profit, because unless the people earn abundantly from industry, agriculture, and commerce, they will end up like the

Republic of San Marino, which sent one small cheese, two bottles of diluted wine, and one wretched gun to the national exposition. Athens erected the Parthenon and the Theseum [Temple of Hephaestus] when it was the richest of the Greek republics. The Florentine merchants of the Middle Ages raised public buildings and installed famous paintings when they were selling their silks to the whole of Europe. Leo X was in a position to commission the completion of the Vatican chambers, as well as the famous Loggia, when he was able to thrust his spendthrift hands into the treasure amassed by the avaricious Julius II. May Italy become rich; or, rather, let her natural riches not be diminished by centralization or administrative and tutelary systems. Let the commune return, as free as it was in the Middle Ages. Let rightful association be approved of by official patronage. There will be enough gold remaining for private persons, as well as nations, to dedicate it to the work of able artists, and the inborn sense of beauty will, little by little, and without government patronage, make us efficacious patrons of an art that will perhaps be less grandiose and magnificent than in the past but always worthy of the soil on which Giotto, Raphael, and [Michelangelo] Buonarotti grew to be giants.

John Stewart: *The Exhibition at Florence*[1]

This exhibition was a vast undertaking for Italy, and all things considered, it is a great success. . . .

The structure in which the exhibition is held was built for the railway station, and will be devoted to its original purpose when the exhibition closes. . . . The large, substantial figures on the front are painted in imitation bas-relievo [sic]; and the back walls of the old houses around the space where the station is erected have been converted, by a very simple process, from defects of ugliness into features of great interest and variety. From this latter process Englishmen may learn a practical and valuable lesson. How to have converted the backs and ends of the houses facing the Westminster Hotel

[1] [Verbatim from the Art Journal (September 1861), 341–44]

in Victoria Street, or those around the Field Lane Refuge, into features of interest, and more especially to have combined these into one important whole, would have taxed the invention of our decorators most fertile in resources; but in Florence the doing of such things seem like every-day demands, and the whole range, of old and ragged remains, of houses on the right-hand side of the exhibition have been converted into a vast Swiss château, through means of three or four colours, with a large amount of inventive genius, and some very clever drawing; yet the men who are doing it, for it is not all finished, are not considered artists. They look as though quite unconscious of doing anything remarkable, and are no doubt working at small wages, while they are producing effects, with mere touches of their ordinary brushes, which few even of our best scene-painters could equal, and which none of them could excel. This accidental part of the exhibition is one of its most interesting features, and prepares the mind with great expectations for the interior decorations of the edifice. From such examples of dexterity we cannot help feeling that these Florentines are destined to be men of marvellous skill in decorations.

. . . The detailed review shall be commenced with the leading specimens of sculpture. . . .

Magni, of Milan, exhibits several works, but the two most important, although for different reasons, are his *Socrates* and *Girl Reading*; the former, one of the grandest historic statues in the collection, being as manly in thought as it is artistic in development—a work which places its author in the front ranks of what, for want of a particular word, must be called public monumental sculptors. The characteristics of the *Girl Reading* are essentially different, and although lower in conception and style of Art, this statue is yet so successful in treatment as to become the most popular in the exhibition— as popular, for example, as the *Greek Slave*, by Powers, was in the Exhibition of 1851. The merits of this figure are extraordinary; the intensity of reading power in her face—you could never fancy her doing anything else but read, although the head were severed both from the body and the book—and the worn consumptive feeling thrown over the features, give

double interest to the effort; but to those very high qualities have been added others, which help to popularity with the multitude, and which are far below the dignity of high-class sculpture. . . .

Spring, by Vela, of Turin, is a piece of what, by way of distinction, may be called ornamental sculpture—that is, the lines flow into the elegancies of ornamental decoration rather than remain subjects to the sterner laws of pictorial truth. But the modelling of the torso of this *Spring* is beautiful; and although in the other parts of the figure the artist seems to have lost his power, yet there are few sculptors in Europe who could have produced such flowers in marble as those thrown around the feet and limbs of this figure, which are marvellous in their manipulation, hiding most successfully limbs less fair than the lilies that surround them. With all its defects, this statue has qualities about it sufficient to make it popular with those able to afford such luxuries in their conservatories or halls. . . .

The studios of Florence have furnished a large proportion of the works in sculpture, and, as was to be expected from the proximity and facility of transmission, at least an equal share of mediocrities. Powers, the American sculptor, being resident in Florence, must be included as with them, although not of them, and he forms one of the strong towers of their artistic strength. His most important work is the statue *America*, a figure of great dignity and beauty treading on a broken chain, and resting on what may be supposed a pillar of Eternal Truth, pointing to her destiny when the chain of slavery shall be snapped, and America rests upon these truths. . . .

It has long been the fashion to assume that the modern Art, and especially the modern picture-painting, of Italy, is far below that of the other countries of Europe that have any reputation in the Fine Arts; and it would perhaps be difficult to find a national exhibition in France, Germany, or England, where there was an equal number of trashy pictures to that which is now gathered at Florence: but, on the other hand, there are some specimens of Art there which will take rank with the best modern productions of any of the other

schools, and which dispel the delusion that the modern Art
of Italy has sunk below the mediocrity of other nations of the
West. The recent political life of the country has exercised
a deplorable influence on the subjects selected by the artists.
Nothing, perhaps, can more vividly portray the actual feelings
of the people than the appeal to their sympathies and con-
sciences which their artists make through pictorial repre-
sentations. It is so in England, where the mass of pictures ex-
hibited speak of peace and home joys. In France they tell of
military exploits and martial glory; and in Germany, of ab-
stract thought amidst high themes. But this exhibition at
Florence in its broad aspect has but two subjects—the cruel-
ties of kingcraft or priestcraft, separate or in combination,
and the struggles of the people to throw off the double-
headed oppressor. . . . All foreigners seem nearly equally as-
tonished at this peculiarity of the pictorial section of the ex-
hibition; and without the least desire to cross the forbidden
boundary line of politics, a fact so conspicuously potent over
the pictures exhibited cannot be entirely ignored.

To begin with Florence. By far the most important work,
as well as the grandest treatment, is, *The Duke of Athens
forced to Sign his Abdication*, by the Florentine artist Ste-
fano Ussi—a picture of remarkable concentration and historic
power, many of the heads and figures being full of character
and well painted, such as the duke himself, and the trem-
bling creature at his side who wears the dagger of an assassin
under the brown robes of a monk. . . .

Morelli can do anything, and he does everything well. His
Iconoclasts, where the figures are life size, is the most vigor-
ous piece of colour of its class in this exhibition: painted with
an eye full of knowledge and refinement in colour, and with
a thought that dares, and hand that obeys without fear or
hesitation to embody the thought. The forms of this artist
are frequently defective, for, like our own Etty, Morelli is es-
sentially a colourist; but he produces great pictures notwith-
standing, and with this unspeakable charm, that without
being peculiar, they recall no previous master as the basis on
which they are built. . . .

In landscape, the Italians are, to English eyes, nowhere;

and yet it is difficult, or rather impossible, to see how it should be so; for there is no better school in the world, and certainly none in England superior to the vale of the Arno, in which these Florentines live, for the study of Nature, in her simpler as well as in her grander effects. True, they want the rolling mist and clouds, which play so important a part in the education of British landscape painters; but they have other excellences of atmospheric effect, that ought to produce tenderness of colour in landscape, of which England's climate teaches her artists little or nothing. But the modern Italians have been so captivated by the great reputations made by the figure painters of their country, as to have become indifferent to the glories of high landscape art; and such is the force of every-day feeling, that artists are found loud in admiration of landscapes remarkable for nothing so much as the absence of every quality of tone and colour, which all the great landscape painters, from Titian and Claude to Turner and Linnell, have, with more or less success, aspired to and achieved. Notwithstanding these discouragements, and absolute difficulties—for there is no such difficulty as mingling with brother artists who have no sympathy with the art you practice—there are still signs in the exhibition of a brighter day for the landscape art of Italy than that now prevalent; and in this revival Florence will probably lead the way, and Turin will follow hard upon the leaders.

Telemaco [Signorini], of Florence, has produced a powerful effect in landscape, exhibited in a masterly background to one of those innumerable battles that line these exhibition walls. The painting is broad and clever to a fault—the grand defect of all the landscape painters of Italy, who seem to mistake breadth of touch for breadth of style, and never has there been a more pernicious confusion of ideas. But Florence has genius to hide, at least partially, the effects of this mistake, which becomes absurd and ridiculous in weaker hands. Borrani, of Florence, is another landscape painter of whom greater things may be expected, being already a successful colourist—that is, he gets away from pigments and paint into genuine atmosphere and light; but with this high quality, there never was such an empty, slovenly style of work

seen, or one which had so little reference to the every-day
realities of nature. Wheatsheaves, cows, women's dresses,
trees, foreground, and distant hills, are all of one texture, and
nothing but extraordinary power of colour could separate
them perspectively; but with this faculty of colour, when Bor-
rani begins to distinguish between the qualities of objects so
essentially different, very high-class landscapes may be ex-
pected from his pencil. Of Temistocle, of Florence, the same
remarks are true, but with still greater force, for his picture of
some cows in a stubblefield is perhaps the very cleverest land-
scape in the exhibition—that is, it shows the highest degree of
landscape power; but it is not a picture, it is an excellent
sketch, from which a picture might be painted, bearing the
same relation to a fine landscape that the rough clay sketch
does to the finished marble statue. This is a grave error, aris-
ing from that negligence of the details of nature, which will
prove the grave of Art to these Italian landscape painters, un-
less their present suicidal course be altered.

Another Florentine artist, Serafino [De Tivoli], exhibits a
small picture of a ruin, some trees, and three figures, bathed
in a flood of sunlight, which is one of the most perfect land-
scapes in the galleries; and although still displaying the faults
of blotchiness, and a style of touch which reveals ignorance
rather than hides knowledge of detail, it is one among that
dozen of small landscape pictures here exhibited which one
may be excused for feeling a strong desire to possess. . . .

The landscapes from Milan are scenic and material in all
their qualities, and there is no picture of an interior, even of
their cathedrals, or of the magnificently picturesque archi-
tectural combinations seen throughout Italy, beyond what
third-rate British artists would produce from the same sub-
jects. In these the want of drawing is often only less conspic-
uous than the want of feeling and effect. It looks as though
this walk of pictorial Art were left to what in sculpture would
be called the journeymen class of artists—men who, by
dint of labour, make up for lack of genius. Perotti, of Turin,
has produced the most perfect landscape exhibited. . . .

Among the other landscapes there are some painted by
artists who have been looking hard at both Turner and

Stanfield, or, more probably, at prints from their pictures, and have attempted to combine the styles without success. Others, who introduce cattle, have as visibly been thinking of Rosa Bonheur. The Florentines named have owned allegiance to no foreign master; they have sought and found inspiration—if at all—from the pictures rather than the nature by which they are surrounded; but only when this process is reversed can they expect to found a great or successful school of landscape. . . .

This exhibition is the first symptom of a return to that grand old strife for pre-eminence which so distinguished the years of the republics; and if the Italians of today retain but a portion of the greatness of their sires, the influence of Italy upon the future of the world's Art will be incalculable. . . .[2]

[2] [The report on the Art Industries has been omitted.]

1861 — 67: FLORENCE

The Exhibition
of a Society:
The Società Promotrice and
the Società d'Incoraggiamento

In the spring of 1861, while preparations for the national exposition progressed, arrangements to open the seventeenth annual exhibition of the Società Promotrice di Belle Arti in April were completed. Like the Società Promotrice organized in Milan in 1822, the Florentine organization was made up of art patrons and artists who hoped its exhibitions, with awards, and purchases by visitors would encourage artists. Similar in organization to the Kunstvereine (art associations) active in different German and Swiss cities and the Art Union in England, the Società financed its annual exhibition by means of membership dues and a lottery system which offered prizes in the form of a painting or an engraving of a painting selected by a committee composed of members. Because the Society's members were socially prominent, the exhibition was noticed by the Italian press, and because entry was comparatively open, the exhibition benefited innovative artists whose technique and style hindered admission of their work in the Academy's exhibitions.

The publications of art associations in other countries—*Die*

Dioskuren in Germany and the *Art Journal* in London—encouraged interest in the activities of their Italian counterparts. The *Art Journal* listed the Florentine exhibition in its announcements. The correspondent of *Die Dioskuren* noted in his review of the Società's exhibition:

> . . . Public interest in art is being promoted by the shift of attention to historical themes. At least historical material serves education more than the constant repetition of flying angels and cupids or sentimental saints' legends. In addition, historical subjects inspire patriotism for the nation and induce many to support art. If elsewhere one sees only paintings which are intended for lottery prizes being purchased at art exhibits, here most paintings which have not been ordered by friends of art are bought by them.

Il Mondo Illustrato: Giornale Universale, launched in Turin in 1847 and resembling in its format and lively style the French *Magasin Pittoresque,* published an informative and illustrated account of the exhibition written by "Demo," whose real identity is unknown. Like many journalists, he continued to use the pseudonym he had adopted before the unification of Italy. He singled out for criticism the landscapists Giovanni Costa, Serafino De Tivoli, and Vincenzo Cabianca, frequenters of the Caffè Michelangelo.

The following year, 1862, after the Società's annual exhibition had closed, Telemaco Signorini (1835–1901), one of the Florentine innovators, explained the group's aims and techniques in a review of the exhibition, signed "X," published by the liberal *Nuova Europa.* Well educated—his father was an artist employed at the Tuscan court—and well traveled beyond the scope of the military campaigns in which he had participated, since 1855 Signorini had, together with Giovanni Fattori, Odoardo Borrani, and others, explored the use of color laid on in *macchia,* or spots, to approximate color seen in nature. Shortly thereafter, in the conservative *Gazzetta del Popolo,* "Luigi"—probably the paper's coeditor, Giuseppe Rigutini (1829–1903)—commented on "X"'s explanation, ridiculing the eleven artists' search for *verismo* of color and dubbing them Macchiaioli. In popular usage the word

suggested fraud or dishonesty toward nature; in more stand-
ard usage a *macchia* was a spot of color. Signorini, signing
again as "X," wrote a restrained explanatory reply, which was
published November 19 in *La Nuova Europa*.

Determined to reach the public in spite of the adverse con-
servative reaction, the Caffè Michelangelo group enlisted lib-
eral support in 1864 to establish La Nuova Società Promo-
trice, modeled in its organization after the artisan guilds of
Florence and connected with the Collegio d'Arte of the Fra-
tellanza Artigiana. Its first exhibition (September 1864) had
the permission of the Minister of Public Instruction and was
held in the gallery of the Accademia di Belle Arti. It at-
tracted crowds but few buyers. Denied that exhibition space
the next year because of a change in ministers, splintered by
discussion, and weakened by departures, those who remained
of La Nuova Società joined with the original Società Promo-
trice to form the Società d'Incoraggiamento and held an exhi-
bition late in 1866 in Florence, then the provisional capital of
Italy.

Aware that without explanations and information the pub-
lic would not be able to understand their innovative approach
to art, and having found the press unsympathetic to them,
Diego Martelli, with the support of the group, established
the weekly *Gazzettino delle Arti del Disegno*. The first issue,
which appeared January 26, 1867, set forth the principles
by which the paintings in the exhibition of the Società
d'Incoraggiamento would be judged: "We declare with
Champfleury that we are not systematic, dogmatic, scholastic,
nor allied under any flag; we love only *sincerità nell' arte* [sin-
cerity in art]."

Telemaco Signorini, who had been assigned to review the
exhibit, ignored the usual principles and adopted a conver-
sational dialogue form common in the eighteenth and early
nineteenth century to criticize specific paintings and develop
his own theory. He believed that political exigency required
that all aspects of life contribute to strengthen the new na-
tion. Proudhon's theses, found in his recently published post-
humous work *Du Principe de l'Art et sa Destination Sociale*
(1865) were timely to Signorini in his attack on the "prosti-

tution of art" and his demand for social and economic conditions that would enable Italian art to recapture its past glory.

During its year of publication, the *Gazzettino delle Arti del Disegno*, the first art periodical in the new nation, brought an international point of view to the art circles in the new capital by publishing translations of reviews by the liberal French art critics Castagnary and Thoré-Bürger, as well as reports of art events in Paris from Belgian and French papers. By serving the avant-garde Caffè Michelangelo group—publishing reviews of exhibitions in other Italian cities, essays on Italian art, and biographies of Italian artists—the *Gazzettino* aroused a consciousness of national identity and a new confidence. Its independence from the international academic art world was expressed in the protest it published against the awarding to Ussi of a medal by the international jury of the Universal Exposition of 1867 in Paris.

Even though Florence was the provisional capital of the new state from 1865 to 1871, there was not sufficient economic support for the *Gazzettino* and it ceased publication. Perhaps one reason for the paper's failure was pinpointed by the French literary historian and aesthetician Hippolyte Taine, a visitor to Italy in 1869, who observed:

> The past is here reconciled with the present; the refined vanity of the monarchy is perpetuated by the refined invention of the republic; the paternal government of the German grand dukes is perpetuated by the pompous government of the Italian grand dukes.[1]

"Demo": *The Società Promotrice di Belle Arti of Florence: Seventeenth Year*[1]

. . . If we hesitate to go to the exhibitions at the Academy of Fine Arts, we hardly dare visit those of the so-called Societies for the Promotion of Art without considerable anxiety. This distressing state of mind is caused by the knowledge that our

[1] Hippolyte Taine, *Italy, Florence, and Venice*, trans. J. Durand (New York, 1871), p. 71

[1] [Translated from *Il Mondo Illustrato: Giornale Universale*, May 4 and 18, 1861, pp. 276–79, 317–18]

eyes, in order to rest on a canvas of pleasing aspect, will have to wander at length among monstrosities of every kind and every color—because these halls which open hospitably to welcome the fine arts really are entertaining what should be called blatantly lucrative art. Rather than a true art gallery, we shall view a sort of auction, a market of painted canvases in which the artists' dominant motivation is to keep their works moderate in price and to depict popular and pleasing subjects so that those members of the society on whom Fortune has smiled will choose them.

If it is the academies' instruction that frightens us, it is the speculation in the Società Promotrice which induces our misgivings. In the end, the Society promoted little or nothing until now; and rather than encouraging true art, it has had the inevitable fault of encouraging crafts.

To pass immediately from the general to the particular, the Florentine Società Promotrice, which is one of the oldest of these institutions, has given us deplorable examples to confirm these already mentioned sad truths. In seventeen years of the most lackadaisical existence, [the Società] has not popularized a single artist; it did not discover an exceptional talent; it did not set any school on its feet, did not heal any wounds, and was of no real benefit to anyone. This, in truth, was the fault not so much of the members as of the indolent nature of the institution initially, and then of adverse circumstances. The number of members in recent years declined rather than grew. The financial resources of the Society were also so meager that until now they have not been able to offer a prize of more than two hundred scudi, a sum which will never be enough to pay for a major piece of work or a historical painting of any significance—whether because of the development of the subject or because of the scale and beauty of the execution. Under the best possible conditions the Società Promotrice can only promote the interests of parlor painters or painters for the boudoir or albums. Florentine society can promote even less, strangulated as it is by the harsh grasp of poverty, against which it has fought for so long. To this, we believe, must be attributed the unfortunate rooms to which this year's exhibition had to be relegated

after it was hounded from the ancient and commodious lodging near the Piazza S. S. Annunziata.

The actual exhibition is taking place in an old tenement of the Fondaccio of S. Spirito. The entrance to the rooms has the aspect and darkness of a cave, because there is not the shade of a hall. Thirty of the exhibitors on the day the exhibition opened (April 3) protested in the newspapers the unseemliness of the place and, to tell the truth, even if a good third of the paintings are only worthy of being exhibited in a cellar, on the other hand the light is scant and poorly distributed for other paintings, which are worthy of complete attention and much praise. Considering these shortcomings, the exhibition this year will not become permanent and, after the prizes are distributed, will immediately go in search of a domicile less disliked by the artists and less unpleasant and inaccessible for visitors. . . .

There is every probability that the two gold medals, however paltry their value, will not be awarded to the best painting and the best sculpture, since they were not awarded last year. In sculpture there is only one object in the present exhibition (since the tiny bust of Garibaldi is not worth mentioning), and this one piece, entitled A *Surprise at the Ambulance,* representing a group of three wounded Garibaldini and a sister of charity, does not seem to us likely to prod the generosity of the commission, even though it has much merit, since the straitened circumstances of the Society are well known and it takes advantage of every opportunity to economize. Unfortunately, their economies are all at the expense of the artists. When the medals are not awarded one year, they are irreparably lost. This, to our mind, is a very severe proviso. The medals not awarded in one year should be added to those of the following year. In this way, the incentives to the artists' zeal would be greater and the effective value of this honor won by the sweat of the brow would be less stingy. Another proviso which seems uselessly harsh is the obligation that the artist furnish the canvases with more or less elegant frames. The precarious conditions under which the majority of the families of artists struggle are all too familiar. Why increase the hardship of the beginner by forcing him—after he

has already used money collected by God knows what sac-
rifices and widespread distress for canvas, brushes, and paint
—to add a final, more painful expenditure for the useless lux-
ury of a frame, which usually reduces the effect? Other art
societies have more wisely ruled that the artists were not
obliged to adorn the paintings with frames and have not
placed obstacles in the path of those who already do not
progress very fast and are easily weakened by inertia and dis-
couragement. The provisos of the Florentine art society do
not seem to us the most appropriate means to promote vigor-
ously the interests of art and artists. . . .

For the most part, the deeds of the recent wars of inde-
pendence seem to have best inspired the painters who were
themselves volunteers in those wars. *The Rout of the Aus-
trians from the Village of Solferino* is admirable in its color,
drawing, expression, and movement. Its author is Telemaco
Signorini, who also exhibited another small genre picture that
should not be scorned, *Girls Fishing at Lenci in the Gulf of
Spazia.* Carlo Adamello, a young Florentine painter, exhib-
ited this year the second page of the gloomy episode of the
Battle of San Martino, of which he gave us the first painted
page last year. . . .

In our quick résumé we failed to include a few canvases
dedicated to the late wars of independence, and we would be
sorry not to point out some worthy of mention, like those by
Silvestro Lega, one representing *The Return of a Platoon of
Italian Bersaglieri from a Reconnaissance* and the other *An
Ambush of Italian Bersaglieri in Lombardy.* In the latter,
however, the crude greenish tones of the color are displeasing
to us, and the former, to tell the truth, is nothing but a sort
of procession in which the *bersaglieri* are seen coming down a
hill in pairs, dragging with them some Austrian prisoners.
Otherwise the character types of the subjects are happily
caught and drawn. . . .

We have arrived at the landscapes.

Having returned to Italy a short time ago after long years
of absence, we were unaware that our landscape painters, like
the romantics and classicists of forty years ago, had divided
themselves into two schools. The first of these groups adheres

to the traditions of the old Italian school, without ignoring the improvements of the modern school, while the other, tangle-haired, disheveled, blundering, upsetting, and unkempt, treats trees, land, water, beasts, and Christians in the same unconsecrated way, affecting the use of the palette knife rather than the paintbrush and apparently rubbing the entire palette on the canvas as a final touch so that the colors seem smeared on with the fingers or stuck on with a ladle. It's true that the first school "combs" nature a little too much; but the other misuses and debauches her. The ringleaders of this sect claim that this is French stuff; one more reason for leaving it in quarantine or at the custom house at the border as infected and dangerous goods. But we know what we are talking about when we tell the Italian imitators that the French landscape painters, who respect themselves, do not go in for this sort of madness, and what is treated there as exceptional is received here, quite wrongly, as an established convention.

The paintings of the school falsely named "progressive" and "modern"—falsely since it seems to me trying to make art revert to primitive and barbaric times—are unluckily superior to those of the school we would like to call the one of common sense. The archimandrite of the new brotherhood of the broom is Sig. Giovanni Costa, whose disciples speak of him with great veneration. This Wagner of the landscapists lavished his canvases on the exposition; there are at least half a dozen of them. The view entitled *Florentine Garden* is a Chinese mixture which would be thrown out of the showcase of a manufacturer of Sienese gingerbread. Another little painting, fortunately Lilliputian in size and falsely entitled *Study from Nature*, is a sample of small sausages and salami which would make a pork butcher's mouth water. Only one quite large painting, *The Roman Beach*, is proof of the exceptional talent possessed by Sig. Costa and angers us all the more since it seems willfully perverse of him to squander his gifts as a draftsman and colorist in order to follow a way of perdition. On that lovely page, sea and sky harmonize in tint and nuance; there is not only color but warmth, light, and truth. It is a pity that the masses in the foreground are, for love of the school, blocked in and thrown on in such a frenzy

that it is impossible to tell if the faggots on the heads of a group of peasants—well conceived but badly drawn figures— are bundles of wood, clothes, or something else. In the foreground, various shrubs and bushes are drawn in a primitive style that would seem childish even to Margaritone d'Arezzo or Cimabue. To this new manner of landscape painting—a fad, let us hope, that will last no longer than a bizarre and stupid fashion usually does—a fortunate barrier is provided by the Marko brothers, Carlo and Andrea, whose landscapes wonderfully recall the studious work of their illustrious father, from whom they learned to see nature's smallest aspects, to discover her most recondite secrets, and to pick out her most delicate features, idealizing her only when necessary so as not to hurt the eye by a too flagrant realism. All these landscapes exhale quiet and harmony. . . . The best of the landscapes exhibited by Marko, as well as the largest, is entitled *A Forest*. Even though the price listed in the catalog is much greater than those fixed for the other principal paintings, we do not doubt that it will find a purchaser.[2] . . .

A small selection of landscape painters not misled by the noisy shouts of Italian Courbets follow in the prudent and measured footsteps of the Marko brothers. Sig. Lorenzo Gelati stands out among them; the readers of *Il Mondo* will soon be able to admire some lovely drawings by him. Among the followers of the so-called "new school" we will mention only two, since they have been able to avoid the rocks and quicksand into which the others, beginning with Costa, have hurled themselves headlong. True talent, even when it imprudently allows itself to be caught in a net for a while, lets the little fish glide and gasp with open mouth to their hearts' content and enlarges a mesh of its emprisoning net and returns to its preferred element.

This is what Sig. Serafino De Tivoli and, even better, Sig. Vicenzo Cabianca of Verona did. We would praise without reservation a wooded landscape with Roman ruins by the former if it were not for the cottony technique and

[2] The *Fond Memory* of Pulcinelli is listed at 1,000 lire; *The Daisy* by Rapisardi at 1,120 lire. *The Forest* by Marko costs 2,000 lire.

repeated accumulation of brushstrokes which are the insane taste of the clique. . . .

"Luigi" [Giuseppe Rigutini?]: *Florentine Chat— The Exhibition of the Società Promotrice*[1]

If I were to follow the usual style, I should have to begin by bowing to the readers of the *Gazzetta del Popolo* on my first appearance and produce a speech filled with the customary conventional phrases . . . But I am what I am and do not know how to string all these complimentary phrases together, so that when I have said that my task is to talk in the *Gazzetta del Popolo* about the gossip in Florence, I believe I have announced my whole program and can go straight to the point.

. . . Artists have been talking for some time about a new school of painting that has been formed, called the school of the Macchiaioli. The painting of this school has appeared frequently in the exhibitions of the Società Promotrice di Belle Arti and this year, too, it is amply represented. But the reader will ask, if he is not a painter himself, who are the Macchiaioli? I propose to explain. They are young painters, some of them undeniably gifted, who have taken it into their heads to reform art, starting from the principle that effect is everything. Have you ever met anyone who offers you his snuffbox and insists that in the grain and various patterns in the wood he can recognize a head, a little man, or a tiny horse? And the head, the little man, and the tiny horse are all there in the fortuitous lines in the wood! All one needs is the imagination to see them. This is true of the details in the Macchiaioli paintings. You gaze at the heads of these figures and look for the nose, mouth, eyes, and other parts of a face. All

1 [First published in the *Gazzetta del Popolo*, no. 301, November 3, 1862, and subsequently in *La Nuova Europa*, November 19, 1862. Translation from *The "Macchiaioli": The First Europeans in Tuscany—Italian Painting of the Nineteenth Century*, introd. by E. Cecci and critical notes by M. Borgiotti (Florence: Leo Olschki [1963]). Catalog published by "Europa Oggi" and the Tuscan Association of Arts]

you see are shapeless splashes: the nose, mouth, and eyes are all there all right—you only have to imagine them! Enough is as good as a feast! There certainly has to be an effect, but it is going too far when the effect destroys the design and even the form. If the Macchiaioli continue at this rate, they will end by painting with a brush on the end of a pole and will scribble all over their canvases from a respectable distance of five or six yards. They will then be sure to obtain nothing but an effect.

A new European, Sig. X, offered our Macchiaioli a consolation the other day. He informed us that although their school of painting is a failure in Old Europe, it will certainly be the rage in the Europe that is to come . . . if brains are refashioned to follow the sayings of the prophets! I really did not believe that the new Europeans of today had such a strange taste in art; but for the Macchiaioli there may be some hope in this idea, and for a lack of anything better they may as well cling to this fantastic vision of the future. Let me make myself quite clear: If I criticize the Macchiaioli it is not because I like polished, smooth painting like miniatures on porcelain; however, the artist can easily choose a middle way between an oily smoothness and a rugged crust, between forms without any effect and effects without any form. No, it would be all to the advantage of art if that kind of haunted, obscure painting were to be abandoned altogether in favor of a return to the Venetian and Bolognese schools. Camino, whom Sig. X has forgotten, represents independent art in the present exhibition of the Società Promotrice, but without the Macchiaioli's exaggeration.

Tivoli, who was among the first to follow in Camino's wake, later claimed to have freed himself from his guide; he now hesitates to throw himself wholeheartedly into the ranks of the Macchiaioli, and in his hesitation has given abortive birth to a *Primavera*—may Heaven forgive him! He has also produced some landscapes, among which Sig. X praises the ugliest because it is the most *macchiaiolo*. Buonamici, however, did not hesitate at all. His painting of a *Barracks in Modena During the Campaign of 1859* (and may we say, in passing, that we do not understand why this picture has not

been purchased by the government instead of by others who are far less worthy) shows that he has really been able to emancipate himself without falling into the exaggerated errors of the Macchiaioli. Oddly enough, Sig. X quite rightly reproaches him for not having finished some of his charming figures. Be logical, dear sir, and tell us how we should reproach the real Macchiaioli, who never do anything but merely sketch out their pictures? The paintings of Induno, unjustly placed by Sig. X among those of the mere producers of commercial pictures, are, for those who look at them without bias, among the most beautiful in the whole exhibition.

The charming and skillfully treated subjects, and the finished and spontaneous execution, which shows no sense of strain, make of Induno's two pictures two little jewels. My attention has been called to the works of Lega by Sig. X's congratulations to him. Alas! If the hideous creatures painted by Lega are to be found among spring roses and garden flowers in the Europe to come, then the new Europeans will have to seek for love among the deepest ravines and in the most inhospitable forests. And what about the washerwomen? Mercy upon us! Everything I have said about the Macchiaioli in general must be applied to Cabianca and Signorini in particular, because they are the most exaggerated examples of their school. Any criticism I might make of their paintings would be a mere repetition of what I have already said. I shall add that in the case of Cabianca, his figures on the eve of a feast day do not walk but fly.

This chat today is not intended to be a review of the exhibition; I therefore do not feel obliged to mention all the exhibitors, whatever their merits may be. All I intended to do was to mention the controversy raging at the moment among the artists and reduce to their proper value the principles upon which the Macchiaioli base their theories. I shall conclude by telling them not to get it into their heads that they are suffering the persecution usually accorded to innovators and leaders of new schools; they are not innovators; the Venetian and Bolognese schools sought for effect long before they did, and more recently Bezzuoli and Morelli have also

tried to do the same; but his brilliant colors could not protect Bezzuoli from the criticism leveled at his careless drawing. The Venetian and Bolognese schools, Bezzuoli and Morelli, obtained their effects without abandoning form, and a fine painting by Celentano in the Italian exhibition proves that effects and light can be achieved without neglecting drawing and finish.

"X" [Telemaco Signorini]: A Reply.[1]

Although we appealed to the press in an earlier article on the exhibition sponsored by the Società Promotrice di Belle Arti, in order to provoke some discussion concerning certain principles which we consider fundamental to the development and future of modern art, we see with regret that we have failed to achieve our aim. The article referring to the exhibition which appeared in issue number 301 of the *Gazzetta del Popolo* in reply to ours cannot be regarded as a serious contribution to the matter under discussion . . .

Leaving aside general discussions and coming to the point, we now wish to comment upon the remarks of the above-mentioned writer.

Let us first of all examine the notion he has formed of those artists whom he so aptly calls Macchiaioli. Perhaps someone he once knew in 1855 and who is now among the progressives once talked to him about the *macchia* (spot or splash). Now, you should know that the *macchia* was only an exaggerated form of chiaroscuro brought about by the need artists felt at the time to free art from the chief fault of the old school, which had sacrificed relief and body in their pictures in favor of an excessive transparency [of color]. Having recognized the fault, they tried to correct it and perhaps exaggerated, which always happens with any force that races ahead before it finds its pivot and eventually its own equilib-

[1] [First published in *La Nuova Europa*, November 19, 1862. Translation from *The "Macchiaioli": The First Europeans in Tuscany—Italian Painting of the Nineteenth Century*, introd. by E. Cecci and critical notes by M. Borgiotti (Florence: Leo Olschki [1963]). Catalog published by "Europa Oggi" and the Tuscan Association of Arts]

rium. When the blind obstinacy of various reactionaries attacked the attempts of the first artists who were trying to improve matters, the innovators naturally exaggerated the practical application of a principle which had been good in itself, and for a time they fell into excesses and eccentricities which were caused more by the reaction they had encountered than by their own desires. In this way, *macchia*, useful as it was as a bold attempt and an incomplete but fruitful type of technique, became the first imprint left upon the new arena open to modern art. Nowadays when you talk of *macchia* you are obviously confusing the first with the last step, the instrument with the work itself, and the means with the end.

Are we leading you into empty fields of abstract discussion? You will reply with the usual commonplaces about the limits of art—as if art had any recognized limits and the progressive activity of the human mind in all fields had any boundaries! But, you will object, surely the ancients conceived and did everything of which the human mind is capable? Agreed, they did all they could in their own age. Refusing to imitate the centuries that preceded them, they were able to understand their own and represent it; they translated into the world of art the inspirations and sentiments they had received from their own age. Our generation, on the contrary, is weak and feeble. Being slaves of innumerable prejudices, we fail to elevate our minds to the free regions of speculation; being unable to understand our own century, we are incapable of representing it. We have been so busy admiring the glorious path our ancestors trod that we have turned our backs on the road we should follow into the future. We have forgotten that every age has its own civilizing task to perform —unless the generations living in a given age are content to be numbered among those who, as Dante says, "lived without infamy and without praise."

And nowadays? All that is left of such a glorious patrimony are our traditions; these must, of necessity, be upheld and continued unless we want to see the blind cult of the past (which cannot and should not be repeated) leading us to a

period of decadence equal to that which lies immediately behind us.

The past should not be praised as the apogee of art but recommended as a study of progress in a period which, however great and glorious, nevertheless did not possess the material and intellectual resources which we have at our disposal nowadays. Let us admire the past but not adore it; since adoration stultifies discussion, let us be disposed to acknowledge merit in all times and all places, but let us not reject the inestimable advantage of free examination and criticism, however authoritative the names and works before us may be. If adoration is a good thing in religion, in art it leads to servile imitation and therefore to decay, just as an exclusive admiration for celebrities produces intolerance; by preventing free use of reason and imposing silence, it inhibits discussion by depriving thought of the principles and foundations wherein its strength lies. This system, in fact, which has been in fashion for so long, will lead you to kneel before Michelangelo and Raphael but never to reason about them, examine them, analyze their qualities, and uncover their defects! Academic inquisitions will forbid you to do so, inveterate prejudice will prevent you, and woe to you if you attempt to overcome them! You would become sacrilegious!

What of the *encyclopédistes* Diderot and d'Alembert?[2] We have covered two thirds of the century they inaugurated and are still prostrate in adoration, dreaming of the past in the temples of our glory! Being fully satisfied with what our fathers did before us, we do not trouble to increase our inheritance; having done but little, we rest upon the laurels they gathered!

One last word to the writer of the article and I will have done.

What you do not appear to have understood, or to want to understand, is the extremely moderate praise we bestowed upon the pictures you criticized. In these works we see not an

[2] [Jean Le Rond d'Alembert (1717–83) was chief assistant to Denis Diderot (1713–84) in the preparation of the *Encyclopédie* (1751–72).]

accomplished fact—since, to repeat, we are going through an age of transition—but simply a powerful aspiration toward the improvement and advancement of art. You undoubtedly fail to perceive this because everything which contains a seed of the future is probably some utopian aberration in your eyes. Like all narrow, positive people, you cannot recognize or see anything except an accomplished fact. Unfortunately, you have the majority on your side: those people who acclaim only the victors of the day but are ready tomorrow to render homage to the new victors . . .

Trusting, meanwhile, that in some indefinite future our own hopes will become an accomplished fact, and faithful to our program, which is complete liberty and reciprocal tolerance, we proceed toward our own goal, opposing all abuses and privileges and proclaiming, as far as lies within our power, the good cause of free inquiry against any inquisitionary tribunal of art, in order that the damage done in the past and our present disgraceful situation may be remedied, if that is possible.

Telemaco Signorini: *Exhibition of the Società d'Incoraggiamento*[1]

The Pictures of Fattori, Lega, and Borrani

If . . . the mission of art criticism is to discover what is defective in a work of art which has been acclaimed as absolutely beautiful, we have done this in the case of the painting [*Dante and Beatrice*] of Sig. Conti. And, now, what is left for us to do is to point out the merit to be found in the works by Fattori, Lega, and Borrani, which the opinion of this art society has considered absolutely—or largely—ugly.

The painting by Sig. Fattori, *The Country Girls*, represents a village listed in the catalog as being near Livorno.

The qualities of this painting have not, so to speak, overwhelmed the connoisseur; if he has felt obliged to stop in

[1] [First published in the *Gazzettino delle Arti del Disegno*, January 31, 1867 (part v) and February 2, 1867 (part vi). Translated from facsimile edition]

front of the picture, it may be to wonder why the Arts Council distinguished it by awarding it a medal, finding this choice inconsistent with others the Arts Council made—without taking into account that because infallibility is not a human quality, a jury may also err. But since the award for merit does not concern us, we will go ahead and talk about the merits and not the award.

Why, everyone cries out, was the award made to Sig. Fattori's picture, since it has an uninteresting subject? Is he permitted—on a canvas of those proportions (which should be reserved for famous characters dressed in handsome antique costumes)—to paint three ragged peasant girls? Was it perhaps for the dark, gloomy, and monotonous coloring, or for the execution, which is so far from elegant, that it was chosen? I myself would not want to be awarded this picture as a prize—or, if it were awarded to me, I would present it to some friend who could paint me something better on that canvas.

Here are the principal crimes of the best artists. Here is the shirt of Nessus[2] which is forced upon them by the so-called Maecenas of art.

It is true that Sig. Fattori's picture has no subject, if by "subject" one means an allegory nobody understands, like that of Sig. Simonetti's *A Ray of Hope After the Storm*. It has no color, when by color one means the lovely green of Sig. Bennassai. It is poorly executed, if by execution one means the conventional workmanship of Sig. Senno's landscape.

Sig. Fattori has not, in this painting, actualized a form; he has actualized a feeling—the feeling of the countryside at a given season in a given village—and he has succeeded excellently.

Whether those women are doing one thing rather than another is of no concern to the painter. They are evidence of the village and the village makes them evident, surrounds

[2] [The centaur Nessus was killed by Hercules when he carried off Deianira, Hercules' wife. Before he died, Nessus gave her a vial of his blood, telling her it was a love potion. When Deianira sent Hercules a shirt soaked in the potion, it consumed him.]

them with its light, reflects them, illuminates them. The color has that manly, grave tonality which is in the work of old masters and which, in an old gallery without the dissonance of overly fresh and "pretty" coloring, would hold its own with dignity. This picture has the rare merit of holding together from one end of the canvas to the other; the sky stays with the mountains, the mountains with the ground. If the figures at first glance seem to lack solidity—since one cannot immediately make sense of several very isolated dark areas, some hues of uncertain value, and undetermined shadows—as soon as one stands back the figures acquire solidity, importance, and life.

If his aim had been to convey the clarity of the form and nothing more, he would have painted a different picture, and I am not discussing the picture he did not paint; he has brought to life the autumnal atmosphere of the season, the character of the village he depicts, and this is why the picture is pleasing to us. In the landscapes which are usually painted, we are only concerned with the more or less able execution, or a particular touch [tocca] which gives way to another, or a fashionable name which is more valuable than a previous name—from Morghen to Camino, from Camino to Senno—that is all.

"What do you read, Prince Hamlet?"

"Words!"

"What do you see in these artists?"

"Brushstrokes!"

When an artist like Fattori is not admired for his skill with the brush, when he does not make brushstrokes merely for the sake of making brushstrokes, and when he obtains a gold medal from an art jury (which, though not infallible, always consists of artistic notables of the first rank), he seems to me an artist worthy of discussion—and serious discussion at that.

Another painter totally unnoticed because he goes beyond the common point of view in his interpretations of nature is Sig. Lega. His painting is listed as The Newlyweds in the catalog. There is nothing new in the choice of subject, but the interpretation of it is all his own and individual. Taking an old subject and making it new constitutes merit in art; it

is not necessary to do the impossible, as the peasants say, by choosing [a subject fit] to hold the public.

Through a half-open door directly facing him, the spectator sees a bridal party entering the courtyard of a peasant's house. . . . The local character, in color as well as drawing, forms so much of what is best in this painting that one who has walked around the walls of Florence and has observed the farmers of the market gardens and the individual family characteristics will recognize them and find them clearly portrayed in this painting. "That is all very fine," says the collector of interesting subjects, "but what do I care about market gardeners, their weddings, or their characters? If they at least wore the picturesque peasant costumes of the Roman campagna, which so lend themselves to art, then I wouldn't object . . ."

It is to satisfy this sort of intelligentsia that the Tuscan countryside has been represented with Roman figures put in to make it interesting; whereas Sig. Lega's picture has the uncommon merit of showing both the people of the village and the village of the people. That is the way it is and it cannot be otherwise, for the cogent reason that each village has to incorporate into itself everything that it consists of and to give back the imprint of its own character.

If this examination of reality were less harsh in its execution, if the arms of the old maidservant had not been so wretchedly short and the arms of the little girl who applauds were of a more plausible shape, Lega's picture would have been more pleasing, but it would not have met so many adversaries who found these faults a pretext for not recognizing its good qualities.

To indicate these qualities seems to me to be the duty of a critic and a friend, when all the critics and many friends do not open their mouths to oppose the judgment of a little public that kills genius with a conspiracy of silence.

A painting which public opinion has favored is the one by Sig. Borrani entitled *Lost Hopes*. It represents a convent terrace on which there are five nuns: One is seated in an ancient armchair and seems to be convalescing from an illness; another nun is amusing her by reading a book; a third is near

the invalid; another picks violets from one of the flowerpots on the edge of the terrace. A fifth nun, coming forward through a door which leads into the convent, has a potion in her hand for the invalid.

The overall impression, the sentiment which shapes and characterizes this scene, is most accurate. The cloistered silence and the monastic tranquillity is present and forms the chief merit of this painting. The totality—which is immediately perceived because it was thought of in its entirety from the first and then in its parts—is what constitutes the merit of these artists' works. When they start to work on a painting, it is no longer a pretty, interesting little head but the whole painting which preoccupies these artists. They have the right maxim: One must not begin with one part in order to proceed to the whole; one must commence with everything in order to go to the part.

Up until now a pretty model was dressed in a pretty medieval costume and reproduced in the middle of a white canvas. After faithfully copying her, it was a matter of giving her a name and of calling her, with equal nonchalance, Marguerite, Ophelia, or Beatrice.

For Marguerite, one would borrow a study of snow from a landscape painter friend and paint the ice of the north around her; for Ophelia, a study of the lake at Pratolino signified the misty, marshy countryside of Denmark; for Beatrice, any old bit of Florence, even the park of the Cascine—as long as there was a view of the cupola in the distance—was more than sufficient. This is the reason the totality of the painting was never achieved and the figure did not go with the place or the place with the figure.

Fattori, Lega, and Borrani have this very important quality: They have not painted the background for the figures or the figures for the background; they have made the picture and have achieved it.

If Sig. Borrani's nuns had been more varied among themselves—for it is all too clear that the same model is seen in different poses—if the black colors of their habits were less even, less tinted, and more painted, Borrani would have achieved perfection—according to those critics who believe in

what is perfect. We believe that Borrani could have done better, but that does not detract from what he has done so well. We believe in striving for perfection, not in ultimate perfection, and we find he who considers everything badly done as much of an artistic reactionary as he who finds perfection.

This is how three artists, three different beings, all with the same artistic ideas and each with a different technique corresponding to his individuality, can produce works which do not seem to us to look like works by pupils of the same school. It was because they derived their conception from nature, and this mother, the fertile giver of constant inspiration, made them original and will keep them so unless success should go to their heads or opposition kill them.

We believe in an ever-increasing development of their qualities, because they are not planned, as people so frivolously believe; they are ripened by the times, and if the times are imposed upon them, they, in turn, will of necessity soon impose themselves upon others, because they will have to represent the period in which we live.

1862: LONDON
The International Exhibition

Our May-day of 1862 was no ordinary May-day. In the broad light of day, in the presence of assembled thousands, surrounded by all that is high in station or great in talent, it was the proud lot of English statesmen and nobles to render homage to human industry and genius and skill, and to ask the world in like manner to recognize their triumphs, so fraught with blessings to our common race. The people—by whom all that is great in the world's history has been achieved, who have bridged over oceans, who have removed mountains, who have planted deserts with busy life, whose works of art (lasting as the sun's glad light or the air's balmy breath) proclaim what man in his majesty can do—are formally recognized by royal princes and crowned heads, and the exhibition of their works draws together a multitude such as a congress of all the kings in Christendom would fail to collect.[1]

The only blight on the festive May 1 inauguration of England's International Exhibition of 1862 was the absence of the queen and her prince consort. Victoria was still in mourning; her beloved Albert had died the year before. All England felt the loss at the May-day celebration, for as president of the Royal Society of Art, Albert had given vital sup-

[1] Quoted from a "London paper" by B. P. Johnson, U. S. Commissioner, *Report on the International Exhibition of Industry and Art*, 1863, p. 13

port to the arrangements for the great exhibitions of 1851 and 1862.

It had originally been intended that the 1851 exhibition would be only the first of a series of international exhibitions that would be held at five-year intervals. After it closed, however, it was realized that the magnitude of the enterprise suggested that decennial exhibitions would be more feasible. Consequently, late in March 1858 the Society of Arts resolved to hold an exhibition in 1861 that would celebrate the achievements of the past ten years. Having participated in the Universal Exposition in Paris in 1855, the first international exhibition to include the fine arts, the Society decided that its 1861 exhibition would also encompass art, including music, along with industry. By late 1859 the Society had begun to raise funds to underwrite the undertaking—a substantial task, since no government financing was expected.

With the outbreak of the Franco-Austrian War, the Society postponed the exhibition until 1862. In February 1861 responsibility for organizing the exhibition was assigned to a commission appointed by the Society. Its members included Earl Granville, who had chaired the 1851 commission, and Wentworth Dilke, chairman of the Society's council and British commissioner for the 1855 exhibition in Paris. Henry Cole, whose organizational skills had contributed so much to the success of the 1851 exhibition, was a consulting officer.

The commissioners secured the use, rent free, of the South Kensington site that had been purchased by the commission with the surplus monies from the Crystal Palace exhibition.

It was intended that a portion of the 1862 exhibition building would be permanently incorporated into the Royal Horticultural Society building adjacent to the site. The commission therefore had to accept the uninspired design of a young artillery engineer, Captain Francis Fowke, who was already engaged on an extension of the Horticultural Society gardens and buildings. Announcements inviting manufacturers to send the work which best demonstrated the advances in design made during the past ten years were sent by the Society to correspondents in all countries.

Immediately after the close of the 1851 exhibition, the

question of what constituted good design had again been brought to the fore as a result of the opportunity to see and compare ornamental styles from all known cultures. Many had noticed what Henry Cole called "the universal likeness which pervades the art of Europe at this time. . . . It was from the East that the most impressive lesson was to be learnt. Here was revealed a fresh well of art, the general principles of which were the same as those in the best period of art of all nations—Egyptian, Grecian, Roman, Byzantine, and Gothic."[2] Articles and discussions attempting to assimilate the lessons of the exhibition proliferated. One of the most influential writers and speakers on the problem was Owen Jones, who had been responsible for the interior decoration of the Crystal Palace and whose travels in Spain, Turkey, Egypt, and Greece had acquainted him with non-Western design long before the exhibition. At the request of Cole, who had been appointed to lead the Department of Practical Art (as the School of Design was now called) Jones lectured in 1852 to England's future industrial designers on "True and False in Decorative Arts." Several years later he published *The Grammar of Ornament* (1856), which illustrated with beautiful chromolithographic plates "a few of the most prominent types in certain styles closely connected with each other, and in which certain general laws appeared to reign independently of the individual peculiarities of each."[3] Drawing on examples from cultures as disparate as Egypt, New Zealand, Greece, and Islam, Jones developed thirty-seven "General Principles in the Arrangement of Form and Colour, in Architecture and the Decorative Arts, which are advocated throughout this work."[4]

Another important figure in defining the standards of design was John Ruskin, whose *Modern Painters* (1843–60) and *Academy Notes* had won him a wide following. With *The Seven Lamps of Architecture* (1849) he had given his

[2] Henry Cole, *Fifty Years of Public Works of Sir Henry Cole* (London, 1884), vol. II, p. 252

[3] Owen Jones, *The Grammar of Ornament* (London, 1856), chap. XIV, pp. 85–87

[4] Ibid., p. 87

support to the increasing number of theorists and architects who, like Augustus Welby Pugin (whose Medieval Court had attracted attention at the 1851 exhibition), advocated that England look back to the Middle Ages for inspiration in design. In 1851 Ruskin published the first volume of *The Stones of Venice*. Attempting in this book to define "The Nature of Gothic," he stated, "Nothing is a great work of art, for the production of which either rules or models can be given." What Ruskin admired in Gothic works was the "love of natural objects for their own sake, and the effort to represent them frankly, unconstrained by artistical laws."[5] By the same reasoning, when he presented a series of lectures to the Society of Arts—later reprinted as *The Two Paths* (1859)—he warned students about "the degradation of temper and intellect which follows the pursuit of art without reference to natural forms, as among the Asiatics."[6]

Much influenced by Ruskin and Augustus Welby Pugin was William Morris, who began his career in the office of the Gothic Revival architect George Street. After working with Dante Gabriel Rossetti on the decorations for the Oxford Union Debating Hall, Morris built the Red House at Upton as an embodiment of his principles of decorative art. When the house was finished, he founded a small company which relied on the architect Phillip Webb and the painters Edward Burne-Jones, Ford Madox Brown, and Dante Gabriel Rossetti to design and execute church decorations, stained glass, metal works, paper hangings, chintzes, and carpets. Morris, Marshall, Faulkner & Company, as the firm was known, submitted their work to the Medieval Court of the 1862 exhibition.

On May 1, 1862, subscribers whose contributions had made the exhibition possible, exhibitors whose wares were to be seen in aisle upon aisle of displays, and numerous government officials from England and abroad proceeded past the

[5] John Ruskin, *The Stones of Venice* (Boston, 1853), vol. II, as quoted in E. G. Holt, *From the Classicists to the Impressionists* (New York: Anchor/Doubleday, 1966), p. 431

[6] E. T. Cook and A. Wedderburn, eds., *The Complete Works of John Ruskin* (London, 1905), vol. XVI, p. 326

bronze statue of Wedgwood and a bronze casting of Milo to the area below the eastern dome of the exhibition building. While they awaited the arrival of the dignitaries for the opening ceremony, they admired the statues of Cromwell, Crompton, Outram, Babbington, and Hallam, which were scattered throughout the area. To the north and south were display cases crowded with an assortment of elegant dressing cases with cut-glass fittings, silver racing cups and testimonials, and a handsome candelabrum with a vase-shaped stem. On the dais itself rose St. George's fountain, designed by the late John Thomas, the celebrated decorative sculptor, and executed in English majolica ware by Messrs. Minton of Stoke-upon-Trent. Those who could see down the southeast transept caught a glimpse, over the heads of the crowd, of the wrought metal screen decorated with marble and mosaic which Skidmore's Art Manufactures Company had constructed for Hereford Cathedral. The view of the northeast transept, if not as rich and splendid, was full of interest, for the peculiar products of some of England's important colonies were arranged there.

The attention of the thirty thousand persons gathered for the ceremony was suddenly aroused by the entrance of the Japanese ambassador and his suite. Even amid the scarlet, blue, purple, and gold of the European military and diplomatic costumes, the fabulous, exotic display of oriental splendor brought a murmur from the crowd. The bizarre brilliance of the Japanese envoys recalled the startling news items that had appeared in the press the past year: "British Legation Attacked in Yeddo"; "American Consular Official Killed"; "H.M.S. Frigate *Odin* Dispatched for Japanese Envoy's State Visit." Until these reports appeared, the British reading public had been only generally aware that in 1853 the American Commodore Perry had forced entrance into two ports of the mysterious, secret island kingdom and secured permission to use them. The treaty concluded between Japan and the United States in 1854 was followed immediately by treaties with England, Prussia, France, and an invitation that brought the Japanese Envoy Extraordinary and Plenipotentiary to the courts of the European sovereigns. Conveyed in a

British frigate, the Japanese ambassadors and their suite of twenty-two first disembarked at Marseilles on April 3, 1862.

The Japanese court had a particular fascination for a number of architects and designers who had studied Gothic works. The Bristol architect Edward W. Godwin, who had looked to medieval prototypes when he designed the recently completed Northampton town hall, redecorated his own house in a spare Japanese manner utilizing asymmetrically hung Japanese prints. Another architect, William Burges, who exhibited designs for chairs showing a medieval influence, was equally enthusiastic about the works of Morris and the Japanese court when he reviewed the exhibition for the *Gentleman's Magazine*:

> If the visitor wishes to see the real Middle Ages he must visit the Japanese Court, for at the present the arts of the Middle Ages have deserted Europe and are only to be found in the east. Here in England we can only get medieval objects manufactured for us with pain and difficulty, but in Egypt, Syria, and Japan, you can buy them in Bazaars. . . . Truly the Japanese Court is the real Medieval Court of the Exhibition.[7]

When the critic William Michael Rossetti (the brother of Dante Gabriel) was asked to review the fine arts segment of the exhibition for *Fraser's Magazine*, he could not resist some observations on the decorative arts and the Japanese court:

> It would be a nice question for an artistic theory to decide where the industrial art of the International Exhibition ends and its fine art begins. Is its decorative art to be classed as fine or industrial? . . . We conceive the faculty for art throughout its whole range to be essentially the same. . . .[8]

After a fifteen-day state visit in France, they then proceeded from Paris to England to attend the International Exhibition. Their participation in the opening ceremony was depicted in the *Illustrated London News*, which advised its readers to seek out the exhibition's Japanese court, "about

[7] *Gentleman's Magazine*, July 1862, pp. 10–11
[8] William Michael Rossetti, "The Fine Art of the International Exhibition," *Fraser's Magazine*, August 1862, pp. 188–89

which there is a quaint picturesqueness," for "few portions of the building are more interesting." The principal part of the "interesting collection of Japanese curiosities" had been contributed by Mr. Alcock, Her Majesty's Ambassador to Japan. Instructed to obtain specimens of the art industries and manufactures of Japan for the exhibition, Ambassador Alcock had methodically selected lacquer ware, inlaid and carved woodwork, straw and basket work, china and porcelain, bronzes, as well as specimens of Japanese papers, costumes, storybooks in the Hirakana character, an encyclopedia, and illustrated works on natural history.

Most of the Japanese articles were utilitarian, but they also had the attractiveness that comes from accurate finish and technical ingenuity. Even the most ordinary item had been given some suggestion of ornament that raised it to an aesthetic level meriting recognition. In contrast to the Japanese objects, visitors observed that European decorative art appeared distorted, pretentious, crude, and inharmonious in its pursuit of originality. As an alternative to the decorative elements of Graeco-Roman culture, to the naturalism required by proponents of the Gothic style, or to the unarticulated overall designs of "Asiatics," the Japanese objects offered decorative elements derived from nature that were novel and appealing. As the *Illustrated London News* observed,

> Holding these opinions, we should feel no difficulty in comprising under the fine art of the exhibition a great deal of its industrial art. The truest estimate of the whole subject might possibly show us that about the very best fine art practised at the present day in any corner of the globe is the decorative art of the Japanese.[9]

William's enthusiasm was shared by his brother and their friend and neighbor in Chelsea, the American painter James McNeill Whistler, who had already seen Japanese designs in New York and Paris.[10] The Rossettis and Whistler began to

[9] *Illustrated London News*, May 3 and September 20, 1862
[10] Whistler may have seen a wider variety of Japanese objects than the artists and connoisseurs of Paris. He was a student at West Point when the "Japanese Curiosities" at the Crystal Palace had

collect Japanese objects. Though Dante Gabriel Rossetti's paintings never showed the influence of his new interest, in 1863 Whistler painted *Rose and Silver: La Princesse du Pays de Porcelaine*, which showed a young woman, dressed in a kimono, holding a fan and standing before a Japanese screen. Later he hired Godwin to design his "White House" in the Japanese manner. William Rossetti acquired, among other things, an uncolored book of Japanese woodcuts which he described in a lengthy article for the *Reader* in 1863. He lent the book to Ruskin, who, when he returned it, wrote in a burst of enthusiasm, "I want to go live in Japan. . . . The seas and clouds [in the prints] are delicious, the mountains very good."[11] Ruskin, however, soon changed his mind about Japanese designs, lumping them with the degraded products of India and China. The Japanese exhibit seems to have had little influence on William Morris, Dante Gabriel's friend and Ruskin's disciple.

The effort to identify the principles which governed Japanese design was widespread, lasting well into 1863. In a lecture at Leeds, Ambassador Alcock drew attention to the valuable instruction to be gained from the study of Japanese art and the value of applying its principles to industrial ends. On May 2 *The Builder*, an illustrated weekly magazine and the leading architectural journal in England, published the first in a series of three articles on Japanese ornament. The anony-

been displayed at the World Exhibition of 1853, held in New York. Some of the items supplied by the king of Holland—a lantern, an umbrella, and sandals—were engraved for the New York *Illustrated News* (September 10, 1853, p. 229). A month later another collection of Japanese objects was added to the exhibition, this one more interesting than that of the king of Holland. It came directly from Japan, having been secured from an ill-starred junk which, bearing one survivor, had been rescued by an American vessel and was brought to San Francisco and then to New York. Specimens of coins and examples of Japanese manufacture, including a bowl, a decorated crêpe scarf, and a purse, were some of the items depicted in the New York *Illustrated News* (October 8, 1853, p. 187).

[11] Letter of 1863 from Ruskin to W. M. Rossetti. William Michael Rossetti, ed., *Rossetti Papers, 1862–1870* (London, 1903), p. 28.

mous writer defined Japanese ornament as a style consisting in part of purely ideal shapes, in part of forms derived from nature, and in part of symbolic forms. Concerning the forms derived from nature, he noted,

> The birds are not created naturally but ornamentally. Conventional forms are produced sufficiently like the creature intended to suggest it to the mind. This is the true way to use natural objects for the purpose of ornament. We do not produce ornament if we merely imitate nature; we do so only when we adapt the object chosen as a theme, to the position for which it is intended.

Finally, the writer reminded his readers,

> Rather than copy ornamental forms, we should extract the good from all styles and appropriate it to our uses. . . . While we cannot approve of copying the ornaments of any style, we yet think that more real art is to be found in Japan than in many countries whose ornament we largely use. If we cannot produce original decoration and must copy others, we may, with advantage, study and appropriate Japanese ornaments.[12]

The day before *The Builder*'s series began, the Royal Institution's Friday-evening lecture was given by John Leighton (1822–1912), a fellow of the Society of Arts, on the subject of the Japanese art at the international exhibition. Leighton, who also wrote under the pseudonym Luke Limner, was principally known as a book illustrator, but he had also worked as a photographer and designer. The stained glass window he designed for St. Helens Crown Glass Company had been exhibited at the 1851 international exhibition, and for the exhibition of 1862 the Art Union of London commissioned him to design the Albert Memorial Tazza. Leighton's lecture, "profusely illustrated with native productions," many of them drawn from the 1862 exhibition, compared Japanese architecture, sculpture, drawing, and manufactures with Chinese, Indian, Egyptian, Greek and Roman, and Assyrian works in an effort to distinguish those elements of Japanese art common to other cultures and those that were unique. Leighton's

12 *The Builder*, May 2, p. 308; May 23, p. 364; June 13, p. 423

ideas were summarized in the *Illustrated London News* of May 9, 1863, and consequently reached a wide public.

After 1862 the Royal Society of Arts abandoned the idea of large-scale international exhibitions arranged by country. Even before the 1851 exhibition, the prince consort had suggested that the exhibition be arranged not by country but by class of objects—"put all the pianofortes together," he said —so when they planned the exhibition that would celebrate the ten years of progress since 1862, the commissioners decided on small-scale annual exhibitions of items arranged according to type. These exhibitions provided useful technical instruction, but the works of different cultures lost their clarity because they were split up and scattered, and none of the displays had the impact that the Japanese court had had at the International Exhibition of 1862.

John Leighton: *On Japanese Art: A Discourse Delivered at The Royal Institution of Great Britain, May 1, 1863*[1]

JAPANESE ART. Illustrated by native examples.

Of all the marvels of Art and Industry collected at the International Exhibition, in 1862, none excited greater attention or admiration from the reflective visitor than the contributions of Asia, including as they did the productions of India, Turkey, China, and Japan, as also a host of islands— the inhabitants of which seem alike gifted with Art powers, indigenous to the soil on which they grow, as the gorgeous plants of the tropics flourish independently of care or culture: I allude particularly to that marvellous perception of form and colour, founded upon the laws of nature, and demonstrable by the aid of science or the rules of art, that seems the heritage of all Asiatics.

Certainly, the lions of the last London season were from the far East, the land of fable and romance seeming brought to our very doors, when the two-sworded Hatamoto and suite,

1 [*On Japanese Art: A Discourse Delivered at The Royal Institution of Great Britain, May 1, 1863* (London, 1863)]

as ambassadors from Japan, walked in procession at the opening of the Universal Exhibition and viewed in that grandest of all displays—the most perfect the world has yet seen—a choice collection of many of the products of their island home, in the North Pacific, a region sealed against us for three centuries, and only known to Europeans through the works of early navigators; . . .

To the Dutch we are much indebted for keeping alight the feeble flame, the spark of European intercourse, that has never been allowed to die out, greatly to the benefit of all.[2] Through this channel many things reached the court of the Tycoon, as others found their way via the Netherlands, into Europe; yet the Hollander seems to have profited little by the aesthetic lessons of Japan. The *Cabinet Royal de Curiosités*, at the Hague, though a great source of attraction to strangers, is certainly not so interesting or instructive as it might be made; scarcely rivalling the *Musée Siebold*, at Leyden . . .

The Great Exhibition of 1851 had to content itself with a Chinese collection from the stock of a London trader in such wares, by no means remarkable as a sample of Celestial art, and to put up with the best mandarin it could convert out of one of the crew of a Junk exhibiting at that period in the Thames; the individual assuming the peacock's plumes having nothing of the importance or the reality of the two-sworded dignitaries from Japan. In 1862 the Chinese court was but little better than before; the city house was there, again, with its tea-pots, josses, lanthorns, fans, hand-screens, and painfully elaborated ivory carvings, balls within balls, a gathering, rendered, doubtless, more interesting by the contribution of some articles of loot from the sacking of the summer palace at Pekin[g],[3] many enamelled vases being of great

2 [In the mid-seventeenth century the Japanese adopted a policy of excluding European traders and missionaries. Until the nineteenth century only the Dutch were permitted limited trading rights.]

3 [In 1858 China had been forced to accept trade treaties with France and England. The following year the Chinese refused to honor the treaty and executed a negotiating party. In retaliation, English and French forces entered Peking and sacked the Summer Palace.]

beauty, though not the production of this century, rather ranking as curiosities—even in China.

In contrasting the arts of China and Japan, what strikes one forcibly is the marked difference of labour, the Japanese aiming to produce the greatest possible effect at the least expenditure of trouble, whilst the Chinese make pains a principal virtue; they toil and spin, but lack inventive power, working from instinct rather than from the dictates of reason—a fault with all Asiatics, in greater or lesser degree—degrees that seem to reach their climax as they near the coast, and are lost in the great ocean, or are tided over to the numerous islands, there to be modified, translated, and adapted to other wants.

The Japanese court in the International Exhibition was, as you all remember, on the right of the main avenue, cutting the building from south to north, near the entrance to the Horticultural Gardens, being divided by a gulf of six feet from China, which it immeasurably distanced. . . .

But to begin upon the arts of these extraordinary people, who seem, whilst they seek safety in seclusion, by no means to be blind to outward influence; to learning from any source: with all their love of feudalism and seclusion, the Japanese appear much more free in thought, than their neighbours, the Chinese, being a people who, though bound by strong tradition, are ever ready to learn, as many of their arts and manufactures clearly demonstrate. European influence is to be found in their fire-arms and ships; it has taught them linear perspective, as it will many other sciences. . . .

I commence with architecture, because building is the primary office of man—construction came before decoration— though one can hardly exist without the other; the man who constructs a deal box produces a pretty ornament, at the

same time making a dove-tail doubly beautiful, because it grows out of the construction; thus construction and decoration go together.

As architect the Japanese have many difficulties to contend

with; they build as their fathers built—not from conservative feeling alone, like the Chinese, but because the elements are against them. Man may raise *up*, but the elements in Japan can raze *down*, earthquakes being of frequent occurrence there, rendering a wooden construction necessary—buildings that, in ordinary hardly rise above the dignity of a Swiss châlet of the most plain proportions: the gable finials and ridge tiles being, perhaps, the principal features of erections, rarely higher than two stories, with galleries and verandahs— the doors and divisions of rooms composed of sliding-shutters —the whole edifice resting upon a foundation of stone supported upon legs of wood, somewhat as a four-post bedstead stands; this form being best suited to resist concussions caused by the trembling earth.

The temples and gateways are of timber, with massive tent-shaped roofs, like the homes of the Tartars and Chinese, but with many details purely Indian, as these photographs will show; some of the edifices, as they stand upon their stone bases, reminding one strongly of the Assyrian restorations at Sydenham Palace[4]; indeed, it is very curious to find many types from the ancient Egyptian, Assyrian, and Greek, perpetuated in the works of these remarkable people; how they came to be embalmed in a living art of the present day it would require deep research to prove,—a subject for the antiquarian, who looks backward, rather than the man of science who looks forward: though men of the past and future alike teach the present.

In my outlines A is taken from a tomb, hundreds of which are to be found in their cemeteries; a treatment of the sacred bean and lotus, so common in ancient Egypt, as also in India. Figs. 1 & 3 are purely classic, though in every day use both in China and Japan. Fig. 2, in which scrolls are united in a bud, is also common, though more Assyrian than either of the others.

[4] [The Crystal Palace was dismantled and reassembled at Sydenham, south of London, in 1854. It was used for permanent and temporary exhibitions, concerts, and athletic contests until it was damaged by fire in 1936. It was finally demolished in 1941.]

A 1

2

3

As workers in stone the Japanese are decidedly clever; though the nature of the foundations will not permit of nine-storied pagodas, they do wonders with the material; having a timber architecture—they imitate wood in stone, instead of stone in wood and plaster, as we are apt to do; here I have a photograph of a semi-circular bridge in stone—the struts, planks, mortices, and all being as if of timber, copied.

A B

In their architecture and sculpture devoted to the purposes of religion, the Japanese seek the aid of symmetry to give dignity, a majesty obtainable by no other means, a rigidity carried to the greatest extent in the works of the ancient Egyptians, though the Greeks and Romans were well aware of its powers. In ornamenting their secular objects the Japanese seem studiously to avoid exact repetition or a counterpart of lines, or, if they find them, do all they can by means of decoration to destroy an exact division or repetition of any portion. All other nations seek symmetry on principle, save these people and the Chinese, though the latter in lesser degree.

By way of illustration, I may say they shun an equality of

parts, or rather the appearance of an equality of parts, weighing with the steelyard instead of the scales. Justice with them is not evenhanded; and, though they give weight in another way, they do not do so by diametrical division. Division, or repetition of parts, *has* been considered the acme of architectural and ornamental art, though not so of pictorial art, which must be more varied, and is, save in exceptional cases, where the high position or centre is appropriated to a deity or hero; in such the pictorial is subservient to the decorative.

Diametrical division the Japanese dislike. Fig. 1 has not variety enough for them; they do all they can to get rid of a vacuum, as in Fig. 2, following the precedent of Nature[,] who never repeats herself either in spangling the skies with stars or the earth with daisies of the field, as in Fig. 3. Dia-

pers and conventionalized forms, as in Fig. 4, are not so popular with them as with us, who appreciate their value to break up surfaces and lead the eye to measure distances.

The arts of Japan may be said, in an eminent degree, to depend upon the picturesque, though rarely to reach the pictorial, that is to say, they never produce a picture, because the principal element of pictorial art is wanting; light and shade—a cloak with us that covers a multitude of sins—they know not of. Art of the highest kind may, and often does, exist without chiaroscuro; for instance, the divine compositions of Flaxman owe none of their world wide fame to shade or colour . . .

In Japan we are told there are no academies of Art, nor have the artists any status above that of the cunning craftsman; a hopeful thing, perhaps, for the future—Nature's students standing the less chance of being fêted, lionized, or spoiled.

For powers of drawing the native examples I have been enabled to collect differ widely, and I doubt if they are the best the country can supply; they vary greatly, though all are deeply interesting to the art student, who may learn from the humblest specimen. They have principally been selected from the late Exhibition, and I believe are mostly from Yeddo[5]; the larger coloured examples being very remarkable for a certain typical rendering of the human face divine, not to be found in the smaller engravings or in Nature, a droll sort of leer pervading all with an Egyptian uniformity; though,

[5] [Yeddo is now modern Tokyo.]

unlike the ancient examples from that nation, perspective has taught the Japanese artist to put eyes in profile as well as faces, not to do thus,

but thus;

apart from this abominable leer, always to be found in the three-quarter faces (A), combined with defective drawing of heads (B), hands and feet, these examples are very interest-

C D

ing, showing much good proportion, action, and drawing of drapery; whilst in colour they are very suggestive, some of the hues and patterns being handsome in the extreme.

The landscapes are very quaint, aërial perspective seeming beyond their powers, except in one or two cases where white mists have been attempted, as also rain, fog, and snow. In depicting clouds the Japanese artist seems sorely puzzled— the tinted ribbons they stretch across the heavens looking like labels for inscriptions rather than floating vapours.

The smaller samples, cut from their books, I fear you cannot all see; they are full of fun and first-rate drawing, being quite in spirit equal to anything done here in the present day; ay, and done with few lines and marvellously little effort; many of them have been engraved in Sir Rutherford's recent work. . . .[6]

In composition they are good, two or more figures uniting in the production of admirable lines; though, like the early artists of other nations, the Japanese make their point of sight very high, all figures being as if looked down upon.

[6] [Sir Rutherford Alcock's *The Capital of the Tycoon*, 2 vols. (London, 1863) was illustrated with wood engravings after Japanese woodcuts and photographs. Chapter XXXV included a discussion of Japanese art.]

In colour, as a nation, they are very judicious, rarely producing discords, either in their attempts at picture-making or applied art—a thing that can hardly be said of either English or French. The British manufacturers, traders, and people in general, have but little love of colour, though her painters and architects appreciate it highly. In France this is "au contraire"—*her* manufacturers and traders claim colour as an inheritance, but her painters disregard it, or place it as a minor accomplishment; the French school being one of form rather than colour . . .

I think we may say that conventional art, including architecture and sculpture, was never lower than when the great school of genre and imitative art flourished.

But to the East, where colour reaches its climax, as it tans the skin and renders man fit to support primitive hues, the love of which perhaps is to be found most highly in the negro, though in the Hindoo must be sought the subtle appreciation of it. Leslie has somewhere said, the only perfect specimen of colour he had seen was in a Chinese picture. What he would have said to these of Japan we can only conjecture—colour with perspective, and shade nowhere!

We come now to sculpture, of which I have little evidence to show, though the Japanese are cunning carvers in stone, modellers, and metal workers, having a veritable passion for relief in everything; even their painted lacquer boxes are raised, enabling me to show some of them by rubbings rather than reality. I wish I had more of their animals in metal to place before you, showing how they catch the salient peculiarities of Nature in every case. . . .

Having disposed of the higher elements of genius in Japan, we now come to those phases of applied art by which a people become known to the future historian of art.

In art applied to manufactures the Japanese stand very high, their versatility of thought being remarkable; rarely repeating anything by rule of thumb, or copying without some modifications. How different to the Chinese, where a tailor will reproduce a garment for you stitch for stitch, patches included; or porcelain fabricants copy china vases, cracks, rivets and all, effects and defects likewise. In their manufactures

they studiously avoid symmetry (as I said before), aim to condense the greatest variety in the smallest space, and, whilst they conventionalize, worship Nature in the utmost; some of their ways being marvellously droll to us. This I will illustrate in the decoration of a very common box, brought me by Sir R. Alcock. You will perceive the lid of the article being square offended the Japanese eye, as it would any other eye properly constituted; decoration being sought, a line is drawn across the article, not horizontally or vertically, as any other nation would have done, but diagonally, because it produced the greatest variety at the cheapest rate, being particoloured, as in B, the smooth surface of the lacquer being again broken up with irregular stamps, disposed in the most

B

irregular manner. These devices I have drawn on a larger scale, and contrasted them with figures from India (A), showing how types begin to differ; forms that in Japan are lop-sided, become in India, more symmetrical, and in Europe quite so.

Here, again, is a book-cover, stamped all over with representations of coins, relieved here and there by a dab of gold (like the tin-foil in a government stamp), and a sprinkling of the like metal. Variety is charming, but unity is handsome and respectable. Europe adores unity, but the far East wor-

A

ships variety. Reason is sorely puzzled to make a choice . . .

Volcanic eruptions and grand storms, doubtless, have had much to do with the perfecting that terrible myth the dragon, who, though never seen, has been often heard, being finely rendered, as are most of the animal and vegetable wonders depicted upon Japanese ware, all kinds of creatures being pressed into the service, and made to meet the wants of the article decorated. The manner in which flowers and birds are bent and twisted over surfaces is highly curious, as also the way they suggest ideas for shapes—sometimes so true to Nature as to make one wonder at the draughtsman's skill, whilst in others so highly conventionalized are they as to make one doubt the authority. Hawthorn, bamboo, and rush are very common, as also cranes and tortoises, and landscapes touched in golden outlines . . .

Small round ornaments are very popular in Japan, doubtless from the resemblance they bear to the crests or badges of Daimios-forms[7] defended by law; hence their popularity amongst the people in general, as at home lions rampant and dragons displayed may be bought of every stationer.

It is curious that all those badges, or nearly all, should be derived from floral ornaments, Japanese heralds being guided by some principle—for here, in a first book for children, I find a popular badge in its conventional form with the plant it is

[7] [Daimyo were Japanese feudal lords.]

derived from, E. A red sun, or rather a red ball, as we should call it, is the emblem of the Emperor of Japan. . . .

As engravers upon wood and metal, the Chinese are known to have been skilled long before civilization had dawned upon England, or even Europe had dreamed of tomes in black letters; but few, a year ago, would have ventured, I think, to claim the priority of colour printing for Japan[8]; yet this may be the case; for in no instance do the specimens before you bear evidence of having been copied from anything done in the Western World, being all hand proofs, worked in flat tints, without a press; secondaries or tertiaries in very few instances being produced by working colour upon colour, as with us, who use no outline to indicate form.

Truly may we say there is nothing new under the sun, and particularly under the red sun of Japan; for here we have two recent inventions superseded, one being graduated or rainbow printing, and the other some method by which blocks or prints can be reduced.

If the printing excites our wonder, what shall we say to the

8 [The Chinese developed printing from wooden blocks in the sixth century A.D. and polychrome printing in line in the sixteenth century. Late in the seventeenth century the Japanese perfected color woodcuts under the influence of Chinese color prints.]

paper, for certainly we have nothing like that article, which plays so important a part in Japanese life. . . .

Verily the Japanese are a clever people; and earnestly do I hope they may be richer and happier for their intercourse with Europe, though I doubt it, in some respects. A people so sensitive will copy many of our defects, as the natives of British India have done, degrading themselves to meet the wants of European taste, as we all saw in the Indian department of the late Exhibition. . . . I would advise art missionaries to Japan, not to propose or dictate to a people our superiors in so many things; to supply them with objects of science rather than objects of art; teach them perspective, the laws of proportion, and of colour (if you can); supply them with photographs, but let Nature teach *them* art—teach not until you have learned.

1863: PARIS

The Gallery Exhibition
of the Dealer:
Martinet's Gallery and
the Official Exhibition
of the State:
The Salon and
the Salon des Refusés

Visitors eager to see the fashionable part of Paris were
directed by guidebooks to the boulevard des Italiens, a part of
the great avenue which ran in a semicircle from the Bastille
to the Madeleine.[1] Elegant Parisians crowded that section be-
tween the boulevard Montmartre and the boulevard des Ca-
pucines where the new Opéra, designed by Jean Louis
Charles Garnier, was being hurriedly completed. After the
nearby Bourse closed, tables were difficult to find in the Café
Riche or the Café Cardinal, then crowded with dandies,
flâneurs, and "lions." Visitors and Parisians interested in
contemporary art walked down the right side of the boule-
vard des Italiens. Located on the boulevard was the studio of

[1] See *Triumph*, pp. 449–60

the popular photographer Disdéri, the Théâtre d'Hamilton, the entrance to the Opéra, the excellent restaurant Tortoni and the Café Riche and, at no. 26, the art gallery of Louis Martinet. In the spacious rooms of the former Hôtel d'Hertford, art exhibitions took place comparable to the annual charitable exhibition once held at the Bazar Bonne Nouvelle. This commercial art gallery—the entrance fee was one franc— had been opened in 1859 by Louis Martinet (1810–94), a moderately successful portraitist and painter of floral pieces.

The son of a Corsican named Martinetti,[2] he had been a pupil of Gros and the architect Huyot. At the height of the revolution of 1848, chance suddenly permitted Martinet, a lieutenant of the Garde National, to become the rescuer and savior of the Duchesse d'Orleans, the Comte de Paris, and the Duc de Nemours. Obliged to stop painting because of an eye infection, Martinet was brought into the Direction des Beaux-Arts as inspector in charge of the exhibitions of painting and organizer of public *fêtes*. He was decorated for his work under Lefuel for the exposition of 1855 and his bravery in 1848. Now well known, Martinet began to organize art exhibitions—his first was devoted to the work of Ary Scheffer —and soon made successful sales. His gallery was an innovation in the Parisian art world, for its special exhibitions gave serious artists an opportunity to show work outside of the Salon. The Salon admitted works that could be assigned and judged within the traditional categories or classifications that had been determined by the Academy. Martinet's exhibitions also differed from those at the respected art-auction house, the Hôtel Drouot, located near the Bourse, and from the random displays at Goupil's print and art shop or at Paul Durand-Ruel's paint and paper store in the rue de la Paix, which had first sold paintings, watercolors, and drawings in 1839.

With the opening of Martinet's and other galleries, the Parisian art world acquired a characteristic of London. There, art connoisseurs, patrons, and dealers had brought the work of contemporary artists and prospective purchasers together

[2] He was not related, as is often thought, to the Martinet-Hautecoeur family of printers and printmakers.

by means of exhibitions held in a congenial ambience. The British Institute, which in 1806 began to sponsor an annual exhibition of work not to be seen at the Royal Academy, and Henry Bullock's Egyptian Hall, which offered for rent excellent exhibition facilities, served the mounting interest in contemporary art.

The reputation a dealer enjoyed as an art expert became an endorsement of the contemporary work he exhibited. Louis Martinet's qualifications in this respect were impeccable. A one-time fellow student, he knew the artists and their different groups. His official position gave him access to the circle of the patrons and purchasers of art. In March 1860, when no Salon was held, he opened a "small Salon" which included paintings by the eighty-year-old Ingres, who no longer sent his work to the official Salon, and by some painters whose work the jury had refused in 1859. To meet a need for information on contemporary art, he and Durand-Ruel assembled and published L'Album (1860), a massive ten-volume work with photographs of a hundred paintings, each accompanied by an informative note written by an art commentator. Financially secure, in June 1861 Martinet launched Le Courrier Artistique, a four-page fortnightly costing twenty centimes, which reported on events in the art world. A few months later, officials, patrons, connoisseurs, and artists assembled at the Martinet gallery to elect the jury which would select the artists who would represent France at the London international exposition, scheduled to be held in 1862. Martinet was one of those chosen. When he proposed the creation of a Société National des Beaux-Arts for amateurs and artists that would sponsor exhibitions to be held at 26 boulevard des Italiens, Minister of State Comte Walewski agreed to be the honorary president; Théophile Gautier its acting president, and Martinet and the sculptor Préault vice-presidents. In June 1862 the Society's first exhibition of one hundred paintings—including works by Millet, Delacroix, and Rousseau—was held. Ingres's canvas Jesus Among the Doctors, recently purchased by the emperor, was assigned the place of honor.

The increasing interest in art, which contributed to the

success of galleries like Martinet's, had been stimulated, as
Charles Blanc had pointed out, by the international art exhi-
bitions. After the first exhibition held in Paris in 1855, where
the art of the various countries had been placed side by side
and comparisons could be made between them, government
officials and patriotic art patrons in each nation began to im-
prove their exhibition facilities. The government-sponsored
eighteenth-century academies were rejuvenated and art un-
ions and art societies flourished. Brussels, Munich, Turin,
Zurich, and Milan built suitable buildings for large national
and international art exhibitions. A schedule of international
fine arts exhibitions became available. In France the desire to
maintain the country's preeminent position in the arts had
brought its own changes. The Salon had returned to the bi-
ennial schedule in 1857—it was generally on an annual
schedule from 1830-57—and control by the Academy was
strengthened.

On January 15 it was announced that for the 1863 Salon
scheduled to open in May each artist would be limited to
three entries—a stipulation that had also been in effect in
1852 and 1853—which would be received between March 20
and April 1. As had been the case in 1851, entries sent by art-
ists who had already won first- or second-class medals would
not have to be submitted to the jury. This was a privilege for-
merly enjoyed by holders of the Légion d'honneur. It was
given only after the other medals had been won. By admit-
ting artists with medals, the number of exhibitors was in-
creased. All were agreed that some limitation on the number
of entries was necessary, but young artists struggling for rec-
ognition and those whose work had previously been rejected
by the jury felt they were adversely affected by the ruling,
since the number of artists who did not have to submit to the
jury was increased, leaving little exhibition space free for the
unknowns. On March 1 Gustave Doré and Édouard Manet,
representing a group of artists who had been excluded, pre-
sented Comte Walewski with a petition appealing for more
liberal provisions. Despite Walewski's gracious reception, the
petition was ignored. Manet, anticipating possible exclusion,
approached Martinet, who replied on March 13 that "the ex-

hibition rooms of the Society cannot become a showplace for pictures refused by the Palais de l'Industrie."

Well aware of the lively interest aroused by the debate between the artists and the "establishment," in late March 1863 Louis Martinet opened an exhibition that Paul Mantz, the respected critic and collaborator of Charles Blanc, called in the *Gazette des Beaux-Arts* a "preface" to the Salon. Grouped around David's own copy of his *Coronation of the Emperor* were paintings by the century's recognized masters as well as by contemporary artists. Some pictures were suitable for a prosperous gentlemen's drawing room; others—such as those of Courbet and Manet—were sufficiently controversial to attract the public to the exhibition. Mantz touched briefly on the wide variety of works to be seen at the influential dealer's gallery—sketches by Richard Bonington, battle pieces by Eugène Lami, John Singleton Copley's *The Death of Major Peirson*, and Delacroix's sketch for the ceiling of the Louvre's Galerie d'Apollon.

In the prestigious *L'Artiste*, now under the direction of Arsène Houssaye, notice of the exhibition appeared in "L'Art Contemporain," the regular fortnightly review of art events by Ernest Chesneau (1833–90). A young protégé of the powerful Comte de Nieuwerkerke, and therefore admitted to the Princesse Mathilde's salon, Chesneau had also been assigned the art criticism for the *Constitutionnel*, the daily paper notable for Sainte-Beuve's weekly Monday column. Chesneau's interest in the relation of the arts to society and his enviable social connections attracted readers. The year before (1862) he had published *La Peinture Française au XIX*e *Siècle*. His *L'Art et les Artistes Modernes en France et en Angleterre*, based on his articles for *L'Artiste*, would appear before the year's end.

When the results of the Salon jury's selection became known on April 12, the worst fears of young and unrecognized artists were confirmed. Of the five thousand entries, less than half were accepted. Discouraged artists asked Martinet to open his gallery for an unjuried exhibition, but the dealer insisted on his right of selection. A week before the Salon's opening, the *Moniteur* announced that, at the wish

of the Emperor, the works of art rejected by the jury would be exhibited in a section of the Palais des Champs-Élysées. "This exhibition will be voluntary and the artists who do not wish to participate need only inform the administration, which will hasten to return the works to the artists." During an afternoon walk on April 22 the emperor had visited the Palais de l'Industrie, had looked at some fifteen or twenty of the refused works and, finding them no different from those accepted, had made his decision. On April 24, the *Moniteur Universel* stated that the exhibition of the Refusés would open on May 15; artists not wishing to participate should remove their works before May 7.[3] To defray the cost of preparing the galleries, admission would be one franc; Sundays would be free; no catalog would be printed.

The decision to hold simultaneous exhibitions stimulated discussion concerning the role and responsibility of the State in artistic matters. Ernest Chesneau, perhaps reflecting the views of his patrons, de Nieuwerkerke and the Marquis Laqueuille, Director of Fine Arts, believed the jury was not as indispensable as the Academy. Others pointed out that in England and Germany artists were largely free to manage their own affairs.

When the official Salon was opened by the imperial couple on May 1, journalists, critics, and aspiring writers swarmed in, eager to be the first to report to the public. One of the first of the twenty-seven or more reports to be published in a brochure, album, or newspaper was that of the aged dean of art critics, Étienne Delécluze. Written with the help of his distinguished nephew, Eugène Viollet-le-Duc, it appeared in the *Journal des Débats* on April 30. Young Ernest Chesneau had begun his report in the *Constitutionnel* on April 28. Not until May 23 did Gautier's descriptive review appear in the official *Moniteur Universel*. Excellent coverage was to be found in the non-French press. Jules Castagnary's thoughtful report to *Le Nord* in Brussels appeared simultaneously with his nine articles in the *Courrier du Dimanche* and his report for *L'Artiste*.

[3] *Le Moniteur Universel*, April 24, 1863

Papers aligned with the government could conveniently ignore "The Exhibition of Works Not Admitted to the Salon" when it opened on May 15. Many approved the jury's selections and were critical both of the decision to hold the exhibition and of the works shown. In their opinion, the exhibition of the Refusés vindicated the jury's selections. To stem the waves of criticism, Jules Castagnary, using the prestige of *L'Artiste*, explained the dilemma faced by artists who, when they were given the opportunity to exhibit, did not observe the technical standards and traditional classifications required by the jury. The role of spokesman for a group of writers to explain and defend the artists' right to rebel was assumed by Fernand Desnoyers (1828–69), who published a brochure supporting the artists against the theorizing critics.

Rejection by the Salon jury and the resulting controversy among the critics gave the independent artists a certain notoriety. They would continue to be exhibited, if not by the government—which liberalized the Salon regulations in following years but refused to repeat the experiment of the exhibitions—then by perspicacious dealers like Martinet, who recognized that the public's interest in art extended beyond that approved by the Academy.

Ernest Chesneau: *Contemporary Art: The Exhibition at 26 boulevard des Italiens*[1]

The exhibition at the boulevard des Italiens has opened its doors and inaugurated its new installation. Undoubtedly, serious material difficulties have prevented the director from calling the members of his society together earlier. Indeed, the timing of this reopening coincides rather unfortunately with the dispatching to the Palais des Champs-Élysées[2] of the works of art destined for the Salon of 1863. The rooms of the boulevard des Italiens therefore show us only a very small number of really recent works which have not previously

[1] [Translated from *L'Artiste*, February 15, 1863]
[2] [Built for the Exposition Universelle of 1855, the Palais des Champs-Élysées was also known as the Palais de l'Industrie.]

been exhibited in the same gallery. We are not at all surprised to rediscover there a sort of branch office of the old official exhibitions, an extension of the Palais de l'Industrie. The artists' abstention, which M. Martinet might be tempted to call a desertion, is all to their credit. The boulevard des Italiens is their sales agency, but at the Champs Élysées they are going to seek their titles of honor, to establish or confirm their reputations before the great public. There could be no indecision for any artist concerned about his dignity. We should also note that none have hesitated, because the painters who are exhibiting at the boulevard have only sent old canvases or those of their works which remained after they withdrew the three best for the Salon. If, as we hope, the Minister of State decides in favor of the return to annual official exhibitions, I strongly fear that the exhibition on the boulevard des Italiens would increasingly see itself reduced to the modest role which it already plays this year, unless it turns into a *salle des débuts* for young artists on whom some hopes can be pinned but whose talent is at this point no more than a promise for the future. Time will reveal whether our premonitions on this subject are correct or not. Until then, let us look through M. Martinet's galleries as curious amateurs of works of art, whatever be their origin or destination.

If in this study we are to follow the chronological order rather than the order of merit, we must stop first in front of the *Coronation of the Emperor Napoléon* by [Jacques] Louis David. One recalls that when the first consul became emperor, he named David "First Painter to the Emperor" and ordered him to execute four great decorative paintings for the throne room: the *Coronation*, the *Distribution of the Eagles*, the *Enthronement in the Cathedral of Notre Dame*, and the *Entry into the Hôtel de Ville*. The artist never even began the last two of these subjects. He only finished the *Coronation* and the *Distribution of the Eagles*, which are in the historical galleries of the Musée de Versailles. The painting exhibited at the boulevard des Italiens is a copy executed, if we are not mistaken, during his exile under the Restoration. Certain detailed parts are better handled than in the original,

but we believe that the effect of the whole is not the same, and that the effect of this work is less successful than that of the original. . . . David is the painter of immobility; we explain ourselves by saying that he has almost succeeded in the grave and imposing scene of the *Coronation*. By the same token, we can understand the stumbling block which he met when he tried to represent a crowd throwing itself towards a single objective. The group of colonels in the *Distribution of the Eagles* seems to have been struck with paralysis in the midst of the most violent gesture. It presents the strange spectacle of extreme agitation without movement. The same fault is found in the *Sabines*, only pushed to its furthest limits. We should note in passing that if one could justly say that in this painting David sought "unity in variety" without achieving Beauty, it is because this famous definition of Beauty is much too elastic. It has the drawback of being precisely applicable to the very antithesis of Beauty, that is to say, to Ugliness, which can unite Unity and Variety as easily as can Beauty. I need no other example of this than the different kinds of animals considered ugly: monkeys or pigs— unified as a breed and varied in their individuality.

The least productions fallen from the hands of Géricault will always excite our curiosity; one searches eagerly there for the secret of his power, a revelation which the works can no longer give us concerning what is still left to come from the young master who painted the most audacious work of modern times, the *Raft of the Medusa*. Here we have only a watercolor, the *Lions*. Great artists have no speciality; all of nature and man belongs to them. And if this thin sheet of paper on which grimaces the monstrous noses of these superb animals were signed by Barye, no one would be astonished.

Who would believe after seeing these three small canvases —*Anne of Austria and Richelieu*, *View of Venice*, and a *Historical Sketch*—with their ease, the grace of their composition, and their knowledge of color, that they are signed by an English name? It is true that this Englishman studied with us, fought in the front ranks of the romantic army, and by rights it is more just for us to claim him as our own than it is for those foreigners who catalog Poussin among the painters of

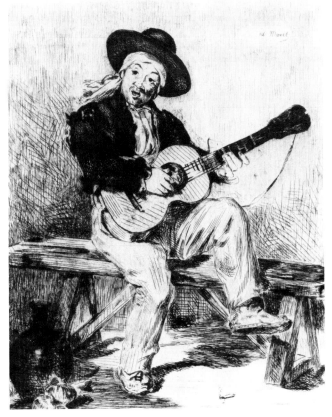

35. Manet: *Spanish Singer* [*Guitar Player*]

36. Baudry: *Charlotte Corday*

37. Millet: *The Gleaners*

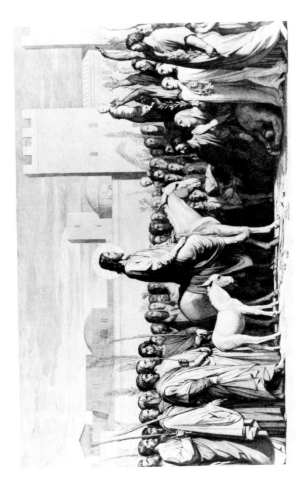

38. Flandrin: *The Entry into Jerusalem*, engraving by J. B. Poncet

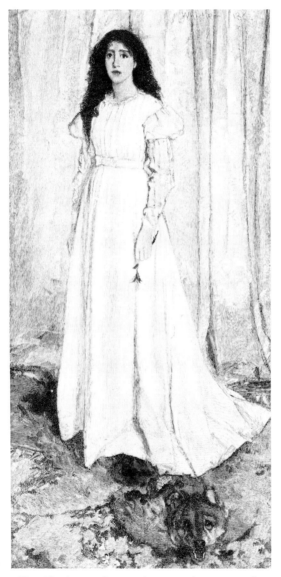

39. Whistler: *Lady in White*, wood engraving by
Timothy Cole (Photo: Courtesy Museum of Fine
Arts, Boston)

40. Préault: *Massacre*

41. Carpeaux: *The Dance*

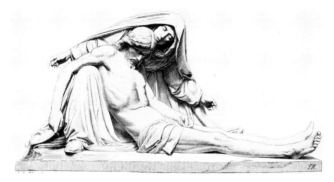

42. Dupré: *Pietà*

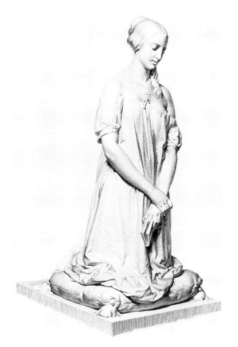

43. Vela: *The Prayer*

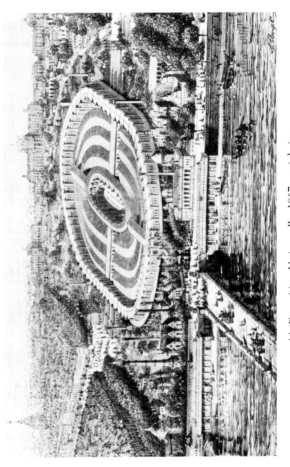

44. Exposition Universelle, 1867, aerial view

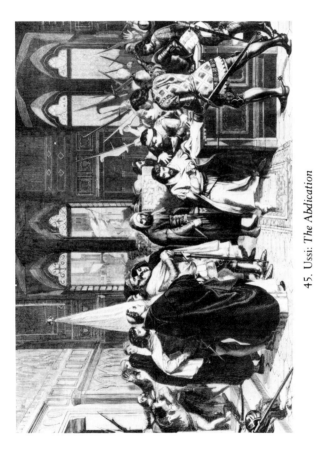

45. Ussi: *The Abdication*

46. Piloty: *Seni Before Wallenstein's Corpse*

47. Leibl: *In the Studio*

48. Lenbach: *Count Adolf von Schack*, etching by W. Hecht

49. Böcklin: *Sea Idyll*

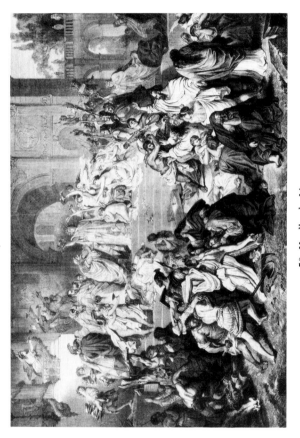

50. Kaulbach: *Nero*

51. Worcester Japanese Porcelain at the Vienna Exhibition

52. Makart: *Cleopatra*

the Italian school. This Englishman is Bonington. He was neither a philosopher nor a moralist, qualities which in France confer the right to an artistic reputation; he was content to be a painter in love with light and elegance, and he painted the way Musset wrote verse, because painting was his most natural means of expression, the means which best responded to his instincts and the one which formulated most exactly his soul and his thought. Although he was very severe with himself and was rarely satisfied, his works show no effort; everything is facile and pleasant, as if it flowed from a spring. This is what Decamps never was even at his best, and it is easy to be convinced of this on the spot, because not far from the Boningtons there are two or three watercolors of the master's best manner. Happy is the owner of all the works that form a part of this gallery, because it would be difficult to make a choice from among Géricault, Bonington, and Decamps as they are represented on the boulevard. If it were necessary to decide absolutely, I think that the *Historical Sketch* would outshine the others. . . .

M. Bonnat is a very young man who several years ago won a second grand prize at the École des Beaux-Arts. Renouncing the competition the next year, he left for Rome and from there brought back an *Adam and Eve Finding the Body of Abel*. This painting was exhibited at the last Salon, where it was very much noticed by some amateurs. A little later he painted a *Martyrdom of St. Andrew* which was exhibited at the boulevard des Italiens. This was a *grande machine* in which, alongside some very fine coloring, there was much coloring in the manner of Jouvenet, startling blues and reds and whites which were—we must say—a little gaudy. Since then I have seen, in a drawing room where it is a great honor for a painter to be represented by his works, two life-size figures of Italian children executed by the same artist in a completely different style. Evidently M. Bonnat is still seeking his way. It would be very pretentious to say of a beginner that he already had several styles, but one can note that he has tried three different paths: first of all, classical or academic; then romantic to excess in his *Martyrdom*; finally, he seems to have adopted another, almost sentimental, vein, and his

works are reminiscent of those of M. Hébert. They are more cheerful, however. I take the time for this short history of M. Bonnat's talent because he has constantly progressed. Thus, in his new canvas, *The Frolic*, while maintaining his very particular feeling for color, he has managed to properly paint the head of a child; this is praise which could not have been addressed to him only two years ago.

After M. Bonnat, the exhibition of the boulevard reveals to us the talents of another newcomer, M. Manet. Until now his works have raised more criticism than sympathy. However, I must state that certain youthful audacities do not repel me at all, and that although I willingly recognize all that M. Manet still lacks to justify such boldness, I am not at all unhopeful that we will see him conquer his ignorance and become a pedigreed painter.

In my eyes he has one great quality: He is not at all banal and he does not drag along in the rut where he will obtain easy merit and vulgar success. I will say nothing more today about M. Manet, but will return to him at leisure if there is occasion. I only wanted, by naming him, to mark a date for him and his efforts. Finally, I would add that alongside his numerous figures in which there is too much to find fault with from the point of view of drawing, he has presented one which is very good and has a very unusual sense of color and sincerity, *The Boy with a Sword*.

We now regain the familiar tendency of our school.

The Convent, the *Closed Door* of M. Bouvin, who paints heavily but with an excellent taste of reality, small interior scenes in the manner of Chardin.

The *Return from the Ball*, in which M. Tassaert's pale colors seem to me to have regained some youth.

The beautiful ethnographic studies of M. Valerio, and among his etchings some good watercolors, copies after Flemish masters.

The *Singers*, the *Bohemians* of M. Ribot, a talented young painter whose only mistake is to make too much use of "kitchen models" . . .

Then our strong landscape school; a drawing by M. Bellet du Poisat in which all the harshness of the Provençal sun is

vigorously depicted; A *Stop in the Desert* by M. Bechère; a *Gust of Wind* across a desolated landscape, a study superior to everything I have seen by M. Breton—undoubtedly because he has not introduced into it his usual personages, those noble, false peasants and his shimmering lights; the romantic pages of M. Corot, not very truthful but so dreamy and with such true feeling that they produce the illusion of reality; a *Mouth of a River* by M. Herst, beautiful large waters, agitating their thousands of small pointed waves in the rosy gleam of the rising sun; the drawings of M. Saint-François, patiently worked and broad; a landscape by M. Vernier, as powerful and firm as those of M. Courbet, although heavier; and numerous studies by M. Courbet himself in which he has surpassed himself; I will mention as especially valuable *Trees and Rocks*, the *Bank of the River*, and the *Forest*.

There is little sculpture at the boulevard des Italiens. Eight romantic medallions of M. Préault, a master who has let himself be too forgotten, and whom we would like to see again at the official exhibitions, M. Mine's animals, finely handled; and a handsome bust by M. Cordier. But I have not rediscovered the talent of M. Carrier-Belleuse. We have known this talent, gifted with precious qualities of color, warmth, and life. But this lively portraitist has made a mistake this time. The other day M. Théophile Gautier was there, in the rooms of the boulevard, and those who were familiar with his beautiful head—with its features, both broad and fine, like those of an antique Jupiter—could they recognize him in this bust which is only a shadow of him? A friend of the famous writer said familiarly, "It almost looks like Theo." And this rigid immobile head, almost cast on the body, is that M. Charles Blanc? And this other, is that M. Daumier? Yet M. Carrier-Belleuse has great gifts. Please, be yourself again and bring back your earlier talent.

In sum, the exhibition at the boulevard des Italiens, if not the prologue to the salon as it was intended to be, is nonetheless interesting, and amateurs of modern art willingly visit it. It is a small center of good company where one comes to talk freely about art, where all tendencies can be shown, where

they are welcomed and discussed, that is to say, acknowl-
edged and baptised. That is the main thing.

I have just at this moment, while finishing this chronicle,
learned that M. le Comte Walewski favors more and more
the reestablishment of annual Salons. The day when this
measure becomes an official government act will be gratefully
acclaimed by all artists. They have suffered, indeed, by the
long intervals that have separated the exhibitions for several
years. Illness, an accident, a refusal by the jury can deprive
them for four years, if not longer, of the publicity which is
the very condition of artistic progress by the emulation which
it provokes. And I am not considering their natural interest,
which depends absolutely on the reputation which they can
acquire only by this same publicity. It is far from the legiti-
mate protection of these interests to the establishment of a
"boutique for mediocre art, a bazaar for the dry fruits of
painting and sculpture. . . ."

Jules Castagnary: *The Salon of 1863*[1]

The Three Contemporary Schools

If time permits and you feel like it today, we are going to
bend our steps toward the Champs Élysées and follow the
crowd that presses around the entrances to the Palais de
l'Industrie. Like the moving and colorful crowd, the Salon to
which I have the honor of introducing you is tumultuous and
diverse. It is not quite like a museum—silence and quiet are
missing—nor is it a studio, because of its dimension and its
crowding.

Is it a bazaar, as some have said? Yes, in the diversity of its
products; no, in the financial results. The great fairs of
France often leave more money in the register of a single
merchant than a whole Salon leaves in the collective pocket
of all the artists. It is therefore a simple exhibition, but an ex-

[1] [Translated from Castagnary, *Salons, 1857–1870*, vol. I (Paris,
1892). Originally published in *Le Nord* (Brussels), May 14, 19, and
27; June 4, August 1 and 15; and September 12, 1863. Another
account of the Salon of 1863 appeared with Castagnary's signature
in the *Courrier du Dimanche*.]

hibition of special merchandise; extremely interesting, finally, because it is not a question of money but of fame and glory for those who have placed the merchandise before our eyes.

I only wish to be a *cicerone* for you, a guide fond enough of the things he is showing to exhibit them in their smallest detail, but not such a fanatic as to declare them superior to everything of the sort that you have already seen. I will lead you slowly through these vast, well-lighted and airy halls, before all the major works—or at least the principal ones, great and small. I will explain the works and the artists in my own way, telling you their origins and their backgrounds, showing you the good and the bad products, telling you the points on which you should base your judgment so that you will place it, if my hope is fulfilled, in agreement with my own. This is a delicate matter, as you know. The most skillful and most conscientious sometimes go strangely astray.

How could it be otherwise? Everyone brings to the examination of works of art his personal background, his sometimes arbitrary preferences. No one is completely impartial—or at least I do not know anyone who is. For "a critic" necessarily means "a man with theories." To criticize, is it not to judge, to determine, to classify, to establish ranks, a hierarchy? Depending on your conception of art, of its means and its aim, you are inclined to pardon this one, to condemn that one. Are you wrong? Are you right? Who dares to say? Those who start from the same premises as you will agree with you; the others will argue with you and say that you understand nothing.

It is therefore essential, if not to agree on the point of departure—which might involve a considerable detour—at least to present one's premise frankly, so that all are well aware of it, and there is consequently no ground for surprises or misunderstandings. I am going to explain my own in the clearest terms I can. The matter is abstruse because we are touching on the very philosophy of art, but I will be quick. Whether you accept or reject my point of view, it will be useless to tell me so and to try to convert me. You can understand that one does not change one's system in a day. If we sometimes disagree in our appreciation of an individual artist,

you will have the key to our differences, and you will not be angry with me for not thinking as you do.

What is the object of painting?

"To express the *Ideal*, depict the Beautiful," cries a chorus of enthusiasts.

Hollow words!

The Ideal is not a revelation from on high, set before a striving humanity whose duty is always to approach it without ever attaining it. The Ideal is the freely conceived product of each person's consciousness placed in contrast with external realities and, in consequence, an individual conception that varies from artist to artist.

Beauty is not a reality existing outside man, imposing itself on the mind in the form or the aspect of objects. Beauty is an abstract word, an abbreviation under whose label we group a crowd of different phenomena that act in a certain manner upon our organs and our intelligence; thus, it is an individual or collective concept that varies, from society to society, from age to age and, within one age, from man to man.

Let us come down to earth, where truth lies.

The object of painting is to express, according to the nature of the means at its disposal, the society that produces it. It is thus that a mind freed from the prejudice of education should conceive it. It is thus that the great masters of all times have understood and practiced it. Society, actually, is a moral being which has no direct knowledge of itself, and which, to become conscious of its reality, needs to externalize itself, as the philosophers would say, to exercise its faculties and to see itself in the sum of the products of these faculties. Each epoch knows itself only through the actions it produces: political actions, literary actions, scientific actions, industrial actions, artistic actions—all of which are marked with the stamp of its particular genius, bear the imprint of its particular character and simultaneously distinguish it from the preceding epoch and the epoch that is to follow. Consequently, painting is not an abstract conception lifted above history, a stranger to human vicissitudes, to revolutions in thought and custom. It is a part of the social consciousness, a fragment of the mirror in which generations contemplate

themselves in turn. As such, painting should accompany society step by step and mark its incessant transformations. Who would dare to say—assuming for all mankind that every civilization and each epoch within every civilization has placed its image on canvas and revealed in passing the secret of its genius—that we would not have for the entire extension of time all the successive aspects that humanity presents to art, and that the destiny of painting would not be fulfilled?

Having made this first point concerning the aim of painting, I must ask, "Where are we, in France, at the present time, as far as its realization is concerned?"

Here—I should not hide it—I am in almost complete disagreement with my best friends and brother critics. Where they shout decadence, I affirm progress for the same reasons. It is therefore necessary that my pen should not falter and that I should clearly develop my idea.

However radical and profound the differences that separate our artists, however complete the antagonism in their theories and their manners, however vigorous, in a word, that precious individuality which they want made plain today and which is so dear to them, one can, without doing great violence to temperaments and tendencies, divide all painters into three principal groups: the classicists, the romanticists, and the naturalists.

The classicists, from [Jacques] Louis David, their Saint John the Baptist, to Ingres, their Messiah—supported on the left by the École des Beaux-Arts and on the right by the School in Rome, having in addition the protection of those in power, the rewards and the commissions—do not appear, in spite of the repeated warnings of public opinion, ready to give up and abandon their country.

The romanticists—their ranks thinned by death, abandoned by the literature that once carried them so high and is now devoted to other glorifications, discouraged by the general defection of supporters, shaken in self-esteem—have turned silent and are already dreaming of the capitulation which could remove them, bag and baggage, from a place they are no longer able to defend.

The naturalists, young, ardent, convinced, heeding neither

blows given nor received, mount the assault on all sides; and already their foolhardy heads are appearing at all the summits of art. Thus, two schools menaced, one school invading; this is the situation in the area we are going to inspect. In the Salon of this year, the three flags are still flying. Let us salute the past and the future in them and, before proceeding to enumerate their forces, let us examine a little the characteristics which differentiate each army.

The classical school, the romantic school, the naturalistic school—all three are in agreement on the point of departure: Nature is the basis of art.

Only the classical school asserts that nature should be corrected by means of the methods furnished by antiquity or by the masterpieces of the Renaissance. Reality troubles it or makes it afraid. Under the pretext of purifying it, of idealizing it, the classical school attenuates or deforms reality; it is always a weakening, even when it is not purely conventional.

The romantic school affirms that art is free, that nature should be interpreted freely by a liberated artist. It is not afraid of reality, but escapes it by disguising it according to the whims of imagination; it is always an approximation, if not always somnambulism.

The naturalist school affirms that art is the expression of life in all its forms and on all its levels, and that its sole aim is to reproduce nature by carrying it to its maximum power and intensity: It is truth in balance with science.

Such are the tendencies, such the results. The classical school, with its high ideals, its fastidious choice of models, its constant search for noble drawing, has preserved in pure form the dignity of art in France. But by imposing preconceived attitudes and traditional forms on groups and on combinations of groups that the exterior world presents, and by neglecting color, which, of all the elements of painting, gives the most lively sensation of life, it has suppressed the artist's spontaneity, petrified imagination, injured naïveté and grace (those two wings of genius), created immobility and coldness in all its productions and, finally, has ended in the negation of even its principal and its aim.

The romantic school, with its unthinking individualism, its

exclusive preoccupation with color, its optical disorders, its repeated incursions into the literary domain, has thrown art off its course and led it to disorder and anarchy. By worshiping accessories, furnishings, arms, costumes, antiques and bric-a-brac, and by making the figure subordinate to the picturesque effect, it has created a class of superficial, turbulent amateurs whose baneful influence is not yet exhausted, and has opened the door to the most shameful commercialism. To it, in the final assessment, we must attribute the principal causes for the debasement of painting during the past twenty years.

The naturalist school reestablished the broken relationship between man and nature. Through its double approach—to the life in the fields, which it already interprets with so much aggressive power, and to the life of the cities, in which its highest triumphs are yet to come—it tends to embrace all the forms of the visible world. Already it has returned line and color, which are no longer separated, to their true roles. By placing the artist at the center of his epoch with the mission to reflect it, the naturalist school determines the true utility and, in consequence, the true morality of art. These few words are sufficient for us to have confidence in its destiny. What, up to the present, neither the artistic eccentricity of the Valois, nor the refined tastes of the Medici, nor the ostentatious aspirations of Louis XIV, nor the heavyhanded protection of monolithic powers could give us, only the development of liberty, only the awakening of decentralizing instincts will produce among us.

For the first time in three centuries, French society is in the process of giving birth to a French painting that is created in its own image and not in the image of forgotten peoples; that describes its own aspects and customs and not the aspects and customs of vanished civilizations; that, at last, carries the mark of its own luminous grace, its lucid, logical, and penetrating spirit on all its faces.

May posterity find it, in several hundred years, the equal of Spanish painting, so fierce and so energetic; Dutch painting, so intimate and so familiar; Italian painting, the purest, the

most harmonious, the most glorious that has ever flourished beneath a beautiful sky!

The Classical School

I. The classical school has as its banner and its motto *tradition,* which means that, indifferent to the ideas and the customs of the age, it perceives living nature only through the formulas of the past, and can only conceive it interpreted, modified, and corrected according to the supposedly final results obtained by ancient art.

The models of the classical school were originally the best specimens of Greek sculpture; its means of translation, drawing; its preferred themes, scenes from history and mythology. But the rigor of this teaching, imposed by [Jacques] Louis David, was soon forced to give way under the pressure of a progressive society whose every instinct runs against the idea of immobility. Less than forty years after the *Oath of the Horatii,* the classical school was already tending to enlarge the narrow circle in which it had moved, and as a beginning, modified its theory and practice by enlarging them.

Ingres was the Luther of this reform, H. Flandrin its Melanchthon.[2] To the imitation of Greek sculpture Ingres added the imitation of cameos and engraved stones; above all, he recommended the study of the Roman school and its fortunate founder, Raphael Sanzio, called the Divine, thus joining, with an arbitrariness that ignorant painters did not perceive, two methods of interpretation as different from each other as the two civilizations that had produced them. H. Flandrin completed the doctrine by placing all of Raphael's predecessors—from Giotto to Ghirlandajo, including Masaccio and Filippino Lippi—among the ranks of masters to be consulted, *corpus juris picturalis.*

As far as the latecomers, the bastards of the Villa Medici,[3] are concerned, squeezed between the necessity of continuing the tradition they were taught and that of satisfying the

[2] [Philipp Melanchthon (1497–1560) was the follower and collaborator of Martin Luther.]

[3] [The Villa Medici was secured in 1801 by Napoléon I to house the French Academy in Rome.]

changing taste of the public, through weakness or through the love of money they have abandoned the violent opinions of their two forerunners. Tossed between School and Fashion, wandering through Italian memories or made impotent by present aspirations, they are lost in the uncertainty of a vague eclecticism, without direction, without a goal, and without influence.

Let us trace the steps of the lamentable degeneration.

II. In the absence of Jean Auguste Dominique Ingres, king of the pale regions of classical art, it is Jean-Hippolyte Flandrin who commands.

For all who, in France or elsewhere, place the classical school in first place, Ingres is the foremost master, Flandrin the second.

From king to viceroy, politeness is obligatory: Ingres willingly says of Flandrin, his pupil, that he is "his best work."

In truth, Flandrin alone among the numerous disciples of the master of Montauban[4] has been able to make the doctrine yield its essential contents; a skillfully conceived form, a considered composition, an archaic saviour.

H. Flandrin has a calm temperament, a methodical and reflective spirit. From the beginning, his serene intelligence placed him above the turmoils of passion. But if he has never been subjected to its vagaries, neither has he ever possessed its vigorous accents. Cold, elegant, discrete, he hovers equally distant from reality and from the ideal, in that happy world of knowledge, order, and good taste where distinguished men who are merely distinguished have met since time immemorial.

H. Flandrin does not see the outside world; he sees within himself, through the memories or impressions of his artistic education. What he places on canvas—his colors, forms, and arrangements—are things conceived in imagination or carried in his memory, never things looked at, observed, or alive in nature. The exterior world could be suppressed, yet he would still paint, and he would paint neither better nor worse. He

4 [Montauban was Ingres's birthplace.]

does do portraits, but if he asks for a model it is purely out of politeness, to make us think that he will concern himself with a likeness. We will return later to his portraits, particularly that of the Emperor Napoléon III, his great work this year. Let us first say a word about the things that have made him particularly famous, his mural paintings.

Flandrin is considered France's great religious painter today. He decorated Saint-Vincent-de-Paul; he is finishing Saint-Germain-des-Prés; he will soon begin Strasbourg. If he had Briareus' hundred arms[5] he would be commissioned to do all our churches.

The painter's first attempt in this difficult category (the Church of Saint-Séverin in Paris) drew little attention. He had not yet clearly seized upon that ideal which consists in translating religious sentiment by the suppression of modeling, flatness of colors, rigidity of contour, and immobility of gesture—a method that has won him such success that we seem unable to conceive of any other for the interior of our cathedrals. This manner developed itself more obviously in the great frieze of Saint-Vincent-de-Paul, and later in the central nave of Saint-Germain-des-Prés.

These two decorations, whose system is controversial at the very least, established Flandrin's reputation as a religious painter in the highest sense of the word. Orsel and Périn, the decorators of Notre-Dame-de-Lorette, were forgotten in his favor; and in this special sector of art in which they had shone an exceptional and honorable place was made for him, a newcomer.

This is not, however, because Flandrin, more than any other, has preserved that living faith that animated the Byzantine painters and still inspired, even though already belatedly, Fra Angelico, the monk of Florence. I have not heard that, in our skeptical day, painters have retained the habit of kneeling as they take their palettes and consecrating to the Lord the work that will come from their hands. But Flandrin, more than any other, and precisely thanks to the teachings of Ingres, his master, has remembered that his best resource in this world consists of remembering.

[5] [According to Greek mythology, Briareus was a sea giant with one hundred arms. See illus. 38]

Italy, where he lived after winning the Prix de Rome, was for him a revelation—how can I best express it?—the personification of art itself. The whole world disappeared for him; all that remained before his eyes was Italian painting. Everything that it had produced, from Cimabue to Giulio Romano, he saw, he examined, compared, studying here the ingenious and awkward grace of childhood, there the generous and skillful drawing of maturity. He stored in his sketchbooks the grave forms and the noble attitudes with which the Italian artist had presented the Italian race, whose harmonious aspect, if somewhat redundant, must be recognized.

On leaving, he carried Italy with him, not on his shoes but under the brim of his hat. So deep was the impression that everywhere he has since gone and studied he has been unable to perceive nature and life except through an Italian veil, with Italian contours and expressions. Italian forms have invaded his spirit so much that his personality has melted into them. He sees Italian, he thinks Italian, he paints Italian. It is not he who possesses tradition, it is tradition which possesses him.

In all that he has done, his dream seems to have been only to create, here in France, an art that buries the French character under the synthetic character of the Roman school, a pictorial résumé of Italy; and in order to do this [he has had] to unite the deep feelings of the primitive masters with the slightly grandiose methods of the sixteenth-century masters.

Perhaps a true Christian, a Christian who has slaked his thirst at pure, mystical springs, would find something else to say about this arbitrary confusion whose least fault is the simultaneous weakening of the naïveté of some and the science of others; in other words, to compromise, with one blow, feeling and form. I, whose theology is content with little, will limit myself to reproaching the painter for his weak coloring, his flat modeling, and his drawing, which is too often reduced to a simple silhouette.

Having pointed out these faults, I will restrain myself from condemning the rest. I will admit that Flandrin, to our unbelieving eyes, has sufficiently caught the intimate sense of Catholic legend. He has successfully wrought the miracle of making a dead art live again for a moment. That which was

once spontaneously created he has reconstituted through pa-
tience and erudition—a remarkable effort that speaks for the
determination and, if you wish, the intelligence of the man,
but which will do nothing to prolong a category that has long
been condemned, and justly so.

The religious painting of H. Flandrin explains his portrait
painting. In both categories there is the same spirit of at-
tenuation in the depiction of life, the same discretion of the
brush in the vigor of the modeling. But what is under-
standable in the painting of saints dead these eighteen hun-
dred years is less acceptable when it depicts persons now
living. . . .

III. Leaving Hippolyte Flandrin, we descend from the peaks
to the plains of classical art, where the ordinary students of
the School of Rome do battle. We will therefore simplify our
analysis and shorten our judgments.

Three pictures of Venus Emerging from the Sea contend
for the golden apple and seem to call for a Paris to judge. At
first glance I feel little inclined to play the role. However, the
public presses toward these canvases, which are one of the
Salon's highlights. We must follow and take part in what in-
terests them.

Paul Baudry's Venus, which he has titled, I know not why,
The Pearl and the Wave, a Persian Fable, has just been
deposited on the beach by a blue wave which is already gath-
ering itself and opening as if to take her back. As far as I am
concerned, it would do no harm for her to be carried back
out to sea. The young lady is vigorous and well-muscled: She
should know how to swim. Presented as she is, her back to-
ward us, lying on her left hip, her arms lifted around a lasciv-
ious face, she makes me think of a boudoir Venus.

I like the damp look of the canvas, the grasses, the shells,
the dripping roughness of the shore. Perhaps also the line of
the body—not wanting in amplitude—that runs from the
shoulder to the knee and stands out against the waves. But
how much better this pretty woman with her air of a Pari-
sienne modiste would be on a sofa! She who lives so comfort-
ably in her rich apartment on the Chaussée d'Antin must feel

very ill at ease on these hard rocks, near those sharp pebbles and those prickly shells.

But think a minute: What is she doing here at this hour, alone, rolling her enamel eyes and twisting her coquettish hands? Is she laying a trap for a millionnaire wandering in this savage place? Will she no longer be the Venus of boudoirs but the Venus of sea bathing? Venus of *bains de mer* or boudoir Venus, her torso is badly modeled, her tibia too short, and her hair thin. But she is a pretty color, fresh, moist. She is the best painted of the three Venuses.

Carried on the languid breast of the sea, lying in a harmonious pose, one leg buoyant, the other folded beneath her, an arm thrown over her face, half hiding it, accompanied by a group of cupids who fly above her blowing on conch shells: This is the way Alexandre Cabanel's Venus [*The Birth of Venus*] presents herself, advancing slowly on the crest of the wave which carries her. Her long blond hair spreads itself in the water. The waves foam around her body. From the depths of the canvas, the procession comes toward us. We feel that the young goddess is looking forward to the moment when, setting foot on the shore, she will rise and reveal herself to men in her dazzling, immaculate, naked beauty.

Alexandre Cabanel is not a painter. He is ignorant of color and its profound charm, its power and its triumphs, but he is a skillful draftsman. All the skill that he possesses has been spread in profusion. All the effect that it is possible to gain from pure and skillfully constructed contours, from cunningly balanced lines, from well-contrasted movements, he has placed in his work. His Venus is the best drawn of the three; and if drawing without color is worth something, he should take the prize from his rivals.

Amaury-Duval's Venus is shown standing in the attitude in which Alfred de Musset described her at the beginning of *Rolla:*

> *Virgin still, she shakes off her mother's tears*
> *And impregnates the world by wringing out her hair.*

It is the traditional pose and method of painting. In spite of some good bits of drawing, the body of the goddess ap-

pears too long, stretched at top and bottom, too violently arched in the middle. For the rest, there is no accent, no new feeling.

In the classical school, where nature has a bad reputation, where truth is dismissed and reality never supports the painter's interpretation, when by chance drawing and color are both lacking, there is nothing left. This is the case with Amaury-Duval's Venus. . . .

IV. When speaking about Bouguereau it is impossible not to speak about drawing. For if Baudry is the Titian of the School of Rome, Bouguereau is its Raphael. The way one seems to have idealized color the other has idealized form: to each his domain.

But what a distance there is between the little ragouts of Baudry and the feasts of the Cadore's great painter! What a distance there is between Bouguereau's purring design and the harmonious lines of the elegant master of Urbino!

A *Holy Family* for a sacristy, an *Orestes* from the fifth act, a reclining *Bacchante* playing with a buck, those are the various paintings Bouguereau sends. If absolutely forced to choose among these three pictures, I would prefer the *Bacchante* as the most natural and prettily composed. But how can this draftsmanship, which has been so praised, satisfy a purist? I see the head of a young boy on a girl's body; I observe that the right femur is too short, that the left femur is broken in the middle, and that the two halves try in vain to meet. A banal conception, incorrect drawing, indifferent color: useless art.

Bouguereau is a wise spirit, a hardworking artist, whose patience and application have developed those honest and temperate qualities that always disarm bitter critics. He has cultivated, in turn, religious painting (*The Martyr's Triumph*, 1855) and official painting (*The Burning of Tarascon*, 1857). Along the way he has found some idylls within the reach of girls' boarding schools (*Fraternal Love, The Return from the Fields*). At least he sighed for the greater affliction of bereaved families, the plaintive elegy of *All Soul's Day*, which has moistened more than one bourgeois handkerchief.

All these works of praiseworthy intention have earned him, like his young compatriots in the School of Rome, the first medal and the cross of honor: Rewards on earth to men of good will. . . .

V. Now I come to the two truly important men in this series: Louis Duveau, who is often forgotten, and [Pierre] Puvis de Chavannes, who is too often spoken about. . . .

Puvis de Chavannes does not seem to me to have been in luck this year. Why did he imagine that his decorative paintings of the last salon needed a complement? And how do *Work* and *Repose* complement *Peace* and *War*? Do not *Peace* and *War* form the contradiction whose resolution is "Justice"? If he therefore wished to complement his idea, the complement could only be a picture of "Justice." But this picture is so difficult and so complex that I do not advise the painter to attempt it yet.

Therefore *Work* and *Repose* do not terminate, as Puvis de Chavannes pretends, his decorative work of 1861. They are two separate and distinct motifs, the continuation in the same abstract category, if you wish, but not the complement, that is to say, the synthesis. When one wishes to be philosophical in painting, one must do it correctly. . . .

I quarrel with Puvis de Chavannes' conception. It is not my fault. Puvis de Chavannes presents himself as a thinker. He does not wish to be in debt to color; his muddy drizzles are sad and repulsive-looking. He does not wish to owe very much to drawing: for one well-executed female torso there is a hunchbacked woodcutter, a crippled blacksmith, and two oxen, lacking eyes and horns, that vaguely resemble blocks of stone. He asked nothing of nature, of the living model: His characters are imaginary, without racial characteristics, without individual types; his landscapes are timeless, without climate, without light.

Is this really painting? Fresco has been mentioned. Luckily, light and luminous frescoes have nothing in common with the gray and dirty tones of these canvases, which resemble washed-out tapestries; luckily, also, frescoes never thought of transporting their scene into the ideal world to

avoid the control of nature. Puvis de Chavannes is on a wrong road. He devotes himself to a gigantic work with little value: The little painting there is on his canvases harms their effect. If he really wishes to attempt fresco, and if he knows how to draw, why does he not limit himself to making cartoons!

The Romantic School

I will be wary of developments with regard to this famous school, whose decadence so quickly follows its triumph. Everyone knows the resistance that it encountered at its origin, the battles that it fought, its rapid ascension and radiant explosion—more than I could say in this magazine.[6]

I will limit myself to stating in principle, unless I happen to demonstrate it elsewhere later, that the romantic revolution, excellent in literature, where it was meant to develop the imagination of all by fostering individual liberty, became unacceptable as soon as it tried to impose itself on painting, since imagination in painting is subordinate to science and the faculty of observation.

Before romanticism, in all countries in which art developed spontaneously painting had its domain, its own field of observation. Painting was inspired directly by life, and it translated by the means available to it the things that life brought it to represent. Between painting and nature, between the interpreter and the model there was no intermediary. In this way society (with its multiple forms, types, physiognomies, and customs) and the country (with its mobile forms, lines, shadows, and highlights) were translated, expressed, and depicted in their true light, tó the extent that they could be by a relatively limited art and with the degree of perfection inherent in the very development of this art. It is thus that Italy, Spain, and Holland find themselves in the succession of schools of painting which they have produced and which reflect each of these countries exactly. It is thus also that France distinctly perceives her image in the works of the Janets, Callots, Watteaus, Chardins, Le Nains, and a part in those of David and Gros.

[6] [See *Triumph*, pp. 238–44]

The romantic revolution found this bad and changed it—in one day, an unprecedented feat! Painting lost its independence, its autonomy, as one says nowadays. In a misguided moment that will be judged more severely later, it became the servant of literature. From the sovereign it had been it became a vassal. The painter no longer places himself, as in the past, before Nature to receive his impression directly from her; he reads books. He is no longer the creator of his own ideas; he is the translator of the ideas of others. He asks epics, novels, dramas, ballads, elegies, and odes to furnish the subjects of his composition. Mistaking the essential characteristics of the poetry suited to his art, he borrows from the poets of the *word*, the conceptions that they have dreamed, the types that they have found, the scenes that they have described, and limits his ambition to reproducing them as a picture on canvas. At this time Shakespeare, Byron, Goethe, Schiller, Chateaubriand, Victor Hugo, and Lamartine were in every hand. Except for one or two names, it was an overflowing of literature without discipline. Thirsting for the infinite, hungering for the ideal, the songs of these troubling dreamers lulled souls and reopened their inner wounds in an endless repetition of the pages on which had been spread reverie, doubt, sadness, or bitterness. Painting began to wail with them. The few healthy spirits who, through shyness or pride, remained apart could watch the long procession of Fausts, Marguerites, Mignons, Hamlets, Don Juans, Francesca da Riminis, Romeos—all the imaginary victims of unrequited love or incurable melancholy—file by.

Thus the painter abdicated his marvelous privilege of inventor and poet to become the universal illustrator of romantic literature.

This evil gripped us for a long time. Today, thank God, we are cured of it. At the present hour the romantic school is dissolving. Its principal leaders—Bonington, Marilhat, Roqueplan, Delaroche, Chassériau, Ary Scheffer, Decamps, Vernet—are dead; the others—Eugène Delacroix, Robert-Fleury, Couture, Meissonier—fall silent. The rank and file, suppressed by the rising tide of new ideas, only waits, hesitant or dis-

couraged, for a favorable moment to desert their flag and go over to the enemy.

But if the school played a transitory role, its moral influence has endured; if the school's great men have disappeared or fallen silent, their followers are still active: detestable influence, horrible hangers-on, a rain of sulphur and toads after a great storm.

A whole volume would be necessary to characterize the moral influence in its smallest details. The imitation of all schools and the substitution of cosmopolitanism for French thought; the introduction in art, of the picturesque which serves to mask an ignorance of drawing, of archaeological research, and of bric-a-bracs that are striking in the unusualness of their accessories; the love of anecdote, which catches interest by itself without the aid of craftsmanship; a total ignorance of contemporary society, which has remained unnoticed by art for twenty years; futility on one side and wandering on the other; to top it all off, the cult of the gold piece; disdain for artistic dignity; finally, a general lowering of the intellectual level—those would be the unhappy chapter titles of a book to be written.

I pass over those and better ones.

One does not mistake the very essence and the direction of art with impunity; it is not with impunity that instead of seeing in it a spiritual function which has humanitarian perfection as its end effect, one sees in it only an industry invented to tickle the curiosity of collectors and sharpen the fluency of dilettantes. . . .

The Naturalist School[7]

In this rapid review I am trying less to determine the true value of painters than to give an exact idea of the forces at work in the art of our day.

[7] [French critics disagreed about what label to attach to the works of Courbet and Millet. Champfleury and Courbet himself used "realism" (see p. 159, Paris, 1855). The Goncourts used "materialism" (see p. 134, Paris, 1855); Castagnary had avoided the word "realism" when he wrote in 1857 (see pp. 199–202); the word "naturalism," which he adopted in 1863, had first been used by Delécluze in 1850–51 (see p. 14).]

In proceeding thusly, I do not believe I have shirked the duty of a critic, which consists above all in telling us about men and their works. I am among those who believe that one cannot fully understand the details without a vision of the whole of which they form a part. We know the soldier by his flag, the artist by his school.

But until now I have been concerned with two schools that had attained and even passed maturity. Consequently, it was easy to determine their point of departure and trace their development. The school with which I am now going to concern myself has hardly been born. Many deny its existence; few have seen it. What sure diagnostic procedure will I use to root out the secret of its being? Go and search for the man in the unformed embryo! Deduce a whole revolution from the dull muttering that growls in the throats of an angry people!

It is, however, a revolution, the movement which we now see taking place and which already is gathering our scattered generation from everywhere and giving them a unique direction. Twenty years ago no one would have expected its existence; visible today, it is startlingly obvious to a philosopher. While still young, even before having taken breath, it was persecuted; later, probably so that nothing that ensures success might be lacking in its destiny, it found mockery and insult. It passed through this painful period, escaping both the snares of its enemies and the follies of its friends. Today it exists. Still unconcerned with the formulas that will one day sum up and fix its doctrine, it exhibits itself in all places, sometimes with unsuccessful attempts and sometimes there with shining triumphs. . . .

Where does it come from? It is born from the depths of modern rationalism. It springs from our philosophy, which, by again placing man within the society from which the psychologists had extracted him, has made social life the principal object of our future research. It springs from our morality, which, by substituting the imperative notion of justice for the imprecise law of love, has established the relationships among men and thrown new light on the problem of destiny. It springs from our politics, which, by taking for a principle the equality of individuals and the equality of conditions as a

desideratum, has banished from the mind false hierarchies and lying distinctions. It springs from all that is within us, from all that makes us think, move, and act. *In illa movemur, vivimus et sumus.*

But if you wish more detailed origins, more visible sources, they must be sought in literature, for twice in our century it has been literature's destiny to give the fine arts their direction and open the way for them. . . .

For spirits tired of waiting and restless with indefinable presentiments, it must have been a joyous surprise when Balzac, taking up the thought of Stendhal, who had already rejected conventional heroes and romantic complications, took for the entire subject of his work the acts and the gestures of everyday life; fashioned the principal characters that surrounded him into powerful archetypes; colored the whole of his creation with the very reflection of the manners and the ideas of his time; who, finally, in *La Comédie Humaine* lifted real life to the dramatic heights and the moving grandeur of history.

By this double stroke of genius, nature and the everyday life of France was suddenly elevated to the height of art. The two novelists had, without realizing it, determined the new character and even the object of modern painting. They pointed out the path; it was necessary only to follow it.

I realize that I am transposing dates and suppressing distances. But my only intention is to group similar acts, to bring together the effects and their causes. If I give the impression of passing over the English influence, which accelerated the bloom of landscape painting in France, it is not because I deny the influence of Constable,[8] for example, on the artists of the Restoration, but because I am convinced there would have been no lasting consequences if literature, taking the same turn, had not maintained and confirmed it.

Thus the breach was opened. The new field was given. Nature and human life became objects of study; respect for the visible world and observation replaced all principles and all methods.

[8] [On Constable, see *Triumph,* pp. 240–41, 256–59, and 270–71.]

From every side people pressed forward toward the newly opened horizons.

First there was the great army of the landscapists: Flers, Cabat, Paul Huet, Jules Dupré, Théodore Rousseau, Corot, Français, Diaz; later Daubigny, Rosa Bonheur, Troyon; then the battalion of the young—Hanoteau, Blin, Nazon, Lavieille, Harpignies, Chintreuil, and so forth.

In the beginning, the literary tendencies then dominant in great painting made themselves felt in the humble landscapists. Paul Huet, for example, is a romantic, as is Delacroix himself. The new movement is so weak, so uncertain that the artist cannot escape that fatal influence. It follows him into the fields in which he does his studies, in spite of himself, and forces its way into his work. But with romanticism weakened on all sides and a feeling for the real on the increase, this influence disappeared even before the first mutterings of 1848's approach could be heard and the peasant from Berry, with his big hat, his blue smock, and his noisy nailed sabots, had come upon the scene.

I would have preferred not to speak of Courbet, because Courbet was represented in the Salon by only two inferior sketches and his principal work, *The Return from the Conference*, has not yet been seen by the public.[9] But how can we neglect, in a review of French painting, the man who today seems to sum up its only remaining strength? How can I omit from this gallery of naturalists that I am sketching the bust of the man who, reacting against the tendencies of romanticism, truly determined the new movement?

I will speak of Courbet with all the more relish because, whatever one says or thinks of him, he remains—through the incontestable vigor of his temperament, the excellence of his technique, and even the selectivity of his theory—one of the most original characters of this century.

Courbet is the foremost socialist painter. His entire personality can be found in each of his works. The liberty of his

9 [*The Return from the Conference*, destroyed by its owner in the 1870s, was rejected by the Salon and excluded from the Salon des Refusés. Courbet then exhibited it in his studio. See illus. 21.]

manner comes from the liberty of his education. He is, as he says, a student of nature. He learned to draw in the Académie Suisse,[10] where he copied living models; he learned to paint in the Louvre, where he studied the technical procedures of the earlier schools. It is this long-pursued double study which gave him the broad, easy, and vigorous brushstroke that distinguishes him.

From *After Dinner at Ornans*, which is in the Lille Museum, to *The Return from the Conference*, which the Luxembourg Museum will doubtless neglect to purchase, Courbet has never deviated for a moment. He has always walked the same path, obeyed the same tendencies; all his works are marked with the stamp of the same preconceived system and carry the seal of the same personality. If he first desired to acquire a perfect knowledge of tradition, it was, as he himself has written, to extract from it a reasoned and independent sense of his individuality. "To know in order to be able to do, this was my thought," he says. "To translate the ideas, the spirit of my time according to my appreciation of them, in a word, to make living art, this was my goal."[11] For my part, I do not know of any higher one, and I doubt that the great masters of any age have ever proposed another.

This unusual artist, so different from all who surround us, puts extraordinary means at the service of his personal aesthetic. He is a painter in the exact sense of the word. PICTOR, *pittore*, he sees clearly and depicts accurately. His marvelously varied craftsmanship is so supple as to change by itself with each object that he treats. With a single stroke his brush both outlines and gives form and movement. Nothing that comprises the visible world is foreign to him: figures, landscapes, animals, seascapes, portraits, flowers, and fruits—Courbet treats them all, and with the same superior skill. Submissive, above all, to things, he pulls his print from Nature, who allows him to be as varied as she. For this power

[10] [At the Académie Suisse, named after the former model who opened it, artists paid a small fee to work from a live model.]

[11] [Quoted from Gustave Courbet, *Exhibition et Vente de 40 Tableaux et 4 Dessins de l'Oeuvre de M. Courbet;* see "Paris: 1855," pp. 112–13]

and variety I would gladly compare him to Velazquez, the great Spanish naturalist; but with a shade of difference: Velazquez was a courtier; Courbet is a Velazquez of the people.

Courbet's great claim is to show what he sees. It is even one of his favorite axioms that whatever fails to draw itself upon the retina is outside the domain of painting.

Here, then, is what Courbet has seen in the valley of Ornans, in the heart of that beautiful and robust Franche-Comté, that former Spanish domain so profoundly Catholicized.

On the main road descending from the village that lies at the foot of small hills crowned with gray rocks, under a luminous sky, a group of black men are advancing. By the living God! They are priests. They are returning from a conference; that is to say, gathered together at a brother priest's, they have debated some points of theology and emptied several bottles of wine. They are seven, like the seven fat kine of the Bible or the seven capital sins of the Evangelists. The discussion must have been heated, for the good gentlemen are visibly moved. . . .

Laughing, perspiring, noisy, exhilarated, at the very hour the laborer in the field is sweating and straining to cultivate the rebellious earth, the procession thus advances. It arrives before an oak in whose hollow a statue of the Virgin is kept standing for veneration. At any other time these men would have stopped and crossed themselves. Now they pass unseeing.

Meanwhile, two villagers who were spading, hearing the noise of these rejoicings, have come to the edge of the field and are watching. It is difficult to watch something without becoming interested in what is happening. The husband, a freethinker, is laughing fit to burst his buttons; his wife, always pious, recognizes religion and kneels to adore it.

The *Return from the Conference* has caused a scandal. In this country of satirical songs, laughter, and insubordination, satirical painting is found hard to swallow. Yet irony is a weapon that no one neglects on certain occasions. Why should not the artist also have his pamphlet from time to

time, as does every writer who springs from good honest stock.

But God keep me from apologizing here for a subject such as this! I have no other desire than to assign its artistic value. This picture takes its place in the work of the master. It is an excellent Courbet. The color is beautiful and transparent. If the drawing has occasionally been neglected, this fault disappears before the reality of the faces and the natural charm of the attitudes. Never in his life as a painter has Courbet been so lucky in his position. One's eye is truly seduced and enchanted. Our grandchildren will come to laugh in front of this witty and gay canvas. Why are their fathers not permitted to laugh now?

The painter François Millet has placed himself in another order of ideas and at the extreme opposite end of art. Devoted to the depiction of country life, he brings into his interpretation something fierce and austere that causes light spirits to shy away. Prettiness and grace are repugnant to this stern nature. The heavy occupations of rustic life, work that keeps the population of the land stooped over, their awkward idylls and their eclogues, and, above all, the sinister grandeur of the implacable destiny that broods over them—these are the usual themes and feelings of this dour evoker of the darkest miseries.

Those who have followed the long succession of his works, who have seen the *Gleaners* of 1857, the *Cowherd* of 1859, the *Shepherdess* and *Waiting* of 1861, know what emotion seized and filled them as they stood before each canvas. The *Man with a Hoe* goes further, it seems to me, and moves one even more deeply.

He has been working since morning and the task is far from finished. But there are moments when the ox stops in the middle of the furrow, when the horse stops on the unending road, when the donkey, bending beneath his burden, refuses to go farther. In every task one must pause for a breath. The man, too, has straightened his stiffened back, wiped the sweat from his brow and, standing with his two hands resting on the handle of his hoe, his head thrust for-

ward, gazes into the immense distance. Paulus Potter's cows, which stretch their necks along the edges of Dutch fields, have no more intelligence in their faces, no more hope in their eyes, no more light in their heavy skulls. The earth stretches out all around him until it is lost to sight. Will he hoe it all until he falls upon it, his strength and his life exhausted? This implacable earth has already devoured his father and his mother and the fathers of his fathers; it will devour him also. And when he is gone, it will be the turn of his children, then of his children's children, and for always and forever until the end of time. Never will the work be over; never will the hour of repose come. Death must come here or there, a little sooner or a little later, but death in this furrow, which must always be reworked. Some dried brambles that he has carelessly thrown on the fallow earth have taken, without his noticing it, the form of a crown of thorns and, while he is questioning with his gaze, the horizon that is closed to him seems to announce his fate softly, the fate reserved for this pitiful Christ of eternal labor.

It is beautiful, it is great, it is religious. The impression is so elevated that it causes the defects in the execution to be forgotten. Execution is unfortunately not one of Millet's strong points.

Philip G. Hamerton: *The Salon of 1863*[1]

Painting in France

The distinguishing characteristic of a public Art Exhibition is that it is a contrivance for *publishing* pictures and statues, not merely for selling them. The French have a good phrase, "an unpublished picture," *un tableau inédit;* in England we speak of publishing books, but are not much in the habit of classing pictures as published or unpublished. Yet here is the very kernel of the most important of all practical questions in the lives of painters: How are they to publish their pictures?

1 [First published in *The Fine Arts Quarterly Review,* October 1863. Verbatim from P. G. Hamerton, "The Salon of 1863," in *Painting in France* (London, 1868), pp. 225–51, 259–61]

A picture differs from a book in this, that it cannot be sent to all the persons who desire to study it; but that they must be brought bodily to *it*; a singular difficulty and disadvantage. When a book is printed there are, say, a thousand copies of it, each as good as any other, and these thousand copies go into ten thousand houses, where they are worn to pieces with handling, without in the least injuring the real book that the author made. A picture exists only in one exemplar, and is so delicate that an injury to any part of it is ruin to the whole; consequently that one canvas must be made accessible to all men, and to that end hung in some place where it is not only safe but easily visible, and where great numbers of spectators congregate.

The way in which a picture is published is familiar to the reader. It is hung on the wall of some public building in a large town, and people are invited by advertisements to come and look at it. For the publication to be thoroughly effective, the town selected must be the metropolis of a rich and highly cultivated nation.

Now as each artist cannot hope that very many people will come to look at every one of his pictures just when they are finished, the plan of combination is usually resorted to, and many artists send, each of them, one or more pictures which, when united, form for a time what is called an "Exhibition," and thither thousands of people go, attracted by the number and variety of the works to be seen. These pictures, thus publicly exhibited, or at any rate such of them as are so hung as to be easily visible, are *published*; all pictures not publicly exhibited remain unpublished. The first are like printed books, the others like books which remain in manuscript.

There is, however, another notable difference between pictures and books. A book may be equally well published by very many different houses. There are at least ten firms in the metropolis, any one of which can give a new book as good a chance of fame and success as can possibly be desired. But the picture-dealers in no sense correspond to the book publishers. The dealer can seldom be truly said to publish a picture. It is only in the exceptional case of sensation pictures that a dealer really publishes, or when he has a very well-

frequented exhibition, as, for instance, the French Exhibition of M. Gambart.[2] In most cases a picture sold to a dealer passes out of his hands quite privately, just as an unpublished manuscript might be transferred from one person to another.

The true publishers of pictures are the several artistic corporations, such as the Royal Academy, the Society of British Artists, and the Water-Colour Societies.

But since, as we have seen, it is necessary to the publication of a picture that many people should be induced to go and see it, they will always go in the greatest numbers where the inducements are most numerous and attractive. Hence it happens that a painting, to be published under the best conditions, must be hung visibly in the chief show of the kind in the nation, for there everybody goes.

This natural tendency of people to go in crowds where the best things are to be seen, and to patronize one show, shop, or exhibition of one kind to the neglect of others, is so marked that many persons have come to doubt whether there is any utility in having so many picture-shows, and whether one large one would not be at once more advantageous to the painters of the pictures, and more convenient for the people who go to see them. In one large exhibition, it is argued, so arranged that all the pictures in it might be easily seen, all painters would have a fair and equal chance of *publishing* their works, that is, of laying them before the *whole body* of the art-studying public; whereas, at present, a picture exhibited on the line in Suffolk Street[3] cannot be said to be published in the same sense as one on the line in the Academy.[4]

There is, however, a little pecuniary difficulty. The publication, in this combined manner, of all the good art of the year

[2] [Starting in the 1830s, Gambart sponsored an annual exhibition of French artists on Pall Mall in London. He "managed" Ruskin's 1859 lecture tour and introduced him to Rosa Bonheur.]

[3] [The Society of British Artists opened exhibition rooms in Suffolk Street in 1823.]

[4] [At Royal Academy exhibitions paintings were hung from the floor to the ceiling. There was a line which ran around the room at a little below eye level; a painting hung "on the line" could be clearly seen, but those above or below the line were often poorly lit and were difficult to see.]

would be an extremely profitable business—would yield, in shilling admissions, several thousands of pounds annually. Who is to pocket these proceeds? Who is to be the publisher?

The Royal Academy, as a respectable and long established firm, has the priority. But the other societies might justly claim some share in the returns, and this might lead to undignified dispute. It is therefore suggested by some persons, with strange foreign ideas, that, instead of all these respectable private firms, it would be well if the Government were to undertake the publication of pictures and statues,[5] as trustee for the interests both of the artists and the nation, and that the whole of the profits, after deducting the expenses, ought to be made to benefit the exhibiting artists and the nation at large, by being laid out in the purchase of works in the exhibition which should be immediately added to the National Gallery. The partisans of this scheme assert that it is already in operation in France, and that it works well there.

The principal object of the present paper is to ascertain whether French artists have a better chance of publishing their pictures than ours have.

At first it would appear that they have not. There are only two regular exhibitions in Paris, one called the Salon, hitherto biennial, but henceforth to be annual, and a permanent exhibition on the boulevard des Italiens, where the pictures are constantly changing, so as to induce the same visitors to go there about once a month. But then the Salon has remarkable merits.

1. Everybody who cares at all for art, or who has a place in refined society where art is talked about, goes to see the Salon.

2. It is also visited by the whole body of the Parisian people, there being one day in each week when it is opened gratuitously.

3. The pictures admitted by the jury may all be said to be published, because they are all hung in positions which allow them to be seen.

[5] [Though the Royal Academy had received a charter from the crown, it was a private institution.]

4. Every picture refused by the jury may also be published if the artist desires it, in an exhibition close to the Salon, and as well lighted, being separated from the Salon only as the different rooms of the Salon itself are separated from each other. The real separation is that of honor, not locality, nor even notoriety. A rejected picture enjoys precisely the same publicity as an accepted one.

Now the question is whether *one* exhibition like this is not more favorable to the interests of artists and the convenience of the public, than a dozen exhibitions like ours.

It may safely be asserted that in our Royal Academy there is no true publication of any pictures but those on the line or near it, except in the case of very large and coarse works, which *cannot* be hung out of light. And even if every picture in the Academy were published, there is not room for more than half the pictures of the year.

Nor has the artist any satisfactory means of appeal from the judgment of the Council [of the Royal Academy] to that of the public and the press. Pictures refused at the Academy are sometimes to be seen in obscure exhibitions,[6] such as that in Berners Street; but for the appeal to mean anything, it ought to be made to all the people who go to see the accepted pictures, and to *all* the critics who review them.

The French Salon of 1863 presented to the world an almost perfect ideal of all that an exhibition ought to be, and it is the first time that such an ideal has ever been even partially realized. To be absolutely perfect, an exhibition of pictures ought to present only one line to the spectator, and in the French Salon there are always two, and sometimes three lines of pictures. Nevertheless, there are no pictures near the ground, and a projecting ledge the height of a man's elbow, at once protects the pictures from the crowd, prevents any of them from being hung too low, and offers a desirable support to the student who bends long over a favorite work. And although there are two lines of pictures, the hanging is, with very few exceptions indeed, most judicious, the simple plan

[6] [In June 1863 artists whose works had been rejected at the Royal Academy were exhibited at Charles Street, Berkeley Square. Some of the rejected works were also "rejected" by this exhibition.]

of putting small and delicate works on the lower line, and vigorous ones that can be seen at a distance on the upper, having been generally followed. Indeed we ought never to forget that in all places which are likely to be crowded, it becomes desirable that works which are intended for distant effect should be hung rather high, because, if they were low enough to be hidden by the bodies of the nearest spectators, no one would ever be able to see them at their own distance, or, in other words, no one would ever *see them* at all. Taking this fact into consideration, and making allowance for a few obvious instances of bad hanging, I may express my conviction that in the French Salon of 1863 is realized that wild dream of so many artists, an exhibition of pictures arranged on rational principles.

The Emperor's intention of allowing the rejected painters to appeal to the public has been in a great measure neutralized by the pride of the painters themselves. With a susceptibility much to be regretted, and even strongly condemned, the best of these have withdrawn their works, to the number of more than six hundred. We are consequently quite unable to determine, in any satisfactory manner, how far the jury has acted justly towards the refused artists as a body.

A striking contrast between this exhibition and that of our Royal Academy is that the French Salon is a *national* institution, held in a great national exhibition building with all but boundless space at its disposal; while our Royal Academy exhibition is in the hands of a private company, with such insufficient accommodation that it has to reject many excellent works and to put two-thirds of the accepted ones where they cannot possibly be seen. Another difference of some importance may also deserve attention. The shillings received at the doors of the English Royal Academy go to swell the savings of that corporation; the francs received at the doors of the French Salon, after deducting the expenses of the exhibition, are entirely employed in the purchase of works of art exhibited there, which thus become national property. The visitors to the English Academy are contributing to the enrichment of a body already wealthy, but they are not in any obvious way advancing by their contributions either the

interests of the exhibitors or those of the nation. The visitors to the French Salon are *all* picture-buyers, they advance the interests of the artists who exhibit by purchasing some of their works, and they contribute to the public wealth by presenting those works to the French people. . . .

The rooms are arranged alphabetically according to the names of the artists whose works they contain. Each room is lettered over the door. If you want to find a particular artist's works, nothing can be easier. Suppose, for instance, you want Lambinet; you go at once to the room lettered "L," and there you find him. The same arrangement is adopted in the following notes.

*Baudry (Paul Jacques Aimé).[7] His picture, entitled *The Pearl and the Wave* is said in the catalogue to be an illustration of a Persian fable. Divested of this allusion, it is simply a beautiful girl lying on the sea-beach and waiting for a breaking wave. A pretty play between two of the loveliest things in the world. . . .

Bonheur (Auguste François). Auguste Bonheur is ranked by many artists higher than his sister Rosa, who, by the by, does not exhibit this year. The reputation of Auguste is in a great degree overshadowed by that of Rosa[8]—almost entirely so in England, where everybody has heard of her, and only the few have any idea that her brother is a great artist also. This year's Salon has placed Auguste Bonheur higher than ever. He has three very noble pictures indeed, as remarkable for the landscape, which so few appreciate, as for the animals which attract the crowd. It is within Bonheur's power, if he were so minded, to become very shortly the greatest landscape painter in France. His work is at once quiet and masterly, two qualities often united in the best French painters of this generation. One of these pictures is a scene on the coast of Brittany, with sheep in the foreground guarded by an

[7] An asterisk preceding a name indicates that the painter is a Chevalier of the Legion of Honor.
[8] [Rosa Bonheur did not exhibit at the Salon from 1855 to 1867.]

old shepherd, a wild stony coast, and then the sea in the distance. It is very interesting to compare this picture with Hunt's *Strayed Sheep*, a similar subject. Both are realistic works, both quite sincere and independent of conventionalism, yet Bonheur's looks true, whereas Hunt's looks false, and we only believe in it after some thought and reasoning. When artists are highly sensitive to colour, they try, in England, to rival the brilliance of natural colour, and as they cannot at the same time give the natural light, their work looks wrong, Hunt's sunshine especially. The French principle may be stated in a sentence. As you cannot give *both* the light and the colour, you must subdue your colour just as frankly as you do your light, or else there will be discord between them. For true colours without the true light will look false, whereas a scale of colour cunningly adapted to your scale of light will produce a result in reality more harmonious and apparently more true. There can be no question of the comparative effect of the two systems on the popular mind. Bonheur's picture pleases everybody, Hunt's offended everybody at the first glance, and it is only after accepting his principle that one accepts his work. But the people accept Bonheur's work without knowing anything about principles. It may also be asserted of painting, as an art, that its business is simply to represent things as they appear, and not too scientifically as they are. I mean that if a colour in nature can be scientifically proved to be pale purple, but is turned by the contrast of other colours into a dark green, the colours that we put for it in our picture must *look* dark green too, and not pale purple. . . .[9]

*Cabanel (Alexandre). His portrait of the Countess of Clermont-Tonnerre is one of the most admirable and perfect works of its kind ever produced. Independently of its value as a mere likeness, it has so much other value as a picture, that people stop before it, and are bewitched by it, and feel enthralled by its soft, sweet, womanly grace, and perfect dignity, and infinite refinement. This picture is a curious proof

[9] Turner's scarlet outlines are especially questionable.

of how a great artist can follow a foolish custom, and yet make it wise by the way he does so. . . .

And close to this portrait with its dark and quiet colour, close to this clothed lady of modern France, they have hung for a contrast, which helps both works, Cabanel's dazzling Venus lying naked on the sea. . . .

To my mind this picture is ruined by a flight of foolish Cupids in the air. Of course no models could be had for the attitudes of these, and they are quite infinitely inferior in drawing to the Venus. Besides, neither Cupids nor Cherubs ever resemble real children at all; they are invariably mere ideals, and in this case we feel the contrast painfully; because the Venus is really a woman, though a glorified one, but these little Cupids are not children, nor anything else in nature. . . .

*Corot (Jean Baptiste Camille). Corot is one of the most celebrated landscape painters in France. The first impression of an Englishman on looking at his works is that they are the sketches of an amateur; it is difficult at first sight to consider them the serious performances of an artist. Eight years ago, when I first became acquainted with Corot's works, I felt much as a Frenchman does when you show him Turner's, that is, utterly at a loss to account for the fame of the painter, looking for something to attribute it to, and finding nothing. I understand Corot now, and think his reputation, if not very well deserved, at least very easily accounted for. Corot is a poet, not a great one, but perfectly genuine in his way. He feels the mystery of nature, he feels the delight-fulness of cool, grey mornings and dewy evenings; he feels the palpitating life of gleaming river shores, and the trembling of the light branches wherein the fitful breezes play. Now a poet who paints, however feeble or even false his imitation of nature, is always sure of fame in the end, for there is nothing so powerful in our art as the poetical gift. The immense fame of Claude is due to a certain quiet but genuine poetry, and Corot's mind seems to me to be just about of the same caliber as Claude's. They are neither of them great poets, but both *are* poets, in a tame and limited way. . . .

Courbet (Gustave). M. Courbet is looked upon as the representative of realism in France; the truth is that Troyon, Édouard Frère, the Bonheurs, and many others are to the full as realistic as Courbet, but they produce beautiful pictures, and consequently do not represent the idea which the ingenious French critics have contrived to attach to the word realism. That idea is the willful preference of ugliness to beauty. Truth herself, to whose majesty all great men are loyal, has become degraded in the popular French mind by the unfounded notions that these ugly pictures of Courbet are truer and more realistic than the beautiful ones of better men. His works are therefore a definite injury to the noble cause of truth, because they make it understood that truth is of necessity disgusting. Now there are beautiful truths and ugly truths, and the business of art is with the beautiful truths; *only admitting the ugly ones when they will enhance the beauty of the others,* but not erecting these ugly truths into the standard of *all* truth.

Still M. Courbet is a clever painter. His handling is extremely skillful, and even the French critics, very severe on this head, admit that he is versed of such high quality in this respect that one only regrets the more that he should hold such a wrong theory about truth. . . .

*Daubigny (Charles François). The chief of French landscape painters, so far as fame goes; as to merit, perhaps another estimate might be arrived at. If landscape can be satisfactorily painted without either drawing or color, Daubigny is the man to do it. He works immensely from nature, and has a boat with a little cabin in it, wherein he passes much time on the French rivers in summer, with canvases and colours in abundance. The result is the annual production of a considerable quantity of greenish grey oil sketches, full of a certain kind of sentiment for nature, and not offending the popular taste by the presence of colour, which, in landscape, is a great impediment to popularity. Daubigny's works are the precisely popular ideal, never in the least transcending the commonest knowledge of nature, and their popularity was therefore inevitable. . . .

*Doré (Paul Gustave). The reputation of Gustave Doré ought to be by this time European, his designs being all engraved on wood, and thus disseminated. He is distinguished by two great gifts, a prodigiously prolific and original invention, and a sympathy as universal as it is profound. He is only just thirty years old this very year. His published designs may already be counted by thousands—perhaps even by tens of thousands. He is a great and marvelous genius—a poet such as a nation produces once in a thousand years. He is the most imaginative, the profoundest, the most productive poet that has ever sprung from the French race.

This estimate may seem extravagant, but it is based on the careful study of Doré's works for several years past. The illustrations to Dante's *Inferno* [published in 1861] are hitherto his masterpiece. It is not the place to discuss their merits here, not those frank and obvious defects which the smallest critic can find out, and which Doré, like all great men, carelessly leaves in the mere exuberance of productiveness. His landscape, got from impressions of wild nature (especially, I think, from the Jura forests), mixed with recollections, or at least often modified by the influence of the old masters, is often full of falsities and conventionalisms; his figures, being drawn by the thousand, are not always correct as to anatomy, but every subject is grasped greatly, every landscape is full of mystery and infinity, every figure alive.

So much for Doré as a designer. But he is not a painter, in the true sense. He paints as well as many reputed "painters" of the French school; but his colour will not bear the least comparison with that of a real painter such as Cabanel or Paul Baudry.

His pictures are conceived simply as *designs*, and all pictures so conceived inevitably fail. A picture must be conceived, from the first, in colour, so much form being added as will not destroy the colour, *and no more*. When a real painter thinks of a new picture, it haunts his mind as a new assemblage of tints which grow into forms as he dwells upon them. Doré's pictures are, of course, always very impressive, very great as inventions, but that is not enough. I am quite sure that when a new picture enters his head, it takes the

form of a design in black and white. Why not leave it so? It
is also observable that of the three pictures here, one is sim-
ply an enlargement of a design already published in the *In-
ferno*. . . .

Jules Castagnary: *Salon des Refusés*[1]

I. Neither the Edict of Milan, which, after two centuries of
proscriptions and martyrdoms, put an end to the anguishes of
the early Christians, nor the Edict of Nantes, which, after
forty years of butchery and massacre, restored liberty of con-
science to the Huguenots, carried as much joy to the hearts
of those suffering from oppression as the three lines inserted
in the *Moniteur* on April 24:

> Numerous complaints have come to the Emperor concerning
> the works of art refused by the jury of the Exposition. His Maj-
> esty, wishing to allow the public to judge the basis of these
> complaints, has decided that the works of art which were re-
> fused would be exhibited in another part of the Palais de
> l'Industrie.

When this note was made known to the Parisian public,
there was universal relief and joy in the studios. They
laughed, they cried, they hugged each other. . . .

II. We would not be answering the obvious intention of the
powers that be, and we would be betraying the legitimate
hopes of the artist, if we undertook this study with the sole
preoccupation of determining with rigorous precision the qual-
ities and the faults of the works rejected by the jury. Higher
and slightly more philosophical aims are demanded of us by
the very nature of the circumstances in which the counter-ex-
position was produced.

In effect, what did the emperor wish in deciding to form a
second Salon in the very palace in which the principal Salon
was taking place? He wished, as the note in the *Moniteur*

[1] [Originally published in *L'Artiste*, August 1 and 15 and Septem-
ber 1, 1863. Translated from Castagnary, *Salons, 1857–1870*, 2 vols.
(Paris, 1892), vol. I, pp. 154–82]

expressly states, [to] "let the public judge the validity of these complaints."

And what would the artists expect of us? Eh! My Lord, let us not be afraid to say it: what the defendant expects of the lawyer—a good defense, warm, convincing and, if necessary, even biased.

On one side, justice asks us to appreciate at their exact values the operations that have been accomplished, to weigh equally the artists and the jury, and to declare ourselves for one or the other in the entire liberty of our judgment and the entire sincerity of our conscience. On the other hand, the artists beg us to take up their cause, to accuse boldly the errors and prejudices of the jury, to demand the end of a guardianship that annoys them; in the end, to help, if we can, their final emancipation and the formation of their independence.

Between these two opposing demands, it is up to us to follow the laws of a healthy mind and to decide according to the commands of strict justice.

III. First of all, I cannot help regretting one thing: the elective character that the government has felt necessary to give to the counter-exposition.

I understand the feelings of conciliation and propriety which guided the powers that be in this measure, certainly more liberal than that which I would have proposed. It was necessary to cater to easily bruised feelings. Care was needed in order neither to interfere with interests nor to hurt some people. I admit in advance all that might be said on this subject. But how can one judge a case when some of the evidence is not before one's eyes? The majority of the ostracized works have been withdrawn by their creators. As a consequence of this massive withdrawal, the control of public opinion has only been able to operate in an incomplete fashion. And now that the Salon is closed, now that the debates might be considered closed, it is seen that one point required for a definitive solution remains obscure: What was the true value of the withdrawn works?

The parties seize on a doubt that hovers over this question and exploit it in various ways. . . .

IV. In this time of abundant literature, it is quite commonly known in France what a boring novel, a badly constructed play, an insipid bit of poetry, a declamatory or diffuse newspaper article consists of. Before the exposition of the rejected works, we had no idea what a bad picture was.

Today, thanks be given to Apollo, O God of the arts, we do know. We have seen them, touched them, realized them. We can boldly say that of all foolish productions, the most foolish do not come from the pen but from the brush. The man of letters stops halfway on the road to imbecility. Luckier than he, the painter has the privilege of attaining—what am I saying?—of pushing back the frontiers of stupidity. . . .

One might take pity on the religious, historical, or genre paintings, so numerous that they offend the eye on every side. But these naïve attempts by beardless beginners or balding oldsters leave the spirit irritated or indifferent. Let us again pass on.

By violent elimination we come to the only works that, in certain respects, merit the critics' attention, and a certain number of which doubtless caused the jury to hesitate more than once. I will follow the order of the catalog itself to particularize my praises as much as possible. . . .

VII. . . . Fantin-Latour. I wish this young man, skilled among the skillful, might cast off a timidity that restricts and limits him. His portrait is vague and somehow haggard, coated with rice powder and pale as though it were dusk. Heavens, my friend, return to health, to vigor, to a bright and accurate vision. You are one of the most skillful beginners I am now naming. You know how to draw, you know how to paint; you are also well liked. What a beginning! Do something then. Don't be afraid. Take your knife for me and scratch out this *Fairy* that belongs no more to the world of imagination than to the world of reality. Within it there is neither form nor background. Then, on the same canvas construct for me something simple, true, seen in nature that will

be accessible at once to our spirit and our senses. If you are
then attacked, call me; I will be at your side and will out-
shout the others. . . .

IX. . . . Jongkind. Here is another painter whose exclusion I
find difficult to understand, especially his total exclusion. His
talent, so expressive and original, has long been unques-
tioned. All those who have followed his work are united in
admitting it. The jury of 1852 rewarded him with a third-
class medal. Since that time he has not ceased working and
producing. Has his imagination weakened? Has his hand be-
come clumsy? It is unlikely, because it is just from this period
of his life that his best works date, the strange "Moonlights"
that you are acquainted with, and those eye-catching "Views
of the Seine" that are not forgotten once they have been
seen. For myself, I like Jongkind; to me he is an artist to the
tips of his fingers; I find him to be of a true and rare sensi-
tivity. In his work all lies in the impression, his thought car-
ries his hand. He is no longer preoccupied with his craft, and
because of this, once in front of his canvases his craftmanship
no longer preoccupies you either. Once the sketch is finished,
the picture completed, you do not worry about the execution;
it disappears before the power or the charm of the general
effect.

XI. . . . Édouard Manet. This young man has been much
discussed. Let us be serious. Le Bain [The Bath or Luncheon
on the Grass], the Majo [Belle], L'Espada [Mlle. Victorine
in Bullfighter's Costume] are good beginnings, I agree. There
is a certain liveliness in the tone, a certain freedom in the
brushstroke, and nothing vulgar about either. But in addition
to this? Is this drawing? Is this painting? Manet believes him-
self to be strong and powerful; he is only hard and, oddly
enough, as soft as he is hard. This is because everything in his
work is uncertain and left to chance. No detail is in its final,
precise, and rigorous form. I see clothes without sensing the
anatomical structure that carries them and justifies their
movement. I see fingers without bones and heads without
skulls. I see sideburns painted like two strips of black cloth

glued on the cheeks. What else do I see? An absence of conviction and sincerity in the artist. . . .

XIV. Pissarro. Not finding his name in the preceding catalog, I suppose he is a young man. Corot's manner seems to please him: a good master, sir, but whom one must above all not imitate. . . .

David Sutter. Twenty years ago he exhibited some *Views of Switzerland,* and later bits of landscape taken from the forest of Fontainebleau. I cannot say anything about those paintings; but what I can say is that from that time on their author has never ceased a single day from using pencil or brush. . . . He has put the result of his reflections and his studies into a book entitled *Philosophie des Beaux-Arts,* a work of a healthy eclecticism, which was approved without difficulty by the Académie des Beaux-Arts. Later, feeling the need to shorten for other young painters the long apprenticeship of painting that had cost him so much work and effort, he wrote a *Nouvelle Théorie Simplifiée de la Perspective* which, with the same academic approval, obtained the approval of the most competent men. This continuity of work, showing such a profound love of Art, was worthy of something more than a refusal.

In looking at the three landscapes entitled *The Entrance to the Gorge at Apremont, The Properties of Jean de Paris,* and *The Road Going to the Observation Point,* I admit that it is impossible for me to understand what the jury that refused them was thinking. I do see in these little compositions the traces of a minute, uncertain, perhaps embarrassed manner of working; however, I feel in them that breath of the universal life which animates Nature and which becomes great art when it is transmitted from the artist's head to canvas. I call Théodore Rousseau and Diaz, whom Sutter seems to take particularly as models and inspiration, as witnesses.

XV. . . . James Whistler. I have proposed an interpretation of *Woman in White,* which has nót been popular with anyone except myself, so reluctant are we to attribute ideas to painters. What did you wish to do? I asked the strange artist

whose fanciful etchings were at that time the only part of his work I had seen to admire. A tour de force of your skill as a painter, consisting of painting white on white? Permit me not to believe this. Allow me to see in your work something higher, the *bride's* awakening, that confusing moment in which the young woman examines herself and is astonished no longer to recognize in herself the virgin of yesterday.

Standing, her feet set on a white carpet barely tinged with blue; clothed in a long white robe that clings and outlines her delicate torso; standing in front of the white curtains of a closed alcove, behind which *the other* is undoubtedly still sleeping; holding in her hand a flower that has lost its petals; her nostrils quivering, her eyes dilated, her hair falling loose, she stands surprised and frightened, looking straight before her, doubtless thinking how little it takes to make a girl into a woman, a mother.

Do you remember *The Broken Pitcher* or *The Girl Crying for Her Dead Bird*,[2] gentle subjects so beloved by Greuze, and of which our Diderot spoke so nicely? . . .

Whistler's interpretation is graver, more severe, more English. His *Woman in White* is obviously married: The night that she has just passed is in order, legitimate, approved by the Church and the world. Yet she is astonished by the great change which has come about: Everything is white except herself. Ask the faded flower she holds in her hand; it alone can answer you. It is the continuation of the allegory begun by the broken jug and the little dead bird. . . .

XVIII. By way of conclusion I would like to throw myself into a great tirade against all the inconsequential artists who, never having been able to organize their own affairs, demand protection, guidance, favors, Salons, rewards from the state and who, when everything has been freely granted them, find nothing better to do than to rail against the gifts of the state. The reform that has been made in the regulations frees me from this unhappy task. From now on painters will be judged

2 [Both paintings are allegories of the loss of innocence.]

by those from whom they receive their mandate, and those who are refused will keep their right of appeal to public opinion. This is good. These outcasts, these pariahs have won their fight. What am I saying? Their fate is becoming rosier because none are now exempt, and because probably some medal winner or some illustrious legionnaire will come to take his place among them each year. Let Parisians, with their caustic humor, beware.

Philip G. Hamerton: *The Rejected Pictures* (Whistler, Manet)[1]

The Rejected Pictures

Mr. Whistler's famous *Woman in White* is among the rejected pictures and to his great credit, he courageously left her there. The hangers must have considered her particularly ugly, for they have given her a sort of place of honor, before an opening through which all pass, so nobody misses her. I watched several parties to see the impression the *Woman in White* made upon them. They all stopped instantly, struck with amazement. This for three or four seconds, then they always looked at each other and laughed. Here, for once, I have the happiness to be quite of the popular way of thinking.

The pictures exhibited as refused are generally very bad, but there appears to have been some injustice in the matter of landscape, three men especially—Chauvel, Blin, and Lapostelet—being as good as many painters whose works are admitted. Perhaps the jury does not know or care much about landscape. Very few of the refused figure-pictures are good, still there are two or three which seem wrong to have rejected. There is a very clever picture of a table spread with refreshments, oysters (de Cancale), peaches, etc. The oysters and peaches are imitated with great truth, and none of that unnatural texture and violent color so common in superfine English fruit-pictures. The painter of this work, M. Jules Leroy, has some right to complain. Artists who have a talent

1 [Excerpted from "The Salon of 1863," *Fine Arts Quarterly Review*, vol. 1 (October 1863), 259–62]

for imitation ought not, however, to waste it on oysters, of which, if people only take care, there will always be a plentiful supply. Good imitators ought always to imitate rare things that can seldom be seen. Blaise Desgoffe is the only man who seems to have understood this thoroughly.

The principal absurdities among the refused pictures are an amazing gentleman in a Freemason's costume (unrivaled for symmetric accuracy, both sides precisely alike to the very ears); a picture of horses; a topographic landscape with a railway, and mill, and road in it; some queer things of the school of Courbet, and almost as ugly; and, lastly, a huge picture by M. Cazal, of a gaunt, bay, tailless horse that has just stopped one of his pursuers with a kick in the ribs, and is rearing in the foreground, while another, seizing his nostrils, is thus lifted off the ground. I ought not to omit a remarkable picture of the realist school [*The Bath* or *Luncheon on the Grass*] a translation of a thought of Giorgione into modern French. Giorgione had conceived the happy idea of a *fête champêtre*, in which although the gentlemen were dressed, the ladies were not, but the doubtful morality of the picture is pardoned for the sake of its fine colour, and it hangs not far from the *Marriage at Cana*, in the noblest hall of the Louvre. Now some wretched Frenchman [Édouard Manet] has translated this into modern French realism on a much larger scale, and with the horrible modern French costume instead of the graceful old Venetian one. Yes, there they are, under the trees, the principal lady, entirely undressed, sitting calmly in the well-known attitude of Giorgione's Venetian woman, another female in a chemise coming out of a little stream that runs hard by, and two Frenchmen in wide-awakes sitting on the very green grass with a stupid look of bliss. There are other pictures of the same class, which lead to the inference that the nude, when painted by vulgar men, is inevitably indecent. Cabanel's *Venus*, though wanton and lascivious, is not in the least indecent; neither is Paul Baudry's beautiful girl on the sea-beach—but these pictures *are*. . . .

1864 – 67: NAPLES

The Exhibition
of a Society:
The Società Promotrice

The first national exposition held at Florence aroused Italy's artists. On their return home, the Neapolitan artists who had participated in it established a Società Promotrice di Belle Arti, with the innovative landscape/genre painter Filippo Palizzi as its president. Its exhibition was to be held annually: the first, in 1862, would take the place of those formerly held by the Accademia Reale. That Academy had been suppressed after Garibaldi and his red-shirted "thousand" had entered Naples, the capital of the Kingdom of the Two Sicilies, on September 7, 1860, after liberating Sicily. The Bourbons, its rulers since 1743, had fled before their advance. Garibaldi declared himself dictator and proclaimed the Real Museo Borbonico—formed in 1790 by Ferdinand IV from the Farnese Collection and art objects from the excavations of Herculaneum, Pompeii, and other sites—to be the National Museum and the ancient sites to be national property. The French author Alexandre Dumas, who accompanied Garibaldi, was named director of the National Museum. The literary historian and aesthetician Francesco de Sanctis, who had returned

from his exile in Switzerland, was named Minister of Education. Fearful lest Garibaldi proclaim a republic, Victor Emmanuel came south to meet him and on October 26 Garibaldi transferred his conquests to the king. After a plebiscite favoring union with the Kingdom of Sardinia, it became a part of the United Italian Kingdom instead of the confederated republic for which Giuseppe Mazzini and the revolutionaries of 1848 had fought.

Located on the slopes of volcanic hills at the edge of a bay, always celebrated for its beauty, Naples had long been an artistic center. Recently the classical tradition, the dominant style in Naples, was represented by Vincenzo Camuccini, a Roman, who headed Rome's Academy of San Luca and also the Neapolitan Academy in Rome.

The Palizzi brothers and Domenico Morelli had, since 1855, reestablished in Naples a school of realistic painting, continuing the tradition of Caravaggio, Giuseppe Ribera and, finally, of Salvator Rosa. An immediate predecessor of the Palizzi and Morelli in observing color in landscape had been Antonio Van Pitloo, professor of landscape painting at the Academy. He and his students had used warm, harmonious tones to depict the views of Naples, its bay, and Vesuvius, which were so popular with the tourists. The Palizzi favored chromatic realism in landscape. Accused of imitating the French landscapists, they were referred to as "les Courbet napolitains,"[1] who gave to the environs of Naples the aspect of Normandy's or Holland's green, foggy fields and replaced its blue sky and golden atmosphere with the pearly gray of northern rivers. The Palizzi and Morelli, although differing from each other in their choice of subject and their treatment of nature, were alike in their concern for obtaining accurate color renditions of what they saw. Because they used a villa at nearby Posilippo as a center and painted the farm country surrounding it, they and anyone else whose technique and subject matter differed from the academicians were lumped together as the "Scuola di Posilippo."

[1] Théodore Vernes, *Naples et les Napolitains* (Paris, 1860), p. 281.

From the innovative Neapolitan group emerged a new art critic, Francesco Netti (1832–94). He had completed his study of law before entering the art academy and studying in Rome in 1859 and 1860. A painting of his had been included with those the Neapolitan painters, headed by Morelli, had sent to the National Exposition in Florence in 1861. Between 1860 and 1864 Netti was among those to whom Filippo Palizzi taught his method of figure painting. Netti's first criticism, a review of the Società Promotrice's third exhibition in 1864, was written for the *Napoli Artistica*.

While his aesthetic concepts were derived from de Sanctis, Netti's criticism was tempered by his practical experience as a painter. He brushed aside the academic classifications that determined subject matter. He considered the work of art as an expression of feeling in which complete harmony should exist between execution and expression, thus eliminating any distinction between form and technique. He likewise accepted without question the idea that the subject was a form realized by the artist. This approach enabled him to esteem the work of artists who, like the Morelli, Palizzi, or *macchiaioli*, varied in their technique.

After 1866, when Netti went to paint in Paris, his place was taken by Vittori Imbriani (1840–86). Born in Naples, Imbriani had grown up in Nice and Turin, where his outspoken liberal parents lived during their exile. At eighteen he studied in Zurich, transcribing Francesco de Sanctis' lectures for him. A year later Imbriani fought as a volunteer until the central Italian campaign had been successfully concluded. To continue his study of German philosophy, especially Hegel and Schiller, Imbriani went to Berlin. A German's disparagement of Italian valor resulted in a duel and Imbriani's expulsion from Prussia. He returned to Naples and in 1863 won an appointment as an instructor of German literature at the University of Naples. He left the university in 1866 and enlisted with Garibaldi's troops to free Venice from the Austrians. On his return, in November 1866, he assumed the direction of the paper *La Patria*.

The opening of the Neapolitan Società Promotrice's fifth exhibition in the autumn of 1867 gave Imbriani an opportu-

nity to develop his aesthetic concepts and to evaluate the exhibition in a series of thirteen letters written between December 1867 and January 1868 and addressed to a close friend, the engraver Saro Cucinotta (1830–71), who had left Naples to work in Paris. Using a fantastic pseudonym (Ciarusarvangadàrsana) Cucinotta had collaborated with Imbriani in 1864 to launch a short-lived weekly, *L'Arte Moderne,* as the organ of the "rivoluzione pittorica." Characteristic of their bizarre satirical criticism had been a proposal that teachers of antiquated methods of instruction be transferred from the Instituto di Belle Arti to an Instituto di BBAA.

Imbriani's epistles were published in *La Patria.* In the fourth and fifth *pistolotto* (a *pistoletta* is a short epistle; a *pistoletto* a small pistol; a *pistolotto* a joking, short letter) are developed his aesthetic theories on *la macchia,* a spot or splash of color. "The *macchia* is the pictorial idea as the musical idea is a given chord of sounds from which the composer determines the theme."

According to Benedetto Croce, Imbriani's critical writing was "the result of two intellectual movements: the renewal of aesthetic criticism in general caused by de Sanctis and the pictorial revolution against 'Accademismo' effected in southern Italy by Filippo Palizzi and Domenico Morelli." The similarity between de Sanctis and Imbriani lay in their conception of art "as a product of imagination understood as organic activity."[2] Like Signorini in Tuscany, Imbriani evaluated art as a social fact and a reflection of the changed political situation in Italy. There were too few such liberal middle-class thinkers to erase the geographical and historical divisions that kept the peninsula divided into regions. The growth of a national school of art comparable to that found in France or England thus was thwarted.

[2] B. Croce, *Nuovi Saggi di Estetica* (Bari, 1920), pp. 239–40.

Francesco Netti: *Apropos the Third Promotrice Exhibition, Naples, 1864–65*[1]

The Public Exposition

The place least suited to the purpose of showing paintings and works of art in general is the exposition, which should be the place best adapted to such a purpose and the place to which one goes or one should go solely to view them.

To see a painting under favorable conditions is a part of painting. The light, the place occupied, and the surroundings are like so many aids for a painter: They are the other colors of his palette. One can be an artist independently of aids, but it is not possible to paint without them.

When a painter shows you his painting in the studio, he turns his easel to the best angle: He creates (so to speak) its light; he offers you a seat that imposes upon you the distance at which he wants it to be seen; he removes any drapery or other objects that might interfere with the painting or with your attention; he shuts out the sunlight; he curses the white cloud that does not know that its inharmonious face of brilliance is jarring as it crosses the atmosphere; all in all, he makes you see his work at its best. But conditions at the exposition are very different. Besides the unfavorable space and lighting, a painting displayed is like a wretched man caught in the midst of unknown, implacable, and numerous enemies. Between one painting and the others nearby there is enormous antagonism, a pitiless struggle, because every picture (especially if it is a good one) represents, first of all, an egotism of its own. Naturally those that are most egotistical of all, that is, the most individual works, save themselves and are victorious . . .

Well! These disadvantages, this struggle, this hatred between picture and picture, this loss of 50 percent, represents

[1] [First published as "A proposito dell'esposizione napoletana della Società Promotrice di Belle Arti" in *Napoli Artistica*, 1865. Translated from F. Netti, *Critica d'Arte* (Bari, 1938), pp. 1–5, 16–19, 19–23]

progress! The three expositions of the Società Promotrice, from 1861 to today, are the most convincing statistic for this.

Criticism

It is difficult to be an art critic; but the most difficult thing in art is to be understood. We often see a painting or a statue considered a masterpiece by one critic, while the same work in the hands of another critic becomes, as the saying goes, trash. One critic greatly admires the qualities which another considers faulty, and the worst of it is that both are logical in their reasoning. How can this happen? It seems to me that it is because one proceeds from abstract systems inapplicable to painting, because one's own ideas are the only ones admitted as being good ones, and one wants to submit work conceived in individual beliefs and purpose to a different profession of faith and different standards, so that a work is often executed according to principles contrary to those of the critic. This happens because exclusiveness is the general rule.

Art, particularly the art of painting, cannot be defined, because a thousand special definitions could be made, all of which are good, inasmuch as each contains some of the thousand facets of the marvelous gem which is called Painting.

One defines those things which have definite limits, which are unalterable, and which are known. Now, art always marches forward, and we who are hardly able to count what art has produced until now cannot say what it is, much less what it will be. We cannot say what new aspect the combative youth that is there will reveal to us. We can only say that art is the eternal skein that unwinds in every century and that no century will finish unwinding. It is like Jacob's ladder, which, starting on earth, continued to heaven, where only angels ascend.

The definitions of art can only yield the individual or, at most, the school—which will forever be a marker of relative progress even when the principle that shaped it is changed. The academies were born out of the definition of art applied to education, so that as art advanced, the definition and, consequently, the teaching were found to be false and defective. . . .

Let us therefore set aside for further study our profession of faith, but, beyond that, let us accept the artists for what they are, with their strengths and their weaknesses. As we look at their work, let us try to put ourselves in their footsteps, follow their intentions and the path taken to attain them, and let us set down our observations not dispassionately, which does not seem to me humanly possible, but sincerely and without rejecting any sort of merit. And while respecting each artist's way of seeing, it is well to remember that the critic must not force the artist to do this or say that, but must limit himself to seeing whether what the artist wanted to say is said well or badly—remembering that a perfect picture perhaps does not exist and, in fact, individuality may consist of a predominant idiosyncrasy raised to sensitive understanding . . .

Many reviews and articles have been published on this Third Exhibition of the Promotrice: a fact which is a panegyric to the artists and a good indication of the popularity that art is gaining among us. Therefore, I do not mean to redo a complete examination of the works shown. The exhibition is already closed, and I would arrive late. Besides, it has been done already and frequently felicitously by various unknown writers; furthermore, I don't feel equal to the task. I intend only to take the opportunity offered by some paintings to talk about art just as the painters do in their studios, where they fight about their works with such frank determination that they become better friends than before. Therefore, I will be frank . . .

Execution and Truth

. . . Among the works in the exhibition that lend themselves best to discussion are, without doubt, those by Girolamo Induno: the *Lodging Bill*, the *Sad Foreboding*, and the *View of Pescarenico*, a village gracefully situated on the water. I will begin by saying that I would take all three of the paintings and carry them home with me—sharing in this the opinion of many of his admirers.

Induno is an artist who knows what to do, and in his paintings everything is done well from one end of the canvas

to the other. He always has a mastery of his brush, which runs swiftly to define his subjects, and in everything that spontaneously issues forth from his hand; there is a certain elegance which arrests our public, unused as it is to finding these qualities in our artists, who tend to be careless or even vulgar.

This skill of which I speak is even a bit excessive in the *Pescarenico*, where the cottages, the windows, the reflections in the water, the boats with figures are sketched with the hasty writing of a vignette. The *Lodging Bill* is more solid. The placing of the three figures is most lifelike. The characters are happily conceived and the head of the mayor, or his delegate, is as thoughtful as the hand that cradles his chin. The room, the chair, and the little table have the authentic flavor of a municipal office.

But the *Sad Foreboding* seems to be only a pretext for the artist, who evidently had thought more about painting a bachelor's room—in which a beautiful girl in her shift neither stands nor sits—rather than painting the sadness of any foreboding. Nothing is sad in that room. Induno's painting is light, easy, without any inner turmoil. His execution, which can be thought of as graceful, skims over the surface of the objects and conceals the difficulties without overcoming them. One would think that he fears light and shadow. His light tones are dull, his dark ones are muffled. For instance, in *Sad Foreboding* a ray of sunlight that grazes the window shutter strikes the two pilasters of the fireplace at the left end of the room, and this has less light on it than there is on the woman's flesh and her shift, whereas it should have been many degrees brighter than all the rest of the whole painting, putting in the room that half light full of reflections and harmony which turns painting into music. Not that his intonation is on a *light* scale, but it is devoid of relationships between one object and the next. After all this, I repeat, I would willingly take Induno's paintings as those of an artist who, at the point he has reached, could not acquire the qualities he lacks without losing the very fine ones he now has. . . .

The *Macchia* and the Finished Painting

One word that is the burden of almost every artistic debate
or discussion and in many instances is a good escape from
embarrassment for many art critics is the word *macchia*. I
don't know the origin of it and I don't understand the reason
for the meaning of this word, but since all accept it we must
put up with it. The *macchia* is said to be the general impres-
sion of the color or of the effect, so that a finished painting
has its *macchia*, and when the painting is limited to a hint or
harmony of the color, the painting itself is called a *macchia*.
All this, as you see, is inadequate and vague and gives no idea
of what the finished painting really is. A work by Giovanni
Ponticelli, *Torquato Tasso in Company of Sciarra Colonna*,[2]
would, according to this nomenclature, be a *macchia*. In
fact, it is not a finished painting, though not in the sense
usually attributed to the word finished, because I cannot see
in what way Ponticelli's painting is less finished than the one
by Achille Guerra, *The Cardinals Sent to Cesare Borgia*,[3]
which is one of the most meticulously worked of the entire
exhibition. I name these two pictures in the same breath for
the very reason that they are immensely different. I recognize
the diversity of tendencies and theories of art of the two art-
ists. But it is not a question of that.

I mention them together in order to prove that two pic-
tures, diametrically opposed in their execution, can both be
finished paintings; and in this case neither one nor the other
is finished. In Guerra's painting no tiny detail is neglected,
nothing escapes his carefully sharpened brush, not a lace of
the hose, nor an eyelash, a fingernail, not even a hair. In Pon-
ticelli's picture, on the other hand, the painting is on a large
scale, with wide planes, broad brushstrokes, and heavy color.

[2] [Torquato Tasso (1544–95), the poet and author of *Rinaldo*
(1562) and *Jerusalem Delivered* (1575). The Sciarra Colonna were
a branch of the Florentine Colonna family.]

[3] [Cesare Borgia (1476–1507), the son of Pope Alexander VI, was
made a cardinal after his father was elected pope (1593). He led a
profligate life and five years later asked the College of Cardinals and
the pope for permission to renounce the priesthood.]

Evidently the first aims at drawing, the second at tone. Thus far there is nothing to say: An artist is the master of presenting to himself what pleases him best. Nor can he be held accountable for going in one direction or another. One must submit to his will and admire him if he succeeds in his aim. Therefore, the only mission of the critic is to see whether the aim is achieved. So I ask: Is Guerra's aim true drawing? Is Ponticelli's true harmony? It seems to me that in Guerra's [painting] the drawing is academic, niggling, outlined but without form, and that Ponticelli's placing of the color is not planned accurately. All that imposing landscape lacks solidity; the road and the land, uncertain in shadows and movement, are neutral and vaporous, almost like the mountains; without the tone of the crowd, which, while uniform, is very fine, the picture would be a total failure. And I dare say, as a simple personal opinion, that if Guerra had omitted some shrill tendencies of color and, instead of floundering between two opposite principles of art, had composed his picture well, and if Ponticelli had suppressed even the few heads and occasional legs that one recognizes in his canvas and had obtained a more truthful tonality—I dare say that their paintings would be finished pictures, that is to say, each one would have attained the truth by his own means. I would say the same of the painting by Michele Tedesco, *The Friends of Dante's Childhood*. The predominant feeling of this painting is that certain poetic calm of eventide which transfuses the figures and harmonizes with sweet song. This is surmised but not described. It has been thought of but not yet painted: And precisely because it is only guesswork this picture leaves a void for the spectator, as though those flat and even tones were only prepared for eventual painting and the picture removed from the easel ahead of time.

The finished painting, therefore, would not be one that is minutely finished or without gaps but one where the predominant quality—that which determines the character of the painting and is the expression of the artist's manner of seeing —is revealed in a perfect manner.

Some paintings have a bit of everything, a little drawing, a little color, a bit of thought, an ounce of everything, executed

neither badly nor well, balanced as a scale. These are not finished pictures but correspond in painting to those people in the world who have a dusting of everything, a bit of science, a bit of literature, a bit of art, who are acquainted with everything and know nothing. I confess that I prefer absolutely ugly paintings to this kind of work, just as I prefer elegant idiocy to light and ignorant encyclopedists. . . .

The Subject and History Painting

As one looks at a painting, it is easy to see whether the subject has been truly felt by the artist and if some new aspect of the subject that had not occurred to earlier painters appears in the painting. This would seem to prove that the subject, whether historical or not, is within the artist, that it is the result of thoughts that have been revolving in his head and wandering spiritlike for a long time before finding a garment of colors in which to show themselves and become a painting. Since the subject is the creation of the painter, ten painters can use it, each in a different way; otherwise the repetition of the subject would be a theft. We all know that Tasso read his poems to the court of the d'Este, and that half a dozen pictures of Tasso reading at court have been painted. Despite all this, Domenico Morelli has taken up this subject and has made of it a new thing, and I do not hesitate to say that it is the best work in the exhibition. Every time one sees the picture, one is left with the eager desire to see it again. . . .

Who would have thought that representing a man reading a page to three women could be the cause of so much poetry? Afterwards I read in the catalog—so I know that this man is Torquato Tasso—that the ailing woman is Leonora d'Este, and that those other two women are princesses, whose names are of no importance to me.[4] With this information I could

[4] [Torquato Tasso (see footnote 2) joined the court of Cardinal Luigi d'Este at Ferrara in 1565. In later years, because of his mental instability, Tasso was institutionalized by Duke Alfonso II d'Este, but it was believed by many, including Goethe (whose *Torquato Tasso* was published in 1789) that the duke had locked him up as a result of a romance between Tasso and the duke's sister, Leonora d'Este.]

determine whether the artist has done the historical research for the costume, the faces, the ages of his characters; but this does not change the situation, and the true subject of the painting always remains the feeling that an artist perceives in a situation. This work alone would suffice to establish the fame of the artist and the painter. What makes you feel all the poetry you feel in the subject is precisely the execution, conceived as an impression of truth. The light that is in the picture helps to explain the subject. . . . What is indescribable in this painting is the air that circulates around the figures and actually breaks the flatness of the canvas. And if only the yellow wall on the left were just a little more in place and the shadow of Tasso's right hand were less transparent, I would say that this painting had been completely achieved. The way it is now appears to me a masterpiece.

And after this I beg you, let us leave the usual disputes about historical or genre painting. They would not advance painting an inch and the painters would keep on making paintings in their fashion, which is the best thing in the world. It is simply a question of epithets, and it does no one any harm if someone still wants to use conventional jargon or if, when in doubt about whether a painting should be described as history or genre, someone wants to invent a third word as conventional as the first. The evil begins when, by using this jargon, someone wants to establish a scale of preeminence in painting by putting one kind above another, a scale that in reality does not exist. The harm of such ideas is greater than one thinks. They have destroyed some capacities and inflated many other artistic incapacities of persons who, instead of looking into themselves to find there the concept of their painting and shaping it into a subject, have believed that by leafing through the first history book that has fallen into their hands and fishing out any hero who achieves any heroic action and making out of him a well-balanced composition, they could obtain a historical painting as a result. Later, with their heads held high and deploring the fall of painting into genre, they have considered themselves the representatives of great historical painting—and all that in good faith. Had they not copied to the letter everything the book

said? There is only one difficulty, which is the fact that paint-
ing will be, first of all, a witness to the art of painting and
never a historical narrative or a chronicle. Since painting is
free, a subject can voice the artist's judgment on certain indi-
viduals, certain events, and certain customs that have taken
place in ancient or modern history and involve society. But
then that will only be the artist's own idea shaped according
to his own premise of what may never have existed, which
the artist creates and perhaps no history records. . . . In con-
clusion, it will be necessary to call each revelation of a social
thought historical.

For my part, I will set these questions aside, preferring to
believe that choice of subject is a consequence of the aspira-
tions and character of the artist, that the subject will be more
or less important according to the more or less elevated feel-
ing of everyone; but that the best painting is not the one that
belongs to one type or another but the one in which the art-
ist's intention in the field of painting is most completely ex-
pressed . . .

Vittorio Imbriani: *The Fifth Exhibition of the Società Promotrice*[1]

To Saro Cucinotta: FIRST EPISTLE. . . . Art invites us to
a banquet here in Naples, not to speak in metaphors, for the
Exhibition of the Promotrice is to open. I want to write you
at length and have you attend at least in spirit.

It opens in the refectory of the former convent of S.
Domenico Maggiore, on the floor above the S. Tommaso
d'Aquino School, now the assembly room of the Pontaniana.
There, where a flock of gravy-stained, unimaginative monks
ate and drank, there our painters will exhibit their attempts
to embody the Ideal. . . .

The Promotrice will doubtless contain a lot of trash,
but that trash has to be there, otherwise the exhibition

[1] [First published in *La Patria*, December 25, 1867, and January
3, 9, 12, 14, 1868. Translated from Vittorio Imbriani, *Critica d'Arte
e Prose Narrative*, a cura di Gino Doria (Bari: Giuseppe Laterza e
Figli, 1937), pp. 6-7, 41, 51]

would not reflect the state of the arts among us. That trash is admired, praised by many and, alas, fulfills the aesthetic needs of our country. It would be foolish to deny the fact. It would be childish to be irritated by it. It is for serious men to try to comprehend it and to ascertain the reason for it. I will try to be aware and to make you aware of everything with that impartiality I profess. . . .

I detest self-importance, everything half naked and half prettied up. I want the account of an epoch or of a person to be represented to me with the beautiful parts and the defective parts equally outlined. . . .

FOURTH EPISTLE, January 9, 1868. When the philosophers admitted Art into the circle of their disquisitions, they said in their agreeable language that in every work of art—poem, score, statue, building, painting—there had to be an Idea. They spoke well indeed, but they did not speak clearly, and unfortunately they themselves were deceived by their polysensical vocabulary and were misunderstood by the public and by artists. I, too, erred; I confess it and repent. Padre Ciarusarvangadàrsana, prostrate at your holy knees, and full of contrition for my *Letter About Bernardo Celentano*, I retract everything, from the first syllable to the last. Absolve me for not having had sufficient judgment even to suspect, at the very least, that the pictorial idea could and must differ substantially from the poetic; pardon me for having presumed to reduce paintings to learned pages of books. Pardon this unpardonable foolishness only out of regard for the repentance I feel and because of the virtue I demonstrate in shaming myself so publicly for the greater edification of the very few who take art seriously.

Yes, gentlemen, every painting must contain an idea; but a pictorial idea, not just a poetical idea; just so, every poem must contain an idea, but a poetical idea, not just a philosophical one. And all of the doctrine that might be transfused into it does not make a poem of Giambattista Vico[2]

2 [Giambattista Vico (1668–1744) was a philosopher with a particular interest in cultural history. His major work was *Scienza Nuova* (1725), but as a young man he also wrote poetry.]

readable, just as all of the poetry with which they are crammed is not enough to satisfy the eye in the frescoes of Kaulbach there in the stairway of the New Museum in Berlin.[3] Even every plant and animal contains an idea, although in these it is no longer syllogism and ratiocination: it is vegetation, it is life. When the idea of beauty is given definition in the artistic idea, it is modified by every Art in such a way as to change nature and appearance completely. But don't think that it is like the same water transformed into drops of various forms and colors. Not at all. It is carbon which becomes both coal and diamonds. I might call this phenomenon ideal isomorphism. That which is *thought* in poetry is *motive* in music and *type* in sculpture.

But of what does the pictorial idea consist? What is the thing that constitutes the painting and that it cannot be without, at least if it is to be called a painting? The soul, in brief, of the painting? Well, I believe it to be the *macchia*, a word whose meaning I am going to take the liberty of defining at length in order to avoid equivocations like those provoked by *idea*.

I remember that one time in your studio you showed me the album printed for the Florentine Exhibition of 1861. Seeing I was not content with the engravings and photographs, you took the volume from me, saying you wanted to show me the best thing in it. The best thing was a fly flattened between two pages, just as nicely as could be. And you exclaimed, "Look what a beautiful spot [*macchia*]! There, truly, is a picture! . . ." These words made me reflect, and I remembered how as a boy I used to sprinkle ink on a piece of paper, then fold it, and be delighted by the variegated designs, by the spot [*macchia*] which resulted.

If in an inkspot, in a squashed fly there can be a picture—in a rudimentary state, to be sure—it is evident that the essential element, the constituent, of this picture is not in the expression of the faces, the perspective, the disposition of the groups, nor in as many other accidentals to which excessive value is attributed by this one or that.

[3] [Wilhelm Kaulbach's frescoes in the Treppenhaus of the Neues Museum in Berlin were begun in 1847. See p. 179.]

Another time I was in that studio of Filippo Palizzi, which you know well, similar to which, with the simple addition of a couple of houris and a cupboard well stocked with food and drink, I should picture paradise, in case I had the weakness to believe in it. Why? Because I can't conceive of greater enjoyment and delight than that which I find in contemplating the *studies* which line its walls. But let's return to the theme. Among the many paintings, on one wall hung a tiny sketch a few centimeters across, splendidly framed, in which there were only four or five brushstrokes. Well, in all conscience, Ciarusarvangadàrsana, I tell you—you doubtless remember the tiny piece—those five brushstrokes representing nothing at all definable were so happily composed that no other painting in the two rooms, no matter how perfect plastically or interesting in subject, seemed to me to equal them. That formless harmony of colors moved me to spirited gaiety. I could not take my eyes from it, and the more I looked at it the more my imagination swarmed with harmonious visions. In a word, it had stimulated the productivity of my mind, which is exactly the end that art purposes, since the modification to which art subjects material is but the means adopted to move my imagination. . . .

Every evening Filippo Palizzi, before closing up shop, washes his brushes, cleans his palette, and spreads with his palette knife the colors that remain on it over the white canvases destined to receive his future thoughts. Thus, he not only prepares the canvases with a layer of paint to which successive colors will better adhere, but often obtains some strange and singular shapes which arouse in him the idea for a painting which he later executes. And this last example serves to demonstrate how a simple indeterminate *macchia* may find definition not only in the mind of the spectator but also under the hand of the painter, who knows how to develop effectively from it that picture which our imagination constructed ideally. Michelangelo saw his statue in the rough form of the mass and did nothing more with the chisel than to remove a few importune flakes which partially hid it from him; and in the same way Palizzi, on some happy occa-

sions, only gives to the casual shape a somewhat greater precision of form.

And how many beautiful *macchia* are often made on the tablecloth from fallen drops of wine, tomato sauce, or coffee! And, speaking of that . . . what time is it? Five? Good-bye now; you are fine and good, these discourses are fine and good, but dinner is even better and finer. . . .

FIFTH EPISTLE, January 12, 1868. What, then, is the *macchia* reduced to final definition? An accord of tones, that is, of dark and light, capable of evoking in the soul a sentiment of any kind exalting the imagination to the point of productivity. And the *macchia* is the sine qua non of the painting, the indispensable essential, which can sometimes make one forget any other quality that might be absent and can never be supplied by any other. The *macchia* is the pictorial idea, as the musical idea is a given harmony of sounds from which the composer determines the theme. And just as there must be, at the root of the longest and most varied score, a fundamental theme from which everything organically unfolds and derives, so at the root of the most enormous painting, even if it is as large as Michelangelo's [Last] *Judgment*, there must be a particular organization of light and dark from which the work takes its character. And this organization of light and dark, this *macchia*, is what really moves the spectator. It is not at all, as the vulgar delude themselves, the expression of the faces or the sterile materiality of the bare subject. Likewise in music it is not the tacked on words, the libretto, but the character of the melody that produces emotion in the listener, wrings tears, quickens the pace, fills with fury, leads to dancing, and quiets the disturbed.

And here, my fine Ciarusarvangadàrsana, I am pushed by the demon against my will to consider a philosophical question, the position of which seems totally changed by the above ideas on the essence of painting and on the nature of the pictorial idea. You know that in aesthetics and disputes on the system of the arts every philosopher pretends to classify the arts in his own way, deducing criteria from the mate-

rials, from the states of the imagination, from the degrees of independence of the work. Saint Hegel[4] classified the arts into symbolic, classical, and romantic; Vischer, more Hegelian than Hegel, reduced them to the fundamentals that he and many others consider undeniable: *objectivity* (plastic arts), *subjectivity* (music), and *conciliation of objectivity with subjectivity* (poetry).[5]

Our Antonio Tari[6] opposes this classification and wants to dethrone poetry and make painting declare, "Esci di la, ci vo' star io." [Go out from there, there I want to stay.] You know Tari, he is a great philosopher like Giambattista Vico, and largely for the same reasons as Vico (it is not necessary to specify them here) is little appreciated by his contemporaries. When they stumble over a great genius these blessed Italians act like greedy children who, when the dessert is brought to the table, want to save it. But "he who saves, saves for the cat"; it happens, then, that a foreigner finds out and dresses himself up with our peacock plumes and—good night! someone is cheated out of an honest and merited glory. So Tari classifies the arts otherwise than all the preceding classifiers, concentrating attention only on the link between form and content. Thus he obtains three cycles: *semi-arts* (landscape gardening, music, dance, pantomime, ornament); *whole arts* (architecture, sculpture, painting, poetry, music); and *evanescent arts* (declamation, oratory, dialectic). Leaving aside the semi-arts and the evanescent arts, which would involve much discussion, let us note only how painting is actually placed by Tari at the vortex of the artistic pyramid and, according to him, bests even poetry, if not for comprehension and nobility of intention, at least for the normality of the organism consistent in the achieved equilibrium postulated in art between

[4] [Georg Wilhelm Friedrich Hegel (1770–1831), German philosopher; his *Philosophy of Art* was edited posthumously from his lecture notes.]

[5] [Friedrich Theodor Vischer (1807–87), German writer on the philosophy of art, was the author of *Ästhetik; oder Wissenschaft des Schönen* (1846–57).]

[6] [Antonio Tari (1809–84), philosopher of aesthetics; his major work was *L'Estetica Ideale* (1863).]

form and content. "Equilibrium which only painting, as its special aim, grasps. Art of sentiment and not of intellectuality; art of color and not materiality. Nature and Spirit, the world of things and that of ideas, meet in vision, an immaterially material point in which (as Byron said) only a look can contain an entire soul. So the rainbow of peace between *Form* and *Ideal content* does not show itself in the heavens of the arts except in the art of the brush."

However mad or impudent it may seem to rise up against an opinion of Tari, however the refutation of very great men must not be risked by one "Che star non posse con Orlando a prova" [who is no match for the mighty Orlando (Furioso)] I allow myself to oppose this classification and take sides with poetry, which Tari expelled rudely from its legitimate throne. Unfortunately, painting seems to me to remain a step lower, almost on a par with music, and to be but the music of colors as music is but the painting of sounds. These two arts are directed equally at the sentiment and move it, one with the harmonies of light, the other with harmonies of sound. Both have, then, an equivalent material element which keeps them in narrow confines: narrow, that is, in comparison with the infinite field that poetry occupies.

And now let us scrutinize the entire content of that *macchia* which we define as the harmony of light and shadow. Effects of light and dark are not presented without an effect of color; rather, color is the effect itself, it is light itself rendered visible by its relationship to shadow. Light and shadow, speaking absolutely, both deny the activity of the eye, which can see nothing defined in either, it is from their varied mixture that color results. This is the second element we find in the *macchia*, immediately after the tone. But under color there is yet something else. Color does not exist solely for itself, lodged in the air; just as the vine and the ivy do not mount to the sky under their own power but require some sort of support to maintain them upright, so color needs to rest on forms and incorporate itself in objects. Not otherwise than through the will of the philosopher or critic can it detach itself from these, in which it exists only, with-

out which it is not imaginable, and it pleases us in the degree to which it characterizes the object well. The squashed fly between the pages of your album, the little sketch with the four brushstrokes in Palizzi's studio, the rosy veining in my column of African marble, and the canvases smeared with colors left on the palette after a day's labor contain the harmony of colors necessary for a painting, impel my fancy to imagine this painting possible, but are not yet the painting. The first beat of the theme is certainly not the score, even though the entire score is only the development of that first beat. Color becomes a full element of art only when it serves to define the form that only it can characterize to the sense of sight.

We are now, then, in a position to explain more practically what the *macchia* is. It is the portrayal of the first faraway impression of an object or, rather, of a scene, the first and characteristic effect which is impressed on the artist's eye, whether he sees the scene or object materially or perceives them with his imagination or memory. It is the salient, the characteristic feature in the effect of light, produced by the special grouping of variously colored people or things. And when I say *faraway* I do not refer to the fact of material distance but rather to moral distance, which consists in not yet having taken in the full perception with all its particulars, an assimilation which can take place only through prolonged understanding, through loving attention.

To this first indeterminate, faraway impression that the painter affirms in the *macchia* there succeeds another [impression], distinct, minute, particularized. The execution, the finishing of a painting, is simply a continuous coming closer to the object, which extricates and fixes that which has passed under the eyes in a dazzling procession. But, I repeat, if it lacks that first fundamental harmonious accord, the execution and the finish, no matter how great, will never succeed in moving or evoking in the spectator any sentiment; on the other hand, the solitary, bare *macchia* without any determination of objects is most capable of arousing such sentiment.

Do not imagine that I think I am telling you anything very new: This theory can be seen *in nuce* in the words that Vin-

cenzo Cuoco[7] put in the mouth of the crotoniate [neo-Pythagorean] Nicomachus:

> Do you see that woman walking along the beach? The west wind now blowing in her face fills out her dress a bit and blows her hair about. The first image that comes to me is of an almost cylindrical mass of dark to which are attached two other masses which might be called conical, one at the head, the other, larger, at the feet, both having their vertices opposite the side from which the wind is blowing. This is the first image, confused, obscure; and if either I or the woman should pass in a hurry, this will be the only image that I shall have. But if I continue to observe her, this first image is little by little rendered more clear and more distinct. I shall observe all of the parts. The dark that the hair created for me will appear less dense than that of the dress, and this will even be a bit shaded in comparison with that of the body. Neither the one nor the other will seem to me any longer two cones, but the dress will be groups of different darks which fold gracefully one above the other . . .

Now note a phenomenon. In the painter's coming closer in his attention and execution to that which formed the *macchia*, it too often happens that part of the vigor is lost; in fact, it is sometimes lost entirely. How frequently are not the sketches for a painting, artistically speaking, a great deal superior to the executed painting itself, all polished and perfect. But it is always the case that the first cast of any work of art reveals more powerfully the artist and his thought than the work when bounded and complete. The very incorrectness which causes the character to be overstressed exaggeratedly in the first manifestation of a powerful impression adds strength to the manifestation. Execution weakens the first robust perception; close attention often generates confusion. The *macchia* is entirely the artist's; it is his own way of fixing the proposed theme, it is his idea, it is the subjective part of the painting; on the other hand, the execution is the objective part, it is the subject which takes on value and imposes itself.

[7] [Vincenzo Cuoco (1770–1823), Neapolitan writer and politician; his works included *Saggio storico sulla rivoluziana napolitana* (1801).]

He who succeeds in reproducing details with such exactness
as to create illusion, without in the least way weakening or
losing the expressive *macchia*, is, in truth, a consummate art-
ist and can boast of having produced a masterpiece by au-
tomatism. It sometimes happens; it is not impossible.

So, from a pure accord of tones the *macchia* is established
in the harmony of colors; and the color is determined in the
forms. It is well; the painting is finished. Let us consider a bit
the impression it produces on one who lingers to look at it. I
believe that in the effect of the pictorial work we shall find a
new reason for assigning it its place on the same step as
music. And it is resigned to remain without a murmur, except
in the crazy lucubrations of the not illustrious but famous
music of the future, which pretends to obtain from that art
that which it cannot give, just as it is impossible to squeeze
blood out of a turnip, that is to say, the determinateness of
the passion, the full and absolute individuality. But of this,
my boy, the day after tomorrow; that is, if the day after to-
morrow there still lives your Quattr' Asterischi.

1866 — 68: PARIS
The Official Exhibition of the State: The Salon

On May 1, 1866, while the gardens of the Tuileries were being prepared for the season's first concert by the Imperial Guard Band, the Salon of 1866 was opened in the Palais de l'Industrie by Marshal Vaillant, former Minister of War and now Minister of the Imperial Household and the Fine Arts. The official party walked through the galleries with satisfaction and confidence, for it was a Salon *comme il faut*. If there were few works distinguished enough to arrest the attention of viewers, there were no controversial canvases such as those which in previous years had aroused the ridicule of critics and public. Differences in technique and approach were apparent, but on the whole the exhibition maintained a high level of consistency—some might have called it monotony. The Salon had been organized by the Superintendent of Fine Arts, the Comte de Nieuwerkerke, with the cooperation of the jury and the full support of the government. Three years earlier, the controversy provoked by the Salon of 1863 and the simultaneous Salon des Refusés had demonstrated the need for reform in the jurying of the exhibition. The re-

sponsibility for initiating changes which would not compromise the government's authority over the Salon and would, at the same time, make room for the ever-increasing number of artists who sought admission had devolved to Nieuwerkerke.

Appointed by Napoléon III in 1863 to the newly created office of Superintendent of Fine Arts, which controlled all government art programs, Nieuwerkerke conscientiously attempted a gradual liberalization of the Salon. Coupled with the announcement, in June 1863, in the official *Moniteur* that a Salon would be held in 1864 was another announcement, namely, that henceforth it would be held annually rather than biennially, a concession to the demand of many artists for more frequent opportunities to display their work. In August 1863 it was announced that in 1864 each artist would be limited to two entries in order to reduce the number of works the jury had to consider while permitting more artists to exhibit, and that three quarters of the jury would be elected by artists who were either members of the Institute (i.e., the transformed Academy) had been decorated with the Légion d'honneur, or had won medals. One quarter of the jury would be appointed by the government. The same jury would also name the award winners. Works judged too weak to compete for the awards would be exhibited in separate galleries. These decisions were welcomed by some artists who had exhibited at the Salon des Refusés in 1863. One hundred artists, including the landscapists Daubigny and Troyon, signed an open letter praising the emperor for the liberal measures. The jury for the Salon of 1864 judged works by 529 artists "too weak to participate in the competition for an award," but when the Salon opened, of the 3,085 works exhibited only 375 by 286 artists appeared in this category. Though many preferred to remove their works rather than see them labeled unfit for competition, the remainder were pleased that their works were nevertheless exhibited. In 1865 this category was abandoned, but a lenient jury accepted 3,559 works.

The regulations for the Salon of 1866 remained unchanged from the year before; however, when the selections became known in April, it was evident that the jury had been much

stricter in making its decisions. Canvases by artists whose works had been accepted in the past were rejected, and the total number of exhibited works was reduced to 3,338, of which 1,998 were paintings. There was a storm of protest. Among the numerous letters received by Nieuwerkerke was one by an unknown painter who had submitted work for the first time, Paul Cézanne. A rejected painter whose two paintings had been accepted in 1865 committed suicide. Groups of artists demonstrated in the streets, calling the jury assassins, and were dispersed by the police. Some newspapers demanded a return to a type of Salon des Refusés, while others saw in the results proof that a jury elected by members of the Légion d'honneur and medal winners was no more liberal than that of the Academy. Charles Blanc, the editor and founder of the *Gazette des Beaux-Arts*, who had been active in the organization of the revolutionary free Salon held in 1848,[1] noted that this exhibition marked the centennial of the public Salon and questioned the appropriateness of its organization, asking whether the Salon should not be divided into two sections to accommodate the differences among the artists which had been evident since 1863.

A vehement attack on the jury, signed "Claude," astonished the readers of *L'Événement*, the daily paper launched by the flamboyant press lord Hippolyte Villemessant, whose first magazine, *La Sylphide*, had created a sensation with its perfume-scented pages and whose literary biweekly, *Le Figaro*, was notably successful. "Claude" was the pseudonym of Émile Zola (1840–1902), whom Villemessant had employed to write a column on "Books for Today and Tomorrow." Readers had found Zola's comments on literature diverting, and Villemessant had given his consent when Zola requested the assignment as critic for the Salon of 1866.

On April 27 and 30, 1866, the first two installments of "Mon Salon," as Zola called his review, appeared. Written before the exhibition opened, they attacked the jury and ended with a demand for a Salon des Refusés. *L'Événement's* sales soared. In the following weeks Zola explained the con-

[1] See *Triumph*, pp. 484–88

cept that was the basis of his aesthetic criticism: "A work of art is a corner of the universe viewed through a temperament."[2] Disdaining the customary language of the professional *salonnier* for the blunt style of a realist writer, he reported on what was to be seen at the studio of Manet, a rejected painter, rather than on what was to be seen at the Salon. Though he admired the earlier work of Courbet, Zola shied away from a complete reliance on "realism," the term seized by Courbet to signal his rejection of the style of conventional artists. For this reason, Zola was also impatient with Proudhon's interpretation of Courbet in *Du Principe de l'Art et de Sa Destination Sociale* (1865) as an artist who chose a subject for a social purpose; Zola saw Courbet as "simply a personality" who was "led by his very flesh towards the material reality which surrounded him, heavy women and powerful men, planted, fertile fields."[3]

Zola, who soon identified himself as "Claude," enjoyed a notoriety which continued even when Villemessant abruptly terminated "Mon Salon" (but not Zola's literary criticism) after numerous outraged readers canceled their subscriptions to *L'Événement*. To capitalize on the attention he had attracted, Zola published *Mon Salon* as a pamphlet in June. It was dedicated to the as yet unknown painter Paul Cézanne, and in the preface Zola identified himself with the misunderstood and rejected artists.

Zola and Cézanne, who had grown up together in the south of France, had attached themselves to the group of artists and writers in Paris that had first assembled in the late afternoons at the Café de Bade, located next to the Galerie Martinet on the boulevard des Italiens; in the winter of 1865–66 the group moved to the Café Guerbois, next to Père Lathuile's restaurant in the worker's district of the Batignolles. The group was composed of the poet-sculptor Za-

[2] Zola first expressed this idea in "Proudhon et Courbet," which appeared in the July-August 1865 issue of the *Salut Public*, published in Lyon.

[3] Zola, "Les Chutes" [Salon of 1866] in *Emile Zola, Salons*, edited by F. W. J. Hemmings and Robert J. Niess (Geneva: Droz, 1959), p. 74. Originally published in *L'Événement*, May 15, 1866.

charie Astruc, the novelist Edmond Duranty—he had published, together with Champfleury, the short-lived journal *Le Réalisme*—the art critic Théodore Duret, the engraver Félix Bracquemond, and the painters Degas, Bazille, Fantin-Latour, Pissarro, and the slender, fastidiously groomed Édouard Manet.

These artists and writers were exploring a world outside the one circumscribed by the conventions of composition, subject matter, and technique which the École des Beaux-Arts and the Academy had insisted should be respected. Discussions at the Café Guerbois centered on the relation of painting to nature and the technique which could best represent the visible world. The group's position had been stated by Manet in a reply to Thomas Couture, in whose studio he had studied between 1850 and 1856: "I paint what I see and not what it pleases others to see. I paint what is and not what does not exist."[4] Manet had met with little success in the official art world. Between 1859, when he submitted work to the Salon for the first time, and 1866 his paintings had been rejected as often as they had been accepted. The works which had been exhibited, including three at the Salon des Refusés, had aroused the public's antagonism and ridicule.

Manet's rejection of the conventions of painting had its literary counterpart in the harsh, realistic approach of Gustave Flaubert and the Goncourt brothers, whose novel *Germinie Lacerteux* had shocked Paris in 1864. In 1865 Zola's autobiographical novel *La Confession de Claude*, also won him mention as a writer whom "it is dangerous to read." As a result, he was asked to resign at Librairie Hachette, where he had been employed in the sales department. Zola adopted Balzac's method and the theses of Hippolyte Taine, who applied the technique of scientific investigation in the study of history, to his own novels. He defended the "kind of scientific analysis I have attempted" by arguing that in it the critics "will recognize the modern method of universal inquiry, the tool our age is using so enthusiastically to open up

[4] Quoted by A. Proust, *Édouard Manet, Souvenirs* (Paris, 1913), p. 31

a future."[5] In his book reviews for *L'Événement* Zola admitted he was severe in his criticism of works of pure imagination, "being unable to understand the necessity for dreams when reality offers such a human and gripping interest."[6] For the same reasons Zola preferred Manet's attempts to "interview reality" to the "confections of the artistic sweetmeat makers" which crowded the Salon walls.

If Zola's article on Manet reminded the public of the scandals of past years, the critics for the popular press were aware that the majority of the public visited the Salon in search of a pleasant distraction and sought to review the Salon in the same spirit. As A. J. Du Pays expressed it in *L'Illustration*, visitors who had been "offended by the roughness, the coarseness, the savagery of execution, the inaccuracies of the vaunted improvisors"[7] were pleased with Bouguereau's paintings of mothers and children and Gérôme's *Cleopatra and Caesar*, curious about the two works Princesse Mathilde exhibited, and surprised by Courbet's *Woman with a Parrot*, which suggested that this "revolutionary" had undergone a "conversion." . . .

On August 14, 1866, official functionaries, members of the jury, painters, sculptors, and the society leaders of the French art world assembled in the grand Salon Carré of the Louvre, as was customary for the awarding of prizes. Standing before Murillo's *Assumption* and facing Veronese's *Marriage at Cana*, the elderly Marshal Vaillant read his address. With well-chosen words he noted that the jury of 1866 had awarded no medal of honor. He conceded that "although the exhibited works are as numerous as in the past, and although the general level is quite high, the Salon this year was not as brilliant as usual." He quickly added that the decline should not inspire fear for the future of French art: "It seems that the French school is regrouping, conserving its strength, and many of the most famous among you have undoubtedly

[5] Zola, *Thérèse Raquin*, trans. Leonard Tancock (London, 1969), p. 17

[6] Cited by F. W. J. Hemmings, *Emile Zola* (Oxford: Clarendon, 1953), p. 22

[7] Du Pays, *L'Illustration, Journal Universel*, June 2, 1866, p. 342

remained occupied in your studios, putting the finishing touches on the works destined for the very important competition [the Universal Exposition] which will open next year."[8] Applause greeted his announcement that in 1867 the annual Salon would be held as usual; in 1855, when the last international exhibition was held, there had been no Salon.

Many were less pleased, however, when the regulations were published on August 22: One third of the jury members would be elected by the members of the Légion d'honneur and medal winners, one third would again be appointed by the administration, but the final third would be members of the Academy. Did this indicate that the reforms initiated three years earlier had been partially retracted? On January 22, three months before the Salon of 1867 was to open, Nieuwerkerke announced a change: Two thirds of the jury would be elected by the members of the Légion d'honneur and medal winners and one third would be appointed. Shortly after the Salon opened, the artists whose works had not been included again forwarded a petition demanding the reestablishment of the Salon des Refusés. Although Nieuwerkerke did not concede to this request, he again altered the jury composition for future years.

The regulations for the Salon of 1868 were made public on November 5, 1868. One third of the jury would again be appointed and the remaining two thirds would again be elected, but there was an important modification in the regulations concerning those eligible to vote: Any artist could vote who submitted work to the Salon and had had one or more works accepted at any previous exhibition, with the exception of that of 1848. Between 1864 and 1867 only artists who had been awarded official honors had been eligible to vote for jurors. The results were awaited with curiosity by artists, critics, and the public.

On May 2, 1868, the day the Salon opened, Paul Mantz, the well-known critic—his first reviews had been written for

[8] "Distribution des Récompenses aux Artistes Exposants du Salon de 1866," *Moniteur Universel,* August 15, 1866; quoted in catalog, Salon of 1867.

L'Artiste in 1845 and 1846—visited the exhibition. He re-
ported for *L'Illustration* on the effect of the new regulations:

> Let us not hesitate to say that the result has been excellent. A
> month before the opening of the Salon, the body of artists was
> animated with new life, groups were formed, rival lists circu-
> lated the studios, and then the vote was taken and a respon-
> sible jury was the result; equal to its delicate task, it honors the
> voters and all of us. Some beloved names, some names which
> are the pride of the French school, are included in the list, and
> universal suffrage, as one might have foreseen, has been at least
> as intelligent as restricted suffrage. We hope the administration
> has noticed the result.[9]

Continuing his review with a consideration of what was on
view, he commented on the two works in the Salon by
Manet, *Woman with a Parrot* and a *Portrait of Zola* painted
during the winter of 1867.

> M. Manet, whose name has become a kind of bugbear for
> peaceful men, is himself prey to many worries. A legitimate
> search, an apparently solid conviction inspired his first works.
> The frankness of tone and the bravura brush of the *Spanish
> Guitar Player* and the *Boy with a Sword* recalled the masters of
> seventeenth-century Spain. Since then M. Manet has strayed
> from these healthy practices. As a colorist he has less courage;
> in execution he is less original. He has taken an unusual fancy
> to black tones, and his ideal consists of opposing them to
> chalky whites so as to present on the canvas a series of more or
> less contrasting blobs. This manner, new to France, was for-
> merly used in Spain. El Greco and Goya himself sometimes
> played this game, but the former had seen Venice and even his
> shadows remained golden; the latter was very resourceful and he
> knew, fine printmaker that he was, how blacks and whites set
> each other off; these two masters understood, moreover, that
> color is a language, and they sought hazy, strident, or dramatic
> effects in order to translate an emotion. The need to express an
> emotion hardly torments M. Manet. He succeeds well enough
> in still life; as a portraitist he is less happy. In the portrait of
> M. Emile Zola the principal interest is not the subject but sev-
> eral Japanese drawings which cover the walls. The head is

[9] Paul Mantz, "Salon de 1868," *L'Illustration, Journal Universel,*
May 2, 1868, p. 283

indifferent and vacant, and as for the blacks which M. Manet boasts of loving, they are heavy and lack daring. In his other painting the artist shows us a young woman in a dressing gown standing beside the perch of a gray parrot; lying on the floor is an orange peel. Here the range of colors is delicately written. It is distressing that this woman does not have a comely head. M. Manet's intention, one must suppose, was to enter into a symphonic dialogue, a sort of duet between the woman's pink dress and the pinks of her complexion. He has in no way succeeded, because he does not know how to paint flesh. Nature has little interest for him; the spectacles of life do not move him. This indifference will be his downfall. M. Manet seems to have less enthusiasm than dilettantism. If he had a minimum of passion, he would excite someone, because there are at least twenty people in France who have a taste for novelties and boldness. But M. Manet does not even use his models or the resources of his palette. With the little he possesses, he could say something—and he says nothing.[10]

Perhaps in the hope of boosting its circulation, the little-known, recently launched *L'Événement Illustré*—it had no connection with the former periodical—asked Émile Zola to review the Salon. Zola's gruesome novel *Thérèse Raquin* had been denounced as pornography when it appeared in 1867, yet it had already gone into a second printing. Presented in seven installments, the first appearing on May 2, Zola's review discussed "The Opening," "Manet," "The Naturalists," "The Actualists"—as he dubbed Monet and Bazille, two artists who depicted contemporary life—"The Landscapists," "Several Good Paintings," and ended, on June 16, with his first discussion of "Sculpture," in which he questioned the relevance of conventional sculpture to the contemporary environment. A school companion from Aix-en-Provence, the sculptor Philippe Solari, was an exhibitor and in need of recognition; Zola discussed his work at length. Since a more indulgent jury had admitted the works of many of his friends, Zola muted his attack on the *peintres à succès* to discuss the quality of their work and to defend the painting technique of

[10] Paul Mantz, "Salon de 1868, II," *L'Illustration, Journal Universel*, June 6, 1868, p. 362

Manet, which, he felt, was beginning to receive the recognition he had prophesied for it two years before.

"Claude" [Émile Zola]: *Mon Salon*[1]

I. The Jury: April 27, 1866

The Salon of 1866 won't open until the 1st of May and only then am I permitted to judge the plaintiffs at the bar. But, before passing judgment on the artists admitted [to the Salon], I think it well to judge the judges. You know that in France we are very prudent, we never go anywhere without a passport duly signed and countersigned, and when we permit a man to do a somersault in public he must first have been examined at length by the proper authorities.

Since unsupervised manifestations of art could be the occasion for unforeseen and irreparable disasters, a guard is placed at the door of the sanctuary, a sort of customs house for the Ideal, charged with probing packages and expelling all fraudulent merchandise attempting to enter the temple. May I be permitted a comparison, perhaps a little farfetched? Imagine that the Salon is an immense *ragoût* which is annually served up. Each painter, each sculptor contributes his bit. However, since we possess a delicate stomach, it has been thought wise to appoint a whole battery of cooks to cook up these victuals of such varying taste and appearance. Fearing indigestion, the keepers of the public health were told: "Here are the ingredients for an excellent dish; be careful of the pepper, for pepper is heating; water the wine, because France is a great nation which must not lose its head."

After this it seems to me that the cooks have the stellar role. Since our admiration is seasoned for us and our opinions are predigested, we have the right to occupy ourselves first and foremost with these complacent gentlemen who are quite

[1] [Translated from *Emile Zola, Salons*, edited by F. W. J. Hemmings and Robert J. Niess (Geneva: Droz, 1959), pp. 50–69. Previously published in *From the Classicists to the Impressionists*, edited by Elizabeth G. Holt (Garden City, N.Y.: Anchor/Doubleday, 1966), pp. 371–88. Originally published in *L'Événement*, April 27, May 4, 7, and 11, 1866.]

willing to watch that we do not gorge ourselves like gluttons on bad *potage*. When you eat a steak do you worry about the animal? You think only of thanking or cursing the scullion who serves it too rare or not rare enough.

It is well understood that the Salon is not an entire and complete expression of French art in the year of our Lord 1866, but that it is most certainly a sort of *ragoût* prepared and simmered by twenty-eight cooks specially named for this delicate task.

A Salon, in our time, is not the work of artists, it is the work of a jury. Therefore, I concern myself first with the jury, the creator of those long, pale, cold halls in which are spread out, under a harsh light, all the timid mediocrities and reputations past their bloom.

Once upon a time, it was the Academy of the Beaux-Arts that tied on the apron and put its hand to the dough. At that time, the Salon was a gray, solid dish, invariably the same. One knew ahead of time how much courage one needed to have in one's pocket to swallow those classical morsels, solidly round, without even one poor little angle, which slowly and surely choked you. A methodical, well-grounded cook, she had her personal recipes which she never varied; she cooked with an unshakable calm and conviction. She managed, no matter what the temperament or the time, to serve up the same dish to the public. The good public, suffocating, complained at last. It begged indulgence and asked that it be served spicier, lighter dishes, more appetizing to the eye and to the palate.

You will remember the wails of that old academic cook. She was being deprived of the pot in which she had fried two or three generations of artists. She was left to whimper and the frying pan was given to other sauce curdlers.

Here one practical sense that we have of liberty and justice bursts forth. The artists complained about the academic coterie; they should choose the jury themselves, it was decided. From then on they would have nothing to fuss about; they would give themselves their personal, severe judges. Such was the decision.

Perhaps you think that all the painters, that all the sculp-

tors, all the engravers, all the architects were called upon to vote. It is quite evident that you love your country blindly! Alas, the truth is sad, but I must avow that only those name the jury who have no need of a jury. You and I, who have a medal or two in our pockets, are allowed to go and elect this one or that one, whom we do not care much about anyway, because he hasn't the right to look at our canvases, whose admission is already an accepted fact.

But the poor devil, tossed out the door of the Salon five or six years running, has not even the permission to choose his judges, but is obliged to submit to those we give him out of comradeship or indifference. . . .

. . . I do not know how these judges understand their mission. Truly they do not give a fig for truth and justice. To me a Salon is never just the statement of an artistic movement. All France, those who see white and those who see black, send their canvases to tell the public, "This is where we are, the spirit moves and we move; here are the truths which we believe we have acquired in the past year." But, men, being placed between the artist and the public, with their all-powerful authority, show only a third, only a fourth of the truth; they amputate and present to the crowd only its mutilated corpse.

Let them realize they are there only to keep out mediocrity and vacuity. They are forbidden to touch things that are alive and individual. They may refuse, if they please—actually it is their duty—pensioners of academies, bastard pupils of bastard masters, but, please, will they respectfully accept free artists, those who live outside, who search elsewhere and further afield for the strong and bitter realities of nature?

Do you wish to know how they proceeded to the election of this year's jury? A circle of painters, so I am told, made up a list which was printed and circulated through the studios of the voting artists. The entire list was accepted.

I ask you where is the interest of art among all these personal interests? What guarantees are given to young workers? Everything appears to be done on their account and they are declared difficult to please if they are not satisfied. We're joking, aren't we? But the question is a serious one and it is time

to take a stand. I would prefer to have that good old cook of an academy taken back. No surprises with her; she is constant in her likes and dislikes. Now, with these judges elected out of *camaraderie*, one no longer knows which saint to call on. If I were a needy painter, my great care would be to guess whom I would have for judge in order that I might paint according to his tastes.

Among others, M. Manet and M. Brigot, whose canvases were accepted in previous years, have just been refused. Evidently these artists cannot have done much worse, and I even know that their recent canvases are better; how, then, can this refusal be explained?

It seems to me that logically if a painter has been judged today worthy of showing his works to the public, his canvases should not be covered tomorrow. This, however, is the idiocy which the jury has just committed. Why, I will explain to you.

Can you imagine civil war among the artists? One group banishing another, those in power today show those in power yesterday the door. There would be a horrible uproar of hate and ambition, rather like a miniature Rome in the times of Sulla and Marius,[2] and we, the good public, are entitled to the works of the triumphant faction! O Truth, O Justice!

The Academy never altered its judgments in such a manner. It kept people waiting at the door for years, but once in she never chased them out.

Lord save me from harping too much on the Academy. Only, the bad is preferable to the worst.

I do not even want to choose the judges and designate certain artists as being impartial jurors; Manet and Brigot would doubtlessly refuse MM. Breton and Brion, as they refused them. A man has his unalterable sympathies and antipathies. However, here it is a matter of truth and justice.

Create, therefore, a jury, no matter which. The more mistakes it makes, the more it spoils its sauces, the more I will

[2] [The Roman generals Lucius Cornelius Sulla (138–78 b.c.) and Gaius Marius (155–86 b.c.) both wanted to be appointed as leader of the Roman army against Mithridates; they quarreled and their supporters rioted.]

laugh. Don't you think those men provide me with an amusing spectacle? They defend their little chapel with a sacristan's thousand petty tricks that I think funny.

But at least let us bring back the so-called "Salon des Refusés." I beg all my confrères to join me. I would that my voice were louder, that I had more power to obtain the reopening of those halls where the public went to judge in its turn, both the judges and the condemned. There, for the moment, is the only way of satisfying everyone. The rejected artists have not yet taken back their works; let us hurry to drive nails in somewhere and hang their pictures. . . .

III. Present-Day Art

Perhaps before publishing a particle of criticism, I should have categorically explained my views on art, what my theory of aesthetics is. I know that the bits and pieces of opinion which I have been obliged to let fall have contradicted accepted ideas and that these bald, apparently unsupported affirmations are resented.

I have my own little ideas like any other person. And like any other person, I think that my theory is the only true one. At the risk of boring you, I will set forth this theory. My likes and my dislikes are naturally deduced from it.

For the public, and I do not use the word in the derogatory sense—for the public a work of art, a picture, is an agreeable thing which moves the heart to delight or to horror; it is a measure where the gasping victims whimper and drag themselves beneath the guns which threaten them; or else it is a delightful young girl all in snowy white who dreams in the moonlight, leaning on a broken column. I mean to say that most people see in a canvas only a subject which takes them by the throat or by the heart and they demand nothing further of the artist than a tear or a smile.

To me, and I hope to many, a work of art is, on the contrary, a personality, an individual.

I don't ask that the artist give me tender visions or horrible nightmares, I ask him to give himself, heart and body, to affirm loudly a powerful and personal spirit, a strong, harsh character, who seizes nature in his two hands and sets it

down before us as he sees it. In a word, I have the most profound disdain for the little tricks, for the scheming flatteries, for that which can be learned at school, for that which constant practice has perfected, for all the theatrical *tours de force* of this Monsieur and all the perfumed reveries of that Monsieur.

But I have the deepest admiration for individualistic works which are flung from a vigorous and unique hand.

It is no longer a question here, therefore, of pleasing or of not pleasing, it is a question of being oneself, of baring one's breast, of energetically forging one's individuality.

I am not for any one school because I am for a true humanity which excludes coteries and systems. The word "art" displeases me. It contains, I do not know what, in the way of ideas of necessary compromises, of absolute ideals. To make art, is that not to create something outside of man and nature? I want them to create life; I want them to be alive, that they make new creations out of all contexts according to their own eyes and their own temperaments, that which I seek above all in a painting is a man, and not a picture.

There are, according to me, two elements in a work: the element of reality, which is nature; and the element of individuality, which is man. The element of reality, nature, is fixed, and always the same. It exists equally for everyone. I will say that it may serve as a common measure, if I admit that there may be a common measure.

The element of individuality, man, on the contrary, is infinitely variable. No two works or characters are the same. If it were not for the existence of character, no picture could be more than a simple photograph.

Therefore, a work of art must be the combination of a variable element, man, and a fixed element, nature. The name "realist" does not signify anything to me who declares reality to be subordinated to temperament. Be realistic, I applaud; but above all, be an individual and alive, and I applaud louder. If you depart from this reasoning, you are forced to deny the past and create definitions which you will have to enlarge each year.

For it is another good joke to believe that there is, where

artistic beauty is concerned, an absolute and eternal truth. The One and Complete Proof is not made for us who fabricate every morning a truth which we have worn out by evening. Like everything else, art is a human product, a human secretion; it is our body which sweats out the beauty of our works. Our body changes according to climate and customs and, therefore, its secretions change also.

That is to say that the work of tomorrow cannot be that of today; you can neither formulate a rule nor give it a precept; you must abandon yourself bravely to your nature and not seek to deny it. You who spell your way painfully through dead languages, are you afraid of speaking your mother tongue?

IV. M. Manet: May 7, 1866

. . . I wish to explain my feelings about M. Manet as plainly as possible, not wanting any misunderstanding to exist between the public and myself. I do not and will not admit that a jury has had the power to prevent the public from viewing one of the most truly alive individuals of our day. My sympathies lying outside the Salon, I will not go into it until I have satisfied elsewhere my need of admiration.

It seems that I am the first to praise M. Manet unreservedly. This is because I care little for all these boudoir paintings, these colored engravings, these miserable canvases where I find nothing alive. I have already said that character alone interests me.

I am accosted in the streets and told "you don't really mean it, do you? You're just starting out and want to draw attention to yourself. But since we're alone, let's have a good chuckle over the oh-so-funny *Dîner sur l'herbe* [later known as *Déjeuner sur l'herbe*], the *Olympia*, the *Joueur de fifre*." . . .

The majority opinion of M. Manet is as follows: M. Manet is a young dauber who locks himself in to smoke and drink with ne'er-do-wells of his own age. After he has drunk several kegs of beer the dauber decides to paint some caricatures and exhibit them that the public may make sport of him and remember his name. He goes to work, he does

unheard of things, he holds his sides in front of his own picture. He dreams only of making fun of the public and making a reputation as an eccentric. . . .

I have been only once to M. Manet's studio. The artist is of medium stature, more slight than otherwise, with blond hair and a delicately colored face. He seems to be about thirty, his glance is quick and intelligent, his mouth mobile and slightly mocking from time to time. His whole face, irregular and expressive, has a certain indescribable fineness and energy. Even so, the man expresses in his gestures and in his voice, a profound modesty and gentleness.

He, whom the crowd treats as a waggish dauber, lives a secluded life with his family and keeps the regular hours of a bourgeois. He works relentlessly, always searching, studying nature, questioning himself and going his own path. . . .

I saw *Dîner sur l'herbe* again, that masterpiece exhibited at the Salon des Refusés and I defy any of our fashionable painters to give us a wider horizon or one more filled with light and air. Yes, you are still laughing because you have been spoiled by M. Nazon's voilet skies. This well-constructed nature should displease you. Also, we have neither M. Gérôme's plaster Cleopatra, nor M. Dubufe's pretty pink and white demoiselles. Unfortunately all we can find there are everyday people who make the mistake of having muscles and bones like everyone else. . . .

I saw the *Olympia* again too, which has the serious fault of resembling many young women of your acquaintance. Also, is it not an odd idea to paint differently from the others? If M. Manet had at least borrowed M. Cabanel's rice powder puff and applied a little makeup to Olympia's cheeks and breasts, the young lady would have been presentable. There is a cat there too that greatly amused the public. It is true that this cat is very comical, isn't it? and that one must have been mad to have put a cat in that picture. A cat, imagine that! and a black cat to boot! . . .

This is the impression above all that this canvas left with me. I do not believe that it is possible to obtain a more powerful effect with less complicated methods. . . .

You know what effect M. Manet's canvases produced at

the Salon. They simply burst the walls. All around them are spread the confections of the artistic sweetmeat makers in fashion, sugar-candy trees and pie-crust houses, gingerbread men and women fashioned of vanilla frosting. This candy shop becomes rosier and sweeter, and the vital canvases of the artist seem to take on a certain bitterness in the midst of this creamy flood. The faces made by the grown-up children who go through the hall are something to see. For two *sous* you could never get them to swallow honest, raw meat, but they eagerly lap up all the nauseating sweets they are served.

Never mind the neighboring paintings. Look at the living people in the hall. Study the contrasts of their bodies to the floor and the walls. Then look at M. Manet's canvases: you will see that they are true and powerful. Now look at the other canvases, those stupidly smiling ones around you; you break out laughing, don't you?

M. Manet's place is marked out in the Louvre as is that of Courbet and of every artist of a strong and unyielding temperament. Besides, Courbet and Manet have not the least resemblance to each other and if these artists are logical they should deny each other. It is precisely because they have nothing in common that each can go his own way.

I do not have a parallel to establish between them. I obey my own manner of seeing by not measuring artists according to an absolute ideal and by only accepting unique individuals who affirm themselves in truth and power.

Émile Zola: *My Salon*[1]

II. Édouard Manet: May 10, 1868

I just read, in the latest issue of *L'Artiste*, these words of M. Arsène Houssaye: "Manet would be an outstanding artist if he had a hand. It is not enough to have a brow which thinks, an eye which sees: it is also necessary to have a hand which speaks."

To me that is a precious acknowledgment to have won. I

[1] [Translated from *Emile Zola, Salons*, edited by F. W. J. Hemmings and Robert J. Niess (Geneva, 1959), pp. 122–26]

note with pleasure the statement by the poet of refinements, the novelist of great ladies, that Manet has a thinking brow, a seeing eye, and that he could be an outstanding artist. I know that there is a reservation, but this reservation is easily understood: M. Arsène Houssaye, the gallant epicurean of the eighteenth century, lost in our time of prose and analysis, wants to attach several "mouches"[2] and a dash of rice powder to the serious and precise talent of the painter.

I will respond to the poet: "Do not wish too strongly that the original and obstinate master of whom you speak had a hand which said more than it did, more than it should. Look at the paintings full of curiosities, of clothing in *trompe l'oeil* at the Salon. Our artists' fingers are too skillful. If I were the grand justiciar, I would cut off their hands, I would open their eyes and minds with pincers."

Moreover, at present M. Arsène Houssaye is not the only one who dares to find some talent in M. Manet. Last year, when the artist held a private exhibition, I read praise of a large number of his works in several journals. The inevitable, necessary reaction which I predicted in 1866 is quietly happening: the public is becoming accustomed to his work, the critics are calming down and are willing to open their eyes; success is on the way.

It is above all among his fellow artists that Édouard Manet finds a growing sympathy this year. I do not believe I have the right to cite here the names of the painters who welcome the portrait exhibited by the young master with frank admiration, but they are many and are among the leading painters.

As for the public, it still does not understand, but it no longer laughs. I amused myself last Sunday by studying the physiognomies of the people who stopped before Édouard Manet's canvases. Sunday is the day of the thronging crowds, the day of ignoramuses, those whose artistic education is still to be acquired.

I saw people arrive who came firmly determined to entertain themselves a little. They stood with their eyes in the air,

[2] [*Mouches* are beauty spots, especially the artificial ones fashionable in the eighteenth century.]

their mouths open, all put out, not finding the least smile. Without knowing it, their gazes had become accustomed to his work; the originality which had seemed so enormously funny no longer caused them anything but the anxious surprise of a child faced with an unknown spectacle.

Others enter the room, glancing the length of the walls, and are attracted by the strange refinements of the painter's work. They approach; they open the catalog. When they see the name Manet, they try to burst out laughing. But the canvases are there, clear and luminous, seeming to look back at them with a serious and proud disdain. And they leave, ill at ease, no longer sure what to think, moved in spite of themselves by the severe voice of talent, ready to admire in the coming years.

In my mind, M. Manet's success is complete. I never dared dream that it would be so rapid, so honorable. It is remarkably difficult to make the wittiest people on earth realize their mistake. In France, a man at whom one has foolishly laughed is often condemned to live and die a laughing stock. For a long time to come you will see jokes about the painter of *Olympia* in the small newspapers. But after today, intelligent people are won over, the rest of the crowd will follow.

The artist's two paintings are unfortunately very badly hung, in corners, very high, beside the doors. . . .

I will not speak of the painting entitled *A Young Woman*. It is familiar; it was seen at the artist's private exhibition. I only advise the clever gentlemen who dress their dolls in gowns copied from fashion plates to go to see the pink dress which this young woman wears; it is true that one cannot identify the texture of the material, one cannot count the needle holes, but it falls marvelously over a living body; it belongs to the family of supple and handsomely painted fabrics which the masters tossed over their subjects' shoulders. Today, painters get their supplies at a first-rate dressmakers, just like a lady.

As for the other painting.

One of my friends asked me yesterday if I would speak of this painting, which is my portrait. "Why not," I responded. I would like to have ten columns to repeat aloud everything

that I quietly thought during the sittings as I watched M. Manet wrestle with nature. Do you think my pride is so slight that I take some pleasure in talking to people about my face? Certainly, I will speak about the painting, and the malicious jokers who find something in this for their witticisms are simply imbeciles.

I remember the long hours of posing. In the numbness which took hold of my immobile limbs, in the weariness of gazing into full light, the same thoughts always floated through me, with a soft and deep noise. . . .

I thought for hours on end about the destiny of individual artists which makes them live apart, in the solitude of their talent. Around me on the walls of the studio were hung the powerful and distinctive canvases which the public has not wanted to understand. It is enough to be different from others, to think privately, in order to become a monster. You are accused of knowing nothing about your art, of making fun of common sense, just because the knowledge of your eye, the thrust of your temperament lead you to original results. As soon as you do not go along with the broad stream of mediocrity, the fools stone you, treating you like a madman or an egocentric.

While sifting through these ideas, I saw the canvas fill. What astonished me was the artist's extreme conscientiousness. Often when he was tackling a secondary detail, I wanted to leave the pose and gave him the bad advice that he improvise it.

"No," he answered, "I can't do anything without nature. I do not know how to invent. As long as I tried to paint according to the learned formulas, I produced nothing that was worth anything. If I am worth anything today, I owe it to precise interpretation, to faithful analysis."

That is his talent. He is above all a naturalist. His eye sees and renders objects with an elegant simplicity. I know well that I cannot make the blind like his paintings, but true artists will understand me when I speak of the slightly bitter charm of his works.

The portrait he exhibits this year is one of his best canvases. The color in it is very intense and of a powerful har-

mony. It is, nevertheless, a painting by a man who has been accused of knowing neither how to paint nor how to draw. I challenge any other portraitist to put a figure in a room with equal energy, without the surrounding still life encroaching on the head.

This portrait is a collection of difficulties overcome. From the frames in the background and the charming Japanese screen at the left to the least details of the figure, everything takes its place in a scale that is knowledgeable, light, and dazzling, and so real that the eye forgets the accumulation of objects and sees simply a harmonious whole.

I do not mention the still life, the accessories and the books that are lying about on the table; Édouard Manet is a past master in this area. But I will point out in particular the hand placed on the subject's knee; it is a marvel of execution. At last here is skin, real skin, without ridiculous *trompe l'oeil*. If the entire portrait could have been pushed to the same point as this hand, the crowd would have proclaimed it a masterpiece.

I will end as I began, by addressing myself to M. Arsène Houssaye.

You complain that M. Édouard Manet lacks skill. In fact, beside him, his colleagues are wretchedly dextrous. I have just seen several dozen portraits which had been worked and reworked and could have served very well as labels on glove boxes.

Pretty women find this charming. But as for myself, since I am not a pretty woman, I think that these feats of skill deserve at most the curiosity offered by a petit point tapestry. The canvases of Édouard Manet, which are painted as a stroke like those of the masters, will be eternally interesting. You have said it: he is intelligent, he has an exact perception of things; in a word, he is a born painter. I think that he will be content with this great praise which he alone, with two or three other artists, deserves today.

1867: PARIS

The Universal Exposition:
The Exhibition by
an Artist of His Work

On April 1, 1867, Napoléon III, with the Empress Eugénie and the Prince Imperial beside him, walked with effort down the steps of the Palais des Tuileries to a waiting carriage. Despite his ill health, he glanced with satisfaction around the Place du Carrousel to the restoration of the Louvre's Pavillon de Flore, now nearly completed, a monument to his reign. A cannon shot announced the departure of the imperial party for the Champ de Mars to open the Exposition Universelle. The spring sun glistened on the helmets of the Imperial Guards; mounted on black horses, they escorted the imperial family among the Seine. "Huzzahs" marked their progress past the Palais des Champs-Élysées, where the Salon would open in two weeks. As he nodded to the crowd which lined the avenues, Napoléon III had time to review the history of the exposition.

He had not known, when he agreed to it in 1863, what a fortuitous event it was to be. Only the previous summer Prussia had demonstrated by her victory at the Battle of Sadowa (Königgratz), which ended the Austro-Prussian War, that she was now a power to be watched. In the European coun-

cils Napoléon III had seriously misjudged her strength, and he now hoped that the international exhibition would again focus attention on France as the center of Europe.

Following the 1862 exhibition in London, the head of the French commission, Comte Léon de Laborde, director of the Archives de l'Empire and a founder of the Union Centrale des Arts et de l'Industrie, had informed Napoléon III of the marked improvement in the English-designed goods, which matched the increasing efficiency of their machines. In January 1863, when he congratulated the exhibitors who had participated, the emperor reminded them that there was more at stake in these exhibitions than simply an opportunity for them to acquire new markets for their goods:

> Messieurs: You have worthily represented France in a foreign land. I thank you for it; for these universal expositions are not simple bazaars, but brilliant manifestations of the force and genius of the peoples. The state of society is revealed by the greater or lesser advancement of the diverse elements which compose it; and, as all progress marches abreast, the examination of any one of the multiplied products of intelligence suffices for the appreciation of the civilization of the country to which it belongs. It is not, then, a matter of indifference to the character of France to exhibit in the view of Europe the products of our industry; in fact, they alone testify to our moral and political condition.
>
> I congratulate you upon your energy and your perseverance to rival a nation which is in advance of us in certain branches of industry. And here, at last, we see realized that formidable invasion of the British soil so long predicted. You have crossed the Channel. You have boldly established yourselves in the capital of England. This campaign has not been without glory; and I come today to give you the recompense due to the brave.
>
> This kind of war, which makes no victims, has much merit. It stimulates a noble emulation, promotes those commercial treaties which bring peoples together, and causes national prejudices to disappear without diminishing love of country. From these material exchanges there springs up an exchange still more precious—that of ideas.[1]

[1] John Stevens Cabot Abbott, *The History of Napoléon III, Emperor of the French* (Boston, 1870; c. 1868), p. 608

When he agreed to the Parisian exposition of 1867, the emperor knew that if France was to maintain the lead she had gained through the exhibition of 1855, she would be obliged to mobilize all her resources. State support for the Écoles de Dessin, which trained designers, was increased. He had assigned full responsibility for the building and organization of the exhibition to Prince Napoléon, "Plon-Plon," the son of Jérôme Bonaparte. In his own hand the emperor had written the invitations to the heads of state throughout the world. In spite of the Austro-Prussian War, the response had been excellent.

Napoléon III realized that France had never seemed as prosperous as it did now in the spring of 1867. Millions of francs that had been poured into public works and the basic industries and railways now yielded higher and more equitable living standards. His astute awareness of the far-reaching implications of universal suffrage in 1850 and the role the masses now played in molding public opinion had assured support for him and his programs. Paris was again gay and animated, filled with millions of foreign visitors and provincial Frenchmen, as it had been in 1855. France was seen as Europe's leading power in the troubled international scene.

Napoléon III's thoughts were interrupted as the procession reached the Place de l'Alma. Glancing to the north, he saw the pavilion erected by the painter Courbet, of which Nieuwerkerke had spoken. Disdaining participation in government exhibitions, Courbet preferred to exhibit his work privately, even though his *Landscape: The Hidden Brook* had been purchased by Nieuwerkerke in 1865 and, as the property of the government, would hang in the Exposition Universelle. Next to Courbet's pavilion was another pavilion which Nieuwerkerke had said was being built by Manet to exhibit his paintings. These works did not meet the standards of the majority of the art community, which refused to accept *bizarrerie* for originality.

The view across the Seine to the exposition site was blocked by the long, low Halle des Machines until the Pont d'Iéna was reached and the procession turned to cross the river. Ahead of the imperial party now stretched the Champ de Mars, filled, as though by the wave of a magician's wand,

with exotic buildings from the four corners of the world. In the midst of the colorful pavilions was an immense oval building of cast iron and glass designed by the engineers Alexandre Gustave Eiffel and Jean Krantz to house the exhibition proper.

The imperial procession advanced up the flag-lined avenue d'Europe to the Porte d'Honneur. Greeted by Prince Napoléon, Princesse Mathilde, and Minister of State Rouher, the emperor proceeded down a long vestibule which led to the garden in the center of the building. After the commissioners of the foreign states were presented to him, the emperor began his two-hour inspection of the exposition, with the paintings and sculpture arranged in the galleries overlooking the garden.

The huge building, which covered 6,750,000 square feet of space—more than three times the space that had been devoted to the 1855 exhibition—was designed in the shape of seven concentric, elliptical galleries. Each gallery was devoted to a separate class of objects: The innermost ring housed the fine arts, the second ring materials used in the liberal arts, and the third furniture and articles necessary for dwellings. For the first time an exposition had been given a theme, "The History of Labor and Its Fruits," and the outermost ring contained exhibits representing manufacturing processes, from ancient to modern times, to illustrate the theme. Passages stretching from the central garden to the outermost ring cut the galleries into sections, and each section was assigned to a different nation. This ingenious system of double classification enabled the visitor to plan his tour of the building nation by nation or category by category. The scheme had the disadvantage of being somewhat inflexible: Not all the countries had the same amount of material in each of the seven categories. In the adjacent park a number of countries had increased the space allotted to them by erecting small buildings in their native style. There was a Swiss chalet, a Turkish mosque, an English lighthouse, and a Russian stable. Some of these buildings were theaters where visitors could enjoy singing, dancing, or dramatic performances; others housed restaurants where weary visitors could rest and compare their impressions as they sampled foreign delicacies.

The more than eleven million visitors included not only
the rulers of Europe, the Sultan of Turkey, and the brother
of the Tycoon of Japan but working men and artisans from
France and England whose journeys were subsidized by the
French Commission Ouvrière and the English Society of
Arts. The King of Bavaria spent many hours wandering
through the gardens incognito as the Count von Berg. The
Princess of Prussia, delighted with a suggestion that a "Con-
vention for Promoting Universally Reproductions of Works
of Art" be organized to enable museums to exchange repro-
ductions of the works lent to illustrate the history of labor,
obtained signatures from other royal visitors who approved of
the idea. The Goncourt brothers, who predicted in January
that the exposition would be "the last blow to the past: the
Americanization of France," were seduced by the fantastic
spectacle in May when they toured it with Théophile Gau-
tier:

> Little by little, things around us took on a fantastic appearance.
> The sky above the Champ de Mars put on the tints of an Ori-
> ental sky; the confusion of the constructions in the garden
> outlined against the violet sky the fretwork of a landscape by
> Marilhat; the domes, the kiosks, the colored minarets put into
> the Parisian night the reflected transparencies of a night in an
> Asian city. . . . And at times it seemed to us that we walked
> in an image painted in Japan, around this infinite place, under
> the roof which projected like that of a bonzery, lit by frosted
> glass globes, like the paper lanterns of a Feast of Lanterns; or
> even under the flapping standards and flags of all the nations,
> we had the impression of wandering in the streets of the Mid-
> dle Kingdom, as painted by Hildebrandt in his *Tour du
> Mond*,[2] under the clattering zigzags of their signs and their
> *oriflammes*.[3]

[2] [The Chinese referred to their country as the Middle Kingdom.
The German painter Eduard Hildebrandt (1818–68), influenced
by Humboldt, had traveled around the world in 1864–65. The
watercolor sketches he made during this journey were reproduced by
means of chromolithography.]

[3] Edmond and Jules de Goncourt, *Journal, Mémoires de la Vie
Littéraire*, vol. III (1866–70) (Paris: Flammarion, 1872–96), pp. 77
and 101

Painters and sculptors came from everywhere. As exhibitors, they came to appraise their position; if not exhibiting their works, they came to note the qualities which would secure their admission in the future. Adolf Menzel, who wrote on June 3 that he was still finding corners of the exhibition that he had not seen before, confessed that he would not have worried so much about the work he exhibited had he known what else would be on view.

The Fine Arts Gallery housed the largest collection of contemporary art the world had ever seen, containing painting and sculpture, executed between 1855 and 1867, from fifteen countries. Each participating country had arranged for a commission to select the artworks that would represent that nation and prepare them for exhibition. (Each country was also responsible for shipping the works and completing the flooring, decoration, and partitions in the area of the exhibition building assigned it.) Henry Cole, who led the English commission, complained bitterly when he realized what would be necessary:

> To invite people to show works of art when there is no commercial or indeed any other kind of motive but simply the desire to meet the wishes of a good neighbor, and to ask the senders to place them within bare walls, seems to me like inviting guests to come see you in their best clothes, jewels, and velvets and putting them into a temporary shed and telling them to furnish it at their own cost and make themselves comfortable if they can.[4]

On June 10, 1866, the vice-president of the French Imperial Commission had announced the regulations that would govern French artists. They could submit any number of works to the jury, which would be made up of fifty-four members divided into four sections: There would be twenty-four jurors for painting, fifteen for sculpture, six for engraving and lithography, and nine for architecture. One third of the jury members for each category would be elected by medal winners and members of the Légion d'honneur, one third

[4] Henry Cole, *Fifty Years of Public Works of Sir Henry Cole* (London, 1884), vol. I, p. 256

would be appointed by the Academy from among its members, and one third would be appointed by the Imperial Commission. The jury would have the right to admit works that were "incontestably famous" without the artist submitting it to the jury.

By September 1866, however, it was becoming clear that the latter regulation was causing confusion among the artists: What works were truly "incontestably famous"? To clarify the question, a month later the Imperial Commission issued a new rule: By December 15 the artists were to submit a list of the works they wanted to exhibit; artists who, by January 1, had not received word that their works had been accepted on the basis of their list were to submit the works themselves. On November 10 still another change was announced: Two thirds of the jury would be elected by medal winners and members of the Academy and the Légion d'honneur and the remaining third would be appointed by the Imperial Commission. Five days later the election took place. Among the painters chosen by their fellow artists were Cabanel, Gérôme, Breton, Meissonier, Bida, Français, Fromentin, Pils, Rousseau, and Couture. Sculptors included Barye, Soitoux, and Jouffroy.

Two weeks after French artists submitted their works to the jury, many received a letter informing them that because of the limited space in the French gallery their entries would not be sent on to the exposition's jurors and pointing out that the annual Salon in the Palais des Champs-Élysées would be equally well visited. The Salon jury for 1867 was to be selected by the same method as that used for the Exposition Universelle; when the list of jurors was published in March, the names on it were virtually the same as those who had served on the jury for the Exposition Universelle.

Among the artists to receive such a letter were the sculptor Jean Baptiste Clésinger and the painter Édouard Manet. Manet decided that if he wished his work to be seen, he had no alternative but to build a private exhibition pavilion. A precedent had been set in 1855 by Courbet's Pavillon du Réalisme, and this year Courbet was again constructing a gallery on the Place de l'Alma to exhibit 135 canvases. Borrowing

money from his mother, Manet erected a temporary structure to display over 50 of his works and published a catalog with an unsigned preface to explain his reasons for holding a private exhibition. Zola, who had written a long article on Manet for the January issue of the *Revue du XIX^e Siècle*, suggested that this article be reprinted for distribution at the exhibition. Though Manet declined the offer, Zola reprinted the article as a brochure, illustrated with Bracquemond's portrait of Manet and Manet's etching of his infamous *Olympia*. Few reports on the exhibition, which opened six weeks late on May 24, appeared in the Paris press, and few visitors stopped in the Place de l'Alma on their way to the Champ de Mars, where there was so much to see.

Many reporters and critics who came to Paris throughout the spring and summer of 1867 to view contemporary art at the Exposition Universelle remembered the first international exhibition held in Paris twelve years earlier and were disappointed. "The art of picture making has not advanced since 1855," wrote the *Art Journal's* reporter.[5] In a guidebook for French-speaking visitors, H. de la Madeleine went into more detail: "Perhaps the sum of the talent is the same, and the wealth of artworks is at least equal. But if the great summons which sounded from one end of the world to another has made thousands of artists appear, it has unfortunately revealed no man of genius. . . . The whole is dull, colorless, without accent, and this general mediocrity once more attests to the universal stampede, the confusion of genres, and the disorder and poverty of spirit."[6] "What we learn from the concourse of all the nations," noted the *Art Journal's* critic, "is not only the positive but the comparative position of each school, the strength of one, the weakness of another."[7] If the work England exhibited was "strikingly inferior" to that it had shown in 1855, in the opinion of H. de la Madeleine, Belgium had advanced to a position immediately behind France, thanks to Leys and Stevens, both of whom were

[5] *Art Journal*, May 1, 1867, p. 131

[6] H. de la Madeleine, "Les Beaux-Arts à l'Exposition," *Paris Guide* (Paris, 1867), vol. II, p. 2031

[7] *Art Journal*, May 1, 1867, p. 131

made officers of the Légion d'honneur by the French Govern-
ment. The German art exhibited was "cosmopolitan,
nourished more by erudition than by live impressions, prefer-
ring a learned theory to the personal, spontaneous spark."
Nevertheless, Prussia and North Germany could be assumed
to be in the first rank "if the number of artists in a country is
truly a sign of artistic vitality." There were important groups
of artists in both Switzerland and Holland; the former
painted "glaciers and cascades," the latter "cattle and
calves."[8]

Performance was measured by the standards of the art
academies, the same standards employed by the jurors to se-
lect the works which would represent their countries. Almost
half of the twenty-six members of the prize jury were French,
and all the French members of the prize jury had also been
members of the admissions jury. When the awards were an-
nounced in July, four of the eight medals of honor for paint-
ing went to Frenchmen (Meissonier, Cabanel, Gérôme, and
Rousseau), one to a Bavarian (Wilhelm von Kaulbach), one
to an Italian (Stefano Ussi), one to a Prussian (Ludwig
Knaus), and one to a Belgian (Henry Leys). All of the non-
French prizewinners were members of the academies of their
respective countries, and of the four French winners—all of
whom were members of the prize jury—only Théodore Rous-
seau was not a member of the French Academy. The regi-
mentation of European art that had begun in Paris in 1855
and was reinforced in London in 1862 was again in force.
French artists who refused to submit to these standards could
arrange private exhibitions to attract the attention of visitors
to Paris, but artists elsewhere who wished to exhibit in the
most important artistic center in Europe had no choice but
to conform. Those who sought to break away from the aca-
demic conventions of technique, subject matter, and compo-
sition could only voice their defiance by protesting the award
to a countryman who was an exponent of the academic sys-
tem. In Italy Diego Martelli (1838–96), who, in January

[8] H. de la Madeleine, "Les Beaux-Arts à l'Exposition," *Paris
Guide* (Paris, 1867), vol. II, p. 2041 (English); p. 2044 (Belgian);
pp. 2049–50 (German); p. 2054 (Swiss); p. 2056 (Dutch)

1867, had founded the *Gazzettino delle Arti del Disegno* in Florence with the support of the Macchiaioli, denounced the awarding of a medal to Stefano Ussi in the journal's July issue. The future effects of the regimentation and standardization of European art by the juries of the international expositions were considered by Ernest Chesneau (1833–90), whose review was published as a brochure entitled *Les Nations Rivales dans l'Art*.

Europe remembered 1867 as the year of the exposition, when royalty honored Paris with their presence and the newly opened boulevards were thronged with pleasure-seeking crowds. As *le grand monde* hurried from dinners to balls and gala performances and the *demimonde* enjoyed a second carnival in the exposition's park, the war of 1866 and the Austrians' defeat at Sadowa were forgotten. Gaiety prevailed even when the emperor and his court went into mourning for Prince Maximilian, who was executed by Mexican republicans, and the czar's narrow escape from a Polish assassin's bullet did not postpone the ball scheduled at the Russian embassy that evening.

On October 31, three weeks after the exhibition closed, Napoléon III opened the new legislative session with these words:

> The Universal Exposition, which nearly all the sovereigns of Europe attended and where the respresentatives of the laboring classes of all countries have met, has drawn closer the ties of fraternity between nations. It has disappeared, but its traces will leave a deep impression upon our age: for if the Exposition rose majestically to shine with only momentary brilliance, it has destroyed forever a past of prejudices and errors. The shackles of labor and of intelligence, the barriers between the different peoples as well as the different classes, international hatreds—these are what the Exposition has cast behind.[9]

[9] Abbott, op. cit., p. 670

Ernest Chesneau: *The Rival Nations in Art:*
On the Influence of the International Expositions
on the Future of Art[1]

. . . The question inevitably intrudes on the observer after leaving the Champ de Mars when he begins to reflect: What influence will the international expositions exert on the future of art? . . .

Information which permits the association and continuity of effort—that is the fundamental law of the rapid progress of industry, a law long anticipated and put into practice by earlier societies to the limited extent permitted by the difficulty of communication and consequently the exchange of ideas among even the closest countries. It is thus certain that the frequent repetition of the industrial expositions, by spreading information about isolated discoveries over the surface of the globe, focuses in simultaneous activity forces which were formerly dissipated at random. Collective effort follows individual effort. Because of that—to look at only the immediate effect of the periodic convocation of the inventive energies of all nations, without dwelling on the higher and more distant hopes—one is well entitled to affirm that the universal expositions of industry, one of the century's great ideas, go directly to their goal, which is so laudable, I would even say so noble: the liberation from the servitude which hostile nature imposes so heavily on humanity.

Is it equally evident that the universal expositions necessarily contribute to the progress of the fine arts? Is it unquestionable that from this point of view they exercise an equally happy influence for all nations? The question is complex; it is necessary to treat it methodically and carefully.

A priori, no matter what conclusions we reach, we proclaim that they cannot force us to oppose the principle of the admission of the fine arts to these international contests, and

[1] [Translated from Ernest Chesneau, *Les Nations Rivales dans l'Art* (Paris: Didier, 1868), pp. 457–67]

it would be perfectly useless, in fact, to keep them out of it. The evil, if evil there is, is not due to the fact of these conglomerations, which are themselves the result of higher and more general causes. It would be entirely possible not to mix the fine arts in these great exhibitions, since the ease of communication created by modern industry would still have the effect of spreading among the nations the status, resources, tendencies, and manifestations of art in each. . . .

Clearly, the nations still in their infancy, as far as the cultivation of the fine arts is concerned, will extract precious fruit from the lessons about all the European schools provided them by the expositions. They will learn our methods and, even better, how one can view and interpret external phenomena by means of art. Those among whom this capacity dwells in a latent and still unrevealed state, at a stage of only vague aspirations, will receive from these circumstances the confirmation of their instincts, and they in turn will engage themselves in the delicate pleasures which satisfy man's noblest appetites. The only danger for these beginners is that they will uncritically accept existing formulas, and rather than interpreting their personal sensations directly, they will limit themselves to mechanically reproducing, so to speak, the manifestations of art which belong to peoples whose genius is different.

That is precisely the peril which menaces not only those peoples who will henceforth enter the world of art but also the ancient continental schools. . . . if originality is truly an artist's or a school's principal claim to the sympathetic thronging of the crowds, is there not reason to fear that by frequent communication among the schools the originality of each will fizzle away and that the art of the future will be reduced to casting itself into a uniform mold, without distinction of race or national genius, to the detriment of native pungency and to the greatest profit of banal mediocrity? It is evident that the question deserves to be asked. Since it cannot be evaded, it must be met frankly and treated without fear of facing coolly all its consequences.

Formerly schools existed at a distance from each other, in almost complete isolation. On a primitive foundation trans-

mitted by a tradition across the long night of the Middle
Ages, in which had been gathered from manuscripts the for-
mulas of Byzantine art, in the North and the South, in Italy
as in Germany, men of the liveliest genius established the
first bases of a new art. . . . There was certainly a bond, a
bond which formed a school among the diverse generations
of artists, but this school derived as much from the com-
monality of origin—that is to say, a commonality of manners,
passions, and sentiments—as from common principles culled
from a similar source.

It was in this relative isolation that the northern schools—
German, Flemish, Dutch—and the southern schools—Sienese,
Florentine, Roman, Bolognese, Venetian—were formed,
schools living side by side in a small space, but each marked
quite plainly with the stamp of local genius. From such a
state of things there appeared the Albrecht Dürers, the Rem-
brandts, the Ruysdaels, the Rubenses, the Raphaels, the
Leonardos, the Michelangelos, the Titians, the Veroneses—all
those names which illumine the history of art and shine with
such a personal and lively light. Today things have changed
greatly. Education is collective, not only for the artists of a
single nation but for the schools of the whole world. The
public institutions devoted particularly to artistic education
admit students of every nationality. Moreover, many foreign
artists come to ask for lessons from French artists and, rather
than taking the lessons they have gathered home with them,
they adopt French life permanently, take up residence in
Paris, exhibit at our national Salons, share in all our competi-
tions and in all our awards, and of their foreign origin they
retain only their name. On the other hand, the majority of
artists in foreign schools, without going so far, keep their eyes
turned towards France, periodically come to visit our exhibi-
tions, drawing from them techniques and definite models
rather than a general guide and a manner of observation.

The Universal Exposition at the Champ de Mars shows us
the first results of what apparently must occur from the
schools' constant rubbing against each other. I mean a sort of
inevitable dulling of the national artistic temperament and
the birth of a cosmopolitan art. Clearly, if the multiplicity of

communication among peoples inevitably were to cause and produce the absolute effacement of all originality in art, we would have to check our hopes for the future at this point and close forever the glorious book of the history of art. But it is impossible that this should be so. Blindly, and without any reason other than that of pure feeling, we fearlessly deny that we have touched bottom and reached the end of this artistic faculty which is the crown of human civilization.

Man received the artistic sense just as he received his feeling for truth and goodness. He will no more let the former die than he would let the two latter die. Furthermore, it is impossible that the social phenomena which contribute to the development of industry—that is to say, to our material emancipation—could also lead, by a peculiar and unacceptable contradiction, to the collapse of precisely that which dominates matter, to the suffocating of the ideal. We can have no doubts about the continuance and acceleration of the industrial and social movement which tends to bring together and confound the peoples more and more. We have seen that this coming together brings benefits with it; we cannot accept [the fact] that what in one way brings such great profit to humanity should be harmful to it in the domain of art. Therefore, this law of modern society should not be revolted against but should be taken into account. The period of blunting, of cosmopolitanism, which we will enter will be more or less long, but I am firmly convinced that it can only be a transitional period. Perhaps there will be no more great local or national schools; but there will always be great individuals who, since they will no longer be specialized and enclosed in the limits of a school tradition, can only have a greater and larger effect on humanity. Rather than being representatives of Flanders, Holland, Germany, Rome, Florence, or Venice, they will represent all of humanity. . . . Here, as in industry, collective effort will have magnified the affirmation of individual genius.

Let us add, on the other hand, that predestined artists are almost insensible to the influence of the aesthetic milieu in which they develop. They borrow from their predecessors and

their direct masters an initial sum of knowledge and material processes necessary to formulate their thoughts, but they do not accept any ready-made formulas. Only the public, art lovers, and inferior artists study the climate of contemporary art; the latter are also the only ones to borrow the elements of action and success from the numerous works which the universal expositions put before their eyes. Each year one sees, like a new plague in Egypt, the cloud of the fashionable locusts. . . . There has always been—there will always be—plebians in art as in all other activities. Is not an increasing number of what I will call practitioners necessary to satisfy the increasing number of demands? Their impulse comes from outside themselves. They have received their inspiration from their masters, the creative artists, and their activity is limited to extending it, to vulgarizing it more or less skillfully with modifications and alterations which correspond to the differences in the fineness of taste developed in the various classes of the social milieu.

As for the original masters, let us not fear to repeat that there is no need to worry about this transformation of manners which we are witnessing in the nineteenth century. Local art or cosmopolitan art, in whatever situation exists, genius will appear spontaneously, will develop freely, without pausing at apparent hindrances, because genius is an irresistible force, a capacity independent of secondary causes. Possibly the average level of art will undergo the influence of that transformation, and it will gain in knowledge and processes and lose in originality. But, on the whole, my profound conviction and my fondest hope are that this will not cause the human patrimony to be diminished. As a guarantee we have history, which reveals to us in each of its pages the constant action, the providential action, of genius. . . .

Édouard Manet: *Preface, Catalog of Paintings Exhibited at the Avenue de l'Alma in 1867*[1]

Since 1861 M. Manet has exhibited or tried to exhibit.

This year he has decided to show the body of his work directly to the public.

In his first appearance at the Salon, M. Manet won an honorable mention. But since then he has too often seen himself turned down by the jury[2] not to think that if artistic endeavors are a battle, it is at least necessary to be equally armed for the fight—that is to say, to be able also to show what one has done.

Without that, the painter is too easily shut in a circle without an exit. He is forced to stack up his canvases or roll them up in an attic.

Admission, encouragement, official awards are said to be a certification of talent in the eyes of a part of the public, which is thereby prejudiced for or against the works that are accepted or refused. But, on the other hand, the artist is told that it is the spontaneous feeling of this same public that determines the cool reception which the various juries give his work.

In this situation, the artist is advised to wait.

Wait for what? Until the jury is no more?

Today the artist does not say "Come and see works without a fault" but "Come and see sincere works."

It is sincerity that gives the works the character of a protest, when the painter intended merely to render his impression.

M. Manet has never wanted to protest. On the contrary, the protests have been directed at him, who never expected it, because there is a traditional education in the forms, tech-

1 [Édouard Manet, Préface, *Catalogue des Tableaux Exposés à l'Avenue de l'Alma en 1867* (Paris, 1867)]

2 [Manet had submitted a work in 1859 which was refused. In 1861 *Le Guitarrero* [*Spanish Singer*] was not only accepted at the Salon but won him an honorable mention. In 1862, however, the work he submitted was again refused.]

niques, and modes of painting, and those who were educated according to these principles do not recognize any others. Nothing is valid except their formulas, and they make themselves not only into critics but into adversaries, vigorous adversaries at that.

For the artist, the vital matter, the sine qua non, is to exhibit, because after looking at something for a while one becomes familiar with what was once surprising or even shocking. Little by little one understands and accepts it.

Time itself acts on paintings as though it were an insensible burnisher and softens the original rough edges.

To exhibit is to find friends and allies in the struggle.

M. Manet has always recognized talent wherever it is found and has aspired neither to overthrow an older mode of painting nor to create a new one. He has only tried to be himself and no one else.

Besides, M. Manet has been substantially encouraged and has seen how the judgment of truly talented men becomes daily more and more favorable to him.

For the painter it is now only a matter of winning over the public, which has been made into his so-called enemy.

1869: MUNICH
The International
Art Exhibition

An attempt to follow the general German exhibition of 1858
with an international exhibition in 1863 had aroused little re-
sponse; only Belgian and Swiss artists had participated. How-
ever, when the Akademie für bildende Kunst announced, in
March 1869, that a general exposition of the fine arts would
be held in Munich from July to October under the spon-
sorship of King Ludwig II of Bavaria to celebrate the Acad-
emy's centennial, the European capitals promptly lent their
support. Three years earlier Europe had seen Prussia deci-
sively defeat Austria and the allied southern German states at
the Battle of Sadowa (Königgrätz) and end the Austro-Prus-
sian War. The treaties which followed had secured Prussia's
annexation of Hanover, the Elbe duchies, Hesse-Kassel, Nas-
sau, and Frankfurt. Venetia had been ceded to Italy and the
Venetian paintings and sculptures that had been removed by
the Austrians in 1838 and 1866 were returned to Venice. By
1867 Prussia had organized a new North German Confed-
eration which included all the states north of the river Main.
Confronted with Prussia's increasing strength, the European
nations—especially France—were eager to encourage the con-
tinued neutrality of Bavaria and the other South German
principalities.

Ludwig II, who had succeeded Maximilian II to the Ba-
varian throne in 1864, had supported Austria in 1866 and

after the Battle of Sadowa had recognized the necessity for reforming the Bavarian army, but his real interests lay elsewhere. For the first three years of his reign his resources had gone to support Richard Wagner, whose opera *Lohengrin* had enchanted him as a boy of fifteen. To enable Wagner to complete the tetralogy *Der Ring des Nibelungen*, the king, who had purchased the libretto, installed the composer in a luxurious house in Munich in the summer of 1864. "So that the production of *The Ring* might be perfect," Ludwig commissioned the architect Gottfried Semper, a friend of Wagner and professor of architecture in Zurich, to design and complete by 1867 a large stone Festspielhaus. Planned together with Wagner, the hall would have an innovative interior that would enable the audience—drawn from all strata of society, as in ancient Greece—to participate actively in the performance of the *Gesamtkunstwerk*, a synthesis of all existing art media: color, light, and sound.

In the midst of this project, approximately six months after the premiere performance of *Tristan und Isolde* on June 10, 1865, public opposition to Wagner's extravagance and his political influence with the monarch, spearheaded by the conservative Ultramontanists, obliged Ludwig II to send Wagner away from Bavaria. The king now turned his attention to architecture. Traveling incognito as the Count von Berg, he had visited Paris in 1867 and had thrilled to the buildings in the garden of the Exposition Universelle, Viollet-le-Duc's restoration of the medieval château de Pierrefonds, and the palace at Versailles, which he longed to emulate. He had already begun rebuilding the castle of Neuschwanstein "in the genuine style of the old German castles," as he wrote to Wagner. However, he permitted two hundred thousand guldens from the five million that had been assigned for the Festspielhaus to be made available to the Munich Kunstgenossenschaft (Art Society) and the Akademie für bildende Kunst so that the interior of the Glaspalast could be prepared for an international art exhibition.

The exhibition committee was headed by the landscapist Eduard Schleich the elder, who served as president of the Society, and Arthur Ramberg, a professor of genre at the Acad-

emy, who served as deputy. Originally destined for a career as a diplomat, Ramberg painted genre scenes of elegant society and was not a follower of the classical historicism favored at the Academy by its director, Wilhelm von Kaulbach. Schleich, director of the exhibition's jury of the Kunstverein, was a leader of the nonacademic artists encouraged by the Kunstverein. He had abandoned the classical landscapist Karl Rottmann to become a student of Christian Morgenstern, who had studied at the Copenhagen Academy and, after a study trip to Norway, had turned to painting objective studies of northern nature. In 1851 Schleich had visited France to see the work of the Barbizon painters; on his return to Munich he became an advocate of realism toward whom younger painters like Wilhelm Leibl gravitated.

The Munich exhibition of 1858, initiated by the Kunstverein, had made it clear that there was a growing gap between the adherents of realism and the historical painters sponsored by the Academy and King Maximilian II. State commissions calling for immense representations of episodes in world history had been assigned to Kaulbach and adherents of academic conventions. Kaulbach, a former student of the onetime Nazarene Cornelius, had embellished the New Pinakothek, built between 1846 and 1853 and located opposite the Old Pinakothek, which Cornelius had decorated, with frescoes illustrating the history of modern German art. Kaulbach's immense *Battle of Salamis* was among the works that hung in the Maximilianeum, the school for royal pages.

In the 1850s historical classical painting in Munich had been directed towards the romantic school by Karl Piloty. Once a student of the Nazarene Julius Schnorr von Carolsfeld, Piloty had been strongly influenced by the Belgian history painters Gallait and de Biefve, whose work had been exhibited in Munich in 1843. In 1852 he studied with Gallait in Belgium before proceeding to Paul Delaroche's studio in Paris. Possessing consummate technical skill, he combined the accurate and detailed observation of Netherlandish art with sensuous color and striking light effects reminiscent of scenes in the theater, where gas lighting had recently made illusionistic effects possible. Upon his return to Munich, Pi-

loty painted *The Adhesion of Maximilian I to the Catholic League in 1699* for Maximilian II and won great acclaim with his *Seni Before Wallenstein's Corpse* (1855). Appointed a professor at the Academy in 1856, Piloty attracted to his studio history and genre painters who admired the painterly treatment of surface and the delight in fabrics and costumes found in the fifteenth-century painting of the Netherlands and Germany. His influence could be seen in the history paintings of Gabriel von Max and the genre paintings of Franz von Defregger, who sympathetically and meticulously depicted the peasants of the Tyrolean Alps.

In 1859 the innovative group Jung München was established by adherents of realism. It included several pupils of Piloty, Kaulbach's student Wilhelm Busch, the popular opera composer Kremelsetzer, and Basserman, the publisher of the influential satirical journal *Fliegende Blätter*. When the group dissolved ten years later, some of its former members—Wilhelm Busch, Franz von Lenbach, and Hans von Marées—joined with the younger artists Wilhelm Leibl and Lorenz Gedon to form a group which met at the Lettenbauer Wirtschaft and became known as the Dochte. The Swiss painter Arnold Böcklin joined them when he came from Basel. Their patron was the Prussian Count Adolf Schack, who settled in Munich in 1855 and built a house and gallery on the Maximilianstrasse to house his outstanding collection of contemporary art and copies of masterpieces.

In March 1869 the commission for the exhibition visited artists, dealers, and collectors to personally select the works that would be included. Schleich traveled to Paris, where he chose works by contemporary artists from studios and galleries—the dealer Petit lent him several canvases by Courbet—as well as works by earlier artists (Vernet, Ingres, Delacroix, Decamps, and Troyon) from private collections. Other members of the committee traveled throughout the German states, visiting such renowned collectors as Ravené in Berlin and Lustig in Vienna. In Milan and Rome they chose sculpture. To encourage the lending of paintings and sculptures, the committee paid all transportation costs—the French Gov-

ernment demonstrated its support for the exhibition by as-
suming the shipping costs of fifty canvases—and agreed to ne-
gotiate sales free of charge and arrange a lottery. Although
June 15 was the deadline for receipt of objects, many arrived
late. The commission was engaged until the last moment in
arranging the 1,641 paintings, 761 drawings and watercolors,
and 392 works of sculpture.

On July 20, 1869, the stirring strains of the Tannhäuser
March, composed by Wagner for Ludwig II, filled the central
pavilion of the Glaspalast. Prince Adalbert presided in place
of the king, who always absented himself from such cere-
monies. The president of the Munich artist's association,
the sculptor Konrad Knoll, replied to the address given by
Minister of Culture von Gresser, and the international art ex-
hibition was opened. The artists' choral society brought the
ceremony to its conclusion, freeing the officials, guests, and
journalists to walk through the galleries. The central court of
honor was hung with huge cartoons and paintings, while
smaller paintings filled the galleries leading to the eastern and
western pavilions. Sculptures had been grouped amid foun-
tains and plants in the western pavilion rather than being
scattered throughout the painting galleries, where they might
have seemed to serve merely as decoration.

The attention of the European artistic community, which
had been focused on the Paris Salon until it closed on June
20, was now drawn eastward to Munich. "Since the Paris ex-
hibition of 1867, there has not been found in Europe so
grand and complete an assemblage of continental schools,"[1]
noted the Art Journal's reporter. Though the Munich exhibi-
tion competed for attention with the long-established Salon
of Brussels, in the words of the reviewer for L'Artiste, "It
would be debated whether Munich or Brussels held the more
memorable art exposition in the summer of 1869."[2] Patrons,
artists, and critics from the German-speaking cities were
pleased and gratified by the opportunity to welcome their
counterparts from London, Brussels, and Paris. The exhibi-

[1] Art Journal, October 1869, p. 314
[2] L'Artiste, August 1869, p. 276

tion contributed to Munich's becoming the art center where eastern and western artists, patrons, and art lovers mingled.

The vast majority of the works listed in the catalog were from the German states, but France (which was second only to Munich in the number of works sent), Belgium, and Holland were well represented. Italy had contributed sixty-five works; England, Russia, Sweden, Spain, and the United States had collectively sent no more than fifty. Russia's only entry was a *Madonna* by Schulkowsky; the Kunstverein correspondent from St. Petersburg explained that after the exhibition was announced the police had required that all works be submitted for inspection before being shipped. The exhibition demonstrated, in the words of the *Art Journal*, that "taken collectively, German art is one of the great powers of Europe—chiefly powerful perhaps in prolific production—powerful, too, by perseverance and plodding persistency; whereas, on the contrary, the French have more of the instantaneous flash of genius and the ready facility of extemporaneous utterance."[3]

For the first time it was possible to distinguish the strengths of the various German schools and to compare them with their continental neighbors. Italy dominated history painting, with 35 percent of this category, but it was closely followed by southern and central Germany, Austria, France, and Munich. France and Munich, however, showed the greatest number of portraits and figure studies. Munich, France, and Italy were strong in genre and southern Germany in landscape. In their attempt to assess the strengths of the schools in each category, critics and visitors were forced to consider the subtle differences apparent in each nation's treatment of a particular category. The definition of history painting was especially susceptible to different interpretations. German critics distinguished among painters of history, painters of historical genre, and painters of genre. French and English critics, however, continued to use the more traditional classifications of "history" and "genre"— though the *Art Journal*'s critic did refer to Karl Piloty, recog-

[3] *Art Journal*, October 1869, p. 314

nized in Germany as a leader in the historical genre, as "the great Historic realist."[4]

Paris's *Gazette des Beaux-Arts* sent Eugène Müntz (1845–1902) to review the exhibition. Müntz had studied law and then had traveled in Germany and England to pursue his interest in art. His first article for the *Gazette des Beaux-Arts*, "L'École Française Jugée par la Critique Allemande," which appeared in 1868, demonstrated not only his learning and meticulous methods but his familiarity with contemporary German art and criticism. His review of the Munich exhibition, which included an analysis of the differences between the conditions in which French and German artists worked, was equally thoughtful. He found French art to be stronger than German art and predicted that the French influence would soon predominate in the German states.

Courbet, whose canvases, including the *Stone Breakers*, brought him acclaim and the award of the Bavarian Order of St. Michael, visited the exhibition and was frankly contemptuous of German history painting:

> Germany hardly knows what good painting is. They are all concerned with the negative qualities of art; perspective is one of the principal qualities in their eyes. They speak of it all the time. They also believe the accuracy of historical costumes to be important. They are very concerned with anecdotal painting, and all the walls of Munich are covered with frescoes as though with a wallpaper veil of red, blue, yellow, green, pink, etc., silk-stockings, riding boots, doublets; here is a king preaching a sermon, there a king abdicating, a king signing a treaty, marrying, dying, etc., etc.[5]

After painting excursions with students, drinking bouts at the Lettenbauer Wirtschaft, and visits with Leibl and von Marées, however, Courbet conceded that "the young men of Munich are all right. . . . They have decided to give up all

[4] *Art Journal*, October 1869, p. 315
[5] Translated from *München, 1869–1958: Aufbruch zur modernen Kunst. Rekonstruktion der Erster Internationalen Kunstausstellung 1869* [exhib. cat.] (Munich: Haus der Kunst, 1958), p. 28

the old trifles. I have seen the young painters turn up their noses at all the princes of German art."[6]

The French contributions to the exhibition were criticized by the author of a series of articles that appeared in *Die Dioskuren*, the organ of the Kunstverein, which reached a wide readership. While he admired the veracity of individual works, like Courbet's *Stone Breakers* and Doré's *Juggler*, he found that French painting in general lacked ingenuousness or unaffectedness in technique and that its subject matter mirrored the corruption of elegant Parisian society.

The *Zeitschrift für bildende Kunst*, launched in 1865–66 by Karl von Lützow, a scholar in Vienna, and E. A. Seeman, a Leipzig publisher, was the periodical preferred by scholars and connoisseurs. Lützow had studied philology and archaeology at the universities of Göttingen and Munich, where he received his doctorate in 1856. An interest in classical art had taken Lützow to Berlin, but he turned to art history after coming under the influence of Wilhelm Luebke, who supplemented his meager salary as a professor by writing for the *Deutsche Kunstblatt* until it ceased publication in 1858. Lützow was introduced to Seeman, Luebke's publisher, who had established a press for art books and colored prints in Leipzig in 1858. When Lützow received an instructorship at the University of Munich, he returned there in 1861. The following year Seeman published Lützow's *Die Meisterwerke der Kirchenbaukunst*, a study of modern and medieval ecclesiastical monuments. Consistent with Luebke's approach, Lützow eschewed aesthetics in favor of a historical and technical approach to art. Like Luebke, he believed it was essential to understand the history of the culture that produced the art and sought to stimulate his reader by a scientific approach to subject matter.

In 1863 Lützow was offered a position as an instructor at the University of Vienna in the department of art history, established in 1852 for Eitelberger von Edelberg. The year before Lützow had been made editor of the *Rezension u. Mitteilungen über bildendende Kunst*, published in Vienna. For

[6] Loc. cit.

it he solicited contributions from Eitelberger von Edelberg, Jakob Falke (the historian who left the German Museum in Nuremberg to become keeper of the archives in Dresden), Franz Pecht (a painter and art critic for various newspapers), and his mentor Wilhelm Luebke.

Two years later, in 1865, Lützow was named director of the library and print collection of the Vienna Academy and became editor of the *Zeitschrift für bildende Kunst, mit Beiblatt die Kunstchronik*, published by E. A. Seeman. The magazine's aim was "to present all that is remarkable and beautiful in contemporary art—chiefly in Germany—and to advance by image and word the spirit of the broad, cultivated public." It would offer its readers the opportunity "not only to read and make judgments about art but also to see and compare," and would endeavor "to nourish and develop not erudition but, on the contrary, a sense of beauty."[7] Lützow himself wrote the report of the international exhibition held in the Glaspalast in 1869. Approaching the exhibition as a scholar, he examined the art and its relation to contemporary German cultural tendencies.

Karl von Lützow: *The International Art Exhibition in Munich*[1]

I. Introduction

The population of Munich has every reason to be satisfied with the success of this summer's exhibition. . . .

The honor of organizing the first grand international exhibition in Germany was not, however, accomplished easily. It is indeed a testimony to the good reputation which the Bavarian capital and its school enjoy in France that the beckoning of the Munich artists set half of the Paris Salon into motion. The situation became somewhat more precarious when it seemed that the entire marble quarries of Sessa and Carrara had undertaken the journey, with the result that

[7] *Zeitschrift für bildende Kunst*, vol. I (1866), 1–2.
[1] [Translated from Karl von Lützow, "Ausstellungsberichte, 1869–1879," *Zeitschrift für bildende Kunst* (1870), vol. V, 22–26]

in the exhibition committee's books the entry for "transport expenses" approximated the height of the mountains of crates in the vestibule of the Glaspalast. All that, and even an actual deficit, is ultimately acceptable only if there is no want of a crowd of foreigners streaming by in search of a purchase, the prompt echo of critical recognition in the journals and, finally, the ever-welcome veritable shower of bright ribbons and crosses bestowed by princely favor. Such recognition has richly rewarded this undertaking, which arose among so many cares and difficulties.

A serious evaluation of the exposition has, to be sure, nothing to do with more or less superficial success. . . .

Criticism, as we understand it, should restrict itself to the general, to the large, common tasks of art and should not lose itself in parochial questions and interests. It must realize that the intent and meaning of international exhibitions can only consist in giving us a general notion of the state of contemporary art. It is noteworthy that the interest in such intellectual contests among the nations is beginning to displace more and more the earlier, more limited undertakings in this field. Ten years ago in Germany there rang out the call for historical exhibitions of a strictly national character. Conscious that German art had essentially ended the cycle begun at the turn of the century, we then wanted to look back with proud self-contemplation upon the path which had been traversed in order to draw strength and clarity for the future from that abundance. Such was the guiding idea of the German historical exhibition of 1858. It signified a turning point in the history of our native art. We need only draw a comparison between it and the current Munich exhibition to become aware of the change in conditions. At that time the exhibition was limited to national art, but it extended back to the beginnings of its modern history. Now it has been expanded to include the total production of all artistic cultures of the present, but without the fundamental consideration of historical development. At that time it was an internal succession tinged with homogeneity. Now it is a loosely joined, motley juxtaposition. That is the basic difference between the two Munich exhibitions.

How diversely informative and instructive the fashion can be which has now become so common has been demonstrated by the world exhibitions of the past two decades. The first and most important condition for the success of such international undertakings is a methodical arrangement of the items displayed. Without that, chaos results from multiplicity, and instead of a clarifying and elevating impression a confusing and discouraging one dominates. However self-evident these realities may be, they seem to have escaped the initiators of the Munich international art exhibition. . . .

If one looks at the content and the independence of representation and asks where the decisive blows are being registered in this artistic competition, one's gaze falls immediately upon Germany and France. Whether the indefatigable creative energy of our nation will withstand the vigorous impact of our western neighbors, or whether the complacent receptivity that is also a quality of the German nature will follow them along all their paths is the question anxiously asked in connection with this exhibition. . . .

In the area of painting, where we shall begin our consideration, the historical school traditionally stands at the head. It is commonly asserted that its time is past. Whether or not that is so, the exhibition certainly has no important evidence to offer in opposition. There is many a painted canvas of colossal dimensions, but nowhere a grand, outstanding success! The elder generation of Germans is represented in a very fragmentary manner: Cornelius, Overbeck, Genelli, Schwind, Rahl, Schnorr, Bendemann, Lessing, Menzel, and many others are missing or must be compensated for with prints in the sections devoted to the graphic arts or with sketches, portrait heads and the like. There is also no finished picture by W. v. Kaulbach in evidence, for the oft-exhibited *Battle of Salamis*, a discussion of which we can spare ourselves, belongs in the category of india-ink cartoons. We shall appraise the new chalk sketches of this master below.

A class of Munich masters is grouping around Kaulbach who might be called the *cultural-historical* idealists inasmuch as they seek to unite the grand style of composition, which rests upon strict design, with a faithful realism in costume,

architecture, and all other details that the modern science
of *cultural history* offers in such ready-made abundance. We
are thinking of the four colossal pictures which were commis-
sioned by the previous Bavarian king to be hung in the Max-
imilianeum in Munich. . . . The most appealing of these
paintings is undoubtedly A. v. Ramberg's *Frederick II*, a rich,
charming picture of princely life, capably drawn and of fresh,
rich color. But, as with the others, we can scarcely extract a
deeper interest from the representation. . . .

. . . It is the young generation of the early sixties in tight
phalanx that first penetrated the ranks of the old academi-
cians at the Munich "international" exhibition *en miniature*
of 1863. They boldly opposed a new ideal of coloring to the
dusty realism of historic costume painting. Skepticism about
the durability and soundness of these promising talents was
already emerging. In addition to Feuerbach, we shall mention
only Böcklin, Viktor Müller, and Lenbach (among the sculp-
tors, as is well known, Reinhold Begas is counted among
those related in spirit). In the case of the first two men-
tioned, whose initial work gave rise to expectations of
significant achievement, it definitely seems as if some doubts
are about to be proved true. The tendency toward the bizarre
has already reached a critical degree in Böcklin's *Nymph and
Fauns* (no. 448). We fear that Feuerbach will also perish in
the breach which he helped create if he is not able to save
himself soon by a bold leap from his present position.

That French historical painting is in no better a position,
insofar as soul has also deserted the grand tradition of that
school, the exhibition would be able to show anyone other-
wise uninformed. But despite this similarity there is immedi-
ately evident a notable difference between the two nations.
In the case of the Germans, there is a tendency for the exte-
rior form and internal stability to degenerate into superfici-
ality and coarseness. Among them art is more immediately
and inwardly connected to personal life and emotion. In
French painting, on the other hand, we often find repre-
sentation and technique still on a very respectable level
amid emptiness and confusion. Art is more a product of the
school; the school exercises, at least through the development

of the artist, a far more lasting influence on the individual
than among us. . . .

Nor is our opinion of the incomparably more significant
appearance of Alexandre Cabanel any different. He is repre-
sented at the exhibition with three works: a painting, *Girl
Playing a Lute* (no. 1497), of singularly trivial, dull forms,
but soft and warm in color; then *Priestess in the Forest* (no.
1474); and finally *Paradise Lost* (no. 1192), familiar to us
from the last world's fair, a colossal composition which was
ordered by King Maximilian II for the Munich Max-
imilianeum. What strikes one as unpleasant or, at first
glance, puzzling about both the latter pictures is the affect-
edly pale color, tempered almost to the tone of watercolor,
with which is joined in the facial expression of the druidess a
trace of hectic exhaustion. The representation of the first hu-
mans in paradise is fresher and livelier, although not free
from coquettish sensuality. Jehovah, depicted very much like
Zeus in his styleless, violet-tinged robe, surprises the pair, ap-
parently without arousing any strong emotion in them. The
sullen Adam and the whining Eve have, we feel, an almost
comic element. However little we may like the expression and
the sentiment, we should give sincere recognition to the strict
and conscientious study evident in all parts of the repre-
sentation. The lower half of the picture—with the splendidly
drawn and modeled figures of Adam and Eve and the deli-
cate, charmingly treated foreground abounding in flowers—
could be recommended as an example of faithful study to
many of our German idealists who paint nature from their
head.

Even Chenavard—whose *Divine Tragedy* was both in Mu-
nich as in this year's Paris Salon an object of vehement con-
troversy, most of which ended unfavorably for the artist—
deserves, according to the approach taken here, a more re-
spectful consideration than he has received from most. For
the throng of hasty visitors, his painting suffers from its unat-
tractive lead color. But if one sees the composition divested
of this veil, as is the case, for example, with the woodcut
prepared after the master's drawing in the *Album Boetzel,
Salon de 1869* (Paris, Berger-Levrault), then the richness of

invention and the energetic vitality of the figures emerges in a surprising way. That nothing should be said in favor of the picture's obstruse basic idea and that we should not claim to be dealing here with who knows what misunderstood original genius are indeed self-evident. But if you are going to damn all intellectual painting to hell, then throw in also a few of your German favorites! They are not a whit better than Chenavard.

II. Mural Sketches and Watercolors of Historical Style by German, French, and Belgian Masters

The mural cartoon[2] was long and justly considered to be the real domain of our native art. The "New Germans"[3] entrenched themselves behind it against the mawkish color and the spongy flesh of the late rococo style. From there Cornelius, with his "pure contour," directed his steely jabs against all traditional routine and mannerism. The half century which followed in his steps clung to the "line" as to the national banner. In our age of coloristic and realistic tendencies, one is often inclined to look down contemptuously upon that cult of contour. As a result, the cartoon print and the simple linear style of the woodcut and related branches of reproductive technique also received an unfavorable judgment. Indeed, this opinion is justifiable if one judges from the stereotyped sketching of illustrations and the numberless mural sketches executed without study, observation, or style which we now see! They are only suited to demonstrate to the whole world the weakness of this school. On the other hand, for the epoch of Cornelius—the first half of our century may be so designated—the return to contour meant not only the return to severity of style, to the ideal, to seriousness of thought, but above all to nature. From this master's mural sketches a world full of concrete perception of nature and of emotion springs forth with the fullness of its spiritual content. Without these sketches where could efficacy and true beauty be found? In these unperishable creations the means

2 ["Cartoon" refers to the working scale drawings for paintings, frescoes, or tapestries.]
3 [A reference to the Nazarenes]

to express them are restricted to the least degree of the possible, to an essence of form, to the frontier of nothingness—and yet it is a frontier which embraces everything that supplies true art with its worth.

If we consider the mural cartoons and drawings in the grand manner offered at the Munich exhibition, a not very consoling picture emerges. Not that the majority lacked concept, a sense of beauty, or external accomplishment. On the contrary! But nature, closeness of observation, and seriousness of execution are evidently on the decline precisely in this area where the strength of this school once lay. Whoever seeks these qualities would do best to keep to the older generation. Among the more recent productions only very few praiseworthy exceptions have avoided falling victim to mannerism and stereotype.

On the other hand, that there are also undistinguished exceptions among the older generation would be evident to one acquainted, for example, with the productions of W. v. Kaulbach. He is the incomparable master among those who, in the service of photography, have made a fashionable business out of the noble art of the drawing of mural cartoons. In his mural cartoons prepared for King Ludwig II with subjects from Schiller, Shakespeare, Richard Wagner, and the *Nibelungen* (nos. 102–107), all is empty beauty and virtuosity. One seeks in vain for life, perception, nature; their place is taken by mawkishness and sensuality.

It is truly refreshing when the eye falls, in the midst of these aberrations of a significant talent, upon the work of a master who from his youth was able to preserve true and pure the spirit of the older German school, ripening his talents, unconcerned with the enticements of the day. We refer to the charming composition of E. Steinle's no. 98 (from Shakespeare's *As You Like It*), which H. Merz etched so masterfully for the readers of this journal. . . .

How is it that we are seldom obliged to complain of similar deficiencies in the work of the zealous, well-schooled Frenchmen? What a disparity between them and us if one considers inventiveness, rhythm, and size of composition; character and originality of conception; in short, the basic

properties of sublime art. In all these features our art towers
mountain-high above theirs. Under the points indicated one
need only compare an Ingres with Cornelius, an Orsel with
Overbeck, a Flandrin and Périn with Neher, Fischer, or
Heinrich [von] Hess, and one can not doubt the superiority
of German art in this respect. It was all the more striking for
the visitor making comparisons at the Munich exhibition to
see confirmation again that the serious French masters are,
precisely in the field of historical art, often far superior in
conscientiousness of nature study and diligence of execution.
We do not intend to attach any significance to the allegorical
figures of Alphonse Périn. On the other hand, we found
study of Victor Orsel's sketches unusually instructive. A main
work of this master is the votive picture for the preservation
of the city of Lyon from cholera; it hangs there in the church
of Notre-Dame-de-Fourvières. We saw the color sketches and
a number of studies for this work, which presented to us all
stages of the preparations for the work. The charming, inde-
fatigable striving after truth and nature revealed in it could,
if the initiates still needed it, reduce several false conceptions
of French art to their proper measure. In the immediate vi-
cinity of Orsel's studies were hung several drawing by H.
Flandrin and Ingres. In addition, the latter was represented
by several painted study heads and the nude study in oil of
the lictors in the *Martyrdom of St. Symphorian* (no. 1347).
This nude study has something of an old master's work in
the unique freshness and brilliance of tone and in the grand,
fresh conception of nature.

The Belgians Guffens and Swerts have, as is well known,
sought to establish in their country a severe style of historical
painting—partly based upon the Florentine Quattrocento—
under the influence of the "New German" art. Numerous
cartoons of religious and profane historical subjects which
decorated the transept of the Munich Glaspalast (nos. 78ff.)
document this extremely worthy effort. They all show a sure
feeling for style and a skillful touch. However, over them
hovers the same danger which we took pains to indicate
above in the discussion of the works of the same category—
namely, that of the stereotype. The Belgians will indeed be

confronted with Horace's dictum, *naturam expellas furca, tamen usque recurret*[4]—or, naturalism will come overnight and seize by force that which one neglected to grant willingly to nature.

III. Historical and True Genre; Portrait Painting

German criticism has often been reproached for being skilled only in the interpretation of pictures and for lacking the immediacy of purely artistic contemplation. Since the advent of international art exhibitions here, it becomes clearer and clearer that the peculiarity of a primarily inward, spiritual, or emotional conception of art is a trait of our national character rather than a deficiency in our criticism. It would indeed be surprising if it were otherwise, for both the method of treating and that of judging flow from the same source: the German manner of dealing with things. The Munich exhibition offered the most striking proofs of this and in precisely the areas of genre and of historical motif treated in the genre fashion, which are both particularly susceptible to a predominately superficial representation. Whatever in these areas could be designated as genuinely, purely German was so by virtue of the strength and sharpness of characterization, by virtue of depth of feeling and candor and wholesomeness of emotion, by virtue of pithy humor and imaginative mood—in short, by virtue of the reflection of a rich inner life. Once again it came through successfully against the most skillful and splendid achievements of our neighbors and elicited from hundreds of serious, unprejudiced visitors the delighted, open confession that German genre painting, the German family picture and, not to be omitted in this context, German portrait painting need not fear competition from other nations. . . .

This is also the reason why in general most of the historical genre pictures of large and small format which modern realism has been sending to our exhibitions for decades find such a cool reception. Heinrich Laube, in his history of the

[4] [Horace: Nature may be expelled with a fork, but it will nevertheless constantly return.]

Vienna Burgtheater,[5] gives an excellent definition of that class of modern dramas which, originating from purely literary considerations, are in most cases merely illustrations of aesthetic theories. A corresponding class of pictures is comparable to these "literature-dramas," as they have been called. The former vanish, as do the latter, with the particular art movement which produced them, since they are rooted only in a transient aesthetic tendency and not in actual life. Belgian realism, with Gallait and de Bièfve, made up the strongest contingent of this group. The four pictures of the first-mentioned master which were displayed at the exhibition reveal clearly its gradual, irretrievable decline. With the exception of H. Robert-Fleury's famous *Persecution of the Jews*, no work worthy of mention among the French (to whom preference should have been due as the actual originators of the modern realistic historical picture) followed directly in the path which was trod, particularly by Delaroche, with such brilliant success. . . .

Even the eminent talent of Karl Piloty, the gifted teacher and enthusiastic apostle of realistic historical painting, was, in spite of all his verve and personal warmth, unable to find its way into the heart of the nation. Is he also to be only a phenomenon of transitory importance in the history of art? When we weigh his productions, one against the other, *Seni Before Wallenstein's Corpse* still has a most decisive superiority. The theatrical and melodramatic element in the historical form of this artist's conception does not get out of hand in the subdued atmosphere of this monologue. The masterly painting of detail finds its cohesion in the energetically executed overall tone. In neither of these two directions can the most recent work of this master, *Maria Stuart* (no. 972), boast of like merit. Its chief attraction is the perfection of workmanship and a certain dull mellowness of coloring, except for the occasionally quite chalky heads. . . .

Among the numerous, at times masterly executed, representations from the cultural life of the past which came to

5 [Heinrich Laube (1806–84), dramatist and novelist, director of the Hofburgtheater, Vienna, from 1849 to 1867]

the exhibition from Belgium, Italy, Germany, and Spain, only very few have a claim to the same distinction as Lindenschmit. Of the noteworthy pictures of Alma-Tadema, the Dutch artist, definitely the best seen in Munich is *The Tournament Among the Children of Clotilda.*[6] (It has recently become more generally well known through the etching by Rennefeld, likewise on display in Amsterdam.) Here indeed something of the spirit of the period of the Great Migration [of barbaric peoples] is embodied in lively figures. Young Goths with blond locks, watched by their royal mother, who sits in Byzantine stiffness, seek with youthful ambition to strike the target with an axe and are cheered on by the warriors gathered around, who already sense in the youngsters their future leaders—all this is vividly conveyed to us with a bold stroke and with that tremendous repository of knowledge of historical costume over which this master has command. But historical genre degenerates into affected archaism or pompous costume painting in most of the painted court anecdotes or histories of artists. . . .

Now we have cleared the path for a consideration of contemporary genre painting, definitely the strong point of the German school. Nowhere else does the school display such an abundance of individualities, so much richness of imagination, so much freshness and strength of representation; it is proof that our people have suffered no damage to their souls, in spite of the troubles and hardship of the times. The pictures of Knaus and Vautier, P. Meyerheim and Riefstahl, Enhuber, Hagn and Seitz, Waldmüller and Pettenkofen—to begin with only a few names—guarantee for us the independent continuation [i.e., permanence] of German art which the lack of direction in our historical painting had led many of us to doubt. . . .

In the field of genre, as in the others, the most abundantly represented of all the German schools was that of Munich. We give characteristic examples of two of its most outstanding genre painters: the *Dilettante Quartet* by Anton

[6] [Clotilda (d. A.D. 545), the wife of Clovis of the Franks, incited her sons to provoke the Burgundian War.]

Seitz (no. 1000) and L. V. Hagn's *Library of the Jesuit Col-
lege in Rome* (no. 936), reproduced in two etchings by our
W. Unger. . . .

The best of the Austrian genre painters who had already
been seen in the Vienna exhibition were represented by the
same pictures a few weeks later in Munich. A characteristic
development of this school which deserves to be pointed out
is that the life of the immediate present and of the immedi-
ate surroundings is not given nearly as much preference as be-
fore. Only Friedländer still holds with marked success to the
portrayal of the distinctive types of the Austrian people to
which Fend and Waldmüller had given such incomparable
truth, while Pettenkofen and Schönn (again to name only
the most important representatives) seek to capture for Ger-
man art the vast world of the East, the wild sons of the Hun-
garian plains and the venerable figures of oriental patriarchs.
No wonder, then, that the great dowser Ludwig Knaus, when
he first stepped on the soil of exuberant and robust Vienna,
felt an irresistible urge to cultivate this soil, so neglected by
the Austrians themselves though its picturesque qualities are
certainly second to none.

Proof that catching hold of the plenitude of life is always
the surest way to victory was also furnished by some remarka-
ble examples of French art in this category. The supremacy
of their genre painting over ours has been emphasized often
enough. There is no need to speak in detail of Meissonier or
his numerous pupils and imitators, like Madou, Brillouin,
Plassan, Fichel, Vibert, the Spaniard Zamacois, and many
others in whose works the charming spectacle of a masterful
handling of the artistic means surpasses every other interest.
However, the indifference with which we walk past even such
little wonders of technique as these proves there is not so
much allure in craftsmanship after all. An unassuming little
picture like *The Vow* by Castan (known in Vienna as *The
Widow's Elder Son*) has a much more lasting fascination for
us, through the warmth of feeling and the honesty in its sim-
ple garb of unpretentious painting, than all those old gentle-
men who are smoking or reading [and appear] in the cos-
tumes of the rococo. And among the small masterworks of

Meissonier there was hardly one that aroused as much interest as that exquisite scene of contemporary history depicting the reception of the Empress Eugénie in a French provincial town, which the artist evoked with a clever brush dipped in gentle irony. How else can we explain the enormous success which Gustave Courbet, that bold assailant of nature, enjoys in the very heart of German idealism if not by the eternal truth that the most sophisticated skill is as naught before nature—even nature at its rawest and most unrestrained. "Out with the cabinet pieces," exclaims the exhibition visitor hungry for nature, "especially if they are mere imitations of Ostade, like Leys', or mere redyed satin gowns of Terborg, like Willem's!" Neither can I abide the minuscule size. It was intended for the small, intimate, neat chambers of a Dutch patrician home. That neat art was the flower of their perennially scoured, scrubbed, and brightly polished existence! But this small, dainty art makes little sense in our large drawing rooms looking out on broad streets and sunny squares and even less in the world of international exhibitions. There the impact must come from sheer bulk, from the reverberation of the loud speech of the day, from the world showing itself as it is. Naturalism is the order of the hour, and even the social issue, so admirably recorded on canvas in the *Stone Breakers,* moves in through the wide open gates of Art. . . .

A comparison between the German and the French genre paintings of martial subjects, too narrowly defined as "battle scenes," would be of very special interest. It is remarkable to see how in this field, too, German art asserts its proclivity to individualize and to characterize. The mere telling of the war episode bores us thoroughly; strategy and tactics we leave to our excellent generals and the commanding officers of our regiments. But we delight in making the personal acquaintance, as far as possible, of the brave chaps who stormed Düppel or Custozza.[7] W. Camphausen owes his well-earned laurels to this distinctive national trait. He is an unsurpassed interpreter of the German—especially the North

[7] [In 1864 the Prussians defeated the Danes at Düppel, Denmark. In 1848 and 1866 the Austrians defeated the Italians at Custozza, near Lake Garda.]

German—soldier's nature, racially as well as individually. In French art this ability to characterize is not rare either, but on the whole the taste for the warlike action as such, for the glorification of the nation's heroic deeds, or for a jovial illustration of camp life, with its idyllic and humorous improvisations, predominates, as in Horace Vernet's delightful painting *The Soldier as Wet Nurse*, in which a bearded warrior has the regiment's baby nursing at the breast of a ewe. The entire French exhibit, however, did not present a single picture so acutely perceptive of the character of human races and so rich in individualization as Herschel's superb pen drawings from the war in the Caucasus.

Extending the comparison between the two nations to the field of portrait painting, we found that many German visitors were probably struck by the fact that the one quality by which the French made the contest quite difficult for their rivals was just the one with which we credit them least of all, that of being unassumingly natural. . . .

IV. Sculpture

The Renaissance somehow shook the three spatially representational arts out of their paths. As architecture shows the decorative element more often in its external appearance and prefers to work toward a pictorial effect of the masses, sculpture and painting have left their position in architecture to wander alone—independent, often aimless and homeless. Painting has assumed its role to the extent that it has become the fashion-setting art to whose laws sculpture must subordinate itself. Because this is so does not mean that this should be subscribed to as the correct state of affairs. Since we live in our own time, we must reckon with its viewpoints, but the eternal basic laws of every art are not those of the general public. The latter should and can never be more than that which is best in relative and momentary terms. They change with conditions and become perfected, only to give way to the new.

Among the arts, sculpture has suffered most from the failure to recognize its essence. It lacks nothing more and noth-

ing less than style itself. For the most part, it does not employ its own means to express a particular idea and to give it the outward form which is most suitable in terms of plastic representation; instead, it casts furtive glances to its sister art, painting, in order to pick up and borrow from it the effect, the appearance.

Neither does it take into sufficient account the material in which the sculpture is to be represented. The model is formed with little consideration as to whether it is destined to be executed in marble, cast in bronze, and so forth. Nor does sculpture in the embryo stage of the composition differentiate clearly enough whether it is to be a work in the round or in relief, whereby the final work falls prey to the greatest blunders.

If we consider, from this viewpoint, the three main groups of sculpture at the Munich exhibition—the Italian, the French and the German works—first of all in a general manner, then the stylistic faults can be divided approximately in the following manner: The Italian group possesses the least ideal and the most formal style. In the Italian's case there is no talk of expressing the basic idea of his work. He does not consider it necessary to treat his subject other than as a foil for a charming development of formal beauty; so, without a trace of inwardness or veracity, he offers merely a parade of demonstrations of his talent in rendering the purely external charm of form. On the other hand, the Italian produces sculptures like an artist with a chisel, with a complete understanding of his sculptural task. He creates in marble works which, as such, are entirely correct and perfect. The marble style is transformed by him into flesh and blood. In its entirety and in its details, his model is conceived for execution in marble. The case of the Frenchman contrasts with that of the Italian. The Frenchman successfully endeavors to give his sculptural form an inward expression and as much veracity as possible. He strives to express completely the essence of his subject, and in harmony with it he at least approaches style. Admittedly, if he goes too far and likes, on the one hand, to exaggerate and, on the other, to represent a certain patho-

logical ideal, his heroine is too often the passionate grisette.[8] She also holds sway with her pseudoheroic stature on the French stage, with a veracity which shocks the German visitor. The Frenchman expresses the complete volition and emotion of this, his ideal, in strict contrast to the cold schemes which, as mass-produced models, degrade the Italian works. On the other hand, he knows how to express himself only in bronze, and his weakness, particularly in relief, is incredible. Also, there is no style determined by the period. His works do not bear the particular stamp of our century; rather, they depend upon suitability, fashionableness, inclination, and whim: He reaches here into the cinquecento, there into the age of Louis XIV, or into the style of the Roman Empire —better still, even mixing, varying, and shining in all colors, as in life, which constantly seeks variety, so also in art. At least the German takes a middle position between the two nations. Here he depends upon the typical representational method and formal perfection of the Italians—especially if he received his training and was active in Italy a long time—and in his cosmopolitan receptivity he does not spurn the technical skill and charm of the French, when, as a rule, he goes along his own academic way. He does, nonetheless, add one ingredient which his neighbors lack: spirit. For him the hollow mask of the Italian representation is as impossible as the burned-out grisette-passion of the French ideal. Chaste and naïve charm distinguishes his works, and the more inferior in technique they are to the Italians and in verve to the French, the more evident it is.

Apart from the above-mentioned stylistic weaknesses of modern sculpture, the questionable influence of marketing assumes more importance in this art than in painting. Since an artist seldom decides to execute a major work in marble which is not a commission, and since even examples of work which have not been ordered are, for the most part, executed less out of uninfluenced creative impulse than with an eye to the current fashion, so the influence of the buying public is

[8] [A grisette was a capricious and pretty French girl who earned her living by her charm.]

uncommonly great, as was very evident at the exhibition. That half of the works betray their reliance on the princely salons where the ladies exercise their sweet dominion, and that the ladies love charming, naïve representations, preferably taken from the world of children, is not intended as a reproach to them. The result is that, excluding the field of mythology and allegory, the genre group included not less than 45 representations of children.

This leads us to consider the statistics of the exhibition according to subjects. Of the 395 items in the division, 49 belonged to the category of religious representations. Among these, a collection of 12 apostle statues and 6 Benno reliefs were of great importance; after their subtraction, 31 items remained in this category. Among these, only three masters of outstanding importance were to be found. The majority of the madonnas and saints statues were affected and cold products of the art industry, without originality or true artistic independence. The Old Testament and Christian subjects (mostly legendary) not intended for worship were handled more fortunately and with more love. In this group of only 9 there were 4 Old Testament subjects. From this as well as from other experiences the conclusion must be drawn that the fine arts are withdrawing more and more from the service of religion and abandoning the field to quicker and cheaper mass production.

The reasons for this seem to lie in the limited feeling for art and understanding of those in a position to award commissions in this field and in their narrow viewpoint, for they dictate their commission not merely with regard to the conception but primarily with reference to the contemporary preference for the Gothic style. It is easy to understand that a true artist who does not consider the prescribed ideal taken from the cathedrals of the thirteenth and fourteenth centuries his own—which seldom is the case—cannot be completely docile when he is faced with the commission, and therefore prefers to withdraw from the arena of religious representation, especially since the commissioners want and are capable of paying for not a work of art but sculptural padding. The time when the highest desire of the friend of art was to donate an

important work to the church of his native city and the
greatest pride of the artist was to receive a place there for his
work is certainly past. The artists work much more for salons
or museums. In this respect the latter has taken the place of
the richer churches, and following the example of the antique
collections, the artists have turned toward subjects that are
not religious. Museums prefer to demand mythological repre-
sentations, which are quite naturally suggested by the fact
that for several centuries (if not since Niccolò Pisano, at least
since the founding of the Paduan art school) the young artist
drew, and still draws, his training from antiquity. It is there-
fore understandable that among the fifty-nine items of myth-
ological representations, Cupids and youthful satyrs—of the
former there were eighteen, of the latter fourteen pieces—
represented more than half of the entire group. In the light
of the above, it must be recognized that this is the dominant
genre type to which the larger part of the group
belonged. . . .

But particularly for the Italians, the very inner emptiness
of such subjects is a desirable foil to set off their technically
and formally beautiful bravura. This is the only way to ex-
plain, for example, the three appearances of *Spring* next to
the two of *Flora* (not to mention the other seasons) and the
personifications: *Modesty, Innocence, Dream of Innocence.*
These subjects are always best where they permit a genrelike
conception. The area of poetry, especially Germanic poetry,
seems gradually to be winning growing importance, as evi-
denced by twenty representations from this field. Drawn
from German sagas are Lorelei (twice), Hagen, Brunhilde,
Tannhäuser, Lohengrin and Elsa, Cinderella, Faust and
Gretchen (twice); from Dante, Beatrice; from Shakespeare,
Romeo and Juliet, Othello, Desdemona, Hamlet, Ophelia,
Lady Macbeth; from Calderón, *La Vida Es Sueño*; from La
Fontaine, *The Cricket*; from Goethe, *Lotte*. How much un-
appealing material is among them. How formally and exter-
nally the sculptors, particularly the Italians, treat such sub-
jects, and indeed in the most striking way. . . .

How seldom the necessary conditions come together is
shown by the small number (a half dozen) of works that are

suitable. That the statuesque, in the narrower sense, was present in such small number (nineteen entries) lies in the nature of the subject. Our public sculpture must be colossal by reason of our soaring architecture, but colossal statues appear as a discordant note in the soft harmoniousness of salon and museum pieces. They are thus at a disadvantage in being disharmonious. They also exercise a belittling effect upon the environment and reduce the effect of the other works without gaining any themselves. If, therefore, only one colossal statue were at the exhibition, and that one excellent in itself, it would still, for the reasons given, have been better left excluded. The reason for this is not the prevailing lack of work in this field—on this point we in Munich at least have not the slightest reason to complain,[9] but rather the opposite, along with other reasons indicated. In monuments honoring great persons we are so accustomed to the colossal that we no longer tolerate life-size ones, even under the most favorable conditions, and in the exhibition they stand in the midst of less-than-life-size works. Even Rauch's excellent standing figure of Drake appeared minute. Smaller than life-size, however, statues shrink easily to decorations for stoves and even sink to the level of knickknacks. In such conditions busts, which were also represented in extraordinary numbers, are always more appropriate. Among the eighty-six busts were thirty-nine portraits from life and fifteen more or less ideal portraits of famous persons of the past. Only a few of them were of a purely ideal nature; most of these were allegories like Venice or Poetry. More numerous (twelve items), on the other hand, were ideally executed study heads, mostly of Italian women—a gratifying phenomenon which offers a guarantee that the emptiness and purely external beauty of form which has been decried as such a great defect of Italian sculpture will not become a general stereotype. . . .

9 [Courbet remarked on the sculpture in Munich, "There are easily three thousand statues in the city, all alike. I suggested something very simple: If the heads were attached to screws, they could be changed every two weeks and the city would only need a dozen statues. A wit said that a visitor to Munich has only one thing to fear: that they will erect a statue to him."]

Eugène Müntz: *The International Art Exhibition in Munich*[1]

When touring the Munich exposition, one at first feels deceived. While it is true that innumerable statues and paintings fill the immense Glaspalast, those that come from France have already been exhibited at our Salons and as a result no longer have the charm of novelty. One seeks in vain in the list of German entries for many of the great names which constitute German glory; the other nations—except for Italy, Switzerland, and the Low Countries—are largely absent. The bad arrangement of the objects, the gaps and errors in the catalog, and the exhuming of old paintings, which are sent here as though to an auction, are hardly sufficient to make up for these shortcomings. Add, finally, that as a whole the exhibition lacks clarity, that where one expects to find powerful and respected traditions one sees nothing but disorder and uncertainty, and you will acknowledge that the critic who expected to find in this exposition a mine that was rich and easy to exploit has every right to show his irritation.

If, however, he overcomes his first impression, due in part to the exposition's physical problems, and if he makes a point of examining more intimately the role and significance of this exposition, things will soon take a different turn in his eyes. He will discover that the international exposition has great historical importance and that it will mark an epoch in the annals of German art. "The artistic battle of the Glaspalast," says M. de Lützow, "is at bottom nothing but a duel between the Germans and the French." For the first time the French school presents such an ensemble of important forces on German soil, and its influence, which until now has been partial and restrained, threatens to become a true invasion and to transform German painting from top to bottom. On the eve of this revolution it is interesting to ascertain the existing state of affairs and to study the men who will accom-

1 [Translated from "Exposition Internationale de Munich," *Gazette des Beaux-Arts*, October 1869, pp. 301–31]

plish this, young and vigorous talents who will quickly compensate Germany for that which they have deprived her of. This exposition, which at first seems so insignificant, is the point of departure for a new era.

We don't believe that a German exhibition has ever, in fact, gathered together so many important, if not outstanding, works; never has public interest been so lively; never have circumstances been so propitious. The international exhibition held in Munich in 1863 included only 434 works in all (355 paintings, cartoons, etc.; 33 engravings, etc.; 39 sculptures and medals; 7 architectural projects), of which only a dozen were sent from France. The international exposition held in Vienna in 1869—almost all the works seen in Vienna have come to the Glaspalast in Munich —only contained 602 artworks. The present exhibition includes 3,386 works (1,631 oil paintings; 760 drawings, engravings, etc.; 392 statues and medals; 7 stained glass; and 596 architectural works). Public sympathy, like everything else today, can also be translated into statistics, and the statistics are eloquent. Between July 20 and August 31 the entrance fees (one florin ordinarily, half a florin Sundays, Wednesdays, and Fridays) totaled about fifty-five thousand francs. During the same period the administration sold thirty million francs worth of lottery tickets. That means, on the one hand, that a part of the cost of the exhibition will be covered by the receipts and, on the other, that the acquisition of art objects purchased for the lottery will form a very respectable total. To date, the choice of objects has proved the great impartiality of the [lottery] committee, which is composed of twelve members and is distinct from the prize jury. Its nineteen acquisitions include four works from France, five from Munich, four from northern Germany, three from southern Germany, one from Belgium, one from Holland, and one from Italy. Finally, the sales of exhibited works (which are negotiated for free by the prize jury) are very numerous and prove that the pecuniary interests of the artists are by no means neglected. The attitude of the German public seems excellent; the encouragements which it lavishes on this art

festival prove that it is suited to receive the exhibition's salu-
tary influence.

Let us also examine right now the role and conduct of the
administration that organized the exposition and that must
evaluate the works sent to it. It is subject to criticism from
more than one point of view, and we must reproach it on sev-
eral counts. We would ignore the criticisms if it were a mat-
ter of a single exhibition, but since the international exposi-
tions of Munich seem to have a certain periodic quality, we
believe it useful to point out these criticisms for future refer-
ence. We must criticize, first of all, the makeup of the prize
jury, which is composed entirely of citizens of Munich (it has
twelve members, half chosen by the Academy and half by the
Artists' Association of Munich). We do not question the ju-
rors' learning or their independence, but we would have
wanted to forestall the complaints that their decisions, how-
ever fair they may be, will provoke among foreigners. By ad-
mitting several Austrians, Prussians, French, and Belgians to
the jury, one could have avoided complaints and endowed
the distribution of the prizes with the solemnity which ought
to surround such an act. . . .

All the information to which we are accustomed in our
Salon catalogs and which provides invaluable documentation
for the history of modern art has been omitted. In vain do we
seek the exhibitor's place of birth, the name of his master, his
exact address, the list of prizes he has received, and often
even his first name. . . . The catalog of the Universal Expo-
sition of 1867, which was criticized so much, was a master-
piece compared with this one.

But all these faults or advantages are only extraneous. It is
time to enter the heart of the exposition itself and try to gain
a sense of the ensemble of 3,386 works—which, let us not for-
get, was not entirely planned. One fact struck us most
strongly and will impress the visitor no matter what country
he is from: the triumph of French painting. We announce its
superiority without national vanity, just as we would an-
nounce the superiority of German painting if the occasion
warranted. When we appreciated or admired the Achenbach
brothers, Heilbuth, Hittorff, Lehmann, Knaus, Schreyer,

Vautier, and twenty others, we never troubled to know whether they were French or German; for that matter, have we ever blushed to learn the philological or historical methods of Bonn, Berlin, or Göttingen? Today any sensitivity of this sort would be ridiculous, and if, in the face of the hospitality which Germany has just offered our artists, we award the prize to French painting, it is because Germany herself has long recognized our right to this prize. She has given us the substantial work which no Frenchman dreamed of writing or could have written with more love: *The History of French Painting Since 1789.*[2] She has eagerly hoped that imitation of France would spread, and more than one critic has stated that six months from now color will have reconquered its [former] position in the German empire thanks to the French school's influence at the International Exposition of 1869. For a long time Meissonier, Théodore Rousseau, Courbet, etc., have had numerous German students. The bulk of the French Army will advance in turn and end the conquest. The bulk of distinguished artists and accomplished workers who make up the French school at this marvelous exhibition is so formidable and the median is so superior to that of our neighbors that its pressure will be complete and irresistible; it will transform the taste of the German public and the tendencies of her painters. It will compel the latter to study their craft more completely but not, as many fear, to imitate France slavishly. France will teach Germany the technical processes of which our school is the trustee at the moment, but which are the inheritance of all nations. In the past the grandeur and power of Germany's thought have enabled her to compete with all the nations; in the future she can compete with them in the perfection of form. . . .

We begin our review with the French works, which we will treat summarily so that we can stop at leisure before the German works, which are unfamiliar to our readers. France has sent almost 450 works. This number includes many surprises

[2] [Julius Meyer, *Geschichte der modernen französischen Malerei* (Leipzig, 1867)]

and mysteries. You expect to find here Germany's favorites, happy to offer themselves for her admiration. Not at all. On the contrary, you meet the famous names which were forgotten at our Salons and whose reappearance abroad was unhoped for. Even the dead leave their tombs and come to join the battles of the living; even worse, works dead and buried expose themselves to the light of day, as if to prove to us (did we not already know it?) that we have progressed. . . .

Let us leave the dead and turn our attention to contemporary artists and the works by which they hope to uphold the honor of the French school in a foreign country. We find among them every nuance and every temperament; Bonnat, Henner, Ribot, Roybet, etc., are the champions of color; Meissonier, Comte, Vibert, Zamacois, and twenty others represent painting of wit; Courbet, Auguste Bonheur, Charles Jacque, Philippe Rousseau, and three or four artists who are half German, half French represent animal painting. Landscape painting includes MM. Appian, Bernier, Corot, Hanoteau, Harpignies, etcetera; never before has France offered so varied and so imposing a collection to a foreign country. At this exhibition France shines especially in smaller works. My colleagues in the German press delight in praising our technical skill and deploring our lack of ideas. I would make the same observations, but without drawing the same conclusions. They also protest the abuse of nudity, and I content myself once more with the observation that the German part of the exhibition includes only one study of a nude woman, a *Bacchante* rather weakly painted by M. Felix of Vienna. The accusations of immorality, of realism, of the search for effect are not missing either, but they are rarer than one might have expected and they are drowned in a torrent of praise.

French history painting shines rather sadly at the Munich exposition, and only one thing consoles us for her barrenness: the recognition that German history painting is equally weak . . . *pariter que jacentes* . . . *The Fall from Paradise* by M. Cabanel (property of the Maximilianeum) is somewhat above the general level but has all the familiar faults. . . .

Reaching the intermediate regions between history and genre painting, I find so many excellent works that I don't

know how to group them or where to begin. I will set to
work haphazardly. In the first line is this *Falconer* by Rubens
—no, I mean Couture—already aged but endowed with the
eternal youth of beauty. . . . It dominates the exposition;
the vivacity and freshness of the falconer's complexion, which
stands out against a light background, overshadows the best
colorists of France, Belgium, or Germany. Today it belongs
to M. Ravené's beautiful gallery in Berlin. Ribera—no, I
mean Ribot this time—has also sent several brilliant works.
Portrait of an Aged Man (property of M. Schwab) has a
virile and noble treatment; one wonders whether he repre-
sents one of our contemporaries or one of those proud old
Spaniards of the sixteenth century. . . .

Then comes a crowd of history, genre, or fantasy paintings,
good, bad, and indifferent, whose titles alone would fill many
pages of the *Gazette*. I will pass them in silence, because I
think it is more interesting to investigate the influence which
certain French schools have on Germany than to seek the
value of the French works themselves, about which the Pari-
sian public has long since rendered a definitive judgment.

There seem to me to be three of these schools: the small
masters, the realists, and the French landscapists. The small
masters are here in full force, from Meissonier to Viger.
Meissonier has long been a favorite in Germany, and the
works exhibited at the Glaspalast can only confirm his great
reputation. . . . Comte, Vibert, Zamacois, Brillouin, and an
infinite number of other artists supplement the master's work
and succeed in clearing the path which he opened up in Ger-
many.

There is less unity in the activity of the second group of
painters of which I speak. M. Manet goes virtually unnoticed
with his *Philosopher* and his *Spanish Singer* [*Le Guitarrero*].
M. Courbet, on the other hand, has a large following. He is
praised for seeing nature like a peasant and painting it like a
professor. Courbet, says one critic, pursues his course un-
troubled by success or the lack of it; he knows how to keep
his manner of seeing pure and fresh, and all he seeks in art is
a way to express his own impressions. He is one of the most
comforting figures in modern French art, for if his subjects

are sometimes repulsive, the efforts of those who want to pro-
duce an effect and make a name for themselves at any ex-
pense—even at the expense of art—are even more repulsive.
About *Hallali* the same critic says, "Unusual strength is nec-
essary to create such a work; compare it to the miasmas of
refinement and degeneracy which generally make up French
art and you will find this work superior to them because of its
spontaneity and its natural rustic awkwardness." And that is
the judgment of most of the German critics. In addition to
Hallali, M. Courbet is exhibiting: *Landscape near Mézières,
Woman with a Parrot, The Stone Breakers,* etc., etc. Another
realist, Gustave Doré, has sent *Saltimbanques*—his best can-
vas, I think—*Young Mendicants of Cordova, Neophyte, Ma-
careno of Granada,* some landscapes, etc. At Munich he is
the butt of the sarcasm of all the critics. . . .

Between France and Germany there are various countries,
some of which merge with one of these great nations and
some of which serve as intermediaries between them. Among
the first are Switzerland and Italy; among the latter Holland
and Belgium. . . .
Only M. Böcklin is truly Swiss and owes nothing to any-
one. . . . The painting by M. Böcklin (of Basel) titled
Nymph and Fauns has provoked a real storm. It has become
an object of scorn for the public, which criticizes his baroque
air, and an object of commiseration for his friends, who de-
plore a talented man's mistake. Thus, he does have something
exceptional, and in this section he deserves our attention for a
minute. Let us examine his work without prejudice. . . . It
has been perceived that the color is wrong—an easy thing to
discover, since the artist had the good sense to neglect the
values and the nuances in a painting as fantastic as this.
Moreover, he likes to play with color: In his compositions at
the Schack Gallery, he made the sharp notes that tear at the
ear shine from a heavy context. It is often said that he wants
to parody Diaz. He is criticized for the extreme liberty of his
drawing, as if in a work such as this it is necessary to aim at
the severity and correctness of the academic style. But the
public has neglected to look for the idea behind *Nymph and*

Fauns, absorbed as it is in the pleasure of playing connoisseur and declaring that because A + B—because the patterns are drawn from the colors and the patterns are taken from the drawing—the work must be detestable. The idea is nevertheless very clear and has a unique strength and pungency. M. Böcklin wanted to represent the eternal contrast between ugliness and beauty, and he sought to give an original and truly artistic form to this very common idea. Instead of giving us any Quasimodo and Esmerelda[3] whatever, he has, with the inspiration of genius, invented a scene which seems to be taken from life and which nevertheless has a certain poetic character, and he has treated it with a fantasy and naïveté worthy of antiquity. Furthermore, he has scattered over the canvas a perfume of youth and gaiety which ultimately makes one forget the ugliness of the fauns and preserve a harmonious and poetic memory of the work as a whole. . . .

The Belgian and Dutch artists occupy a place of honor at the exhibition, their works exciting the visitors' greatest admiration. Their execution is, in fact, very remarkable, and this school, so enamored of color, seems to me better able than the French school to educate the Germans in this area, because its influence will awaken fewer sensitivities. Not long ago Antwerp was a shrine for German artists; today most of the colorists of Düsseldorf or Munich still imitate Gallait and Leys more readily than they do Delacroix or Decamps; they prefer the warm and harmonious though dry and monotonous color of the Belgians to the luxury of the French palette. The artist who will hold our attention still exerts great power over them, although the influence of his name has diminished in France: Louis Gallait. He plays a large role at the exposition through his own works and through the German students whom he has trained and to whom I will return later. *Murillo Seeking the Subject for a Painting* (1854) . . . *The Violinist* (1863) . . . *The Musicians of Bohemia* . . . and *The Condemnation of the Counts of Egmont and Horn* (1864) . . . all show the firm brush and the brown

[3] [Quasimodo is the hunchbacked bell ringer of Notre Dame and Esmerelda the gypsy dancer in Victor Hugo's *Notre-Dame de Paris* (1831).]

color range so dear to the master. All these works are also pervaded by the sadness and desolation that once overcame all of Europe and have given us so many tearjerkers. . . . *The Condemnation of the Counts of Egmont and Horn*, one of the master's last works, I presume, is excessively dry in tone and imagination. . . .

Holland is equally well represented. M. Alma-Tadema's great success is due to two works already exhibited in Paris, about which more need not be said. M. Alma-Tadema seems to me to follow a bad path. What a difference there is between the superb *Education of the Children of Clotilde*, his point of departure (or very nearly), and his current productions, whose color is so heavy and conception so bizarre! One more step and he will become an insufferable mannerist. . . .

We have finally arrived in the promised land of great history painting; first we must examine its condition during the last few years. . . . Alas! History painting is dead in Germany, too, and its final champions sadly attend its funeral. At the exposition we find only one work by a great master, and in admiring it we must note that Kaulbach is the sole artist in Europe at the moment who can create a work as colossal and brilliant as this. It dates from about a dozen years ago, and I only mention it because it is still unknown in France: it is the immense cartoon for the *Battle of Salamis*, with its hundreds of figures, boats, temples, gods, and its flashes of genius. Kaulbach has used all the resources of his brilliant facility, his great talent as a decorator. He has skillfully distributed the masses, thinning or shrinking them according to the demands of clarity or pathos. He has triumphed over the innumerable details, arranging them in five or six distinct groups and combining them all into a shining and passionate action. . . .

Kaulbach also exhibits several smaller cartoons, probably destined to be photographed and to flood France, Germany, and America in that form. They date from the past few years (*Lohengrin*, 1866, etc.), and I mention them only to demon-

strate that the artist pays no attention to his critics and that
he hears only the applause of the crowd. . . .

Contemporary history painting in Germany has, as we
have seen, so few representatives that it is not worth the
effort to try to classify them by schools or nationalities. . . .

The conditions [in several German cities] about which
something should be said, are very favorable to the material
interests of artists. They have all the facilities possible for
studying, selling, obtaining commissions. What more do they
want? The sympathy of the public is sincere, though unen-
lightened—but what does it matter, since there *is* sympathy?
Twenty different cities offer them the intellectual excitement
which in France is concentrated in Paris. Again, what more
do they want? Thanks to innumerable societies of friends (or
rather executioners) of art, the beginner rapidly disposes of
imperfect works and knows nothing of the harsh arguments
which French artists endure. A piquant title, a flash of wit, or
a pathetic gesture and he is proclaimed a painter, whether he
knows how to hold a brush or not. Few young men are able
to resist these seductions. They earn money, but while for-
tune smiles on them their consciences can reproach them
with doing hackwork. The evil, moreover, is that they win
consideration and fame, the highest consecration of talent
and knowledge. They see no further than that. Thus are born
the local reputations which suddenly appear before the for-
eigner at an international exhibition and remain for him an
indecipherable enigma. Thus, support for artists becomes de-
structive to art. Ignorant of struggles with the difficulties of
execution, ignorant of struggles against life, they are very ca-
pable of having their moment of humor, their moment of in-
spiration, but they do not have the strength to pursue a work
with the perseverance and the will which transform the ini-
tial, formless idea into a perfect work of art. . . .

Let us consider Munich, which in the nineteenth century
is a true temple to art. What resources for artists, what excel-
lent models! Thousands of ancient works in the public galler-
ies, admirable architecture, the Glyptothek, the Propyläen,
the National Museum, the richest in the world. What sincere
and persistent efforts on the part of the inhabitants to put

style into their buildings and their furnishings. What sacrifices to keep the *thousand* artists in Munich busy! Art has truly taken root in their lives and should prosper, at least according to the lessons which history has taught us. A king more generous than cautious wants all at once to offer artists a great opportunity to develop their talent; he would like this flower which blossoms so slowly to bloom suddenly, and he commands 150 colossal frescoes (more precisely 143) in the National Museum and 30 enormous compositions destined for the Maximilianeum. The painters respond to his appeal, and in three or four years (from 1860 to 1865) the works which should have taken a whole generation are finished. Entrusted to young men whose heads swell with honor, or to more mature men who are led astray by the rush, the commissions have hastened the downfall of fresco and the Munich school. . . .

On the ruins of all these old systems a young and ardent generation is rising which rallies around the cult of form. All these artists—Viktor Müller, Lenbach, Makart, Adam, Max, Czermak, Canon, Füssli—are free of all German tradition and all shackles; they seek their inspiration either directly at the source (whether in Italy or the Low Countries) or in the country which has the task of adapting these traditions to the demands of the nineteenth century—France. Their excesses must be pardoned; a revolution cannot happen without them. Germany will go through several years of realism, a realism as complete as that of Daubigny and Courbet. She knows this and she hopes that the regime will retemper her strength and reconcile her with genuine art and nature. Her genius is strong enough to permit her to withdraw again when the time for that has come.

The newcomers try their skill, above all, in genre and fantasy, which sometimes takes its subjects and its dimensions from history painting. . . . Let us study them individually.

M. Makart is the Richard Wagner (others would say the Offenbach)[4] of German painting. His reputation dates from

[4] [Jacques Offenbach (1819–80) won success in Paris with such operettas as *La Grande Duchesse de Gérolstein* (1867).]

only last year and already he has his supporters and his crit-
ics. I have seen four of his works. . . . *The Nymphs Com-
ing to Touch the Lute of a Sleeping Singer* at the Schack
Gallery has taught the public and the artist himself that he
does not know how to draw or paint grand figures. The
Sketch [for the Decoration of a Hall] at the present exhibi-
tion confirms this observation and, what is more, extends it
even to small figures. The torsos, the arms, the legs are all in-
correct, and as for the hands, the artist has slurred almost all
of them in order to hide his ignorance of anatomy. He has
made a brave decision as a result of this discovery. Renounc-
ing the vulgar routes, he has sought a genre which demands
no knowledge of drawing or painting, but only a certain taste
for combining colors, and he has found it. . . .
 Painters of country life are numerous, as one would expect.
Except for three or four, they drag along in the old rut and,
to a greater extent than their colleagues in the genres of his-
tory or fantasy, they neglect color. Let us explain ourselves,
however. To tell the truth, they are preoccupied with ways to
use all seven colors of the rainbow in their works, and they
are careful not to omit one; but this banal juxtaposition only
produces the effect of an eternal rainbow. Colorists of this
sort are like musicians who only use perfect chords. In their
compositions they alternate between the comic and the senti-
mental, blending these two extremes into a uniform tedium.
Their peasants must laugh or cry, as though the peasants,
who are as human as the artists who have devoted the brush
to them, were condemned perpetually to a scowl or a laugh.
The naïveté which they affect succeeds in making them odi-
ous. . . .
 Our neighbor's landscape painting is in a period of transi-
tion, as is every other type in contemporary German painting.
There are still two camps, but the outcome of the battle is
clear: The new school will be victorious. Several years ago,
nature for the landscapists beyond the Rhine consisted of the
light of the moon, glaciers and lakes, and ruins. Today more
than one canvas is still filled this way, but young and gifted
painters can nevertheless be seen who are each laboriously

clearing their own corner of the earth, waiting until a more intimate knowledge of nature and the techniques of painting enable them to embrace it again in all its grandeur and variety. . . .

1871: BRUSSELS

The Exhibition

of a Society:

La Société Libre des Beaux-Arts

Brussels, the capital of Belgium and undeniably one of the most beautiful cities in the world, was spread out like an amphitheater between two hills. Though its population equaled that of Berlin or Vienna, the city covered a much larger area, for most families occupied a house with a garden, as in London, rather than being piled up in houses of five or six stories, as in Paris. The center of the city was the Grand' Place, the square overlooked on one side by the Palais de la Nation, where the legislature met, and on the other by the king's palace, which since 1831 had been the home of King Leopold I.

Filled with the spirit of revolution that swept through Europe in 1831, Belgians had rebelled against William I, formerly prince of Orange, a Dutch Protestant who at the Congress of Vienna in 1814 had been named king of the Netherlands, which included both Protestant Holland and Catholic Belgium. When they met in London at William's request, the European powers granted Belgium its independence and guaranteed the country a neutral government similar to that of Switzerland. Leopold I, who was chosen to

rule Belgium as a constitutional monarch in 1831, had encouraged government policies of toleration and moderation; during the forty years since its independence Belgium had become a center for liberal thought that served all of Europe. Belgian newspapers, both well-established journals and short-lived avant-garde "little magazines," enjoyed a wide circulation in liberal circles outside the country. Political exiles who fled revolutions in other European countries found refuge in Belgium. Paris was only a few hours away by rail, and since French was the language of the Belgian Government, newspapers, and the cultivated classes, French liberals and republicans escaped to Belgium at each change in the French Government. When he left France following the June days of 1848, Théophile Thoré settled in Brussels and wrote for *L'Indépendance Belge*. After Louis Napoléon Bonaparte seized power in 1851, Victor Hugo and the socialists Victor Schoelcher, Louis Blanc, and Pierre Joseph Proudhon fled to Brussels. Hugo's satirical pamphlet, *Napoléon le Petit*, printed in England by a Belgian in 1852, was distributed from Brussels and became one of the first of such attacks to provoke a diplomatic incident between the two countries. The publication by Jean Lacroix in Brussels of *Les Misérables* (1862), the novel credited with advancing the revolutionary events of 1870 in France, brought an international gathering of liberals to the city to honor Hugo at a banquet.

Brussels was a haven from creditors. Alexandre Dumas père arrived in 1851 as much for financial as political reasons. In 1864 Baudelaire followed his bankrupt publisher, Pierre Poulet-Malassis, to Belgium; the latter had been ruined by the lawsuit brought against him for publishing Baudelaire's *Fleurs du Mal* (1857). Baudelaire remained in Belgium until a few months before his death, hoping to secure Lacroix as his publisher. Aided by the Belgian art dealer Arthur Stevens (younger brother of painters Alfred and Joseph) and the engraver Félicien Rops, he gave three lectures at the Cercle Artistique et Littéraire. These were announced in *L'Indépendance Belge*, which regularly reported on events—such as Manet's private exhibition of 1867 in Paris—that were of in-

terest to the avant-garde everywhere. Castagnary's Salon review of 1863 was published in *Le Nord* (Brussels).

The tolerant policies of Leopold I were continued by Leopold II after his succession in 1865. Constant diplomatic maneuvering was necessary to maintain Belgium's political and economic neutrality in the face of Prussian expansion and French efforts to gain control over all the territory south of the Rhine River, including Luxemburg and Belgium. In 1869 Napoléon III's attempts to extend the Customs Union with Luxemburg to include Belgium and bring the Belgian railway system under the control of the French state railway were blocked.

Saved from invasion by the guarantee of neutrality, Belgium again became a sanctuary for Frenchmen after the decisive defeat of Napoléon III's army by Prussian forces at Sedan on September 2, 1870. The country provided an escape both from the Prussians and from the political turmoil that wracked Paris during the next year. Paris managed to resist the Prussian siege until January 1871. In the parliamentary elections that followed the capitulation of the government in Paris, the aged royalist Adolphe Thiers became the president of the Third Republic of France. His acceptance of the humiliating peace terms demanded by the Prussians and his economic policies had provoked Parisian socialists into establishing the revolutionary Paris Commune. Buildings symbolic of former governments—the Hôtel de Ville, the Palais de Justice, the Tuileries, and the Ministry of Finance—were burned. Courbet, president of the Artists' Federation, did not hinder the dismantling of the Napoléon I column in the Place Vendôme. When government troops wrested Paris from the socialists in May 1871, many fled to the surrounding countries.

The exiles who had managed to escape to Brussels in the year after Napoléon III's defeat included artists like Diaz and Eugène Boudin, who were attracted by the traditionally strong cultural ties between Belgium and France. In the eighteenth century the academies founded in Belgian cities— the Royal Academy of Antwerp (created in 1750), the Academy of Ghent (established in 1771), and that of Brussels (es-

tablished the following year)—were closely affiliated with the French Royal Academy: not only were its conventions and techniques assiduously observed by Belgian sculptors and painters who aspired to have their work accepted at the Salon, but it was customary for Belgian students to finish their training in Paris. Jacques Louis David, whose classicism dominated French painting during the Revolution and Empire, chose Belgium as his place of exile after Napoléon I's defeat in 1815 and was provided with a room in the Hôtel de Ville in Brussels. Staffed by his former students, Belgium's art academies virtually became branches of his studio.

French romantic painters admired the color and bravura brushwork that marked the grand style of sixteenth- and seventeenth-century Flemish painters. Eugène Delacroix made a study trip to Belgium instead of going to Italy. Contemporary French landscapists found inspiration in the seventeenth-century Netherlandish landscapists. Belgian artists, in turn, frequented the studios of French artists. Louis Gallait, a friend of the French history painter Paul Delaroche, established, together with Édouard de Bièfve and Gustave Wappers, a style of historical painting that incorporated the realism of Flemish painting of the Renaissance and the vibrant color of Rubens with the romantic sentiment of the French school. In their enthusiasm for Belgium's recently won independence, Gallait and de Bièfve depicted episodes of heroic resistance to despotic authority drawn from their country's history. Gallait's *Last Honors Paid to the Counts of Egmont and Horn* (1851) and de Bièfve's *The Compromise of the Netherlandish Nobles* won acclaim and popularity when they were exhibited in different European cities; they were included in the Belgian section at the international art exhibitions in London and Paris. Also popular was the work of Hendrik Leys, which was influenced by trips to Paris in 1835 and Germany in 1852. An effect of simplicity achieved by observing the clear light and pure color of the fifteenth- and sixteenth-century Netherlandish painters made his paintings appeal to people throughout Europe and England.

After the establishment of a national museum in Brussels in 1835, a system of national annual art exhibitions was insti-

tuted whereby Brussels, Antwerp, and Ghent obtained, in succession, a triennial exhibition. The organization of each exhibition was on a municipal rather than a national basis and, by the authority delegated by the academies, came under the direction and auspices of the Royal Society for the Encouragement of the Fine Arts. The first exhibition was held in Ghent in August 1851. Amateurs, patrons, and artists served on the executive committee responsible for the arrangements. The exhibitions were supported by subscribers, who received a share of the net proceeds from the sale of works. Foreign artists were invited to send their work, and because the Belgian exhibition was usually held later in the summer than the French Salon, many artists who exhibited in Paris sent the same works to Belgium. In 1851 Courbet's *Stone Breakers*, after it was exhibited at the Salon, vied with Gallait's *Last Honors Paid to the Counts of Egmont and Horn*, popularly known as "les têtes coupées," as an attraction in Belgium.

Belgium's exhibitions contributed to Brussels' growth as an international art market, as Antwerp had been in the seventeenth century. The Belgian art dealer Arthur Stevens established branches of his gallery in Paris and Brussels. Durand-Ruel would bring his exhibitions of the works of avant-garde painters to Brussels in the next decade.

In August 1862, stimulated by the international exhibition just held in London and those preceding it, an international Congress of Fine Arts was held in Antwerp at which all the different artistic styles were represented. The realism of Courbet was singled out for vigorous defense by such Belgian painters as Charles de Groux. Four years later de Groux lent support to a group of young artists—including sculptors Antoine Boure and Constantin Meunier; engraver Félicien Rops; landscapist and animal painter Louis Dubois; marine painter Louis Artin; portraitist Charles van Camp; and others —who had just formed the Société Libre des Beaux-Arts. Many of these artists had been brought together by an open studio which provided an alternative to the Academy's instruction. Though the Atelier Saint Luc, founded in 1846, had lasted but a few years, it and another open studio that

had been maintained until 1863 had supplied a meeting place for independent students dissatisfied with academic conventions. The members of the Société Libre were united in a desire to revitalize academic-sponsored art, whether classical or romantic, by seeking greater veracity in the interpretation of nature. They invited the French painters Corot, Millet, and Jules Breton and the critics Théophile Thoré (William Bürger) and Philippe Burty to be honorary members. With the financial backing of its president, an amateur painter, the Société Libre established an open studio at the Galerie du Roi, which was located in the same building that housed the offices of the liberal paper *La Chronique.*

The Society's efforts to secure adequate recognition from the Executive Committee of the Royal Society for the Encouragement of the Fine Arts, which organized the annual official exhibitions, had met with opposition: If not excluded altogether, their works were poorly hung. Therefore, on December 2, 1868, the Society opened its first exhibition in the Galerie du Roi; concurrently the national exhibition was being held at Ghent, where twelve paintings by Courbet were on view. To demonstrate the distance which separated their work from the *grandes machines* of official art and to emphasize that the members considered themselves artisans who labored to create their finished works, some studies and unfinished paintings were included in the exhibition.

Simultaneously, a similar independence had appeared in the applied arts. A Congrès de l'Enseignement des Arts du Dessin was held in September and October 1868 in an attempt to secure greater freedom from state control, encourage the development of new talent where it was found, and refine public taste. Officialdom, ignoring the country's past excellence in the applied and decorative arts, had relied on France for designers rather than providing educational facilities as England had begun to do. Therefore, architects, sculptors, and designers assumed the task of training artisans in local studios. The designers, ornamentalists, and decorators were thus brought in contact with the mainstream of Belgium's creative activity at the same time that they were engaged in designing objects for the public.

Confident of support from liberal elements in the art world and innovative groups, the periodical *L'Art Libre* was launched in December 1871. The first issue, which appeared on December 15, 1871, included a manifesto expressing the Society's acceptance of realism as a pragmatically sound substitute for the outworn and visionary idealism. It was written by Léon Dommartin, a member of the staff of *La Chronique* who often used the pseudonym "Jean d'Ardenne." He would become *La Chronique*'s editor in 1898. After a successful first year, the little magazine continued its advocacy of realism as *L'Art Universel*, which was now published by Camille Lemonnier, a friend of the Société Libre des Beaux-Arts. Other members regrouped themselves to found the equally innovative La Chrysalide in 1876, from which, in turn, some of the founders of Les Vingt emerged in 1884.

Léon Dommartin: *Manifesto*[1]

Five years ago in Brussels several young men met and formed a group called the Société Libre des Beaux-Arts.

They felt the pressing desire to follow new tendencies and to break, once and for all, with all the prejudices that too long endured as tyranny. The hour of vain recriminations was over; the signs of a new art had become too pronounced; they must act.

This art appeared with all the characteristics of freedom: The main idea here, as in all modern reforms, was liberation.

The simple act of creating a free society must have significant consequences. This act had the appearance of nothing. It arose in the most modest circumstances. It seemed to be one of those commonplace attempts which occur daily in an unsuspecting world and leave no shadow of their birth.

In reality, this endeavor had enormous importance, because it was a claim made at the right time.

That five or six people gathered one evening in an ordinary

[1] [Translated from *L'Art Libre*, December 15, 1871, vol. I, no. 1, pp. 1–3. I am indebted to Jane Block for the selection and translation of these documents.]

place is something absolutely insignificant in itself; it is impossible to assign any importance to it.

That these people assembled in the name of artistic liberty —that is entirely different.

They themselves did not know what would result from their association and scarcely appreciated its importance; they did not claim that the idea that united them was inevitably destined to gain ground by virtue of the great laws that govern humanity.

They had conscience and faith, nothing more.

That sufficed, and the Société Libre was founded.

Today the Society affirms its principles in a journal: *L'Art Libre.*

Tomorrow the principles will triumph everywhere.

It is the law.

It is therefore not a question of our seeking victory, or preaching a gospel, or even issuing some propaganda in the name of a coterie. It is simply a question of stating this:

We represent the new art, with its absolute freedom of appearance and direction and its features of modernity.

Our ideas will inevitably triumph and assert themselves sooner or later, despite united opposition.

What we desire is to hasten the hour of victory, to formulate the principles of modern art, to affirm openly and sincerely that we will fight with energy against everything which stops, diverts, or impedes us.

Some will say this implies intolerance.

Of course.

This is not the place to return to the eternal social discussion of compulsory education, that so-called assault on freedom. We know, alas, that man does not accept freedom without being constrained; in effect, the first condition for knowing and appreciating liberty is self-awareness, which is only obtained by education: It is the well-known vicious circle from which we can escape only by an act of authority.

It is the same in art: It is necessary to germinate from the strength of artistic independence—as one grows certain vegetables with the aid of special cultures—under the threat of dragging oneself indefinitely along miserable ruts.

We want a free art. This is why we will combat unflaggingly those who wish to enslave it.

If that is intolerance, so be it!

We can die tomorrow or weaken at the task; our association may dissolve; our journal may disappear, after the most ephemeral of existences, into that special limbo reserved for newspapers that fail.

What does it matter? The concept will remain; others will pick it up and will take it where we were incapable of leading it ourselves.

Whatever happens, we will always be able to claim the honor of having been the first in this country to hoist the flag of artistic freedom.

It is often said, "The Gods are departing." I find that they are still ever-present. The art of this time must have for its mission dispelling what remains of them and returning to man and to nature—to the great nature that we have learned to know better than our forefathers and that appears to us today in all its abundance.

To create lovingly and honestly what one sees—such is the slogan of modern painting. I will not enter, in this regard, the tedious dispute of the ideal and the real, a pretext for endless, tiresome harpings: One has come to accept the emptiness of this argument that conveyed words rather than substance. There is hardly anyone other than M. Prudhomme[2] who is capable of seriously taking up this archaic issue and executing several heartfelt variations on it while reproaching the "realists'" lack of poetry.

As for us, we know that poetry exists in abundance everywhere, that it is embedded as a spark in stone, and that it remains for the artist to release this magic spark by diligent contemplation of all that the senses perceive. If the talent is there, the spark will inevitably be set free and the dilettantes of "poetry" will have nothing to lay claim to, because by continuing their ridiculous complaints they will acknowledge

[2] [Joseph Prudhomme, created by the satirist Henri Monnier (1799–1877), typified the stupid and self-satisfied bourgeois.]

that their poetry is false, counterfeit, and offers a hollow dream in place of startling reality.

Besides, it is absurd to claim that by being engrossed in the contemplation of present-day things, by taking life by surprise and studying it in its immediate manifestations, one withdraws from tradition. Our forefathers did not do otherwise; each age has its own ideal which serves as a goal: antiquity had Venus; the Middle Ages the Virgin; we have the female, who suits us well, I suppose, and relieves us of looking to the past for lost models in order to communicate a false life through an artificial stimulation process.

Simply because recognized men of talent gave us this example does not mean we must follow them, because it is precisely there that they have sinned.

Moreover, their memory will be consecrated to unending censure because their evils were in proportion to their greatness.

A Delacroix is free, in an age when modern art still struggles in its infancy, to increase his efforts to give free play to his genius and to seek inspiration everywhere.

But we will never accept that the painter of today, deliberately and in a stereotypical way, diverts his gaze from the living world, confines himself to death, seeks to give us an extinct world which has nothing to do with us and which his contemporaries have left to us with a superiority which he will never attain, because they saw and he did not.

These are the painters who created the Société Libre, this is the painting which inspired our publication; this is why the main space is devoted to it here, but not exclusively; the artistic movement in all its manifestations, such is the concern of *L'Art Libre*.

Here appears one of the most burning issues of the time: the musical question.

However little one reflects on it, one will find in music the same tendencies and the same symptoms of liberation.

It seems that the symphonic form was exhausted and that one could scarcely conceive of progress after Beethoven.

But there is a musical form corresponding to our time which is its special product, as the novel is in literature—a

form entirely new, imperfect, submitted to ardent research, subject to the oppression which accompanies beginnings. I wish to speak of dramatic music, whose idiom par excellence is opera.

The struggle here is less advanced than in painting, and musical renovation becomes incarnate today in one unique personality: Richard Wagner.

It is not a question, for people who profess freedom in art, of siding passionately and blindly with a man; it is a question of distinguishing what this liberty for which they are fighting is. Now, I proclaim it loudly, without fear of being contradicted by any of those who pursue the new ideal: Richard Wagner is the one who stands fast, despite all hostility, to the torch of truth we are seeking.

I cannot in this brief article, which cannot extend beyond the outlines of a program, examine the Wagnerian system to show how this system, with its subjects borrowed exclusively from legend, is perfectly in agreement with our modern tendencies. In effect, the legend is for all time, it belongs to all of humanity; it is appropriate, therefore, above all, to the expression of a dramatic musical: *Tannhäuser, Lohengrin, The Flying Dutchman*, though fixed in space and time for dramatic reasons, in reality take place in the vague places and indeterminate time where Shakespearean drama placed King Lear.

I am ending.

The great poet Heinrich Heine wrote in *Intermezzo*: "It is a question of burying the old and wicked songs, the heavy and sad dreams. Let me look for a large coffin. I would put in many things! . . ."

Ah! brothers, what things we will have to put in this coffin, where it is a question of burying our old rubbish. We will need giants stronger than the St. Christopher from the dome of Cologne to carry this coffin and throw it into the sea so that it will remain there forever!

Louis Dubois: Our Program

Artists today are divided into two camps, as they have nearly always been: the conservatives at any price and those who think that art can only endure by transforming itself.

The first condemn the second in the name of the exclusive cult of tradition. They claim that one should not deviate, without inviting failure, from the imitation of certain schools or undisputed appointed masters.

The present review is published to react against this dogmatism, which would be the negation of all liberty, all progress, and which could only base itself on the scorn of the old national school and of its most illustrious masters and its most original masterpieces.

L'Art Libre admits all schools and respects all originalities as so many manifestations of human invention and observation.

It believes that contemporary art will be all the richer and more prosperous as these manifestations become more numerous and more varied. Without disavowing the immense service rendered by tradition, taken as a strong point, it knows no other point of departure for the artist's research than that which has renewed the art of all eras, that is to say, the free and individual interpretation of nature.

1873: VIENNA

The International Exhibition:
The Universal Exposition of
Arts and Industry in Vienna

Since 1814, when the leaders of Europe met at the Congress of Vienna, there had not been such an extensive gathering of dignitaries as that which assembled for the opening of the Universal Exposition of Arts and Industry in Vienna on May 1, 1873. In a chilling rain, crowds clustered beneath black umbrellas to watch the gilded court carriages pass through the grounds of the Prater to the exposition building. Inside, music filled the nave as the royal couple, invited guests, and their entourage proceeded past the intersecting transepts where contributions sent from nations as far west as the Americas and as far east as China and Japan were displayed. The diplomatic corps, foreign and provincial commissioners, members of the press, ticket holders, and thousands of others had already assembled in the Rotunda (beneath the largest dome ever constructed) to await the royal party. Franz Josef, Emperor of Austria and King of Hungary, Empress Elizabeth, and the heirs apparent to nearly half the thrones in Europe—including the Prince of Wales, the Prince and Princess Imperial of Germany, the Crown Prince of Denmark,

the Countess of Flanders, and the Sultan of Turkey—created a dazzling display of aristocratic power and wealth. Their glittering medals and resplendent green, scarlet, or blue uniforms and their rich velvet tunics laced with gold and bordered with fur brightened the cold, gray light that filtered through the dome's lantern three hundred feet above. With dignity and ceremony the emperor expressed his gratitude to the organizers and officially declared the Universal Exposition of 1973 open.

The plan and project for this international exhibition, a celebration of the twenty-fifth year of the emperor's reign, had been endorsed in the presence of Archduke Rainer at a meeting of the Imperial Academy of Sciences on September 17, 1871. The Director General of the Academy, Baron Wilhelm von Schwarz-Senborn, had headed Austria's participation in preceding world expositions. The official organizers intended this exposition not only to represent the state of modern civilization and to promote its further development and progress "but to be retrospective, and trace back the industrial, intellectual, scientific, and artistic progress of the race, from the flint weapons of the drift, dating from prehistoric days, faintly sketched out in the Paris show of 1867, to the glories of Raffaelle [sic] and the 'resonant steam eagle' of Watt."[1]

In planning the mightiest display of the labor of all nations ever held—the exposition was to be four times the size of the Paris exhibition of 1867—the organizers had ignored the recommendations of the executive commissioners of the countries represented at the 1867 exhibition, who had stated, "The usefulness of the international exhibitions does not depend upon their size but on their selectness and quality." They also ignored the recommendation that "to promote the comparison of objects, the general principle of the arrangement should be by classes rather than by nationalities."[2] The rational plan of the Paris exhibition, which had made it easy to examine and compare similar kinds of objects, had been abandoned in favor of a simple geographic arrangement. This

[1] *Art Journal*, May 1873, 149–56
[2] *Art Journal*, October 1873, 293

meant that the number of objects displayed could be increased, but despite its size the exhibition failed to teach its lessons as completely as a smaller, better-arranged exhibition might have done.

Because of its size, three separate buildings to house displays relating to industry, art, and machines were erected in the Prater on the banks of the Danube River. The most important building was a palace surmounted by a dome, which covered the vast space thought necessary for the opening and awards ceremonies. Constructed from cast iron after a design by John Scott Russell, the innovative engineer and designer of ship hulls, the dome's 354-foot diameter was more than double that of Saint Peter's in Rome. The vast buff hemisphere, stenciled with gilt angels 20 feet long and supported by slender gray columns, narrowed to meet a lantern 100 feet in diameter and 40 feet high. Surmounting the lantern was an enormous gilt crown encrusted with jewels of colored glass, an exact replica of the imperial crown. The crown and the building's Renaissance facade, designed by Baron Karl von Hasenauer, were appropriate symbols of the emperor's efforts to revitalize and rebuild the city of Vienna.

Though the political influence of the capital had been reduced by the military defeats of 1859, 1866, and 1867, the economic importance of Vienna was growing. It was the hub of a railway system that extended throughout the Dual Monarchy. Recent efforts to regulate the Danube's course and link it with the Rhine would soon make it possible to ship goods from the North Sea to the Black Sea. The river and the rails contributed to making Vienna the banking and commercial center of eastern Europe. The city's wealth helped to sustain theater, music, and the fine arts.

Emperor Franz Josef hoped to make Vienna the artistic and architectural rival of Paris. On December 25, 1857, he informed his Minister of the Interior, "It is my will that the widening of the inner city of Vienna be undertaken. To this end I permit the opening of the walls, fortifications, and moats."[3] By 1873 the ramparts and glacis which encircled

[3] H. Steed, *The Hapsburg Monarchy* (New York: Scribner, 1913), p. 586

the medieval town, St. Stephen's Cathedral, and the Hofburg of the Hapsburgs had been replaced by the magnificant Ringstrasse. On this boulevard the Opera House had been erected, as splendid as the one in Paris, and new public buildings were also planned. To design the museums of art and natural history, Gottfried Semper had been called from Zurich in 1871 to collaborate with Hasenauer, who also collaborated in the design of the Opera House. A university designed by Heinrich von Ferstel, Parliament buildings designed by the Dane Theophilus von Hansen, and the new Rathaus by Friedrich von Schmidt were commissioned. Equally impressive to visitors were the long new streets devoted to private dwellings, infinitely more varied than those of Paris. They were divided into blocks of buildings with an individuality all their own, yet at the same time a general harmony was maintained.

Accompanying the radical renovation and modernization of the ancient capital were efforts to rejuvenate the arts. Commissions for monuments to be placed in the new squares and gardens and for statues in the grandiose public buildings were given to Anton Fernkorn, Emmanuel Max (1810–1901), Kaspar Zumbusch, Josef Myslbek, and Victor Oskar Tilgner (1844–96). Historical and allegorical canvases for public edifices were supplied until his death by Karl Rahl, professor of painting at the Academy, whose cool style was similar to that of Wilhelm von Kaulbach and other followers of Peter Cornelius. After the acclaim that greeted his *Modern Amoretti*, Hans Makart became the leader of fashion in the Austro-Hungarian art world thanks to a lively, theatrical temperament, a strong sense of color, and technical virtuosity. His natural talents had been encouraged by his teacher, Karl Piloty. Determined to create nothing small, Makart, like a second Tiepolo, supplied the immense pictures needed for the walls and ceilings of palaces and public buildings.

The decorative and industrial arts were also supported and encouraged by the government. On his return from France, Rudolf Eitelberger von Edelberg, one of Austria's commissioners to the London exhibition of 1851 and the Paris exhibition of 1855, had published "Letters Concerning Modern

Art in France at the Paris Exhibition."[4] His suggestions for the improvement of the fine and decorative arts in Austria had received governmental endorsements. Eitelberger was named to the newly established chair of art history at the university. In 1863 he secured official support for a school of industrial art and later for a museum based on the plan of England's South Kensington Museum, which would encourage the industrial arts by oral and written instruction, practical training, and exhibitions.

The modernization of Vienna stimulated similar activity throughout eastern Europe. Vienna's architects were called upon to design theaters, banks, business establishments, and dwellings from Vienna to Odessa. To meet the demand for what was virtually a housing industry, a *Baubureaustil* developed. Vienna became a center of architectural decorators, ornamental designers, and artisans of applied art.

Visitors to the international exhibition of 1873 admired the furnishings and ornamental objects, known as "articles de Vienne"—including toilet accessories, jewelry, cases in Russian leather, writing-table accessories, and carved meerschaum, amber, and ivory—that were featured in the special "trophy" cases in the rotunda, where each country displayed objects reflecting consummate skill and artistry. The products of Viennese designers competed with the wealth of cashmere and gold cloth, niello work, and "quaint jewelry and quainter costumes"[5] that filled India's trophy case, a bust of the king of Italy executed in walnut, Belgian metalwork, and German porcelain from Berlin and Meissen.

In many displays the single outstanding object—designed for a limited clientele that had predominated at the first international exhibition—had been replaced by objects whose use would be widespread. Previous expositions had taught manufacturers "what could be done with cheaper labor aided by industrial training and with artisans trained in art united to manufacture."[6] The spread of industrial art education in all countries had resulted in an advance in usefulness and

[4] See section entitled "1855: PARIS" in this volume.
[5] *Art Journal*, June 1873, 183
[6] Ibid., p. 186

finish of objects. Displays of raw materials from around the globe had provoked questions as to the most suitable uses for them. Displays of small utilitarian objects successfully attracted attention. According to the *Art Journal*, "These examples demonstrate how purely mechanical appliances, prosaic in themselves—as wheels, levers, windlasses, anchors, or chains—when artistically arranged and grouped become productive of the sensation of the agreeable, if not the beautiful."[7]

The stimulus of the international exhibitions had also affected oriental manufacturers: "Japan, with all its strength, has put itself on a European footing and endeavors to modernize its civilization. . . . We have seen the little men in brightly embroidered costumes, sabres across their bellies, transform themselves into Salon gentlemen in cutaways and top hats. And now they have collected what European civilization and industry have created and sent it home as samples. We do not doubt that the clever men with the small, quiet, cunning eyes have done right for the salvation of their people and their country, but we, the friends of every good, well-executed and, above all, original work of art, we will lose much pleasure and eventually, instead of charming, original, and also bizarre objects, we will have to receive barbaric copies of our own works. There will hardly be another world exposition —may it come on hesitant feet—that will bring us these countries and, for that matter, the entire Orient in fuller originality."[8]

On leaving the kaleidoscope of colors and forms in the gigantic industrial building, the visitor crossed a formal garden, ornamented with a replica of the famous fountain of Sultan Achmed in Constantinople, to reach the elegant Gallery of Fine Art. The emperor had opened the fine arts exhibition on May 15 with a special ceremony in the gallery's immense central hall. Two life-size portraits of the monarch—one by the Munich portraitist Franz von Lenbach and the other by Franz Josef's court painter Heinrich von Angeli—dominated

[7] Ibid., November, p. 325
[8] Jakob von Falke, "Wiener Austellung," *Zeitschrift für bildende Kunst*, 1874, 248

the hall, overshadowing portraits of the protector of the exposition, Grand Duke Karl Ludwig, and its president, Archduke Rainer. Several large canvases were also hung in the place of honor: Representing the newly united Germany were the Bavarian Karl von Piloty's *Triumph of Germanicus* and, from Stuttgart, Hans C. Canon's *Reconciliation of the Confessors*; from Belgium there was Antoine Wiertz's *The Fall of Angels*, a confusion of enormous bodies and a fiery dragon; and from France had come an immense oval ceiling painting of a mythological dance by Alexandre Cabanel.

It was the largest exhibition of art ever held on the banks of the Danube: Architects, painters, sculptors, and graphic artists from twenty-six countries had sent works created during the past ten years. Austria, allotted eight rooms in the Fine Arts Gallery for its 811 paintings, had designated one room to Hungary for its 155 canvases. Belgium, with 296 works, England with 203, and Holland with 167 were each given one large and two small rooms. The United States and Greece shared a corner pavilion, as did Spain and Portugal. Italy, Sweden, Norway, Denmark, Russia, Brazil, and Turkey were not given space in the Fine Arts Gallery, but they were provided with rooms in the Pavilion of Collectors and the Pavilion of Museums. Sculpture was placed in the central hall and the two entrance halls. The greatest amount of space in the Fine Arts Gallery was given to France and Germany, which had met recently in a contest of arms: Each was assigned half of the central hall and four large and four smaller rooms.

Germany, which had become a political entity only two years earlier, lacked a centralized administrative organization to coordinate its participation in the exposition and therefore had to rely on the cooperation of the network of Künstlergenossenschaften and Kunstvereine to provide for its representation of 1,017 artworks. Debate on the character of Germany's participation had been possible. Some members of the Munich Künstlergenossenschaft, led by the sculptor-architect Lorenz Gedon, had held that simply to hang paintings on the walls and place sculpture on pedestals without concern for the decoration of the exhibition space did not corre-

spond to the character of a world exposition. It was suggested that an impressive room ensemble could be created by a sensitive, tasteful arrangement of good furniture and harmonious wall tints and textures. The proposal, supported by many of the Society's younger members, was summarily dismissed by its president, the painter Konrad Hoff, with the expression *Allotria!* (tomfoolery!) Some thirty artists adopted the name for a society opposed to officially recognized organizations.

France, which had intimated that were it not adequately represented this exhibition would be unimportant for the history of art, made full use of the extensive space allotted to it to display 1,527 works. Determined that France should maintain its supremacy in the art schools of Europe, Du Sommerard, creator of the Cluny Museum and French commissioner for the fine arts exhibition, had suspended the restrictions on lending pictures from the Luxembourg Museum, then the museum of modern art, and had prevailed on private collectors to contribute. Meissonier and other eminent artists assembled the works they had executed during the last ten years. The official French announcement, after noting the advantages to be gathered by participating, appealed to the patriotism of French artists:

> It is important that France be worthily represented at the International Exposition in Vienna: She must prove that she has not fallen from the rank which belongs to her in the civilized world, and that even on the day after the sad events which have taken place she is ready to sustain the traditional reputation which she has conquered in the arts, the productions of modern science, and knowledge, in all the industries in which taste, invention, and skill of hand have given her a superiority that can never be questioned.[9]

There was in the fine arts exhibition a stylistic coherence provided by the universal acceptance of the academic traditions of the French school, but critics did notice that works from the countries north and northeast of the Rhine tended to show a variance in color and a less stylized treatment of nature than the works from France and the Mediterranean

[9] *Chronique des Beaux-Arts*, November 10, 1872, 378

countries of Spain, Portugal, and Italy that lay within the French artistic orbit. Italian sculpture's uniqueness was ascribed to its early "industrialization" or mass production. Throughout Europe, however, the importance of the Salon regulations, the rigidity of government-sponsored exhibitions, and an increasing lack of interest in historical and religious themes had focused the attention of artists on objects from earlier periods to intimate scenes and genre. Material prosperity permitted larger numbers of persons to make purchases for their living rooms. At the same time, offices and office buildings were required for the expansion of the functions of government and commercial enterprise: The gulf between the type of art and furnishings required by the government and businesses, on the one hand, and the private individual, on the other, became greater than the one between the palace and the cottage.

For critics the problem of assessing the state of the fine arts in this "peaceful artistic combat" of twenty-six nations and five thousand examples was formidable. The *Art Journal*, already noted for its excellent illustrated reports on the decorative arts at previous world expositions, again concentrated on them and gave slight attention to the fine arts. In keeping with the current interest in Germany's new position in Europe, *The Portfolio*, a magazine for art lovers and collectors of prints in England and the United States, published by Philip G. Hamerton, the noted artist and writer on art, provided its subscribers with an informative essay by J. Beavington Atkinson on the German contributions.

Like the *Art Journal*, the newly important *Zeitschrift für bildende Kunst* ignored the fine arts in order to print excellent essays on architectural drawings and applied art. In its "Beilage," a supplement which, like the *Gazette des Beaux-Arts's* "Chronique des Arts," announced events and gave short reviews of art exhibitions, there appeared a report of an exhibition being held at the handsome new headquarters of the venerable Gesellschaft Bildender Künstler. By an arrangement with Durand-Ruel, Courbet's dealer, his *Artist's Studio, Burial at Ornans,* and twelve other paintings were to be seen for the first time in Vienna. Courbet's canvases offered a

striking contrast in technique, composition, and subject mat-
ter to Wilhelm Kaulbach's *Nero*, which hung in the same
room.[10] This exhibition would have attracted the Allotria
group and other painters of the Kunstvereine.

No mention of this exhibition was to be found in the
widely circulated *Gazette des Beaux-Arts*, which had selected
the landscape painter René Joseph Ménard to report on the
Vienna exhibition. His judicious and noncontroversial report
was in keeping with the tone set by the magazine's staff:

> Touring the rooms of the fine arts exhibition, one is astonished
> to see that . . . today all Europe seems to be traveling the
> same route. From the Seine to the Vistula, the transitions are
> barely noticeable, and there is often a greater difference be-
> tween an artist and his neighbor than between one country and
> another. Twenty years ago the distance between France, Bel-
> gium, and Germany was enormous. . . . today the effort is the
> same almost everywhere. . . . In Munich and Berlin, in Düssel-
> dorf as in Brussels or Paris, the battle is engaged on the same
> terrain, that of execution and reality.[11]

Freeing himself from aesthetic principles that no longer
had any validity or force in the art world, thirty-seven-year-
old Italian architect Camillo Boito (1836–1914) wrote a joc-
ular, perceptive appraisal of the painting and sculpture exhib-
ited at Vienna. Son of a successful miniature portraitist from
Venice and brother of Arrigo Boito, the poet-composer, Ca-
millo had studied architecture with Pietro Selvatico in
Venice,[12] interrupting his studies with visits to Poland, the
home of his mother. Appointed a teacher of contemporary ar-
chitecture at the Academy, Boito remained in Venice, except
for study trips to Florence and Rome, until he fled from the
Austrian police and arrived in Milan in 1859. Already re-
spected for the fresh approach to art found in his articles,
which appeared in the *Spettatore* and the *Crepuscolo*, Boito
was named a professor of architecture at the Brera Academy
in 1860. During this time, as Italians sought to shed their re-

[10] See Hamburger Kunsthalle, *Courbet und Deutschland* [exhib.
cat.], 1978, p. 586
[11] *Gazette des Beaux-Arts*, sér. 2, vol. 8, September 1873, 186–87
[12] See section entitled "1861: FLORENCE" in this volume.

gional provincialism, Boito became an important figure in art circles that were turning away from romantic history painting and classicism in architecture. He was a significant figure in the search for a style in architecture that would correspond to the country's culture and satisfy its nationalistic ambitions. The architectural style Boito chose was Lombard Gothic, a style common to all regions of Italy, one that Boito held was as truly representative of Italian culture as Tudor architecture was of English culture. He defended and explained his idea in an essay entitled "L'Architettura della Nuova Italia," which appeared in the liberal *Nuova Antologia* of Florence.[13] In 1862 he had served as one of the judges for the cathedral facade competition held in Florence. He interrupted his commission for the Paduan Palazzo delle Debitte (1872–77) in order to visit the Vienna international exposition and write a critique of the painting and sculpture on view there.

Camillo Boito: *Painting at the World Exposition of Vienna*[1]

. . . The fact remains that the universal expositions have never produced a result proportionate to the effort necessary to hold them. This one, certainly the most grandiose, will waste fifty million lire for Vienna, to put it mildly, and, furthermore, will have ruined, in part, the pretty Prater, where one happily eats sausage and smilingly quaffs foaming glasses of beer amid the sound of band music. And for what? . . . It is better to compare the civilizations of different nations with one another by traveling, since arts industries and other things are best seen in their own surroundings and traveling is indispensable to see them well. . . .

I. There are about 6,500 objects of art; many beautiful, the majority good, and few truly poor. France sent 1,560; then come Germany, Austria, and Italy with 560 objects. But Italy, which is fourth in number of items submitted, what

[13] *Nuova Antologia*, vol. XIX, 1872, 757–73
[1] [Translated from *Nuova Antologia*, vol. XX, Sept. 1873, 28–49]

place has it won, with respect also to Belgium, Hungary, Switzerland, Russia, England, the Netherlands, Sweden, Norway, Denmark, leaving out poor Greece, too old, and America, too young?

The art of the different nations is becoming more and more assimilated; in everyday occupations, in things that concern the mind, too, the spirit of nationality and the influence of tradition is receding, and yet we find traces of them here and there. For example, the character of the old German art still exists in the pictures of a painter from Olmütz who lives in Brussels, Koller, one of the most notable in the Austrian show. He treats German subjects—Dürer, Fugger, Gretchen— with clear drawing and rather rigid contours, with strong and contrasting colors without too much shading, composing with a certain natural archaïcism, more attractive and accurate than Leys, who followed the older painters even in their faults. While Leys has very little atmosphere in his paintings and often neglects correct drawing for a love of archaeology, Koller does not neglect any part of the artistic process. The Tuscan [Amos] Cassioli [1832–91], in his large painting [*Provenzano Salvani Collecting Ransom for an Imprisoned Friend*] in Vienna, does not want to emulate, as do Koller and Leys, the Germans of the school of Cologne nor the Flemish school, but rather the Tuscan art of the fifteenth century. . . . It seems that Cassioli only cares to demonstrate a certain vague affinity to Masaccio or Ghirlandajo or other venerable men of their kind, with rather faded color, without aerial perspective, but here and there with delicate drawing. He is affected in his merits as well as in his faults, so that one would swear that his style does not come from the bottom of his heart as an artist, as was the case for Leys or is the case for Koller, but from a preconceived and artificial idea. It suffers the punishment of artificiality: It is frozen.

On the other hand, the enormous picture by a new Paolo Veronese is full of warmth, life, and gaiety. It sparkles with sapphires, emeralds, pearls, and diamonds like a king's treasure. . . . The group of speculators which bought the picture for a very large sum, and therefore out of self-interest protects it with loving care, will exhibit it for an admission charge in

town after town—let us hope as far as Italy. The new colorist is Hans Makart, a young German who lives in Vienna and is already famous and rich. He is exhibiting *Venice's Festive Celebration for Caterina Cornora.*

In a fanciful scene in a piazetta of a fanciful San Marco the pillars of Leopardi are transported to the quay in front of the Ducal [Palace] and the portico of the Library of Sansovino is transformed into an open loggia. Under draperies, amidst garlands and festoons, the Queen of Cyprus, daughter of the Republic, is enthroned. . . . Actually, the painting is not so much the triumph of "the noble image of femininity" —a thoroughly German phrase in the catalog—as the triumph of King Color. At the lower right is the blue canopy of a boat bedecked with hangings and a figure clad from head to foot in gaudy scarlet; in the center the complete scale of whites, from azure blue to gold; at the left, deep, neutral, solid tones; at intervals new and powerful reflections in the most refined and delicate gradations join that variety of sonorous instruments to sound in one magnificent harmony. We have never seen work by a contemporary painter's brush that delighted the soul so much or gave a sensation so similar to that produced by the music of great masters played by a great orchestra. As for the composition? It is disorganized and odd. And the drawing? Good God, it is not correct in many places. But do not bore us, for heaven's sake, with these observations of learned men. Be content to feel within you the pure, smiling joy of beauty which descends from the eyes to the heart without following the path of the intellect. And yet, how much knowledge, how much patience, how much feeling in that orgy of color. . . .

II. To relate modern art to the past and to give it a positive national character are two entirely different things, so that it can be said of the German Makart's painting that if he were an Italian it would have an Italian national character. But some artists put into their work the air and the soul of their own country; and though at times one cannot quite understand what the sense of country actually may be, still it rarely happens that, having become aware of it, one is not

moved. It seems always to be touched by a lofty, disin-
terested, overwhelming passion. Nor does the national stamp
derive from the types, the clothes, the customs, the peculiar
costumes which a painter could represent, and not even from
portraying the places of the native land. Indeed, it seems to
be something much more complicated and yet vague, some-
thing of a moral nature. Therefore, on the one hand it is con-
nected with the vicissitudes, the history, of mankind and, on
the other hand, with the poetry of the people. It is a note-
worthy fact that the great countries where art flourishes have
fewer competent national painters, whereas in countries
which are or were enslaved, or in those where there is little
political or artistic life, the souls of artists are more involved
with the love of country.

France, which is ever so far ahead in the disciplines of
beauty, has not a single national painter in the sense which
we give to this word, since all the painters desire to place in
view freely—and often excessively—the mark of their own per-
sonality.

Germany has left to one side Kaulbach, Overbeck,
Schnorr, Cornelius, Hess, and the other elder painters who,
when they illustrated the *Nibelungen* or painted the *Last
Judgement,* the *Reformation,* or the *Madonna and Saints* in
their churches, always instilled a strange flavor of Ger-
manism, as much in the philosophy as in the form of their
works. Nowadays German artists instead try to liberate them-
selves from every tradition and escape every boundary. They
are French, Flemish, and Italians rather than Germans. Al-
ready in the great countries man makes of himself a nation-
ality and a king.

There could not exist a painting more German than the
huge painting by Piloty, which shows us *Thusnelda in the
Triumphant Procession of Germanicus.* It is Germany, pure,
haughty, looking to a prosperous future, facing Rome, cor-
rupt, decadent, with a rich past. It is a challenge of the Ger-
man race to the Latin race. That strong and beautiful woman
who walks with head high before the emperor and the senate
certainly prophesies the future greatness of her country. In
the conquered, those in chains, and those who bear the yoke

is the strength and the prosperity. In the victorious and those who applaud is decay.

Notwithstanding, the canvas of the Munich professor, though ably composed and drawn with supreme mastery, does not have a German character. The execution is flabby. The work, which has not emerged in an outburst of passion from the inmost heart, is the work of a cosmopolitan man. A Frenchman could have painted it without knowing a syllable of the "Ja" language. . . .

But Austria does have Koller, who, as we have said, is German. Hungary has Munkácsy, who is actually a Hungarian. Neither he nor the other painters who are his fellow countrymen, are quiet observers of nature. He favors brown intonations and willingly paints vagabonds who at dawn are thrown into prison among women and beggar boys. But the others, such as Zichy, enjoy their national legends, the intellectual allegories, and though in historical pictures they have a certain character native to their country, this is mostly because of their weakness. So weakness or faultiness here becomes an occasion for originality—for certain kinds of vices are actually virtues.

Russia, while busying herself to portray the countryside and costumes of her provinces, is seen borrowing the forms of art from Munich, Rome, and Paris without finding anything so far that will shape Russian painting in the future. Her best artist, Remiradsky, has in his brushes the longing for the ardor of the sun, while miserable Poland possesses a great painter, completely Polish, Matejko. During his sojourn in Paris, the praises of the French did not move him from his style, which is not too far from that of Tintoretto with something of Spain added. He does not concern himself with subjects other than Polish history and looks at nothing but his own torn, lacerated country. His composition is often jumbled and confused, his drawing exaggerated to the point of caricature, the color often broken and unbalanced; but his art, full of frenzied life, chafing at restraint and moderation, in a way clumsy and unfinished, reveals not only the artist's soul but also that of his country.

Spain, filling only one room with mediocrities, is inferior

to Norway in national character as well. Norway occupies one of the larger halls with dignity. Beautifully painted bodies of water—in two marine pieces by Tidemand, the lovely landscape by Munthe, gloomy with a dark sky and greenish pools on the ground which stain the pristine snow—are reproductions, one might say moral tales, of that melancholy land where artists, as they always do in frosty climes, feel the inspiration of fairy tales, which they illustrate with vigor and conviction.

While Norway is happy in her snows, England would like to dissolve her mists and fogs. . . . The mark of British national painting should be a subtle inquiry into individual expressions, sometimes detailed and lengthy as in their novels. The execution should be delicate and a little faded, but gently romantic in tone, quiet but lively. One historical painting by Stone, a handsome *King Edward II*, comes close to such a style, as do two small pictures of Shakespearean subjects by Orchardson and Pettie, some portraits, and a painting by Riviere, suffused with an Anglican air.

As it is, the English did not trouble themselves much about the Vienna exhibition. They sent very little and did not even care if they were represented on the jury for the fine arts. Most assuredly the French did just the opposite. They collected their best things and sent them without troubling themselves to limit the number, and with the help of their useful petulance—which we most certainly do not know how to imitate—succeeded in having them all shown and shown well. They even resorted, without shame, to displaying the work of painters already deceased. . . .

The fortuitous misfortune of the French is to bring their own inclination to the uttermost limits, eliminating, if need be, every barrier. They do more than necessary to exaggerate their own character or create a fresh one. . . .

However, restricting ourselves to things exhibited at Vienna, we do not find even in the best French painters, except partly in Breton, that strength which we find, for example, in Alfred Stevens. That is the strength of representing in art the character of our age, of the society in which we live. . . .

III. . . . Genre paintings are painted scenes from come-
dies and plays. Between the plays of twenty years ago—in-
terlaced with events and scattered with sentiment—and the
plays of today—which usually are built around a given dra-
matic situation, or a given situation of the spirit, in order to
show the development of events and their consequences—
there is the same difference as between genre paintings of
twenty years ago and those of today. More than in any other
branch of art or literature, the genre painter and the play-
wrights need to be always freshly contemporary. They can
grow old without harm just as long as they constantly renew
their youth. . . .

The two most famous Italian painters of genre subjects
are certainly the Induno brothers, men who are still fresh
in their outlook, and have held on tenaciously to their youth-
ful way of thinking and painting. Perhaps they do possess, as
Delécluze said, some of Hogarth's qualities. They have the
unbroken tints of Bisschop, of the Netherlands, with less
light and substance. They have the palette of some of the
Munich school painters, who, slow to move, as Germans gen-
erally are, have adopted, though young, a manner that to
many seems antiquated. The performance of the two able
Milanese artists seems altogether more foreign than Italian.
Their subject matter is either limited to old-fashioned compo-
sitions or they enjoy painting comic or dramatic scenes of a
rather decadent kind of truth. . . .

Beyond this meager modernism of spirit, one can almost
always find in German painters the mark of a rather inflexible
hand. It seems as though art costs them an effort of the will
which they are unable to conceal. Virtually the opposite is
true of the French: The work seems to spring from their
brush without a shadow of toil, almost like a pleasantry of
the art spirit. Just as this facility, even if only gaudy and
superficial, is agreeable, so toil at first sight is displeasing. But
it often happens that a French painting, very delightful at
first sight, almost immediately turns out to be tedious, while a
German painting, which at first seems mediocre or unpleas-
ant, gradually comes to be appreciated and loved. Even the

famous Knaus shares in this impression of German strain.
Some of the figures in the foreground of his *Children's Fête*
are rather stiff, while the ones farther away are loosened from
any encumbering form and become real little girls, real live
little boys who eat and play and laugh among the leafy
trees. . . .

Vautier certainly is the most notable painter among the
Swiss, who, since they have not a common language, have no
general characteristics in art. . . .

Between the art of the Low Countries and the art of Bel-
gium there must exist some analogy, though the latter leans
toward France. It is Belgium, more than other countries, that
demonstrates how deceitful the foundations of fame can be,
how art which was fresh yesterday can appear jaded today.

IV. As for Italy, the misfortune of its painting is to be aca-
demic. In the attempts of the young painters, whether of
Lombardy, Piedmont, Tuscany, or Naples, certain new quali-
ties shine forth. But they are not perfected; as happens in
countries which are not ready for reforms, they tend to be ex-
cessive. . . .

But if there is one branch of art in which we can face for-
eigners without lowering our heads, it is landscape. We have
no attractive Italian tradition, no influential academic school
for it. On the other hand, we feel the need to consult nature
all the time and follow her meekly. The Roman campagna,
with its wild cattle, its ruined monuments, severe and impos-
ing like the lines of plains and hills; the beach of Astura,
with the sea inlets, the fishing boats, and the boys swimming;
a country of pale green grassland, sombre green trees . . . In
spite of the occasionally heavy and encrusted color [Ver-
tunni's paintings] can be ranked with the best of foreign
landscapes. What a pity that Rossano, d'Avendano, and
d'Andrade have each only shown one painting—and not even
their best. What a pity that Rayper d'Avondo and the other
landscape painters have not shown anything. Italy would
then have won, thanks to landscape, the praises of cultivated
people, for which, as we shall see, neither figure painting nor
sculpture can make her worthy.

Sculpture at the World Exposition: I. To cross over from painting to sculpture is very restful.

. . . If there is an art whose temper is unsuited to our century, it is sculpture. Ancient societies leaned toward repose. Modern ones want movement at any cost. The ancients progressed step by step without sweating. We go ahead—in matters of the spirit, if there is progress nowadays—with somersaults. . . .

Think, in this impatient modern age, if the art that needs to make a model in clay, always keeping it wetted down so that it may not dry out, to shape it in plaster, transfer it to marble with compasses, or cast it in bronze; that art which owns only two colors, sugar white and dirty green; that art which has no background, no space, no surroundings, and must content itself with one or few figures, piled up and stuck together; just think, can this inert art incorporate the restless modern spirit? Nor is it of any consequence that sculptors are, as we have said elsewhere, fortune's pets. The monuments which they erect in cemeteries and city squares, whatever do they have to do, as art, with the modern spirit? The figures which are so widely touted for commercial purposes at the expositions, are they not, with few exceptions, a marble or bronze industry, or an excitement to the senses?

As for painting, it is another matter. It swiftly and impetuously follows every fluctuation in the character of nations, even the whims of fashion. It possesses the most delicate as well as the most vigorous means to represent reality. It embraces all of nature. While sculpture consents slowly and unwillingly to embody the individual feelings of the artist, painting has in this area almost the freedom of poetry and music.

Now, in today's art the importance, that is, the immediacy and the true power, of a work of art cannot come from anything but the vigorously truthful image of the artist's feeling, an artist both able and sincere.

Monteverde, for instance, although he is a sculptor, knows this. Notice his struggles to bend his rebellious art to his own will, and to reach a goal—which we can guess—his art is stubbornly reluctant to reach. His sculpture, step by step, has

steadily become more pictorial. His youthful renown began with a small group of children, simple and affectionate. Then came *Columbus as a Child* . . . Then came *The Young Genius of Franklin* . . . and, now, here we have *Jenner.* Dressed in short trousers with buckled shoes, in an awkward suit with wide collar and ruffled cuffs, Jenner with his hair in a pigtail. He sits on the cradle, has the naked child on his knee. He clasps the little arm gently in his hand and, bending over, holding his breath,. marks the spot that the lancet is about to prick. . . . Nature, observed with scrupulous attention to the minutest detail and slightest movements and understood with firm intelligence, is reproduced by a hand so masterful as to appear inimitable. Yet who does not feel that a great effort has been made? Who does not feel, looking at the group, the shift in sensations? That *Experiment of Vaccination* in sculpture, that lancet about to inflict a wound, makes one shudder, not because the subject rebels against art in general but because it rebels against the special conditions of the sculptor's art. . . .

The two best known Italian sculptors, not young like Monteverde but not yet old, are like each other in one respect only, that is, in honestly following their own bent. As far as Dupré is concerned, he is always a sculptor, and it seems that he does not desire anything in his inmost heart but what pertains to his beloved marble; and he finds that in this material he has all he needs for the embodiment of his every feeling. Vela is at one time a painter and at another a naturalist. He is master of the two styles of the sculptors in Italy, a master who is perhaps not recognized. But without the author of the *Dying Napoleon,* which created such a furor at the Universal Exposition of Paris, perhaps *Jenner* would not be what it is and the other Italian statues would not be what they are either. . . .

II. Anyone who would say that France is ahead of us in sculpture would run the risk of seeming eccentric. Everywhere, in Paris, London, and Munich, Italy has seemed to be first. Even in Vienna the French have sold nothing and we have given away so much.

None of their statues are seen in photographers' windows, but our groups of children and our figures of women are now admired in printsellers' shops, in book shops, on the small tables of those who, upon leaving Vienna, wished to take back with them an attractive souvenir.

In the French rooms there are many spectators looking at the canvases that cover the walls; few look at the marbles and the bronzes that they stumble on as they go. Even though our paintings do not attract the onlookers, it has to be seen how people are all eyes in front of our plastic art, how they comment on it, laughing with delight, their mouths watering with the desire to possess some of it. . . .

The French have had the good sense not to want to thrust that nimbleness and pictorial richness so appropriate to the art of the brush into the art of the chisel, which, as we said before, it would not have happily assimilated. For this they are to be highly praised, since they had to conquer their natural inclination to liveliness rather than to solidity. And this is how—precisely because the two sister arts do not resemble each other—they keep their own individuality in France and, to say it without petty envy, are both extremely good.

The good fortune of the French is to have made a thorough study of antiquity. The Academy of theirs in Rome, which is of no use to painters or architects and, to tell the truth, also misdirects the sculptors into the chill of classical imitation, is singularly useful to up-to-date sculptors.

Their spirits become accustomed to a certain nobility of feeling. Their eyes practice looking at the harmony and the healthy beauty of the human body. Besides antiquity, they study fourteenth-century art, as well as from life. The *Florentine Singer* by Dubois has the flavor of Verrocchio and Donatello; a youth who plays the mandolin and sings; a trifle which was much praised at the exhibition in Paris eight years ago but which will always please because its basis is in its natural elegance and its archaic grace is sincerely felt, not an affected imitation. The same grace that Dubois also put in *The Child, John the Baptist Preaching in the Desert*, and in his *Narcissus* is found again in a few groups of nude youths: in the bronze *David* by Mercié, who replaces his sword in its

scabbard; in a *Tumbler* by Blanchard; and in other such work where the attraction is not that of the very simple subjects but that of delicate, tasteful form.

The grace of the lines is not an adornment, the ingenuity of expression is not hypocritical. These figures are not made so, just for the sake of making them and with the intention of aping the Greeks or the Florentines. They seem—it is enough for us that they seem, since the effective procedure of an artist's brain is the secret of the artist—they seem, we say, to be conceived in the author's mind during an hour of serenity, half thoughtful and half gay, then searched for in the living model, chosen to correspond to the idea scrupulously copied by an eye and a hand which, being in love with Florentine and Greek beauty, transfuse a breath of its spirit into the clay. The truth of the statue remains exact yet nonetheless it acquires a certain life of dignity and loveliness which attracts and for a moment ennobles the soul of the spectator. This science which becomes nature, this knowledge which becomes method, serves to give to the marbles and to the bronzes that "je ne sais quoi" which makes them endure. It is a magic spell which too often is lacking in the best Italian works, real, witty, most pleasing at first but, except for a few [works], very short lived. . . . France is a charlatan in so many things; who can deny it? But we—may our country forgive us for these words—we are the charlatans of sculpture. . . .

The French, in religious art, often work for nuns and bigots, making those mawkish and insipid marble statues that we call Jesuitical. Of *Magdalen in the Desert*—Chatrousse has one—they make a plump seductive female; of a *Christian Martyr*—there's the one by Falguière—a prettily contrite youth. On the other hand, the French have a broad and serious feeling for monumental art. It is one of their glorious traditions. But by monumental art they mean the real one, that is, that which closely unites sculpture and architecture in one building and makes two things into one. Their pointed Gothic cathedrals and the buildings of their Renaissance have in two such diverse styles, as far as sculpture is concerned, the same qualities: in the cathedrals, spare but elegant, geometric

but quite fluid; and in the seventeenth century, soft, rounded, even swollen, but corresponding to the amplitude of the total forms. . . .

Frémiet, celebrated fashioner of cats, dogs, goats, rams, centaurs, minstrels, falconers, and other similar little things of bronze, odd and accomplished, gave a most curious example of the flexibility of French genius when, being asked to make a colossal equestrian statue for the old castle of Pierrefonds, he modeled a Louis of Orléans which is to be seen, in bronze, in one of the loggias of the Palace of the Arts in Vienna. The horse [is] immobile and symmetrical, the rider erect, closed in his armor, with his lance on the ground, severe, mysterious, majestic, really monumental. In short, if one of those neighbors of ours from beyond the Alps needs two groups of animals to face each other architectonically on the prominent pedestals of a vast flight of stairs, lo and behold, Cain casts in bronze a tiger attacking a crocodile and a Nubian lion trampling an ostrich, astounding things for veracity of forms and dashing movements; an industrialist needs groups and little figures for cuckoo clocks, for candlesticks, for the foot of a table, for the headboard of a bed; and here are the docile plastic artists obligingly carving with grace very pretty things.

So we have people who raise art to the level of monuments and others who raise industry to a fine art.

The restless spirit of Carpeaux defied these laws of conformity when, for a group to be placed in front of the new Opéra theater of Paris, he carved a circle of women in a whirling dance, so naked that they do not have a scrap of veil around them, with vulgar limbs, fat, leaping in a disorderly way. Those who praise this group, to show that it seems to be alive, say, "One can smell the sweat."

But there is no dignity in the composition of the group: here an outline with no counterpart, there an unbalanced mass. The whole group, which might be a handsome one if seen in isolation, is so badly framed within the lines of the great edifice and is placed there so uncomfortably that they have, as a matter of fact, decided to take it away. This Carpeaux, a genius who does not know how to bow to any stand-

ard, prefers, when he has the choice, terra-cotta to marble and bronze, which allows him to indulge his whims with greater impetus. In Vienna, of the ten pieces he sent only one is marble, a female portrait, and only one bronze, his *Neapolitan Fisherman*, a child that is holding a seashell to his ear to listen to its humming, a youthful and careful work. The other things—animated busts; delightful statuettes; even his *Count Ugolino [and His Children]*, all ribs, who bites his hands and looks at his skeletonized children—are modeled in clay, which, when it was baked, had kept the imprint of his most skillful hands. They say he is a realist. He is, certainly, because he studies nature; but he is not because, as with his colleagues, one perceives the spirit of Greece as the quattrocento; in him one perceives the spirit of Bernini, of Vittoria and the others whom it is customary to call baroque artists but who, in their way and Carpeaux's way, were realists.

They may say what they like, but truth, pure truth, is not enough for sculpture. It may be enough for painting because painting has color, which becomes of itself a powerful means of expressing the highest ideals. . . . The conclusion: In painting the most passionate and arch-inveterate realist is absolutely unable not to put something of his own into it, that is, something which is ideal. That is why in painting the reproduction of truth is art, whereas in sculpture if one does not put something of one's own into it on purpose, there remains only the artisan. Everything lies in knowing, in feeling what and how much one should put in. . . .

We already knew how mediocre the Austrian and Prussian sculptures were when we entered the Universal Exposition of Vienna, where, notwithstanding, the German sculpture seemed to us more pitiable than ever. Not one new and vigorous piece to shake the soul of the viewer, not even one artist who, making motions to cast off the reins of clumsy traditions and scholastic standards, gave cause to be spoken of. . . .

The discovery that these Germans and other non-Latin peoples who are rich in the way of painting and, as we shall see, in architecture are so poor in their sculpture comforts us because we believe that in order to draw out of clay living

men who are alive, strong, and handsome, new Adams, a certain spontaneity of a most dextrous talent is needed which not all peoples have as a gift of God.

Anonymous: *From the Austrian Kunstverein Künstlerhaus*[1]

Rarely have such obvious extremes met at an art exhibition as they do at this moment in the halls of the Austrian Art Union, where Kaulbach was brought together with Courbet at an involuntary rendezvous. The former's *Nero* is contrasted with the latter's great painting, *The Artist in His Studio*. There will probably be no fight carried out between these two artists; they met by accident, and each speaks in his own innate artistic idiom, each so peculiar and so different from the other that they cannot understand each other; and the attempt to incite them by establishing parallels or comparisons must fail every time. On the one hand, there is superelegance of form, superharmony in the order and construction of the composition; on the other hand, the bluntest, the most common manipulation of technical means, a puzzling arbitrariness of arrangement, a purposeful exposure of everything nonbeautiful, elevating it nearly to the unnatural. Kaulbach and Courbet do not have one single spark in common; next to each other their peculiarities appear even more exaggerated.

With *Nero* the famous German master has increased his series of major paintings. The work has been sufficiently described already and is generally well known through photographic reproductions, so that we do not have to go into a detailed description of the great composition. Kaulbach again has remained Kaulbach: the sharp, witty characterizer; the virtuoso in drawing and the distribution of light and shadow; the idealist everywhere, where it is a question of masking something common; and the fascinating dramatist, where the emotion of passion pours forth. But he has also remained

[1] [Translated from the *Zeitschrift für bildende Kunst, Beilage*, vol. VIII. June 6, 1873, p. 544; July 4, 1873, p. 604ff.]

that Kaulbach whose grand thought is split into episodes which barely relate symbolically to the central point and whose forms are merely connected by the fascinating rhythm of the lines, but which lack the deeper organic relationship with the essence of the representation. In connection with the great Kaulbachian compositions, one returns again and again to Raphael's frescoes in the Camera della Segnatura, where the solution of similar problems develop with peace and clarity that cannot be found in Kaulbach's works in spite of his pompous employment of technical means. If one compares Kaulbach with Raphael, it becomes immediately obvious that the weak spots in the paintings of the former are based upon the fact that his symbolism goes far beyond the limits of painting. The symbolic idea with him becomes obtrusive and loosens the painterly relationship, when, indeed, it does not destroy it completely.

Now we must turn to *Courbet's* paintings, which have been exhibited in the course of the season. . . .

Artists and men stand before these paintings of figures, shaking their heads, wondering how such painting is to be brought into harmony with the reputation of the name. Some smile and pass by indifferently; others indignantly condemn the "degradation of art" and condemn wholesale the hero of the Vendôme pillar; still others even try to interpret like gypsies, from the lines on a hand, and believe they have found the origin of such art in deeply hidden symbols which can be represented only in this manner and no other. But most agree that the Kunstverein and Courbet could have spared us this doubtful artistic pleasure; these paintings were the least responsible for having made him the famous Courbet; in them we recognize, just like his compatriots at the time of their appearance (1851–55), the confusion of a significant but rough and unschooled talent which does not bind itself to any artistic laws because they are foreign to him by nature, which rejects every spiritual leaning, every characteristic of spiritual feeling, since he was not given that language. . . . His *Burial at Ornans*, as well as his *Artist's Studio* offer only an arbitrary arrangement of figures that lack any psychological connection. When, at the beginning of the

1850s, he appeared with pictures of this kind, the small group of followers of Courbet proclaimed the weakness of his talent as reformatory satire of academic hollowness, this appeared to everyone as an extremely doubtful excuse, because a reformer of art does not establish the common and the ugly as an ideal of all of art! Realism, like idealism, has its limits in painting; but Courbet was too incapable to be able to rule the terrain as an artist. He continued his immoderate opposition to all ideal principles of art—on the canvas, unfortunately, rather than in the *Journal Amusant*, where it would have been more suitable—and the world was blessed with pictures heralded as the political lead articles of a prophet of art but were really the pitiful witnesses of his shortcomings.

In the year 1855, on the occasion of the great exposition, Courbet exhibited forty of his pictures in a booth next to it. Having arrived at the zenith of his confusion, he had affixed on the door of the booth the label "Realism, G. Courbet"; only the robe of Apollo and the lyre were missing for the Nero of modern art history to have been complete. He painted himself in his atelier as an allegory of "Seven Years of Artistic Creation," surrounded by that fine society of his ideals, which he presents in all seriousness as the models for painting of the future. It was an apotheosis of the most extreme realism, of dull arbitrariness and, moreover, a picture of mediocre production. There has been a lot of interpretation of this allegory, but one factor has been overlooked, and it is precisely the one of significance for the artist, namely, he sits in his atelier and collects around himself a mass of models, one uglier than the next. A naked woman stands right next to him; Courbet, however, is painting this figure—allegory in a landscape! The artist was thereby unconsciously ironic, and meanwhile, in fact, [he] confirmed that his brush was just not fit for human depiction but could only produce its healthiest fruits in landscape and animal genre. Earlier he constantly cultivated landscape on the sideline; now he approaches it in full power, enlivens it with animal and hunting pieces, and purifies in this chaste sphere again his naturally excellent gift of observation, of the externals, color, and mood. The simplest subjects become attractive be-

cause of the surprising truth with which they have been ex-
tracted from nature. Courbet's technical treatment exhibits a
marvelous virtuosity; it is broad and sure, renouncing all sen-
sationalism. The landscapes and animal pieces have secured
his significance as an artist. His *Deer Resting Place in the
Canyon,* which was exhibited in 1866 in the Salon, was con-
sidered to be the pearl of the exhibition; the owner was
offered the highest prices. In his pictures lighting is quiet,
even, and keeps the forms solidly plastic. If the Kunstverein
exhibits more pictures from this period, then a grateful
public will certainly come. For the rest of these pictures
an old knight's castle can certainly be found where they
could be kept as curiosities; the walls of our art exhibitions
belong to a different sort of realism. . . . If in the *Burial at
Ornans,* beside the dog and the landscape, human beings ap-
pear more true to life, nevertheless the picture is terrible in
its unartistic treatment and in its representation of the
crassest reality. It is this alone which shakes the viewer out of
his indifference, but not in order to draw from the impression
a satisfying, conciliatory solution, but rather anger at this
misuse of art.

Anonymous: *The London and Vienna Exhibitions, Retrospective*[1]

Almost at the same moment there have closed the London
Exhibition of '73 and the Great Exhibition of Vienna, inau-
gurated as it was so auspiciously, and carried on under so
much of Imperial help and patronage. . . . And now we may
look back on them without disturbing influence, and ask our-
selves, What is the result of it all? And what do such displays
point to and indicate in the future of art and art production?
All important questions, these, and well worth a little cogita-
tion.

In the first place, it may be useful to bear in mind that the
Great Exhibition of 1851, the parent of so many, included
four main divisions or sections: Raw materials, as they are to

[1] [Verbatim from *The Builder,* December 6, 1873, p. 960]

be got from the earth itself, or which grow upon its surface; machinery, more or less complicated, for the purpose of moulding these raw unformed materials into shape and practical usefulness; the useful *results* of this machine work in the form of manufactured goods of all kinds, from a sheet of note-paper to a complicated coloured lithograph; and then, lastly, the fourth division, the Fine Art, as it is termed, which is applied more or less to those manufactures, and which makes them *ornamental*. Pictures, it may be remembered, did not form a part of the first Exhibition of '51. In the later Exhibitions pictures were included, so that these last great shows comprehended everything. Sculpture, a word grown not a little indefinite in meaning, was to be seen in both Exhibitions, as was architecture, more or less. A few words on each one of these several sections, and on what they indicated, and on their special worth may be useful, and may, perhaps, foreshadow a something in the future of art.

Raw materials, then, are the foundation of these displays of the world's productions. . . . It is, doubtless, a very good and interesting proceeding to collect as large a quantity of such rough and natural materials together, from different quarters of the earth, into one building, and to place them side by side, and then to compare them one with the other, and to note what they are best fit for. It is interesting and profitable to find out what other countries and climates yield, and what more can be done when quite a *new* and unknown material turns up. Trade, too, here brightens up at the sight of it. Science pries curiously into it, and analyses it, and puts it to its best purpose. But still with all those advantages and prospects, there is one consideration worth looking into, and it is—looking at such matters artistically—that the special materials to be found in each country and peculiar to it, would seem almost, in some mysterious way or other, to be best fitted for it, and for its special needs and requirements, both usefully and artistically. It is, when we come to look closely into it for the first time, a little doubtful how far any one country is able to work well with the materials peculiar to another and a distant one; or if it can do this, whether the energy and skill expended on them would not be better applied

in working on the materials proper to itself. . . . It is a question for the future, maybe when art takes a new turn, how best to make use, without loss of power, of a *new* material. The true secret of a real success, and a real "progress" in art would seem to lie, not so much in new, and still less on foreign materials, as in the finding out how best to utilise our own materials and work in them. It may be, we think, safely affirmed, that if the British wood-carver, for example, cannot do good work with his own British oak wood, he will hardly be likely to do better with Indian teak, or iron wood, or Australian wood, so strange to the touch and the eye. . . .

Machinery, wonderful machinery! which bids fair before long to take the world's work out of man's hands altogether, would need a volume to do any justice to it. To the artistic eye the triumphs of machinery in these Exhibitions were almost appalling. The mechanism all but lived, there was nothing it did not seem to be capable of doing almost at any speed, and to produce almost any quantity of new stuff. It would be vain to attempt to do any kind of even poetical justice to the magic power of the complicated systems of mechanism which were shown at work, and which brought forth their produce before the very eyes of the wondering spectators. . . .

But the thoughtful spectator all this while could not but look, not only at what this mechanism did, but must have thought—at least, we often did—at what it *could not*, and did not, do! Here it could go no further; a limit was set to its action and power of production. In this is the key to the future of art and artistic action. The magic engine could roll and press and cut and stamp the raw metal, and even count the coins as they fell, but it could not *design* the device on the coin, nor cut without the hand and brain of the man the steel die which impressed the penny-piece! . . .

We would pass now from the raw materials and producing machinery as seen in these important Exhibitions to what was produced, to the useful products, out of the raw materials, through the costly machinery, and as, in so many cases, "ornamented" by art. Art was the last element which entered into the idea of these Exhibitions of the world's industry. But

few of the objects exhibited, and which could not in any wise
be "ornamented," were to be met with which had not had
some artistic thought bestowed on them. All the "textile"
fabrics had in them either in pattern or colouring some art el-
ement. It was a curious and not a little instructive sight.
Some analytical power was needed sometimes to decide on
the relative merits of the almost rival arts at work on the fab-
rics. Sometimes it was the pattern or design that carried all
before it. The mind had to travel all the way to old Assyria
sometimes to find the original of the strange device, after-
wards to figure, might be, on a table-cloth or a muslin
window curtain! Sometimes China drew the pattern on a
hearth-rug, while the carpet on which it rested so comfort-
ably got its novel and attractive pattern from a quaint gothic
source, invented perhaps by an old monk of the twelfth cen-
tury. It was, indeed, wonderful to note where the patterns
came from, and the mind had to travel fairly round the
world, and through centuries of times, while contemplating
the limited amount of textile fabrics necessary in the furnish-
ing of an ordinary bedroom or comfortable little boudoir.

All the world literally came together to contribute to the
novel display, and something surely ought to come out of it
all *permanently* and beyond the mere idea of a passing show.

It has sometimes occurred to us, when looking at what was
done at so much cost in these Exhibitions, to ask how is it
that they have not in some way or other done a something
[*sic*] towards the creation of a new and untried style in
art? All and everything seen in them was more or less copied,
or, if not copied, the idea artistically of the object was foreign
and distant—foreign to the country altogether sometimes, and
distant—sometimes centuries distant from the age in which
we live. How is this? It is, says a great authority in such mat-
ters, "mere affectation and priggishness" to reject help from
the past of art. In simple despair we must needs go back in
time and borrow from what has been done. But why is this?
Looking at things philosophically, and looking at the great
part of art, we cannot be struck with the contrast it presents
to the present in *principle of production*. It is truly mar-
vellous to contemplate. The closer we look, the greater the

mystery and wonder of it. The old artists had, as it would seem, nothing to go by but that which had immediately preceded them. Not a thought else. The old Goth built his tower, not of Babel, and as he built it it changed in expressional power, as the style he worked in progressed, as the old passed into disuse, and the new grew into life and freshness. The old poetic thought not only alone grew as stone was piled on stone, but it changed also. A wonderful progression from foundation to spire-top. We can now in nowise equal this feat of art; but could not the future of these Exhibitions do a somewhat to enlighten us as to the future of art and architecture, and to point the new way that once upon a time was old?

BIBLIOGRAPHY

Ackerman, Gerald. "Gérôme and Manet." *Gazette des Beaux-Arts,* LXX (September 1967), 163–76.

Ames, Winslow. *Prince Albert and Victorian Taste.* London: Chapman & Hall, 1968.

Bell, Quentin. *Victorian Artists.* Cambridge: Harvard University Press, 1967.

Bøe, Alf. *From Gothic Revival to Functional Form: A Study in Victorian Theories of Design.* Oslo Studies in English, no. 6. Oslo: Oslo University Press, 1957.

Boime, Albert. *The Academy and French Painting in the Nineteenth Century.* London: Phaidon, 1970.

——. "The Teaching Reforms of 1863 and the Origins of Modernism in France." *Art Quarterly,* n.s., I, no. 1 (Autumn 1977), 1–39.

Brion, Marcel. *German Painting,* trans. W. J. Strachan. New York: Universe Books, 1957.

Brookner, Anita. *The Genius of the Future.* London: Phaidon, 1971.

Broude, Norma F. "The Macchiaioli as 'Proto-Impressionist': Realism, Popular Science, and the Re-shaping of Macchia Romanticism, 1862–1886." *Art Bulletin,* LII, no. 4 (December 1970).

——. "The Macchiaioli: Effect and Expression in Nineteenth-Century Florentine Painting." *Art Bulletin,* LII, no. 1 (March 1970).

Bury, Shirley. "Felix Summerly's Art Manufactures." *Apollo.* (January 1967), 28–33.

Champa, K. *German Painting of the Nineteenth Century* [exhib. cat.]. Yale University, 1970.

Clark, Timothy. *The Absolute Bourgeois: Art and Politics in France, 1848–51.* Greenwich, Conn.: New York Graphic Society, 1973.

——. *The Image of the People.* Greenwich, Conn.: New York Graphic Society, 1973.

Dunlop, Ian. *The Shock of the New.* London: Weidenfeld & Nicolson, 1972.

Evans, Joan. *John Ruskin, Lamp of Beauty.* New York: Oxford University Press, 1954.

Finke, Ulrich. *German Painting: From Romanticism to Expressionism*. Boulder, Colo.: Westfield Press, 1975.

Forster-Hahn, Françoise. "Adolph Menzel's 'Daguerreotypical' Image of Frederick the Great: A Liberal Bourgeois Interpretation of German History." *Art Bulletin*, LIX, no. 2 (June 1977).

Fredeman, W. E. *Pre-Raphaelitism: A Bibliocritical Study*. Cambridge: Harvard University Press, 1965.

Gaunt, William. *The Pre-Raphaelite Dream*. New York: Schocken Books, 1966.

——. *The Restless Century: Painting in Britain, 1800–1900*. London: Phaidon, 1972.

Gauss, Charles. *Aesthetic Theories of French Artists, 1855 to the Present*. Baltimore: Johns Hopkins Press, 1949.

Gernsheim, Helmut. *Creative Photography, Aesthetic Trends, 1839–1960*. London: Faber & Faber, 1962.

Goncourt, Edmond and Jules. *Pages from the Goncourt Journal*, trans. Robert Baldwick. London: Oxford University Press, 1962.

Hamilton, George Heard. *Manet and His Critics*. New Haven: Yale University Press, 1954.

Hanson, Anne. *Manet and the Modern Tradition*. New Haven: Yale University Press, 1977.

Herbert, Robert, ed. *The Art Criticism of John Ruskin*. Garden City, N.Y.: Anchor Press/Doubleday, 1965.

——. "City vs. Country: The Rural Image in French Painting from Millet to Gauguin." *Artforum*, VIII (February 1970), 44–45.

Hofmann, Werner. *The Earthly Paradise: Art in the Nineteenth Century*. New York: George Braziller, 1961.

Kessani, James. "Art Historians and Art Critics, IX: P. G. Hamerton, Victorian Art Critic." *Burlington Magazine*, vol. CXIV (January 1972), 22–55.

Lethève, Jacques. *The Daily Life of French Artists in the Nineteenth Century*, trans. H. Paddon. London: Allen & Unwin, 1972.

Licht, Fred. *Sculpture: 19th and 20th Centuries*. Greenwich, Conn.: New York Graphic Society, 1967.

Lindemann, Gottfried. *History of German Art: Painting, Sculpture, Architecture*, trans. T. Sayle. New York: Praeger, 1971.

Lister, Raymond. *Victorian Narrative Paintings*. London: Museum Press, 1966.

Mirolli, Ruth B. *Nineteenth-Century French Sculpture: Monuments for the Middle Class*. Louisville, Ky.: J. B. Speed Art Museum, 1971.

Mitchell, Peter. "The Success of Alfred Stevens at the Exposition

Universelle of 1867." *Connoisseur*, CLXXIII (April 1970), 263–64.

Muther, Richard. *The History of Modern Painting*. New York, 1896; rev. 1907.

Nicoll, John. *The Pre-Raphaelites*. London: Studio Vista, 1970.

Nochlin, Linda. *Realism*. Baltimore: Penguin, 1971.

Novotny, Fritz. *Painting and Sculpture in Europe, 1780 to 1880*. Harmondsworth, England: Penguin, 1960.

Pevsner, Nikolaus. *High Victorian Design*. London: Architectural Press, 1951.

Pinckney, D. H. *Napoleon III and the Rebuilding of Paris*. Princeton: Princeton University Press, 1958.

Richardson, Joanna. *Théophile Gautier, His Life and Times*. London: Reinhardt, 1958.

Robertson, David. *Charles Eastlake and the Victorian Art World*. Princeton: Princeton University Press, 1978.

Rosenblum, Robert. *Modern Painting and the Northern Romantic Tradition: Friedrich to Rothko*. New York: Icon Editions, 1975.

Scharf, Aaron. *Art and Photography*. London: Penguin, 1968.

Schrade, Hubert. *German Romantic Painting*, trans. Maria Pelikan. New York: Abrams, 1977.

The Second Empire, 1852–1870: Art in France under Napoleon III [exhib. cat.]. Philadelphia Museum of Art, 1978.

Sloane, Joseph C. *French Painting Between the Past and the Present: Artists, Critics, and Traditions from 1848 to 1870*. Princeton: Princeton University Press, 1951.

Steegman, John. *The Consort of Taste, 1830–1870*. London: Sidgwick & Jackson, 1950 (republished as *Victorian Taste* [London: Nelson, 1970]).

Stranahan, Clara. *A History of French Painting . . . including an Account of the French Academy of Painting*. New York, 1888; 1907.

Trapp, Frank. "The Universal Exposition of 1855." *Burlington Magazine*, CVII (June 1965).

White, Cynthia, and Harrison White. *Canvases and Careers: Institutional Change in the French Painting World*. New York: John Wiley, 1965.

INDEX

Abecedaire du Salon de 1861 (Gautier), 282

Abel de Pujol, Alexandre D., 4, 112

Académie des Beaux-Arts (Academy of Fine Arts), France, 2 n, 3, 5, 8, 196, 198

Académie Royale (French Academy), xxv–xxvi, 2 n, 265, 379, 381, 383, 455, 458, 460, 462, 484, 536

Académie Suisse, 410

Academy, Berlin, 179, 181, 182, 183, 217

Academy, Royal (British). *See* Royal Academy of Art, British

Academy, Royal (Brussels), 535–36, 537

Academy Notes (Ruskin), 357

Academy of Art (Bavaria), 216, 495, 522

Accademia Reale (Italian Academy), 432

Achenbach, Andreas, 239, 522

Achenbach, Oswald, 239, 522

Achmed, Sultan (Turkey), 546; fountain of, 550

Adalbert, Prince (Bavaria), 497

Adam (German painter), 530

Adam, Adolphe, 196

Adam and Eve Finding the Body of Abel, 387

Adamello, Carlo, 340

Adhesion of Maximilian I to the Catholic League in 1699, 496

After Dinner at Ornans, 158, 410

Akademie für bildende Kunst, 493, 495

Albani (Italian painter), 149

Albert, Prince Consort (Great Brit-

ain), 44 n, 49–50, 53–54, 57, 58, 164, 170, 355–56, 364
Album, L' (periodical), xxix, xxx, 380
Album Boetzel, Salon de 1869, 505
Alcock, Sir Rutherford, 361, 362–63, 372, 375
Alembert, Jean Le Rond d', 348
Aligny, Cornelle, 86 n, 95
Allgemeine Zeitung, 220
Allier (French sculptor), 5
Allotria group (Vienna), 552, 554
All Soul's Day, 402
Alma-Tadema, Sir Lawrence, 511, 528
Altamura, F. S., 318
Amaury-Duval, Eugène E., 401–2
Ambush of Italian Bersagliere . . . , An, 340
America, 304, 329
Amphitrite, 286
Ancient Door to the Library of the Louvre, 262
Andromache, 149
Angeli, Heinrich von, 550–51
Angers, David d', 4, 76, 149, 196, 212
Anne of Austria and Richelieu, 386
Annual Fair Scene, 193–94
Antigna, A., 18–19, 20
Antwerp, 535, 537; Congress of Fine Arts, 537; Royal Academy, 535
Apelles (Greek artist), 155, 157
Apocalyptic Host, The, 218
Apotheosis of Homer, The, 210
Apropos the Third Promotrice Exhibition, Naples, 1864–65 (Netti), 436–44
Arago brothers, 117
Architecture (architects), xxv, 50–52, 68, 73, 108–9, 214–16, 224, 357–63, 366–69, 494–95, 514, 547–49, 554–55, 566–67, 568. *See also* specific people, places, works
"Architettura della Nuova Italia, L' " (Boito), 555
Ariel, L', 271
Aristotle, 12
Arnim, Bettina von, 179
Arnolfo di Cambio, 304
Art and Poetry (periodical), 32, 47
Art-association (art-society) exhibitions, development of, xxvi–xxvii, xxviii, xxix, 334–35. *See also*
specific aspects, associations, developments, exhibitions, people, places, societies
Art au XIXe siècle, L' (publication), 248
"Art Contemporain, L' " (publication), 382
Arte moderne, L' (periodical), 435
Art et Les Artistes Modernes en France et en Angleterre, L' (Chesneau), 382
Art galleries, development of, xxviii. *See also* specific developments, galleries, people, places
"Articles de Vienne," 549
Artin, Louis, 537
Artiste, L', 5, 6, 78, 81, 94 n, 116, 117, 167, 168, 247, 270, 271, 301, 382, 383, 384, 424 n, 461, 471, 497
Artists' Federation (France), 535
Artist's Studio, The (*L'Atelier*), v, 112, 162–63, 553, 569, 570
Art Journal (formerly *Art Union Journal*), xxix–xxx, 31, 32, 34, 35 n, 55, 58, 113, 165–66, 221, 242, 246, 301, 327 n, 335, 483, 497, 498, 546 n, 549, 550, 553
Art Libre, L' (Belgian periodical), 539, 540, 542, 544
Art magazines, early, xxix. *See also* specific people, places, publications
Art of Fresco Painting, The (Merrifield), 55
"Art Social et Progressif, L' " (Thoré), 117
"Art Treasures of Great Britain" exhibition (1857), xxix, 164–76
Art Union (England), xxvii, xxix, 334
Art Universel, L' (Belgian periodical), 539
Assassins of Buondelmonte, 306
Assault in Hochkirch, 234
Association des Artistes (France), 1, 3
Association for Historical Art (Germany), 183–84, 217
Association of German Art Unions to Promote Historical Painting, 183–84, 217
Astruc, Zacharie, 457–58
As You Like It, 507; *The Wrestling in,* 102–3
Atalanta, 22

Atelier, L'. See Artist's Studio, The
Atelier Saint Luc, founding of,
537–38
Athenaeum (England), xxix, 32–33,
35–36, 250
Athenaeum Français, L', 113
Augsburger Allgemeine Zeitung
(publication), xxix
Aupick, General Jacques, 266
Austria and the Austrians, 111,
113–14, 119, 129, 214–40, 266, 297,
493–94, 498, 512, 522, 545–76. *See
also* Vienna; specific people,
places, works
Avondo, Rayper d', 562
Awakening of Lazarus, 128

Bacchante, 402, 524
Bacchus, 149
Bacchus and Ariadne, 104
Baden, 111
Bain, Le (*The Bath* or *Luncheon on
the Grass*), 427, 431. *See also
Déjeuner sur l'herbe*
Balzac, Honoré de, 212, 408, 458
Bank of the River, The, 389
Banks of the Gardon, The, 27
Banks of the Loire in Springtime,
203
Banks of the Loue, The, 205
Barbes (French Socialist), 3
Barbizon painters, 117. *See also*
specific painters, works
Bark of Dante, The (*Dante and Vir-
gil*), 143, 211
Barouche, J., 4
*Barracks in Modena During the
Campaign of 1859*, 344–45
Barre, Jean-Auguste (Père), 5
Barrot, Odilon, 2
Barry, Charles, 42 n
Bartolini, Lorenzo, 77
Barye, A. L., 4, 22, 81, 91, 112, 386,
482
Basserman (German publisher), 496
Bathers, The, 115, 161–62, 207, 289
Battle of Magenta, The, 306–7
Battle of Salamis, 229, 495, 503, 528
Battle of San Martino, 340
Battle of Solferino, 284
Battle of Springtime, The, 289
Battles, paintings of, 293–94. *See
also* specific artists, works
Baudelaire, Charles, 114, 116, 247,

266–71, 272–81, 534–35; on the
Salon of 1859, 272–81
Baudry, Paul, 284–86, 400–1, 402,
419, 423, 431
Bavaria and the Bavarians, 111, 119,
214–40, 480, 484, 493–532. *See also*
specific people, places, works
Bazille, Frédéric, 458, 462
Béatitude, 87–88
Beaux-Art en Europe, Les (Gautier),
271
Beavington-Atkinson, J., 553
Bechère (French painter), 389
Beech Tree Forest, A, 192–93
Beer (photographer), 254
Before St. Bartholomew's Night, 181
Begas, Reinhold, 179, 504
Belgium and the Belgians, 111, 119,
139–40, 180, 483–84, 498, 506,
508–9, 511, 521, 522, 525, 526, 527,
533–44, 551, 556, 562 (*see also*
specific people, places, works); art
academies, 353, 535–36, 537
Bell, Quentin, 52 n
Belles-lettres journals, xxix. *See also*
specific people, places, publications
Bellet du Poisat, P. A., 388–89
Bendemann, E. J. F., 503
Bennassai (Italian painter), 350
Bénouville (French painter), 211
Benvenuti, Pietro, 311
Berg, Count der (pseud.), 494. *See
also* Ludwig II, King (Bavaria)
Berlin, xxiii, xxviii, 177–94, 220 (*see
also* Germany; specific people,
publications, works); Academy,
179, 181, 182, 183, 217; Friedrich-
strasse, 178; gallery exhibition of a
dealer (1857), 177–94; Unter den
Linden, 177
Berlioz, Hector, 161
Bernardin de Saint-Pierre, Jacques
Henri, 205
Bertin, Victor, 273
Bertins, the, 7
Bezzuoli, Giuseppe, 314, 345–46
Bièfve, Édouard de, 180, 495, 510,
536
Bird Keeper, The, 103–4
Bird's-nesters, The, 93
Birth of Venus, The, 401
Bisson (landscape artist, photog-
rapher), 252, 262

Blackwood's Edinburgh Magazine,
32, 99, 100
Blake, William, xxvii
Blanc, Charles, 2, 4, 167–76, 247–48,
381, 456, 534; *Treasures of Art at
Manchester (1857)* by, 168–76
Blanc, Louis, 117, 167–68, 175 n
Blanchard (French sculptor), 566
Blin, François, 430
Böcklin, Arnold, 496, 504, 526–27
Bohèmes, Les ("bohemians"), 116,
198, 267
Bohemians, The, 388
Boito, Arrigo, 554
Boito, Camillo, 554–69; on the
Vienna World Exposition (1873),
555–69
Bonaparte (First Consul), 109. *See
also* Napoléon I
Bonaparte, Charles-Louis Napoléon.
See Napoléon III, Emperor
Bonaparte, Prince Jérôme. *See*
Jérôme Napoléon, Prince
Bonaparte, Prince and Princess An-
toine, 296
Bonheur, Auguste F., 419–20, 422,
524
Bonheur, Rosa, 28, 122, 333, 409,
415 n, 419, 422
Bonington, Richard, 92, 382, 387,
405
Bonnat, Léon, 387–88, 524
Bon Sens, 167
Bonvin, F., 116
Borrani, Odoardo, 331–32, 335, 349,
352–54
Bosio, *Republic* statue by, 22–23
Botticelli, 103, 166
Boucher (French artist), 6, 139, 150
Boudin, Eugène, 535
Bouguereau, W.-A., 78, 402–3, 459
Boulanger, Louis, 78
Bouquet de Violets, Le, 81
Boure, Antoine, 537
Bouvin (French painter), 388
Boy with a Sword, The, 388, 461
Bracquemond, Félix, 458, 483
Braun, Adolphe, 269
Brazil, 551
Bremer Sonntagsblatt, 185
Brera Academy, xxix
Breton, Jules A., 19, 78, 389, 452,
482, 538
Briefe über die moderne Kunst

*Frankreiche bei Gelegenheit der
Pariser Austellung* (Eitelberger
von Edelberg), 118–31
Brienne, Guattieri (Walter of
Brienne, Duke of Athens), 305
Brigot (French painter), 466
British Institute, 380
British, the. *See* England and the
English; specific developments, ex-
hibitions, organizations, people,
places, publications, works
British Museum, 31
Broken Pitcher, The, 429
Brosse, Abraham, 139
Brotherhood of St. Luke. *See* Naz-
arenes
Brown, Ford Madox, 358
Browning, Elizabeth Barrett, 301
Brussels, xxvii, 381, 497, 533–44 (*see
also* Belgium and the Belgians);
Academy, 535–36, 537; Société
Libre des Beaux-Arts exhibition
(1871), 533–44
Builder, The (periodical), 113,
362–63, 572 n
*Bulletin de la Société Française de
Photographie,* 245
Bullock, Henry, Egyptian Hall of,
380
Bulwer-Lytton, Edward, 36
Bunsen, Baron Christian Karl Josias
von, 33, 180
Buonamici, Ferdinando, 344–45
Burckhardt, Jacob, 179
Bürger, William. *See* Thoré,
Théophile
Burges, William, 360
Burial at Ornans, v, 4, 5–6, 7, 9–14,
18, 95, 116, 161, 162–63, 198, 207,
553, 570, 572
Burklein, Friedrich, 215
Burne-Jones, Edward, 358
Burning of Tarascon, The, 402
Burty, Philippe, 248–49, 256–64, 538
Busch, Wilhelm, 496
Busts, 70–71. *See also* Statues;
specific exhibitions, kinds, people,
works

Cabanel, Alexandre, 286–87, 401,
420–21, 423, 431, 482, 484, 505,
524, 551
Cabianca, Vincenzo, 300, 318–19,
335, 342, 345

Caffè Michelangelo (Florence), art group at, 300, 337
Caldesi (photographer), 251, 257, 259
Calvary, 91–92
Cambacérès, Duc de, 112
Cambi, Ulisse, 296
Camino, G., 344, 351
Camuccini, Vincenzo, 433
Cancale (French painter), 430
Canon, Hans C., 530, 551
Canova (sculptor), *Cupid and Psyche* by, 149
Capital of the Tycoon, The (Alcock), 372 n
Capture of the Malakoff Tower, 197
Caravaggio, Michelangelo da, 150, 315, 433
Cardinals Sent to Cesare Borgia, The, 440
Carl, Grand Duke of Weimar, 218
Carpeaux, Jean-Baptiste, 567–68
Carpenter Shop, The. See Christ in the House of His Parents
Carracci brothers, 149
Carrier-Belleuse (French portraitist), 389
Carrière, Moritz, 217
Carstens, Asmus Jakob, xxviii, 218–19, 224, 230, 232, 234
Cartes de visite, xxviii, 269
Cartoons (cartoonists), 218–19, 229, 506–7. *See also* specific exhibitions, kinds, people, places, works
Cartoons of Hampton Court, 257, 259
Cassioli, Amos, 556
Castagnary, Jules, 337, 383, 384, 390–413, 424–30, 535; on the Salon des Refusés, 424–30; on the Salon of 1857, 198–213; on the Salon of 1863, 390–413
Castan, G., 512
Caumont, de (art juror), 83
Cavalcaselle, Giovanni, 166
Cavalier (sculptor), *Gracchii* by, 149
Cavour, Count, 248
Cazal (French painter), 431
Celentano, Bernardo, 316–17, 346, 445
Cennini, Cennino, 55
Cézanne, Paul, 456, 457
Cham (pseud.), caricatures by, 6
Chambers, Robert, xxix

Champfleury. *See* Fleury-Husson, Jules
Chance Brothers (glass manufacturers), 54
Chardin (French painter), 150
Charivari, 114
Charlotte Corday, 284–86
Chassériau, Théodore, 212
Chatrousse, Émile, 566
Chaucer, Geoffrey, 42
Chauvel (French painter), 430
Chenavard, A., 272–73, 505–6
Chenier, André, 16–17, 285
Chennevières, Philippe, Marquis de, 78, 79, 111, 266
Chesneau, Ernest, 382, 383, 384–90, 485, 486–90
Chevreul, M. E., *De la Loi du Contraste Simultané des Couleurs,* 55
Chien-Caillou, 116
Child, The, 565
Childhood of Callot, The, 93
Children in the Wheatfields, 20
Child's Portrait, A, 85
China and the Chinese, 365–66, 367, 374–75, 376, 480, 545, 575
Christ Crucified (Christ on the Cross), 24, 25
Christ in the House of His Parents, 34–35, 39–40, 48
Christ in the Tomb, 149
Christabel, 103
Christian Martyr, 566
Christ's March to Jerusalem, 189
Chronicles, 305
Chronique, La (Belgian periodical), 538, 539
Chronique des Beaux-Arts (periodical), 552 n
Chrysalide, La (periodical), 539
Ciceri (lithographer), 92–93
Cimabue (Italian painter), 173, 313, 342
Cimabue's Madonna Carried in Procession through the Streets of Florence, 105–7
Classicists (Classical School), 393–95, 396–404. *See also* specific aspects, developments, people, places, works
Claude (French painter), 421
Claudet, Antoine, 242
Clément de Ris, Louis, 6, 81, 94–96, 301

Cleopatra and Caesar, 459

Clermont-Tonnerre, Countess of, portrait of, 420–21

Clésinger, Jean Baptiste, 23, 482

Cloister at St. Triomphine, 262

Cloister of Moissac, 262

Closed Door, The, 388

Clout brothers (Flemish painters), 151

Cluny Museum, 169 n, 171, 552

Cogniet, Léon, 83, 112, 141

Cole, Henry (Felix Summerly), 53–54, 57, 356, 357, 481

Collins (English painter), 47

Collinson, James, 32, 104

Columbus as a Child, 564

Comédie Humaine, La (Balzac), 408

Comines, Philippe de, 140

Comité Historique des Arts et Monuments, 120, 122

Compromise of the Netherlandish Nobles, The, 536

Comte, Auguste, 198

Comte, Pierre Charles, 181, 524, 525

Concert of Frederick the Great in Sanssouci, The, 186, 190–92

Concordia, 287–88

Condemnation of the Counts of Egmont and Horn, 527, 528

Condizione dell'Odierna Pittura Storica e Sacra in Italia . . . , La (Selvatico), 308

Confession de Claude, La (Zola), 458–59

Congrès de l'Enseignement des Arts du Dessin (Belgium), 538

Conradin, 234

Constable, John, 408

Constitutionnel, Le (publication), 117, 382, 383

Conti (Italian painter), 307, 349

Contrasts (Pugin), 50

Convent, The, 388

Copley, John Singleton, 382

Copper engravings, v. *See also* specific kinds, people, places, works

Corneille, Pierre, 155

Cornelius, Peter von, 53, 111, 119, 130, 136, 179–80, 184, 216, 218, 219, 229–30, 495, 503, 506, 508, 548, 558

Coronation of the Emperor, 382, 385–86

Corot, J.-B.-C., 4, 27–28, 205, 389, 403, 409, 421, 524, 538

Correggio, 148

Corsaire-Satan (magazine), 267

Costa, Giovanni, 335, 341–42

Cottrau, F., 5, 83

Country Girls, The, 349–51

Count Ugolino and His Children, 311, 568

Courbet, Gustave, v, xxviii, 3, 4, 5–7, 9–14, 18, 154, 267, 268, 288–89, 382, 406 n, 409–12, 422, 457, 459, 471, 478, 482, 496, 499–500, 513, 523, 524, 525–26, 530, 535, 537, 538, 553–54, 569–71; Champfleury on realism and, 157–63; exhibits his own work (1855), 112, 114–16, 154, 157–63; Gautier on, 288–89; in Salon of 1850–51, 3, 4, 5–7, 9–14, 18; in Salon of 1852, 80, 81, 84, 94–96; in Salon of 1857, 197, 198, 204, 205–8

Courrier Artistique, Le (periodical), 380

Courrier du Dimanche (periodical), 383, 390 n

Courrier Français, Le (journal), 167, 168

Couture, Thomas, 85, 91, 112, 143, 405, 458, 482, 525

Cowherd, 412

Cranach, Lucas, 173

Crepuscolo (publication), 554

"Critical Wanderings Through the Art Institutes and Studios of Berlin," 185

Critics (reporters, reviewers), development of art exhibitions and, xxx. *See also* specific aspects, developments, exhibitions, people, places, publications, works

Critiques d'Art et Littérature (Clément de Ris), 81

Croce, Benedetto, 435

Cromwell, 88

Crowe, Catharine (Stevens), 277

Crowe, Joseph Archer, 166

Crucifixion in the Mountains, The, 226 n

Crystal Palace (London), xxiv, 54–74, 109, 170, 357, 367

Cubitt, William, 54

Cucinotta, Saro, 435, 444

Cunningham, Peter, 169

Cuoco, Vincenzo, 451–52
Cupid and Psyche, 149
Curti, Pier A., 301, 302–7; on the Italian Exhibition at Florence (1861), 302–7
Cybele, 286
Czermak, Jaroslaw, 235, 530

Daguerre, Louis, 242, 262, 275
Daguerreotypes, xxviii, 262. *See also* Photography
Dahl, Johan, 219
Daily News (London), 251, 254
Daisy, The, 342 n
D'Alembert, Jean Le Rond, 348
D'Ancona, Vito, 316
Danjoy (French architect), 83
Dante Alighieri, 143, 211, 316–17, 303, 316–17, 349, 441, 518; *Divine Comedy* of, 289–90; *Inferno,* 423
Dante and Beatrice, 349
Dante and Virgil (The Bark of Dante), 143, 211
Dante Meeting Beatrice, 316–17
Daubigny, Charles F., 90–91, 95, 203–4, 409, 422, 455
Daubigny, Pierre, 530
Daumas (French sculptor, art juror), 5
Daumier, Honoré, 260, 273
Dauzats (French lithographer), 93
Davanne (French photographer), 261, 262–63
David, 565
David, (Jacques) Louis, xxviii, 7, 21, 130, 151, 272, 309, 311, 382, 385–86, 393, 396, 536
Dawn of Italian Independence, The, 303–4
Deane, J. C., 164, 169
Death of Major Peirson, The, 382
Death of St. Francis of Assisi, The, 211
Death of Valentin, 211
Debay, A., 4, 17–18, 83
Decameron, 298, 311
Decamps, A. G., 4, 82, 83, 93, 143–44, 154, 387, 405, 496, 527
Dedication of the Freiburg Cathedral, 236
Deeds of Charlemagne, The, 218
Deer Resting Place in the Canyon, 572
Defeat of Ezzelino da Romano, 306

Defregger, Franz von, 496
Degas, Edgar, 300, 458
Déjeuner sur l'herbe, 469, 470. *See also Bain, Le*
Delaborde, Henri, 168
Delacroix, Eugène, 4, 5, 8, 16, 83, 84, 92, 110, 121, 133, 140–41, 142–43, 154, 181, 211, 212, 245, 268, 269 n, 273, 282, 310, 380, 382, 405, 409, 496, 527, 536, 542; "Des Variations du Beau" essay by, 198
De la Loi du Contraste Simultané des Couleurs, 55
De la Madeleine, H., 483
Delamotte (French painter), 252–53
Delaroche, Hippolyte (Paul), 88, 142, 166, 180, 196, 212, 279, 405, 495, 536
Delécluze, Étienne, 4, 6, 7–8, 130, 285 n, 383, 561; on the Salon of 1850–51, 9–29
"De l'État des Beaux-Arts en Angleterre en 1857" (Mérimée), 166–67
Delferier (French photographer), 254
"De l'Influence des Peintres sur les Destinées de l'Italie" (Moncaut), 301
Demidoff, Prince Anatole, 77
"Demo," 335, 337–43
Denmark and the Danes, 111, 551, 556. *See also* specific people, works
De Sanctis, Francesco, 432–33, 434, 435
Desgoffe, Blaise, 431
Deshoulières, Antoinette, 208
Desnoyers, Fernand, 384
Despréaux Boileau, Nicolas, 6
D'Este, Luigi Cardinal, 442
Destruction of Heidelberg, The, 234
"Des Variations du Beau" (Delacroix), 198
De Tivoli, Serafino, 300, 332, 335, 342, 344–45
Deutsche Kunstblatt, Das, xxix, 113, 165 n, 166, 181, 184–85, 220, 500
Deverell (English painter), 47–48
Diana, 149
Diaz de la Peña, N. V., 4, 16, 27, 136, 409, 428, 526, 535
Dickens, Charles, 36–37, 38–43
Dictionnaire de Phrénologie et de Physiognomie (Thoré), 156 n

Diderot, Denis, 267, 271, 274 n, 348, 429
Dietz, Feodor, 217–18, 234
Dilettante Quartet, 511–12
Dilke, Wentworth, 356
Dinner in Sanssouci, The, 186
Dioskuren, Die, xxix–xxx, 184, 185, 186, 221, 301–2, 334–35, 500
Disdéri, André, xxviii, 245–46, 269, 379
Disraeli, Benjamin, 36
Distribution of the Eagles, 385–86
Dividing of the Peoples, The, 229
Divine Comedy, The, Doré's illustrations for, 289–90
Divine Tragedy, 505
Dochte, the (Munich group), 496
Dombey and Son (Dickens), 36
Domenichino (Italian painter), 149
Dommartin, Léon, 539–43; *Manifesto* by, 539–43
Doré, Gustave, 289–90, 381, 423–24, 500, 526
Dream of Innocence, 518
Dresden Opera House, 57, 58
Dubois, Louis, 537, 543, 565
Dubufe, C. M., 136
Dujardin, Karel, 28
Dumas, Alexandre, 261, 432, **534**
Dumesnil, Françoise, 84
Dumont, Augustin, 5
Du Pays, A. J., 6, 459
Dupont, Pierre, 267
Dupré, Giovanni, 77, 302–3, 564
Dupré, Jules, 3, 85–86, 90, 95, 136, 299, 307, 409
Du Principe de l'Art et de Sa Destination Sociale, 457
Durand-Ruel art gallery, 380, 537, 553
Duranty, Edmond, 458
Dürer, Albrecht, 173, 488
Duret, Théodore, 458
Du Sommerard, Alexandre, 169 n, 552
Du Sommerard Museum, 169
Düsseldorf, Germany, 220
Dutch, the. *See* Netherlands
Duveau, Louis, 403
Dyce, William, 33, 44, 46–47, 103
Dying Napoleon, 564

Eagles, John, 32
Early Flemish Painters, 166

Earthenware, 68
Eastlake, Lady, 98, 165
Eastlake, Sir Charles, 33, 34, 53, 97–98, 242
Ébauche, xxvi
Ecce Ancilla Domini, 47 n
Éclair, L' (weekly review), 79, 81, 82 n
École des Arts Décoratifs (Paris), 51
École de Dessin (Paris), 52, 120, 478
École des Beaux-Arts (Paris), 9, 112, 120, 196, 197, 458
École Française Jugée par la Critique Allemande, L' (Müntz), 499
Edge of the Loue, The, 96
Edinburgh Review, 32
Education of the Children of Clotilde, 528
Eggers, Friedrich, 113, 181
Egyptian Dancing Girl, 252
Egyptian Hall (London), xxviii, 380
Eiffel, Alexandre Gustave, 479
Eitelberger von Edelberg, Rudolf, 113–14, 118–31, 184, 500–1, 548–49
Elizabeth, Empress (Austria), 545, 546
Elster, G. R., 189
Émaux et Camées, 270
Émeric-David, Toussaint Bernard, 83, 91
Empty Road, 27
En 18 . . . (Goncourt), 80
Engelmann, Godefroi, 92
England and the English, xxiii–xxiv, xxvi–xxvii, xxix, 30–48, 49–74, 97–107, 113, 119, 137–39, 164–76, 241–44, 246–56, 301, 327, 334, 335, 355–57, 379–80, 386–87, 415, 416, 417, 418, 477, 480, 481, 483, 498, 551, 553, 556, 560, 572–73, 574. *See also* London; Manchester; specific exhibitions, people, works
Engraving(s), v, xxv, xxx. *See also* specific kinds, people, places, works
Enhuber, Karl von, 511
Entrance of the Duchess Elizabeth into Brabant, The, 183
Entrance to the Gorge at Apremont, The, 428
Epaminondas, 149
Episode from the Thirty Years' War, 128
Episode in 1793, at Nantes, 17–18

Ernest I, Duke of Saxe-Coburg-Gotha, 53
Espada, L' (Mlle. Victorine in Bullfighter's Costume), 427
Étex (French sculptor), 196
Études d'Art, Le Salon de 1852, La Peinture à l'Exposition de 1855 (Goncourt), 82 n
Eudorus and Cymodocea, 298, 311–12
Eugénie, Empress, 108, 110, 476, 513
Eva, 303
Événement, L' (periodical), 6, 456–57, 459, 462
Événement Illustré, L', 462
"Evolution," historical exhibitions and, xxix
Exaltation of the Holy Cross, 303
Examiner (London), xxix, 32, 36, 43 n
Experiment of Vaccination, 564
Exposition des Artistes Vivants (Delécluze), 6 n, 9 n
Exposition Universelle, Paris: (1855), xxiv, 108–63; (1867), 476–92
Expulsion of the Duke of Athens from Florence, 298, 305, 311–12, 330

Fading Away, 253
Fairy Tales of the Seven Ravens, 218, 235–37
Falconer, 142–43, 525
Falguière (French sculptor), 566
Falke, Jakob von, 501, 550 n
Fall of Angels, The, 551
Fall from Paradise, The, 505, 524
Fancher, Léon, 2
Fantin-Latour, Théodore (Henri), 426, 458
"Fantômes Parisiens" (Baudelaire), 270
Farmer Coming Home from Work, 193
Fattori, Giovanni, 300, 335, 349–51, 353
Faust and Marguerite, 211
Felix, E., 524
Fend (Austrian painter), 512
Fenton, Roger, 97, 242, 246–47, 251–52
Ferdinand (from *The Tempest*), 48
Ferdinand IV, 432

Ferdinand Lured by Ariel, 34
Fernkorn, Anton, 548
Ferrier, C. M., 269
Ferrier, J. A., 269
Ferstel, Heinrich von, 548
Fetis, François J., 159
Feuerbach, Anselm, 504
Fierlands (Brussels photographer), 257
Figaro, Le (periodical), 456
Fine Arts—Eighty-Second Exhibition of the Royal Academy (Anonymous [John Forster?]), 43–48
Fine Arts Quarterly Review, The, 413 n
Fishermen, 152
Flamand, François, 172
Flamm (German painter), 239
Flandrin, Jean-Hippolyte, 248, 396, 397–400, 508
Flandrin, Paul, 27, 112
Flaubert, Gustave, 78, 197–98, 458
Flemish painters and painting, 536. *See also* specific aspects, exhibitions, people, places, works
Flemish Painting of the Fifteenth Century, 257
Fleurs du Mal, Les (Baudelaire), 267–68, 496
Fleury-Husson, Jules (Champfleury), 7, 115–16, 157–63, 267, 406 n, 458
Fliegende Blätter, 496
Flood, The, 25
Flora, 518
Florence, Italy, xxvii, 77, 296–333, 334–54; National Exposition (1861), 296–333, 432; society exhibition (1861–67), 334–54
Florentine Garden, 341
Florentine Singer, 565
Fohr (German painter), 227
Foltz, Philipp, 233
Fond Memory, The, 342 n
Forest (Courbet), 389
Forest, A (Marko), 342
Förster, Ernst, 184
Forster, John, 32, 36, 37, 43–48
Founding of the League, The, 234, 235
Four Times of Day, 227
Fourtoul (French sculptor), 5
Fowke, Francis, 356
Fox and Henderson (engineering firm), 54

Fox in the Snow, The, 289
Foyatier (French sculptor), 149
Fracaroli, Innocenzo, 304
Fragonard, Jean-Honoré, 150
Français (French painter), 136
France and the French, xxiii, xxiv,
 xxv–xxvi, xxvii, xxix, 1–29, 51, 52,
 75–96, 108–63, 195–213, 244–46,
 256–64, 269–95, 301, 309–10, 314,
 378–431, 457–75, 476–92, 493,
 496–97, 498, 499–500, 501, 503,
 504, 506, 507–8, 512–14, 515–16,
 520–26, 527, 529, 531, 535–36, 551,
 552–53, 555, 560, 561–62, 564–68.
 See also Paris; Salon, the; specific
 exhibitions, people, places, works
France Littéraire, La, 271
Françoise de Rimini, 211
Franz Josef, Emperor (Austria),
 545–46, 547–48, 550–51
Fraser's Magazine, 32, 360
Fraternal Love, 402
Frederick II, 504
Frederick the Great, 184, 186,
 190–92, 219; Rauch statue of (Ber-
 lin), 178
Frederick the Great at Hochkirche,
 219
Frederick the Great Traveling, 186
Frederick William III (Prussia), 177
Frederick William IV (Prussia),
 174–75, 179, 180
Frémiet (French sculptor), 23–24,
 91, 567
Frère, Édouard, 422
Frescoes, 44, 55. *See also* specific
 people, places, works
Freytag, Gustav, 221
Friedlander, G., 512
Friedrich, Caspar David, xxviii, 219,
 224, 226 n
Friends of Dante's Childhood, The,
 441
Frith, W. P., 252
Froissart, Jean, 140
Frolic, The, 388
Fromentin, Eugène, 78
Fuller, Charles Francis, 297–98, 304
*Funeral Procession of the Emperor,
 The,* 93
Furioso, Orlando, 450
Füssli (German painter), 530

Gainsborough, Thomas, 171

Gallait, Louis, 79, 88–89, 180, 495,
 510, 527–28, 536, 537
Gambart, Ernest, exhibitions of,
 xxviii, 415
Garibaldi, Giuseppe, 297, 300,
 432–33; bust of (Florence), 339
Garnier, Jean Louis Charles, 378
Gärtner, Friedrich von, 57, 214
Gate of Constantine, The, 86
Gau, Franz, 57
Gautier, Théophile, 6, 78, 113, 117,
 196, 245, 267, 268, 270–71, 282–95,
 380, 383, 389, 480; *The A.B.C. of
 the Salon of 1861* by, 282–95
Gautier, Théophile (fils), 271
Gavarni (French caricaturist), 80,
 93, 114
Gazetta del Popolo, 335, 343, 346
Gazette des Beaux-Arts, xxx, 247–48,
 249 n, 256 n, 257, 382, 456, 499,
 520 n, 525, 553, 554; "Chronique
 des Arts," 553
Gazzettino delle Arti del Disegno,
 336–37, 349 n, 485
Gedon, Lorenz, 496, 551
Gelati, Lorenzo, 342
Gelée, François Antoine, 4
Genelli (German painter), 218, 503
Genre painting, xxvi, 6, 29, 114, 135,
 524–32, 561. *See also* specific as-
 pects, developments, exhibitions,
 kinds, people, places, works
Gentleman's Magazine, 360
Gérard (French portrait painter),
 160
Géricault, (J.-L.-A.) Théodore,
 xxviii, 92, 152, 386, 387
Germ, The, "Art and Poetry" num-
 ber of, 32, 47
Germania, 218
Germany and the Germans (German
 states), xxvii, xxix, 113, 119, 172,
 173, 177–94, 214–40, 334, 484, 488,
 493 ff., 520–32, 551–52, 553,
 556–57, 558–59, 561–62, 568–69
 (*see also* specific exhibitions, peo-
 ple, places, works); Federation,
 119, 126, 130–31, 136–37, 214–40
Germinie Lacerteux (Goncourt), 458
Gérôme, Jean-Léon, 78, 290, 459,
 470, 482, 484
Gesamtkunstwerk ("consummate
 art"), 186, 494

"Geschichte der bildenden Künste im neunzehnten Jahrhundert" (Springer), 221–22

Geschichte der modernen französischen Malerei (Meyer), 523 n

Gesellschaft Bildender Künstler, exhibition of, 553 ff.

Ghent, Belgium, 535, 537, 538; Academy of, 353

Ghirlandaio (Ghirlandajo), Domenico, 35, 173

Gibbons, Edward, 215

Gillray, James, 37

Giordano, Luca, 306

Giorgione, 431

Giotto (di Bondone), 99, 106, 173, 327

Girardin, Émile de, 78

Giraud, Eugène, 78

Girl Crying for Her Dead Bird, The, 429

Girl Playing a Lute, 505

Girl Reading, 328–29

Girls Fishing at Lenci in the Gulf of Spezia, 340

Glaspalast (Munich), 216, 217, 219, 493–532

Gleaners, The, 204–5, 412

Glyptothek (Munich), 214, 216, 493–532

Gobelin tapestries, 79, 109

Godwin, Edward W., 360, 362

Godwin, George, 113

Goethe, Johann Wolfgang von, 34, 182, 223, 224, 263, 405, 442 n, 518

Goldsmith, Oliver, 138

Goncourt, Edmond de, xxx, 75–76, 78, 79–81, 82–93, 114, 132–57, 458, 480; *Painting at the Exposition of 1855* by, 131–57

Goncourt, Jules de, xxx, 75–76, 79–80, 82–93, 114, 132–57, 458, 480; *Painting at the Exposition of 1855* by, 131–57

Good Samaritan, 33

Goujon, Jean, 149

Gounod, Charles-François, 78

Goupil, print and art gallery of, xxviii, 379

Gouthière, candelabra by, 172

Gower, John, 42

Gracchii, 149

Graham, *Voyage in the Biblical Lands* by, 262

Grammar of Ornament, The (Jones), 357

Granville, Earl, 356

Great Britain and the British. *See* England and the English; specific people, places, works

Greece and the Greeks, 155–57, 551, 556. *See also* specific aspects, people, places, works

Greek Slave, 56, 328

Grenzboten, Die (periodical), xxix, 113, 166, 221

Gresser, von (Bavarian Minister of Culture), 497

Greuze, Jean-Baptiste, 150, 429

Groux, Charles de, 537

Gude, Hans, 188, 189, 192–93, 219

Guerra, Achille, 440–41

Guffens (Belgian painter), 508

Guido, 149

Guitarrero, Le (Spanish Singer), 291, 491 n, 525. *See also* Spanish *Guitar Player*

Guizard (Directeur des Beaux-Arts), 4, 5

Guizot, F. P. G., 260

Gust of Wind, 389

Gypsy, A, 85

Gypsy Woman, 193–94

Hagar, 306

Haghe (French lithographer), 93

Hagn, L. V., 511, 512

Hallali, 526

Hamerton, Philip G., 413–24, 430–31, 553

Hamlet, 211

Handbook of Art History, A (Kugler), 57

Handbuch der Geschichte der Malerei . . . , 179

Handbuch der Kunstgeschichte, 166, 179, 221–22

Hansen, Theophilus von, 548

Harding (English lithographer), 92

Harding, Viscount, 97

"Harmony of Colours as Exemplified in the Exhibition, The" (Merrifield), 55

Hart, Joel, 298

Hartman, Frederick, 32

Harvest, 90, 91

Harvesters, 152

Hasenauer, Baron Karl von, 547, 548

Hasselt, van, catalog by, 149
Haussmann, Baron, 110, 195
Haydn, Franz Joseph, 161
Haydon, Benjamin, 52
Hébert, A. A. E., 14, 211
Hébert, Ernest, 78
Hegel, G. W. F., 449
Heilbuth, F., 522
Heine, Heinrich, 195, 264, 271, 308, 543
Henneberg, Rudolf, 181
Henner, Jean-Jacques, 524
Henriquel-Dupont (French engraver), 4, 5, 83
Herbelin, Jeanne-Mathilde, 122 n
Herbsthofer, Charles, 128
Hernani (Hugo), 270
Hersent, Louis, 112
Herst, A. C. J., 389
Hess, Heinrich von, 508, 558
Heyne, Christian G., 15
Hildebrandt, Eduard, 181, 480
Histoire de France (Michelet), 215
Histoire de la Société Française Pendant la Révolution (Goncourt), 114
Histoire de la Société Française Pendant le Directoire (Goncourt), 114
Histoire des Peintres Français au XIXᵉ Siècle (Blanc), 167–68
Histoires Extraordinaires (Baudelaire), 268
Historical Sketch, 386
History (historical art and exhibitions), xxix, 215–16, 219, 232, 234, 319–21, 442–44, 498–99, 500, 503–4, 508, 509–14, 524–25, 530–32, 536. *See also* specific artists, aspects, events, exhibitions, people, places, works
History of Frederick the Great, 184
History of French Painting Since 1789 (Meyer), 523
"History of Labor and Its Fruits, The" (Paris exposition), 479–92
History of the Decline and Fall of the Roman Empire, The (Gibbons), 215
History of the Painters of All Nations, 167–68
History of the Popes (Ranke), 215
Hittorff, Jacques Ignace, 57, 58, 522
Hockert (Swedish painter), 136

Hofer, Andreas, 230
Hoff, Konrad, 552
Hoffmann, 93
Hogarth, William, 41, 138
Hoguet (French painter), 90
Holbein, Hans, 173
Holland. *See* Netherlands
Holy Family, 402. *See also Christ in the House of His Parents*
Homer, 159
"Homerists," 8
Home Treasury, The (Cole), 53
Horace, 509
Hors-concours category, xxv, 265
Hôtel d'Hertford exhibitions (Paris), 379
Hôtel Drout art auction house (Paris), 379
Hour of the Night, 22
Household Words, A Weekly Journal, 36, 38 n
Houses of Parliament (London), reconstruction of, 50–51, 53
Houssaye, Arsène, 78, 81, 271, 382, 471–72, 475
Huet, Paul, 409
Hugo, Victor, 6, 76, 145 n, 270, 450, 527 n, 534
Hulsen, Botho von, 178
Humboldt, Baron Alexander von, 178, 181
Hume, Joseph, 31
Hungary, 545, 548, 551, 556, 559. *See also* specific exhibitions, people, works
Hunger, 19
Hunt, Thornton, 35, 47–48
Hunt, William Holman, 32–33, 100, 138, 298, 420
Hunting Deer in the Forest of the Grand Jura, 205–6
Huntsman, The, 289
Husson, Jules. *See* Fleury-Husson, Jules (Champfleury)

Iconoclasts, The, 298–99, 305–6, 317, 319, 330
Idealism, 571
Illustrated London News, xxx, 32, 115, 166, 169, 360–61, 364
Illustration, L', xxx, 78, 266, 459, 461
Imbriani, Vittori, 434–35, 444–53
Indépendence Belge, L', 534
Independent artists' organizations,

development of, xxvii. *See also* specific aspects, developments, exhibitions, organizations, people, places
India, 549
Induno, Domenico, 306–7, 325, 345, 561
Induno, Gerolamo, 321, 325, 345, 438–39, 561
Indusco, M., 137
Industrial arts exhibitions, xxiv–xxv, xxix, xxx, 49–74, 476–92, 545–76. *See also* specific exhibitions, kinds, people, places, works
Industrie und Kunst (Semper), 58, 59–74
Ingres, Jean Auguste Dominique, 8, 110, 112, 121, 133, 140–42, 209–10, 212, 248, 282, 312, 380, 393, 396, 397, 496, 508
Innocence, 518
Institut de France, 2 n
In the Name of the Prophet, Alms, 252
Inventions, 51, 61. *See also* Industrial arts exhibitions; specific kinds, people, places
Isabella and Lorenzo, 32–33
Isabey (French painter), 93, 248
Italy and the Italians, xxiii, xxvii, xxix, 8, 128–29, 136, 157, 166, 173–74, 266, 296–333, 334–54, 432–53, 484–85, 488, 498, 511, 515–19, 520, 521, 526, 549, 551, 553, 554–55 ff., 561, 562, 564–65. *See also* specific people, places, works

Jacob and Rachel (Rachel and Jacob), 33, 46–47
Jacque, Charles, 524
Jaguar Devouring a Hare, A, 91
Jahn, Otto, 221
Jairus' Daughter, 181
Janin, Jules, 5, 80
Japan and the Japanese, 359 ff., 480, 545, 549
Jeanron, Philippe, 2, 3, 77, 168, 248
Jenner, 564
Jérôme Napoléon, Prince, 110, 117, 122
Jerrold, Douglas, 36
Jeunes-France, Les (Gautier), 270
Jockey on Horseback, 260

John the Baptist Preaching in the Desert, 565
Jones, Owen, 54–55, 57, 357; "General Principles in the Arrangement of Form and Colour in Architecture and the Decorative Arts . . ." by, 357; *Grammar of Ornament* by, 357
Jongkind, J. B., 427
Joueur de fifre, 469
Jouffroy (French sculptor), 482
Journal: Mémoires de la Vie Littéraire (Goncourt), 76 n
Journal des Débats (publication), 7–8, 78, 80, 130, 383
Journal of Design and Manufactures, 54
Journal of the Photographic Society, 242, 243, 244, 246, 249 n
Journet, Jean, 261
Juggler, 500
Julius II, Pope, 327
Jung München group, 496
Juries (jury system, jury selections), xxiv, xxv–xxvi, 2–3, 4–5, 78–79, 112, 196, 265, 381–83, 384, 454–55, 456, 459, 460, 463, 466, 481–82, 485. *See also* specific aspects, developments, exhibitions, people, places, works
Justice, 46

Kaiser Rudolf Rides to Speyer to Die, 183, 184
Karl Ludwig, Grand Duke (Austria), 551
Kaulbach, Wilhelm von, 119, 130, 136, 179, 189, 216, 218, 220, 229–30, 446, 484, 495, 496, 503, 507, 528–29, 548, 554, 558, 569–70
King Edward II, 560
Kingsley, Charles, 31, 100
Kiss, August, 111
Kladderadatsch (publication), 179
Klenze, Franz Karl Leo von, 52, 214
Klostersuppe, 193
Knaus, Ludwig, 127, 511, 512, 522, 562
Knight Kurt, 236
Knoll, Konrad, 497
Kobell, Wilhelm von, 34
Koch, J., 227, 230, 231, 232, 234
Koller (Austrian painter), 556, 559
Kotzebue, August, 182

Krantz, Jean, 479
Kremelsetzer (opera composer), 496
Kretzschmar, Eduard, 185
Krüger, Franz, 180
Kugler, Franz T., 57, 120, 179, 184
Kunstblatt, Das, 184–85
Kunsthistorischen Briefe (Springer), 221
Kunstkronijk (Dutch periodical), 113
Künstlergenossenschaft, 220, 551–52
Kunstvereine, xxvii, 113, 166, 182–83, 184, 185, 216, 217, 220, 334, 495, 500, 551, 554, 569, 570, 572
Kunstwerke und Künstler in England (Waagen), 165

Laborde, Count Léon de, 83, 256, 477
Labourieu, Théodore, 248
Labrouste, Henri, 58, 83
Lacroix, Jean, 534
Laensberg, Mathieu, 84–85
Lafenestre, Georges, 168
Lake Starnberg, 193
Lami, Eugène, 382
Lancret, Nicolas, 309
Landelle, Charles, 87–88
Landscape: The Hidden Brook, 478
Landscape near Mézières, 526
Landscapes (landscape artists), xxvi, 25–28, 45, 114, 117, 135–36, 148–49, 156, 198, 202–8, 219, 226–28, 232, 237–40, 243–44, 252, 261–62, 268, 281, 330–33, 335, 340–42, 388–89, 409, 419–22 ff., 428, 430, 432, 433, 441, 498, 524, 525, 526, 531, 536, 562; (*see also* specific artists, exhibitions, works); Japanese, 372; photography and, 243–44, 261–62
Landseer (English painter), 138–39
Lanfredini, Alessandro, 325
Langhans, Karl G., 177
Lantara, S. M., 28, 86
Lapostelet, Charles, 430
Laqueville, Marquis, 383
Larsson (Swedish painter), 186–89
Lasteyiu, Ferdinand de, 5
Last Honors Paid to the Counts of Egmont and Horn, 88–89, 536, 537
Last Judgment, 448
Last Roll Call of the Victims of the Terror, 5, 16
Laube, Heinrich, 509–10

Laurent, Marie L., 261
Lawrence, Thomas, 171
Lebas, Hippolyte, 87 n
Lebrun, Charles, 272, 309
Ledru-Rollin (French Socialist), 3
Lefuel, Hector M., 109
Lega, Silvestro, 300, 340, 345, 349, 351–52, 353
Legend of the Van Eyck Brothers, The, 93
Légion d'honneur, 3, 78, 117, 121, 196, 197, 265, 381, 455, 456, 459, 460, 481–82, 484
Le Gray, Gustave, 250 n, 256
Lehmann (German painter), 522
Lehmann, Henri, 112, 128
Leibl, Wilhelm, 495, 496, 499
Leighton, Frederick, 105–7
Leighton, John, 363–77; *On Japanese Art . . .* by, 364–77
Leipziger Illustrierte Zeitung, 185
Lemmonier, Camille, 539
Lemond (French lithographer), 93
Le Nain brothers, 115
Lenbach, Franz von, 496, 504, 530, 550
Leo X, Pope, 327
Leonardo da Vinci, 16, 20, 315, 488
Leopold I, King (Belgium), 533–34, 535
Leopold II, King (Belgium), 535
Lepke, N., art gallery of, 182
Lepoittevin, Eugène, 4
Leroy, Jules, 430–31
Lessing, Gotthold Ephraim, 186, 223
Lessing, Karl, 219, 503
Le Sueur, E., 20, 21
Letters Concerning Modern Art in France at the Paris Exhibition (Eitelberger von Edelberg), 118–31, 548–49
Leutze, Emanuel, 234
Leveque, Charles, 198
Leys, Hendrik, 140, 142, 483, 484, 527, 536, 556
Library of the Jesuit College in Rome, 512
Light of the World, The, 100
Limner, Luke (pseud.), 363. *See also* Leighton, John
Lind, Jenny, 178–79
Lindenschmit, W., 511
Lions, 386
Liszt, Franz, 220

Literary Gazette, 254, 256
Lithography (lithographers), v, xxviii, 89, 92. *See also* specific developments, exhibitions, kinds, people, places, works
Lodging Bill, The, 438–39
Lohengrin, 528
Lombardy, xxix
London, xxviii, 30–48, 49–74, 97–107, 241–44, 246–56, 379–80, 572–76; International Exhibition (1862), 355–77; photography exhibition (1859), 241 ff.; Royal Academy of Art Exhibition (1850), 30–48; Royal Academy of Art Exhibition (1855), 97–107; Works of Industry of All Nations Exhibition (1857), 49–74
London *Times,* 32, 98 n, 100, 248–49, 251, 255
Long Live the Emperor!, 245–46
Longperier, de (Louvre curator of antiquities, art juror), 83, 112
Lost Hopes, 352–54
Lottery ticket sale, early exhibitions and, xxvii
Louis XIV, 395
Louis Napoléon Bonaparte. *See* Napoléon III, Emperor
Louis of Orléans, 567
Louis-Philippe, King (France), 76, 77; abdication of, 2
Louvre, the, 2, 3, 4, 5, 76, 109, 125, 168, 170, 196; Musée Napoléon, 109; Pavillon de Flore, 476
Low Countries, 173, 530, 562. *See also* specific countries, developments, exhibitions, people, places, works
Ludwig I, King (Bavaria), 53, 214, 215, 216, 217, 220, 222
Ludwig II, King (Bavaria), 493–94, 497, 507
Luebke, Wilhelm, 181, 500, 501
"Luigi" (pseud. of Giuseppe Rigutini?), 335–36, 343–46
Lumière, La (periodical), 245
Lustig (Vienna art collector), 496
Luther, Martin, 182
Lützow, Karl von, 500–1; on the International Art Exhibition in Munich (1869), 501–19, 520
Lux, Adam de, 285
Luxembourg Museum, 552

Mabuse, Jan, 171
Macaire, Robert, 260
Macareno of Granada, 526
Macbeth (Koch), 227
Macbeth (Müller), 16
Macchiaioli (Italian school of artists), 300, 335–36, 343 ff., 434–35, 440–41, 446–53, 485
"Macchiaioli": The First Europeans in Tuscany—Italian Painting of the Nineteenth Century, The, 343 n, 346 n
Machines (machinery), xxiii–xxiv, 51. *See also* Industrial arts exhibitions
Maclise, Daniel, 36, 37, 44 n, 46, 102–3, 138
Macready, William, 36
Madame Bovary (Flaubert), 197–98
Mademoiselle de Maupin (Gautier), 270
Madonna (Cimabue), 313
Madonna (Schulkowsky), 498
Magasin Pittoresque, 335
Magdalen in the Desert, 566
Magni (Italian painter), 328–29
Magnus, Eduard, 180
Maindron (French sculptor), 24
Maison, Marquis, 83, 112
Majo (Belle), 427
Makart, Hans, 530–31, 548, 557–58
Malaria, 14, 211
Malatesta, Adeodato, 306, 307
Manchester, England, xxix, 164–76, 219–20; International Historical Exhibition (1857), 164–76, 219–20
Man Choosing a Sword, 89–90
Manet, Édouard, xxviii, 291, 381–82, 388, 427–28, 431, 457, 458, 459, 461, 466, 478, 482–83, 525, 534; Place de l'Alma private exhibition of (1867), 482–83, 491–92; *Preface, Catalog of Paintings . . . by,* 491–92; Zola on, 469–75
Manna, 25
Mannerists, 6
Manners, John, 36
Mantz, Paul, 6, 168, 382, 460–62
Man with a Hoe, 412–13
Man with a Pipe, 13, 208
Marées, Hans von, 496, 499
Margantin (French landscape artist), 261
Maria Stuart, 510

Marina, 254
Marko, Andrea, 342
Marko, Carlo, 342
Marriage at Cana, 431
Martelli, Diego, 336, 484–85
Martin, T., 50 n
Martinet, Louis, Paris gallery of, xxviii, 379–82, 384, 385
Martyrdom of St. Andrew, 387
Martyrdom of St. Symphorian, The, 142, 210, 508
Martyr's Triumph, The, 402
Marx, Karl, 100
Mary Magdalene, 149
Mass, Recollection of Salzburg, 189–90
Massacre, 24
Massacre at Chios, 8, 153
Massacre of the Cignoli Family, The, 307
Master Wolframb, 93
Matas, N., 303 n
Matejko (Polish painter), 559
Materials for a History of Oil Painting (Eastlake), 34
Mathilde Bonaparte, Princess, 3, 77–78, 382, 459, 479
Maurice, F. D., 100
Max, Emmanuel, 548
Max, Gabriel von, 496, 530
Maximilian, Prince (Mexico), execution of, 485
Maximilian II, King (Bavaria), 215, 216, 217, 493, 495, 496, 505
Mayall, J. E., 242
Mayer (photographer), 248
Mazzini, Giuseppe, 300, 433
Mechanical arts, xxiii–xxiv, 51. *See also* Industrial arts exhibitions; specific exhibitions, kinds, people, places
Medusa, 152
Meeting of Frederick the Great and Joseph II, 219
Meissonier, Jean Louis Ernest, 4, 78, 89–90, 291, 405, 482, 484, 512, 513, 523, 524, 525, 552
Meisterwerke der Kirchenbaukunst, Die (Lützow), 500
Ménard, René Joseph, 554
Mendelssohn, Felix, 178
Mengs, Carstens contrasted to, 232
Menzel, Adolf von, 180–81, 182,

183, 184, 185–86, 189–92, 219, 222, 234, 481, 503
Mercey, Duc de, 5, 83, 112
Mercié (French sculptor), 565–66
Mérimée, Prosper, 78, 83, 166–67
Merino, Ignacio, 136
Merrifield, Mary P. W., 55–57, 58
Merz, H., 507
Messager de l'Assemblée, 7
Meunier, Constantin, 537
Mexico and the Mexicans, 119
Meyer, Julius, 523 n
Meyerbeer, Giacomo, 178–79
Meyerheim, P., 511
Michelangelo (Buonarotti), 23, 149, 155, 156–57, 173, 282, 289, 290, 327, 447, 448, 488
Michelet, Jules, 215, 285
Milan, Italy, xxix, 128, 129, 300, 301, 381
Millais, Sir John Everett, 32–33, 34–35, 44, 47, 48, 98, 104–5
Millet, Jean-François, 19–20, 81, 204–5, 291–93, 380, 406 n, 412–13, 538
Milon de Crotone, 149
Minerva, 149
Minton (H.) and Company, 68
Mirror of Art, The (Baudelaire), 272 n
Misérables, Les (Hugo), 534
Modern Amoretti, 548
Modern Painters (Ruskin), 99, 357
Modesty, 518
Moncaut, Cenac, 301
Mondo Illustrato: Giornale Universale, Il, 335, 337 n, 342
Moniteur Universel, Le, 4, 7, 113, 271, 301, 382–83, 424, 455, 460
Monnier, Henri B., 84
Mon Salon ("My Salon," Zola), 456–57, 463–75
Montecchi (photographer), 251, 257, 259
Monteverde (Italian sculptor), 563–64
"Moonlights," 427
Morel, Jean, 266
Morelli, Domenico, 298–99, 300, 302, 305–6, 307, 317, 318, 319, 324, 325, 330, 345–46, 433, 434, 435, 442–43
Morgenstern, Christian, 219, 495
Morning Chronicle, 253
Morny, Duc de, 75, 77, 83, 112

Morris, Marshall, Faulkner & Company, 358
Morris, William, 100, 358, 360, 362
Moses (Michelangelo), 149, 282
Mouilleron (French lithographer), 4, 83
Mountain, The, 27
Mouth of a River, 389
Müller, Charles, 3, 5, 15–17, 197, 245–46
Müller, Viktor, 504, 530
Mulreadys, the (English painters), 138
Munich, xxiii, xxvi, xxix, 214–40, 381, 493–532; architecture, 214–15; Exhibition of 1858, 214–40; Exhibition of 1869, 493–532; Glaspalast, 216, 217, 219, 493–532; Glyptothek, 214, 216, 493–532; Königsplatz, 214; Ludwigstrasse, 214; Maximilianstrasse, 215; National Historical Exhibition (1858), 214–40
Munkácsy, M., 559
Munthe (Norwegian painter), 560
Müntz, Eugène, 499, 520–32; on the International Art Exhibition (Munich, 1869), 520–32
Murger, Henri, 81, 115, 116, 267
Murillo, 84, 282, 527
Murillo Seeking the Subject for a Painting, 527
Musée Napoléon (Louvre), 109
Musée Royal de Madrid, Le (Clément de Ris), 81
Musées de Province, Les (Clément de Ris), 81
Museo de Famiglia—Rivista Illustrate (periodical), 300–1, 302 n
Museum (German periodical), 184
Musset, Alfred de, 81, 195, 401
Mussini, Luigi, 298, 311–12
Myslbek, Josef, 548

Nadar (pseud. of Felix Tournachon), 80, 248, 260–61, 268, 269
Nanteuil (French lithographer), 93
Naples, 297, 298–99, 300, 432–53; Società Promotrice exhibition (1864–67), 432–53
Napoléon, Prince ("Plon-Plon"), 478, 479
Napoléon I (Napoléon Bonaparte), 1, 177, 195, 536; column (Paris), 535; statue, 78

Napoléon III, Emperor (Louis Napoléon Bonaparte), xxiv, 3, 75, 76–77, 108, 109, 117, 166, 180, 266, 297, 398, 418, 424–25, 455, 476–79, 485, 534, 535
Napoléon Le Petit (Hugo), 534
Napoli Artistica (publication), 434, 436 n
Narcissus, 565
National Gallery (London), 31 ff., 97–107
National Museums (France), 77–78
Nations Rivales dans l'Art . . . , Les, 485
Naturalists (naturalism), 14, 20–21, 23–24, 152, 393–95, 406–9, 513. *See also* specific aspects, developments, exhibitions, people, places, works
Nazarenes (Brotherhood of St. Luke), 33–34, 35, 53, 180, 215–16, 219, 225 n, 298
Neapolitan Fisherman, 568
Negretti (landscape artist), 252
Nelson, Lord, statue of, 30
Nemours, Duc de, 379
Neophyte, 526
Nero, 554, 569
Netherlands (Holland, the Dutch), 111, 113, 119, 151 ff., 173, 219, 365, 484, 488, 495, 496, 498, 511, 521, 526, 527, 528, 533, 536, 551, 556. *See also* specific people, places, works
Netti, Francesco, 434, 436–44
Neufchâteau, François de, 109
New History of Italian Painting, A, 166
Newlyweds, The, 351–52
New Tendencies in Art (Thoré), 117, 118, 144–57, 197
Niebuhr, Barthold, 180
Niepce, Joseph, 262
Niepce de Saint-Victor, 262–63
Nieuwerkerke, Comte Alfred Emilien de, 3, 4, 5, 77–79, 112, 197, 382, 383, 454–55, 456, 460, 478
Night Side of Nature, The (Crowe), 277
Night Watch, The (*Nachtwacht, Night Guard*), 152
Nord, Le (Belgian publication), 383, 390 n, 535
Nordic Pine Forest, 189

Norway and the Norwegians, 111, 551, 556, 560
Notes on Some of the Principal Pictures Exhibited in the Rooms of the Royal Academy (Ruskin), 98–107
Nouvelles Histoires Extraordinaires (Baudelaire), 268
Nouvelles Tendances de l'Art, Les (Thoré), 117, 118, 144–57, 197
Nouvelle Théorie Simplifiée de la Perspective (Sutter), 428
Nubian Water-Carrier, The, 251–52
Nuova Antologia (publication), 555
Nuova Europa, La (publication), 335, 336, 343 n, 346 n
Nuova Società Promotrice, La, 336
Nymph Abducted by a Faun, A, 284
Nymph and Fauns, 504, 526–27
Nymphs Coming to Touch the Lute of a Sleeping Singer, The, 531

Oath of Horatio, 396
Oath of the Saxons to Napoléon After the Battle of Jena, The, 311
Objets d'art, xxix, xxx. *See also* specific exhibitions, kinds, people, places, works
Odyssey, landscape illustrations for, 218, 227
Oeuvre Complet de Rembrandt, L' (Blanc), 168
Offenbach, Jacques, 530
Old Lamps for New Ones (Dickens), 38–43
Olivier (landscape artist), 227
Olympia, 469, 470, 473, 483
Olympic Games, xxiv
One-man (and one-picture) shows, xxviii. *See also* specific exhibitions, galleries, people, places, works
On Japanese Art: A Discourse Delivered at the Royal Institution of Great Britain (Leighton), 364–77
On Realism, Letter to Madame Sand (Champfleury), 157–63
"On the Nature of Gothic" (Ruskin), 100, 358
Ophelia, 24
Orchardson, William Q., 560
Ordre, L' (publication), 116
Orestes, 402
Organization of Work (Blanc), 167
Original Treatises, The, 55

Orléans, Duchesse d', 379
Orsel, André-Jacques-Victor, 88, 508
Otto, King (Greece), 214
Overbeck, Johann Friedrich, 33, 119, 130, 218, 298, 503, 528, 558
Oxen On Their Way to Work, 136
Oxford Movement, 32

Pagliano, Elentino, 306, 307, 318
Painter, The, 291
Painting at the Exposition of 1855 (Goncourt), 131–57
Palais de l'Exposition, Le, 113
Palais de l'Industrie, 108–63, 196–97, 265–66. *See also* Palais des Champs-Élysées
Palais des Beaux-Arts, 109–63, 197
Palais des Champs-Élysées, 256–64, 265–95, 382, 383, 384–431, 454–75, 476–92. *See also* Palais de l'Industrie
Palais National, 4, 6
Palais Royal, 3–4, 9–29, 77, 79–96
Palazzo dell'Espositione Italiana, 296–333
Palizzi, Filippo, 299, 300, 432, 433, 434, 435, 447–48, 451
Palizzi, Francesco, 299, 300, 433
Palizzi, Giuseppe, 299, 300, 433
Palmerston, Lord, 248
Panthéon Nadar, 260–61
Papal States, 111
Paradise Lost (Cabanel), 505, 524
Paris, xxiii, xxiv, xxvi, xxviii, 1–29, 51, 75–96, 108–63, 195–213, 244–46, 256–64, 265–95, 378–431, 454–75, 476–92, 534, 546, 548–49 (*see also* Salon, Paris); reconstruction of, 195–96
Paris (periodical), 80
Paris, Comte de, 379
Paris, Treaty of, 195
Paris Commune, 535
Passavant, J. D., 184
Pasture, 86
Patria, La (newspaper), 434, 435, 444 n
Patrie en Danger, La (*The Country in Danger*), xxiii
Patrons, art, xxvi–xxvii. *See also* specific aspects, exhibitions, people, places, works
Paul et Virginie (Bernardin de Saint-Pierre), 205 n

Paxton, Joseph, 54, 109
Pays, Le (publication), 267
Peace and War, 403
Pearl and the Wave, A Persian Fable, The, 400-1, 419
Pecht, August Friedrich, 220, 223
Pecht, Franz, 501
Peel, Lady, 30
Peel, Sir Robert, 30
Peinture Française au XIX⁰ Siècle, La (Chesneau), 328
Pensieri sulla Architettura Civile e Religiosa (Selvatico), 301
Périn, Alphonse, 508
Permanent Exhibition of Paintings, Sachse Gallery, 186-94
Perotti, E., 332
Perrier, Charles, 116
Perry, Commodore, 359
Persecution of the Jews, 510
Persigny, Duc de, 77
Peru and the Peruvians, 111, 119, 136
Perugino, 34, 35
Petit, Pierre, xxviii, 496
Petitot (French sculptor), 4-5, 172
Petroz, Pierre, 6
Pettenkofen, August von, 193-94, 511, 512
Pettie, John, 560
Phidias, 72, 155, 157
Philosopher, 525
Philosophie des Beaux-Arts (Sutter), 428
Philosophie du Salon de 1857 (Castagnary), 199-213
Philosophy of Art (Hegel), 449 n
Philosophy of Progress (Proudhon), 162
Photographic Society of London: Exhibition of 1859, 241-44, 246-56; *Journal* of, 242, 243, 244, 246, 249 n
Photography (photographers), v, xvii, xviii, xxix, xxx, 241 ff., 243, 254, 259, 260-61 ff., 269, 274-77. See *also* specific developments, exhibitions, people, places, works
Picot, F. E., 4, 5, 83, 87 n, 112
Pierson (English photographer), 248
Pietà (Clésinger), 23
Piloty, Karl, 219, 234, 235, 495-96, 498-99, 510, 548, 551, 558-59
Pisano, Niccolò, 518

Pissarro, Camille, 428, 458
Planche, Gustave, 130
Poe, Edgar Allan, 268, 269
Poems before Congress (Browning), 301
Poetry, 519
Poland, 559
Pollastrini, Enrico, 312
Pollet (French sculptor), 22
Pollock, Sir F., 242
Polychromatic Ornament of Italy, The (Jones), 54-55
Pompadour, Mme. de, 151
Pompeian Bath, The, 305-6, 319
Ponticelli, Giovanni, 440-41
Portefeuille, Le (publication), 267
Portfolio, The (magazine), 553
Portrait of a Man, 85, 96
Portrait of an Aged Man, 525
Portrait of a Woman, 235
Portrait of M. Pourtalès, 88
Portrait of the Empress Holding the Imperial Prince, 197
Portrait of Zola, 461-62, 473-75
Portraits à la Plume (Clément de Ris), 81
Portraiture (portraits, portraitists), xxviii, 70-71, 135, 141, 198, 208-10, 243, 254, 259, 260-61, 498, 519, 550-51. See *also* specific developments, exhibitions, people, places, works
Portugal, 551, 553
Poulet-Malassis, Pierre, 534
Pouncy (inventor of a carbon printing process), 255
Poussin (bust), 24-25
Poussin, N., 20, 21, 24, 25, 139, 151
Powers, Hiram, 56, 298, 304, 328, 329
Pradier, Charles S., 22, 149, 212
Prati, Giovanni, 319
Pratsch (photoengraver), 255
Preaching of the Hussite, 219
Préault, Antoine, 3, 24-25, 273, 380, 389
Preller, Friedrich (son), 218
Preller, Friedrich J. (father), 218, 227
Premier Grand Prix de Rome, 121
Pre-Raphaelites (Pre-Raphaelitism), 32-33, 35, 36, 37-43, 44-48, 99-100, 103 ff. See *also* specific de-

velopments, exhibitions, people, places, works
Pre-Raphaelitism (Ruskin), 100
Présent, Le, 198, 199
Presse, La (publication), 6, 78, 220, 271
Priestess in the Forest, 505
Primavera, 344
Principles of Harmony and Contrast of Colours, The, 55
Prints, v, xxx. *See also* Photography; specific developments, exhibitions, kinds, people, places, works
Private exhibitions, development of, xxviii. *See also* specific aspects, developments, exhibitions, galleries, people, places, works
Prix de Rome competition, xxv, xxvi, 8–9
Properties of Jean de Paris, The, 428
Proudhon, Pierre-Joseph, 115, 162, 198, 206, 336, 457, 534; *Du Principe de l'Art et sa Destination Sociale* by, 336
Provenzano Salvani Collecting Ransom for an Imprisoned Friend, 556
Prudhomme, Joseph, 541
Prussia and the Prussians, 111, 119, 177–94, 217, 467–77, 484, 493, 522, 535. *See also* specific exhibitions, people, places, works
Psyche, 149
Pugin, Augustus Welby, 42, 50, 358
Pujet (sculptor), *Andromache* by, 149
Pujol. *See* Abel de Pujol, Alexandre D.
Pulcinelli (Italian painter), 342 n
Punch (magazine), 36
Purismo school, 298–300
Puvis de Chavannes, Pierre, 248, 287–88, 403–4

Quadriga of Victory, 177
Quatremère de Quincy, Antoine, 8

Rachel and Jacob (*Jacob and Rachel*), 33, 46–47
Raft of the Medusa, 386
Raguet (sculptor), *Republic* by, 23
Rahl, Karl, 503, 548
Rainer, Archduke, 546, 551
Raising of Jairus' Young Daughter from the Dead, The, 234–35

Ramberg, Arthur, 494–95, 504
Ranke, Leopold von, 215
Raphael [Sanzio], 16, 20, 34, 38–39, 72, 132, 148, 155, 156–57, 173, 244, 251, 262, 282, 287 n, 311, 322, 327, 396, 488, 570
Rapisardi, M., 342 n
Rauch, Christian Daniel, 178, 179, 519
Ravené gallery (Berlin), 496, 525
Ray of Hope After the Storm, A, 350
Reach, Angus B., 32
Real Allegory, 160
Realism (realists), 114–16, 152, 157–63, 198 ff., 219, 221, 231–34, 268, 281, 283, 288, 292, 406 n, 422, 431, 457, 458–59, 468, 495, 496, 499, 503–4, 510, 525, 526, 537, 539, 541, 571–72 (*see also* specific developments, exhibitions, people, places, works); in photography, 243, 244
Réalisme, Le (Champfleury), 157 n
Réalisme, Le (publication), 458
Real Museo Borbonico, Garibaldi's proclamation of, 432
Rebecca, 25
Reconciliation of the Confessors, 551
Redgrave, Richard, 54, 57, 103–4
Refusés, Salon des, 378, 381–90, 424–31, 454–55, 456, 458, 460, 466
Regent Street Exhibition (London), 47–48
Regional federations, xxvii
Regnault (French painter), 256
Reiset, de (Louvre curator), 83, 112
Rejlander, Oscar, 244, 253
Religious (sacred) art, 134–35, 321–27, 398–400, 402, 517–18, 566. *See also* specific aspects, developments, exhibitions, people, places, works
Rembrandt, 20, 46, 151–52, 231, 318, 488
Remiradsky (Russian painter), 559
Renan, Joseph Ernest, 78
Rennefeld (Dutch painter), 511
Republic (Bosio), 23
Republic (Raguet), 23
Republic (Soitoux), 22–23
Rescue, The, 104–5
Rethel, Alfred, 218
Return from the Ball, 388

Return from the Conference, The, 409–12

Return from the Fields, The, 402

Return from the Hunt, 287

Return from the Market, 13

Return of a Platoon of Italian Bersaglieri . . . , The, 340

Revolution(s), xxiii, xxv, 1–3, 75–77, 146. *See also* specific aspects, countries, developments, events, people, places

Revue Comique du Salon de 1851 (publication), 6

Revue des Deux Mondes (publication), xxix, 130, 167, 198

Revue du XIXᵉ Siècle (periodical), 483

Revue du Progrès (publication), 167

Revue Française, La (periodical), 266, 269–70, 272 n

Revue Républicaine, La (publication), 117

Reynolds, Sir Joshua, 171

Rezension u. Mitteilungen über bildendende Kunst (periodical), 500–1

Ribera, Giuseppe, 150, 433

Ribot, A. T., 388, 524, 525

Ricard (French painter), 273

Richter, Gustav, 180–81, 222, 234–35

Riders, 152

Ride to the Grave of Rudolf von Habsburg, The, 236

Riefstahl (German painter), 511

Rienzi, 32–33

Rietschel, statues by, 119, 126

Rigutini, Giuseppe, 335–36, 343–46

Rival Nations in Art: On the Influence of the International Expositions on the Future of Art, The (Chesneau), 485, 486–90

Riviere, William, 560

Road Going to the Observation Point, The, 428

Robert, Léopold, 152

Robert-Fleury, H., 510

Robert-Fleury, Joseph N., 4, 112, 197, 248, 510

Robinson (English photographer), 253

Rochette, Raoul, 83

Rock at Oragnen, The, 289

Rococo painters, 224–25. *See also* specific developments, exhibitions, people, places, works

Roman Beach, The, 341

Romanticism (Romanticists), 153–54, 219, 224, 226, 298–99, 393–95, 404–6, 409, 495, 536. *See also* specific aspects, developments, exhibitions, people, places, works

Ronde de Nuit, La, 152

Roos, Philipp Peter, 173

Rops, Félicien, 534, 537

Roqueplan, Camille J. E., 212

Rosa, Salvator, 21, 433

Rosa di Tivoli, 173

Rose and Silver: La Princesse du Pays de Porcelaine, 362

Rossetti, Dante Gabriel, 32, 47–48, 100, 358, 360, 361–62

Rossetti, William Michael, 32, 360–62

Rossi (Italian painter), 324

Rossini, G. A., 161

Rottmann, Karl, 219, 495

Rouher (French Minister of State, 1867), 479

Rousseau, Jean-Jacques, 84

Rousseau, Philippe, 83, 524

Rousseau, Théodore, xxvi, 3, 4, 25–27, 86, 90, 95, 112, 117, 136, 202–4, 261, 299, 380, 409, 428, 482, 484, 523

Rout of the Austrians from the Village of Solferino, The, 340

Rouvière, Philibert, 158

Rowlandson, Thomas, 37

Royal Academy of Art, British, xxvii, 30–48, 51–52, 97–107, 243, 380, 415, 416, 417, 418–19 (*see also* specific developments, exhibitions, people, places, works); exhibition (1850), 30–48; exhibition (1855), 97–107; Select Committee (1835), 52

Royal Commission on the Fine Arts (England), 53–54

Royal Gazette, 31

Royal Prussian Academy, 180

Royal Society for the Encouragement of the Fine Arts (Belgium), 537, 538–39

Royal Society of Arts (England), 355–56, 358, 363, 364

Rubens, Peter Paul, 20, 143, 150, 160, 227, 279, 282, 318, 488, 536

Rude, François, 4, 83, 91–92, 112, 196, 212
Runge, Philipp Otto, 219, 224, 226
Ruskin, John, 98–107, 357–58, 362, 415 n
Ruskin, Mrs. John (Effie), 98, 99
Russell, John Scott, 547
Russia and the Russians, 498, 551, 556, 559
Ruysdael, 488

Sabatelli, Luigi (the elder), 311
Sabines, 386
Sachse, Max, xxviii, 181–82, 186–94
Sad Foreboding, 438–39
Saint-Beuve, Charles-Augustin, 78, 382
Saint Cecilia, 24
Saint-François (French painter), 389
St. George and the Dragon, 111
Saint-Saëns, Charles-Camille, 78
Saint-Victor, Paul de, 260
Salon, Paris, exhibitions and, xxiii, xxv–xxvi, 1–29, 245, 378–431, 454–75, 476–92, 553; (1849), 2–3; (1850–51), 1–29; (1852), 75–96; (1857), 195–213; (1859–61), 265–95; (1863), 381–84, 390–424; (1866–68), 454–75, 476–92; Exposition Universelle, 108–63, 476–92; Martinet Gallery, 379–82, 384, 385; Salon des Refusés, 378, 381–90, 424–31, 454–55, 456, 458, 460, 466
Salon, The (Clément de Ris), 94–96
Salon des Refusés, 378, 381–90, 424–31, 454–55, 456, 458, 460, 466
Salon of 1852 (Goncourt), 82–93
Salons de T. Thoré . . . , 145 n
Saltimbanques, 526
Salvator (painter), 150
Sanctis, Francesco de, 299, 324
Sand, George, 84, 116, 167
Sanzi, Luigi, 85
Sardinia, 297, 433
Scandinavia (Scandinavians), 219. See also specific exhibitions, people, places, works
Scene from Shakespeare's Twelfth Night, 48
Scene of a Fire, The, 18–19
Schack, Count Adolf, 496
Schack Gallery, 526, 531
Schadow, Friedrich, 184

Schadow, Johann G., 177, 179, 180, 230
Schasler, Max, 185, 186–94
Scheffer, Ary, 4, 133, 211, 235, 298, 379
Schick, K. F., 230, 231
Schiller, Johann-Christoph Friedrich von, 223
Schinkel, K. F., 180
Schirmer (German painter), 227, 239
Schleich, Eduard, 239, 494–95, 496
Schmidt, Friedrich, 548
Schnasse, and Das Deutsche Kunstblatt, 184
Schnornsche Kunstblatt (publication), xxix
Schnorr von Carolsfeld, Julius, 495, 503, 558
Schoelcher, Victor, 534
Schongauer, Martin, 173
Schönn (German painter), 512
School of Design (England), 52–53, 54
Schorn, Ludwig von, 184
Schrader (German painter), 186
Schreyer, Adolf, 522
Schulkowsky (Russian painter), 498
Schwarz-Senborn, Baron Wilhelm von, 546
Schwind, Moritz von, 183, 184, 218, 222, 235–37, 503
Science, 50 ff., 70 ff. See also Industrial arts exhibitions; specific aspects, developments, exhibitions, people, places
Science, Industry, and Art (Semper), 58, 59–74
"Science du Beau, La" (Leveque), 198
Sculpture (sculptors), xxiv–xxv, xxvi, xxvii, xxix, 8, 10–14, 21–25, 33, 111, 125–31, 149, 224, 294–95, 462, 514–19, 551–52, 553, 562–69, 573. See also specific aspects, developments, exhibitions, people, places, works
"Scuola di Posilippo," 433–34
Sechan, Charles, 3, 5, 168
Seeman, E. A., xxx, 500, 501
Seitz, Anton, 511–12
Selvatico, Pietro, 301, 308–27, 554; The State of Contemporary Historical and Sacred Painting in Italy as Noted in the National Exposi-

tion in Florence in 1861 by, 308-27

Semper, Gottfried, 57-58, 59-74, 494, 548

Senefelder, Aloys, 92, 182

Seni before Wallenstein's Corpse, 219, 496, 510

Seris, Claire-Joseph Hippolyte, 83

Seven Lamps of Architecture (Ruskin), 79, 357-58

Sèvres porcelains, 109, 168

Shakespeare, William, 16, 42, 48, 102-3, 158, 161, 189, 405, 507, 518, 543, 560

Shee, Sir Martin Archer, 33, 52

Sheep Shearer, A, 292

Shepherd, 27

Shepherdess, 412

Shipley, William, 51

Shipwreck at the Bohus Country Coast of Sweden, 186-89

Shipwreck of Don Juan, 211

Shipwreck Survivor, 304

Sicily, 297, 432-33

Siècle, Le (publication), 118, 167

Siege of Rome, The Taking of Bastion No. 8, 79, 86-87

Signorelli, Luca, 35

Signorini, Telemaco, 300, 331, 335, 336-37, 340, 345, 346-54, 435

Silvy, Camille, 242, 269

Simart, P. C., 149

Simonetti, A., 350

Singers, The, 388

Singers at the Wartburg, 236

Sketches, xxvi, 26, 197, 452. *See also* Cartoons; specific developments, exhibitions, kinds, people, places, works

Sketch for the Decoration of a Hall, 531

Skidmore's Art Manufactures Company, 359

Società d'Incorraggiamento, xxvii, 336-37, 349-54

Società Promotrice di Belle Arti, xxvii, xxix, 336, 337-49, 432-53; exhibition (Florence, 1861-67), 334-35, 336, 337-49, 432-53

Société Française de Photographie, 245, 247, 256

Société Héliographique, 244-45

Société Libre des Beaux-Arts (Brussels), 537-44

Société National des Beaux-Arts, 380

Society for the Encouragement of Arts and Manufactures (England), xxiv, 51, 53, 54

Society of British Artists, xxvii, 415

Socrates, 328

Soitoux, Jean-François, 22-23, 482

Solari, Philippe, 462

Soldier as a Wet Nurse, 514

Soll und Haben (Freytag), 221

Sower, The, 19-20, 81

Spain and the Spanish, xxiii, 111, 119, 136, 488, 511, 551, 553, 559-60. *See also* specific people, places, works

Spanish Guitar Player, 461. *See also Guitarrero, Le*

Spanish Singer, 491 n, 525

Spartacus, 149

Spectator, The (London), 32, 35

Spettatore (publication), 554

Spring, 518

Spring (Vela), 329

Springer, Anton, 166, 221-40; on *The All-German Historical Exhibition* (Munich, 1858), 223-40

Stag in Water, The, 289

Stanfield, Clarkson, 97-98

Statues, xxiii, xxv, xxviii, xxix, 22-25, 71, 566 (*see also* Sculpture; specific developments, exhibitions, people, places, works); revolutions of 1848 and, xxiii

Steinle, E., 507

Stendhal (Marie-Henri Beyle), 161, 267, 408

Stephens, Frederick, 32

Stevens (Belgian painter), 139, 483-84

Stevens, Alfred, 534, 560

Stevens, Arthur, 534, 537

Stevens, Joseph, 534

Stewart, John, 301, 327-33; *The Exhibition at Florence* (1861) by, 327-33

Stone (English painter), 560

Stone, Frank, 32, 35-36, 37

Stone Breakers, The, 4, 13, 206, 207, 499, 500, 526, 537

Stones of Venice, The (Ruskin), 99, 100, 358; "On the Nature of Gothic," 100, 358

Stop in the Desert, A, 389

Storia Estetico Critica delle Arti del Disegno (Selvatico), 301
Strack, Johann H., 179
Strayed Sheep, 420
Street, George, 358
Study from Nature, 341
Study of an Elm, 261
Süddeutsche Zeitung (Munich paper), 220
Summerly, Felix (Henry Cole), 53–54, 57, 356, 357, 481
Summerly's Art Manufactures, 54
Sunset, 27
Surprise at the Ambulance, A, 339
Sutter, David, 428
Sweden, 111, 136, 498, 551, 556. *See also* specific exhibitions, people, works
Swerts, Jan, 508
Swiss View, 252
Switzerland, 111, 484, 520, 526, 556, 562
Sydenham Palace (London, England), 367
Sylphide, La (magazine), 456
Système de Contradictions Économiques (Proudhon), 198

Taine, Hippolyte, 78, 198, 337, 458
Taking of Bastion No. 8, The, 79, 86–87
Talbot, William Henry Fox, 62 n, 242, 255, 262 n
Tari, Antonio, 449–50
Tassaert (French painter), 388
Tasso, Torquato, 440, 442
Technology, 63. *See also* Industrial arts exhibitions; specific developments, exhibitions, people, places
Tedesco, Michele, 441
Temistocle (Italian painter), 332
Temptation of St. Anthony, 186
Théâtre Lyrique, 196
Theory of Color (Goethe), 34
Thérèse Raquin (Zola), 462
Thierry, Augustin, 143
Thiers, Louis-Adolphe, 1–2, 76, 535
Thomas, John, 359
Thompson, Thurston, 244, 251
Thoré, Theophile (William Bürger), 117–18, 144–57, 167, 168, 197, 337, 534, 538
Thusnelda in the Triumphant Procession of Germanicus, 551, 558–59

Tidemand, Adolph, 219, 560
Tieck, Ludwig, 236 n
Tilgner, Victor O., 548
Tilly, Johan Tserclaes, Count of, 233
Times, The (London), 32, 98 n, 100, 248–49, 251, 255
Tintoretto, Jacopo Robusti, 99
Tischbein (German painter), 234
Titian (Venetian painter), 39, 104, 148, 488
Torquato Tasso in Company of Sciarra Colonna, 440
Tournament Among the Children of Clotilda, The, 511
Toussaint (French sculptor), 4
Transport of the Wounded, 194
Treasures of Art at Manchester (Blanc), 168–76
Treasures of Art in Great Britain (Waagen), 165
Treatise on Painting, A (Cennini), 55
Trees and Rocks, 389
Trésors d'Art de la Russie Ancienne et Moderne (Gautier), 271
Trésors de l'Art à Manchester (Blanc), 168–76
Triumph of Germanicus, 551, 558–59
Troyon, Constant, 112, 136, 248, 273, 299, 409, 422, 455, 496
"True and False in Decorative Arts" (Jones), 357
Tuileries, 2–3, 109, 196
Tumbler, 566
Turin, Italy, 381
Turkey, 546, 550, 551
Turner, J. M. W., xxvii, 34, 45–46, 99, 331, 332–33, 420 n, 421
Turpin de Crisse, H. L. R. de, 83, 112
Tuscany, 111, 435
Two Paths, The (Ruskin), 358
"Two Ways of Life, The," 244
Tyrolean People's Army, 230, 234

Unger, W., 512
Union, L' (publication), 113
United States (American artists), 111, 498, 551, 553, 556. *See also* specific exhibitions, people, places, works
Urquhart, David, 100
Ussi, Stefano, 298, 302, 305, 306,

307, 311–12, 317, 324, 325, 330, 337, 484, 485
Ustazade de Sacy, Samuel, 78

Vaillant, Marshal, 454, 459–60
Valenciennes, P.-H., 273 n
Valentin, Francis, 150
Valerio, T., 388
Van Camp, Charles, 537
Van Dyck, portraits by, 171, 172
Van Pitloo, Antonio, 433
Varcollier (art jurist, Paris, 1852), 83
Varnhagen von Ense, Karl A., 179
Vasari's Lives, 298, 323
Vautier, M. L. B., 511, 523, 562
Veit, Philipp, 218
Vela (Italian artist), 329, 564
Venice, 519
Venice, 129, 279, 493. See also Italy and the Italians; specific exhibitions, people, works
Venice's Festive Celebration for Caterina Cornora, 557
Venus, 400–2, 421, 431
Vénus de Milo, 8
Verbindungen deutscher Kunstvereine für historische Kunst, 183–84, 217
Vernes, Théodore, 433 n
Vernet, Horace, xxviii, 4, 79, 83, 86–87, 112, 121, 197, 244, 279, 320, 405, 496, 514
Vernet, Joseph, 85
Vernier (French painter), 389
Veronese, Paolo, 105, 160, 488, 556
Vertunni (Italian painter), 562
Vestiges of the Natural History of Creation (Chambers), xxix
Vibert (French painter), 524, 525
Vicar of Wakefield (Goldsmith), scene by Maclise from, 46
Vico, Giambattista, 445–46, 449
Victor Emmanuel II, King (Italy), 133, 296–97; statue of, 296
Victoria, Princess (Prussia), 179
Victoria, Queen (Great Britain), xxiv, 51, 54, 170, 244, 355
Viel, Jean-Marie, 108–9
Vienna, xxiii, xxvi, 128, 129, 220, 512, 521, 545–76; Academy, 501, 546; Baubureaustil, 549; Franz Joseph and modernization of, 547–49; Ringstrasse, 548; Universal Exposi-

tion of Arts and Industry (1873), 545–76
View of Pescarenico, 438–39
View of Venice, 386
Views of Switzerland, 428
Views of the Seine, 427
Village Maidens, The, 207, 289
Villani, Giovanni, 305
Villedeuil, Count de, 79
Villemessant, Hippolyte, 456
Villot (curator of painting, Louvre), 83, 112
Vingt, Les (periodical), 539
Violinist, The, 527
Vischer, Friedrich T., 221, 222, 449
Voillet-le-Duc, Eugène A., 383, 494
Volunteers Enlisting, 91
Von Hansen, Theophilus, 548
Vossische Zeitung (publication), 179
Vote Universel, 6
Vow, The, 512
Vow of Louis XIII, The, 210
Voyage in Biblical Lands, 262
Voyages in Ancient France, 93
Vraie République, La (publication), 167

Waagen, Gustav E., 52, 164–65, 166, 179, 184
Wächter (German painter), 230
Wagner, Richard, 159, 186, 494, 497, 530, 543; Der Ring des Nibelungen, 494, 507; The Flying Dutchman, 543; Lohengrin, 494, 543; Tannhäuser, 543; Tristan und Isolde, 494
Wait, The, 292–93
Waiting, 412
Waldmüller, F. G., 193–94, 511, 512
Walewski, Comte, 380, 381–82, 390
Wappers, Gustave, 536
War, 287–88
Ward, E. M., 44 n
Washington Crossing the Delaware (Leutze), 234
Watercolor societies, British, xxvii, 415
Watercolors (watercolor artists), xxvii, 415. See also specific exhibitions, people, places, works
Watteau (French painter), 150, 151
Webb, Phillip, 358
Wedgwood statue, 359
Wellington, Duke of, 30

Werner, Fritz, 181 n
Whistler, James McNeill, 361–62, 428–29, 430
Widow's Elder Son, The (Castan), 512
Wiegmann (German art critic), 184
Wiener Zeitung (publication), 113
Wiertz, Antoine, 551
Wild Hunt, 181
Wilkie, Sir David, 43
William I, King (Netherlands), 533
Williams, T. R., 254
Wilson, Charles Heath, 34
Winckelmann, Johann, 15
Winterhalter, Francis X. (François), 16, 180, 197
Woman in White (Whistler), 428–29, 430
Woman with a Parrot (Courbet), 459, 526
Woman with a Parrot (Manet), 461, 462
Women of Algiers, 153
Wood engravings, v, xxx. *See also* specific exhibitions, kinds, people, places, works
Woolner, Thomas, 32
Work and Repose, 403
Wornum, Ralph N., 58
Wounded Achilles (Fracaroli), 303
Wounded Bear Smothering a Man (Frémiet), 23–24
Wreck of the Hope, The (Friedrich), 226
Wrestling in "As You Like It," The (Maclise), 102–3
Writing Lesson, The (Collinson), 104

Württemberg, artists in Paris Exposition (1855) from, 111
Wyatt, Matthew Digby, 57
Wynants, Jan, 28

Young England movement, 36, 38
Young Genius of Franklin, The (Monteverde), 564
Young Ladies of the Village (Courbet), 95–96
Young Mendicants of Cordova (Doré), 526
Young Woman, A (Manet), 473
Young Women on the Banks of the Seine (Courbet), 206, 207–8, 289 n
Yvon, Adolph, 197, 284

Zamacois (Spanish painter), 524, 525
Zambra, stereoscopic views by, 252
Zeitschrift für bildende Kunst (publication), xxx, 500, 501 n, 553, 569 n
Zenter, Wilhelm, 218 n
Zichy (Hungarian painter), 559
Ziem, Félix, 90
Zimmerman, Albert, 239
Zola, Émile, 456–59, 462–75, 483; "Claude" as pseudonym of, 456–57, 463–75; Manet's portrait of, 461–62, 473–75; *Mon Salon* by, 456–57, 463–75
Zona, Antonio, 324, 325
Zumbusch, Kaspar, 548
Zur Farbenlehre (Goethe), 34
Zurich, Switzerland, 381
Zwehl, and opening of Munich exhibition (1858), 217